T0393276

# NINETEENTH-CENTURY INTERIORS

# NINETEENTH-CENTURY INTERIORS

*Edited by*
*Clive Edwards*

**Volume I**
**Theories and Discourses Around the Home**

Routledge
Taylor & Francis Group

LONDON AND NEW YORK

First published 2024
by Routledge
4 Park Square, Milton Park, Abingdon, Oxon OX14 4RN

and by Routledge
605 Third Avenue, New York, NY 10158

*Routledge is an imprint of the Taylor & Francis Group, an informa business*

*British Library Cataloguing-in-Publication Data*
A catalogue record for this book is available from the British Library

ISBN: 978-1-032-26913-9 set
ISBN: 978-1-032-26915-3 (volume I) hbk
ISBN: 978-1-003-29049-0 (volume I) ebk

DOI: 10.4324/9781003290490

Typeset in Times New Roman
by Apex CoVantage, LLC

# CONTENTS

**VOLUME I   THEORIES AND DISCOURSES**
**AROUND THE HOME**

*General Introduction*                                                    xiii

**PART 1**
**Aesthetics and Beauty**                                                  1
**Introduction**

1   'Some Remarks on Architectural Design, as Affecting
    the Inferior Arts Connected With Building'                             7
    EBENEZER TROTMAN

2   'Making the Best of It'                                               13
    WILLIAM MORRIS

3   'Art in Domestic Matters; or Æsthetics in the House'                  21
    R. W. ARNE

4   *Beauty in the Household*                                             29
    MARIA O. DEWING

5   *Beauty in the Household*                                             35
    MARIA O. DEWING

6   'Principles of Interior Decoration'                                   41
    ROBERT W. EDIS

# CONTENTS

**PART 2**
**Taste**                                                                49
**Introduction**

 7 'Homes of Taste'                                                  55
   SHIRLEY HIBBERD

 8 'Mr. Eastlake on Taste'                                            65
   [ANON]

 9 'Principles of Good Taste in Furniture'                            73
   [ANON]

10 *Principles of Domestic Taste:* A Lecture delivered
   in the Yale School of the Fine Arts                        83
   EDWARD ELBRIDGE SALISBURY

11 'Principles of Good Taste in Furniture and Decoration'                 89
   [ANON]

12 *The House in Good Taste*                                              95
   ELSIE DE WOLFE

13 'Good and Bad Furniture'                                              105
   GEORGE L. HUNTER

**PART 3**
**Decorating Advice**                                                    111
**Introduction**

14 *The Cabinet Dictionary*                                              119
   THOMAS SHERATON

15 'Concerning Interiors'                                                125
   HUMPHREY REPTON AND JOHN CLAUDIUS LOUDON

16 'The Dining Room. No. I' 'Hints for the Decoration
   and Furnishing of Dwellings'                             133
   [ANON]

CONTENTS

17  *Home Truths for Home Peace*                                    143
    M. B. H.

18  'The Arts in the Household; Or, Decorative Art
    Applied to Domestic Uses'                                       149
    JOSEPH BEAVINGTON ATKINSON

19  'Interior Decoration of the House', 'The Influence
    of Art in Daily Life'                                           157
    JOSEPH BEAVINGTON ATKINSON

20  *Ornamental Interiors Ancient & Modern*                         167
    J. MOYR SMITH

21  'Decoration of the House'                                       177
    JOHN ALDAM HEATON

22  'What to Avoid in House-Furnishing'                             183
    MARTHA CUTLER

**PART 4**
**Cleanliness and Housekeeping**                                    **191**
**Introduction**

23  'On the Care of Parlors'                                        197
    CATHERINE ESTHER BEECHER

24  *Miss Leslie's Lady's House-Book: A Manual of Domestic
    Economy, Containing Approved Directions for Washing,
    Dress-Making, Millinery*                                        203
    ELIZA LESLIE

25  'The Influence of Order, Method, and Cleanliness, in Factories
    and Workshops, Upon the Homes of the Industrial Population
    of Large Towns'                                                 211
    SAMUEL WALL RICHARDS

26  *Household Organization*                                        223
    FLORENCE CADDY

CONTENTS

27  *The Art of Housekeeping: A Bridal Garland*                               233
    MRS MARY HAWEIS

28  *Common-Sense Homes: A Practical Book for Everybody Upon*
    *the Essential Equipment and Treatment of the Home*                       241
    SPENCER SILLS

**PART 5**
**Comfort**                                                                   **247**
**Introduction**

29  *Saunterings in and about London*                                         253
    MAX SCHLESINGER AND OTTO WENCKSTERN

30  'Home Is Home Be It Never So Homely'                                      263
    HENRY MAYHEW

31  'Our Household Goods'                                                     271
    [ANON]

32  *The Gentleman's House: Or, How to plan English residences, from*
    *the parsonage to the palace; with tables of accommodation*
    *and cost, and a series of selected plans*                                279
    ROBERT KERR

33  *Notes on England*                                                        283
    HIPPOLYTE TAINE

34  *Thrift*                                                                  287
    SAMUEL SMILES

**PART 6**
**Domesticity**                                                               **291**
**Introduction**

35  *The Nemesis of Faith*                                                    297
    JAMES ANTHONY FROUDE

36  'The Home Paradise'                                                       301
    JOSEPH WATTS LETHBRIDGE

CONTENTS

37  'Three Hundred Pounds a Year'                              307
    ELIZA COOK

38  'The Ideal Home'                                           311
    ANNIE S. SWAN

39  *Shelter and Clothing: A Textbook of the Household Arts*   317
    HELEN KINNE AND ANNA M. COOLEY

**PART 7**
**Gender and Identity**                                        **321**
**Introduction**

40  'Decorating Art as an Employment for Ladies'               327
    [ANON]

41  'Women's Aesthetic Mission'                                339
    JACOB VON FALKE

42  'How to Decorate a Room'                                   347
    LEWIS F. DAY

43  *The Duties of Women: A Course of Lectures*                357
    FRANCES POWER COBBE

44  'Relations of Interior Decoration with Costume
    and Complexion'                                            363
    [ANON]

45  'Women and Men: Women as Household Decorators'             369
    [ANON]

46  'Amateur and Architectural Amateur Decorators'            375
    J. MOYR SMITH

47  'How to Beautify a Home'                                   381
    MARY TEMPLE BAYARD

48  'Interior Decoration as a Profession for Women'            389
    CANDACE WHEELER

# CONTENTS

49  'Mrs. Kate Collins the Artist-Decorator'                       397
    MRS OLIVER BELL BUNCE

50  'A Beautiful Woman's Home'                                     405
    MARQUISE DE FONTENOY

51  *The Home, Its Work and Influence*                             417
    CHARLOTTE PERKINS GILMAN

52  'The Views of the Woman in the Home'                           427
    AVERIL FURNISS, DOROTHY SANDERSON AND MARION PHILLIPS

**PART 8**
**Role of Architects, Designers and Decorators**                  **435**
**Introduction**

53  'The Architect Versus the Cabinet Maker and Others'            441
    [ANON]

54  'Doing Up One's House'                                         447
    MRS M. J. LOFTIE

55  'The Relation of the Architect to the Decorator'               453
    LEWIS FOREMAN DAY

56  'The Aims and Conditions of the Modern Decorator'              461
    CHARLES FRANCIS ANNESLEY VOYSEY

57  'Crace Company'                                                473

**PART 9**
**Role of Retailers and Purchasing Practices**                    **479**
**Introduction**

58  *Home Truths for Home Peace, or 'Muddle' Defeated, A Practical*
    *Inquiry Into What Chiefly Mars or Makes the Comfort of*
    *Domestic Life. Especially Addressed to Young Housewives*      485
    M. B. H.

CONTENTS

59 'An Art Room' 493
JOHN V. HOOD

60 'A Visit to Bailey, Banks & Biddle's Art Rooms' 499
R. RIORDAN

61 *Two Centuries of Soho: Its Institutions, Firms,*
*and Amusements* 511
J. H. CARDWELL

62 'Decoration by Correspondence' 519
LEWIS FOREMAN DAY

63 'Parlours' 527
JANE ELLEN PANTON

64 'Hints to Purchasers' 541
JOHN H. ELDER-DUNCAN

65 *Hints on House Furnishing* 547
WALTER S. SPARROW

**PART 10**
**Spiritual Matters** **553**
**Introduction**

66 'The Happy Home' 559
JESSE E. DOW

67 *Remarks on Secular and Domestic Architecture,*
*Present and Future* 563
GEORGE GILBERT SCOTT

68 'Luxury in House Decoration' 569
[ANON]

69 'The Ethics of Home Decoration' 575
JAMES RUSSELL MILLER

CONTENTS

70  *The Hearthstone, or Life at Home: A Household Manual
    Containing Hints and Helps for Home Making: Home
    Furnishing; Decoration; Amusements . . . Together
    with a Complete Cookery Book*                                    581
    LAURA C. HOLLOWAY

    *Bibliography*                                                   590
    *Index*                                                         607

# GENERAL INTRODUCTION

This work is a four-volume edition of primary source materials (mainly British and US) that document the histories of domestic interiors across the long nineteenth-century (c. 1789–1914). The four-volume format has offered an opportunity to multiply the number of texts and their length, as opposed to short or edited excerpts, and therefore much of this selection includes complete articles or book chapters. The texts are arranged thematically, then within the sub-themes, chronologically. The mix of well-known and lesser-known texts is intended to demonstrate a range of, sometimes competing, approaches to the themes.

It might be argued that the availability of online sources of published works has made anthologies redundant. However, the prodigious amount of information now available electronically actually increases the need for some form of direction and navigational assistance through an edited selection of texts. Therefore, anthologies remain essential as guides to a field that would otherwise be overwhelming. Anthologies also act as compact accounts of a larger story that stand as both a gateway and a guide. Inevitably, anthologies are about exclusions as well as inclusions, but the choices made in this selection are considered as one part of a set of helpful tools towards an understanding of the beliefs and practices, theories, actions, politics and practices related to the domestic interior in the nineteenth century.

This general introduction first considers some of the major themes and strands covered by the entire edition. It then briefly considers the publishing history of nineteenth-century interiors. This is followed by an overview of the individual volume contents that introduce the range of topics covered. Finally, there is a brief note on the rationale and the editorial processes used.

## GENERAL THEMES AND STRANDS COVERED BY THE ENTIRE EDITION (4 VOLUMES)

The nineteenth century, often imprecisely described as the Victorian Age,[1] was particularly distinguished by immense and volatile changes and progress in most arenas of activity. Although there were numerous wars and conflicts, political upheavals, dynastic changes and economic disruptions, great progress was made

in the fields of science and technology, arts, literature and culture, and some progress on social changes. Alongside these issues was the continuing development of capitalism and business, the politics of colonialism and abolition, and an increasing interest in philosophy and religion. Britain's attitude towards these changes was initially one of certainty and conviction built partly on economic success, but this was ultimately usurped by feelings of doubt about its role and position in the world.

The reasons why we can start a consideration of the interior in the nineteenth century are numerous. The importance of the pace of change, the nature of industrialization and the changes that it wrought meant that the concept of 'dwelling' and the use of spaces in other contexts became altogether different issues, away from the production and distribution of goods. The growth of nationalism and liberalism, in part stemming from the French Revolution, provided the background for the changes that were to make this the century of transition. The gradual reforms in education and representation of the people, and the developments in industrialization and communication, were all part of a tendency towards improvement, growth and material gain. Other changes, such as the development of electrification, personal communications and the mechanization of many parts of industry, all helped to develop and improve the infrastructure that was necessary for an expanding economy.

There is no doubt that during the nineteenth century, a redistribution of wealth encouraged more spending on consumer goods. However, overall there was an ongoing change in most people's approaches to their spaces. Living conditions gradually improved, assisted by sanitary improvements, and this in turn laid stress on the notions of comfort and well-being, certainly for the burgeoning middle classes.

Architecturally, the search for a style for the nineteenth century was confounded by the demands of the new age. Railway stations, hospitals, courts, museums, factories and warehouses all made demands on architecture and interior design and planning that they were ill-equipped to handle. The search for, and the subsequent battle of, styles led to an eclectic approach to architecture, and consequently furniture and furnishing design, which resulted in a series of revivals and other configurations. In contrast, there were the industrialized building changes of Joseph Paxton, Henri Labrouste and Gustave Eiffel, who employed iron and glass in their work. This meant that an alternative visual ethos developed in parallel; one that would only be fully recognized in the early twentieth century. However, this was certainly, in terms of interiors, a minority taste, and eclecticism actually better reflected the varying tastes of the wide range of consumers.

## The Industrial Revolution: Workshop of World

The Industrial Revolution is a blanket term that embraces the technological, scientific and industrial innovations that were further developed during the century, thus fuelling a massive increase in production and subsequent consumption. In response to these enormous changes and the upheaval they brought with them,

there were many who found the revolution highly disturbing and morally unsatisfactory. They challenged the conditions within workplace, the use of child labour, and the development of cities with their associated pollution, poverty and disease. These challenges were addressed directly by social reformers, but in terms of interiors it was often the case that the opposition between industry and culture was expressed in nostalgic and romantic terms. However, the technological changes in materials and processes had a substantial impact on the nature, cost and design of the furnishings of homes of the period.

## Social Reforms and the Growth of Democracy

Rapid and unregulated industrialization brought about increases in wealth and economic success, but it also brought a host of social and economic problems. These were characterized in the population by poor health, unemployment, poverty and rioting. This age saw the rise and growth of political movements, particularly socialism, liberalism and later, organized feminism. The Chartists' organization of workers helped create an atmosphere open to further reform, whereby religious belief in the infallibility of the Bible, and the nature of the human species in the universe, were increasingly called into question.

Although society was ostensibly ordered by rankings, there were some opportunities for social and geographical mobility. Entrepreneurs used their growing prosperity to buy into society, professionals developed their practices and a growing middle class developed. For some, the impulse to emigrate, for hopes of self-improvement was also a key feature of the century. However, by 1901, forty per cent of adult men were still ineligible to vote, and no women were enfranchised, so for many, democracy was an illusion. Nevertheless, the social changes that included the growth of the concept of domesticity; a clear work ethic; the model of improvement; the developing roles for women; the increasing educational and employment opportunities, and the growth of leisure, were particularly linked to the rise of the middle classes. In terms of homes and interiors these classes required differentiation in their consuming patterns, but were conversely somewhat limited by the demands of social conformity.

## Expansion of Empire and a World Power

The rise of competitive colonialism was linked to Britain's trading dominance, naval and military strength, and the growth of other major nation states. In the latter part of the century, i.e. from 1870 on, there were increasing threats to Britain's military and economic supremacy. Nevertheless, the jingoistic idea of Empire was a very powerful concept that was supported by British notions of free trade and Christian civilization, which were buoyed by attitudes of racial superiority, that made expansion seem almost inevitable. In terms of design, there was a two-way traffic in both goods and cultural imagery that was seen as commercially successful in England, though it was simultaneously potentially debasing to indigenous cultures.

## Taste

By the 1790s, a plurality of design styles was developing that included versions of the classical, the exotic and the gothic. These were all linked to aesthetic judgements that were often based around the picturesque, which stressed both the importance of the visual and the unity of the arts. This plurality was to grow into a major concern for nineteenth-century design reformers, not least in relation to the issue of a national taste or style.

The idea of the development of a national taste that would raise the aesthetic threshold and act as a guide to morality and propriety was therefore of great concern. The perceived problem of novelty and fashion, which appeared subversive, had to be countered by the development of 'good taste' and appropriate education. This proved to be easier said than done. In fact, a major issue that was to confront the British design world was the rapid development of a design infrastructure in Europe, especially in France and Germany. By the beginning of the nineteenth century, these countries had already developed design education, with the establishment of specialist schools and technical institutes. Both countries developed exhibitions of manufactured goods: in France from 1798 and in Germany from 1812. The issue of 'good taste' was therefore closely linked to economics, politics and education as well as societal norms.

## Nineteenth-Century Domestic Interiors

Domestic interiors are intimately related to both house and home. The house is a fixed shelter whereas the home often refers to the interior space and its furnishing and decoration. However, it also implies an idea and a set of complex emotions, that merge together with the physical spaces. The *Oxford English Dictionary* defines the interior as 'the inside of a building or room, esp. in reference to the artistic effect' with the earliest example of this use notably being from 1829. Although this conscious 'artistic effect' had clearly been in evidence before the nineteenth century, it was in this period that the most important social change, the usurpation of the aristocracy as arbiters of taste in favour of a prosperous middle class, developed rapidly. The employment of an architect (in limited cases), a retailer or upholsterer, or the perusal of contemporary journals and writings were the main ways by which people could develop their interiors, until the advance of professional interior decorators/designers in the late nineteenth century.

The ideal of a respectable family and the associated cult of the home developed through the century. However, it should be borne in mind that the concept of home is an ambiguous one. Houses as physical shelters and homes as spaces in which humans interact makes for complexity. In addition, as David Benjamin has pointed out, 'the home is a symbol, so that even though we recognize it, and "know it", it will always defy a rational deconstruction and complete explication of its meaning content'.[2]

The home was also one of the opposites in a series of culturally separate spheres, which included 'the inside' and 'the outside', respectability and deviance, and industry and home. The introduction to the Census of Great Britain for 1851 confirms this ideal of home: 'The possession of an entire house is, it is true, strongly desired by every Englishman; for it throws a sharp, well-defined circle round his family and hearth – the shrine of his sorrows, joys, and meditations'.[3]

As the subtle graduations of goods developed ever more, the meanings they held, which were designed in part to deal with the nonverbal communications, became more complex. A knowledge and understanding of the narrative nature of selected objects, intended to reinforce respectability was increasingly important. Furnishings became more domesticated and homely, although they initially related morals to comfort, and not directly to presentation. These considerations were achieved in great measure by the common use of a language of display that was both shared and individual, which was both 'purchased' from a retailer and 'constructed' at home.

According to Walter Benjamin, 'we must understand dwelling in its most extreme form as a condition of nineteenth century existence'.[4] He went on to explain his take on the concept of the nineteenth-century home.

> The original form of dwelling is existence not in the house but in the shell. The shell bears the impression of its occupant. In the extreme instance, the dwelling becomes a shell. The nineteenth century, like no other century, was addicted to dwelling. It conceived the residence as a receptacle for the person, and it encased him with all his appurtenances so deeply in the dwelling's interior that one might be reminded of the inside of a compass case.[5]

Benjamin was critical of nineteenth-century patterns of family life and the 'cluttered' interiors that supported them. He thought that, as society took on the role of warmth and security associated with the home, there would only be a need for sparse living spaces so that material things became less important than a social spirit.

This theme is of course explored through the texts in the volumes of this series and rather shows that his ideas were not fulfilled, but rather adapted to the changing conditions of society, economy and fashion.

## PREVIOUS PUBLISHING HISTORY ON NINETEENTH-CENTURY INTERIORS

Early interest in nineteenth-century interiors and their furnishing was initially developed by publications aimed at connoisseurship and collecting. Early academic interest in the topic was demonstrated by the 'Victorian Exhibition' held in 1931, which took over 23a Bruton Street, London, where its rooms were furnished in a mid-Victorian style. One-time director of the V&A (1909–1924) Sir

Cecil Harcourt-Smith chaired the scheme. A contemporary review of the exhibition noted

> Leading from this landing was the Morris Room, excellent as showing the contrast between the truly Victorian taste and that of the first of the Moderns, though its vivid clashes of colour and insistence on pattern would make it a very trying room to live in to-day.[6]

In 1930 John Betjeman published an illustrated article titled '1830–1930-still going strong: A guide to the recent history of interior decoration' in *The Architectural Review*.[7]

In 1952, a seminal exhibition, titled *Victorian and Edwardian Decorative Arts*, was held at the V&A. It was responsible for increasing the interest in Victorian design studies far more widely.

In the mid-century, topics such as the symbolism of the home and technological developments were written about. Siegfried Giedion's *Mechanisation Takes Command* (Oxford University Press, 1948) looked at aspects of the home as part of an industrial or even managerial revolution. Ralph Dutton's *The Victorian Home: Some Aspects of Nineteenth-Century Taste and Manners* (Batsford 1954) looked at the nineteenth-century interior through a social history approach. In 1961, Winslow Ames published 'Inside Victorian Walls' in *Victorian Studies*,[8] and in the same year, John Gloag's *Victorian Comfort. a Social History of Design 1830–1900* was published.

Pictorial source books are one particular genre that illustrate nineteenth century primary source materials with or without commentary. These survey books include Mario Praz, *An Illustrated History of Furnishing from the Renaissance to the 20th Century* (Thames and Hudson 1964); Nicholas Cooper and H. Bedford Lemere, *The Opulent Eye: Late Victorian and Edwardian Taste in Interior Design.* (Architectural Press 1980); Peter Thornton, *Authentic Decor: The Domestic Interior 1620–1920.* (Weidenfeld & Nicolson, 1984); Edgar de N Mayhew and Minor Myers, *A Documentary History of American Interiors: From the Colonial Era to 1915.* (Scribners 1986); Jeremy Cooper, *Victorian and Edwardian Furniture and Interiors: From the Gothic Revival to Art Nouveau* (Thames and Hudson, 1987) and Charlotte Gere, *Nineteenth Century Nineteenth Century Decoration: Art of the Interior* (Thames and Hudson, 1989.)

More recently, other disciplines including anthropology, architecture, geography, design history, material culture studies and political science have considered interiors as spaces worth investigating. These may be from the point of view of semiology, Marxist consumption theory, gender studies, social contexts, as well as interdisciplinary approaches. These include Mark Girouard, *The Victorian Country House* (Clarendon Press, 1971): Asa Briggs' 'Hearth and Home' chapter in *Victorian Things* (Penguin Books 1990); Janet Floyd, et al. *Domestic Space: Reading the Nineteenth-Century Interior* (Manchester University Press, 1999); Deborah Cohen, *Household Gods: The British and Their Possessions*, (Yale

University Press, 2006): Stefan Muthesius *The Poetic Home: Designing the 19th-Century Domestic Interior*, (Thames and Hudson 2009). These works are only indicative of some of these approaches, since a meaningful bibliography is well beyond the scope of this introduction.

A very brief selection of other academic publications addressing various aspects of the nineteenth-century interior include M. J. Daunton, *House and Home in the Victorian City: Working-Class Housing 1850–1914* (1983); P. Tristram, *Living Space in Fact and Fiction* (1989); C. Hall, 'The sweet delights of home,' in (ed), M. Perrot, *A history of private life: from the fires of revolution to the great war* (1990), pp. 47–94; V.D. Dickerson (ed)., *Keeping the Victorian House: a collection of essays* (1995); K.C. Grier *Culture and Comfort* (1998); T. Logan, *The Victorian parlour* (2001); L. Davidoff and C. Hall, *Family fortunes: men and women of the English middle class* revised edition (2002); M. Ponsonby, *Stories from Home: English Domestic Interiors 1750–1850* (Aldershot, 2007), Jane Hamlett, *Material Relations: Domestic Interiors and Middle-Class Families in England, 1850–1910*, (Manchester University Press, 2015).

Numerous articles have appeared in a wide range of journals including *Home Cultures*, *Journal of Design History*, *Interiors*, *Design and Culture*, and academic research through dissertations and publications in a wide range of disciplines has addressed aspects of nineteenth-century interiors. Specialized institutions such as the Museum of the Home (London), Museum of Domestic Design and Architecture, (Middlesex University) and the Kingston School of Art's Modern Interiors Research Centre are promoting research into the subject.

A word should be said about published readers or anthologies that have addressed the topic more recently. One of the first was Bernard Denvir's *Documentary History of Taste in Britain*. The relevant volumes were *Art Design and Society – The Early Nineteenth Century 1789–1852* (1984) and *The Late Victorians 1853–1910* (1986). More recently *Intimus: Interior Design Theory Reader* (Academy Press 2006), and *The Domestic Space Reader* (eds.) Chiara Briganti and Kathy Mezei (Toronto University Press 2012) have been published.

Finally, a whole industry around 'Victorian interiors' has grown up, with an enormous range of publications from decorator magazines to coffee table books, from journals to academic publications on many aspects of the period and its design in the broadest sense. These include period surveys, books on individual designers and critics, books on various product groups, all ranging across a wide field, from the popular to the collector/connoisseur, to academics of many various persuasions.

## OVERVIEW OF THE CONTENTS OF EACH VOLUME

### Volume I: Theories and Discourses Around the Home

The first volume concerns the nature of the home and the theories and discussions around the concept thereof. The discourses also address the process of purchasing and decorating a home, advice on decoration and home management, the nature of

taste and comfort, and the symbolic roles of the home as an anchor in society. The main headings addressed are aesthetics, taste, decorating advice, cleanliness and housekeeping, comfort, domesticity, gender and identity, role of architect, role of retailer and purchasing practices, and spiritual matter and morality.

## Volume II: Styles of Decoration and Design

This volume considers the nineteenth-century search for a representative style and the alternating fashions for interiors that demonstrated the consumerism of the period. Although in some senses every interior is unique, so that a style canon may seem to be meaningless, there have been important historical trends or styles that have influenced individual interiors, and these have formed the groundwork on which other styles and tastes have developed and changed.

The volume also looks at the class divisions that become evident with the ostentatious lifestyles of political and society hostesses at the peak, whilst middle-class housing, often in suburbia, seemed to have created a separation of home and work, arguably suggesting men and women lived in separate spheres. Working-class interiors, often seen through the eyes of middle-class observers, were at the bottom of the hierarchy and often reflected concerns of social inequality and misery. The range of styles that were employed during the century ranged from antiquarian to avant-garde; from the utilitarian to the exotic; and from the Greek Revival to Art Nouveau.

## Volume III: Domestic Interior Spaces

The third volume investigates domestic interior spaces. This volume includes texts that look at the particular spaces of the nineteenth-century home, as rooms often became more precisely planned according to specific purposes even while the styles reflected the owner's taste and position. The range is of course vast – from single-room dwellings to large-scale mansions and numerous variations in between. The extracts consider aspects of each room in turn. The first set of texts considers overviews which are then followed by specific room discussions. The following set looks at particular spaces, their furnishing and decoration.

## Volume IV: Products and Processes

The fourth volume addresses the essential practical aspects of making a home, decorating it and then furnishing it. The crucial constitutive parts that make up an interior from floor to ceiling are considered here in detail. The role of advice books and articles that attempted to direct homemakers in particular directions are of importance here, as are the more practical how-to publications that demonstrated the processes of interior decoration. These cover the following topics: flooring (including carpets and rugs); walls and wallpaper; ceilings; woodwork; paintwork; plasterwork; colour schemes; furniture and furnishings; textiles and

drapery; fireplaces and mantelpieces; lighting; plumbing and sanitation and water supply; ventilation and heating; home management; pets and animals (live and stuffed); and DIY and home crafts.

## *A Note on the Selection and Presentation of the Texts, and the Editorial Principles*

The aim of this work is to offer an overview of aspects of and attitudes towards interiors as reflected in the writings by contemporary commentators. It is not a history of interiors in the period; rather, it is a collection of selected texts that explore and explain a range of aspects of the nineteenth-century interior. The volumes are intended to stand alone, but each one will inform the other in an overall picture of nineteenth-century interiors. Taken together, these annotated sources with their contextual introductions and headnotes present a valuable overview of a broadly defined field of design during the long nineteenth century.

Texts have been taken from books, newspapers and journal publications. In many cases we have reproduced the full text of an article or chapter. In some cases, missing text is indicated by ellipsis. In other cases, extracts are used that make a particular point. It is worth noting that several of the selected texts cross over the topic divisions or themes in which they are located and could easily fit elsewhere. The texts are written mainly by English-speaking authors, with around one-fifth of them being published in the United States. In particular cases, works were published in both countries, some being edited to suit the local market, Eastlake's famous text *Hints on Household Taste* being the most obvious example.

The transcriptions in the volumes aim to preserve as much of the original format as may be meaningful. Original capitalization and italicization have been retained where possible and American spellings have also been retained. Original punctuation has mainly been respected with the occasional addition of a comma for sense. It is also important to note that different editions, and even individual copies of the texts transcribed here, can have variations.

The choice of texts includes material that is well known to scholars, as well as lesser-known sources. The guiding principle in selecting texts has been to assume that well-known and important texts are more likely to be useful to students or interested lay readers than to established scholars working in the field. With the same idea in mind, the introductions to each sub-topic prepare the reader for a greater understanding of the particular subject matter than would otherwise be possible if simply considering the sources without some context. At a more drilled-down level, the headnotes to each individual text offer details about the author when they are known; details of the publication and its after-history if relevant; and any thematic and textual relationship to other works by the author, as well as to other contemporary works. The contemporary critical reception of the texts is also of interest because this offers further insights into the attitudes and debates of the time. In this regard, extensive reference and quotation from primary sources is made.

Finally, it is recommended that these readings are combined or connected with viewings of actual interiors in relevant houses and collections, in order to relate to them more closely and therefore understand something of the nature of nineteenth-century interiors.

## Notes

1 George III reigned up to 1820, George IV from 1820–1830, and William IV between 1830 and 1837.
2 David Benjamin and David Stea, *The Home: Words Interpretations Meanings and Environments*, (Aldershot: Avebury 2000).
3 *The Census of Great Britain in 1851* (London: Longman, Brown, Green, and Longmans 1854), p. 8.
4 Walter Benjamin, *The Arcades Project,* (Cambridge, Mass: 1999), p. 220.
5 Ibid. p. 256.
6 B. B., 'Ghosts at the Victorian Exhibition', *Connoisseur,* 88, July 1931, p. 58.
7 John Betjeman, "1830–1930-still going strong: A guide to the recent history of interior decoration," *The Architectural Review* 67, 402, 1930, pp. 230–240, 240a, 240b, 241–252, 252a, 253–260, 260a, 261–268, 268a, 269–272.
8 Winslow Ames, 'Inside Victorian Walls', *Victorian Studies,* 5, 2 (December 1961), pp. 151–162.

# Part 1

# AESTHETICS AND BEAUTY

# AESTHETICS AND BEAUTY

The works of Kant and Hegel that suggested idealist concepts of aesthetics, recognized the experience of beauty with disinterested satisfaction (or dissatisfaction) whereby beauty was not a property of any object, but an aesthetic decision based on an individual's feelings. During the early part of the nineteenth century this approach started to be challenged by the materialist idea of the aesthetic being subject to the same 'laws' as other physical things where beauty was recognized in an object's or a space's fitness for use. Nineteenth-century aesthetic discourse then concerned itself with both a subject's emotional experience and an object's qualities, which were determined by what kind of object it was.

In his *The Philosophy of the Beautiful* 1848, the French philosopher and historian Victor Cousin suggested that 'the three conditions of Beauty are, the moral idea, unity, and variety'.[1] These ideas were reflected in the majority of nineteenth century interiors in one way or another. The moral idea was addressed by both the concept of home as a centre of morality as well as by more prosaic idea such as truth to materials in products and an acknowledgement of status in society. Unity in the decoration of spaces was one the key concepts advised by reformers and commentators alike. In parallel with this notion was the introduction of variety and personality into the home by way of choices in accessories and home crafted objects. The aesthetics of decorating a home therefore went beyond the physical design and decoration, in that the results were important signifiers of the owner's intellect, social status and taste.

The American author Helen Campbell, in her text on household economics, commented that decorative laws and principles of design had become 'the study of the worker, and man's creations blossomed into beauty as naturally as those of God. Careful and extended study will be needed here, for this subject of "mere decoration" is one of the most vital in household economy'. She went to explain the role of beauty in the household:

> until every student of household economics recognizes that such beauty
> is part of the house and must be learned with no less diligence than aught
> else that goes to the making of a home, it cannot be, as it must come to
> be, the simple, natural inheritance of the nation. Beauty in the home must

DOI: 10.4324/9781003290490-2

come from that higher knowledge given by the higher education, and in such beauty will come the repose and calm that we sigh for and seek, and seek in vain, amid surroundings that would turn the Greek into a basilisk and draw a grin from even a South-Sea islander.[2]

The texts in this section cover a range of approaches to beauty and aesthetics: from a plea for the application of design principles over mere effects to William Morris's call for order and meaning; from Arne's notion of fitness and his bizarre associations to concepts of precedent and the picturesque and the rejection of sham effects.

## Notes

1  V. Cousins, *The Philosophy of the Beautiful. Translated with Notes and an Introduction by Jesse Cato Daniel* (London: William Pickering 1848), p. 134.
2  Helen Campbell, *Household Economics: A Course of Lectures in the School of Economics of the University of Wisconsin* (New York: G. P. Putnam's Sons, 1896), pp. 89 and 94.

# EBENEZER TROTMAN, 'SOME REMARKS ON ARCHITECTURAL DESIGN, AS AFFECTING THE INFERIOR ARTS CONNECTED WITH BUILDING' (1835)

## Editorial Headnote

Ebenezer Trotman (1809–1865) was an English architect specializing in churches and railway stations. Much of his work was carried out as principal assistant to Sir William Tite, whose efforts were often associated with railway stations, cemeteries and especially the Royal Exchange in London. Trotman also wrote a long and detailed entry on the native British pointed style architecture and its suitability for domestic buildings published in Loudon's *Encyclopaedia of Cottage Farm and Villa Architecture* (1839). This link with Loudon had been established earlier.

In March 1834, John Claudius Loudon first published *The Architectural Magazine, and Journal of Improvement in Architecture, Building, and Furnishing, and in the Various Arts and Trades Connected Therewith*. It was intended as an educational work for architects, students, and clients and was published monthly until January 1839. Trotman contributed several essays to the journal from 1834, with one particular essay titled 'On the Alleged Degeneracy of Modern Architecture', which supports his argument for pointed architecture as being simple in form and economical in cost.

Trotman followed Pugin's principles when he wrote of 'architecture, having for its first object, the expression of the parts and method of construction, and, for its second, the application of the appropriate ornament to those constructive parts'.[1]

In this article (below) written for the *Architectural Magazine*, Trotman makes an interesting observation when he suggests that it would be better for designers 'rather to modernise the antique than to Gothicise the modern, rather to modify old outlines than to fill up common place outlines with old details'.[2] The value of historic examples in relation to modern work is clear and in this article examples of the application of Gothic designs to household products a discussed.

A little later, in 1845, Trotman read a paper to the Institute of British Architects 'On the Economical Application of Pointed Architecture to Domestic Purposes', where he developed these ideas and further considered the issue of simplicity in design, and the distinction between form and decoration. He argued

> that, in the present taste for applying the architecture of the Middle Ages, we had little information before us in any published works devoted to the subject, except in ecclesiastical architecture, and absolutely nothing on the common and practical modes of design and construction which are the best adapted for every-day use. . . . The principal obstacles which have stood in the way of the successful application of ancient modes

has been the tendency to exhibit ornament at the expense of outline; not meaning by outline the studied complication of the parts of a composition for the sake of making it busy and picturesque, but those simple and well-contrasted forms arising from perfect harmony with the construction which characterise the ordinary English dwelling as late as the reign of Charles the Second.[3]

Trotman's plea (in his case based on Gothic examples) for the application of design principles over mere effects (especially in practitioners of the so-called inferior arts) was a foretaste of the major debates that were just beginning to occur, not only in architecture, but also in house decoration and design.

# 1

# 'SOME REMARKS ON ARCHITECTURAL DESIGN, AS AFFECTING THE INFERIOR ARTS CONNECTED WITH BUILDING'

*Ebenezer Trotman*

Source: Ebenezer Trotman, "Some remarks on architectural design, as affecting the inferior arts connected with building", *Architectural Magazine*, 2, 11, January 1835, pp. 3–7

By the term "inferior arts," we would be understood to refer to those which are called into operation to render an edifice complete, but which are not essentially concerned in its construction and stability. With the works of the mason and bricklayer, of the carpenter and carver, is obviously the first business of the architect; but his attention might often extend, with advantage, to the less important performances of the ironworker and cabinet-maker, not to say of the paper-hanger and upholsterer. In these we have been surprised to observe how much labour is thrown away in the endeavour to produce effect, from want of a proper acquaintance with leading principles, which would serve, not unfrequently, to abridge the toil, and improve the result in precisely the same proportion. The reason of this is obviously to be met with in the fact that superficial observers have no idea of character in minutiae, except such as may be gained from a general imitation, on a small scale, of great and striking objects. They do not discover that their originals would furnish them with details and detached features, analogous in office to the subjects which they have to decorate, and capable of being moulded into a chaste and unobtrusive consistency: but they must needs endeavour to secure character, by crowding as much elaborate detail as possible into a small space; and thus, grasping at too much, they lose all. We may take an illustration of this, in the current Gothic of stoves, grates, fenders, and the generality of ironwork; wherein the established usage is to begin at the wrong end, with the unsparing application of tracery, crockets, imitations of church windows, and the like; as one should expect to find a Grub Street versifier manufacturing an epic with bard words and the rhyming dictionary: the pains, in both cases, being rewarded with similar success. In different style, but in the same feeling, the most handsome design for such a thing as a candlestick would, a few years ago, have been sought

for in some form like that of a little Corinthian column, fluted, cabled, enwreathed with garlands, and mounted on a pedestal equally gay, with flowery festoons. To whatever degree the recent preference for Grecian models of architecture may have impoverished many of the compositions of our own day, it has at least been productive of this good effect, that it has led to the rejection of some of this frivolous crowding with ornament: thus preparing the way for a better style; a style for which, too, it has furnished material, in introducing us to a greater acquaintance with foliage and details of classical design.

It is worthy of notice, that all artificial forms of decoration, as applied to the commonest objects that come under our daily observation, where the productions of nature are not imitated, are borrowed from, and are truly the property of, architecture. Reeds, hollows, flutings, fillets, and the like, are constantly applied (somewhat indiscriminately, indeed,) to the most ordinary kinds of turnery, metal, and cabinet-work. As more decoration of figure is attempted, the more is architecture laid under contribution. Caricatured its members often may be, as applied to the inferior arts; but they are still to be referred to it as their source, varying with the popular changes in architectural taste, though lagging far behind the standard of professional acquaintance with any particular mode. Nor is it to be expected that the improvement will be much greater, until those who are intrusted with the execution of such things feel the necessity of acquiring an extensive knowledge of architectural decoration and precedent, and thus of discriminating between the showy and the expressive. In short, in all these subjects expression of purpose is everything. In Gothic furniture and fittings, for instance, the back of a chair is not to be the front of a doll's cathedral, a stove is not to be a shrine, nor a fender a miniature screen wall. As little is a clustered column to be transformed into a gas-pillar, or a buttress-flanked arch into a scraper. In such cases the borrowed and misapplied character makes those matters ridiculous, which, under a less assuming, and apparently less studied, form, would contribute to, instead of interrupting, the harmony of the architectural features with which they come into connection. Hints for the better design of such articles may be obtained without difficulty by those who have the discernment, and will take the trouble, rather to modernise the antique than to Gothicise the modern, rather to modify old outlines than to fill up common place outlines with old details. Thus, the simple flowing lines which describe the plain stalls in some of our ancient churches might be adapted to the purposes of the modern Gothic chair, with decision of character, yet without necessarily involving cumbrousness. The dogs and andirons of the old fireplaces might afford a suggestion for the improved consistency of a grate, even without causing the rejection of coal fires or of the principle of the register stove. To do this, it is not needful to seek for the relief of many mouldings, but to know how to use even one, the simplest and plainest, with force and expression. The mere chamfering-off of an edge will often bespeak more of this perception of expression than could any elaborate decoration. So acute, indeed, was such perception in the minds of our old builders, that we see them constantly adopting this particular mode of giving character to the timbers even of roofs which were

never intended to be, nor indeed could be, exposed to public sight; and that, too, in the most rugged and economical order of workmanship. Masters in their own peculiar style, they felt themselves at no loss for means by which to give significancy to their work, where, from considerations of economy, they were denied the use of elaborate ornament. We should not have found them, in the design of some commonplace piece of metal-work, covering every square inch of surface with tracery, for the purpose of classification, like the painter's explanatory "this is a lion." This architectural quackery, like other kinds, betrays itself in its overeagerness to be fine.

Those who have to do with the works of art, even in its inferior departments, have no less need than artists of a higher order, to remember that character and force of outline are matters of the first importance; and that, when these are rightly understood, a well-stored mind will supply the detail almost mechanically. In character of outline, we would understand both the expression of purpose and the expression of style; and this, as united with force, comprehends both elegance and individuality. Thus, in the outlines of the painter, the expression of purpose is identical with that distribution of form which, at the first glance, reveals the master passion of the subject; while the expression of style necessarily governs all matters of costume and of circumstance. The outlines of architectural compositions are ruled by precisely the same principles of character; in the application of which, indeed, a parallel representation with the former case might be extended to a considerable length. The same rules will hold good as we descend to all less important classes of ornamental figure; and their necessary effect will be, an increased simplicity of composition in the progress downward, and a less decided assumption of those architectural forms which we have shown to be inseparable from the decoration of all regular figures. Thus, to revert to a former simple object of comparison, we shall, of course, be led to reject the conceit of the Corinthian-column candlestick, and to give the preference to forms which, as applied to a thing so diminutive, will be more free and intelligible: to those, for instance, of a few intertwining bay leaves, or a modified acanthus. Designs of this character are now, fortunately, not uncommon in our shops; and are frequently executed, in the soberness of bronze, with much taste and beauty. It is to subjects which require boldness and ornament, without much architectural pretension (especially as associated with the features of the Italian style), that the mode of decoration known as that of Louis XIV., is so admirably adapted. It is, indeed, a mode which, when amplified, and carried to such an excess as to interfere with, or to supersede, the members of regular architecture, becomes unmeaning and absurd; but, when confined within its proper limits, as applied to various articles of furniture, it is at once characteristic and elegant. It is so, because the flexibility of its prevailing lines renders it easy of adaptation to the forms of common objects; while its playfulness is grateful to the eye, and its want of architectural coherency leaves it the less exposed to abuse at the hands of those whose general knowledge of style may be but superficial.

These principles of attention to expression and beauty of outline on the one hand, and of regard to, and modification upon, ancient precedent on the other, are

undoubtedly the chief guides to excellence in those arts that are subordinate, as in those that are essential, to architecture. We might trace their natural influence through many of those departments to which they are but too little applied, and show how much of beauty and of fitness has been lost by their neglect. Suppose the very agreeable innovation of carpeting required for a suite of Gothic apartments, where shall we obtain ready-made patterns satisfactory to the architect of cultivated taste? For these, however, the designs of our old stained glass, and other occasional paintings, will afford excellent suggestions, in their richly flowing diapers, their undulating foliage on grounds of vivid blue or red, their lozenge compartments of rose and fleur-de-lis, and many other varied applications of leaf and flower. Or, again, hints for the same purpose may be gained from the ornamental tile-paving anciently in frequent use; not to say from the tapestry of correspondent age. Even the paper-hanger may have recourse to some of the same sources of information with advantage. Might not, too, the accompaniments of architecture, after the Roman manner, be improved by a reference to such decorations as those of the paintings of Pompeii, and of the Roman tessellated pavements, not uncommonly met with even in our own country? In addition to those classes already enumerated, we need scarcely remark that the ornamental glazier and glass-stainer are persons in whom an acquaintance with the principles we have noticed is especially requisite; so much so, indeed, that their designs ought always to be under the immediate control of the architect.

But we will not attempt to follow out the operation of these principles in all their relations. We can but briefly suggest and recommend them; leaving it to the reader to supply, by the study of examples, that practical illustration which cannot be afforded by mere verbal description.

## Notes

1 Trotman, *Architectural Magazine*, i, March 1834. p. 33.
2 Trotman, *Some Remarks On Architectural . . .* p. 5.
3 *Gentleman's Magazine*, December 1845, p. 624.

# WILLIAM MORRIS, 'MAKING THE BEST OF IT' (1882)

## Editorial Headnote

William Morris (1834–1896) is well known as a polymath who turned his hand to designing and making in a variety of processes, as well as poetry and novel writing, socialist activism, and publishing, among other achievements. Morris was particularly interested in the crafts and the role of craftspeople as artists. Although considering himself first and foremost an artist-craftsman, he was also a businessman, founding Morris, Marshall, and Faulkner & Co. in 1861. Indeed, it was this business that was an example of his failure to deliver what he preached, in that most of his clients were not from the working classes.

This extract is from one of a series of lectures read before the Trades Guild of Learning and the Birmingham Society of Artists in 1879. These lectures were collated and published as *Hopes and Fears for Art: Five Lectures*, in 1882. They were clearly of wide interest as the volume was reissued in 1883, 1896, 1898, 1903, 1911, and 1919. The work is chiefly a guide for considering how to remodel 'ugly' urban jerry-built housing, which was anathema to Morris. A review in *The Athenaeum* made the point very clearly: 'The only real help, says Mr. Morris, for the Decorative Arts must come from those who work in them if nor must they be led, they must lead'. Craftsmen must all be artists, and good artists, too, before the public at large can take real interest in what they produce. Commerce, 'which should be called the greed of money', cannot and will not help.[1] The review also praises his delivery of the speech saying: 'the occasional bits of whim, the genial dogmatism, and the poetic fancy which add not a little to their charm and secure for Mr. Morris the sympathy of his hearers'.[2]

Morris was clear as the role of design in the home:

> We are heedless if our houses express nothing of us but the very worst side of our character both national and personal. This unmanly heedlessness, so injurious to civilisation, so unjust to those that are to follow us, is the very thing we want to shake people out of. We want to make them think about their homes, to take the trouble to turn them into dwellings fit for people free in mind and body – much might come of that I think.[3]

He explained later in the lecture how this was to be achieved:

> So much for the colour of pattern-designing. Now, for a space, let us consider some other things that are necessary to it, and which I am driven to call its moral qualities, and which are finally reducible to two – order and meaning.[4]

A reviewer in the American journal *The Century Illustrated Monthly Magazine*, (1882) specifically noted this particular lecture 'Making the Best of It' out of the series of five.

> This, by all odds the most fruitful and encouraging lecture of the five, bears in its title the feeling of profound discouragement that exhales from every part of the book. It is merely, one may say, the Morris phase of the glorious British privilege of grumbling. But where there is chronic discontent, there is likely to be a persistent cause for discontent . . . .

The reviewer having critiqued the English propensity to moan and find fault, then goes on to give a supportive comment about Morris, his craft and his place in society.

> But Mr. Morris ought to have not only the calm satisfaction of worldly success, but a conscience which tells him that, in some respects at least, he has been an honor to his country – if not from the excellence of his wall-paper patterns, yet surely from the fact that he has not truckled with artistic snobbery, but has followed his natural bent and striven to be a highly educated First Artisan rather than fifth-rate Royal Academician.[5]

Of course, as Morris was a practitioner of interior decoration, his advice was eminently practical and somewhat dogmatic, in the same vein as many other authors of the period.

The article was reprinted in the *American Architect* in 1881 with the following admiring introduction.

> MR. WILLIAM MORRIS has lately delivered an address on House Decoration, before the Birmingham Society of Artists, which is not only very lively reading, but, as a thoroughly practical essay by the greatest living master in that form of art, is worthy of attentive study. We call Mr. Morris the greatest of living house decorators advisedly, not so much on account of his eminence in any one branch – as the designing of stained glass, wall-paper or carpets-as for the admirable energy and unerring taste with which he has taken up so many drooping arts and set them in the way of renewed life.[6]

# 2

# 'MAKING THE BEST OF IT'

## William Morris

Source: William Morris, "Making the Best of It", A Paper read before the Trades Guild of Learning and the Birmingham Society of Artists, c. 1879. Published in William Morris, *Hopes and Fears for Art: Five Lectures* (London: Ellis & White. 1882) pp. 130–8

So we have got to the inside of our house, and are in the room we are to live in, call it by what name you will. As to its proportions, it will be great luck indeed in an ordinary modern house if they are tolerable; but let us hope for the best. If it is to be well proportioned, one of its parts, either its height, length, or breadth, ought to exceed the others, or be marked somehow. If it be square or so nearly as to seem so, it should not be high; if it be long and narrow, it might be high without any harm, but yet would be more interesting low, whereas if it be an obvious but moderate oblong on plan, great height will be decidedly good.

As to the parts of a room that we have to think of, they are wall, ceiling, floor, windows and doors, fireplace, and movables. Of these the wall is of so much the most importance to a decorator, and will lead us so far a-field that I will mostly clear off the other parts first, as to the mere arrangement of them, asking you meanwhile to understand that the greater part of what I shall be saying as to the design of the patterns for the wall, I consider more or less applicable to patterns everywhere.

As to the windows then, I fear we must grumble again. In most decent houses, or what are so called, the windows are much too big, and let in a flood of light in a haphazard and ill-considered way, which the indwellers are forced to obscure again by shutters, blinds, curtains, screens, heavy upholsteries, and such other nuisances. The windows, also, are almost always brought too low down, and often so low down as to have their sills on a level with our ankles, sending thereby a raking light across the room that destroys all pleasantness of tone. The windows, moreover, are either big rectangular holes in the wall, or which is worse, have ill-proportioned round or segmental heads, while the common custom in 'good' houses is either to fill these openings with one huge sheet of plate-glass, or to divide them across the middle with a thin bar. If we insist on glazing them thus, we may make up our minds that we have done the worst we can for our windows, nor can a room look tolerable where it is so treated. You may see how people feel this by their admiration of the tracery of a Gothic window, or the lattice-work of a

Cairo house. Our makeshift substitute for those beauties must be the filling of the window with moderate-sized panes of glass (plate-glass if you will) set in solid sash-bars; we shall then at all events feel as if we were indoors on a cold day – as if we had a roof over our heads.

As to the floor: a little time ago it was the universal custom for those who could afford it to cover it all up into its dustiest and crookedest corners with a carpet, good, bad, or indifferent. Now I daresay you have heard from others, whose subject is the health of houses rather than their art (if indeed the two subjects can be considered apart, as they cannot really be), you have heard from teachers like Dr. Richardson[7] what a nasty and unwholesome custom this is, so I will only say that it looks nasty and unwholesome. Happily, however, it is now a custom so much broken into that we may consider it doomed; for in all houses that pretend to any taste of arrangement, the carpet is now a rug, large it may be, but at any rate not looking immovable, and not being a trap for dust in the corners. Still, I would go further than this even and get rich people no longer to look upon a carpet as a necessity for a room at all, at least in the summer. This would have two advantages: 1st, It would compel us to have better floors (and less drafty), our present ones being one of the chief disgraces to modern building; and 2ndly, since we should have less carpet to provide, what we did have we could afford to have better. We could have a few real works of art at the same price for which we now have hundreds of yards of makeshift machine-woven goods. In any case it is a great comfort to see the actual floor; and the said floor may be, as you know, made very ornamental by either wood mosaic, or tile and marble mosaic; the latter especially is such an easy art as far as mere technicality goes, and so full of resources, that I think it is a great pity it is not used more. The contrast between its grey tones and the rich positive colour of Eastern carpet-work is so beautiful, that the two together make satisfactory decoration for a room with little addition.

When wood mosaic or parquet-work is used, owing to the necessary simplicity of the forms, I think it best not to vary the colour of the wood. The variation caused by the diverse lie of the grain and so forth, is enough. Most decorators will be willing, I believe, to accept it as an axiom, that when a pattern is made of very simple geometrical forms, strong contrast of colour is to be avoided.

So much for the floor. As for its fellow, the ceiling, that is, I must confess, a sore point with me in my attempts at making the best of it. The simplest and most natural way of decorating a ceiling is to show the underside of the joists and beams duly moulded, and if you will, painted in patterns. How far this is from being possible in our modern makeshift houses, I suppose I need not say. Then there is a natural and beautiful way of ornamenting a ceiling by working the plaster into delicate patterns, such as you see in our Elizabethan and Jacobean houses, which often enough, richly designed and skilfully wrought as they are, are by no means pedantically smooth in finish – nay, may sometimes be called rough as to workmanship. But unhappily there are few of the lesser arts that have fallen so low as the plasterer's. The cast work one sees perpetually in pretentious rooms is

a mere ghastly caricature of ornament, which no one is expected to look at if he can help it. It is simply meant to say, "This house is built for a rich man." The very material of it is all wrong, as, indeed, mostly happens with an art that has fallen sick. That richly designed, freely wrought plastering of our old houses was done with a slowly drying tough plaster, that encouraged the hand like modeller's clay, and could not have been done at all with the brittle plaster used in ceilings nowadays, whose excellence is supposed to consist in its smoothness only. To be good, according to our present false standard, it must shine like a sheet of hot-pressed paper, so that, for the present, and without the expenditure of abundant time and trouble, this kind of ceiling decoration is not to be hoped for.

It may be suggested that we should paper our ceilings like our walls, but I can't think that it will do. Theoretically, a paper-hanging is so much distemper colour applied to a surface by being printed on paper instead of being painted on plaster by the hand; but practically, we never forget that it is paper, and a room papered all over would be like a box to live in. Besides, the covering a room all over with cheap recurring patterns in an uninteresting material, is but a poor way out of our difficulty, and one which we should soon tire of.

There remains, then, nothing but to paint our ceilings cautiously and with as much refinement as we can, when we can afford it: though even that simple matter is complicated by the hideousness of the aforesaid plaster ornaments and cornices, which are so very bad that you must ignore them by leaving them unpainted, though even this neglect, while you paint the flat of the ceiling, makes them in a way part of the decoration, and so is apt to beat you out of every scheme of colour conceivable. Still, I see nothing for it but cautious painting, or leaving the blank white space alone, to be forgotten if possible. This painting, of course, assumes that you know better than to use gas in your rooms, which will indeed soon reduce all your decorations to a pretty general average.

So now we come to the walls of our room, the part which chiefly concerns us, since no one will admit the possibility of leaving them quite alone. And the first question is, how shall we space them out horizontally?

If the room be small and not high, or the wall be much broken by pictures and tall pieces of furniture, I would not divide it horizontally. One pattern of paper, or whatever it may be, or one tint may serve us, unless we have in hand an elaborate and architectural scheme of decoration, as in a makeshift house is not like to be the case; but if it be a good-sized room, and the wall be not much broken up, some horizontal division is good, even if the room be not very high.

How are we to divide it then? I need scarcely say not into two equal parts; no one out of the island of Laputa could do that.[8] For the rest, unless again we have a very elaborate scheme of decoration, I think dividing it once, making it into two spaces is enough. Now there are practically two ways of doing that: you may either have a narrow frieze below the cornice, and hang the wall thence to the floor, or you may have a moderate dado, say 4 feet 6 inches high, and hang the wall from the cornice to the top of the dado. Either way is good according to circumstances;

the first with the tall hanging and the narrow frieze is fittest if your wall is to be covered with stuffs, tapestry, or panelling, in which case making the frieze a piece of delicate painting is desirable in default of such plaster-work as I have spoken of above; or even if the proportions of the room very much cry out for it, you may, in default of hand-painting, use a strip of printed paper, though this, I must say, is a makeshift of makeshifts. The division into dado, and wall hung from thence to the cornice, is fittest for a wall which is to be covered with painted decoration, or its makeshift, paper-hangings. As to these, I would earnestly dissuade you from using more than one pattern in one room, unless one of them be but a breaking of the surface with a pattern so insignificant as scarce to be noticeable. I have seen a good deal of the practice of putting pattern over pattern in paper-hangings, and it seems to me a very unsatisfactory one, and I am, in short, convinced, as I hinted just now, that cheap recurring patterns in a material which has no play of light in it, and no special beauty of its own, should be employed rather sparingly, or they destroy all refinement of decoration and blunt our enjoyment of whatever beauty may lie in the designs of such things.

Before I leave this subject of the spacing out of the wall for decoration, I should say that in dealing with a very high room it is best to put nothing that attracts the eye above a level of about eight feet from the floor – to let everything above that be mere air and space, as it were. I think you will find that this will tend to take off that look of dreariness that often besets tall rooms.

So much then for the spacing out of our wall. We have now to consider what the covering of it is to be, which subject, before we have done with it, will take us over a great deal of ground and lead us into the consideration of designing for flat spaces in general with work other than picture work.

To clear the way, I have a word or two to say about the treatment of the wood-work in our room. If I could I would have no wood-work in it that needed flat painting, meaning by that word a mere paying it over with four coats of tinted lead-pigment ground in oils or varnish, but unless one can have a noble wood, such as oak, I don't see what else is to be done. I have never seen deal stained transparently with success, and its natural colour is poor, and will not enter into any scheme of decoration, while polishing it makes it worse. In short, it is such a poor material that it must be hidden unless it be used on a big scale as mere timber. Even then, in a church roof or what not, colouring it with distemper will not hurt it, and in a room I should certainly do this to the wood-work of roof and ceiling, while I painted such wood-work as came within touch of hand. As to the colour of this, it should, as a rule, be of the same general tone as the walls, but a shade or two darker in tint. Very dark wood-work makes a room dreary and disagreeable, while unless the decoration be in a very bright key of colour, it does not do to have the wood-work lighter than the walls. For the rest, if you are lucky enough to be able to use oak, and plenty of it, found your decoration on that, leaving it just as it comes from the plane . . .

## Notes

1 *The Athenaeum*, 16 September 1882, pp. 374–375.
2 Ibid.
3 "Making the Best of It". A Paper read before the Trades Guild of Learning and the Birmingham Society of Artists, c. 1879. Published in William Morris, *Hopes and Fears for Art: Five Lectures* (London: Ellis & White. 1882 p. 121,
4 Ibid. p. 151.
5 *The Century Illustrated Monthly Magazine,* 27, July 1882 p. 464.
6 *American Architect,* 9, 1881, p. 14.
7 B. W. Richardson, 'Health in the Home', in S. F. Murphy (ed.), *Our Homes, and How to Make Them* (London: Cassell & Co., 1883), pp. 1–32.
8 Laputa: a flying island described in Jonathan Swift's *Gulliver's Travels*, 1726.

# R. W. ARNE, 'ART IN DOMESTIC MATTERS; OR ÆSTHETICS IN THE HOUSE' (1881)

## Editorial Headnote

*The Ladies' Treasury, an illustrated magazine of entertaining literature, education, fine art, domestic economy, needlework, and fashion* was published from 1857 to 1895 with the avowed intention of "offering to our countrywomen the first annual volume of a work undertaken for their benefit, consecrated to their service, and dignified by the name of *The Ladies' Treasury*,"[1] The first editor was the well-known author on household management etc., Eliza Warren. The publication differed from Mrs Beeton's *Englishwoman's Domestic Magazine*, as its advice was suitable for smaller households with just one servant. One particular feature was that Warren encouraged household thrift and she was also engaged with ideas around the managing of the home to reflect concepts of morality and decency.

Little seems to be known about the author of this extract. Four essays were published in this series including talks on materials, and ceramics. Arne also later wrote another unrelated article titled "The Woman at the Well of Samaria" for the *Ladies Treasury* (1882) to accompany two illustrations of the subject.

The two articles discuss various aspects of interior decoration that the author finds irritating. The first extract was critiqued by the *Artist and Journal of Home Culture*. The review noted that

> Most of our periodicals occupy themselves occasionally now with household art. A writer in *The Ladies' Treasury*, R. W. Arne, taking up the subject, condemns the return to mirror work built up of small pieces in frames, as merely imitative of a practice which, in the time of Queen Anne, was dictated by the want of the means of making a glass in one large piece. The writer criticises also the hanging up of china plates as ornaments, and the re-invention of the dado.[2]

The second extract offers a different approach that considered aspects of health in homes and discusses the problems of carbon dioxide and plant life within the home. This had been an issue for Victorians throughout the century. For example, in 1837, the *Floricultural Magazine* announced that houseplants were "exceedingly deleterious" when kept in the bedroom, "as during the night many plants give out carbon instead of oxygen, and by that means instead of purifying the air, help to poison it."[3] This persistent myth of the dangerous houseplant that was still perpetuated by Arne amongst others, reflected the obsession with ventilation, and disease control.

# 3

# 'ART IN DOMESTIC MATTERS; OR ÆSTHETICS IN THE HOUSE'

## *R. W. Arne*

Source: R. W. Arne, "Art in Domestic Matters; or Æsthetics in the House," *The Ladies' Treasury: An Illustrated Magazine of Entertaining Literature*, 1 January 1881, pp. 20–21, and 1 April 1881, pp. 215–16

The term *aesthetics* a word derived from the Greek, signifies to perceive with the senses not alone with the eyes, but with an intuitive perception of the fitness of things. "High Art: and "Fine Art" are different terms for almost the same thing – Excellence. Whether in literature, in painting and sculpture in stone or wood, in jewellery, embroidery and weaving, in fictile art (pottery), in architecture, and in all the arts by which the material is, in its treatment, ennobled by the master-mind of the designer or the worker, is high art, or art in its highest sense. A lump of clay is, in its first form, worthless, but under aesthetic treatment it becomes a model for the sculptor, or the potter turns it on his wheel into a shape of beauty.

An aesthetic nature develops the true artist. Fitness above all things, even before beauty. A man who paints cabbages and other vegetables paints but to one end – the proper adornment of restaurants. No one with an aesthetic spirit would purchase them with any other view. The architect who designs a Gothic house for a contracted space is not aesthetic; neither a poet who sings of the Mavis[4] in rhythm adapted to Miltonian subjects. There must be a fitness in all things, or there can be no beauty.

Embroidery has been from time immemorial both an amusement and a bread-winner. The materials anciently used for foundations were, for court embroidery, silk and satin; for other grades of society, coarse and fine canvases: for curtains and *portiéres* (door curtains), rough serges or frieze-cloth – other materials there were none. It may be asked why we of modern days, with a wealth of fabrics at hand, go back to the meagreness of material formerly used to the workhouse sheeting, the oatmeal cloth, and the rough serge upon which to waste time and fray the silken threads. Why not use the silk or worsted rep, the satin cloth poplins, or the rich velveteen, or the unwearable Utrecht velvet, or the costlier plush which cannot injure. Surely these have greater fitness for the displaying of beautiful work than the coarse and rough serges, or the workhouse sheeting. There may be "fine art", in every sense of the word in the embroidery, but on unsuitable

DOI: 10.4324/9781003290490-5

material, no aesthetic taste is shown, no fitness. Time and money are both spent fruitlessly when "cloth of gold rubs against cloth of frieze" the frieze cloth being rough serge, like cloth formerly made in Friesland, in Holland, from whence it took its name.

To come to household matters. There has been for some time, and is now, "a craze" respecting the adornment of rooms. The noble looking-glass of modern civilisation is to be displaced for one built up of smaller pieces, comparatively almost fragments, and this is termed "a Queen Anne glass." Would not her then Majesty, who has been dead a hundred and sixty years, have looked upon with astonishment and envied the noble pier-glass of our days? Such a thing had, in her time, never been seen. About twenty-nine years before Anne reigned, plate-glass for mirrors and coach windows was first made in Lambeth by Venetian artists,[5] so that moderately small pieces of glass had to be joined together to make a pier-glass of larger size; the smaller pieces forming a border to the centre, and to these joinings brackets of glass or of carved wood were affixed, and on them china cups and saucers, vases, and other priceless matters were arranged. This was the best way of ornamenting a patchy affair, if not of concealing the want of a larger glass, which had never then been made. The rooms in Queen Anne's days were lofty and wide, and doors wide and high enough to admit the stately dames in their graceful robes, that artists now delight to paint. Thus the need of large pier-glasses to give size to rooms was not needed as they now are. True art never degenerates, but improves; hence Queen Anne style of glass is certainly not indicative of progression.

In those days, rare pieces of china were priceless, and were displayed either in velvet cases on the chimney-piece, or on the glass brackets, or brackets of carved wood which harmonised with the walls covered with panels, and surrounded by carvings as of a frame. Some of the panels over the chimney piece had on them paintings of scenery, or of hunting scenes, in which the Flemish horses were conspicuous by their clumsiness.

Some few years back, there was a house in Hatton Garden where one could latterly take sulphur baths.[6] The upper part of this mansion contained thirteen rooms, eight of which were lofty, and on each panel was painted either a lady or gentleman of Queen Anne's time. Whether they exist now we are unable to say. We can fancy that in such a style of house specimens of rare china could be displayed with advantage to both. Corner brackets holding superb vases or dishes, and plates mounted in velvet, or in carved or gilded frames, were in their place in the corners of rooms, lighting up the old wainscoted walls with glints of sunbeams or other light.

The best specimens of such rooms, as to size, are those in Queen Anne Street, Cavendish Square.

In recently erected houses for people of moderate means – £500 a year – the display of china plates of doubtful value or historic interest, when hung on invisible wires, looks near akin to kitchen furniture. Such plates occupy spaces better filled with good engravings or chromos.

On a tier of shelves of a cabinet in a dining or breakfast room is the appropriate place for plates and dishes. Cups and saucers and vases look well in a drawing room cabinet, having glass sides to protect them from the dust.

Most people are desirous of being in the fashion, without regard to circumstances; and like sheep, they blindly follow their leader – oftentimes someone with more folly than wisdom.

The dado[7] is another absurdity, but decidedly useful in its place. Originally an introduction from the East, where with Orientals, who recline on divans placed against the wall, this dado, formed of cubes of pottery or metal, or composition of some kind, was for cleanliness an imperative necessity. It had nothing to do with ornament. Here in England, where the walls of a room of ordinary dimensions are rarely high, the dado effectually diminishes in appearance whatever height there may be. The dado in a nursery, or even in bedrooms, finds its true place and in a nursery, if it be composed of painted tiles, all the better. Scripture history, or any other history, could be taught to children, as by similar means was done in olden time; and in such adornment, young mothers, with otherwise unoccupied time, might find amusement.

The dado (or base of the walls of a room), painted differently from the upper portions, was generally adopted after the discovery of Pompeii and Herculaneum, in 1759, but it was the dado which imitated that found in the ruins of these cities, and which, with panels having subjects mounted on them, formed the chief ornament of the house walls. At first this dado was represented in England by painted lines, then a beaded strip of wood two inches wide was fixed to the wall, and this served to keep the backs of chairs from touching the walls. After a time, the dado disappeared, to be re-invented at the present period without reference to its appropriateness. In halls, passages, and staircases, and in lofty rooms, the dado is appropriate, but not elsewhere, excepting, perhaps, in a bedroom. (To be continued)

1 April 1881 pp. 215–6.

In a last chapter we may dismiss the subject of Aesthetics in Domestic Matters; but these last words are the most important of all. What avails either the costly or the inexpensive furniture, the gilding, and the glass, the pictures, and the curious treasures, if these are placed above a charnel house?[8]

Yet in numberless houses this is so; for if it be not actually dead flesh that works the mischief, carbonic acid gas[9] is equally dangerous to human life. It is an acid which is produced incessantly by the combustion and decay of carbonaceous substances, by fermentation, and the respiration of all animals, human or otherwise, and, although one may drink with benefit mineral waters impregnated with the gas, which has no poisonous action on the stomach, yet to the lungs it is fatal. The late Charles Dickens termed it the "essence of sink," that is, the effluvia which arises from a sink in a scullery, and is indeed similar to sewer gas, one of the most deadly of all gases. It is not only admitted into a house by careless servants removing the bell-trap of a sink, or slop-stone, or whatever provincial name it has, but it forces itself through cracks which are unperceivable. This is the deadly fiend that rides over all the splendid rooms and sets aesthetics at defiance, forcing

its way through sickly odours to sleeping rooms, and bringing with it diphtheria and other often fatal disorders.

It is a lamentable fact that very few heads of households ever think of exploring at night the basements of a house, never see that iron bars safely secure the windows, and insist upon the latter being left open during the night. All the windows in a basement should be so secured and left slightly open.

If it should happen that a drain, suddenly out of repair, becomes offensive, and no help near to remedy it, half-a-pound of copperas (sulphate of iron), dissolved in a gallon of warm water and thrown into the drain, all offensive smell is instantly dispelled. Every drain-pipe and sink in a house should be thus flushed frequently.

Carbonic acid gas makes itself distinctly felt in a house when we say it is "stuffy." It smells as if every room needed air. The great factory for this is the basement of most middle-class houses, when the control is under servants' care, when no mistress appears after morning hours and her consultation with the cook. Wherever vegetable refuse and the remnants of fish or flesh, cooked or fresh, are tossed into a receptacle, and kept in the scullery, so surely, but slowly, carbonic acid gas is produced. And the same with another matter. It should be widely known that if greasy cloths, whether of hair, cotton, wool, or linen fibre, are thrown into corners, or amid the debris of wood or coal, and under pressure these clothes take fire spontaneously, that is to say, that the latent or dormant heat in the greasy clothes has a capacity for absorbing further heat from the object which presses against them; and thus, in darkness and damp, houses are set on fire, and too often the cause is unknown, or if guessed at, cannot be proved.

If too many people sit in a small room without an influx of fresh air, the fire will not burn, the candles look dim, and themselves have a sense of faintness and nausea, which induces a hasty exit into the fresher air. This unpleasantness owes itself to carbonic acid gas, which each person, by his breath, thus helped to create. Hence, in all rooms there should be plants – not cut flowers, but growing plants: these, during daylight, absorb the poisonous breath of men and animals, and give out pure oxygen, but in daylight only. With plants in darkness (cellars, for instance) there is no absorption of carbonic acid gas, and no oxygen is evolved. As carbonic acid is produced from the decay of carbonaceous substances which exist everywhere, it would increase beyond control if the plants and trees did not absorb it from the atmosphere. Hence, in every house green growing plants are to some extent useful to absorb the deadly gas. So it is not alone for decoration that plants are often lavishly used at grand entertainments, where, by daylight, numbers of guests congregate, but they are of especial value in neutralizing the noxious vapours of human breaths. Though, perhaps, this last item in floral decoration has been unthought of.

It must be remembered that all flowers and shrubs in decaying give out carbonic gas, and should be speedily removed; it is only in their first freshness, and in growing plants – not in cut flowers – that their value lies. Flowers are not always wholesome or agreeable after the moment of their first fragrance; among them are the hyacinth, the narcissus, and almost all of the lily family. These last contain a sulphuretted hydrogen, which is speedily obnoxious. Then, again, there is the

lilac, and the jessamine, and the odour of the *polyanthes tuberosa*, which emits its most powerful fragrance after sunset, and in confined rooms causes people to have headache and faintness (asphyxia) from the carbonic acid which the plant evolves. The syringa is another forbidden plant in rooms. But out of doors, and surrounding a dwelling, these and other odorous plants create ozone, become disinfectants, and are aesthetics of nature – "the right things in the right places."

The tall old-fashioned sunflower – alas! that flowers of any kind should be so termed – is as healthy and life-invigorating as the Eucalyptus of modern laudation. In Queen Elizabeth's days this glorious plant was named "The Indian Sun," also the "Golden Flower of Peru." Experience proves that the seeds of the great sunflower thickly sown in marshy and fever abiding places, flourishes upon the malarious air, purifies it, and evolves oxygen enough to render the surrounding air wholesome; in some districts, the plant, if cut across the stem, has a scent not unlike turpentine.

Herbs, as mint, sage, rue, marjoram, thyme, savory, and all that come under the name of fragrant herbs and shrubs, including rosemary and lavender, possess an aromatic principle similar to camphor, hence their value. Where this odorous principle abounds, malaria departs, and leaves pure air (oxygen); hence, in the "Aesthetics of Art in Domestic Matters," these herbs should abound in gardens or jardinieres.

Pliny, in his *Natural History*,[10] mentions eighty-four remedies derived from rue, forty-one from mint, twenty-five from penny-royal, forty-one from the iris, thirty-two from the rose, twenty-one from the lily, and seventeen from the violet. Gerarde,[11] who was born in 1545, gives in his *Herbal* the different uses of plants and flowers, and particularly notes that all sweet-smelling flowers are good for health.

Consequently, plants, fresh flowers, and aromatic herbs in or around a dwelling, constitute a portion of domestic aesthetics not to be neglected.

## Notes

1  Preface, *The Ladies' Treasury*, vol 1, 1857, p. iii.
2  *The Artist and Journal of Home Culture*, February 1881, p. 61.
3  An Admirer of Flowers, "On the Cultivation of Plants in the Windows of Living Rooms, Showing Their Tendency to Promote Health, With Their Poisonous Effects When Introduced into Sleeping Apartments", *Floricultural Magazine* 1:10, March 1837, pp. 217–19.
4  Mavis: An obsolete name for a song thrush bird.
5  George Villiers, 2nd Duke of Buckingham established a factory at Vauxhall (Lambeth) with the help of John Bellingham to make blown plate-glass, and recruited Venetian glassmakers to work there.
6  Probably refers to the baths and medical practice at 32 Hatton Garden, London. c. 1851.
7  Dado: The lower part of a wall, below the dado or chair rail and above the skirting board.
8  A building or chamber in which bodies or bones are deposited.
9  Now carbon dioxide.
10  Pliny (AD 23–79), *Naturalis historia*.
11  John Gerard (1545–1612) first published his *Herball*, in 1597 and it was reprinted in 1633 and 1636. Gerard was curator of the Physic Garden at the College of Physicians.

# MARIA O. DEWING, *BEAUTY IN THE HOUSEHOLD* (1882)

## Editorial Headnote

Maria Oakey Dewing (1845–1927) was born in New York City and is probably best known as an artist. She studied with John La Farge, and her work was influenced by his fascination with Japanese aesthetics. She studied at both the Cooper Union School of Design for Women and the National Academy of Design. However, in her earlier years, Dewing wrote books and articles about housekeeping and etiquette and was author of *From Attic to Cellar: A Book for Young Housekeepers* (1879) and *Beauty in Dress* (1881). This latter was a study of color harmonies in costume and complexion. She also wrote articles about art that were published in *Art and Progress* and the *American Magazine of Art*.

Dewing was especially concerned with color schemes and the effects of light. In *Beauty in the Household*, she describes an amazing colour scheme based on purples and blacks. This extract gives a flavour:

> . . . the wood-work and doors painted purple, of a tone that remains purple at night, and with the surface dull and velvety, like a defacé amethyst. . . . Let the mantel-piece and fireplace be of the same wood, similarly painted; about the opening for the fireplace tiles of cream-white, with a pattern of passion flowers, of a paler, pinker purple; the grate of brass. The carpet of this room may be black, which will make the purplewood work more purple by night; before the fire, or in the centre of the room, a rug, in which purples of dark and pinkish hue are mixed. Let your walls be of a lighter purple than your woodwork, covered with a small stencil pattern in bronze, a deep cornice of bronze and gilt, with a gilt picture rod. . . . .[1]

Dewing was apparently shy about her decorating work as opposed to her painting. Towards the end of her life, she wrote to Royal Cortissoz, the art historian critic of the *New York Herald Tribune:* "Of course you do not know that for forty years past I have at moments broken out into decoration – all sorts of minor arts – sometimes never letting these passing attacks have the least publicity. Ages ago I did a theatre curtain and the famous the infamous Oscar Wilde praised it exorbitantly and said, "Why don't you go into decoration and wipe them all out?'. Because I must paint pictures or die said I".[2]

*The Saturday Review* had a pithy analysis of the publication: "Mrs. Dewing's *Beauty in the Household* is a short and sensible treatise on the graces of domestic architecture, decoration, and arrangement, on the manner in which combinations of form and colour in household life may be made to display good or bad taste,

to render our ordinary living apartments a joy for ever, or a source of constant, if unconscious, annoyance to those who inhabit them."[3]

As an artist she used her own illustrative sketches of furniture, decorative objects, textiles, and room arrangements to explain her ideas. Essentially, she combined artistic aestheticism with domestic planning so that her concept of beauty is found by thoughtful and deliberate room design, planning and layout. For example, later in the book she writes:

> There are many things which are beautiful in themselves which add nothing to the furniture of a room. Where there are small objects they should be grouped effectively, so as to form a larger whole; not scattered about, so as to be lost, or, worse still, to seem nothing but a small blot. The extreme of this style of ornament is to be found in the far-away country farmer's parlor, where a small photograph or tin-type of some friend or relative is fastened up in dread isolation upon a blank wall, where it suggests a blister. Now, to substitute for this photograph the most exquisite Japanese saucer, or tiny Greek glass vase, would not be to materially improve it as an ornament. The fault lies, not in the nature of the object, but in its inappropriate size and situation.[4]

This attitude took material form when Maria Dewing and her husband Thomas Wilmer Dewing established an elite artists' colony in Cornish, New Hampshire, with the sculptor Augustus Saint-Gaudens and his wife, Augusta in 1885. This group, later labelled "Little Athens," linked a mix of classical and aesthetic imagery, located in a Morrisian idyll of rusticity amongst the countryside of New England. This approach was found in their own interiors and also in this text.

# 4

# BEAUTY IN THE HOUSEHOLD

## Maria O. Dewing

Source: Maria O. Dewing, *Beauty in the Household* (New York: Harper & Brothers, 1882), pp. 1–10

There is no stranger spectacle than the obstinate unwillingness that most people have to alter and improve that which they so avowedly consider a distressing burden – the usual manner of conducting a household. They wear their cares with a painful, superstitious martyrdom, as the monk of old wore his hairy shirt; and to attempt salvation by a pleasanter road seems to them to be a shirking of the lot of humanity.

The household is too commonly the synonym for all that is wearing and commonplace – the altar upon which two people who have dreamed of happiness sacrifice their faith and hope to the sordid and realistic.

Often the cause of this is, that to the household management people do not seem to bring the same thought and analysis that they do to other important subjects. In unreasoning blindness they accept precedents. They cling to every weighty fetter that has clogged the progress of their predecessors. Nowhere does reform enter so slowly as into the household. People are possessed with the idea that there is but one way of living, and not being able to *attain* that, the nearer they approach it the better they live. This way is the way of the wealthy English, which, even with money, is easier to follow in an old country, where service is systematized, and where no lady who has a large establishment is her own house-keeper.

This conventional style of living has its own beauty, like the beauty of some stately old gardens, where the trees are cut in artificial forms, and the terraces make a suitable setting for the stiffly dressed ladies who slowly walk there; but, like these gardens, it needs to be in perfection to be beautiful at all, and the incomplete imitations are more absurd and sordid than any original style could be.

There is such a thing as intrinsic beauty and intrinsic elegance quite apart from the received standards. It consists chiefly in proportion and completeness. It is that which is true to its own laws. When we understand the reason for being, and the laws of any thing or system completely, then we can easily see that when its reason for being ceases it becomes folly, and when its laws are but half fulfilled it ceases properly to be. We want a system in our households fitted to our individual needs, and whose laws are capable of fulfilment. Otherwise we have ugliness and confusion.

DOI: 10.4324/9781003290490-6

It is not always possible to attain this without experiment; but it is impossible to attain it at all till we believe in our own ideals, and bravely uphold them against established abuses, against precedent, against criticism. We are often too easily convinced of the failure of our ideals because they do not at once succeed. We are too easily convinced that we have expected too much of life and of people; too easily remember the half pitying, half-sarcastic smile with which the "more experienced" looked upon our enthusiastic launch upon the unknown sea; the prophecies that the rose-color will fade, and that we must settle down to the commonplace like other "practical" people. It is difficult to say why we should be convinced by such frank confession of failure; why we should imagine that failure in the recognized rut is better than even the chance of success on a higher plane.

The fact is, that people rarely expect enough of life, have too little faith in themselves or others, too little courage in seeking the ideal and beautiful in their surroundings. We only assert that to each of us the millennium lies nearer in proportion to our belief in it.

Independence is a right to be limited only by the bounds of common-sense and good taste; and it will be only when we believe it quite unnecessary to emulate our neighbours, and wholly interesting to make our own little plan of life complete in itself and true to its own laws, that we shall attain the ease and beauty that make an atmosphere in which the mind and heart may expand, instead of wearing themselves smaller and smaller against the friction of sordid striving.

Shame of poverty seems to us as vulgar as display of wealth, and good taste may often take the place of wealth in the atmosphere of the home. Poverty is, in fact, a very adjustable term, and need only be used in rare cases.

Where there are abundant means, of course it is easier to keep the details of house-keeping out of sight; and to keep all the machinery hidden is scarcely possible without a combination of executive ability, and that sense of beauty which rarely accompanies it, added to unlimited means. The rich, even oftener than the poor, give prominence to the realistic. But all this is a matter of proportion, and, on a very simple scale, we may so proportion life that it may be filled with beauty. The less our means or capacity, the more we must sacrifice to those things that we wish to make of chief importance. This is a question for each to decide what shall be the prominent feature of his living – and there is no surer gauge of the calibre of a person's mind.

Some make their table, some their dress, some a display of servants, their great expense, and for these objects make the rest of life unbeautiful. Some stirring house-keepers seem to take their family on sufferance, as creatures capable of disturbing the order and cleanliness which is the only aim in life. In such a household one lives grimly face to face with all the skeletons of order and economy, and, as a poor recompense, knows that no other home has cleaner windows, or corners half so free from dust. But, after all, it is but a cleanly prison, from which the Goddess of Poetry has long taken flight.

We knew of an old woman who used to scrub, sweep, and dust her house, and then, closing doors and windows, would turn the key in the lock and go and sit

in the wood-shed, happy in the confidence that the order she had induced was no ephemeral thing. Where a house-keeper of this type has a family, it would, doubt less, be happier in the wood-shed, and need no persuasion to go there.

Cleanliness and order are among the dearest rights of man, but the means of attaining them should be as hidden as our resources and ingenuity permit. We should be clean, as we should be moral, without knowing it. To be conscious of a perpetual contest with dirt is as adverse to the beautiful as to be conscious of a constant war against temptation is narrowing to the moral atmosphere. Each belongs to a low plane of existence.

*The household* is by no means entirely included in "the thought we take for the morrow, what we shall eat and where withal we shall be clothed,"[5] for the larger part of it lies in those things that we do not call "the necessities", but which make up the sum of our education, the charm of our best senses, and the harmony of life; and although the subject of the *household*, in its widest sense, is one so vast in importance, and so varied in its bearings, that it is but imperfectly that the most earnest person can treat it, yet the earnestness with which the subject is approached may be the excuse for treating it at all; and it may, perhaps, in some part be a promise to the reader that the thoughts here set down may not be without their value, nor the arguments without their proof.

## Notes

1  Dewing, 'The Drawing Room', *Beauty in the Household*, pp. 114–117.
2  Dewing to Cortissoz, 20 February 1921, cited in Doreen Bolger Burke, *In Pursuit of Beauty: Americans and the Aesthetic Movement* New York, Metropolitan Museum of Art, 1986, p. 420.
3  "American Literature" *Saturday Review of Politics, Literature, Science and Art*, 55, Mar 31, 1883, p. 422.
4  Dewing, "A Few Words on Form," p. 45–46.
5  Matthew 6:31

# MARIA O. DEWING, *BEAUTY IN THE HOUSEHOLD* (1882)

## Editorial Headnote

This is the second extract from Dewing's *Beauty in the Household* and is taken from Chapter IV 'A Few Words About Form'. The chapter clearly reflects her artistic training and interests in form as proportion and line. This is followed by a critique of furniture and furnishing practices.

# 5

# BEAUTY IN THE HOUSEHOLD

## Maria O. Dewing

Source: Maria O. Dewing, *Beauty in the Household* (New York: Harper & Brothers, 1882), pp. 39–50.

Form is quite as necessary to beauty (if not more so) as color; and the word "picturesque," which is the opposite of "classic," has done more harm, in the acceptance of the unintelligent, to modern art, especially household art, than, in its intrinsic sense, it could be held responsible for. Picturesque means, to most people, the chaotic, the ugly – recommended by brilliant color – the uncouth, the clumsy. Now, the picturesque, properly speaking, means the opposite of the severe and sculpturesque. It means the original and characteristic; but it means, also, the beautiful, and must be no chaos, but a new, unconventional revelation of law.

That idea of the picturesque in furnishing which fills the corners with autumn leaves, and seed-vessels, and shells (all beautiful in themselves, but formless for decoration, and suggesting clutter and dust), throws meaningless draperies about, loads the tables with bric à-brac, and covers the walls with Japanese fans, chooses the furniture because it is old, not because it is pretty, and, If there are pictures, prefers faces of hideous old people, in strange, ugly head dresses – all this idea of the picturesque shows not an artistic sense, but an absence of the true capacity of selection, of distinction between beauty and ugliness, fitness and unfitness.

Proportion is the first element of form; line comes next. Most of us have to accept such forms as we find already made in the rooms we furnish; but we may apparently alter the proportion greatly by our arrangement of line and mass. An ancient Eastern proverb says, "The building of a house is fraught with troubles, and ne'er brings comfort; therefore, cunning serpents seek for a habitation made by others, and, creeping in, abide there at their ease." The opposite, with sufficient means, may be quite as true; for the creeping into a habitation made by others is also fraught with its troubles, when, as frequently, the maker is only a builder, and not an intelligent architect; for we have then usually to deal with annoying problems of proportion. A room appears too high or too low, too narrow or too wide. We need only look at the two panels here shown to see that the same wall, treated with a dado and frieze which cut it into horizontal lines, makes that appear broad and short which appears narrow and long when treated in perpendicular lines.

DOI: 10.4324/9781003290490-7

**1.**    **2.**

**PANELS.**

## 1, horizontal lines ; 2, perpendicular lines.

Yet, though at first sight we would say that No. 1 was a broad panel, and No. 2 a long panel, they measure exactly the same . . . .

Harmonious color alone will not make a room beautiful. One must guard against two extremes – first, that lack of repose which too many and too striking forms produce; then the effect of weakness that too minute and ineffective forms produce. To imagine an extreme instance: a large wall covered with a paper designed in a small check would be painfully monotonous; while the same wall covered with strong-colored, irregular forms, that catch the eye like crooked rustic boughs tied with ribbons (we have seen such a paper), is worse in the opposite direction.

Plain spaces of wall contrasted with portions of wall broken with objects – pictures or other ornament – are quite as valuable as the decorated portions. One of the finest friezes we ever saw in a room was a simple band of soft, warm green, bounded on the lower side by a bronze rod and a narrow border of brilliant metallic green. On the warm green band were painted dancing fauns charmingly and gracefully grotesque. These figures were placed on either side of the windows and doors that cut against the frieze, while in each corner of the room, instead of figures, a tripod and a classic mask was painted in bronze, making a charming harmony with the warm green band, which was left with long, unbroken spaces, between where, in the corners, the masks and tripods were, and the doors and windows, where the figures were.

There are certain very simple principles to be observed in furnishing in the matter of proportion and form, after which all rules must have many exceptions,

being modified by the condition of the surroundings. One invariable rule is not to have the objects in a room too uniform in size; neither must each one differ from every other in size. The first mistake makes your furniture appear like a regiment of regular troops, the second like a company of fantasticals, in which the eye finds no rest.

There are many things which are beautiful in themselves which add nothing to the furniture of a room. Where there are small objects, they should be grouped effectively, so as to form a larger whole; not scattered about, so as to be lost, or, worse still, to seem nothing but a small blot. The extreme of this style of ornament is to be found in the far-away country farmer's parlor, where a small photograph or tin-type of some friend or relative is fastened isolation upon a blank wall, where it suggests a blister. Now, to substitute for this photograph the most exquisite Japanese saucer, or tiny Greek glass vase, would not be to materially improve it as an ornament. The fault lies, not in the nature of the object, but in its inappropriate size and situation. We have seen a room actually crowded with rare and costly bric-à-brac, where the effect was as unpicturesque, and far less comfortable, than a glass or china shop.

In the choosing of furniture, old or new, it is well to divest the mind of prejudice, and judge of its intrinsic beauty. There are bad pieces of furniture made in all periods, and their being solid enough to last a hundred years or so does not make them beautiful, nor fit objects for the decoration of our rooms. In some periods the taste was almost universally good or universally bad. There was a period (about fifty years ago) when huge size and a veneer finish was the characteristic of the style. Even in the furniture belonging to *this* period one finds occasionally some piece that is good; but as a rule, it is the worst of all styles.

The Renaissance was an age when the movement toward beauty was great, and usually guided by a very true instinct. In the furniture of this period one finds the most exquisite things. Yet, if we blindly accept all, we shall find ourselves sometimes with a piece where the desire for delicacy and grace has run into weakness. Sometimes the supporting legs of some chair or chest of drawers are fluted away till they seem to hold their burden with danger.

In the finest periods of carving – Dutch or Italian or Spanish – we find sometimes the Gothic, or grotesque, carried to an excess; and the beauty of the work cannot make some hideous monster, which we might see with amusement or even confess to be an appropriate ornament in the decoration of some large building, an agreeable companion in the narrow limits of a room. It is not enough that the piece we choose should be valuable or rare, or even belong to a good period; it must be *beautiful*. There are, side by side with these grotesques, exquisite cherubs, angels, youths and maidens, flowers, and conventional forms of great elegance, garlands of fruits, leaves. These are charming objects for a room.

There is a kind of grotesque which is not hideous, and has an extreme elegance, entirely robbed of the horrible. It seems one with the classic lines of the conventional acanthus-leaf; but it represents no caricatured natural object, like the grinning devil, the devouring fanged monster, the deformed creature, that would

frighten a child. This elegant grotesque has a repose and dignity that makes it entirely appropriate for household decoration – the winged griffin, the solemn sphynx, almost any of the Egyptian emblems.

There is a modern fashion which passes our understanding – that of using as ornaments in a room china dogs and cats, sometimes so realistic as to be mistaken for life. The larger and the uglier they are the more their collectors seem to admire them, but must also have a pack of small ones filling their tables or cabinets. The pug-dog, the ugliest of animals, is the favorite; and of cats, those with malign, green eyes, that glare at one even when the twilight gives one hope of repose, and when a soft, warm, living cat would close her eyes and present a smooth back to your sympathetic hand.

We know that the fair purchasers of these hideous china objects do not pretend to be gratifying their sense of the beautiful or sentimental. We know that their object cannot be scientific. We give up the riddle.

# ROBERT W. EDIS "PRINCIPLES OF INTERIOR DECORATION" (1883)

## Editorial Headnote

An architect, Robert W. Edis (1839–1927), joined the Architectural Association in 1859 and became an associate of the Royal Institute of British Architects in 1862, before becoming a fellow in 1867. He is particularly known for work in the 'Queen Anne' style of the 1870s and 1880s. Edis's most well-known publication *Decoration and Furniture of Town Houses* was first available in 1881. This book was based on his Cantor lectures at the Royal Society of Arts in 1880.

Edis also published *Healthy Furniture and Decoration* (London: William Clowes and Sons, Limited, International Health Exhibition, 1884) at the time of the International Health Exhibition in 1884. He was one of a number of architects/critics including E. W. Godwin who addressed the topic of domestic hygiene and its relation to interior decoration. Approaches to design and layout that lessened the impact of dust and dirt, increased fresh air and comfort and improved ventilation were all part of this agenda. Edis and the aesthetic interior had come in for some gentle ribbing by *Punch* magazine not only in Du Maurier cartoons but also in a brief article titled 'Quod Edis Ede' which was directed at Edis and his Cantor Lectures, and poked fun at the aesthetes attempts at individuality.[1]

In the introduction to his *Healthy Furniture and Decoration* Edis apologizes for using already published material, saying

> it would be impossible, in the writing of a short popular treatise on sanitary decoration and furniture, to avoid trenching to some slight extent on what I have previously written in my book on the 'Decoration and Furniture of Town Houses,' and in my article on Internal Decoration in "Our Homes.[2]

The general editor of the volume in which this extract is located was Shirley Foster Murphy, a public health official, and vice-president of Royal Sanitary Institute. The book, with essays by sixteen experts, had sections on architecture, internal decoration, lighting, warming and ventilation, drainage and house cleaning, among others. This text was one of a number of texts that were published in the 1880s,[3] some in conjunction with the London International Health Exhibition of 1884.[4]

The art periodical *The Portfolio* reviewed the book and noted that

> The great merit of this book is that it is thoroughly practical: the reader is told not only what to avoid but also what to do, what to buy, where to buy, and how much to give. Mr. Edis, who speaks with the authority of twenty years' experience in the constructing and decorating of houses, has a preference for the style of the Jacobean period as regards furniture.

The review went on to mention his interest in health issues saying, 'It will be seen that the foulness of London has taught Mr. Edis to wage fierce war against it and indeed, his pages bristle with warnings against "dust-traps"'. And then finally and rather disdainfully: 'Mr. Edis has written an unpretentious book of artistic advice, calculated to meet the necessities of modern life and the incomes of average people; and if not very original he is at any rate practical and sound'.[5]

In this chapter Edis invokes Pugin's theme of constructed decoration as opposed to decorated construction and avoidance of shams. He argues that these approaches are a healthier alternative to the usual practices so that 'a greater regard and attention to house decoration will pleasurably or prejudiciously influence our own comfort and health'.[6]

# 6

# 'PRINCIPLES OF INTERIOR DECORATION'

## Robert W. Edis

Source: R. W. Edis, 'Principles of Interior Decoration', in S. F. Murphy (ed.), *Our Homes and how to make them Healthy [Papers on sanitary subjects.] Edited by S.F. Murphy* (London: Cassell & Co., 1883), pp. 319–24

As a first principle in all true decoration it must be always borne in mind that good ornament should invariably be associated with, and form an integral part of, the real construction of the building. If this principle were always understood and adhered to, the cost of the generally trashy composition and plaster-work with which the ordinary builder has thought it necessary to over-lay the walls and ceilings of our houses would be considerably reduced; all this over-laying of sham constructive ornament is not only bad in taste and expensive, but often-times a source of danger, and always an element of dirt in our rooms. What can be more hideous and more useless than the elaborate plaster or papier mâché cornices which are generally to be found in every modern house, in which long lines of recessed mouldings, and trumpery cast enrichments of the worst possible design answer no practical purpose, and serve only as recesses and resting-places for dirt and dust, while the elaborate and vulgar centre-flowers and corners which are stuck on to so many of our ceilings are so far an element of danger that they add materially to the thickness of the plaster-work, and being altogether false in construction, are liable to give way and fall down at any moment; in themselves are entirely opposed to any true principles of decoration, and if picked out in vari-ous colours according to the fashion usually followed by the general run of deco-rators, are eye-sores in the room, and in every way objectionable and out of place. Simple plain mouldings, or hollows to take off the stiffness of the square break between the walls and ceilings, are all that are necessary, without enrichment or stuck-on ornament of any kind; these breaks can then be treated in a quiet and simple manner, and help to improve the general decorative effect of the rooms, whether they be papered, painted, or distempered.

From every point of view these constructional shams are objectionable. They weary the eye with their long monotonous multiplication of the same moulded truss, leaf, or flower; they are essentially false and untruthful, and so far are opposing elements to the association of fitness and reality which are so eminently desirable

DOI: 10.4324/9781003290490-8

41

in everything around us; they are conducive of dirt and dust wherever they occur, and must naturally thus add to the stuffiness and unhealthiness of the room; while at the same time they are opposed to all true taste and artistic beauty and simplicity in the decorative ornamentation of our walls and ceilings. In objecting to all such constructional shams as these, I am anxious that it should be understood that I do so, not only upon the point of taste, but on the more substantial basis that they are, to a great extent, elements of useless expense, and tend to deaden the mind to an unhealthy and careless disregard of false art and construction, and so far to prevent any better feeling for true taste in decoration. Shams of all kinds are to be objected to, whether it be in expensive and pretentious plaster or papier mâché ornament, unwieldy and pretentious trusses to windows or mantelpieces which support nothing, and are often so badly set on that they can hardly hold themselves up, or in the imitation of other materials by use of graining and marbling. What can possibly be worse in taste and so utterly cold and miserable as covering staircases or other walls with paint or paper in imitation of blocks of marble or granite, or so trumpery and tasteless as graining wood-work in imitation of various woods; perhaps, as I have seen in many instances, satinwood or maple for one side of a door, with dark walnut or wainscot on the other side; and after all, when this is done, it is a miserable travesty of the real material, and deceives no one who really knows anything of the particular materials the graining is intended to represent. This, I may be told, is an argument in its favour, that it deceives no one, and therefore does not matter; but the intention is the same, and whether the lie be well or badly told, it is a lie, anyway, and so far subversive of a healthy turn of mind or true artistic feeling.

"In art," says Mr. Redgrave, the late Art Inspector-General at South Kensington, "a back-ground, if well designed, has its own distinctive features, yet these are to be so far suppressed and subdued as not to invite especial attention; while as a whole it ought to be entirely subservient to supporting and enhancing the principal figures – the subject of the picture. The decoration of a wall, if designed on good principles, has a like office; it is a back-ground to the furniture, the objects of art, and the occupants of the apartment. It may enrich the general effect, and add to magnificence, or be made to lighten or deepen the character of the chamber; it may appear to temper the heat of summer, or to give a sense of warmth and comfort to the winter; it may have the effect of increasing the size of a saloon, or of closing in the walls of a library or study; all which, by a due adaptation of colour, can be easily accomplished. But like the back-ground to which it has been compared, although its ornament may have a distinctive character for any of these purposes, it must be subdued, and uncontrasted in light and shade; strictly speaking, it should be flat and conventionalised, and lines or forms, which are harsh or cutting on the ground should be as far as possible avoided, except where necessary to give expression to the ornamentation. Imitative treatments are objectionable on principle, both as intruding on the sense of flatness, and as being too attractive in their details and colours to be sufficiently retiring and unobtrusive."[7]

I believe it has been shown by experiment and observation, that, to a certain and distinctly appreciable degree, various colours act upon our optic nerves to their fatigue

and injury, and so far to the weariness and unhealthy action upon the brain, and that therefore it is a matter of interest to us how far we may use colours which present an harmonious and pleasant contrast to the eye, or which fatigue and annoy us by their harshness and inharmonious arrangement. Quite certain it is, however, that proper and harmonious contrast and arrangement of colours is an important question in all artistic decoration, as by proper contrast various colours may be made to look more beautiful and effective, while a dingy and unpleasant effect may be easily produced by any bad or violent combination; and, as a natural consequence, the graceful and pleasant appearance of our rooms will be naturally enhanced or decreased by a study and knowledge of the contrasts and effects of various colours. Without being able to define the exact shade, and even sometimes the exact colouring, of any room we enter, we are sensibly affected pleasurably or the reverse by its general tone and treatment; even as in admiring good taste in dress we may not always be able to describe what it was that caused our special delight or admiration. How often do we hear it said that this or that lady was well dressed, and on being asked for a description of the dress or colour we are unable to remember or describe it. In the like manner, the prettiness and general pleasant effect of a room is often marred by some injudicious or inharmonious contrast of colouring or design in the paper or decoration, and ornament that should be in subjection and subordinate to the general effect is made staring and obtrusive, to the destruction of the artistic effect, and to our own mental annoyance. Without further entering into the physiological causes which enable us to judge between the proper and pleasant contrast and association of colours and the reverse, it will, I think, be admitted that a greater regard and attention to house decoration will pleasurably or prejudiciously influence our own comfort and health; and if this be admitted when our bodily health is good, and our nerves strong and vigorous, how much more will it be admitted when suffering from bodily or mental ill-health and fatigue. In the selection of paper or other hangings, and in the arrangement of all ornament in wall or panel decoration, it becomes therefore a matter of importance to select none which shall have distinct and strongly-marked patterns in which the ornament stands out and repeats itself in endless multiplication and monotony; all such patterns would be a source of infinite torture and annoyance in times of sickness and sleeplessness, would materially add to our discomfort and nervous irritability, and after a time have a ghastly and nightmare effect upon the brain.

Naturally the walls of various rooms will require different treatment. Halls and staircases should be of some warm, quiet tones of colouring, such as reds or greens which are not positive colours, as the eye on entering a house is generally fatigued by the strong glare of daylight; in the drawing-room, a good all-over decorative pattern, such as "Morris" blue pomegranate, or some of the generally decorative and well-designed modern French patterns, forms an exceedingly good covering, as being essentially gay and decorative without being especially defined in colour or ornament; in the drawing-room the wall-covering becomes often a material portion of the decoration, and is not usually required for a background for pictures or prints, and any good pattern in which the general colouring is brilliant without being gaudy, and in which the ornament and colours are so well

arranged and balanced that they do not attract the eye by any strongly-defined pattern or colouring, may safely be used. In a dining-room or library, dull reds or warm russet-browns form good backgrounds for pictures or engravings, and even brilliant golden-flecked vermilion or quiet tones of blue, if relieved with enrichment or top friezes of warm vellum or lighter shades of blue and white, can be used with good effect, and do not by any means form disagreeable backgrounds. It must be manifest that the cutting up of any wall-surface by hanging pictures from the cornice-line by means of long cords or wires must be disagreeable in effect; if, therefore, picture-rods are used in any room of ordinary size, say from ten to twelve feet in height, they should be placed from two to three feet lower than the cornice, and be affixed to or form part of a small wood dividing moulding or rail. The top frieze, or surface, can be left plain or covered with a light self-tinted diaper paper, greenish. or with arabesque enrichment, in one or two light shades of colouring, so arranged that they should not take away from the flatness of the wall-surface or attract the eye by too great prominence of colouring or ornament.

Dark golden yellow with russet and white ornament form also a pleasant general wall-surface when treated with a dado of dark brown or stamped leather: while all colours which contain oxide of iron, such as umbers, reds, and ochres, are serviceable and lasting. Good effects can also be produced on wall-surfaces by the use of a recently-introduced washable silvering, which is said not to tarnish and not to be injured by gas or atmospheric influences-in combination with black.

As all pleasant and artistic decoration must, to a certain extent, depend upon the proper arrangement of colours, and upon a knowledge of their various effects when placed in contiguity to each other, and the changes which take place under the influence of contrast, it will be useful to note a few of the more important changes in colours which are more or less largely used in the decoration of our rooms, whether with paint, paper, or distemper; and I give below a table compiled from Professor Rood's valuable book on "Modern Chromatics, applied to Art and Industry."[8]

| Pairs of colours. | Change due to contrast. |
|---|---|
| {Red. | becomes more purplish. |
| {Yellow | "          greenish. |
| {Red. | "          orange red. |
| {Blue | "          greenish |
| {Yellow | "          orange yellow. |
| {Green | :          bluish green. |
| {Green | "          yellowish-green. |
| {Blue | "          purplish. |
| {Red. | "          purplish. |
| {Orange | "          yellowish. |
| {Blue | "          greenish. |
| {Violet | "          purplish. |

44

Red placed on a white ground appears darker and more intense, on a black ground it becomes more orange in tone and more luminous; yellow on a white ground appears darker and more greenish than on a black ground, in the latter case it is particularly brilliant, and gives a bluish tint to the black ground. Yellow and grey or black constitute, therefore, a pleasant combination. Green on a white ground looks deeper and richer, on a black ground somewhat paler. Blue on white appears dark and rich, on black by contrast becoming more luminous. The eye tired by gazing at green, is rested by looking at its complement, i.e., at a mixture of red and violet; vermilion with gold or yellow, or blue or greenish-blue, orange with green, sea-green with vermilion or violet, and red with blue, all give excellent combinations.[*]

A good yellow diaper on a bluish-grey ground, or grey ornament on light yellow or vellum ground, form good combinations for the upper portion or frieze of any room where the lower portion is treated with dark chocolate or purply-brown grounds. White ornament on soft blue or green grounds, similar to Wedgwood ware, is very effective, especially when applied to ceilings or friezes in which the ornament is in low relief, as is the case in ceilings of the houses of the end of the last and beginning of this century.

How far different colours have any really practical influence upon the mind there are at present no reliable experiments to prove, but it is quite certain that various colours exercise distinctly-marked influences. Dr. Ponza of Alessandria[9] has made various experiments in treating certain forms of insanity by the action of coloured light. The following extract from the British Medical Journal will explain the nature and theory of these investigations: – "Dr. Ponza's experiments consisted, in the abstract, in placing his patient in chambers coloured red, blue, and violet, with the most surprising results. In the red room he placed a melancholic man who had refused his food, but who three hours after wards was found lively and hungry. In the blue chamber he placed a violent lunatic, who became much quieter within an hour. In a violet room he procured equally good results. Of all the rays of the spectrum, the violet are those which possess the most intense electro-chemical rays; the red are richest in calorific rays; whilst the blue, devoid of calorific, chemical, or electric rays, are in fact the negation of all excitement, and are most useful in calming violent excesses of fury."[10] It is said that Paracelsus[11] recommended red coral as a remedy against melancholy; while Esquirol and Rösch assert that indigo-dyers are melancholy, and those who dye scarlet are choleric.[12]

To my mind nothing can be more objectionable and false in art than the overlaying of good coloured plain surfaces with flowers fossilised, so to speak, into unnatural forms, so as to present longways and crossways, and in any way in which you look at them, clearly-marked lines or patterns, or continual spots on the general surface, which fatigue the eye, and perceptibly set up mental irritation even in those who are in good health; and which tend to the infinite discomfort and

[*] From Professor Rood's chapters on "Contrasts" and "On the Combination of Colours in Pairs or Triads."

mental annoyance of those who are suffering from sickness or brain weariness. No matter how well-drawn or how artistic in general treatment, birds seemingly in flight, or cherubs holding festoons frozen into rest, seem to me utterly unsuitable for ordinary wall-decoration, by the absence in them of all quiet and repose. The pattern and colouring of a paper should be so treated that there should be no spotty effects, and no vividly-marked lines to break up the general surface into set forms. Plain colouring for wall-surfaces has the objection of showing scratches and finger-marks more easily than pattern papering; but walls thus treated give a much more harmonious and quiet appearance, and can readily be broken up, if need be, with simple enrichment with good effect. Pure vermilion – toned with a little yellow chrome to take off its crudeness, and relieved with a darker surbase or dado, and some simple stencil-work in the frieze – or pure Antwerp blue, look very effective; but both colours are too delicate to use in distemper, except on painted surfaces.

In all decorative art, whether it be in simple monochromy or single colour, or in its more elaborate treatment by use of polychromy in various distinct colours used simultaneously, much must naturally depend on the size and shape of the spaces to be treated. To quote the late Owen Jones, "The secret of success is the production of a broad general effect by the repetition of a few simple elements, variety being sought rather in the arrangement of the several portions of the design than in the multiplication of varied forms."[13]

In all modern decoration there is to a great extent an absence of simplicity and natural harmony of colours, and a want of knowledge of proper combinations and contrasts, so that the wall-surfaces are either made flaming and vulgar in tone or cold and lifeless, when by a little thought and artistic judgment they may at the same cost be made agreeable and pleasant to the eye, and offer good backgrounds for the pictures and engravings which are placed upon them, or pleasant decorative effects in monochrome or polychrome. It is true that in most modern houses the work of the plasterer and the painter is of the most tasteless description, the proportion and contour of the mouldings, whether in ceilings, cornices and so-called enrichments, or enclosing-mouldings or architraves round the doors and windows, being generally coarse and bad, and offering no good constructive lines for decorative treatment; but there is no reason why the mere decorator should be allowed to run riot in over-laying every bit of bad enrichment – and thus emphasising its badness – with gaudy colouring or gold, or in picking out, as it is called, the various sham ornaments and mouldings with brilliant colouring, with no attempt at harmonious treatment or artistic blending together of tints and shades. The mere conventional decorator is a being to be avoided of all others, for his idea of artistic decoration would seem to be in gaudy colouring and gilt, utterly unnecessary and exceedingly expensive.

Gold used in decoration will not stand unless varnished, but becomes black by the effect of noxious gases and impure atmosphere, and in papers it is generally made up of inferior or Dutch metal, and soon becomes destroyed by atmospheric effects or draughts.

In the examples which are left to us of the decorative treatment of ordinary houses in Pompeii, the general arrangement of design and colouring was of great beauty and elegance in outline, and quiet and graceful harmony of colour; and when the ornamentation was in any way elaborated it was made conformable to the proportions of the rooms and in pleasant harmony and contrast with the furniture and general surroundings. We cannot but be struck with the brightness and cheerfulness and general artistic effect of the whole work. In the ordinary rooms the ceilings and upper portion of the walls had simple borders of graceful design in bright and well-arranged colouring, with occasional panels formed either by well-painted frescoes or ornament. Without desiring to see in modern rooms any imitation of Pompeiian decoration, we might study and adapt some of its graceful combinations of colouring and brilliant tones instead of picking out bad plaster enrichments in endless monotony of tints, or in stencilling hard and inartistic designs at various set intervals along the wall or ceiling space.

## Notes

1 House Decoration – "QUOD EDIS EDE" *Punch, or the London Charivari*, 8 May, 1880, p. 210.
2 Robert W Edis, *Healthy Furniture and Decoration* (London: William Clowes and Sons, Limited, International Health Exhibition, 1884).
3 See Michelle Allen-Emerson, Tina Young Choi, Christopher Hamlin, Tom Crook, and Barbara Leckie, *Sanitary Reform in Victorian Britain* (London: Routledge, Taylor & Francis Group, 2016).
4 See, Anon., "A List of Official Publications Issued by the Executive Council of the International Health Exhibition" in *The Health Exhibition Literature* London, 1884, pp. 3–6.
5 *The Portfolio: An Artistic Periodical*, 1881, p. 72.
6 Edis, "Principles of Interior Decoration".
7 Richard Redgrave "Supplementary Report on Design", in *Reports of the Juries* Vol 2 (London, 1852).
8 Nicholas Rood Ogden, *Modern Chromatics: With Applications to Art and Industry* (London: C. Kegan Paul & Company, 1879).
9 Director of the lunatic asylum at Alessandria (Piedmont)
10 "Coloured Light in the Treatment of the Insane", *British Medical Journal*, 25 March 1876, p. 382.
11 Paracelsus in his *Dispensatory and Chirurgery* (London, 1656), provides a treatise on "the Vertues and Preparations of Corals."
12 *The Journal of Psychological Medicine and Mental Pathology*, 1848, p. 500.
13 Owen Jones, *Grammar of Ornament* (London: Quarich, 1868), p. 15.

# Part 2

# TASTE

# TASTE

The role of taste in a rapidly expanding consumer society, along with notions of fashion, proved to be a particularly troublesome issue during the period. David Reid in his *Essays on the Intellectual Powers of Man*, (1785), wrote, 'I think there are axioms, even in matters of taste. Notwithstanding the variety found among men, in taste, there are, I apprehend, some common principles, even in matters of this kind'.[1] According to Reid, these common principles come from two sources: 'There is a taste that is acquired, and a taste that is natural. This holds with respect both to the external sense of taste and to the internal. Habit and fashion have a powerful influence upon both'.[2] Reid then argued that taste could be described as either true or false, through reason: 'This taste may be true or false, according as it is founded on a true or false judgment. And if it may be true or false, it must have first principles'.[3]

Taste, its origins and tenets, the issue of bad taste, and the diffusion of good taste amongst all classes, were all linked to design principles. The concept of improvement of taste was not just an economic issue, but a social one. For many, 'good taste' equated to a universal standard that enabled people to recognize beauty and if taught correctly would eliminate 'bad taste'. These ideas were influential on nineteenth century reformers who saw that the elevation of public taste through education, exhibitions, museums, lectures, and publications was part of the solution to the curse of popular 'bad taste'. Whether it was the 1835–6 Select Committee on Arts and Manufactures, the *Journal of Design and Manufactures* or the Museum of Ornamental Art and its 'Chamber of Horrors', great attempts were made to improve public taste. Correct taste was thought to exist in countries like France and Italy, and its development in England was seen as important, both socially and commercially. Indeed, the idea that correct taste could be taught was the basis of the 1835–6 Select Committee on Arts and Manufactures' report that valued the 'true' and 'unvarying principles' of classical art, which were seen as the basis for a 'national taste'. However, it was an uphill battle. In 1868 Sir Gardener Wilkinson wrote:

> It is the universal remark that those things which are bad in style find a more ready sale than the good; and that not from the price being lower, but solely from the choice of the public. If the bad happens to be attractive it meets with admirers; and high finish, minuteness of detail, and

DOI: 10.4324/9781003290490-10

whimsical shape, are greater recommendations than good form and purity of design.[4]

Other examples of bad taste were mentioned in *Blackwood's Magazine*, in 1869:

> As constructive shams which have rightly provoked hostile criticism, take for instance sideboards formed on the models of Grecian stone altars, cabinets constructed in the fashion of Roman temples, wine coolers suggestive of sarcophagi, and jardinières treated as ruined chateaux with dilapidated roofs, out of which actual flowers disport themselves![5]

The importance of design to the establishment of good taste was important 'to purchasers – the public at large, and particularly to the nobility and gentry – as design is indeed the only quality which can give to articles of taste a lasting value'.[6] It was thought that education in matters of taste would also encourage working people to spend carefully, and it was hoped that this would increase standards of living and thus reduce social discontent. The idea of integrating these groups into the dominant taste culture through education was seen as one way of managing the situation. This approach would encourage consumerism, and then influence social behaviour for the better. However, not all commentators agreed with this didactic decree. A commentator in the *Magazine of Art* (1878) suggested that readers ought to follow their own ideas and not be led by taste or fashion, contrary to a notion of one national taste:

> And the buyer must buy with equal honesty, buy for his intellectual health, and regard in no way the dictum of the critic, but only the desire of his own eyes, and that which his soul feels to be good. Nor can art ever find strong hold in the national history, nor attain to high excellence, until people come to it honestly to seek not fashion, but happiness.[7]

## Notes

1  D. Reid, *Essays on the Intellectual Powers of Man* (Edinburgh: John Bell 1785), p. 599.
2  Reid, p. 600.
3  Reid, p. 602.
4  Sir G. Wilkinson, *On Colour and on the Necessity for a General Diffusion of Taste Among all Classes* (London: John Murray, 1858), p. 178.
5  "The Arts in the Household or Decorative Art applied to Domestic Use", *Blackwood's Magazine*, 105, 1869, p. 361.
6  H. Whitaker, *The Practical Cabinet Maker & Upholsterer's Treasury of Designs. House-Furnishing & Decorating Assistant, Etc.* (London: Peter Jackson, 1847), Introduction.
7  Philostrate, "Sincerity versus Fashion", *The Magazine of Art*, 1878, p. 92.

# SHIRLEY HIBBERD,
## 'HOMES OF TASTE' (1870)

### Editorial Headnote

Shirley Hibberd (1825–1890) was one of the most popular and successful gardening writers of the period. He was a crucial catalyst in developing the field of amateur gardening, as apart from creating gardens he was also a best-selling editor of three gardening magazines.[1]

This text, titled *Rustic Adornments for Homes of Taste*, was first published in 1856. It not only describes gardening practices but also explains the role of aquariums, bee-keeping, bird-keeping and Wardian cases for the amateur. The book was immediately successful, and an enlarged edition was published the following year. In 1858 his publishers, Groombridge, invited him to start a monthly magazine for amateur gardeners. This emphasis on the amateur was important to Hibberd, as he explains in the preface to the 1870 edition.

> Its purport is to enlarge the circle of domestic pleasures and home pursuits; to quicken observation of natural phenomena, so that the meanest of familiar things shall become eloquent in praise of beneficence and beauty; to strengthen family ties and affections by multiplying the sources of mutual sympathy; and to cheer the loneliest with amusements that tend to cheerfulness, and afford solace and society, where, but for such reliefs, life might become unbearably monotonous and wearisome.[2]

The journal *Nature* found the work very satisfactory for a general audience:

> Works of this kind appeal to a large public, not over-critical as to scientific accuracy, but glad to possess that amount of knowledge which enables them to talk about ferneries and aquaria without committing any egregious blunder. We are far from depreciating the value of this smattering of science where it is all that opportunity permits to be attained. Those who like their homes to be surrounded by beautiful natural objects will here find a large fund of information respecting the aquarium, the fernery, the aviary, the apiary, the conservatory, &c., given in a pleasant style, illustrated with woodcuts and coloured plates The volume makes altogether a very pretty gift-book, especially for a young lady.[3]

The text that follows from the 1870 edition is the new first chapter of the book and is the first of his works to discuss the home as a concept. It is evident from the text that there is a strong religious faith that informed the writer and his ideas of home. Indeed, for a while, Hibberd was a speaker and writer advocating

53

temperance and vegetarianism. The appeal to the Victorian middle classes was evident both in his gardening publications as well as this text. The idea of a 'Home of Taste is a tasteful home, wherein everything is a reflection of refined thoughts and chaste desires' clearly appealed to the Victorian notion of home as a source of morality. Hibberd's stress on taste and its link to nature made his approach distinctive. He argues that 'No matter in what form the cultivation of Taste may manifest itself, in paintings and sculptures, in the analysis of scenery, in the grouping of flowers, in the embellishment of the window or the mantel'[4] our lives would be greatly improved in a variety of ways. These ideas about the home representing the character and morality of those that lived in it was another recurring theme during the period.

# 7

# 'HOMES OF TASTE'

## Shirley Hibberd

Source: Shirley Hibberd, "Homes of Taste", *Rustic Adornments for Homes of Taste; and Recreations for Town Folk in the Study and Imitation of Nature* (London: Groombridge 1870), pp. 1–8

> Home! in that word how many hopes are hidden,
> How many hours of joy serene and fair,
> How many golden visons rise unbinden.
> And blend their hues into a rainbow there!
> Round home what ranges of beauty cluster,
> Links which unite the living with the dead,
> Glimpses of scenes of most surpassing lustre,
> Echoes of melody whose voice is fled.
>                          J. W. FLETCHER[5]

Among the emblems of our nationality, not one is more strongly cherished by us than our HOME. We pride ourselves on the strength and healthiness of our domestic life, and we challenge the world to produce an example of people more fondly attached to their native soil, or in whom the fireside affections have a broader development, or a higher aim. We cherish the chimney corner where we first were blest by parental kisses, and through "the aisles of memory" its ruddy glow shines on our grey hairs, and warms our hearts as we hurry to the grave. At any period of life there is, with the majority of us, no dearer object of recollection than remembered scenes of the Home wherein we first lisped "Our Father," and no more hopeful subject of speculation and conjecture than the Home we have or, by the help of God and a noble purpose, are building up, in which to teach that same simple prayer to children of our own.

It is because we are truly a domestic people, dearly attached to our land of green pastures, and shrubby hedgerows, and grey old woods, that we remain calm amid the strife that besets the states around us, proud of our ancient liberties, our progressing intelligence, and our ever-expanding material resources. Those resources daily multiply the means of exalting our social life, and invention keeps pace with the demands of an improving civilization; so that while

> "The thoughts of men are widened by
> The progress of the suns,"[6]

DOI: 10.4324/9781003290490-11

the facilities for calm and healthful enjoyment increase with the growth of more elevated desires. The "Home of Taste" is one of the latest fruits of the high tone to which social life has attained in this country of late years, and its complete development may not be so far off, but that the present generation may witness the union of Nature and Art in happy ministration to human sympathies within doors.

We know already that the luxuries of refinement are no longer monopolized by the wealthy, that the merchant is not rendered sordid by commerce, but that he can delight in the strength of Angelo and the grace of Raphael; the ledger does not dwarf the trader's soul below the appreciation of Titian's lights or Rembrandt's shadows; and the persevering plodder, who from four to six does battle with armies of statistics, can retire to his suburban villa to rejoice as a happy soul in the midst of his family, or fondle his tame birds with the affection of a child. The aboriginal nature can never be drummed out of us, let visionaries say what they may; through all the varying circumstances of life, let the whirl of excitement be never so rapid, or the stupor of despondency never so profound, that which ministers to our perceptions and enjoyments of beauty, grace, and truth, serves at once as rest, and solace, and refreshment. Therefore, we build up Homes of Taste wherein to find epitomes of the natural world, and where, secure from the commotion and dust that prevail without, we may cherish the affections that lie deepest in our nature, and from which spring the noblest and most enduring results in the exaltation of our intellectual and spiritual faculties.

A Home of Taste is a tasteful home, wherein everything is a reflection of refined thoughts and chaste desires. It is a school of the heart, in which human sympathies teach profounder lessons than are found in books, and the ornaments of walls and windows suggest a thousand modes of being cheaply happy. In such a home Beauty presides over the education of the sentiments, and while the intellect is ripened by the many means which exist or the acquisition of knowledge, the moral nature is refined by those silent appeals of Nature and of Art, which are the foundation of Taste. If Taste is an application to nature of the same faculty which in morals enables us to distinguish between right and wrong, then the Beautiful is the highest form, or rather the embodiment of the purest ethics; and to be in constant communication with it, drawing our inspirations from its most palpable phenomena, is to place our spiritual natures under the guidance of a goddess who cannot lead them wrong. No matter in what form the cultivation of Taste may manifest itself, in paintings and sculptures; in the analysis of scenery; in the grouping of flowers; in the embellishment of the window or the table; in the cultivation of criticism, and the appreciation of what is true and good in Art generally; refinement of manners, sensitiveness of personal honour, kindliness of feelings, and a deeper devotion of religion will be its sure attendants. We cannot come into the presence of any work of high-class art without at the instant experiencing emotions that increase our happiness, nor can we take interest in the simplest pursuit of a leisure hour, if that pursuit be

pure and pleasing, without at once passing into an atmosphere of higher moral purity than we breathe at other times, amid

"The weariness, the fever, and the fret,"[7]

that, without such an antidote, harden the heart by degrees, restrain the aspirations of the inner life, and arrest the development of our spiritual capabilities. Such "enchantments are medicinal, they sober and heal us. They are plain pleasures, kindly and native to us."[8]

But the Home of Taste is not necessarily the result of a lavish expenditure – the most humble may command it. Though the several Rustic Adornments treated of in this work admit of extension, commensurate with the most liberal outlay, there is not one but is in some measure attainable by those who have but little leisure and most narrow means, and some indeed may be, and have been cultivated most successfully by those who could not aspire even to the ordinary luxuries of middle life. If the poor man cannot have his picture gallery, he can still gratify his love of art by embellishing his walls with copies of works of great masters, brought within his reach by the multiplying skill of the copyist and the engraver; if he cannot have a library, panelled with palm branches, and containing a collection of Aldines on vellum,[9] and Caxton's worth twelve thousand guineas, he can still command elegant editions of the greatest historians, philosophers, and poets, to whom God ever gave the gift of expression. If he cannot afford pictures, he may have a "garden of delights;" and if palms and orchids are forbidden fruit, he may every day experience a subdued but healthy pleasure amidst ferns and flowers: the rose will shake into his heart her perfume, and the lily recall to him the teachings of the Lord. In the adornment of the home it does not require a princely fortune to set up a vase of flowers, or an aquarium, or a stand of bees that shall sing to their master all day long, and entrap every spare moment of leisure he may be able to afford to "shepherd them." He who lays out his garden in accordance with correct principles of taste, may find in it as much amusement, and as genuine a solace from the cark[10] and care of life, as if it were a domain of thousands of acres- perhaps more so, for it is his own work, it represents his own idea, it is a part of himself, and hence redolent of heart-ease.

It is an error common to writers to believe that the special subject on which the pen is engaged is of pre-eminent importance, and perhaps I may be yielding to this common weakness when I suggest that the embellishments of the household embrace the highest of its attractions apart from the love which lights the walls within. The prose of life is good, food, clothing, safety must be first secured; but the poetry is better, for though the body must be fed, it is chiefly because of the soul it shelters that it must be kept sound and clean. The pleasures of the gar- den, the tending and taming of household pets, the culture of choice plants in the greenhouse and the window, seem to me much more remunerative, both intellec- tually and morally, than even the study of the higher departments of art, because of their suitability to all tastes and means, and their directly educative power,

for they keep us near to nature, and compel us to be students of the out-door world, whence many noble inspirations and humanizing teachings and devotional impulses are drawn. "It seems as if the day was not wholly profane, in which we have given heed to some natural object."[11]

It would be an anomaly to find a student of nature addicted to the vices that cast so many dark shadows on our social life, nor as a matter of fact can we readily recall an instance of a naturalist or philosopher who has been known as a bad man, but of such as have been revered and loved for goodness the names are so numerous that we might liken them in plenitude as well as their nature to the stars in heaven. But to avoid any severe test, is it not true that the most genial natures are of the homely sort, attached to the fireside; cultivators of rural tastes in some form or other; given to simple hobbies that keep the attention fixed on things that breathe purity, and quiet, and peace, answering to their own aspirations? They are healthy folks, healthy in mind as well as in body, and to clear perceptions add the impulses of generous hearts. We must receive the kingdom of heaven as little children, and shape our lives in childish ways to be worthy of it.

In a certain sense the Home is the outside of a man; it is an external vesture, and more or less, but always in some degree, a visible embodiment of his mental character. The man of intellect and taste will impress on everything about him an air of usefulness or elegance, and will make the best of the roughest materials that fate may cast in his path. Architecture – the highest of the domestic arts – springs out of the desire of the mind to dwell in a fair exterior, and to be surrounded by harmonious forms. In this, as in other of the useful arts, elegance, comfort, and convenience usually go hand in hand; and while deformity is invariably more expensive in every sense than grace, so the well-built and tastefully-adorned mansion more readily meets our domestic requirements, and in accordance with our station, affords proper scope for embellishment within and without. Sir Henry Wotton says, "Architecture can want no commendation where there are noble men and noble minds;"[12] and it is not to be doubted that if ordinary residences were constructed in accordance with correct principles of taste, the dwellers in them would attain a higher status in mind and morals, for the character is powerfully impressed for good or evil by what surrounds it permanently. Why should the eye be compelled to gaze on ugly lines and awkward angles, false proportions, and incongruities intended as ornaments, when symmetry is at all times cheap, and accuracy of form the most useful and convenient? If builders were equal to their work we should read art-lessons in the streets, instead of perpetually deploring the violation, in bricks and mortar, of every law which should control domestic architecture, save and except the one primary law that a house must have a foundation. However, in this matter we witness the beginning of a revival; true taste has ceased to be esoteric, and in all our cities evidences abound, to testify that our people are not satisfied with bread alone, but crave the heavenly teaching of beauty as reflex of the divine nature. Art is religious or it is nothing, every touch of grace in outward form is a rebuke to sinfulness, every work of art is a minister of morals to those who can understand.

Lord Bacon says, "Every man's proper mansion, house, and home, being the theatre of his hospitality, the seat of his selfe-fruition, the comfortablest part of his own life, the noblest of his sonne's inheritance, a kind of private princedom; nay, to the possessors thereof, an epitome of the whole world, may well deserve, by these attributes, according to the degree of the master, to be decently and delightfully adorned."[13]

Wealth is certainly a blessing when it is made the instrument of increasing human happiness, and in the gratification of a love of elegance money is certainly a powerful instrument. Still the Home of Taste is within the reach of all, it is the mind more than the money that must make it. Spiritual life will give radiance to a cottage, pure pleasures will sweeten the humblest lot, while the noblest productions of genius may even contribute to the gloom of the mansion, where moral and religious worth are unknown. Whatsoever we look upon reflects our own mood, we see ourselves perpetually, as if all nature and art were but repetitions of a mirror.

"Our sleeping visions, waking dreams,
Receive their shape and hue from what
Surrounds our life."[14]

Where the counsels of wisdom preside over parental love, where those "whom God has united" remain in unity under the bonds of a beautiful affection, than which

"All other pleasures are not worth its pains;"[15]

where woman appears in her true gentleness, and the children grow up in the love of parents and the fear of God, there is a Home of Taste, a Home of Virtue, of Mental Discipline, of Moral Worth, Domestic Affection, and Religious Aspiration. "Round it all the Muses sing;" everything within takes the semblance of the souls that preside over it; the simplest things acquire grace and meaning; vulgarity, meanness, and vice dare not cross the threshold – ennui cannot find its way there, petulance is smiled out of countenance, and temper is rebuked by the pacidity[16] and suggestiveness of the surroundings. "If the Lord build not the house, they labour in vain that build it".[17] The mind, like a sensitive plate in a camera, receives impressions which become permanent pictures in the memory, and these pictures refresh or depress as according to their tone and tinting. In meditative moments we turn them over as the leaves of book, and our hearts leap with joy as the pictures of happy times and generous deeds are revealed. But they sink despondent under a weight of regrets as the great blanks that represent wasted opportunities, or the more demonstrative mementoes of vice and folly, break into the field and pass drearily in review. Hours well spent, like fruits well grown upon the bough, give gladness for the present and afford enjoyment for the future as memory recalls them, and that inward gratulation follows which only the satisfied

conscience can allow. Memory rides above the will, and to forget is a pleasant or a painful impossibility according to the complexion of the reminiscence that flashes upon the inward eye. So for the sake of the future when the calm days approach, and remembrances hold us more strongly than the events of the passing hour, it is well that we should shape our pleasures, in common with our more serious occupations, in accordance with the demands of reason and virtue. The perfection of dullness and indifference may be surest attained by devotion to sordid pursuits and selfish aims: it is the outgoing of the affections in honest sympathies and kindly acts that will most certainly tend to spirit of joyfulness. True mirth is of quieter aspect than the world allows; and there is an inward cheerfulness that makes no noise and appears not to sense, that will ever be welcomed as a foretaste of the blissful condition of the happy dead to the heart that faith has sanctified. For the sake of all around us, who may be blessed or banned by our example and works, no less than for our own sakes, that happy pictures may be painted on the memory to beautify the sunset of our lives, we must shape our course in all things so that "Hope may never lose her youth," and that every individual endeavour shall be as seed sown in the field of the heart to bring forth "the peaceable fruits of righteousness."

> "Thrice blessed whose lives are faithful prayers,
> Whose loves in higher love endure;
> What souls possess themselves so pure,
> Or is there blessedness like theirs?"[18]

In the Home of Taste we find abundant resources for recreation, and many an antidote to care and folly. Its least embellishments fill the mind with a sense of the exhaustlessness of form and colour in this orderly universe; there are household pets that daily teach us we may rule by love and not by fear; there are gatherings of all kinds from the world of art and the world of nature that demand attention, and the exercise of skill, every one of which represents an idea and persuades us to reflection; while every labour they require brings its high reward in mental activities and the gratification of ennobling desires. But above all there is the ripe domestic life which forms the true centre of this circle of adornments, heightened by them in its ever-growing appreciation of what is good in man and beautiful in nature, and in both representative of the Wisdom, Power, and Goodness of the Almighty.

> "Domestic happiness, thou only bliss
> Of Paradise, that hast survived the fall!
> * * . * * . *
> Thou art the nurse of virtue, in thine arms
> She smiles, appearing, as in truth she is,
> Heaven-born, and destined to the skies again.
> Thou art not known where pleasure is adored,

That reeling goddess, with the zoneless waist
And wandering eyes, still leaning on the arm
Of novelty, her fickle, frail support;
For thou art meek and constant, hating change,
And finding in the calm of truth-tried love
Joys, that her stormy raptures never yield."

COWPER.[19]

## Notes

1 For a review of his works see Anne Wilkinson, "The Preternatural Gardener: The Life of James Shirley Hibberd (1825–90)." *Garden History* 26, 2 1998, pp. 153–75.
2 Shirley Hibberd, *Rustic Adornments for Homes of Taste*, (London: Groombridge and Sons, 1870), p. v.
3 *Nature*, 23 June 1879, p. 140.
4 Hibberd p. 3.
5 This poem was first published in 1850: "A short time since, the Editor of the 'Public Good' offered a handsome copy of Miss Cook's *Poetical Works* as a prize for the best short poem on 'Home.' Mr. Fletcher, of Sunderland, was the successful . . ." in *Eliza Cook's Journal* – Vol 3, 1850, p. 248.
6 Tennyson, "Locksley Hall".
7 John Keats, "Ode to a Nightingale".
8 Ralph Waldo Emerson, "Nature".
9 The Aldine Press was established by Aldus Manutius in 1494 in Venice. He produced Aldine editions of the classics.
10 cark: to be burdened with care or anxiety.
11 Ralph Waldo Emerson, "Nature".
12 Sir Henry Wotton, 1568–1639. *The Elements of Architecture, collected by Henry Wotton Knight, from the best authors and examples.*
13 Ibid. Hibberd wrongly attributed the quote to Lord Bacon.
14 *Poems From Greek Mythology* "Dreamland".
15 R. W. Emerson, *"Essay V"* on Love.
16 The state of being placid.
17 Psalm 127.
18 Tennyson "In Memoriam".
19 William Cowper "The Garden Poem".

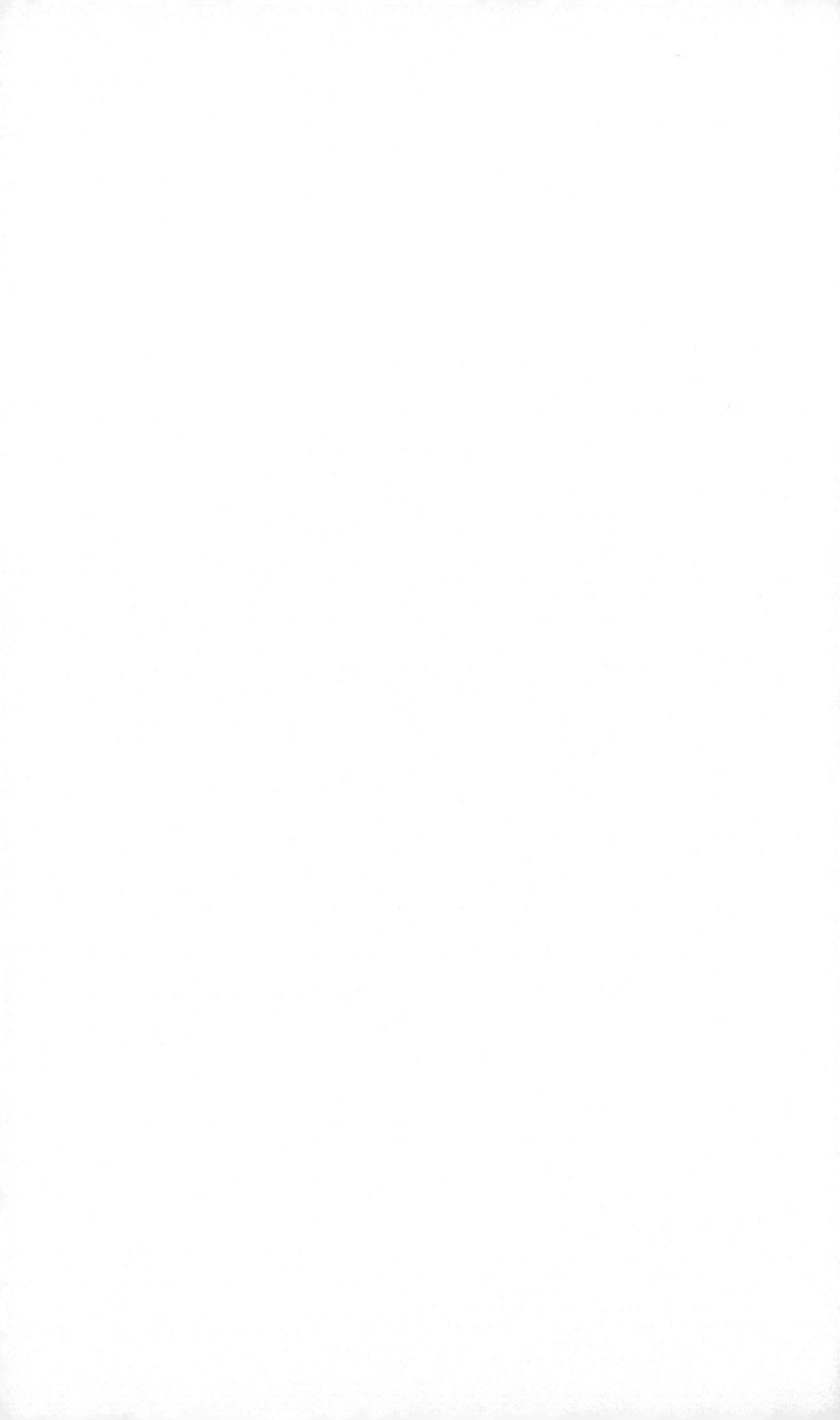

# [ANON] "MR. EASTLAKE ON TASTE" (1869)

## Editorial Headnote

This text is a crushing demolition of the ideas and designs of Charles Eastlake, one of the most influential critics of the period. Charles Locke Eastlake, was a journalist and author who went on to become an art administrator and to write the highly successful book *Hints on Household Taste: In Furniture, Upholstery, and Other Details* in 1868. Its popularity meant that subsequent revised editions were published in 1869, 1872, 1878. Importantly, an American edition with notes by Charles C. Perkins, was published in 1872, and reissued eight times between 1874, and 1886.

Eastlake's publication was instrumental in developing a distinctive 'Eastlake style' of furniture that was highly popular. It is noteworthy that in the preface to his 1878 fourth revised edition of *Hints on Household Taste*, Eastlake said: 'I find American tradesmen continually advertising what they are pleased to call Eastlake furniture, the production of which I have had nothing whatever to do, and for the taste of which I should be very sorry to be considered responsible'.[1] The adopting of his name to a furniture style as a 'sales pitch' was clearly not without its problems. American author, Clarence Cook in his *The House Beautiful* (1878) acknowledged that 'the "Eastlake" furniture must not, however, be judged by what is made in this country, and sold under that name. I have seen very few pieces of this that were either well designed or well made'.[2] Nevertheless, the misappropriation of an approach to design that simply takes certain features and adapts them, demonstrates the mediating power of a famous name.

Despite this problem of the reproduction of the name, Oscar Wilde in his *House Beautiful* lecture to an American audience in 1882 could perceptively critique it. He said that

> Eastlake furniture is more rational than much that is modern: it is economical, substantial, and enduring, and carried out Mr Eastlake's idea of showing the work of the craftsman. However, it is a little bare and cold, has no delicate lines, and does not look like refined work for refined people; Eastlake furniture is Gothic without the joyous color of the Gothic.[3]

Eastlake's 'Hints' book was based on a series of controversial articles originally published in *The Queen*, and addressed the perceived problems of design in relation to contemporary industrial arts. Eastlake condemned the popular rococo and the Renaissance revival, and followed the reformist agenda of simplicity,

rectangularity, and honest craftsmanship in design matters. These dictates included the production of furniture, glassware, fashion and ceramics. Eastlake's agendas included the development of a national style based on English sixteenth and seventeenth-century furniture designs, and also to show readers how to 'furnish their houses picturesquely, without ignoring modern notions of comfort and convenience'.[4]

The anonymous critic in this letter to the editor of the *Building News* takes issue with Eastlake's suggestions on a number of points regarding furnishings. The particular discussion around shams is highlighted in the examples of marbling, graining, veneering, glued on mouldings, varnishing and even upholstery. The critic also has some harsh words to say about women's taste which he seems to blame for the shams and pretensions of contemporary taste. Eastlake himself was not immune to this idea, He wrote that

> unfortunately, our modern furniture does not become picturesque with time – it only grows shabby. The ladies like it best when it comes like a new toy from the shop, fresh with recent varnish and gilding. And they are right, for in this transient prettiness rests the single merit which it possesses.[5]

# 8

# 'MR. EASTLAKE ON TASTE'

## *[Anon]*

Source: [Anon] "Mr. Eastlake on Taste", *Building News*, 19 March (1869), pp. 260–1

Sir, It is but quite recently that I have found time to peruse Mr. Eastlake's Hints on Household Taste, a work which seems to have attracted considerable attention, though I have hitherto noticed little but eulogy respecting it. It appears to me, however, to contain so much that is one-sided and erroneous that I am induced to ask the favour of a little of the space you now so judiciously devote to Furniture and Decoration. I propose, firstly, to notice the exaggerated picture the author has drawn of things as they exist; secondly, to offer a different explanation of much that he rebukes; thirdly, to examine briefly some of his own views and suggestions. But before proceeding, I would premise (as this may possibly give my remarks a trifle more weight than could otherwise attach to them), that I am by no means individually an opponent of the school whose views the "Hints" may be said to embody. On the contrary, my personal predilections run in a groove not unsimilar to those of the author.

Mr. Eastlake argues at the commencement of his book that there is no supply corresponding to the improved state of public taste but as the work proceeds, he appears to arrive at the more correct opinion that it is the public taste itself which requires improvement. This is really the fact. I do not hesitate to say that there is very little difficulty of procuring artistic objects of all kinds to those who desire them; but I do say, and know it to be a fact, that it is excessively difficult to obtain more than a very limited sale for such articles as a real connoisseur can approve of. The following circumstance, as a case in point, recently came to my own knowledge. Some time ago a lady and gentleman entered the establishment of a west-end decorator to look at some chintz papers. The head of the firm came forward and produced some of the fine conventional patterns designed by Messrs. Morris, Marshall, and Co. which were laughed at. Some of the most tasteful of the French chintzes were next tried, but with no better success. "Something more gaudy" was absolutely asked for, but nothing sufficiently so could be found on the establishment. Being a man of tact as well as business, however, Mr. Decorator makes some excuse about his best patterns being out on show, promises to have them home next day. Meanwhile he sends round all through the paper trade and collects the most wonderful assortment of flowered papers that can be conceived.

DOI: 10.4324/9781003290490-12

Peonies and magnolias vied with each other in size and gorgeousness; for, as I saw the specimens myself, I can bear witness as to their hideousness. One or two had certain merits in their way, and these the decorator assured me he had recommended, but without success, Nearly the worst pattern of the lot was eventually selected. It was French, and so old that all the blocks (and there were a large number of them) had to be repaired, and some entirely recut, At length between two and three hundred pounds' worth of this abomination, *chosen by an English gentleman of high position*, was despatched to India for the papering of some law courts! This is, of course, an extreme instance, but such things are of everyday occurrence, only on a lesser scale. And while this is the case it is impossible to blame manufacturers for making and tradesmen for selling inartistic articles, when they cannot dispose of superior ones. I have already endeavoured to show that there is no indisposition on the part of commercial men to produce really tasteful goods provided, they can be made to pay, and this is all we can possibly expect. But, although public taste is considerably better than Mr. Eastlake would admit, there exists, after all, much that must be deplored. The real fact is, I regret to say, that the ladies are principally responsible for the evil, for it is they who mainly determine the various household arrangements, Men, as a rule, have either cultivated tastes (and this is the exception) or they have no taste at all, though they usually possess notions of comfort, fitness and common sense that sometimes advantageously control the vagaries of their fair companions, to whom as a rule they leave these matters. But the innate sentiment of grace and beauty, that exists in women gives them a natural taste, which, if educated, would probably be of a very high order, but which in the great majority of cases is left a prey to vanity and caprice. I should be unreasonably digressing from my original topic were I to attempt to show the connection between public taste and the entire modern system of female education, yet I believe this connection to exist to a far greater extent than is generally surmised: and it is impossible to shut our eyes to the fact that love of show and the peculiar illogical temperament which is so characteristic of women's minds find a striking counterpart in the spirit which animates so much of domestic taste. A bachelor of small means is generally content with comfortable and substantial articles about him, but directly he marries everything must be "elegant," and his wife must be able to keep up the same appearance as Mrs. A, and Mrs. B. Now if he can afford to do all this properly, well and good; but in many cases he cannot. Instead, therefore, of furnishing well – say his dining room and a couple of bed-rooms – and adding from time to time as the funds admit, he will fill the whole of his house with cheap ready-made and tasteless rubbish that is really dear at any price – and all this because his wife *must have a drawing-room*! As long as this spirit exists, so long will flashy imitations and pretentious shams command a market, and while they command a market they will inevitably be made.

I now come to the details of Mr. Eastlake's views, of which, however, I can only notice few of the more characteristic. One of the author's first crusades is against the practice of marbling and graining. I have no particular affection for

these processes myself, but think the day is far distant when they will be gener-
ally discontinued. Of course, everyone will admit the great superiority of real oak
fittings, and I have not the least doubt that their use would be a real economy but
while we have soft deal doors to treat, I can see no efficient substitute for grain-
ing. Staining and varnishing can only be done where the wood has been care-
fully selected and the work specially finished for the purpose, and the expense so
incurred goes a long way towards that of wainscot. But varnish is no substitute in
point of durability for good paint, and the question at issue is practically one of
wear. The real advantage of graining and marbling, setting appearance aside, is
that they combine paint, varnish, and darkish colour, which together resist injury,
show little dirt, and admit of washing, while the play of colour over every inch
of the surface conceals an immense amount of the damage that must inevitably
occur in every household. Little boys' dirty fingers, (servants' aprons as they push
the door with their knees), and dogs' paws (as they scratch for admittance), are
perhaps quite beneath the attention of an apostle of high art, but they are mat-
ters which appeal very strongly to materfamilias' ideas. Other methods of treat-
ment may be employed where there is small liability to injury, or exceptional care
is taken, but for ordinary cases can see nothing which can satisfactorily replace
graining.

The author's heaviest invective is, on the whole, perhaps, directed against the
various processes used in modern cabinet work. Veneering, polishing, the applica-
tion of mouldings, glue, and other matters, excite his indignation over and above
the prime question of design. The latter is so thoroughly a matter of taste that
it can hardly be discussed, but no valid reason for condemning furniture sim-
ply because it does not belong to the packing-case school of design which is
advocated in the "Hints." Carving and curvature, like everything else, are liable
to abuse, but I notice as a rule little to object to on this score in articles sup-
plied by the best upholsterers. Veneering is a process which not only improves
the appearance of the furniture by surface enrichment with wood of so beautiful
a character that to use it in the solid would be positive waste, but, when prop-
erly done, greatly strengthens the wood. Veneer is frequently applied simply for
the purpose of strength and durability without any reference to appearance. The
author's remarks or the subject, not only of veneering, but of shams in general, are
strangely at variance with his views respecting electroplate, which are too long for
quotation, but to which may refer your readers at page 255. As regards polishing,
it is absurd to deny that it greatly enhances the effect of the natural the grain; it is,
in fact, analogous to the "glazing" in oil paintings. Nor does it prevent the wood
from acquiring richness of colour by age, aa witness the splendid tone of old,
well-polished Spanish mahogany. Mouldings are entirely a matter of ornament,
and it must be for clearer brains than mine to discern the difference aesthetically
between mouldings worked in the solid and those run separately and *properly*
fixed. The latter are perfectly strong, and very much cheaper than the former. Mr.
Ruskin has written very eloquently on "The Lamp of Sacrifice," but I ask your
readers, Sir, whether the lamp of sacrifice might not sometimes be more properly

called the lamp of *waste*. The principles of modern cabinet work are very different from those of the old joinery, but I contend that they are perfectly legitimate, and that well-made furniture of the present-day leaves little to be desired in point of strength and durability.

But it is in matters of upholstery proper that Mr. Eastlake's remarks seem to me the most preposterous. I will admit that the forms of chairs, sofas, and couches are not always good; but if there is any one thing on which we can pride ourselves more than another at the present time, is the perfect comfort and delightful luxuriance of these articles as made at good establishments. Many old chairs and sofas are pleasant to sit or lie upon in certain positions, but it is the glory of the modern ones that we may sit upright or lean back in them, may lounge, loll, or lie upon them with equal ease and comfort. Now, this has been attained by the process of "stuffing all over," (derived, I believe, in the first place from Germany), in which the whole of the framework above the legs is padded, thus giving a soft support for the body in every attitude. If it be objected that we have no right to conceal the framing to which the stuffing is fixed, let me ask whether the bones of the human body are anywhere exposed to view. They generally control the contour of the flesh, and in like manner the shape of the stuffing adheres very closely to that of the wood frame. There is no difficulty in designing these articles of pure and simple shape (and many actually are so), while certain parts of the frame are frequently finished ornamentally and exposed to view with little detriment to ease, and with but trifling increase of expense.

I have already trespassed so greatly on be your space that I must be content with the examples to which I have drawn attention of the unresolvable objections which Mr. Eastlake frequently raises to modern work. It is very curious, however, to note the strange inconsistency into which men fall who allow themselves to be carried away by one particular set of ideas. One of the author's staunchest principles is to the effect that we should never imitate in one article or material the treatment or construction of another. In this I concur, provided we are not tied down to a too strict observance of rule. But let us examine for a moment how Mr. Eastlake applies it. On the frontispiece of his book appears a portion of cabinet, and opposite to page 115 a bookcase, both from his own designs. Your readers will observe in both examples superimposed above the cornice a wooden construction which is simply a copy of the roof of a house. In the bookcase the designer has gone so far as even to erect a dormer window to serve as a handle to the trap-door by which access is gained to what I may call the loft. Supposing that a closed cupboard of the kind be required above the bookshelves for the stowage of pamphlets and other unpresentable papers, can any form be more absurd, wasteful, or inconvenient in point of access than that adopted? Again, let me direct attention to the old chair at page 78. Charming as it is, the form of the legs is entirely opposed to the strict principle of wood treatment. The curved pieces which support the seat must of necessity be cut across the grain in some direction and must consequently be of considerable extra size to resist the abnormal strain. It is probable, indeed, that the form of the chair has been originally copied on a much thicker scale from

some seat of iron or bronze, in which the treatment would be consistent with the qualities of the material. These are merely instances of a general illogical state of feeling which exists among a certain art-clique, and I allude to it less in a spirit of condemnation than to claim for others the latitude of taste that I, for one, am ready to accord to what I may term Gothic vagaries. Another characteristic of the school I am speaking of is their admiration of heaviness of materials, rudeness of workmanship, and unsymmetrical design, as constituting in themselves special merits. Mr. Eastlake gives abundant evidence of this throughout the pages of his work. The high praise which he awards to Oriental carpets and to Venetian glass is bestowed rather on what most persons would consider their failings than on their intrinsic beauties. The absence of grace that frequently characterises Eastern forms is well known, and the inaccuracy of dimension that often marks designs which would seem intended to be worked symmetrically is occasionally an eyesore. But when these blemishes exist we still admire (and very greatly) the articles for the excellence of the colour, or for some other good quality, and are content to pass over matters of less moment. Still, the qualities for which we do admire a given article should always be borne in mind by the critic, and not confounded with those *in spite of which* we still admire it. Had I the space I might point to many of the designs which illustrate the "Hints," and ask what beauty is to be found in them: but will merely beg you to look at the huge timbers of which the washstand at page 184 is constructed, and remind you that nowadays people move house many times during their lives, or at the chest of drawers at page 191, and inquire whether you can conceive a reason for its being enclosed by three sides of a packing-case. If the extra horizontal depth can be spared, surely it would be better to give it to the drawers, while the fact that the short upper ones must be partially covered, when wide open, by the top, hardly requires comment. In conclusion, let me again ask if that marvellous specimen of rude hideousness opposite to page 135 could at the present day be designed by anyone in his senses?

## Notes

1 Charles Locke Eastlake, *Hints on Household Taste in Furniture, Upholstery, and Other Details* 4th ed., rev. (London: Longmans, Green. 1878), p. viii.

2 C. Cook, *The House Beautiful: Essays on Beds and Tables, Stools and Candlesticks* (New York: Scribner, Armstrong and Co, 1878), p. 223.

3 Cited in K. H. F. O'Brien, "The House Beautiful" A Reconstruction of Oscar Wilde's American Lecture,' *Victorian Studies* 17: 4, 1974, p. 409.

4 Eastlake, *Hints*, 1878, p. vii.

5 Eastlake, *Hints*, 1869, p. 74.

# [ANON], 'PRINCIPLES OF GOOD TASTE IN FURNITURE' (1869)

## Editorial Headnote

The role and nature of taste in a rapidly expanding consumer society, along with diverging notions of fashion, proved to be particularly troublesome during the century. Reformers saw that the elevation of public taste through education, exhibitions, museums, lectures, and publications was part of the solution to the apparent curse of popular 'bad taste'. Whether it was the 1835–1836 Select Committee on Arts and Manufactures, the *Journal of Design and Manufactures* or the Museum of Ornamental Art and its 'Chamber of Horrors', numerous attempts were made to improve public taste. Correct taste was thought to exist in countries like France and Italy, and its development in England was seen as important, both socially and commercially. Indeed, the idea that correct taste could be taught, was the basis of the 1835–1836 Select Committee on Arts and Manufactures' report that valued the 'true' and 'unvarying principles' of classical art, which were seen as the basis for a 'national taste'. However, it was an uphill battle. In 1868 Sir Gardener Wilkinson wrote:

> It is the universal remark that those things which are bad in style find a more ready sale than the good; and that not from the price being lower, but solely from the choice of the public. If the bad happens to be attractive it meets with admirers; and high finish, minuteness of detail, and whimsical shape, are greater recommendations than good form and purity of design.[1]

Other examples of bad taste in furniture were mentioned in *Blackwood's Magazine* in 1869:

> As constructive shams which have rightly provoked hostile criticism, take for instance sideboards formed on the models of Grecian stone altars, cabinets constructed in the fashion of Roman temples, wine coolers suggestive of sarcophagi, and jardinières treated as ruined chateaux with dilapidated roofs, out of which actual flowers disport themselves![2]

John Cassell published numerous books on household related topics including the four volume *Cassell's Household Guide*, 1869–1871. He also published many magazines and newspapers between 1866 and 1886, including *The Magazine of Art*. Cassell was a reformer who considered that education was a key to improvements in the life of the working class, so his publications were intended to help to develop this group through learning.

This educational initiative is evident in the first section of Volume 1 of the *Household Guide* where it is made clear that

> Far too often an appearance of luxury, but with real wretchedness, exists in the same habitation. Living in a fine house with very straitened means frequently entails great discomfort, and is in most cases excessively imprudent, although, under others, it may be quite the reverse. A respectable-looking house, in a desirable locality, is to a profession or trade absolutely necessary to future success, even though the tenants be poor. The style of a house in a degree determines the respectability, class, credit, or means of its occupier, even though he be without a fixed income, and living to the extent of or beyond his means.

In this text the argument and discussion are augmented by didactic illustrations that reinforce many of the points raised. The author still refers to the Pugin-inspired notion of constructed decoration rather than decorated construction. They also maintain the idea of simplicity over extravagance in furnishings.

# 9

# 'PRINCIPLES OF GOOD TASTE IN FURNITURE'

## *[Anon]*

Source: [Anon], "Principles of Good Taste in Furniture", *Cassell's Household Guide*, (1869), Vol. 3, pp. 75–9

Let us assume that our walls are covered with papers of tasteful designs, suitable for upright and flat surfaces, and quiet and unattractive both in colour and form; and also that carpets and floor-cloths have been chosen of unobtrusive designs, and which are adapted for horizontal surfaces, and for being trodden upon, And let us suppose, also, that these have not been selected without reference to the uses and positions of the rooms in which they are placed; that, if in a dining-room, for instance, the patterns have more richness and depth of colour; if in a drawing room or bedroom, more lightness and delicacy of colour and form. And, again, that if the room have a northern aspect, the colours chosen are not too dark and sombre in the dining-room, nor too cold in the drawing-room.

We have now to introduce our furniture, and in doing so to keep in view the colour and character of our background. As we have already pointed out, the wall and carpet should contrast with the furniture and serve to relieve it; but, in the objects themselves, there should, in each room, be a degree of uniformity in the design. If there is too much diversity, the room will look as if it had been furnished piecemeal, and without due regard to the unity and completeness of the whole. Nothing, for instance, destroys the unity so much as to introduce two or three kinds of wood. But it is not sufficient that the chairs, table, sideboard, sofa, &c., be all of mahogany or walnut, but there should also be uniformity in the character of the forms, and also in the enrichments. Should the table be rectangular (a form most suitable for a dining-room), it would be more in keeping if the leading lines of the chairs, sideboard, &c., be straight; and, whatever the kind or style of enrichment employed on the one, it should be adopted on all. Again, should the drawing-room table be circular or elliptical, or of some other curved outline (which is a more elegant and suitable shape than the rectangular), the backs and legs of the chairs, the sofa or couch, sideboard, &c., would look more in harmony if similarly curved, while the same uniformity should be observed in the style of the enrichments. To obtain this uniformity of style, the two chief things to be attended to

DOI: 10.4324/9781003290490-13

73

are: firstly, that the enrichments be equally simple or florid, the sideboard not being elaborately covered with carved work, while the chairs and tables are destitute of ornament; secondly, that the ornament itself be of one style or character.

It has long been a common practice where most attention has been paid to this uniformity, to adopt some general style, as Greek, or Gothic, or Renaissance or some particular branch, as Elizabethan or Louis Quatorze; and to have the building and the furniture all designed in the one style; and by adopting this course, since each style of the past has its own peculiar spirit and characteristics, if these are not departed from, uniformity will necessarily follow. But great want of taste is often manifested by the indiscriminate mixture of various styles of ornament between which there is not the least affinity. Perhaps the wall-paper consists of diaper in the Moresque style, from which natural forms are strictly excluded, while the carpet design is composed of flowers and foliage naturalistically treated and maybe, the sideboard is covered with Elizabethan strapwork, while the chairs and mirror are of Renaissance designs. Such inconsistencies are by no means uncommon, and indicate great want of taste and judgment. But in many cases, it is not practicable to have the whole of the furniture and enrichments of one style nor do we believe, as many do, in the desirability of adhering thus rigidly to some particular style, or period, of art, and of reproducing the characteristic details again and again with literal exactness.

Such imitation and repetition have already been overdone, and we much prefer to see uniformity which is not dependent upon the correctness with which ornaments of a past style have been copied, but which arises from some similarity and congruity observable in the general character and treatment of the decoration throughout at least the one apartment, or throughout the whole house.

Let us illustrate our meaning. Suppose, for instance, that our taste inclines us to admire ornament which consists chiefly of natural forms, whether vegetable or animal, like the Gothic artists of the middle or decorated period, who introduced flowers, and foliage, and animals, and the human form, in every conceivable combination. Adopting this naturalism as our lending principle, we introduce natural forms through-out the enrichments. We choose for our wall-paper a pattern of some simple diaper, consisting of a geometric basis filled in with leaves.

For our carpet we choose some such pattern in which flowers and foliage are also arranged on a geometric basis. We not only thus choose to have geometric forms mixed with the natural forms on our floor and wall, because it is well adapted for distributing the ornament over a large surface, but also because these, being the inferior parts of the decoration, should have the lower class of forms; the higher forms – such as imitations of groups of flowers, fruit, animals, and the human figure being reserved for the more important features. We choose for our table one with animals crouching underneath (as in Figure 9.1),[3] or, if less elaborate, say with animals' feet only (as Figure 9.2); and our chairs have similar terminals to their legs, and our chairs have similar terminals to their legs, and a little carved foliage or fruit on the legs and back (as in Figure 9.3); and the sofa or couch is designed in the same spirit. In our sideboard or chiffonier, we introduce

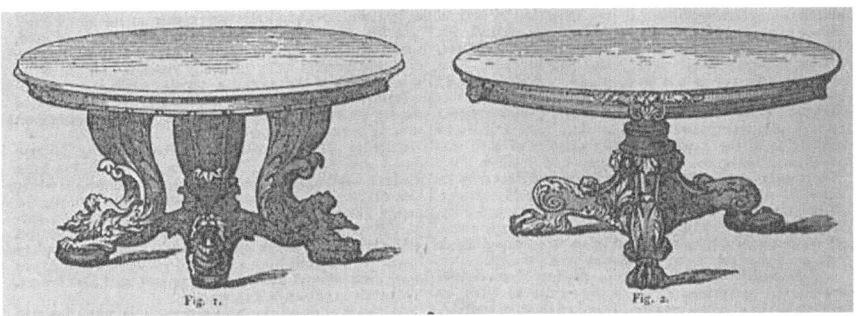

*Figure 9.1* and *Figure 9.2*

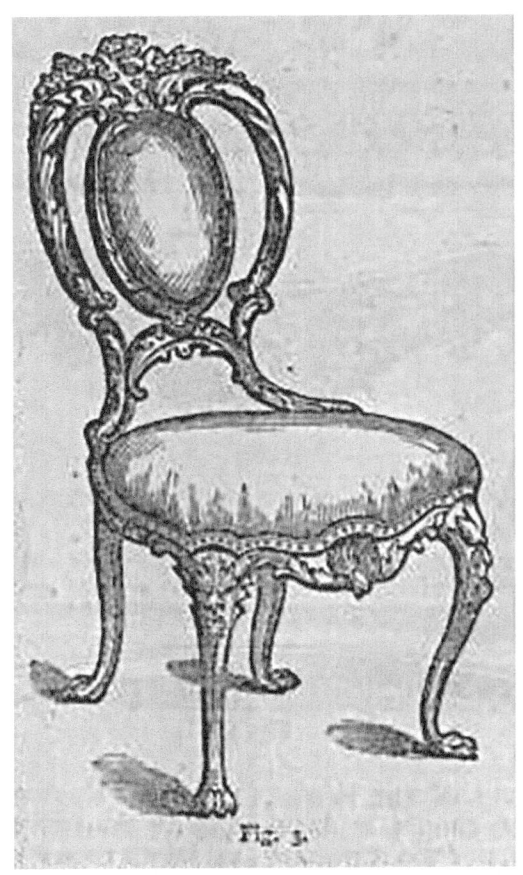

*Figure 9.3*

more richness still. Here the forms may be less conventionalised, and groups of flowers and fruit, of animals or human figures, may be arranged in the panels, or on the back and at the top. At the top of our mirror, and at its lower angles, we have some simple arrangement of natural forms not too heavy, nor too attractive and fantastic and the scrolls to the gaselier pendant are foliated, and the balance-balls and globes have neat and appropriate designs, consisting also of natural forms.

Thus there is a harmony and uniformity observable in the whole scheme of decoration, and each object looks as if designed with reference to all the rest.

Again, if our taste inclines us towards a more geometric and conventional kind of ornament, we should in like manner carry the same treatment throughout the furniture and decorations. We must not have in one place a floral design, with all the details carefully copied from Nature, while in another part we have mere geometric forms and conventional foliage, as in the Moresque decorations. A comparison of Figures 9.4 and 9.5 will strikingly illustrate the incongruity which may arise from the violation of this rule. In these examples, we see two treatments so utterly opposed in spirit that to place them in the same room would show the greatest ignorance of ornament, and want of taste.

Each object indicates a distinct style of ornament, and whichever is selected should be accompanied by objects which, both as to their general structure and decoration, are in keeping with it.

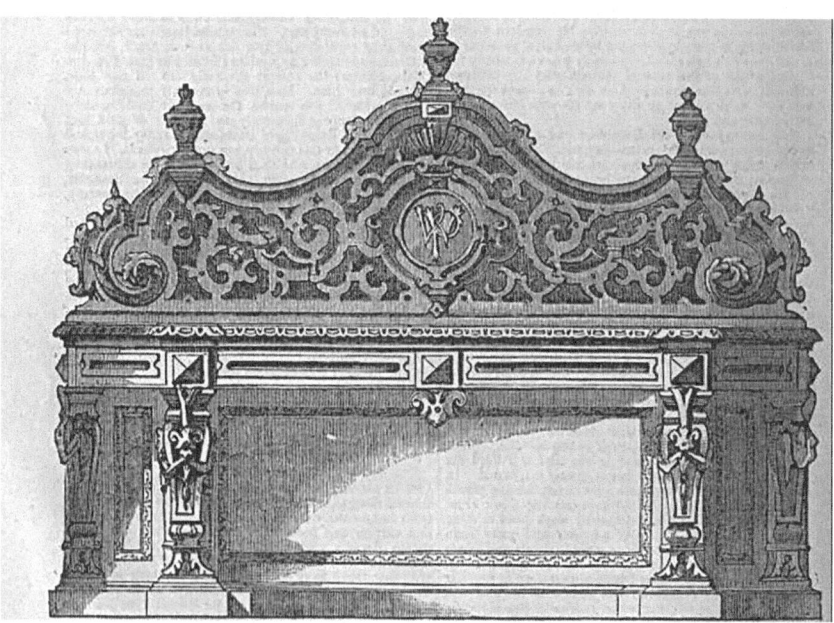

*Figure 9.4*

*Figure 9.5*

The first thing to be considered in the selection of objects of furniture is their suitableness, both as regards size and shape, and these should be regulated by their intended position and use. Fantastic shapes should be studiously avoided; and as simplicity rarely offends, it is far better, as a rule, to select forms which are simple and unassuming. In determining the size, too, it is better to choose furniture which is a little small than such as appears large and cumbrous. A room never looks well when the objects of furniture look disproportionately large. It is best to avoid excess; and it is a better fault not to go far enough than to go too far, for where the furniture is too large for the room, or too elaborately shaped or decorated or disproportioned to the position and means of the owner, it always has an appearance of vulgarity, which is easily avoided by keeping on the side of simplicity and unpretentiousness. Some seem to think that you cannot have too much of a good thing, and that the more ornament you can introduce the better. This, however, is a great mistake, for such excess of elaboration marks the degeneracy of most styles of ornament, while in the best periods of art simplicity has generally been one of the leading principles. The sideboard (Figure 9.5) is an example of this excessive elaboration, and looks as if it had been made and then smothered with ornament. This leads us to another important consideration: viz., the method of ornamenting furniture. So far as possible, it is best to let the ornament arise out of the construction (as in Figures 9.1, 9.2, 9.3, 9.4, 9.6, and 9.7), and not to appear

as if stuck upon the surface (as in Figure 9.5) without any other connection with the object; but it too often happens that the piece of furniture is regarded only as offering a surface which must be covered with decorations and ornaments as large in size and quantity as possible are merely spread over it, without any adaptation or thought about suitableness.

Wherever it is possible, the supports or other parts of the construction should be made ornamental features, by being arranged in graceful lines, or carved into elegant shapes (as in Figures 9.2, 9.3, 9.4), in which the supports and leading lines are in themselves ornamental, and do not depend for their beauty on the enrichment carved upon them. An additional beauty, however, is imparted by the tasteful enrichment of the constructed forms; but it is better that this should be secondary, the graceful shapes of the members being the first consideration, and then their enrichment with carving, inlaying, or painting. In the wardrobe (Figure 9.7), for example, the structural forms, though very simple, are ornamental and tasteful in design, and these are further improved by being enriched with chaste little ornaments carved on

*Figure 9.6*

*Figure 9.7*

the mouldings, &c: the only decorative forms which appear to be applied or put on without forming part of the constructive members, being confined to such parts as naturally suggest some decoration being placed upon them.

But this is a very different method from that adopted in the sideboard (Figure 9.5). Instead of the moulding of the back being itself enriched, whatever beauty its own curve might have had, has been disfigured by flowers and foliage being stuck over it and the same with the beads of the panels, and, indeed, parts of the columns also.

Again, we must be careful that ornamental forms in relief – such as carved work – do not project so much as to be liable to injure the dresses of those who pass near them (as in Figure 9.5). But we shall have more to say on suitable enrichment in a future article.

## Notes

1 Sir G. Wilkinson, *On Colour and on the Necessity for a General Diffusion of Taste Among all Classes* (London: John Murray, 1858), p. 178.
2 "The Arts in the Household or Decorative Art applied to Domestic Use", *Blackwood's Magazine*, 105, 1869, p. 361.
3 Most images (1,2,4,5,6) were originally published in the *Art Journal catalogue of the Great Exhibition*, 1851.

# EDWARD ELBRIDGE SALISBURY, *PRINCIPLES OF DOMESTIC TASTE: A LECTURE DELIVERED IN THE YALE SCHOOL OF THE FINE ARTS* (1877)

## Editorial Headnote

Edward Elbridge Salisbury (1814–1901) was America's first Professor of Arabic and Sanskrit appointed in 1841. Born in Boston, he graduated from Yale University in 1832, and apparently studied theology for three years and then travelled in Europe. Salisbury also served as the President of the American Oriental Society from 1863 to 1866, and again from 1873 to 1880. Although he resigned his professorship in 1856, Salisbury continued to contribute to Yale through his association with the Library Committee and the advisory board of the School of Fine Art.

The *Yale Review* was founded in 1819 as *The Christian Spectator to support Evangelicalism*. Over time it began to publish more articles on history and economics and was renamed *The New Englander* in 1843. In 1885 it was renamed *The New Englander and Yale Review* until 1892, when it took its current name *The Yale Review*.

Salisbury delivered this lecture, which seems to be rather out of his area of direct interest, before the Yale School of the Fine Art. Salisbury is clearly suggesting the importance of a Christian input into the creation of a domestic house (home) with this comment from a later passage:

> Within the house, also, let modesty extend its chastening control. Let there be no ornaments, no pictures, no marbles, no forms of furniture, which would have started a blush on the face of the Puritan maiden of the olden time. American domestic taste cannot be too coy in this particular. It should steadfastly refuse to be catered for with the art-products of corrupted Rome (meretricious in the worst sense), or with those of the modern French school, redolent of Parisian debauchery. What is suitable and necessary in the galleries of a school of art, as respects exhibition of the nude, is not to be tolerated under the domestic roof.[1]

Salisbury also mentions Charles Eastlake and his publication *Hints on Household Taste* (See also 1.8 above) which was enjoying great success in the United States. He both commends and criticises the work, saying that Eastlake was correct in arguing for 'truthfulness, constructive goodness, and adaptation to purpose and material, in all artistic design. Moreover, by showing how use and beauty are not only consistent but interdependent, he has done much towards a real beautifying of our homes'.[2] On the other hand he criticises Eastlake's apparent desire to return to Gothic style and ways of making, which Salisbury sees as inconsistent with nineteenth century ideas of living in comfort.

Salisbury invokes William Penn and John Ruskin in discussing the design and decoration of the home and interestingly in searching for repose, suggested the shunning of religious imagery that represents penitence rather than comfort. His idea of home as being rooted in ideas of truth and morality which lead to a comforting and restful space, seem in line with his initial training as a theologian.

It is fascinating to see that as late as 1905 the British Board of Education noted the use of this volume as part of the required reading for the lecture on the 'House Beautiful' given at the University of the State of New York, Albany, N.Y.'s Home Education Department.[3]

# 10

# *PRINCIPLES OF DOMESTIC TASTE*

## A Lecture delivered in the Yale
## School of the Fine Arts

*Edward Elbridge Salisbury*

Source: Edward Elbridge Salisbury, *Principles of Domestic Taste*: A Lecture delivered in the Yale School of the Fine Arts, Reprinted from the *New Englander*, April 1877, pp. 5–7 [extract]

The subject I desire to bring before you is the Principles of Domestic Taste. Will it be objected, in advance, that there is no disputing about tastes – that, for each individual, whatever is to his or her taste is tasteful? and that, especially with respect to domestic arrangements, everyone is a law to himself? But, although I shall have to condemn some things which seem to me to violate good taste, my purpose is, mainly, to give expression to certain principles, which all must agree in recognizing as true and fundamental, as soon as put into words, yet which need to be brought out and emphasized, in order to their becoming more widely influential. Of course, I speak only as an amateur.

The first thing which it occurs to me to say on this subject, is that the idea of home lies at the foundation of all true domestic taste. There was a time, in the history of man, when the most primitive conception of a human habitation, as a place of shelter, was all that guided in the construction and furnishing of the house. We see traces of this in the rude huts, or moving tents, of certain barbarous tribes still existing, though even in the most primitive habitation it is a rare thing not to find some intimations of the sanctities of home, and some sense of beauty. Perhaps what first consecrated the house as a home may have been the religious instinct, bringing to the domestic hearth a reverence for higher powers, and a consequent spirit of self-control; for it is highly probable that the earliest temples of antiquity, set apart for abiding places of the gods, were modelled after human habitations. This could scarcely have been the case before the latter had begun to gather to themselves an atmosphere of sanctity.

But what riches of meaning invest the idea of home! No place for disguises, nor for mysteries of shame, it is at once sacred to retirement, and appropriate to an open frankness; not given for the indulgence of ignoble indolence, rest and repose brood over it; no lurking-place for the contrarieties and mean selfishnesses of human nature, wherever its true significance is realized, it subdues

DOI: 10.4324/9781003290490-14

into a sweet harmony by the prevalence of divinely inspired love, and becomes a nursery of good cheer though never to be rudely invaded, yet it invites and welcomes the coming guest; birth-place of the tenderest sympathies of earth, it holds itself in constant communication, by many an electric cord, of reverence, affection, memory and aspiration, with the spiritual world. Such are some of those delights of home from appreciation of which all true domestic taste must have its rise. This leads to the further suggestion, that this department of taste, in common, indeed, with all others associated with art-culture, yet even more than any other, derives its life and impulse from moral sources. I hold it to be absurd to look for taste in a house where love does not reign – moral discord, or impurity, must blight every attempt to realize visible beauty. However fair the seeming, to a superficial observer, whatever richness of detail might be included in a description, the aroma of genuine beauty cannot be breathed in an atmosphere morally pestilential, or wanting in healthy vitality. Without moral life and purity, indeed, those sarcastic words of Swift will have their application:

> "I find, by all you have been telling,
> That 'tis a house, but not a dwelling."[4]

There can be no home!

What, then, in respect to domestic taste, do the essential elements of home require? This question may be answered by saying, in the first place, that, as home is for retirement, nothing about it should be primarily designed to catch the eye of a stranger, but everything as if no strange eye were ever to look in upon it. The style which prevailed, until lately, in our chief middle-state city, under the influence of the followers of Penn, to give great plainness to the exterior of the house, reserving its richness for the interior, seems to me to have been consonant with good taste. In the interminglings of men with one another, appearances are to be regarded. Even in such comparatively trivial matters as dress, or outward demeanour, something is due to the conventionalities of custom, and to what people have agreed to consider as becoming, or the contrary. But it is not so in one's home. Withdrawn into that sacred privacy, one should ignore the tyranny of fashion, and scorn to make up a show-picture for prying eyes to remark upon and praise. Too often, through oversight of this, what should be a home becomes nothing better than a museum. Not as being primarily for others to see, but by some impulse within one's own bosom, should all the appointments of one's home be determined. I would not be supposed to claim for the home any privilege of selfish isolation; and yet there is a true and very important sense, with reference to our subject, in which every household should dwell under such a roof, and amid such surroundings, as suit itself alone. Certain it is that, as light cannot be hidden, so a home thus appointed will shine forth with an attractive radiance, all the more effective for being undesigned. True domestic taste, however, is, in its own nature, like virtue, a reward to itself.

But, while the home is to be ordered for retirement, it is not a place for disguises: an open frankness becomes it, and so it should itself be without any false pretences, either in materials used, or in construction, or in decoration. Truth should be written all over it in letters of light. Let me here refer, for a development of this thought, to Ruskin's well-known chapter on truth as one of the lamps of architecture – a reference always timely – which classifies architectural deceits under three heads: 1. the suggestion of a mode of structure, or support, other than the true one, as in pendants of late Gothic roofs, 2. the painting of surfaces to represent some other material than that of which they actually consist (as in marbling of wood), or the deceptive representation of sculptured ornament upon them, and 3. The use of cast, or machine made, ornament.[5]

Again, as home is for repose, nothing should find place in or about it which is suggestive of danger, or agitating to any sensibility, or fitted to let in, rather than to exclude, care – though of care must be said, as the poet says of another certain visitor:

Pallida mors aequo pulsat pede pauperum tabernas
Regumque turres[6]

Many violations of this principle might be referred to, for illustration. In domestic architecture, how many towers do we see which, by their position or construction, rather threaten to crush and destroy than defend! how many garlands of joinery which seem made on purpose to conduct a consuming flame, someday, along the eaves of the house! how often are entrance-porches so built as to endanger the heads of those who venture under them! If one enters in safety, how little of solid durability, or restfulness of aspect, meets one within! not unfrequently one finds door-openings without either proper lintels or side-supports; walls and floors so unsubstantial that sounds are communicated over the whole house, and it shakes with every foot-fall. Then, if we turn to decorative features, why should Crucifixions, Martyrdoms of the Saints, Assassination-scenes, or other forms of human agony, appear under the home roof, where the spirit, wearied and jaded by the struggles and roughnesses of daily outdoor-life, may legitimately ask to find rest? The primitive Christian, who could live in safety only within a catacomb, made even that rough dwelling-place restful, by excluding all intimations of pain, all harrowing suggestions of even that great Sacrifice on which hung all his hopes. Many an abode of Christians in these days seems fitted up more as a penitential chapel than as a place for cheerful repose.

Neither is there repose in too crowded rooms. People fill their parlors with all kinds of curiosities, some so beautiful as to appeal to all tastes, some, having a meaning in their own countries, either sacred or jocose, which to us are simply monstrosities, ugly or grotesque. Amid the medley of 'objets de vertu' and 'bric-a-brac,' as you turn to avoid upsetting a rich, Japanese vase, you stumble upon a porcelain dog or Chinese idol, or you get entangled amid Turkish rugs and mats of Russian fur. With such a variety to examine, to study, to wonder at or admire, the eye and mind become weary, and cease to enjoy.

Think, too, of the disturbance caused to one's equanimity by those mirror-like floors of inlaid woods, however beautiful to the eye, on which one has need of parlor-skates, in order safely to pass from one side to another; and still more when pirouettes of courtesy have to be performed upon them! . . .

## Notes

1 Salisbury, p. 18.
2 Ibid., p. 22.
3 Board of Education, *Special Reports on Educational Subjects. Volume 15; School Training for the Home Duties of Women. Part 1 The teaching of "domestic science" in the United States of America* (London: HMSO, 1905), Appendix L.
4 Alexander Pope, "Upon The Duke Of Marlborough's House At Woodstock"
5 John Ruskin, *The Seven Lamps of Architecture* (London: Smith, Elder & Co.1849).
6 "Pale Death, with impartial foot, knocks at the cottages of the poor and the palaces of kings."

# [ANON] "PRINCIPLES OF GOOD TASTE IN FURNITURE AND DECORATION" (1880)

## Editorial Headnote

In 1852 Isabella Beeton joined her husband Samuel Beeton as joint editor in a new monthly journal titled *The Englishwoman's Domestic Magazine*. One of the first inexpensive magazines for young middle-class women, its emphasis on practical instruction and useful knowledge made it an immediate success. The domestic management material was written by Isabella Beeton and was later collected and published in her *Book of Household Management* in 1861. The journal was renamed *The Illustrated Household Journal and Englishwoman's Domestic Magazine* from 1 January 1880.

The role of taste in a rapidly expanding consumer society, along with notions of fashion, proved to be particularly troublesome during the century. David Reid in his *Essays on the Intellectual Powers of Man*, (1785), wrote, 'I think there are axioms, even in matters of taste. Notwithstanding the variety found among men, in taste, there are, I apprehend, some common principles, even in matters of this kind'.[1] According to Reid, these common principles come from two sources: 'There is a taste that is acquired, and a taste that is natural. This holds with respect both to the external sense of taste and to the internal. Habit and fashion have a powerful influence upon both'.[2] He then argued that taste could be described as either true or false, through reason: 'This taste may be true or false, according as it is founded on a true or false judgment. And if it may be true or false, it must have first principles'.[3]

These ideas influenced nineteenth-century reformers who saw that the elevation of public taste through education, exhibitions, museums, lectures and publications was part of the solution to the curse of popular 'bad taste'. Whether it was the 1835–1836 Select Committee on Arts and Manufactures, the *Journal of Design and Manufactures* or the Museum of Ornamental Art and its 'Chamber of Horrors', great attempts were made to improve public taste. Correct taste was thought to exist in countries like France and Italy, and its development in England was seen as important, both socially and commercially. Indeed, the idea that correct taste could be taught was the basis of the 1835–1836 Select Committee on Arts and Manufactures' report that valued the 'true' and 'unvarying principles' of classical art, which were seen as the basis for a 'national taste'. However, it was an uphill battle.

It was thought that education in matters of taste would also encourage working people to spend carefully, and it was hoped that this would increase standards of living and thus reduce social discontent. The journalism and other writings about the issues around good taste were a veritable industry from the 1850s onward. Amateur and professional artists, architects, decorators, designers, and critics were all able to address the issues from a range of viewpoints. Good design was

seen as 'improving' in its association with morality. John Ruskin in his 1864 'Traffic' lecture explained his viewpoint on this matter:

> Taste is not only a part and an index of morality: it is the only morality. The first, and last, and closest trial question to any living creature is, 'What do you like?' Tell me what you like, and I'll tell you what you are. Go out into the street and ask the first man or woman you meet what their 'taste' is. If they answer candidly, you know them, body and soul.[4]

Ruskin's view of taste as a moral capacity, and not an asset with cash value, also reflected wider ideas about society and crafts.

This anonymous article was the first of four articles published weekly in succession. The final four commands reflect something of the Ruskinian approach tinged with pragmatism.

# 11

# 'PRINCIPLES OF GOOD TASTE IN FURNITURE AND DECORATION'

## *[Anon]*

Source: [Anon] 'Principles of Good Taste in Furniture and Decoration', *The Illustrated Household Journal and Englishwoman's Domestic Magazine*, 1: 5, 10 January 1880, pp. 65+

So much has been said and written of late years about art and taste in connection with the furniture and decorations of the house that the subject has been regarded from every point of view, and apparently well-nigh exhausted. Every writer, too, has, more or less, his or her peculiar groove of fancy in these matters which impart a strong colouring to all that is advanced. Now there is individuality in taste as well as in character, and it is as impossible to follow minutely the guidance of another person as to decoration and choice of arrangement, as it is to copy any particular style of dress, or to endeavour to mould one's character upon the traits exhibited by another. It is a thing most difficult – nay, let us say impossible – to set forth authoritatively and in precise terms rules and definitions by which one may furnish and decorate in a tasteful and artistic manner; for what may satisfy the eye of one may not be equally attractive to another, although the plan that each has followed may exhibit nothing that is absolutely at variance with good and correct taste. All that can be done is to attempt to deduce a few general principles on which anyone may proceed, leaving the secondary details of form, colour, and arrangement to be worked out by the exercise of that inherent feeling which enables most of us to distinguish between that which is satisfactory and that which is unsatisfactory, as the sense of tasting enables us to discriminate between sweet and bitter, or that of hearing between harmony and discord.

That it is possible to educate in good taste and artistic appreciation of that which is really beautiful, there can be no doubt; but all are not equally susceptible of improvement in these points. In some there is an instinctive knowledge, as it were, of beauty of outline and harmony of colour, as evinced in the arrangement of a table and the composition of the floral decorations that adorn it. Such as these will want little, if any, teaching in the principles of good taste. For all others the first steps in the process must be practice in outline drawing, and careful study of the harmony and contrast of colours. These are the keys to good taste in household art.

DOI: 10.4324/9781003290490-15

In nature the prevailing colour covering by far the greatest part of the space, so to speak, on which we are looking – is one that does not fatigue the optic nerve, but. on the contrary, affords rest to it, and recuperates its power. The eye is never weary of gazing on the varied tints of green that are found in the grass and the foliage of flowering plants and trees: it never tires of the blue, more or less deep, of the apparent canopy of heaven spread above our heads. The teaching to be drawn from this is not that our walls are to be painted green and our ceilings blue, but that the expanse of wall and ceilings should be coloured in tints and tones of colour that shall produce the same effect on the eye as the green grass and blue sky out of doors.

Yet there is a certain analogy between natural appearances and effects without, that may be imitated with advantage within doors. The eye will rest with satis-faction on a combination of green carpet and hearth-rug, or a carpet in which green and black are mingled in what is familiarly known as a moss pattern, wall delicately coloured in neutral tint grey or pale brown and ceiling with just suf-ficient cobalt mingled with the composition with which it is whitened to take away the glare that a brilliant white surface reflects. The eyes seldom rest on the ceiling unless the beholder is recumbent on a couch or sofa; and in dark days it is necessary to increase the intensity of light in a room as much as possible, which can only be effected by having the ceiling as nearly white as may be. In lofty, well-lighted apartments, a deeper tone may be allowed for the ceiling: but for the ceiling of rooms in ordinary houses, we venture to think that white, toned down by colouring matter, as suggested above, will be or found more useful, and in no way unpleasant or detrimental to the eyes, although some authorities on decorative art have pronounced in favour of a blue or grey ceiling, or a cream coloured pattern on blue or grey ground, or vice versa. The decoration of a ceiling in a room of ordinary size should be limited to a border just within the cornice, with corner pieces and a centre, all of which may be put on with stencil plates in some pale tint, relieved here and there, if possible, with touches of a darker shade, which may be applied by hand. There are two arguments against excessive deco-rations of ceilings, by excess of decoration we mean covering the entire surface with elaborate pattern, as some suggest – firstly, the expense, and the necessity of cleansing and colouring the ceiling every two or three years in rooms in which gas and fire are frequently used; and, secondly, as our eyes are placed in a position which obliges us to look, for the most part, straight before us, the chief points of attraction in the way of decoration or ornament of any kind should be on the walls, and not on the floor or ceiling.

Returning again to nature, we find, generally speaking, that the flower of any plant-whether white, yellow, red, orange, blue, purple, or any other colour is relieved and contrasted by the foliage, which forms the background or setting to it, as it were. See how the white jasmine is set off by the elegantly-shaped dark green leaves that clothe its slender twigs, and how the yellow jasmine is sprinkled among foliage of lighter colour. The eye would tire of gazing on any flower of brilliant colour apart from its foliage, and yet the flower forms the chief point of

attraction to the eye – the centre on which the vision rests. And this, again, teaches us, not that we are to diversify the surface of our walls with spots and markings of brilliant colour here and there, as flowers are scattered over a plant, but that the wall, tinted in such a manner as shall be grateful and refreshing to the eye, shall serve as a background to some suitable ornamentation in stencil, or as bordering, or to pictures, or to art productions of any kind, such as china, busts, statuettes, etc., and a hundred other objects that we need not mention here, just as the foliage of a plant affords a background to its flowers.

Good taste in furniture is similar in every respect to good taste in dress. There is nothing more satisfactory than a black or white dress adorned with a little good lace and some coloured ribbon, in which the ribbon and lace takes the place of the blossom on the plant or the ornament on the walls, and the dress itself corresponds to the foliage of the one or the colouring of the other. In each case, be it dress, or wall, or foliage, it serves to heighten the effect of the knot of ribbon, the plate or picture, or the blossom respectively; and from these remarks we may gather a few broad and general rules for the treatment of decoration and choice of furniture:

1. Let simplicity, as far as may be possible, be taken as the keynote to success and satisfaction in both decoration and furniture.
2. Let walls and woodwork be treated so as to afford a suitable background for pictures and furniture of every description, the former being tinted in one colour, relieved with simple designs in a deeper tint or contrasting colour, and the latter simply stained and varnished or skilfully grained.
3. Let the ornaments on the walls and chimney-piece, be they what they may, form points of attraction to the eye of the beholder, either by means of beauty of form or colour, contrasting thus with the studied plainness of the walls.
4. Let the furniture occupy a mean between the treatment of the walls and the attractive brilliancy or beauty of their adornments, showing neither the severity of form or colour that is desirable in the former, nor the brightness of tint or the excess of contrast in colour that is admissible in the latter.

## Notes

1 D. Reid, *Essays on the Intellectual Powers of Man* (Edinburgh: John Bell, 1785), p. 599.
2 Ibid., p. 600.
3 Ibid., p. 602.
4 'Traffic', in J. Ruskin, *The Crown of Wild Olive & The Cestus of Aglaia*. ed. Ernst Rhys (London: J. M. Dent & Sons, 1915).

# ELSIE DE WOLFE, *THE HOUSE IN GOOD TASTE* (1913)

## Editorial Headnote

Elsie de Wolfe (1865–1950) is often considered the first interior decorator, playing a key role in the formation of the modern American interior decorating profession. Following an acting career, which involved selecting costumes and designing sets, she moved into interior decoration. Her new career began in 1897 with the design of her own residence, the understated elegance and refined taste of which led, in 1905, to a commission to decorate the women-only Colony Club in New York City. Her connections and savvy led to her providing her services to the wealthy, on both the East Coast and West Coast. Her clients, most of whom were the wives of wealthy men, included the Duke and Duchess of Windsor, Anne Vanderbilt, Anne Morgan, Elizabeth Milbank Anderson, and the Ogden Armours. By 1913, her business had moved to a floor on Fifth Avenue in New York and employed many assistants, but also reached a wider audience through her books, magazines, and radio broadcasts. In that year she began an important commission for the wealthy tycoon Henry Clay Frick on his new project for the decoration of his new house on East Seventieth Street.

Her approach to interiors was founded in comments she made in her autobiography where she proclaimed:

> I live in an ugly age. From the moment I was conscious of ugliness and its relation to myself and my surroundings, my one preoccupation was to find a way out of it. In my escape I came to the meaning of beauty.[1]

Her style was based on a combination of the simple and lighter French eighteenth century neo-classical models with modern concepts of comfort, suitability, and intimacy within a clear 'feminine' appeal. She was particularly recognized for the use of glazed chintz, the placement of mirrors, Louis XVI style furniture, and decorative floral arrangements. Memorable lines in her book declared 'I believe in plenty of optimism and white paint, comfortable chairs with lights beside them, open fires on the hearth and flowers wherever they 'belong', mirrors and sunshine in all rooms.[2]

A series of articles by her in *Good Housekeeping* and the *Delineator* was collected into her widely influential book *The House in Good Taste* (1913). Here she expounds her personal theory of interior decoration that was also illustrated in some detail. She summarized her decorating philosophy in three words: suitability, simplicity and proportion. Other aspects of interior design that she emphasized included the consideration of the needs of the occupants, making rooms comfortable and warm, and the juxtaposition of furniture from various eras and styles.

The social importance of a tasteful interior was a paramount idea in her work. She wrote

> We are sure to judge a woman in whose house we find ourselves for the first time, by her surroundings. We judge her temperament, her habits, her inclinations, by the interior of her home. We may talk of the weather, but we are looking at the furniture. We attribute vulgar qualities to those who are content to live in ugly surroundings. We endow with refinement and charm the person who welcomes us in a delightful room.[3]

A review of her book in *Art and Progress* noted how the chapters on

> 'The Dressing Room', 'The Bath', 'The Bed Room, Sitting Room and Boudoir' give a glimpse of contemporary life which is as valuable and noteworthy, though perhaps unintentional, as the descriptions of appropriate furnishings. An agreeable contrast to these is the chapter on a 'Small Apartment' in which Miss De Wolfe calls attention to the fact that the 'Model Tenement' offers compact domestic machinery, cleanliness and sanitary comforts at a few dollars a week that are not to be had at any price in many of the fine old houses of Europe.[4]

Wolfe has an emphasis on clearance and removal of unnecessary furnishings and bric-a-brac to achieve an interior that was both simple and dignified. This approach put her at the crossroads of old attitudes and the beginning of a new modernity.

# 12

# *THE HOUSE IN GOOD TASTE*

## *Elsie De Wolfe*

Source: Elsie De Wolfe, *The House in Good Taste*, (New York: The Century Co., 1913), Chapter I and II, pp. 3–26

## I THE DEVELOPMENT OF THE MODERN HOUSE

I know of nothing more significant than the awakening of men and women throughout our country to the desire to improve their houses. Call it what you will – awakening, development, American Renaissance – it is a most startling and promising condition of affairs.

It is no longer possible, even to people of only faintly æsthetic tastes, to buy chairs merely to sit upon or a clock merely that it should tell the time. Home-makers are determined to have their houses, outside and in, correct according to the best standards. What do we mean by the best standards? Certainly not those of the useless, overcharged house of the average American millionaire, who builds and furnishes his home with a hopeless disregard of tradition. We must accept the standards that the artists and the architects accept, the standards that have come to us from those exceedingly rational people, our ancestors.

Our ancestors built for stability and use, and so their simple houses were excellent examples of architecture. Their spacious, uncrowded interiors were usually beautiful. Houses and furniture fulfilled their uses, and if an object fulfils its mission the chances are that it is beautiful.

It is all very well to plan our ideal house or apartment, our individual castle in Spain, but it isn't necessary to live among intolerable furnishings just because we cannot realize our castle. There never was a house so bad that it couldn't be made over into something worthwhile. We shall all be very much happier when we learn to transform the things we have into a semblance of our ideal.

How, then, may we go about accomplishing our ideal?

By letting it go!

By forgetting this vaguely pleasing dream, this evidence of our smug vanity, and making ourselves ready for a new ideal.

By considering the body of material from which it is good sense to choose when we have a house to decorate.

By studying the development of the modern house, its romantic tradition and architectural history.

DOI: 10.4324/9781003290490-16

By taking upon ourselves the duty of self-taught lessons of sincerity and common sense, and suitability.

By learning what is meant by color and form and line, harmony and contrast and proportion.

When we are on familiar terms with our tools, and feel our vague ideas clearing into definite inspiration, then we are ready to talk about ideals. We are fit to approach the full art of home-making.

We take it for granted that every woman is interested in houses – that she either has a house in course of construction, or dreams of having one, or has had a house long enough wrong to wish it right. And we take it for granted that this American home is always the woman's home: a man may build and decorate a beautiful house, but it remains for a woman to make a home of it for him. It is the personality of the mistress that the home expresses. Men are forever guests in our homes, no matter how much happiness they may find there.

You will express yourself in your house, whether you want to or not, so you must make up your mind to a long preparatory discipline. You may have only one house to furnish in your life-time, possibly, so be careful and go warily. Therefore, you must select for your architect a man who isn't too determined to have *his* way. It is a fearful mistake to leave the entire planning of your home to a man whose social experience may be limited, for instance, for he can impose on you his conception of your tastes with a damning permanency and emphasis. I once heard a certain Boston architect say that he taught his clients to be ladies and gentlemen. He couldn't, you know. All he could do is to set the front door so that it would reprove them if they weren't!

Who does not know, for instance, those mistaken people whose houses represent their own or their architects' hasty visits to the fine old châteaux of the Loire, or the palaces of Versailles, or the fine old houses of England, or the gracious villas of Italy? We must avoid such aspiring architects, and visualize our homes not as so many specially designated rooms and convenient closets, but as individual expressions of ourselves, of the future we plan, of our dreams for our children. The ideal house is the house that has been long planned for, long awaited.

Fortunately for us, our best architects are so very good that we are better than safe if we take our problems to them. These men associate with themselves the hundred young architects who are eager to prove themselves on small houses. The idea that it is economical to be your own architect and trust your house to a building contractor is a mistaken, and most expensive, one. The surer you are of your architect's common sense and professional ability, the surer you may be that your house will be economically efficient. He will not only plan a house that will meet the needs of your family, but he will give you inspiration for its interior. He will concern himself with the moldings, the light-openings, the door-handles and hinges, the unconsidered things that make or mar your house. Select for your architect a man you'd like for a friend. Perhaps he will be, before the house comes true. If you are both sincere, if you both purpose to have the best thing you can afford, the house will express the genius and character of your architect and the

personality and character of yourself, as a great painting suggests both painter and sitter. The hard won triumph of a well-built house means many compromises, but the ultimate satisfaction is worth everything.

I do not purpose, in this book, to go into the historic traditions of architecture and decoration – there are so many excellent books it were absurd to review them – but I do wish to trace briefly the development of the modern house, the woman's house, to show you that all that is intimate and charming in the home as we know it has come through the unmeasured influence of women. Man conceived the great house with its parade rooms, its *grands appartements* but woman found eternal parade tiresome, and planned for herself little retreats, rooms small enough for comfort and intimacy. In short, man made the house: woman went him one better and made of it a home.

The virtues of simplicity and reticence in form first came into being, as nearly as we can tell, in the Grotta, the little studio-like apartment of Isabella d'Este, the Marchioness of Mantua,[5] away back in 1496. The Marchioness made of this little studio her personal retreat. Here she brought many of the treasures of the Italian Renaissance. Really, simplicity and reticence were the last things she considered, but the point is that they were considered at all in such a restless, passionate age. Later, in 1522, she established the Paradiso, a suite of apartments which she occupied after her husband's death. So you see the idea of a woman planning her own apartment is pretty old, after all.

The next woman who took a stand that revealed genuine social consciousness was that half-French, half-Italian woman, Catherine de Vivonne, Marquise de Rambouillet.[6] She seceded from court because the court was swaggering and hurly-burly, with florid Marie-de-Medicis at its head. And with this recession, she began to express in her conduct, her feeling, her conversation, and, finally, in her house, her awakened consciousness of beauty and reserve, of simplicity and suitability.

This was the early Seventeenth Century, mind you, when the main salons of the French houses were filled with such institutions as rows of red chairs and boxed state beds. She undertook, first of all, to have a light and gracefully curving stairway leading to her salon instead of supplanting it. She grouped her rooms with a lovely diversity of size and purpose, whereas before they had been vast, stately halls with cubbies hard by for sleeping. She gave the bedroom its alcove, boudoir, ante-chamber, and even its bath, and then as decorator she supplanted the old feudal yellow and red with her famous silver-blue. She covered blue chairs with silver bullion. She fashioned long, tenderly colored curtains of novel shades. Reticence was always in evidence, but it was the reticence of elegance. It was through Madame de Rambouillet that the armchair received its final distribution of yielding parts, and began to express the comfort of soft padded backward slope, of width and warmth and color.

It was all very heavy, very grave, very angular, this Hôtel Rambouillet, but it was devised for and consecrated to conversation, considered a new form of privilege! The *précieuses*[7] in their later jargon called chairs "the indispensables of conversation."

I have been at some length to give a picture of Madame de Rambouillet's hôtel because it really is the earliest modern house. There, where the society that

frequented it was analyzing its soul in dialogue and long platonic discussion that would seem stark enough to us, the word which it invented for itself was *urbanité* – the coinage of one of its own foremost figures.

It is unprofitable to follow on into the grandeurs of Louis XIV, if one hopes to find an advance there in truth-telling architecture. At the end of that splendid official success the squalor of Versailles was unspeakable, its stenches unbearable. In spite of its size the Palace was known as the most comfortless house in Europe. After the death of its owner, society, in a fit of madness, plunged into the *rocaille*. When the restlessness of Louis XV could no longer find moorings in this brilliancy, there came into being little houses called *folies*, garden hermitages for the privileged. Here we find Madame de Pompadour in calicoes, in a wild garden, bare-foot, playing as a milkmaid, or seated in a little gray-white interior with painted wooden furniture, having her supper on an earthen-ware service that has replaced old silver and gold. Amorous alcoves lost their painted Loves and took on gray and white decorations. The casinos of little *comédiennes* did not glitter anymore. English sentiment began to bedim Gallic eyes, and so what we know as the Louis XVI style was born.

And so, at that moment, the idea of the modern house came into its own, and it could advance – as an idea – hardly any further. For with all the intrepidity and passion of the later Eighteenth Century in its search for beauty, for all the magic-making of convenience and ingenuity of the Nineteenth Century, the fundamentals have changed but little. And now we of the Twentieth Century can only add material comforts and an expression of our personality. We raise the house beyond the reach of squalor, we give it measured heat, we give it water in abundance and perfect sanitation and light everywhere, we give it ventilation less successfully than we might, and finally we give it the human quality that is so modern. There are no dungeons in the good modern house, no disgraceful lairs for servants, no horrors of humidity.

And so we women have achieved a house, luminous with kind purpose throughout. It is finished – that is our difficulty! We inherit it, all rounded in its perfection, consummate in its charms, but it is finished, and what can we do about a thing that is finished? Doesn't it seem that we are back in the old position of Isabella d'Este – eager, predatory, and "thingy"? And isn't it time for us to pull up short lest we sidestep the goal? We are so sure of a thousand appetites we are in danger of passing by the amiable commonplaces. We find ourselves dismayed in old houses that look too simple. We must stop and ask ourselves questions, and, if necessary, plan for ourselves little retreats until we can find ourselves again.

What is the goal? A house that is like the life that goes on within it, a house that gives us beauty as we understand it – and beauty of a nobler kind that we may grow to understand, a house that looks amenity.

Suppose you have obtained this sort of wisdom – a sane viewpoint. I think it will give you as great a satisfaction to re-arrange your house with what you have as to re-build, re-decorate. The results may not be so charming, but you can learn by them. You can take your indiscriminate inheritance of Victorian rosewood of

Eastlake walnut and cocobolo, your pickle-and-plum colored Morris furniture, and make a civilized interior by placing it right, and putting detail at the right points. Your sense of the pleasure and meaning of human intercourse will be clear in your disposition of your best things, in your elimination of your worst ones.

When you have emptied the tables of *rubbish* so that you can put *things* down on them at need, placed them in a light where you can write on them in repose, or isolated real works of art in the middle of them; when you have set your dropsical sofas where you want them for talk, or warmth and reading; when you can see the fire from the bed in your sleeping-room, and dress near your bath; if this sort of sense of your rights is acknowledged in your rearrangement, your rooms will always have meaning, in the end. If you like only the things in a chair that have meaning, and grow to hate the rest you will, without any other instruction, prefer – the next time you are buying – a good Louis XVI *fauteuil* to a stuffed velvet chair. You will never again be guilty of the errors of meaningless magnificence.

To most of us in America who must perforce lead workaday lives, the absence of beauty is a very distinct lack. I think, indeed, that the present awakening has come to stay, and that before very long, we shall have simple houses with fire-places that draw, electric lights in the proper places, comfortable and sensible furniture, and not a gilt-legged spindle-shanked table or chair anywhere. This may be a decorator's optimistic dream, but let us all hope that it may come true.

## II SUITABILITY, SIMPLICITY AND PROPORTION

When I am asked to decorate a new house, my first thought is suitability. My next thought is proportion. Always I keep in mind the importance of simplicity. First, I study the people who are to live in this house, and their needs, as thoroughly as I studied my parts in the days when I was an actress. For the time-being I really am the chatelaine of the house. When I have thoroughly familiarized myself with my "part," I let that go for the time, and consider the proportion of the house and its rooms. It is much more important that the wall openings, windows, doors, and fireplaces should be in the right place and should balance one another than that there should be expensive and extravagant hangings and carpets.

My first thought in laying out a room is the placing of the electric light openings. How rarely does one find the lights in the right place in our over-magnificent hotels and residences! One arrives from a journey tired out and travel-stained, only to find oneself facing a mirror as far removed from the daylight as possible, with the artificial lights directly behind one, or high in the ceiling in the center of the room. In my houses I always see that each room shall have its lights placed for the comfort of its occupants. There must be lights in sheltered corners of the fireplace, by the writing-desk, on each side of the dressing-table, and so on.

Then I consider the heating of the room. We Americans are slaves to steam heat. We ruin our furniture, our complexions, and our dispositions by this ener-vating atmosphere of too much heat. In my own houses I have a fireplace in each room, and I burn wood in it. There is a heating-system in the basement of my

house, but it is under perfect control. I prefer the normal heat of sunshine and open fires. But, granted that open fires are impossible in all your rooms, do arrange in the beginning that the small rooms of your house may not be overheated. It is a distinct irritation to a person who loves clean air to go into a room where a flood of steam heat pours out of every corner. There is usually no way to control it unless you turn it off altogether. I once had the temerity to do this in a certain hotel room where there was a cold and cheerless empty fireplace. I summoned a reluctant chambermaid, only to be told that the chimney had never had a fire in it and the proprietor would rather not take such a risk!

Perhaps the guest in your house would not be so troublesome, but don't tempt her! If you have a fireplace, see that it is in working order.

We are sure to judge a woman in whose house we find ourselves for the first time, by her surroundings. We judge her temperament, her habits, her inclinations, by the interior of her home. We may talk of the weather, but we are looking at the furniture. We attribute vulgar qualities to those who are content to live in ugly surroundings. We endow with refinement and charm the person who welcomes us in a delightful room, where the colors blend and the proportions are as perfect as in a picture. After all, what surer guarantee can there be of a woman's character, natural and cultivated, inherent and inherited, than taste? It is a compass that never errs. If a woman has taste she may have faults, follies, fads, she may err, she may be as human and feminine as she pleases, but she will never cause a scandal!

How can we develop taste? Some of us, alas, can never develop it because we can never let go of shams. We must learn to recognize suitability, simplicity and proportion, and apply our knowledge to our needs. I grant you we may never fully appreciate the full balance of proportion, but we can exert our common sense and decide whether a thing is suitable; we can consult our conscience as to whether an object is simple, and we can train our eyes to recognize good and bad proportion. A technical knowledge of architecture is not necessary to know that a huge stuffed leather chair in a tiny gold and cream room is unsuitable, is hideously complicated, and is as much out of proportion as the proverbial bull in the china-shop.

A woman's environment will speak for her life, whether she likes it or not. How can we believe that a woman of sincerity of purpose will hang fake "works of art" on her walls, or satisfy herself with imitation velvets or silks? How can we attribute taste to a woman who permits paper floors and iron ceilings in her house? We are too afraid of the restful commonplaces, and yet if we live simple lives, why shouldn't we be glad our houses are comfortably commonplace? How much better to have plain furniture that is comfortable, simple chintzes printed from old blocks, a few good prints, than all the sham things in the world? A house is a dead-give-away, anyhow, so you should arrange is so that the person who sees your personality in it will be reassured, not disconcerted.

Too often, here in America, the most comfortable room in the house is given up to a sort of bastard collection of gilt chairs and tables, over-elaborate draperies shutting out both light and air, and huge and frightful paintings. This style of room, with its museum-like furnishings, has been dubbed "Marie Antoinette,"

why, no one but the American decorator can say. Heaven knows poor Marie Antoinette had enough follies to atone for, but certainly she has never been treated more shabbily than when they dub these mausoleums "Marie Antoinette rooms."

I remember taking a clever Englishwoman of much taste to see a woman who was very proud of her new house. We had seen most of the house when the hostess, who had evidently reserved what she considered the best for the last, threw open the doors of a large and gorgeous apartment and said, "This is my Louis XVI ballroom." My friend, who had been very patient up to that moment, said very quietly, "What makes you think so?"

Louis XVI thought a salon well furnished with a few fine chairs and a table. He wished to be of supreme importance. In the immense salons of the Italian palaces there were a few benches and chairs. People then wished spaces about them.

Nowadays, people are swamped by their furniture. Too many centuries, too many races, crowd one another in a small room. The owner seems insignificant among his collections of historical furniture. Whether he collects all sorts of things of all periods in one heterogeneous mass, or whether he fills his house with the furniture of some one epoch, he is not at home in his surroundings.

The furniture of every epoch records its history. Our ancestors of the Fourteenth and Fifteenth Centuries inherited the troublous times of their fathers in their heavy oaken chests. They owned more chests than anything else, because a chest could be carried away on the back of a sturdy pack mule, when the necessity arose for flight.

People never had time to sit down in the Sixteenth Century. Their feverish unrest is recorded in their stiff, backed chairs. It was not until the Seventeenth Century that they had time to sit down and talk. We need no book of history to teach us this – we have only to observe the ample proportions of the arm-chairs of the period.

Our ancestors of the Seventeenth and Eighteenth centuries worked with a faith in the permanence of what they created. We have lost this happy confidence. We are occupied exclusively with preserving and reproducing. We have not succeeded in creating a style adapted to our modern life. It is just as well! Our life, with its haste, its nervousness and its preoccupations, does not inspire the furniture-makers. We cannot do better than to accept the standards of other times, and adapt them to our uses.

Why should we American woman run after styles and periods of which we know nothing? Why should we not be content with the fundamental things? The formal French room is very delightful in the proper place but when it is unsuited to the people who must live in it, it is as bad as a sham room. The woman who wears paste jewels is not so conspicuously wrong as the woman who plasters herself with too many real jewels at the wrong time!

This is what I am always fighting in people's houses, the unsuitability of things. The foolish woman goes about from shop to shop and buys as her fancy directs. She sees something "pretty" and buys it, though it has no reference either in form or color to the scheme of her house. Haven't you been in rooms where there was a jumble of mission furniture, satinwood, fine old mahogany and gilt-legged chairs? And it is the same with color. A woman says, "Oh, I love blue, let's have

blue!" regardless of the exposure of her room and the furnishings she has already collected. And then when she has treated each one of her rooms in a different color, and with a different floor covering, she wonders why she is always fretted in going from one room to another.

Don't go about the furnishing of your house with the idea that you must select the furniture of some one period and stick to that. It isn't at all necessary. There are old English chairs and tables of the Sixteenth and Seventeenth Centuries that fit into our quiet, spacious Twentieth Century country homes. Lines and fabrics and woods are the things to be compared.

There are so many beautiful things that have come to us from other times that it should be easy to make our homes beautiful, but I have seen what I can best describe as apoplectic chairs whose legs were fashioned like aquatic plants; tables upheld by tortured naked women; lighting fixtures in the form of tassels, and such horrors, in many houses of to-day under the guise of being "authentic period furniture." Only a connoisseur can ever hope to know about the furniture of every period, but all of us can easily learn the ear-marks of the furniture that is suited to our homes. I shan't talk about ear-marks here, however, because dozens of collectors have compiled excellent books that tell you all about curves and lines and grain-of-wood and worm-holes. My business is to persuade you to use your graceful French sofas and your simple rush bottom New England chairs in different rooms – in other words, to preach to you the beauty of suitability. Suitability! Suitability! SUITABILITY!!

It is such a relief to return to the tranquil, simple forms of furniture, and to decorate our rooms by a process of elimination. How many rooms have I not cleared of junk – this heterogeneous mass of ornamental "period" furniture and bric-a-brac bought to make a room "look cozy." Once cleared of these, the simplicity and dignity of the room comes back, the architectural spaces are freed and now stand in their proper relation to the furniture. In other words, the architecture of the room becomes its decoration.

## Notes

1 E. De Wolfe, *After All* (New York; Harper 1935), p. 3.
2 *House in Good Taste,* 1913, p. 48.
3 *House in Good Taste,* 1913 p. 21.
4 *Art and Progress,* 5: 4, 1914, p. 151.
5 Isabella d'Este, the Marchioness of Mantua (1474–1539) was one of the leading figures of the Italian Renaissance.
6 Catherine de Vivonne, Marquise de Rambouillet, (1588–1665) was a French aristocrat who presided over the first of the *salons* of 17th-century Paris. The Hôtel de Rambouillet was at the height of its influence between 1620 and 1645 and it was here that the Marquise sought to promote intellectual conversation, refinement, and good taste, earning her the soubriquet *précieuse.*
7 The *précieuses* were the witty and educated women who frequented the salon of the Marquise de Rambouillet. They were ridiculed in Molière's one-act satire, *Les Précieuses ridicules* (1659).

# GEORGE LELAND HUNTER, 'GOOD AND BAD FURNITURE' (1913)

## Editorial Headnote

George Leland Hunter, (1867–1927) was an American author and expert on decorative art. He was educated at Phillips Exeter Academy and at Harvard University (1889). He taught in Chicago for a decade, then moved to New York City. His writings appeared in many magazine articles including *Arts and Decoration* and the *Good Furniture* journal. He also authored numerous works on furnishing, furniture, textiles and especially tapestries. His books included the important *Tapestries, their Origin, History, and Renaissance* (1912) and *Inside the house that Jack built, the story, told in conversation, of how two homes were furnished.* (New York: John Lane Co. 1914) that described the furnishing of two country retreats. Much later Leland wrote in conjunction with the English furniture historian Herbert Cescinsky, a volume titled *English and American furniture: a pictorial handbook of fine furniture made in Great Britain and in the American colonies, some in the sixteenth century, but principally in the seventeenth, eighteenth and early nineteenth centuries.* (Garden City, N.Y.: Garden City Publishing company, Inc. 1929).

These essays on home furnishings were first published in *Country Life in America*. One report wrote a brief notice of this book noting that

> The author, who has been connected with a journal of the upholstery trade and who in recent years has qualified as an expert in tapestries, has the gift of talking very directly *ad hominem* or, and this is more important, *ad mulierem*.[1] He knows the foolishness of many amateur home makers and the unscrupulousness of some purveyors to their needs and tastes.[2]

Hunter, writing in his *Inside the House That Jack Built* seems to suggest that the employment of a decorator was of clear value as opposed to an individual trying to express themselves through interior design. He said:

> Of all the stupidities and inanities perpetuated by newspapers and magazines on the subject of interior decoration and furnishing, by those who write with little knowledge and less taste, none is more misleading than the idea that a man's home should be the expression of his own personality as he himself understands it.[3]

Hunter's concerns would appear to suggest the need for advisor's or decorator's to ensure their own professional status as taste-makers in opposition to domestic advice authors.

In addition, he seems to have pointedly complained about Mission style furniture. It was not only in this text he mentioned it. In the book *Inside the House that Jack Built*, he wrote

> The mission of Mission said Jack, was to kill the American taste for golden oak machine carvings pasted on to shapes distorted from the French. Mission isn't a style. It was merely a medicine to take the bad taste out of the American mouth.[4]

The illustrations are an important part of the essay as they offer visual evidence for Hunter's argument about furniture design and taste as well as some stinging criticism of the chairs of which he disapproves.

# 13

# 'GOOD AND BAD FURNITURE'

## *George L. Hunter*

Source: George L. Hunter, "Good and Bad Furniture" *Home furnishing: Facts and figures about furniture, carpets and rugs, lamps and lighting fixtures, wall papers, window shades and draperies, tapestries, etc.,* (New York: J. Lane, 1913) pp. 17–23

"ORTHODOXY," said Professor Sophocles of Harvard, "is my doxy. Heterodoxy is somebody else's doxy." So it is with regard to taste. Good taste is what I like. Bad taste is what the other fellow likes.

Taste is the most intimate and definite expression of personality. Even more than by his friends is it possible to judge a man by what appeals to him artistically. If he prefers musical comedy to grand opera, and wallpaper to Renaissance tapestries, we know that his artistic education has been neglected, or that he was born deaf to the beautiful.

Good taste is not wholly a natural gift, nor is it wholly the result of knowledge and experience. It is a combination of both. Without great natural gifts, no one can ever become delicately sensitive to the finer and higher forms of art. Without acquaintance with the best that has been done, no one can ever become noted for the quick accuracy of his critical opinions.

The shibboleth of the novice is simplicity. The young lady reporter can in half a column of the Woman's Section of the Sunday newspaper easily demolish all the French styles, and particularly Louis XV.

But while simplicity is a doctrine easy to preach, it is both hard and dangerous to follow. Simple furniture, like simple gowns, may be inexpensive to look at, but expensive to purchase and use. Ornament skilfully applied conceals uninteresting lines and joints and surfaces, and accentuates beautiful ones. In furniture and architecture, paints and finishes and hardware, though often ornamentally applied, are primarily important from the point of view of usefulness. But of moldings and inlays and carvings and piercings the primary purpose is ornamental, and they are valueless except as they add beauty.

The line between good ornament and bad ornament is the line between beauty and ugliness.

The only good furniture is that which is both beautiful and useful.

All furniture that lacks either beauty or usefulness is bad furniture.

Furniture that is well constructed, of good shape and excellent finish, is good furniture no matter how elaborately it may be decorated.

DOI: 10.4324/9781003290490-17

Furniture of bad shape or bad finish is bad furniture no matter how free from meretricious mounts and carvings.

A large proportion of the worst furniture ever made belongs to the so-called Mission or Arts-and-Crafts type.

The shopkeepers claim that the reason they carry in their showrooms and warerooms so much bad furniture, is that the public demands it. The professional educators of public taste claim that the reason people buy bad furniture is because the shopkeepers force it upon them. The truth probably lies in between. Undoubtedly the dealers do follow rather than lead, and undoubtedly the cheap trade – particularly that of instalment stores – do demand quantity of ornament and color rather than quality.

The abomination of abominations in the form of bad furniture, is the conventional parlor set, copied remotely and ignorantly from some French original and upholstered in fancy velours or satin damask. Nothing more ghastly could be imagined except the illustrations of them that appear in newspaper advertisements with the sign underneath, "Just like the cut."

Other abominations are dining-room tables and sideboards and chairs in oak with huge Italian Renaissance machine carvings obtruding where they will do the most harm; easy chairs and sofas in massive mahogany that has been tortured into incredible shapes; metal beds with stamped and spun trimmings that part company with the object adorned at the first opportunity; wooden beds and bureaus whose veneered and polished surfaces are mirror-like when new, and patchy after a few months' use; writing desks that, in sinuosity of line and fragility of appearance and fact, surpass the most extreme rococo ever devised even in Germany: curio cabinets with painted or transferred ornament under lacquer, that makes the name *vernis-martin*[5] ridiculous.

Of these abominations, the worst are no longer found in the larger shops and departments. During the past ten years the standard of taste has risen appreciably. In the store from which our illustrations are taken, it is evident that a serious and intelligent effort has been made to avoid bad design, bad construction, and bad finishes.

But the mass of inexpensive furniture is still full of serious faults, as our "bad furniture" illustrations show.

Even when well-built and finished, it is apt to have bad proportions. Legs are too short or too long or too slender or too thick to rhyme with the body. Chair backs are too wide or too narrow or too straight or too curved. Arms are too light or too heavy. Seats are too wide or too deep. The upholstery is out of tune with the color and texture of the wood, or with the style to which the frame belongs.

Of expensive furniture that is good – modern reproductions as well as antique pieces – the different historic periods have bequeathed us much. If one has a fat purse there is no excuse for buying bad furniture.

But when the purse is lean, the case is different. The cheap imitations of historic pieces are ridiculous – for instance, the dwarfed and skimpy copies of Chippendale and Louis XV chairs of which there are so many.

Inexpensive furniture should be chosen for its intrinsic merits, and not for its more or less shadowy resemblance to museum examples. The designs – whether classic or modern – will of necessity be those adapted to production in large quantities and inexpensively; the ornament such as is natural to the machine and durable in use.

Especially interesting from the modern point of view are the bentwood furniture made in Austria, and the new turned furniture made in Germany. Both are avowedly and pronouncedly machine-made, and designed along the lines best adapted for machine production. They are splendid examples of good furniture at the least possible cost. Of course. No. 1 suggests the restaurant, but it is vastly more durable and more graceful than No. 2, which is plain "kitchen chair."

1. Austrian bentwood chair, finished in oak or mahogany, at $2.75. It excels in strength and durability.

2. Oak chair at $2.50, crudely and roughly made. The proportions and finish are detestable.

3. A good mahogany chair of simple design, an offshoot of the Chippendale family. It costs $12.

4. Oak chair upholstered in leather, with heavy carvings that attempt to reproduce the Italian Renaissance.

5. "The Washington chair," repro-
duced from the original. In ma-
hogany, upholstered with Colonial
denim, $12.

6. A tapestry-upholstered oak chair
at $10.50, illustrating the effort of
American designers to improve on
Chippendale.

7. A durable and comfortable arm-
chair of the Windsor type at $9.

8. An inferior arm-chair of the Mis-
sion type at $7.

No. 4 is a pretentious failure. Elaborate carving is acceptable only when exe-
cuted by a master. Crude, pasted-on, machine carving is an abomination. This
chair costs enough to be good, but anyone who can afford to pay $94 for a five-
piece set ought to have taste enough to choose No. 3 or No. 5.

No. 6 represents the way some American manufacturers murder Chippendale.
Note particularly the front legs. Could anything be more hopelessly ugly?

It is positively refreshing to turn to No. 7. It not only looks well and wears well,
but it is comfortable. It is a model of grace compared with No. 8, and is built well.

Not all Mission furniture is cumbersome, but No. 8 is. Obvious construction,
moreover, is not necessarily good or honest construction, and cheap Mission fur-
niture shows an aptitude for falling apart.

Of course, I do not pretend that No. 9 is a beautiful chair; but compare it with
No. 10! Is it any wonder that boys leave home when the front parlor is equipped
with "suits" of this type?

9. An arm-chair in mahogany finish, part of a three-piece set, at $65.

10. An arm-chair in mahogany finish, one of a five-piece set, at $130.

## Notes

1 'Talking to men and more importantly women.'
2 Untitled newspaper clipping in book text held by NYPL.
3 George Hunter, *Inside the House That Jack Built (The Story, Told in Conversation, of How Two Homes Were Furnished)* (New York: John Lane Company, 1914), p. 37.
4 Ibid, p. 189.
5 *Vernis martin:* The lacquering products of the French family Martin, were called vernis martin. This became a generic name for all lacquers produced in France in the eighteenth century.

# Part 3

# DECORATING ADVICE

# DECORATING AND
# HOME-MAKING ADVICE

The whole period witnessed a massive growth in the business of advice in relation to the home, whether in terms of major issues or associated topics such as etiquette, rearing children or dealing with servants. Although men wrote many architectural tracts, many women wrote books and published articles, aimed at other women especially in relation to the decoration and organisation of the domestic interior. Advice books provided the recipes and blueprints for the rapid expansion of middle-class homes especially in Britain and North America. Mrs Parkes *Domestic Duties* published in 1825 began to open up topic to a wide audience, especially women. John Claudius Loudon's *Encyclopaedia of Cottage, Farm and Villa Architecture and Furniture*, (1833) was one of the most influential, although probably mainly read by architects, tradesmen and builders than amateurs. The same might be said about Robert Kerr's important work *The Gentleman House* (1864).

Further publications including works such as T. Webster and F. Parkes, *Encyclopaedia of Domestic Economy* (1844), A. J. Downing's *The Architecture of Country Houses*, (1850), Gervase Wheeler's *Rural Homes, or Sketches of Houses Suited to American Life*, (1851), and Catherine and Harriet Beecher Stowe's, *The American Woman's Home*, (1864), were all very influential in developing an ethos of home and its correct decoration. Of course, Mrs Beeton *Book of Household Management* (1861) is one of the most well-known examples of this genre.

One of the most influential books specifically on home decoration and furnishing was architect Charles Eastlake's *Hints on Household Taste*, 1867. This book played a huge role in advising the middle classes in matters of furnishing and decoration. Publishers were also increasingly catering for a working-class market, with books such as *Cassell's Book of the Household*, 1897 edition, and Sylvia's *Home Help Series. The House and Its Furniture*, 1879.

Many of the texts across these four volumes refer to women or were authored by women including Rhoda and Agnes Garrett, Mrs Haweis, Mrs Jane Panton, Mrs Lucy Orrinsmith and. A later example is Edith Wharton's *Decoration of Houses*.

DOI: 10.4324/9781003290490-19

Responding to the general interest in 'artistic' taste, between 1876 and 1878, the publishers Macmillan, issued the cheap Art at Home series, which included Lady Barker's *The Bedroom and the Boudoir*, 1878, and Mrs Orrinsmith's *The Drawing Room*, 1877 at 2s 6d each and Mrs Loftie's *The Dining Room*, 1878. The latter publication was

> not intended for people who can afford to employ skilled decorators, nor yet for those who can give costly entertainments. It merely contains a few practical suggestions for inexperienced housekeepers of small income, who do not wish to make limited means an excuse for disorder and ugliness.[1]

Advice for American audiences was not slow in forthcoming. Many British texts were published in edited versions for the American market. Local authors also contributed important works including Gervase Wheeler, Clarence Cook and Andrew Downing.

In addition, the value of journals was also crucial in shaping opinions and pontificating on matters of fashion, taste and style and offering interior design advice. These were again often specifically aimed at women.

Early in the century, the *Lady's Monthly Museum*, founded in 1798 began to discuss fashions and literary topics. Its rival, Ackermann's *Repository of the Arts*, 1809–28, was at the forefront of taste and technical innovation, using the new medium of lithography from 1817. Originally intended as a general magazine, in its final twelve years it specifically aimed at women. The magazine contained fabric samples, hand-coloured plates of dress fashions, designs for country houses, garden buildings and furniture.

At the other end of the century, in 1897, a publication titled *The House: An Artistic Monthly for Those who Manage, and Beautify the Home* was marketed. In the introduction to the initial issue of *The House*, the editor suggested that 'There are now dozens of journals which have to do with the dressing and adornment of the body; but strange to say, there is not one dealing exclusively with the dressing of the house'. The aim of the new journal was to remedy this situation.

Between these two, numerous other publications with the word 'home' or 'family' were published, usually with the female market in mind, These titles included *The Home Circle, Home Companion, The Home Friend, Home Thoughts, The Home Magazine, Family Economist, Family Record, Family Friend, Family Treasure, Family Prize Magazine and Household Miscellany, Family Paper, Hearth and Home and The Woman At Home*.

Other journals had different ambitions. For example. the didactic *Journal of Design and Manufactures* (1849–1852) aimed to improve the manufacturing of products in terms of 'good design.' Numerous trade-oriented weeklies such as *The Builder* and *The Cabinet Maker* provided guidance for these trades, whilst a

third category that included the *Art Furnisher*, *The Studio* and *The Art Amateur*, amongst many, was aimed at the 'artistic' communities.

The texts below range in date across the long nineteenth century and in their various ways offer samples of the advice on home making, and how issues related to house decoration were addressed.

## Note

1  Mrs Loftie, *The Dining Room* (Macmillan, London, 1878), Preface.

# THOMAS SHERATON, 'FURNISH',
## *THE CABINET DICTIONARY* (1803)

## Editorial Headnote

Thomas Sheraton (1751–1806) born in Stockton-on-Tees was the son of a school-master. He was 'a journeyman cabinet maker, but who, since about the year 1793, has supported himself, a wife, and two children, by his exertions as an author'.[1] He soon afterwards stopped making furniture. Instead, he set up as a teacher. His business card of about 1795 says that he 'Teaches Perspective, Architecture and Ornaments, makes Designs for Cabinetmakers. and sells all kinds of Drawing Books &c'. This new branch of work produced the *Cabinet Maker and Uphol-sterer's Drawing-Book* that was published by subscription in fortnightly numbers, priced 1s between 1791–1793. The subscribers apparently included 'almost all the principal cabinet makers in town and country'.[2] Many copies of this work went to America and a German edition was published at Leipzig in 1794. A facsimile reprint was issued by Batsford in 1895, that encouraged a Sheraton revival that was manifested in the production of reproductions of his designs. Sheraton's sec-ond furniture book *The Cabinet Dictionary*, published in 1803, was significant as not only did it discuss a wide range of furniture-making terms but also dis-cussed how particular items of furniture were to be used and the reason for these decisions.

These sorts of books, as a source of technical information for both craftspeo-ple and patrons, were of increasing importance during the century. Sheraton's introduction specifically suggested that the work was to assist and instruct youths who were entering the trade, as well as 'gentlemen, who being of a mechanical turn, frequently amuse themselves by enquiries into the technical terms of such professions'.[3]

Rather sadly, in the entry on cabinets Sheraton remarked 'though I am thus employed in racking my invention to design fine and pleasing cabinet work, I can be well content to sit on a wooden bottom chair myself, provided I can but have common food and raiment wherewith to pass through life in peace'.[4] In his diaries Adam Black (of the well-known publishing house) wrote of his encounter with Sheraton:

> He lived in an obscure street, his house half shop half dwelling-house, and looked himself like a worn-out Methodist minister, with threadbare black coat. I took tea with them one afternoon. . . . My host seemed a good man, with some talent. He had been a cabinetmaker, was now author and publisher, teacher of drawing, and, I believe, occasional preacher. I was with him for about a week, engaged in most wretched work, writing a few articles, and trying to put his shop in order, working among dirt and

bugs, for which I was remunerated with half a guinea. Miserable as the pay was, I was half ashamed to take it from the poor old man.[5]

In 1803 Sheraton started work on his last venture *The Cabinet-Maker, Upholsterer, and General Artist's Encyclopaedia*, which was never completed due to illness and his subsequent death in 1806. His obituary note that "He has left his family, it is feared, in distressed circumstances."[6]

The selected text shows the importance of guidance in the location, furnishing and decoration of a variety of rooms. For Sheraton it was also important that clients were to be directed to appropriate furnishings that reflected their station and not to try and emulate socially superior furnishing scenarios. This attitude towards furnishing practices recurs throughout the century.

# 14

# THE CABINET DICTIONARY

## Thomas Sheraton

Source: Thomas Sheraton, *The Cabinet Dictionary*, (London: W. Smith, 1803), pp. 215–9

FURNISH, amongst cabinet makers and upholsterers, is generally applied to the act of supplying a house with suitable furniture. When a house is said to be furnished, it conveys the idea of its being fitted up with every necessary, both useful and ornamental. In furnishing a good house for a person of rank, it requires some taste and judgment, that each apartment may have such pieces as is most agreeable to the appropriate use of the room. And particular regard is to be paid to the quality of those who order a house to be furnished, when such order is left to the judgment of the upholsterers; and when, any gentleman is so vain and ambitious as to order the furnishing of his house in a style superior to his fortune and rank, it will be prudent in an upholsterer, by some gentle hints, to direct his choice to a more moderate plan.

There is certainly something of sentiment expressed in the manner of furnishing a house, as well as in personal dress and equipage, particularly so in the appearance of some apartments. And it is the business of an upholsterer not to recommend anything that would offend the known sentiments of his employer, when virtue and morality are not the question, but mere indifferent opinion.

But it is to be lamented, that both the pictures and prints of some gentlemen are but too sure indications of their looseness of principle as to virtue and morality, though these ought to be the principal ornaments of human life, which in no character shines more becomingly than in the gentleman of rank.

The kitchen, the hall, the dining parlour, the anteroom, the drawing room, the library, the breakfast room, the music room, the gallery of paintings, the bed room and dressing apartments, ought to have their proper suits of furniture, and to be finished in a style, that will at once shew, to a competent judge, the place they are destined for.

The library should be furnished in imitation of the antiques; and such prints as are hung in the walls ought to be memorials of learning, and portraits of men of science and erudition.

In the room or gallery of paintings, the best pictures should be placed in the most favourable situation, for still light, which should come from above, not in a diffuse, but collected manner, that it may give the true effect of the picture, as

DOI: 10.4324/9781003290490-20

intended by the painter. And if the shadow of the picture be from the right hand, the light should come to it from the left. The largest pictures should be placed so high only as to bring their centres nearly as may be perpendicular to the eye of the spectator. If this be not duly observed, it will occasion a distortion of the piece. In cases where, for want of room, a picture is required to be more elevated than its natural height, the piece should be hung so as to incline forward, by which means its centre will be brought nearer to a perpendicular to the eye. In small paintings, the distortion, occasioned by an improper height, is not so apparent; to remove the disadvantage, they are easily taken down to be viewed by hand. Observe, that pictures or prints, drawn to a high horizon, should be placed low, and those which have a low horizon, high: and, as in such apartments, the paintings are the chief objects of the spectator's attention, there ought not to be any gaudy furniture to take off the eye, or destroy any of their effect. Hence, plain mahogany chairs of an antique cast, having seats of mahogany will prove the most suitable.

The music room may be conducted in a more gay style; and the paintings or prints of the muses, and masters of music, may consistently make a part of furnishing; and chairs and stools of a richer variety of colours may be admitted with propriety.

As the entrance or hall of any well-built house ought always to be expressive of the dignity of its possessor, so the furniture ought also to be designed in a manner adapted to inform the stranger or visitant where they are, and what they may expect on a more general survey of every apartment.

As the hall is a general, or ought to be a general opening to all the principal apartments, it should be furnished so as not to be mistaken for the most superb division of the structure, or where they may expect to meet the nobler person who resides in it. The furniture of a hall should therefore be bold, massive, and simple. Yet noble in appearance, and introductory to the rest.

The dining parlour must be furnished with nothing trifling, or which may seem unnecessary, it being appropriated for the chief repast, and should not be encumbered with any article that would seem to intrude on the accommodation of the guests.

The large sideboard, inclosed or surrounded with Ionic pillars: the handsome and extensive dining-table; the respectable and substantial looking chairs; the large face glass: the family portraits; the marble fire-places; and the Wilton carpet; are the furniture that should supply the dining-room.

The drawing-room is to concentrate the elegance of the whole house, and is the highest display of richness of furniture. It being appropriated to the formal visits of the highest in rank, and nothing of a scientific nature should be introduced to take up the attention of any individual, from the general conversation that takes place on such occasions, Hence, the walls should be free of pictures, the tables not lined with books, nor the angles of the room filled with globes as the design of such meetings are not that each visitant should turn to his favourite study, but to contribute his part towards the amusement of the whole company. The grandeur

then introduced into the drawing-room is not to be considered, as the ostentatious parade of its proprietor, but the respect he pays to the rank of his visitants.

The anti-room, is an introduction to the drawing room, and partakes of the elegance of the apartment to which it leads, serving as a place of repose before the general intercourse be effected in the whole company. Here may be placed a number of sofas of a second order with a piano-forte or harp, and other matters of amusement till the whole of the company be collected.

The tea-room or breakfast-room, may abound with beaufets,[7] painted chairs, flower-pot stands, hanging book shelves or moving libraries, and the walls may be adorned with landscapes, and pieces of drawings, &c. and all the little things which are engaging to the juvenile mind.

The lodging-room admits of furniture simply necessary, but light in appearance, and should include such pieces as are necessary for the accidental occasions of the night. Here should be a small book shelf with such books as should tend to promote our pious resignation of body and soul to the care of the great author of the universe, and divine superintendent of human happiness.[8]

The dressing-room exhibits the toilet table and commode, with all the little affairs requisite to dress, as bason-stands, stools, glasses, and boxes with all the innocent trifles of youth, with which I shall close these hints on the nature of furnishing a house, taking it for granted, that enough has been said to lead to the proper management of such apartments as are not mentioned in this cursory view of the whole.

## Notes

1 *Gentleman's Magazine*, November 1806, p. 1082.
2 Ibid.
3 Sheraton *Cabinet Dictionary* 1803, p. iii.
4 Ibid, p. 118.
5 Alexander Nicolson, (ed) and Adam and Charles Black, *Memoirs of Adam Black*. 2d ed. (Edinburgh: A. and C. Black, 1885.) p. 31.
6 *Gentleman's Magazine*, November 1806, p. 1082.
7 beaufet; archaic word for buffet.
8 Sheraton was a pious Baptist who published some religious tracts. In his work *A Scriptural Illustration of the Doctrine of Regeneration* (1782, p. vi), he described himself as "a mechanic, and one who never received the advantages of a collegial or academical education".

# HUMPHRY REPTON, & JOHN CLAUDIUS LOUDON, 'CONCERNING INTERIORS', *THE LANDSCAPE GARDENING AND LANDSCAPE ARCHITECTURE OF THE LATE HUMPHREY REPTON, ESQ.*, (1840)

## Editorial Headnote

The landscaper gardener Humphry Repton (1752–1818) saw himself as the successor to the more famous and successful Lancelot 'Capability' Brown. Repton's sketching skills along with his partial knowledge of laying out grounds were combined by him to create what was to become the profession of landscape gardener. One of Repton's unique approaches were his so-called Red Books. These helped clients visualise his designs, along with a descriptive text and watercolour images with a system of overlays to show 'before' and 'after' views of a prospect and location. The publication demonstrates the major styles and contemporary discussions around the topic of landscape gardening. Buildings also played an important part in many of Repton's landscapes and in the 1790s he often worked in conjunction with architect John Nash.

This collected edition[1] of Repton's works, published in 1840 by J. C. Loudon, is much more supportive of Repton and his work which was in opposition to Loudon's earlier comments about him. Loudon had said of Repton in 1835:

> The character of this artist's talents seems to have been cultivation rather than genius; he was more anxious to follow than to lead; and to gratify the preconceived wishes of his employers, and improve on the fashion of the day, rather than to strike out grand and original beauties. This, indeed, is perhaps the most useful description of talent both for the professor and his employers. Repton's taste in Gothic architecture, in terraces, and architectural appendages to mansions, was particularly elegant. His published Observations on these subjects are valuable; though we think otherwise of his remarks on landscape-gardening, which we look upon as puerile, wanting depth, often at variance with each other, and abounding too much in affectation and arrogance.[2]

An encouraging review of this publication in the *Gentleman's Magazine* (1839) noted that

> nothing, therefore, could be more judicious than the choice which Mr. Loudon has made of this work for republication. He has also wisely done in reducing the size and the expense of the former volumes such articles of luxury being not suited to the useful and economical system of the present day. The books themselves are of great value to the Landscape Gardener and Architect, as being the work of a practical and professional

man and secondly, as the places which Mr. Repton has altered and improved may be compared, in their mature and advanced state, with the principles on which his improvements are founded and thus his prospective taste and knowledge brought to a decisive test.[3]

A different review in the *Civil Engineer and Architect's Journal* (1840) also commented on the value of the new edited edition. Further into the review they quote Repton discussing the problems of the architect-artificer relationship in matters of house building, which throws an interesting light on the topic and the difficulties of the relationship that might come about.

> I cannot help mentioning, that, from the obstinacy and bad taste of the Bristol mason who executed the design, I was mortified to find that Gothic entrance built of a dark blue stone, with dressings of white Bath stone; and in another place, the intention of the design was totally destroyed, by painting all the wood-work of this cottage of a bright pea-green. Such, alas! is the mortifying difference betwixt the design of the artist, and the execution of the artificer.[4]

This text in this extract is a discussion of the nature of rooms in a country house (as opposed to a town house). Repton, in his discussion of the distinctions between these spaces and usage, suggested that the 'formal gloom' of the cedar parlour was inimical to contemporary living, and should be superseded by the more sociable 'modern living room'. He illustrated this idea with two images and a rather poor poem. Repton borrowed the phrase 'cedar parlour' from Samuel Richardson's novel *Sir Charles Grandison* (1753)[5] The detailed discussion is typical of the 'how to do it' approach of numerous other authors during the century.

# 15

# 'CONCERNING INTERIORS'

## *Humphry Repton and John Claudius Loudon*

Source: Humphry Repton and John Claudius Loudon, "Concerning Interiors": *The Landscape Garden-*
*ing and Landscape Architecture of the late Humphrey Repton, being his entire works on these subjects,*
*with . . . introduction, . . . analysis, biographical notice, notes and index by J. C. Loudon* (London:
Printed for the Editor, (1840), pp. 455–61

## FRAGMENT XIII

### Concerning Interiors

Whatever the style of the exterior may be, the interior of a house should be adapted
to the uses of the inhabitants; and, whether the house be Grecian or Gothic, large
or small, it will require nearly the same rooms for the present habits of life, viz.
a dining-room, and two others, one of which may be called a drawing-room, and
the other the book room, if small; or the library, if large: to these is sometimes
added, a breakfast-room; but of late, especially since the central hall, or vestibule,
has been in some degree given up, these rooms have been opened into each other,
en suite, by large folding doors; and the effect of this enfilade, or vista, through
a modern house, is occasionally increased, by a conservatory at one end, and
repeated by a large mirror at the opposite end.*

*Where there are two or more rooms, with an anti-room, it is always better not
to let the dining-room open en suite. These rooms may be called libraries, saloons,
music-rooms, or breakfast-rooms: but, in fact, they form one large space, when
laid together, which is more properly denominated the living-room, since the use-
less drawing-room is no longer retained, except by those who venerate the cedar
parlour of former days.

The position of looking-glasses, with respect to the light and cheerfulness of
rooms, was not well understood in England during the last century, although, on
the Continent, the effect of large mirrors had long been studied in certain palaces:
great advantage was, in some cases, taken, by placing them obliquely, and in oth-
ers, by placing them opposite: thus new scenes and unexpected effects were often
introduced.

A circumstance occurring by accident has led me to avail myself, in many cases,
of a similar expedient. Having directed a conservatory to be built along a south
wall, in a house near Bristol, I was surprised to find that its whole length appeared

DOI: 10.4324/9781003290490-21

from the end of the passage, in a very different position to that I had proposed: but, on examination, I found that a large looking-glass, intended for the saloon (which was not quite finished to receive it), had been accidentally placed in the green-house, at an angle of forty-five degrees, shewing the conservatory in this manner: and I have since made occasional use of mirrors so placed, to introduce views of scenery which could not otherwise be visible from a particular point of view. But, of all the improvements in modern luxury, whether belonging to the architect's or landscape gardener's department, none is more delightful than the connexion of living-rooms with a green-house, or conservatory; although they should always be separated by a small lobby, to prevent the damp and smell of earth; and when a continued covered way extends from the house to objects at some distance, like that at Woburn,[6] it produces a degree of comfort, delight, and beauty, which, in every garden, ought, more or less, to be provided: since there are many days in the year when a walk, covered overhead, and open on the side to the shrubbery, may be considered as one of the greatest improvements in modern gardens.

It would be endless to describe the various methods of attaching such covered passages to a house: and, without a plan, as well as drawings, it would be impossible to render the subject intelligible.

To make a house in the country perfect, we must consider in what it principally differs from a house in London: and it is to the inconsistency, I might almost say the folly, and vanity, of transplanting city costumes and fashions into the retirement of rural life, that much bad taste may be ascribed. Some remarks on this subject may not be misplaced, where the comfort, convenience, and elegance of habitation, are to be considered.

First. In magnificent town-houses we expect a suite of rooms, opening by folding doors, for the reception of those large parties for assemblies, when the proprietors are driven out of house and home, to make room for more visitors than their rooms can contain. A provision in the country for such an overflow of society can seldom be required; and, except for an occasional ball, the relative dimensions of the rooms should bear some proportion to the size of the dining-room, and the number of spare bed-rooms. The most recent modern custom is, to use the library as the general living-room; and that sort of state-room, formerly called the best parlour, and, of late years, the drawing-room, is now generally found a melancholy apartment, when entirely shut up, and only opened to give the visitors a formal cold reception: but, if such a room opens into one adjoining, and the two are fitted up with the same carpet, curtains, &c., they then become, in some degree, one room; and the comfort of that which has books, or musical instruments, is extended in its space to that which has only sofas, chairs, and card-tables; and thus the living-room is increased in dimensions, when required, with a power of keeping a certain portion detached, and not always used for common purposes.

Secondly. In town-houses, the principal rooms for company are generally on the first floor, and, consequently, the staircase leading to them requires a correspondent degree of importance; but, in the country, it is generally more desirable to have the principal rooms on the ground floor, and, consequently, the staircase

leading only to the bed-rooms does not require to be displayed with the same degree of importance as that of a town-house.

Thirdly. We often hear objections to a cross light in room, from those who take up their opinion on hearsay, without thinking for themselves; or from having observed in town-house, at the corner of a street, the troublesome effect from noise, and from the through light rendering the room too public to the street, and to the opposite houses. This, however, in the country, is totally different, where an additional window gives new landscapes, and new aspects. If the room be lighted from the end by two windows, it will leave the opposite end of the room dark and dull; while a window, or glazed aperture, opening into a verandah, or green-house, will give cheerfulness, unattended by the objections mentioned in a town-house, and, consequently, due advantage should be taken of it.

Fourthly. The position of the windows and doors very much contributes to the comfort and cheerfulness of a room, and requires very different management in town and country.

A room, longer than it is wide, will be best lighted by three sashes in the long side opposite to the fire-place, because the light is more generally spread over the whole area, and a looking-glass over the chimney will increase the light, and double the landscape, in the country; but, in a town-house, where such rooms are more frequently used by candle-light the looking-glass may be placed betwixt the piers, as the light from the lustres and girandoles will be increased by mirrors so placed; and, if the windows be at the end of a long room, which is often necessary in town-houses, the light of candles will be more central, by being reflected from a mirror betwixt two such windows; but, in the country, the daylight is to be studied, and this will be found very defective in a long room, lighted by two windows at the farther end; because the central pier will extend its increasing shadow till it casts a gloom over the dark end of the room. In such cases, the cross light will be found a most enlivening remedy to the dullness of a room, or, I might rather say, to one so darkened by a central pier, which, if it contains a looking-glass, will increase the gloom, by reflecting the dark end of the room.

Fifthly. The favourite proportion for a room, is asserted to be, the breadth to the length, as two to three, or nearly in that proportion: hence, a room twenty feet wide, is to be thirty feet long; and twenty-four wide, to be thirty-six long; and so in proportion, till it reaches any width and length. But when the dimensions are contracted, we must recollect that a certain space betwixt the door and the fire-place ought to be preserved; and, therefore, I have found it expedient, in small houses, to give more space, by placing the chimney at a proper distance, and forming a new centre to the room . . .

Since the chief object of this collection of Fragments is to bring before the eye those changes, or improvements, which words alone will not sufficiently explain, two sketches [Figures 184 and 185] are introduced, to shew the contrast betwixt the ancient cedar parlour, and the modern living-room: but as no drawing can describe those comforts enjoyed in the latter, or the silent gloom of the former, perhaps the annexed lines may be allowed to come in aid of the attempt to delineate both.

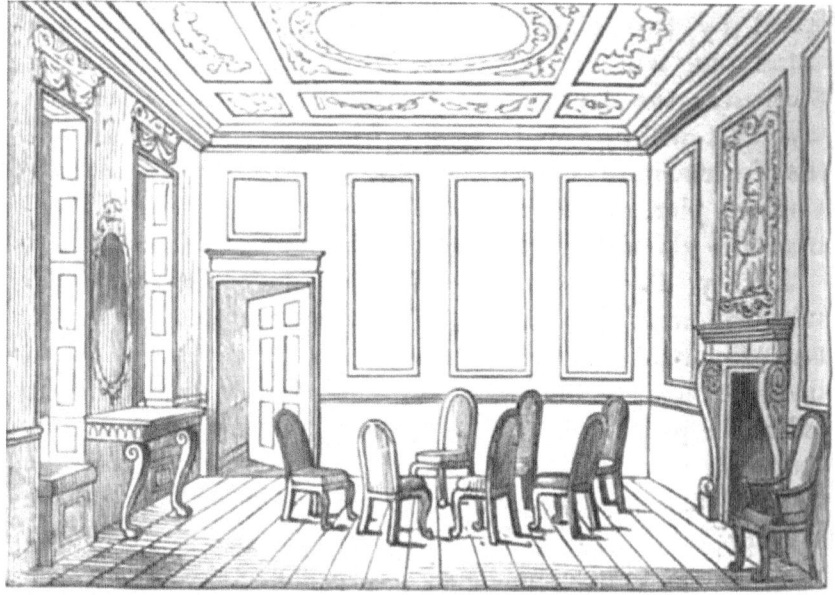

*Figure 15.1* View of the ancient cedar parlour.

## A Modern Living-Room

No more the Cedar Parlour's formal gloom
With dulness chills, 'tis now the Living-Room;
Where guests, to whim, or taste, or fancy true,
Scatter'd in groups, their different plans pursue.
Here politicians eagerly relate
The last day's news, or the last night's debate;
And there a lover's conquer'd by check-mate.
Here, books of poetry, and books of prints,
Furnish aspiring artists with new hints;
Flow'rs, landscapes, figures, cram'd in one portfolio,
There blend discordant tints, to form an olio.
While discords twanging from the half-tun'd harp,
Make dulness cheerful, changing flat to sharp.
Here, 'midst exotic plants, the curious maid,
Of Greek and Latin seems no more afraid;
There lounging beaux and belles enjoy their folly;
Nor less enjoying learned melancholy,
Silent 'midst crowds, the doctor here looks big,
Wrapp'd in his own importance, and his wig.

128

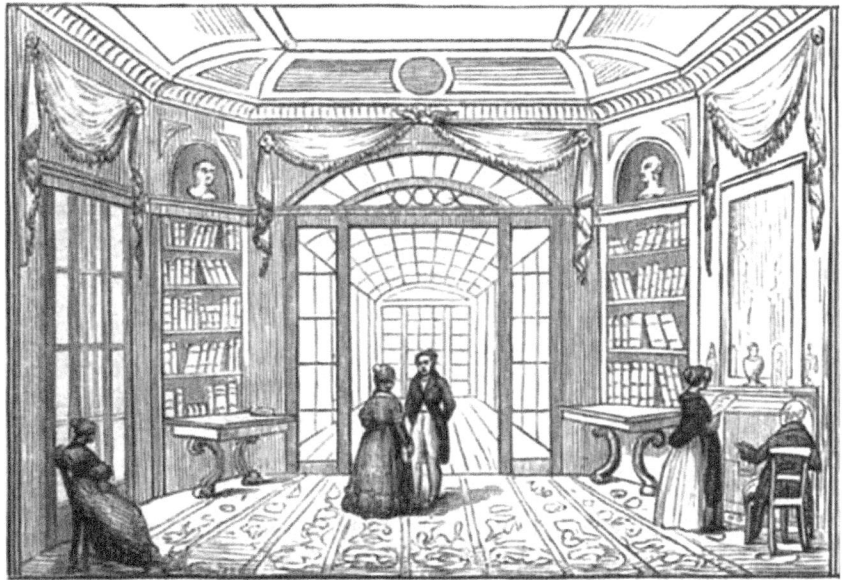

*Figure 15.2* Modern living room

## Notes

1 Loudon collected Repton's five major works on the subject: *Sketches and Hints on Landscape Gardening Observations on the Theory and Practice of Landscape Gardening, An Inquiry into the Changes of Taste in Landscape Gardening, Designs for the Pavilion at Brighton* and *Fragments on the Theory and Practice of Landscape Gardening.*
2 J. C. Loudon, *Encyclopaedia of Gardening,* (London: Longman, 1835), p. 326.
3 *Gentleman's Magazine,* November 1839, pp. 491.
4 *Civil Engineer and Architect's Journal,* February 1840, pp. 52–6.
5 Jon Mee, *Conversable Worlds: Literature, Contention and Community 1762–1830* (Oxford: Oxford University Press, 2011), pp. 228–31.
6 Woburn Abbey, Bedfordshire, home of the Dukes of Bedford. Repton produced a Red book for Woburn Abbey in 1805.

## Editorial Headnote

Edited by Henry Cole (1808–1882) and Richard Redgrave (1804–1888), *The Journal of Design and Manufactures* (1849–1852) was intended to develop and improve attitudes to British industrial design and to refine the public taste. The editors were well placed to publish such a work as they were important leaders in the British design reform movement. Redgrave was an artist, educator, and administrator. Cole was closely involved in arts education and administration; he was also engaged in the Great Exhibition of 1851 and was instrumental in the creation and operation of the South Kensington Museum, (later the Victoria and Albert Museum).

*The Journal of Design and Manufactures* aimed to improve the standards of British industrial design, concentrating on the decorative and applied arts. The editors explained in the Preface to their first volume that they were attempting to offer 'something like a systematic attempt to establish recognised principles'. This idea of sets of design principles that could be widely applied, permeated the design establishment for the next fifty years. More practically, the Journal's intention was explained; 'In respect of the doctrinal part of our journal we think the first step to improve design is to place within reach systematic intelligence of what is actually produced'.[1] In this approach they sensibly not only published illustrations of products but also tipped in physical samples of fabric and wallpaper.

The *Journal*, published in six volumes by Chapman and Hall, between 1849 and 1852, included original articles of design-related topics, book reviews, news items, as well as material samples of fabrics and wallpapers. Its market was quite clear as it was specifically 'addressed to Merchants, Manufacturers, Retail Dealers, Designers and Art Workmen'.

The editor's aim in producing the publication was expressed in his opening Address where they noted that the journal's intention was

> to present to the designer, treatises developing sound principles of ornamental art, and to keep him thoroughly informed of all that is likely to be useful and instructive to him in his profession. We attach the greatest importance to the art-instruction of all workmen engaged in producing ornamental manufactures.[2]

Despite this pronouncement, the text below seems to be written for the client/customer who needs direction in the planning of the room. This advice for decorating

the dining room would suggest that other rooms would be discussed in other editions, but this does not seem to have been the case.

The extract makes recommendations as to the choice of colour, material and patterns for particular rooms and also suggest where they may be obtained from. This promotion of businesses for the supply of recommended goods was to become a feature of many advice works through the century.

# 16

# 'THE DINING ROOM. NO. I' 'HINTS FOR THE DECORATION AND FURNISHING OF DWELLINGS'

## *[Anon]*

Source: [Anon] 'The Dining Room. No. I' 'Hints for the Decoration and Furnishing of Dwellings', *Journal of Design and Manufactures*, Vol 2, (1849–50) pp. 17–22

## INTRODUCTION

All the art of the present day is typical of the prevailing scepticism. There is no general agreement in principles of taste: what principles may happen to be recognised seem only transitional, transitional to what? no one can say. Everyone conceits himself to be a pope in taste and infallible in knowledge of art; he is his own absolute *arbiter elegantiarum*.[3]

Everyone elects his own style of art, and the choice rests usually on the shallowest individualism. Some few take refuge in a liking for pure Greek, and are rigidly "classical;" others find safety in the "antique;" others believe only in Pugin; others lean upon imitations of modern Germans; and some extol the *Renaissance*. We all agree only in being wretched imitators. In this *imbroglio* of faithlessness, it cannot be expected that either our buildings, our furniture, our dress, or, indeed, any of the articles of use which administer to our daily wants and comforts, can exhibit any marked, permanent, or individual characteristics. Such a fact is, perhaps, peculiar to our own time. It exhibits the very reverse of all antecedent times, even of those as late as Queen Anne. Applying these remarks especially to buildings we find them corroborated on all sides. The vast majority are altogether destitute of character, whilst the exceptions display every diversity of style. Mr. Barry constructs an Italian palace for my Lord Ellesmere.[4] In sight of it, in Piccadilly, Mr. Henry T. Hope erects a mansion at least in a somewhat new style – more French than English on whose merits there is infinite disagreement.[5] A few hundred yards to the north-west, in Park Lane, Mr. Charles Russell builds a bay-windowed "perpendicular" house, "bran new, but intensely old," where the details are borrowed from the age of the Tudors.[6] A row of average-sized middle-class houses is simply a wall pierced with holes. Enter the house, and each room is the counterpart of the other. There are no other features than four blank walls give, except in the kitchen, where stern

DOI: 10.4324/9781003290490-22

utility compels the place to have a characteristic look which marks at least its purpose. The colour of the marble for the chimneypiece, and perhaps the grate, are the only signs by which you know the "dining-room" from the "drawing-room" or the "library". As for interior architectural decoration there is little of it indeed, and all that is, is alike, and chiefly of a monotonous Greek type. An egg-and-tongue plaster moulding between the ceiling and walls, and a plaster rosette in the centre of the ceiling, supply generally all the architectural design which the present age demands. Certainly these bald materials have one advantage of leaving the decorator pretty free. He is not bound by any very stringent conditions. If the architecture furnishes him with no suggestions, it does not cramp his imagination. So far, this present state of things may be viewed as an improvement on the age not long passed, where more precise and extensive affectations of Greek architectural ornaments necessitated similar affectations in all the furniture of the room, even in cups and saucers. It is an improvement also on the succeeding age, when somehow it was managed that the furniture and decorations, for consistency's sake, should be of the Louis Quatorze style, which, indeed, has not entirely gone out, especially in the dwellings of the richer classes.

Another point not to be overlooked is, that a tenant now entering upon a house which is a complete blank cannot venture on decorations of a permanent sort, for everything is so essentially ephemeral. The very house itself is built for ninety-nine years only at the utmost the inhabitant has but a twenty-one years' interest in it; why should he put anything into the blank plaster walls to last beyond his tenure? His interest always warns him to do nothing which shall outlast his usufruct[7] of it. He is thus driven away from employing all the more costly and genuine materials and labour in decoration, and must content himself with the cheaper shams. Who thinks, for example, of having a hand-worked plaster ceiling now-a-days? We use rather cheap stereotyped plaster castings. As we must submit to these circumstances, we should at least make the best we can of them; and it will be the object of these papers, which it is intended shall apply chiefly to the dwellings of the middle classes, to point out in some detail how this may be done, and how we may at least try to give our rooms as much character as possible, and that of the most agreeable kind, founded upon principles as good as all present circumstances enable us to call into action.

We need not insist upon the desirableness that the respective rooms in a house should each have its distinctive character: custom has settled this point already. Everywhere some attempt is made to decorate the dining-room differently from the library, and the library from the drawing-room. To prevent misunderstanding we may observe that our remarks are addressed rather to the general public than to professional decorators. We address that large class who, in decorating and furnishing their houses, do so on their own judgment and at their own taste, such as it is, and not those whose means enable them to obtain the advice of Mr. Crace or Mr. Simpson,[8] or other eminent decorators.

The reader, therefore, is supposed to be a proprietor of the room of a new house having no features at all, and no other fixtures than the grate and mantelpiece. If

not too late, by all means let him stop the painting of the woodwork, even with the first coat or priming, and the colouring of the knots of the wood: instead of painting we would advise him to preserve the original characteristic graining of the wood by dyeing and varnishing it. Mr. Stephens, among others, has prepared various dyes.[9] In his prospectus he correctly observes "The natural grain of wood is imitated by art, but the most successful imitation has a sameness of appearance when compared with that continual variety which different woods present in their natural grain. The advantage of using the dye or stain to colour the wood is, that this natural and beautiful grain is not obscured, but reflected more beautifully under the rich tints which may be given to it by dyeing. The varnish, which should be used after the stain, is the chief means of preserving the wood even in artificial graining, and is of course equally efficacious after staining. Specimens of wood of a beautiful grain may be selected for choice rooms, and where it is desirable most to embellish. If this wood is well planed and prepared, and then dyed and sized, and afterwards varnished, it will be found to surpass paint in the agreeableness of its effect and the beauty of its appearance: while the economy attending the process, with the absence of everything disagreeable, will be sure to gain the approbation of those who use it. The quality of the varnish best suited to cover the stain is that which dries and becomes hard quickly, and is at the same time sufficiently transparent to allow the natural grain to be reflected through the most expensive varnishes are not necessary except for the most costly decorations."[10]

The process is decidedly cheaper and more durable than any painting, and in most cases may be rendered more ornamental. What the colour of the stain should be whether dark, or pale, or warm, or cool – will depend upon the general colouring of the room, which we will now proceed to discuss.

The general aspect of a dining-room should be cheerful, lively, rich, and substantial. It should be analogous with the use of the room, and in harmony with its conviviality. A library should suggest quiet and study, but a dining room somewhat spirit and activity.

The *selection* and *treatment of the colours* are next to be considered. Goethe observes, "Experience teaches us that particular colours excite particular states of feeling;" and a witty Frenchman said, "Que son ton de conversation avec madame étoit changé depuis qu'elle avoit changé en cramoisi le meuble de son cabinet qui etoit bleu."[11] Let our tints then depend altogether upon the ASPECT of the room. It would be an uncomfortable mistake to colour a southern dining-room as you would a northern one. The principal masses of colour which are on the walls should be *exactly the reverse*. A good crimson is quite suitable for the north, whilst a green is proper for the south; but a yellowish green – very *warm* would also suit a north aspect. Secondary colours, rather full in tone, are better than primary colours, because the latter may be used in masses in the paper-hanging. Secondary are more suitable, in our view, than neutral tints, which are too negative for a dining-room. We incline to use *full tones* as a general rule, notwithstanding they are thought to make rooms look smaller. We do not want any rooms to look small; but we want dining-rooms to look *comfortable* especially, and this

impression full-bodied tones are most calculated to give. The only safe general rule we can suggest is to regulate the choice of tone by the amount of the light in the room. If the room is dark do not use extremely full tones. We insert a specimen of a dining-room paper by Messrs. Turner, of Pimlico,[12] which, being of a colour and tone suitable for almost every aspect, is calculated for very general use.

If used in a south or south-west aspect, then the carpet should be generally green. If in an east, or north-east, or north, then red should predominate in the carpet. Where a crimson paper of a cheap sort is wanted, we can recommend that which we inserted (vol. i. p. 118) as suiting excellently for a small room.

There is another point to be considered before we leave the paper-hanging question, which is, is anything to be affixed to the paper, engravings or pictures, or brackets? Because to hang these effectively implies conditions which must not be overlooked or is the pattern itself on the paper to be the decoration of the wall? It frequently happens that this may be so good and so important that it would be injudicious to interfere with it. For instance, to hang a room with such a pattern as we have engraved (p. 20 see below), which requires 1844 square inches to shew it, and then cut it up by frames, would be altogether a mistake.

(Paper, manufactured by Turner and Son.*)

The gracefulness of the lines demands that they should not be made a second-ary feature. This same remark applies to the Gothic paper which Mr. Crace has made, after Mr. Pugin's design, for the committee-rooms of the new Houses of Parliament; and still more emphatically to the excellent papers which Messrs. Townsend exhibited at the Society of Arts.[13] If pictures are to be hung, or even prints, these become *the* features of the walls and the pattern on the paper hang-ings must be altogether subordinate to them. It ought to be a *small*, equally-spread pattern, which gives a general impression of equal surface. In this respect, too, we particularly commend the pattern now inserted, also the crimson paper already noticed; also the patterns of Hinchliff's filling (vol. i. p. 171); of Norwood's (vol. i. p. 144): and Redgrave's paper (vol. i. p. 50) furnishes another practical example of what is meant in regard to that equal distribution of pattern, which would not be damnified by being broken up by the hanging of prints and pictures.

In respect of *colour* suitable for prints, Turner's paper in the present number is excellent, and the effect of prints framed with a plain gilt bead would be very good upon it. So would be the tint of green of Clarke's paper (vol. i. p. 80), although the pattern itself, in this instance, is rather prominently ornamental. For this colour, or for crimson, oak frames would not be unsuitable; but in all cases we prefer a plain flat or raised gilt bead.

For the hanging of pictures we know no paper better than Mr. Redgrave's, especially when a little gilding is introduced either in the berries or in some of the leaves. We may also recommend a dark-green flock paper made by Clarke, of Holborn, for Mr. Gibbons' picture-rooms.[14] Crimson is always a safe colour for pictures; and in most cases *flock* adds to the richness of effect.

If it were better known how much agreeable character ever so little colour gives to a ceiling, and how cheaply this may be obtained, we should not so generally see the great majority of ceilings so bald. A simple polychrome ceiling may be put up for twenty shillings: go to Mr. Clarke's for printed ornaments, which are the cheapest, and to Mr. Simpson or Mr. Crace for more artistic hand-work.

The following is one of Mr. Simpson's patterns, executed in three or four shades, with the lines pronounced in some darker colour to match the general decorations. These few geometric lines, simple as they are, stamp a character at once on the room.

The treatment of the wood-work, and other matters connected with the dining-room, we reserve for future chapters.

## Notes

1 'Address', *Journal of Design and Manufactures*, 1, 1849, p. 3.
2 *Journal of Design and Manufactures*, I, 1849, p. 3.
3 a Latin term meaning 'judge of elegance', referring to artistic taste and etiquette. The term was used by Tacitus to describe Petronius, arbiter of taste at Nero's court.
4 Cleveland House in London was re-designed in the Italianate style by Sir Charles Barry. The rebuilding was completed and renamed in 1854 for Lord Ellesmere, heir of the 3rd Duke of Bridgewater.
5 Henry Thomas Hope's mansion, Hope House, was built on the corner of Down Street and Piccadilly in 1850 for £30,000.
6 Designed by W.B. Moffatt, See *The Illustrated London News*, 13 May 1848.
7 usufruct: The legal right of using and enjoying the fruits or profits of something belonging to another.
8 Crace refers to John Gregory Crace (1809–1889) who was an important English interior decorator and author. Part of the well-known Crace family that had been in the decorating business since 1768.
  Simpson refers to the business of W. B. Simpson & Sons, House Decorators, 456, West Strand, London W.C. In 1849 The Society of Arts presented Simpson with a gold medal in recognition of his efforts to promote the improvement of design, particularly in wallpapers.
9 Stephens's Process for Dyeing or Staining Wood, prepared and sold by Henry Stephens, 54, Stamford Street. Blackfriars road, London. Henry Stephens was the inventor of the eponymous ink. The company's wood stains for oak, mahogany and walnut wood stains were used on the doors and panels of the 1851 Exhibition buildings.
10 Part of this text is also found in adverts for Stephens's dyes: See e.g. *The Builder*, Vol. 4, 1846, p. 551.
11 Trans: "That his tone of conversation with Madame had changed since she had changed the piece of furniture in her study, which was blue, to crimson."
12 Turner of Pimlico: Wallpaper manufacturers; exhibitors in the 1851 Exhibition., See also J. T. S. Lidstone, *The Seventh Londoniad: (Complete In Itself.) Giving A Full Description Of The Principal Establishments* . . . (London: The Author, 1860)
13 Messrs. Townsend Parker were an upmarket wallpaper supplier, producing designs by Owen Jones amongst others.
14 T. Clarke, 60, High Holborn, London.

# M. B. H., *HOME TRUTHS FOR HOME PEACE, OR 'MUDDLE' DEFEATED* (1854)

## Editorial Headnote

*Home Truths* was first published in 1851 by the anonymous female author M. B. H.[1] This work has chapters divided into three sections, 'Part I. – Muddle detected', 'Interlude – Muddle of order' and 'Part II. – Muddle defeated'. The book provides guidance on how to operate an 'ordered and efficient home'. In the Advertisement to the second edition the author says she wishes to 'express my heartfelt wish that the present year, 1852, may witness the increasing beneficial influence of my own sex in its own proper sphere of action, suffering, honour, usefulness, and happiness – at Home'. This seems to reinforce the contemporary view of the role of women in the home. Extracts of this article were also published under the title 'A Picture of a Genteel Family' in C. Gough's *The Cruet Stand: Select Pieces of Prose and Poetry*, and also in *Eliza Cook's Journal*.[2]

The book was received well. A review of the first edition (1851) in *The Critic* praises its pragmatic advice:

> This is a neat little volume, the vocation of which is not to take an ambitious stand on the pinnacles of literature, but in a chatty and pleasant manner to give cautious advice and economic lessons to young housewives. Its motto might have been – and we recommend it to the authoress for her next edition, unless she is afraid that her fair readers will be frightened by Latin, *Celebrare domestica facta*.[3] But in truth we must not rank her too low, or at all suppose that household work is all that she is capable of, for she rises almost to a strain of true female eloquence in describing how "Muddle," which it is her mission to defeat in one sphere of human existence, viz., indoors, is in sad fact obtaining and prevailing everywhere . . . .

The reviewer agrees with the author's assessment of the muddled nature of all aspects of society but finished on a gentler note:

> Fair interrogator and orator, we give in; we do not attempt to argue the point with you for a moment; but with feelings of much, though perhaps selfish, gratitude for your suggestive chapter on 'Gentlemen's Rooms', we will with all our heart commend your nice little book to all ladies married or engaged, charging their several husbands or lovers to present it to them, either as a proper reward, or as a warning caution, with all convenient speed, as they value our approbation.[4]

In 1852 *The Observer* commented that

> We have rarely met a work better calculated to diffuse practical Chris-
> tianity amongst the middle-class social circles of this country; and we
> have no doubt, that the labours of this lady will give rise to a cheerful and
> healthy moral tone in many a home.[5]

The reviewer of the *New Quarterly Review* noted of the second edition (it went
into six editions by 1854) the author's apparent zeal for order and clarity.

> Undaunted by the merciless ridicule so unjustly levelled against the
> pious efforts of good Mrs. Partridge, our authoress comes boldly forward
> to try conclusions with 'Muddle', a monster more fatal, more dangerous,
> than even the encroachment of the swelling Atlantic. . . . She is no mere
> theorist, no vague dreamer of the state of things that exists, but in Utopia.
> No, 'Order is Heaven's first law', and she is its apostle, and preaches her
> crusade in the abodes, whether high or low, that most require the aid of
> her mission and the experience she brings to bear upon it.

They went on to say

> The book . . . might well be dedicated to 'Persons about to Marry'. If it
> have a fault, it may be that the fair writer's sparkling and epigrammatic
> style is slightly inconsistent with the plain truths she so ably inculcates;
> however, we will not quarrel with her for her *castigat ridendo mores*[6]
> system, it is worth a thousand homilies, and that it has proved effec-
> tive is amply demonstrated by the fact that her work has attained the
> well-earned honours of a second edition. We should wish particularly to
> recommend it to sundry individuals we have in our ken, and certain are
> we that each would exclaim, after their own fashion: *Major rerum mihi
> nascitur ordo!*[7]

M. B. H. also argues against the drawing room being 'shut up' and only used for
special occasions. However, the concept of a 'best parlour' was difficult to eradicate.

# 17

# *HOME TRUTHS FOR HOME PEACE*

## *M. B. H.*

Source: M. B. H., *Home Truths for Home Peace, or 'Muddle' Defeated, A Practical Inquiry Into What Chiefly Mars or Makes the Comfort of Domestic Life. Especially Addressed to Young Housewives by M. B. H.* (London: Longman Brown, 1854), pp. 61–7

## CHAPTER II

The next thing, after taking a house, is to appropriate and furnish its apartments; and here it will be chiefly necessary to consider

*The contents of your purse,*
*The probability of your remaining,*
*The size of your apartments,*
*The service you will be able to command,*
*The wear and tear to which your furniture may be exposed, and your own happiness and comfort, rather than any fancied obligation of copying the fashion of other persons, whose constitutions, views, and circumstances may be different from yours.*

As the particular application of these general considerations to the numerous classes and conditions to which young housekeepers respectively belong, would exceed the limits of a much larger volume, my remarks will chiefly be directed to the large proportion, who begin housekeeping with small incomes, and must consequently be contented with a small house, in which they hope to remain till they are rich enough to remove to something better, have one or two female servants, and a reasonable prospect of a young and increasing family.

These persons, many of whom are respectably connected, and often *expensively educated*, consider themselves, and are very anxious that others also should consider them, "especially *genteel;*" and they do so with some reason, for gentility has no more devoted worshippers than they are.

In no class, perhaps, has luxury made greater innovations than in this; in no class is the commencement of matrimonial life more showy and extravagant, or its end more miserable and dreary!

DOI: 10.4324/9781003290490-23

When, in acknowledgment of the ornamented cards and orange-flower favours[8] with which you have been distinguished, you pay your wedding visit, and await the entrance of the bride in her tiny, crowded drawing room, you can hardly recognize the locality of the friends you came to see, so completely is all around you a minia- ture imitation of a saloon in St. James'-square. The damask curtains are as rich, the carpet even yet more delicate, the grate and fire-irons will require as much work to keep them tolerably bright, as any you would meet with in a mansion at the west end; chairs and sofa are such as nothing but holiday apparel should approach, whilst any- thing like the touch of "little fingers" upon the gauds and knicknacks about, would be swift and sure destruction. Well, perhaps your friends will *not* have any children; this room at least, is not calculated for them but the master of the house, who has to work so hard for his 300l[£] or something less a year, when he comes in tired from business, he will certainly expect to sit down *somewhere*, and here, you would as soon think of introducing a bull into a china-shop, as of beholding a man, after a day in the city and a dusty walk home, stretching himself at ease in such a boudoir as this, or bringing in a friend to tea, in dirty or rainy weather! Your visit was intended to the lady of a banker's clerk, and all that meets your eye would be handsome enough for the richest banker's lady. This boudoir and its appointments belong to an income twenty times as large as any which their possessors ever dream of, and to a style of living with which their *every-day* existence forms a most striking contrast.

Accordingly, as soon as the wedding visits have been received in it, and its various treasures have been sufficiently displayed, admired, and envied, it will be closely bagged and druggeted, or, perhaps, shut up altogether, excepting on those particular occasions, when the temptation of incurring extra trouble and expense, in order to entertain other genteel people in the neighbourhood, may become too powerful to be resisted. Then, covers are once more taken off, and albums and elegancies taken out, the gilding shines beneath unusual light, the carpet glows unconscious of a drugget,[9] embroidered cats are let out of their bags, and India chessmen stand forth from their boxes; the costly china joins company with the well-whitened silver and full of admiration at her various possessions, and agita- tion as to what may happen to them, the hostess expects and welcomes her invited guests. These take their seats and colds in the seldom-inhabited boudoir, the ladies talk of crochet, the gentlemen of stocks; all pretty things are at a premium, all pretty faces at discount; a flushed maid servant hands coffee to the gentlemen and spills tea upon the ladies; the guests who would make room for her before them, do terrible mischief to what stands behind; everybody's chair is on everybody's dress, everybody sits in everybody's pocket; and, whatever liberty of speech and thought may exist in this select circle of free-born Britons, no one is corporeally free to move. The inviters and invited naturally become fidgety in proportion, and the hour of separation is hailed as a deliverance from heat, bondage, and inexpressible discomfort, not lightly to be incurred again; and, on the morrow, the miniature state drawing room is covered up once more, as useless and as close as ever.

Such is its destiny, in the house of the careful and the childless; but not in every instance is the original sanctuary of gentility allowed to preserve its beauty and

144

seclusion. The children who, at the period of its appropriation, were "neither born nor thought of," may come in spite of every non-preparation for their appearance; and then the idolized boudoir must either become a source of continual scolding or contention, or, if abandoned to the levelling practices of the young republicans, it will remain in faded dilapidation, a monument of parental childishness and childish retribution. And surely, if ever retaliation can be justified, the torn paper, broken ornaments, and soiled furniture of the state drawing-room by infant energies, may be excused. Not only has it deprived them, from their birth, of the comfort of a nursery; but before their persevering encroachments and depredations had produced the tranquillizing verdict that "there was nothing left to spoil," it was connected with the greater part of the privations or punishments they can remember. It was to prevent their being troublesome in the drawing-room, when used for company, that they were consigned to a hot kitchen and a cross maid; it was to gain time for cleaning its bright grate, that they were left dirty and unwashed; the touching of its many pretty things has brought down upon them their hardest slaps; the tripping over its half-fastened drugget has caused their severest falls, whilst the money wasted on its useless grandeur, and which might have been accumulating for their benefit, will be demanded in vain for the education which would be useful to them through life.

O ye dear young housekeepers, whatever you may contemplate in the way of magnificent gentility for the five-and-twentieth anniversary of your wedding-day, do not begin your career with those mere luxuries and ornaments, which are less likely to be used than abused in your establishment; above all, spare yourselves and those around you the unnecessary expense and trouble of a room chiefly to be shut up and cared for.

But whilst it is highly dis-advantageous to have a sealed or state apartment in a small but increasing family, nothing is more conducive to health, order, and convenience, than the regular occupation of two living rooms – one for meals and the more laborious employments of the day, the other for lighter duties, rest, and social intercourse, and especially for the amusements and enjoyments of the evening. Here, though no unsuitable extravagance puts every-day dress to shame, though chairs and sofa are evidently meant to sit upon, and tables, strong enough to lean against, are free for common purposes and common inmates: some of the luxuries or elegances of life, keepsakes or curiosities, pleasant to heart or sight, may find a fitting corner, or give a beauty and a language to the neatly-papered walls. Here, though children may walk about in peace, or drop a bit of cake without ruining the carpet, they may receive their first lessons in the salutary restraints imposed by civilised society, whilst *certain* pretty things are shown to their delighted *gaze*, on condition that they do not *touch*. Here, their own more costly toys may be trusted to their own more tender handling, and here they will regularly expect to receive some extra pleasure connected with their best behaviour, and their *cleanest*, if not always their best dresses. Here, also, the piano, which, never being exposed to the damp of an *unaired* atmosphere, stands *wonderfully* in tune, will invite Mamma to exercise her fingers that her darlings may dance

around her; and when, after their happiest hour, the little ones are safe and still in bed, and husband and wife are left together, – when the modest but ample curtains are snugly drawn, and the fire burns cheerily and bright, and present certain love and happiness contrast with former doubts and fears, here, whilst *habitual* order and refinement restore the exhausted spirits after daily toil and care, old tales will be related, old songs will be sung and, should any friend drop in to pass away an hour, or valued acquaintances accept a cordial invitation to form a larger party, the room, if rather crowded, will be full of happy people, fearless of injuring anything or anybody, and, when they *must* go home, it will be to add to their pleasantest remembrances "a most delightful evening."

Many other considerations combine to render such an arrangement "a great comfort," even to the servants, who often form the excuse for *not* adopting it. Opportunity for thorough ventilation and thorough cleaning, the laying of the morning fire overnight, which is so advisable in the short days of winter; all this is rendered easy by the occupation of a second sitting-room; whilst, in the families in which economy of service and of firing are most felt to be "a great object," very little is really gained by confinement to one room, and shutting up the other. Unless the moth and rust, which claim the *reversion* of all earthly hoards, are to be put into *immediate* possession, rooms that are not used must be aired and cleaned, not only occasionally, but frequently; why then should not the trouble and firing spent on them be made advantageous to the owners? If you *cannot* conscientiously afford yourselves a second sitting-room, well and good you may contrive to be happy without it; but, if you *can*, I fancy you will be healthier and happier with it. For my own part, I would always rather dine in a clean, tidy kitchen, and have a fresh airy sitting-room to retire to afterwards, than remain all day in the cabbage or stuffing-scented apartment, to which so many *genteel* persons condemn themselves and families, for the sake of their acquaintances and drawing-room.

## Notes

1 M. B. H. is so far unidentified.
2 C. Gough, *The Cruet Stand: Select Pieces of Prose and Poetry, with Anecdotes, Enigmas, Etc.* (London: J.S. Hiron, 1853), p. 219. *Eliza Cook's Journal*, Vol 7, (London: J. O. Clark, 1852), p. 207.
3 "Celebrare Domestica Facta": "Celebrate Domestic Affairs" from Horace's *Ars Poetica*.
4 *The Critic,* 1 October 1851, p. 463.
5 *The Observer,* 22 March 1852, p. 7.
6 "One corrects customs by laughing at them"
7 "A greater succession of events presents itself to my muse (Virgil)", *The New Quarterly Review and digest of current literature, British, American, French, and German*; London Vol. 1, 3, Jul 1852, pp. 307–308.
8 Wedding favours are small gifts given by the couple to their guests as a token of gratitude for attending.
9 By the mid-nineteenth century this was a coarsely woven fabric used as a protective cloth for tables, carpets and floors.

## JOSEPH BEAVINGTON ATKINSON, 'THE ARTS IN THE HOUSEHOLD; OR DECORATIVE ART APPLIED TO DOMESTIC USES' (1869)

### Editorial Headnote

Joseph Beavington Atkinson (1822–1886) was born in Manchester of Quaker stock and soon developed an interest in art. He travelled in Europe studying art and then went on to a writing career encompassing both journalism and scholarly book writing. The 1881 census records him residing at Stratford House, 113 Abingdon Road, Kensington, and he gave his occupation as 'Living on Private Family Property, but an Assistant Teacher of Science and Literature'. He was an author of several books on artists and painters and art critic for the *Saturday Review*. Some of the better known of his works included *An Art Tour in Northern Capitals* (Macmillan, 1873); *Studies Among the Painters* (S. P. C. K., 1874); *Schools of Modern Art in Germany* (Seeley, 1880); and Overbeck, in the *Great Artists* series (Sampson Low, 1882.) He contemplated, a book upon the subject 'The Place of Art in the Life of an English Gentleman', but he was unable to complete this work due to ill health.

This text is an extract from a longer piece which represents his journalistic skills in approaching a topic that was important to contemporary readers. This work was quoted by Robert Edis in his essay on 'Internal Decoration' in *Our Homes, and how to Make Them Healthy* (1883):

> To quote a common-sense and practical article from *Blackwood's Magazine* on 'The Arts in the Household', by Mr. Beavington Atkinson, a gentleman who has done much to foster and promote the more general use of artistic culture in everyday life: – 'In a house, as in a picture, above all things shun crowded medleys of mediocre or common forms as you would the unkempt rabble of democracy. Strive against scattered, small, trivial, and frivolous effects. Even a mantelpiece may, by its purposeless and silly baubles, bespeak a childish intellect; each portion of a house should, as far as may be, receive the study due to each component part in a deliberate pictorial composition'. In fine, the whole problem of (decoration and) furnishing may be summed up in the three words – form, colour, composition – terms known by every painter to comprise the whole world of art.[1]

It is evident from this quotation that Atkinson is at home with the art terminology of form, colour and composition and has taken this approach to interiors. Nicely linking the art world with homemaking in the passage below, Atkinson also makes distinctions between austerity based on medieval models and excessive decoration derived from Renaissance examples. Instead, he argues for a 'common sense' approach that is derived from a moral attitude based on integrity.

147

Although written in 1869, there are clear echoes of the arguments around the design of home furnishings arising from the Chamber of Horrors exhibition held in London in 1852.[2] Atkinson's example of the false principles in carpet design follows exactly the criticism of the exhibition organisers. Atkinson also invokes issues such as moral rectitude; regulated action; and 'gentlemanly conduct in life', that he suggested would eliminate vulgarity in one's surroundings.

Founded by a book publisher, William Blackwood, and published in Edinburgh between 1817 and 1980, *Blackwood's Magazine* outlived most other periodicals of its kind, and attracted important literary talents. It was established as a Tory rival to the Whiggish *Edinburgh Review*, and was essentially a literary review that published extracts of memoirs, verse, antiquarian texts, reviews, and essays on history and foreign affairs. Its popularity across Britain's colonies ensured it had a world-wide reach.

# 18

# 'THE ARTS IN THE HOUSEHOLD; OR, DECORATIVE ART APPLIED TO DOMESTIC USES'

## Joseph Beavington Atkinson

Source: Joseph Beavington Atkinson, 'The Arts in the Household; Or, Decorative Art Applied to Domestic Uses', *Blackwood's Edinburgh Magazine*, 105:641, (1869), pp. 361–6

In the present day there are few men and women who do not need and find occasion to exercise an educated taste. In a thousand ways is art brought to bear on the common concerns of daily life. There is scarcely a person, whatever be his station, who does not in some one of the many relations of society call the arts into exercise for useful or pleasure-giving ends. Most men at some period of their lives, either for themselves or on behalf of friend, meddle and possibly muddle in bricks and mortar. And when the house is built and roofed in, a committee of taste may fitly be held to discuss and decide upon internal decorations and details of furnishing. The amount of wealth thus lavished, and not unfrequently misapplied, on villas, mansions, and even ordinary dwellings, is almost beyond parallel in the history of the world. The commerce-created fortunes which the Medici in Italy devoted to the patronage of art were as nothing to the millions that in England, at the present moment, are expended, if not on art, at least on ostentation. Thus the unwonted demand for art of some sort good, bad, or indifferent – has made us think that this is not an inappropriate time to put forth one or more papers under the title, "The Arts in the Household;" or, in other words, "Decorative Art applied to Domestic Uses."

We hope to throw our unpretending teachings into forms not so much technical as plain and popular. It was, we think, Reid, the father of Scottish philosophy, who designated "the common sense of mankind," "the natural furniture of the understanding."[3] Certainly, if people would but furnish their dwellings as well as their understandings according to the dictates of this "common sense," much of the nonsense, extravagance, and bad taste which have found place within the English household, would be turned out of doors. It is, we fear, more usual for houses to be gay than sober, gaudy than truly beautiful. It seems to be thought that extravagance of decoration means of necessity handsomeness: that ponderous heaps of materials, however incoherent and ill-placed, imply magnificence;

DOI: 10.4324/9781003290490-24

that profusion of ornament and intoxication of colour symbolise a certain riot of imagination akin to genius; whereas such inordinate striving for effect best bespeaks a fancy falsely florid, an intellect out of balance, "and shows a most pitiful ambition in the fool that uses it." People would do well to consider that the gaudy inflations of the upholsterer, the pretentious devices of the cabinetmaker, have an aspect shoppy and snobby, and carry the indication of much money and little taste. Against these excesses, long the vice of what is known as handsome furnishing, common sense makes itself heard. If man in the adorning of his house would only be guided by the principles which go to make moral rectitude; if he would apply to inanimate form and colour the maxims which regulate action; if he could see in the furniture of a room something typical of gentlemanly conduct in life; if he could recognise in simple styles of decoration a correspondence with the unassuming bearing which is the sign of breeding and of birth: if by pervading harmony within his dwelling be could find response to the better instincts of human nature: even if, as we have said, he could bring to the ordering of his house a few grains of the common sense which serves him so well in the counting-house then, at all events, might we hope to see banished from the hall, the dining room, and the drawing-room those vulgarities, absurdities, monstrosities, which so often outrage well balanced judgment and sin against sober taste,

Few persons have the resolution to make their houses plain, if they possess the means of loading every wall, and crowding every floor with ponderous and pompous decoration. When purchasers abound in money, and manufacturers have no higher ends than trade, it is to be feared that the virtue of simplicity will in vain make her voice heard in our dwellings. Art in her early rise was almost of necessity simple mere lack of power and appliance, indeed, kept man, in the rude and elementary stages of society, within the bounds of sober moderation; but in our days, as in other periods of luxury and accumulated wealth, art becomes far too proud and grand to utter in plain speech true and simple thoughts. Chaste historic styles and temperate modes of decoration, which sufficed for guileless social conditions, are forsaken for the florid adornings of corrupt eras. There is in art, as in a more sacred walk, a strait and narrow way which it is hard to keep, and there is, too, a broad alluring road, easy and pleasant for the multitude to tread in. And, it would seem, judging by shop fronts and the interiors of our dwellings, that for one man or woman who values what is strictly correct, there are a thousand who delight in forms and colours floridly false.

Examples without end might easily be adduced of corrupt art, false display, and foolish squandering of money. Nothing, for instance, is more common than meaningless jumbles of all styles, confused conglomerations of irrelevant ideas: thus, a lotus flower from Egypt, a honeysuckle from Greece, an acanthus leaf from Rome, fleur-de-lis from France, and a daisy or butter-cup from England, may be found all growing within one and the same drawing-room! Yet even such anachronisms might be allowed to pass, if only in the end the art-result were tolerable. It is indeed but too evident that to the majority of householders any solecism in the treatment of historic styles is a matter of utter indifference when

ignorance of art-principles is absolute, inconsistencies escape notice by reason of blindness, Indeed, the major part of people who set about furnishing scarcely pretend to knowledge; all they know is what they like. "I know what I like" is a common phrase stock argument deemed final and unanswerable. And the kind of thing liked is of course something which may allure the uncultured eye, which generally craves for stimulus. For example, gold lavishly laid on in thick gilding is always liked; a room thus tricked out looks handsome, lights up well, glitters in the burning of wax tapers. And experience teaches "the trade" that a heavy bill is paid all the more willingly when there is plenty of gilding to prove how the money has gone.

We cannot close this opening section, in which we wish to show the prevalence of bad taste and the need of better knowledge, without quoting one or two amusing examples of the style of thing expressly designed to suit the market it is obvious that false constructions and the misuse of materials are fertile sources of error.

As constructive shams which have rightly provoked hostile criticism, take for instance sideboards formed on the models of Grecian stone altars, cabinets constructed in the fashion of Roman temples, wine coolers suggestive of sarcophagi, and jardinieres treated as ruined chateaux with dilapidated roofs, out of which actual flowers disport themselves. In the way of carpets and curtains, it may be admitted that of late a praiseworthy simplicity tends to become the order of the day. Yet too often common sense and right reason are sadly outraged. Carpets still there are exuberant as botanic gardens, marvellous for indwelling creatures as menageries; floor-garnishings, over which visitors are invited to walk regardless of the sky, the clouds, and the rivers beneath their feet, or of the lions and tigers which roar within the thicket! Fit resting-place for houris or winged peris escaped from paradise may be these carpets covered with palm trees and poplars, peacocks, picturesque vases, Italian terraces, with lakes beyond, but scarcely, safe footing for flesh-and-blood mortals encumbered with the belongings and appurtenances of ordinary humanity. There can be but little, doubt. that common sense suffers more pain than imagination can find pleasure in such absurd proceedings. We certainly should be prepared to hear any ridiculous nonsense concerning the family who could live with such a carpet daily beneath their feet.

These sins committed against good taste have their origin mainly in two causes, the one, the stupid routine, or, what is worse, the impudent presumption, of producers: the other, the ignorance of consumers. Both together in joint action bring about the woeful results we have attempted to depict. Schools of art have striven, though in vain, to meet the twofold evil; they have endeavoured to raise up a body of skilled artizans and intelligent manufacturers; and, at the same time, they have tried to imbue the middle and higher classes with principles of taste which might control the vagaries of fashion, elevate the public standard of excellence, and incite the producer, on the ground of even self-interest, to manufacture goods excellent in design, It is extraordinary, however, what persistency there is evil: the original depravity of human nature in matters of taste seems beyond the reach of redemption. Men, and, what is worse, even women, cling to the wrong and

eschew the right – they prefer falsehood to truth, and, ever in the service of fashion, follow the multitude to do evil.

History, we regret to say, is compelled to confess that the styles of domestic decoration which have proved most popular have but too frequently been the panders of vice; The lavish ornamentations which cover the walls of many palaces in Europe betray the profligacy of Courts, and reveal the unlawful indulgence of kings and courtesans. There are household arts which wear the colouring of the seraglio which are tainted with passion and self-indulgence; which are identified with the worst epochs in history with the ill deeds of Catherine de Medici, Diana of Poitiers, and Madame de Pompadour. After this same complexion, too, were the household arts, which in our own land, within living memory, obtained the favour of "the First Gentleman in Europe."[4] Happily the well-regulated Court of the last twenty years has wrought a change for the better not only in social habits, but in matters pertaining to taste. So true is it that the health or disease of the commonwealth becomes felt not only in great national monuments, but in the minor works which embellish even the humblest dwelling. And fortunately of late years there has been a reverting back to the earlier historic periods when simplicity of manners still kept the household in ways of truth and soberness. History, in fact, whether read in Rome, Venice, France, or England, teaches pretty much the same lesson. We find that the very earliest arts are usually rather too severe and crude for our modern uses; while, on. the contrary, the latest developments are apt to degenerate into that lawless luxuriance which beguiles into the adoption of forms that do outrage on decorum, and of colours that are vicious in violence. History, however, teaches no less clearly that there is yet a sound middle course between these two extremes – a line which lies at safe distance alike from the austerity of archaic times and the license of latest developments. Nevertheless the unfortunate propensity of fashion is to fly to extremes: thus, no sooner were our dwellings delivered from the libertinism of the Renaissance, than they became subjected to servitude to austerest medievalism. And so it has of late come to pass that good easy-going people, meaning no harm, were told that it was absolutely wrong to recline in luxury on florid French couches, and that as right-minded Christians it became their duty to rack their weary limbs on the rude angularities of Gothic stretches!

Producer and consumer, as we have said, are alike to blame; manufacturer and purchaser in turn play into each other's hands, or rather give mutual countenance in ill doing; there is, as it were, an evil conspiracy between them for defrauding art of her simplicity and truth. We are sorry to say that the Government Schools[5] have not only done little positive good, but some actual harm. With a latitudinarianism which tells little for the conscience and conviction of directors or teachers, art – good, bad, and indifferent – is with impartial hand sown broadcast over the country. And now, before concluding the present section, let us offer a few words of advice which the foregoing considerations may tend to fortify. We would say to the consumer, Bring not only your wealth but your intelligence to bear on the producer, In short, let the higher and educated classes do all that they can to redeem

the arts from the greed of the shop, and the ignorant caprice of fashion. And for this end, it were well that gentlemen and ladies should take a little pains to inform themselves on the broad principles of art. Let them, for example, in moments of leisure, look into some grammar of ornament, some one of the many works which illustrate historic schools and national styles of decoration. Let them try in presence of the best-known examples to realise the axiom before laid down, that early styles tend to crudity, late styles to corruption, while middle periods are mostly, for our modern purposes, safe, pure, pleasant. The whole subject of decorative art, so far as it bears on the ornamentation and furnishing of private dwellings, is, as we have said, easily mastered; the task lies within the compass of the average intellect. And when each lady and gentleman shall have put herself and himself to these small pains, the arts in our households will be likely to take a change for the better; the common show of the shop, the routine of trade, the ostentation of ignorance and of wealth, the senseless extravagance of the latest and loudest fashion, will give place to individual intention, cultured thought, and even the recondite taste of the student. Thus dwellings, which too often are but as magazines to contain goods made to order, may gather within their walls forms, colours, and compositions which shall declare the personal character and individuality of the inmates, and bespeak not only a taste nicely balanced, but a mind well informed.

## Notes

1 From Robert W. Edis "Internal Decoration" in Robert Brudenell Carter (ed.) *Our Homes, and how to Make Them Healthy,* (London: Cassell, 1883), p. 344.
2 See "Examples of False Principles in Decoration" in Clive Edwards (ed.) *Nineteenth Century Design,* Volume 3, (Abingdon: Routledge 2021), pp. 181–197.
3 Thomas Reid, *An Inquiry into the Human Mind, on the principles of common sense. By Thomas Reid, D.D. Professor of Philosophy in King's College, Aberdeen,* (Edinburgh 1764).
4 This refers to King George IV who was good-looking, elegant and well educated, so that his courtiers named him as the "First Gentleman in Europe."
5 The Government Schools of Design were founded in 1837 to improve the education of designers, which, it was assumed, would in turn improve the output of British industry. They were established in many industrial cities including Manchester, Nottingham, Dublin, Sheffield and Norwich.

# JOSEPH BEAVINGTON ATKINSON, 'INTERIOR DECORATION OF THE HOUSE' (1880)

## Editorial Headnote

Joseph Beavington Atkinson (1822–1886) was born in Manchester, Lancashire, the eldest son of a Quaker family. His father was a textile manufacturer. Atkinson lectured on art at Bristol, Gloucestershire, and eventually was elected as Honourable Secretary of the Bristol School of Art. He developed to become an important London-based art critic, contributing regularly to (among other periodicals) the *Saturday Review* from 1865. In 1881 he gave his occupation as 'Living on Private Family Property, but an Assistant Teacher of Science and Literature'.

Atkinson's early writing included an article for *The Art Journal Illustrated Catalogue of the International Exhibition* Paris 1862 titled 'Art in Its Influence on Art-Manufacture'. Here he explained the well-worn link between utility and beauty:

> Manufactures, whether the products of hand or of mechanism, arise from utility: the Fine Art, on the contrary, less directly utilitarian, are the offspring of beauty. Architecture in its two-fold aspect of structure and decoration, will best serve to illustrate the inherent relation between Art and Manufacture of which we here propose to speak.[1]

The Scottish publisher Alexander Strahan established *Good Words* as a monthly periodical in 1860. The publication was particularly aimed at evangelicals and dissenters, especially those in the lower middle classes. The journal included openly religious material, but also featured fiction and non-fiction articles on a wide range of subjects.

This article is the second in a series on the topic of 'Art in Daily Life'. The first was an introduction, the second (here) was interior decoration, the third furnishing, the fourth on beauty, and the fifth on dress. In the first essay of the series Atkinson explains his approach

> I propose in these papers to show in how many ways the arts serve for pleasure and profit, how they embellish the house and bring joy to the home, how they refine daily life and add grace and finish to individual character. The inquiry has naturally a twofold bearing: the one outward, the other inward; the one dealing with houses and tenements, with furniture, dress, decoration, pictures, and other visible and tangible objects of beauty. This is the concrete, the actual branch of the subject. While the converse side concerns conditions of mind, desires of imagination, taste, and the sense of the beautiful. This is the abstract, the mental, and what may be called the aesthetic phase. To picture one side exclusively would

be to present only one-half of the subject; while to combine the two into a whole brings into view the arts as they exist in the world bodily, and as they affect man mentally.[2]

This approach that links the concrete with the abstract was not a new development. John Ruskin had made similar commentaries as had George Wallis. John Bascom even discussed a 'science of taste'. He explained in his *Aesthetics or the Science of Beauty* that 'the following lectures were written with a desire to supply the want of an exclusive and compact treatise on the principles of taste. . . . To make good its claim to the rank of a distinct science'.[3]

This text was also published in *Appletons' Journal* for the American market.

# 19

# 'INTERIOR DECORATION OF THE HOUSE', 'THE INFLUENCE OF ART IN DAILY LIFE'

*Joseph Beavington Atkinson*

Source: Joseph Beavington Atkinson, 'Interior Decoration of the House', 'The Influence of Art in Daily Life', *Good Words*, 21, January 1880, pp. 418–22

Nothing can be more fatal than the notion that a man, in the decoration of his house, has only to know what he likes, and to do with his own as he chooses. Without some guiding principles the farther he goes the more wide will be his departure from true standards. In the present day the mere diversity of doctrines and multiplicity of appliances, each with some show of truth and beauty in its favour, become perplexing. The conflict between styles, the rivalry among fashions, old and new, the impatience as to methods handed down from time immemorial, the effort to throw off all bondage to traditional arrangements, and the not unlaudable desire to strike out something original and to assert private judgment within the dwelling, have in these latter times too often divided the house against itself and brought upon the domestic arts confusion, not to say anarchy. I shall be glad if the simple suggestions made in the sequel may serve to restore order.

The first thing in the art-treatment of the interior of a house to decide on is a well-considered scheme of decoration. And, of course, must be taken into account all the conditions such as the use, size, and number of the rooms the several requirements of hall, library, breakfast, dining, and drawing-rooms, of boudoirs and bedrooms; their aspects as regards the sun; the distribution of windows and doors, with the means of approach and intercommunication. Certain characteristics all rooms possess in common: they are interiors, and are bounded by walls, floors, and ceilings. These, then, are the surfaces calling for decoration. "The scheme" should primarily provide for "the general effect" whether grave or gay, quiescent, animated, or festive. It should also secure an agreeable sequence among the varied members of the house, so that one room may lead on pleasantly to its next-door neighbour, and the whole suite, whether large or small, combine in harmonious variety. This scheme of the whole and the altogether, which may be called the decorative idea or motive, is of vital import; if happily conceived, the interior is an assured success.

DOI: 10.4324/9781003290490-25

Next to be considered is the means that may best conduce to the required effect and herein it should be borne in mind that the decorator can employ but three agents or instruments of expression-form, colour, and material. The form is the design or pattern; the colour is the harmony of tone; the material, whether stone or wood, paint or paper, woollen, cotton, or silk, gives quality or texture of surface, involves cost or economy, and concerns utility, durability, richness, or plainness of decorative effect. Among these three means of ornament, material is of least moment; it is comparatively an accident, while higher and subtler elements subsist in form and colour-form – lying close upon thought, and colour being in correspondence with emotion. Thus, by the play and interchange of the one with the other over walls, floors, and ceilings, the interior of the house is made responsive to the mind's desires. In the use of these appliances the decorator's purpose, stated in the general, should be to exclude all that is ugly and to embrace every attainable beauty; the one removes all that is disagreeable, the other brings into the house the colours and the forms that give most pleasure. As to colour, let gravity be free from gloom, and let cheerfulness not degenerate into levity or garish gaiety. Domestic decorations should come as genial accompaniments to domestic affections they are scarcely required, like ecclesiastical decorations, to move to solemn emotion. They need not, as works of high art, convey definite ideas to the intellect they attain for the most part their end sufficiently well when, by pleasing impressions, they conduce to tranquil tones of feeling and states of mental felicity.

The principle can hardly be too often insisted upon that decoration is the obedient, though not the servile, handmaid to the master art of architecture, and therefore like that art must conform to symmetry, proportion, order. The geometric construction of an arch, whether round or pointed, the flat lintel of a door or the horizontal line of a cornice, will severally impose accordant compositions in ornament. The decoration must likewise in its scale be apportioned to the size of the rooms and to the wall-spaces to be filled: the ornament should be evenly balanced and disposed over the entire surface, conveying the impression of intention and method. The decoration of a dwelling is indeed little else than the application to flat surfaces of the laws of ornament. And the style of any ornament may be compared to, and has the significance of handwriting: ornament is handiwork, and like writing gives expression to thoughts and sentiments it takes from nature what is most lovely in form and colour, it responds to the craving in the human mind for beauty, it thus brings to our homes in a thousand ways pleasures for the eye and the fancy. Ornament is a language, and its varied styles are as divers tongues spoken from age to age by the great human families. And ornament is no less a history; its developments mark the transition from states of barbarism to civilisation it is an index to culture: and thus it becomes of all the more import what decorative modes, whether Greek, Romanesque, Byzantine, Gothic or Renaissance we admit within our dwellings. The fundamental rules which regulate all ornament, whether of walls, floors, or ceilings, of paper-hangings, carpets, curtains or furniture, have been epitomized by the Government Department of Science and Art in substance as follows:

The true office of ornament is the decoration of utility. Ornament should arise out of, and be subservient to, construction; it requires a specific adaptation to material, and therefore the decoration suited to one fabric needs re-adjustment to another. True ornament does not consist in the mere imitation of natural objects, but rather in the adaptation of the essential or generic beauties of form or colour found in nature to decorative uses, and such adaptation must be in conformity with the material, the laws of art, and the necessities of manufacture.[4]

The decoration of an ordinary dwelling is a comparatively simple affair, provided only a few elementary principles be borne in mind. Domestic decoration, unlike the monumental painting formerly in the service of the State or of princely families, is not usually prompted by patriotism, poetry, or other phases of lofty thought. The cases are rare in which an Englishman can follow the example of the Roman banker who called to his aid Raphael, Giulio Romano, and Giovanni da Udine to adorn the Palazzo Farnesina[5] with poetic scenes from the Greek Parnassus. Still, within recent years private houses have with happy results been intrusted to the decorative skill of many of our English artists, such as G. F. Watts, R.A., E. J. Poynter, R.A., E. Armitage, R.A., H. S. Marks, R.A., W. B. Richmond, Burne-Jones, Albert Moore, W. B. Scott, Walter Crane, and H. Holiday. These are among the best signs of our times, and there seems reason to hope that, emulating the example of the great art epochs, the decorative works of our painters may, like the poetry of our best authors, become as household words the near companions of our daily lives. And it may not be amiss just to mention that money can hardly be laid out more profitably. The wall decorations of Italy are simply priceless, and there can be no doubt that the contemporary works ventured upon in England are year by year gaining a value in excess of the first outlay.

The themes for such decorations cannot be better suggested than by our English poets and writers of romance. And I have long had a favourite idea that the poetic and graceful designs of Flaxman, such as he made for Wedgwood, might with suitable modification work effectively as friezes or panels for our rooms. The designs can be got for nothing, and the execution by hand or by a printing process need not cost much. It has also been with some a cherished idea that our English classics might be turned to good decorative account by furnishing quotations to be illumined on friezes or borders. One advantage accruing from such inscriptions is that decorations which give delight primarily to the senses might be made to appeal also to the understanding and to convey positive truths. Mere ornament may be compared to pantomime or dumb show, but such intermingling of choice quotations from our best authors might seem to break the silence by speech. It may be fitly left to individual taste to determine what literary extracts can best give verbal expression to the art motive; but perhaps a library or a studio might echo the latent thought within by some such extracts, treated decoratively, as the following:

159

"Reading maketh a full man, Conference a ready man, and Writing an exact man."[6]

"In Reading we hold converse with the wise; in the business of life gener-
ally with the foolish."[7]

"Calm let me live, and every care beguile,
Hold converse with the great of every time,
The learn'd of every class, the good of every clime."[8]

"Order is Heaven's first law, and the way to Order is by Rules that Art hath
found."[9]

"The course of Nature is the Art of God."[10]

Many are the methods and materials used in past and present days for the deco-
ration of dwellings. In by-gone ages rooms were not only painted and coloured,
but were hung with tapestries, damasks, silks, and embossed leathers, But now,
for many reasons, for economy, cleanliness, and convenience, most other modes
have given place to paper-hangings. And in point of taste there is no great loss,
inasmuch as some of our chief artists have designed patterns which fulfil the true
conditions of surface decoration. But the difficulty constantly arises as to a wise
choice among the perplexing multiplicity of styles and patterns. In former days
wall designs were made for some actual locality or room, and became part and
parcel of the freehold and inheritance; but paper-hangings, the reverse of mural
paintings, belong to no spot in particular, and are in their habits as itinerant as
easel-pictures. Yet the principles which underlie all wall decorations alike remain
for ever unchangeable, and therefore in the selection of a paper-hanging it is not
sufficient to look to the beauty of the design in the abstract, but to its suitability to
the uses, scale, and proportions of the actual apartment. Opinions differ as to the
rules which should guide the choice, and indeed considerable latitude is permis-
sible; the following laws, though not to be insisted upon too dogmatically, may
be of service:

Paper-hangings bear the same relation to the furniture in a room that a
background does to the objects in a picture. The decoration, therefore,
should not invite attention to itself, but be subdued in effect, without
strong contrasts either of form, colour, or light and dark. The decorative
details should be arranged on symmetric bases, and nothing should be
introduced to disturb the sense of flatness. Colour is not to be in posi-
tive masses, but should be broken over the whole surface, so as to give a
general negative hue and an impression of retiring quietude.

In direct dissonance with such placidities are the eminently pictorial paper-
hangings which come conspicuously from Paris. A peacock disporting the attrac-
tions of his tail on a terrace is just one of those mural placards which the French
love to put up in corridors. Neapolitan peasants dancing the tarantella in the

foreground, with the blue Bay of Naples and Vesuvius flaming in the distance, are likewise chosen to give to interiors a festive and out-door aspect. In Venice I have seen rooms painted freehand, with fancy figures in masks, or revealing gay costumes as they peep out from the ambush of columns. Perhaps it may not be easy quite to justify such vagaries even in decoration, which avowedly is a field for fancy and frolic. But at least these extravaganzas meet the popular taste, and when all is in keeping it were hard to prohibit what pleases. Indeed, almost everything may be permitted that is beautiful! in itself and is rightly placed. Yet war needs to be waged perpetually against the follies of fashion and the eccentricities and conceits which pass for strokes of genius.

What is chiefly to be desired is that each decorative system shall be clearly understood in its character and its conditions, and that then it shall be consistently carried out to its legitimate consequences. In the present day the public are divided into opposing parties. and the utmost diversity of opinion can indeed be tolerated, the golden rule in art ever being, liberty free from license. Some authorities, as just seen, lay down the law that wall decorations shall be retiring and comparatively insignificant, while others would make them conspicuous and self-asserting. Which of the two alternatives may be preferable will greatly depend upon whether the wall relies on its own surface decoration, or whether it will receive additional adorning from easel pictures, drawings, or engravings. The general substitution in modern times of movable pictures in frames for mural paintings attached to the structure, has brought about a radical revolution in the ornamentation of our rooms. Large, obtrusive paper patterns are of course destructive of the delicate tones of pictures. On the whole, small, quiet designs are obviously the safest. Colour is yet another perplexed problem. With some authorities colour has assumed the certitude of a creed, with others it is still subject to controversy. This complex question will in the sequel call for special consideration; in the meanwhile, let it be premised that here likewise stand face to face two opposing schools. The one favours strong positive pigments applied boldly, though of course in balance the other beats a timid retreat behind quiet, retiring tones. Each party claims specific successes the adventurous course has most to gain, the cautious line has least to lose. It need scarcely be added that the treatment of the furniture will have to be reversed with each revolution in the wall decoration. It may further be observed that paper-hangings or other mural adornings can either be in monochrome or polychrome if of one colour, then the pattern will have to be thrown up from the ground by either a lighter or a darker tone of that colour. Or if the decoration be of two or more colours, then a simple and favourite arrangement is to use some complementary hues, such as green for the ground, and red for the patterns, a harmonious contrast exemplified by nature in the red flower of the geranium rising out of a green mass of leaves. It is well that a room should be so decorated that the walls, when looked at near, offer forms of simple beauty pleasingly varied, and when viewed at a distance present as a whole, both in design and colour, a composition which falls into prevailing unity and repose.

Floor-coverings, whatever be their material, should be made to accord with the general rules already laid down for wall-clothings. Indeed the difference in position and use between a floor and a wall would seem to demand that these laws be here enforced with all the greater rigour. Floors are for walking on; therefore they should seldom be embellished with objects that it is outrageous to trample under foot. They moreover serve as the resting-place and support of furniture, and therefore whatever be the materials or fabrics employed, whether mosaics, tiles, marquetry, or carpets, the impression conveyed should be that of a stable and sustaining surface. A floor likewise being the lowest member in a room and the nearest to the ground, should not advance upon the eye, and even when serving as a foreground should appear in shade rather than in sunshine. These considerations incline to sombre colouring and to unostentatious designs. But here again there are no rules without occasional exceptions, and I am not one of those stern critics who would prohibit, for instance, such freedoms as the strewing of floors with flowers. Fra Angelico in his pictures scatters flowers on paths leading to Paradise, and if our homes can in anywise be made heaven-like art will in good degree fulfil its mission. But as to the placing or misplacing of flowers I remember that at the Imperial fête given by the Dusseldorf artists in Jacobi's Garden, now the Malkasten Club,[11] the Empress of Germany started from her seat, exclaiming, "I am trampling lovely flowers under my feet, remove the chair on one side." We may recall, however, on the other hand, how at a certain sacred triumph on the road leading from the Mount of Olives to Jerusalem "a very great multitude spread their garments in the way and others cut down branches from the trees and strewed them in the way." Enthusiasm and love which in religion inspire to acts of devotion, need not be denied humble service in arts of decoration. Yet in our times a cold and barren rationalism would restrain fancy in her innocent sport with things of beauty. But to return to plain matter of fact, it may be of use to sum up the general rules for floor coverings they are briefly these:

> The surface of a carpet serving as a ground to support all objects, should be quiet and negative, without strong contrast of either form or colour. The decorative designs must be flat, without shadow or relief; flowers and foliage from nature must be conventionalised to meet the exigencies of art, and the pattern should be distributed evenly over the whole floor. The entire composition must be brought into balance of lines and masses, and into harmony of colour.

Ceilings, which have been strangely neglected or defaced, claim more than a moment's consideration, did space permit. They have sometimes been surrendered to a negative, sanatory, and undecorative coating of whitewash, and then again they have been heavily weighted with constructional beams serving to give stability to ponderous ornament. As to whitewash, the remedy is easy and inexpensive. Let some colour be added to the wash which shall harmonize with the tone of the upper walls. One purpose in the preceding remarks has been to show that the disposition of light, shade, and colour within a house may be reduced to

certain elementary principles. And a rudimentary axiom is that dark should gravitate downwards, while light ascends upwards. Hence in part the reason why floors should be dusk and shadowy. And while the floor or ground represents the earth, the ceiling or vault leads up into air and space. Some persons, indeed, have pushed the comparison so far as to maintain that ceilings are best dealt with when, after the practice of the ancient Egyptians, they are coloured as the blue sky, spangled with golden stars. Others again have pushed the atmospheric idea to the extreme of covering the expanse of the ceiling with floating clouds; and a member of the Royal Society has not inappropriately employed a well-known artist to compose an astronomical ceiling, with the sun in the centre and the seasons and signs of the zodiac around. Other householders, inclining to botany and floriculture, train over their heads flowering creepers and climbing roses, making the ceiling a bowery canopy, attractive to butterflies and winged birds of bright plumage. At this point the transition becomes easy to Italian-like compositions wherein Cupids and genii float in mid heaven; but it is well to stop somewhere ere the sublime runs into the ridiculous. However, suffice it to say, that ceilings present spheres for diversions of fancy inviting to minds cherishing the laudable ambition of redeeming a dwelling from ordinary commonplace by some pretty spurts of poetry.

When the floor, walls, and ceiling are brought into harmony the decorations of a room are complete. Each part, I repeat, must be in studied relation of design and colour to the rest; the floor must sustain the walls, and they in turn must lead up to and support the ceiling. Yet while all are brought into unity, it is well when each is kept distinct. Accordingly fitting divisions and boundary lines are usually provided structurally in the skirting-board, the dado, the frieze, and cornice. These several members it is wise to pronounce more or less decisively, such points of demarcation in the decorative arts being comparable to punctuation in written compositions, serving, like commas, dashes, or full-stops, as pauses and spaces for rest. In the decoration of a room the crowning victory is in the successful coming of the whole together. And although simplicity is, for ease and economy, to be commended, yet, on the other hand, the greater the complexity and the difficulty challenged and overcome, the more signal will be the triumph gained, and the more subtle the pleasure imparted to the mind. Tyros in any art are timid; experts daring. Elementary forms and negative colours may be safe but designs highly developed and colours lustrous as light will, in a master hand, secure decorative evolutions and effects comparable to the harmonies evoked by a full orchestra.

One or two general considerations may be added. It is not unworthy of remark that the house of the north necessarily differs from the house of the south. In the south protection is sought from heat, from the tyranny of the sun and the blaze of day, accordingly the classic house and the Italian villa provided open courts, cool corridors, and balconies of free outlook, while the walls and floors were clothed with plaster, marbles, or mosaics. But in the north the conditions are reversed; comfort and coziness are desired, and thus the northern house secures closed rooms safe from the assaults of the elements, and provides snug curtains, warm carpets, and tight casements. In northern cities, too, a crying need is for more light

within the dwelling. "The dark ages" were dark in more senses than one, and dirty into the bargain, and when modernism swept away the cobwebs of medievalism, light entered as the herald of truth. Architecture. in its onward and upward growth, has been seeking to secure more light. Early structures are shadowy and cavernous; but at length buildings learnt to spring from the earth into the heavens, and courted companionship with the day. And light seeks association with the bright sisterhood of colour, and all in concert strive to compensate for the darkness and dullness of our northern clime, in the absence or shyness of the sun.

A like current of thought is suggested by the contrasted conditions of a town house and a country house. In England a country seat may be fitly designed for the summer and the sun. It is often in close proximity to nature: the windows possibly command a pleasing landscape; the daily life comes in hourly contact with gardens, trees, meadows; and in proportion as it thus shares in the simplicity of nature can the helps and allurements of art be dispensed with. But the town house is surrounded by opposite conditions. To shut out the external world, the noise of the street, and the gaze of the neighbour, is an end to be gained. And to make the home-life within all the more self-sustaining and satisfying, the mind seeks as a substitute for converse with nature, the companionship of literature and art. The complexities of modern society oust the artlessness of more primitive life, and the converse of cultured intellects, the contact of minds highly wrought, the companionship of books and music, demand that the dwelling shall be decorated to like concert pitch. In fine, in towns and northern latitudes, where the sky is overcast and the life of man sad, it peculiarly behoves us to make our homes lightsome and cheerful, so that in dark days witness shall not be wanting to the promise that, though "weeping may endure for a night, joy cometh in the morning."

## Notes

1 *The Art Journal Illustrated Catalogue of the International Exhibition* Paris, 1862, p. 298.
2 Introduction "The Influence of Art in Daily Life", *Good Words*, 1880, p. 356.
3 J. Bascom, *Aesthetics or the Science of Beauty* (Boston: Crosby and Nichols, 1862), Preface.
4 Adapted from the General Principles of Decorative Art, *Report of the Department of Science and Art of the Committee Department of Science and Art*, 1854 Appendix A, p. 22.
5 Villa Farnesina Rome, is an important mansion built between 1505 and 1511 that shows the epitome of the luxury and opulence in Italian society during the Renaissance.
6 Sir Francis Bacon in his essay "Of Studies" 1597.
7 Ibid,
8 Rev. Samuel Bishop, 'The Library".
9 Adapted from Alexander Pope.
10 Edward Young 'The Consolation".
11 The Malkasten (artist association) was founded in Düsseldorf in 1848 as a social association of artists. It opened itself up the public, and festivities quickly advanced so that the space became a social hub of the city, especially in the times of the Düsseldorfer Karneval.

# J. MOYR SMITH, *ORNAMENTAL INTERIORS ANCIENT AND MODERN* (1887)

## Editorial Headnote

John Moyr Smith, (1839–1912), a Scottish architect and designer, who studied at Glasgow School of Art, became a member of the circle around the architect Alexander 'Greek' Thomson. At the same time, Thomson's coterie, included William Leiper, Bruce Talbert, and Daniel Cottier. In 1866 he moved to London to be assistant to George Gilbert Scott. By about 1867 he was on 'temporary service' for Christopher Dresser and was also supplying designs for the Arthur Silver design studio. From around 1870 he developed an extensive commercial practice in the decorative arts. Major clients included the cabinetmakers Collinson & Lock and Cox & Son, the piano-maker Broadwood & Son and the tile and ceramic manufacturers Minton & Co (later Minton Hollins & Co), W B Simpson & Sons, and Maw & Co. He also published four books: *Studies for Pictures: A Medley*, 1868; *Album of Decorative Figures* (1882); *Ancient Greek Female Costume* (1882) and *Ornamental Interiors, Ancient and Modern* (1888). He also illustrated a great many others.

*Ornamental Interiors, Ancient and Modern* was an important book that stressed the role and nature of decorative ornament in interiors. Smith discusses the history of ornament from ancient Assyria to the 1880s, but the work also has chapters on decorative arts practices as well as examples of modern work.

The book's reviews were mixed. The *British Architect*, noted that the book opened up the discussion around the role of the architect in interior design and decoration

> Mr. Moyr Smith, in his new work on 'Ornamental Interiors', treats architect decorators and lady decorators very much as two little side groups of workers who have no very great part to play in the practice of interior decoration. . . . In order to be fully competent, the architect must see to it that he endeavours to place himself on a level with the ability of those who usurp his functions. We all of us know that architects' furniture is apt to err on 'the side of heaviness', as Mr. Moyr Smith tells us, but we also know that furnishers' furniture is apt to err on the side of over-refinement, and lack of breadth and scale appropriate to the building. Mr. Smith has a good deal to say in his new book of grave rebuke to architects, but he admits that 'much of the best work produced by the artistic manufactures of the present day is done from designs by gentlemen who have served an apprenticeship to architecture'. The great claim for architects doing the decoration of their own buildings is, as Mr. Smith very exactly puts it, that 'if he has a thorough knowledge of his profession, an architect is likely to make the interior decorations in harmony as to scale with his building'.[1]

On the other hand, the *Saturday Review* were not at all impressed.

> The author of this book has attempted too many things. It is hard task to combine in a little more than two hundred pages, copiously illustrated, a history, geographical, geological, and astronomical, of periodic deluges recurring at intervals of 10,500 years; an account of Assyrian, Egyptian, Greek, Roman, Byzantine, Gothic, Renaissance, and modern decorative art; and last, but not least, a series of advertisements of the author's own skill as a decorative artist. Wholesale abuse of Mr. Ruskin, of architects in general, and fulsome praise of Mr. Ferguson,[2] are thrown in at intervals to enliven the duller parts. Students of architectural styles will be pained and grieved to hear that their labour has been lost, and will continue to be lost, unless they can form an intelligent theory of deluges. The question whether this theory is in accordance with natural laws as at present ascertained is of no importance. . . . With a system based on such an 'intelligent theory of deluges',[3] it is only natural to suppose that Mr. J. Moyr Smith does not deal very lucidly with the subject on which his investigations are supposed to throw direct illumination. The whole book is written from the commercial point of view. The historical portions are, when accurate, mere bits of information extracted from well-known text-books or dictionaries. . . . Of general decorative knowledge the author seems to possess but little, a fact which is brought into stronger light by the sweeping criticisms indulged in of other men's work. . . . But it sometimes happens that bad critics are good artists. We wish we could say so in the present instance. Indeed, it would be difficult to say much in praise of the selections from his own work which Mr. Smith has presented to the public in the illustrations to this book. If he had spent the time he has devoted to the abuse of architects in learning something more of architecture, he might have succeeded better; at any rate he would have avoided certain obvious faults. As it is he seems to be satisfied with effects produced by jumbling together incongruous forms, so that his work possesses neither unity, delicacy, nor repose.[4]

Rather confirming the substance of the above critic's analysis, the text below is a harsh and opinionated critique of lady decorators including Mrs Haweis, architects, especially R.W. Edis, as well as critics such as John Ruskin.

# 20

# ORNAMENTAL INTERIORS ANCIENT AND MODERN

## J. Moyr Smith

Source: J. Moyr Smith, *Ornamental Interiors Ancient & Modern*
(London: Crosby Lockwood and Co. 1887), Chapter 10, pp. 76–87

About thirty years ago the chief rooms in many good houses were furnished with a wooden dado rail, which if it had no other use, served to keep chair-backs from injuring the walls. But a change was impending. The first thing a high-class decorator did when he got into a room of that kind was to wrench off the dado rail and cover the walls from skirting to cornice with a French paper of light and cheerful aspect. For dining-rooms the colours might be rich and dark, but for drawing-rooms both decorators and the ladies agreed that there was nothing so refined as enamel white and gold. In those days acknowledgment of the intuitive superiority and delicacy of feminine taste was looked for as a matter of course from all the novelists, and lovely woman reigned supreme in the choice of colours for house decoration.

But this intuitive delicate feminine taste has been dealt with rather harshly of late years. Some cynical being of the masculine sex discovered, and worse, made public his discovery, that woman is a mere imitator and does not possess any original taste at all. She could, it was said, imitate a fashionable taste in millinery, dress, furniture, music, and cookery, but as a rule she originated nothing. The ladies' dresses that lead the fashion, the furniture and decoration of the rooms she lives in, the music she plays, and the mode of cooking the food she eats had, it was said, all been originated by that tasteless creature, man.

The cynic, moreover, said that although many women have devoted a great deal of time to playing music and to cooking, there has not yet appeared a great composer or a great cook of the feminine sex. It was conceded, however, that her gifts in the way of placing anti-macassars where they would make the clumsy male being most uncomfortable, almost amounted to genius. It was likewise granted that she could choose vases of the slightest known degree of stability as ornaments for mantelpiece, and that she could crowd incongruous though perhaps expensive trifles on unstable furniture so cunningly that ordinary persons of the clumsy masculine order, when in her drawing-room, were impressed with the

DOI: 10.4324/9781003290490-26

feeling of her too exquisite refinement, and at the same time taught the much-needed lesson of self-repression.

For the decoration of the drawing-room walls she at that time firmly believed there was nothing so chaste or so elegant as white and gold. Perhaps she was right in her belief; but unfortunately, it was also the belief of every other lady who had the slightest pretensions to fashionable taste. The effect, therefore, produced by the combined fashionable feminine taste of the civilised world was rather monotonous.

The doors were white, or grained to represent satinwood or some other precious timber; the carpet was light in the ground and spangled with roses or garlands of other gay flowers.

But since that time there have been great changes; noble, high-souled men have come forward boldly and shown the awful iniquity of graining doors in imitation of oak, satinwood, or maple; they have denounced the sin and imposture deliberately perpetrated by demons in the guise of wall-paper manufacturers and carpet makers, who put attractive imitations of real flowers on walls and floors where no real flowers were likely to be.

We, however, have not yet reached that transcendently high standpoint which would enable us to denounce imitations of real flowers as soul-destroying shams, or graining of doors as glaring immorality. For while thinking there are better and truer modes of decoration, we do not think it worthwhile to waste good indignation on such harmless fashions.

If we ask the noble denouncers of graining why it is so very wicked to grain a door in imitation of oak, they will probably reply that it is intended to deceive, and all deception is wrong.

But, say we, you yourselves use flowers as decorations for walls.

"Yes, but *our* flowers are conventional renderings, and are not intended to deceive."

Well, we reply, the ordinary builder and decorator's oak graining is quite as conventional as your flowers, and even a blind man would not mistake it for real oak.

But is not all art founded on imitation? We have sham effigies giving the forms of men and women that is sculpture; we have flat surfaces which pretend to give the roundness and colour of human figures that is painting.

Art is conventional imitation and what is decoration of the pure, good, exalted sort favoured by the denouncers of sham graining but a conglomeration of shams? They would cover the walls with paper-hangings – that is, sham hangings – on which there would be sham leaves and flowers; they would gild mouldings which the wicked builder has thoughtlessly made of wood instead of solid gold; they would use veneer of wood or marble; they would probably stain floors dark in some places, so that though plain deal they would look like walnut or ebony.

It seems to us only a question of degree, and in spite of the elaborate distinctions and explanations as to the rights and wrongs of imitation given by denouncers of graining, who have followed each other with sheep-like regularity during

the last twenty years, we persist in believing that graining is only terribly wicked because it is at present so very unfashionable.

Many amateurs, especially ladies, feeling a call to convert the nations to the practice of high-toned decoration, expounded their true principles of Art at Home with as much innocent confidence as if the subject had been the trimming of a dress. Of course, their delicate feminine instinct led them to advocate the style of decoration with which they had most acquaintance, and everyone aspiring to a name for taste had her mantelpiece befrilled, draped, and furnished with a convenient apron or curtain to hide the emptiness of the fire-place. Japanese fans were spluttered over the walls, sometimes on the ceilings as well, and the soul was cheered everywhere with the delectable sight of plates and other articles of crockery adorning the chief points of the apartment.

Mrs. Haweis, who is the author of a book called the "Art of Decoration," however, is entitled to a higher place than that usually accorded to the amateur author who attacks a subject that requires technical as well as practical knowledge. Her information seems to be very extensive, and her conclusions, which are shrewd, are given in her book in a very lively and entertaining manner. She shows up in her book the absurdities of some of the lady decorators in the following fashion: "One of my strongest convictions, and one of the first canons of good taste in house decoration, is that our houses, like the fish's shell or the bird's nest, ought to represent our individual tastes and habits, never the habits of a class. There is nothing so foolish, nothing so destructive to the germination of real taste and art feeling in England, as the sheep-like English inclination to run in a flock. No thoroughly bad fashion would ever take a firm hold on society were it not for the indolence of those who can, but will not, think for themselves, and the timidity of those who dread what is new, For instance, one hears ladies laying down the law in this style: You must have old point on your mantel-shelf; it is indispensable; everyone has it!? Yet good sense tells us that a delicate fabric designed to adorn a lady's dress is as unsuited to the rough and dusty service of furniture close to the fire as a pearl necklace or ostrich plumes. Why, therefore, 'must' we adopt a freak of luxury, founded neither on good sense nor good taste? Again we hear, 'Fire ornaments are quite gone out; you must stick a Japanese parasol in the stove, or fill it with tinsel and waterlilies.' It matters not how outrageous the notion – primroses planted in the fender, a rockery of ferns, a scent fountain playing up the chimney, or a white satin bow from the register – the argument is always the same: "I am telling everybody of it, and they are all doing it!"

Besides the amateurs, however, some architects have endeavoured of late years to show that they were masters of the art of decoration. If he has a thorough knowledge of his profession, an architect is likely to make the interior decorations in harmony, as to scale at least, with his building; but it is perhaps too much to demand that a modern architect should mix all the tints and draw all the details of ornamentation with his own hand, although the best ancient work was probably done under such conditions.

The modern architect has, moreover, sometimes to be brother to the keenest of hucksters, so as to be more than a match for the wiliest of builders on the one side, while on the other he claims to rub shoulders with the immortals who designed the Parthenon and gave Europe its grand cathedrals. Everything, from the construction of a kitchen sink to the building and decorating of a St. Peter's, is supposed to be well within the powers of that combination of modern practical science and of genius made to order-the modern architect.

Plumbing and decorating are in this country of anomalies often coupled together; yet we might be disappointed if we expected the highest type of sanitary plumbing, and the most beautiful and refined series of decorations possible, from the same hand.

Moreover, the modern architect, unless of a very high standing indeed, has to dance from style to style according to the mood, knowledge, or ignorance of those he calls his clients, but who are in reality his patrons. This in itself is rather against his acquiring a thorough knowledge of all the details of any style. The architect who is established as a leader of design may direct his attention to one style, and reach in it something like perfection; but the second or third-rate architect has no such chance. Without fixed ideas himself, he is the enthusiastic adopter of the opinions and designs of those he considers leaders in the profession. At one time a fierce supporter of foreign Gothic of severely early type, at another he gives up his soul to the soft allurements of the gentle Adam or the queer Queen Anne, so that it requires great versatility to be abreast of the fashion in architecture; for no sooner has our second-rate man mastered the principles of a style, or, what to him is the same thing, is able to copy it without knowing its principles, than one of the architectural leaders, Mr. Norman Shaw for instance, discovers that some neglected relic of early Georgian art is a valuable example of what is excellent and appropriate in domestic architecture. The unoriginal architect has to throw up the style he has just learned, and begin to study with avidity the style he formerly despised.

When fashion decrees that a woman shall wear a dress that violates the usual canons of good form, she does not defend the principle, or want of principle, she simply says she wears it because it is the fashion.

Architects, on the other hand, while showing all a woman's eagerness to adopt a new fashion, always manage to convince themselves that the mode they adopt is the best possible and of irreproachable principles, else they would never give it their sanction.

At one time they revel in plaster enrichments, at another you find them cutting away the plaster to make room for painted ornament. Then, all their souls were bent on carved panels in furniture, and now, we find one of their number calmly writing a paragraph like this: "One good painted panel is worth ten thousand times more than all the meretricious carving with which so much of our modern furniture is filled."

As a matter of fact, painted panels are much too abundant in modern furniture, and it is they and not the carved work that are frequently meretricious; for carving,

whatever its faults may be, is usually in harmony, in colour at least, with the furniture it decorates, while much of the painted work used to enrich modern furniture forms a violent contrast to the main body of the fabric.

It is an architect of the present day who is responsible for some inartistic and decidedly ugly concave and broken pediments, spindly furniture, and clumsy, disjointed mantelpieces, and who, in a book of which he is the author, exhibits them as examples for imitation. It is he, leaning his back against his noble profession, who laments that the designing of furniture is handed over to people he calls "upholsterers," who fill the house "with articles incongruous in design, bad in taste, and often utterly commonplace and uncomfortable." If there is an upholsterer who can produce more uncomfortable and commonplace designs than those which bear this fashionable architect's name as the designer, in his book, he must be in truth be a very extraordinary upholsterer; and it is a curious commentary on his statement to find that the best, indeed, the only tolerable things in the work by our really talented, but in this instance much mistaken, author, are those which are produced under the auspices of art manufacturers such as Wilcock & Co., Gillow & Co., Holland & Son, and Jeffrey & Co., and are not seemingly due to the omniscient modern architect.[5]

In truth, however, much of the best work produced by the artistic manufacturers of the present day is done from designs by gentlemen who have served an apprenticeship to architecture, and have added to this the study of decoration and furniture.

In their designs architects are often inclined to err on the side of heaviness, till they have had repeated opportunities of seeing their executed work. This is natural enough, for the hand that is used to designing for large masses of stone does not at first grasp the peculiar requirements of interior wood-work.

The worst designs of the so-called Queen Anne style have been produced by architects who have not had a training in classical architecture; without this advantage, however clever and versatile he may be, the architect is very apt to err in his selection of features belonging to such bastard styles as the Adam, Queen Anne, Georgian, or Louis Seize. The cause is obvious; the styles mentioned are founded on classic work, but they possess a fanciful playing with the lines not usual in classic. Yet, however much they may vary from their parent stem, good work in these styles is always more or less true to classic principles. If an architect clever in Gothic, perhaps, but ignorant of classic, meddles with late seventeenth and early eighteenth decoration and furniture, he is just as likely to take a bad as a good specimen for imitation.

If an architect, in addition to selecting bad forms for his own work, commends in a book intended for popular instruction these bad forms as examples of what modern art ought to be, we fancy it is right politely to point out his error.

Compared with the artistic interiors in Talbert's book,[6] the examples furnished by the architectural decorator already referred to[7] are rather commonplace, and lack in many instances a just sense of proportion. For example, his frontispiece shows us part of a dining-room in which the frieze occupies about one third of

the whole height between the floor and the underside of the cornice. This is an unusual proportion for a frieze, but being unusual does not make it wrong; but what does make it exceedingly unsuitable is that its details are on too large a scale. The figure is too big and is not elegant in form; the rustic porch, wall, and garden-seat delineated on the frieze are all of gigantic proportions compared with the slightly framed furniture and small scaled pictures of the room itself. The frieze crushes the wall space, and each makes the other ridiculous, simply because they are not suited to each other.

Now this same proportion of frieze space would have been quite appropriate if the artist had kept in his work to the scale of the other furniture and decorations of the room. The figures should have been smaller and there might have been more of them, and the various accessories should have been smaller rather than larger than their natural size.

This scale, which is too often misunderstood, is of the first importance in interior decoration. Next to it comes harmony and contrast of colour.

Nothing so readily destroys the effect of size and aerial space as having gigantic figures or ornament in one place and small figures in another, or small ornaments here and large ornaments there.

The tyro, acting under the impression that things that are distant from the eye should be enlarged so as to tell more vividly, does the thing which most surely destroys the spacious effect of an interior; for the eye, trained to the appreciation of perspective, concludes that the figures which look so large cannot be so far distant as they really are.

Figures and ornaments in interiors should rather be gently diminished as they recede from the eye, and those which are nearest the spectator as he stands on the floor should be rather larger in scale than the ornaments and figures on the roof; but this diminution ought to be effected so gradually as to be imperceptible to the eye, accepting the perspective effect of distance thus conveyed, receives an impression of vaster space than would be given if the work was rigidly to one inflexible scale, and the apartment would look infinitely larger than if an opposite course were adopted and the distant figures and ornaments were enlarged in proportion as they receded from the eye.

Perhaps we should not omit to mention in connection with this part of the subject Mr. John Ruskin, a distinguished writer who has been for many years before the public as an exponent of art.

Notwithstanding the noise he has made in the world, we cannot find that he has had much practical influence as a leader of art. His power over the practice of contemporary art may be measured by the small amount of progress made in this country by Venetian architecture, of which Mr. Ruskin is the enthusiastic exponent and recommender.

Mr. Ruskin's qualifications as an art teacher were not of the sort to render him acceptable to architects or decorative artists, however successful he might be in influencing amateurs. His knowledge of his subject is often of a very superficial kind, while his selections are so narrow in scope that they cannot commend

themselves to those more catholic lovers of art who can enjoy the variety and picturesqueness of all styles, however diverse they may be.

This superficiality of information and narrowness of selection are of course not noticed by those who know still less of art subjects than Mr. Ruskin does; but his deficiencies in these respects are painfully apparent to those who have given a life's study to comparative architecture and decoration. They dislike the disingenuous method he has taken to glorify Gothic, in his "Lectures on Architecture" and his futile condemnation of the exquisite conventionalism of Greek decorative sculpture, because it is not of the ordinary natural type.

But perhaps Mr. Ruskin no more expected to be taken seriously when he wrote that jeu d'esprit on art than he expects to be when writing of literature. We understand that Mr. Ruskin has recently advised the extinction or banishment of the works of Thackeray, Kingsley, and others, for the overwhelming reason that Mr. Ruskin does not agree with those authors in their views of life. Mr. Ruskin, we fancy, does not expect or wish his advice to be taken; he merely desires to show the world what an original humourist he is.

"But surely," say some, "Mr. Ruskin must be a good judge of art, for did he not discover that neglected genius, Turner, and reveal him to the British public?" Turner, the neglected genius, had, however, managed by the exercise of his art to extract a fortune of £150,000 from the unappreciative public before Mr. Ruskin became his champion!

With regard to Mr. Ruskin's more pretentious works, such as the "Seven Lamps of Architecture" or the "Stones of Venice," it is not necessary to read his books to detect his weakness; this is abundantly evident from the specimens he has chosen for illustrations, and, we suppose, for extravagant if eloquent laudation. Some of these examples are so puerile in design and form, that we can only imagine that the beauty, sheen, and colour of the marble have caused Mr. Ruskin to overlook the poor quality of the design.

And, after all, Mr. Ruskin was not the discoverer of the architecture and decoration of the Doges' Palace any more than he was the discoverer of Turner's genius. Both, we think, had their admirers before he gave them the aid of his eloquent pen; but they were not blindly worshipped. Allowance was made for the associations of the Doges' Palace, its romantic situation, the glamour of its history and traditions. Its beauties were commended, its faults duly noted, and it received its proper place, which was not, however, "above the Parthenon and all that is great and beautiful in Greece, Egypt, or Gothic Europe."

The difference between the work of an incompetent and a competent critic may easily be perceived by comparing Ruskin's *Stones of Venice* with Fergusson's *Handbook of Architecture*.[8]

Fergusson shows the mature judgment of a man who has studied all styles, whose sympathies are wide enough to appreciate the decorative beauty of detail of Indian work, the regal richness of Saracenic, the virile strength and affluent design of Gothic, as well as the exquisite sense of proportion displayed in Greek. Beside him Ruskin appears like an uninstructed amateur, who, discovering some

glittering gewgaw, concludes in his enthusiasm that it is a jewel of inestimable value, and proceeds to claim for his shiny beads a place above the royal heirlooms which have justly commanded the admiration of centuries.

This position of Mr. Ruskin is quite well understood by artists and by architects; they are pleased to listen to his eloquence, but they do not follow his precepts; for the reason that there is either nothing to follow but elegant words, or the examples he culls support very imperfectly – sometimes very ludicrously – his pretensions to be judge of what is beautiful or appropriate.

## Notes

1 *British Architect*, 27, 4, 28 January 1887, p. 73.
2 James Fergusson, *The Illustrated Handbook of Architecture Being a Concise and Popular Account of the Different Styles of Architecture Prevailing in All Ages and All Countries* (London: J. Murray, 1855).
3 Smith explains in his *Ornamental Interiors* (p. 211) "To comprehend the distribution of the architectural styles it is necessary to have an intelligent theory of deluges. Adhemar supplies this theory. He demonstrates that just as there is a miniature deluge caused by the fluctuation of the tides from low to high water every six hours, there is a similar fluctuation on a much larger scale every 10,500 years. This larger fluctuation is called a deluge. [Joseph Adhémar, (1797–1862) *Révolutions de la mer, déluges périodiques*]
4 *Saturday Review of politics, literature, science, and art*; 63, (Feb 19, 1887), pp. 275–276.
5 This unkind commentary is aimed at Robert W. Edis and his 1881 publication *Decoration and Furniture of Town Houses*. See especially p. 34.
6 Smith was a one-time associate of Talbert who wrote three books on design: *Gothic Forms Applied to Furniture, Metal Work, and Decoration for Domestic Purposes*, (1868),/*Examples of Ancient & Modern Furniture, Metal Work, Tapestries, Decorations*, (1876),/*Fashionable Furniture: A Collection of Three Hundred and Fifty Original Designs Representing Cabinet Work, Upholstery and Decoration* (1881).
7 See footnote 3.
8 James Fergusson, *The Illustrated Handbook of Architecture . . .* (London: John Murray 1855).

# JOHN ALDAM HEATON,
## 'DECORATION OF THE HOUSE' (1897)

### Editorial Headnote

John Aldam Heaton (1830–1897) initially worked as a wool and textile manufacturer in Bradford. Influenced by the Pre-Raphaelites, Heaton became fascinated by all areas of art and interior design, in particular furniture, stained glass and wallpaper design. An adherent of the Arts and Crafts movement, Heaton was outspoken in his ideas on art, design and taste. He published several books on these subjects including *Beauty and Art* and *Furniture and Decoration in England during the Eighteenth Century*. This volume on *Beauty and Art* allowed him to express his extensive knowledge of traditional design. In 1894 he also published *A Record of Work: Being Illustrations of Printing, Stencilling and Painting, Stained Glass, Cabinet-Work, And Marquetry, Embroidery, Woven Fabrics and Other Decorative Works Designed and Executed by Aldam Heaton*.

One of his main arguments was that it was the French Revolution that had paralysed art, and that tradition had died in its aftermath; so he thought designers had to go back into history until they could pick up the lost threads before continuing working with new projects. He was of the opinion that designers and makers could not or should not cut themselves entirely free from tradition.

The critical reviews of *Beauty and Art* were contradictory. The *International Studio*, was quick to condemn and write off the work:

> It is a long time since we have read a book which contains so many excellent, time-honoured precepts, together with so much false reasoning and pernicious dogma as may be found in the pages of this volume. Its title-page is a fitting introduction to what follows: the crudely drawn and coloured flower which sprawls across it is a type of the ill-considered verbal illustrations which mar its pages within.[1]

On the other hand, a much longer and more considered review appeared in the *British Architect*: 'we are glad to find such outspoken and definite criticism on modern art ideas and the so-called general improvement in public taste in Mr. Aldam Heaton's new book on "Beauty and Art."' The review continues

> Mr. Heaton is an artist and a craftsman who has done much good work, and his book is a refreshing exposition of the practical application of sound principles. There is the new school to be reckoned with – the school who seek after novelty and attempt strange gymnastics in the idea that they are accomplishing great feats in high art. Mr. Heaton attempts the reckoning, and we think successfully. He has gone further, however,

and given his readers a most interesting and instructive course of reading on the arts of furniture and decoration. Let us hope that those for whom the book was mainly written may profit thereby. If they will read it, they cannot fail to do so.[2]

Thirdly the *Saturday Review* published a reasonably supportive review:

A good deal of nonsense must be forgiven to every treatise on art, and we should be willing to forgive far more nonsense than we have been able to discover in Mr. Heaton's papers on decoration and furniture, because he pleads so strongly against the contemporary art and craftsman, who has not been brought up in a tradition and starts straight away to evolve a novelty. The teacher who begs the modern architect and decorator to steal or learn (it comes to the same thing) from the brothers Adam is on the right side, and he may be allowed now and again to preach morality, or enjoy any other form of relaxation that amuses him.

The reviewer then made a comment about the role of the architect in interior design work; an issue that had exercised the professions for a while by this time:

The generally architectural tone of the book is highly commendable; in one or two places Mr. Heaton openly declares that the architect, provided he is a good architect, is the most desirable decorator and furnisher – he is even to be listened to when he gives his opinion about woven fabrics. And lest the frequent mention of Ruskin and Morris should frighten away some readers, we would point out that Mr. Heaton admires (and very rightly) a certain quality which was obtained by the old-fashioned painters who used a comb to imitate the grain of wood.[3]

These reviews that acknowledge the rise of a design approach based on novelty and 'strange gymnastics', is presumably a jibe at the Art Nouveau which Heaton saw as being without precedent in historic styles.

# 21

# 'DECORATION OF THE HOUSE'

## *John Aldam Heaton*

Source: John Aldam Heaton, 'Decoration of the House' *Beauty and Art* (London: Heinemann, 1897), pp. 91–100

Decoration. – No one will surely attempt to deny that we live in an age conspicuous for its commonplace. Whether it be the average builder's house, or civil engineer's railway-station, or a scientific man's electric fittings, we recognise modern work by its complete absence of character. Now, commonplace is dull and uninteresting. No one would knowingly seek it or desire it, or, unless he were desperately dull and commonplace himself, would pay good money to get it; and yet most people *do* get it. They rent or buy commonplace houses with commonplace decoration, and complete the thing with common-place furniture; and it, becomes an inquiry of some interest to try and see how this arises, and what are the chief inducing causes, A decorator becomes so wearied and worried by the mountains of commonplace stuff around, that the that the subject has become an interesting study, and we seem to trace its origin in a sort of mis-directed utilitarianism. Now, that brings us upon tangible ground.

As an example: I suppose I am only one among many who have been rash enough to attempt to improve the mouldings and details of a billiard-table and a piano, but always with this result, that it has been proved to me by the foreman or masters of such an establishment, that in several cases the new details supplied would have cost a little more money. This one cut into more wood another wanted cutting at twice; in a third they had been accustomed to cut two out of a square, and the new drawing was not so accommodating – and so on through the list.

Now, this spirit is to be found in every branch of trade, and in ninety-nine cases out of a hundred it is just the little interesting and artistic touch that is found to be more costly or less convenient. Something must be pinched to meet competition. Wages cannot be altered; material and labour must, therefore, be economised. A cabriole leg to a chair requires a carver: a turned leg can be done by the thousand in a steam lathe. A large design goes over three or four printing-blocks: cut it down in dimensions and put it in on one. A sheep-skin for embossing costs 3s. 6d., but paper as stout can be had for 4½d. A door handle with a ray-like set of flutings must be cast and chased: leave out the flutings, and you can "spin" it. And so in every department of work, except, perhaps, those details of a building upon which a good architect rests his reputation, we drop down to utilitarian commonplace.

DOI: 10.4324/9781003290490-27

And the motive force which brings this about is that terrible commercial desire to do the largest business possible, rather than to be content to do a smaller business, and to do it as well as it possibly can be done. Your spirited and enterprising tradesman, with the mercantile instinct very strongly developed, advertises freely and lies freely, and assures all who will read or listen to him that they can live as well, own as pretty houses, and dress as well, as far as appearances go, as their richer neighbours. His competitors of the same street advertise and lie even more freely than he does and down goes the price of every commodity, the *value* going down still more quickly or, are not the savings all made out of material? And as if this was not bad enough, it seems that, to spice the dish, it is necessary to offer the bait of continual novelty – novelty in the spring, further novelty in the autumn and to produce this, huge establishments are required, divided into sections, over each of which presides a manager, trained only in the art of dividend-making the whole being quite beyond the reach of the taste, or influence, or even of the personal scrutiny of the real master – utilitarianism being the only god they all worship.

You will ask, perhaps, how this is to be stopped. That, I fear, would lead us beyond the limits of an inquiry like this but at least we may each do much by fostering the opposite spirit, by carefully avoiding tradesmen who are prominent advertisers, and by influencing our families and friends to do so too.

In comparing, to our constant chagrin and vexation, the beautiful productions of the Middle Ages – tapestry, leather, armour, pottery, figured velvets, embroidery, and the like, with the cheap rubbish of to-day, one cannot but ask how it was that they, with fewer facilities than we, produced this wealth and abundance of beautiful things, while we, with all the results of their experience to help us, seem comparatively impotent. I confidently ascribe it to the loss of tradition – that whereas the mediaeval armourer was generally the son and grandson of an armourer, and brought up his son and his grandson to be armourers too, the painter was the son and possibly the grandson of a painter, the tapestry-weaver also being descended from a family of tapestry-makers and so on through every trade, the country being filled with young men who from boyhood understood their business, and had no thought but of practising the same. Nowadays, we go off into the opposite direction, and our successful upholsterer is the son of a city clerk, and brings up his son to be a country gentleman and a breeder of race-horses.

William Morris used to say that the sixteenth century craftsman lived so happily and joyously, was so well dressed, and housed, and fed (his master being jovial and liberal too), that out of the sheer delight he found in his life and surroundings, he thought beautiful things, hammered beautiful iron, embossed beautiful leather, wove beautiful tapestry, and sang jovial songs. I hope it is all true.

But I think it has been proved beyond dispute that the workman was never nearly so well off in the history of the world as he is to-day. An examination of old workmen's quarters in France and Italy, the Rue de Jerzuel in Dinan,[4] for instance, which has scarcely been touched for two or three hundred years, the dark and narrow *calles* of Venice, slum quarters in Paris and Rome, seem to show that the mediaeval workman was very badly housed in what we should call dark

and dirty quarters. No doubt such details are matters of comparison, and probably their quarters were as good as they desired, their needs not having been increased by the sight of anything better for their class, at least. The workman gained, of course, immensely by the comparative smallness of the towns and thinness of the population as compared with our own. The power of joining in the field sports of the nobles, if only as lookers-on, must have been a great relief, and even, with some natures, it is conceivable that war might have been an agreeable change. Hours of work, we can well understand, must have been less arbitrary, and more according to the workman's own choice and the power of carrying on his work at his own house must have been an enormous gain when we think of the crowded factory of the present day; so that his life, when compared with that of today, may have been tolerable.

In each age, no doubt, the ruling class gets what it wants and has the money to pay for. In the sixteenth century money was in the hands of the few. The mediaeval prince, or baron, or squire, the bishop or canon of the Church, knew how to rule the roost, and, in a rough way, they did it well; and these beautiful things we are talking about were what they liked and wanted, and had the money to pay for; and it was just that traditional craftsmanship we have spoken about which rendered it, in difficult and troublesome times, still possible for certain trades to live though, judging by history, the workmen could not have worked more than half their time, war filling up the other half.

But how different is the social condition now. Where there were one or two of the ruling class in a town or neighbourhood, there are now a thousand burghers, all fairly well-to-do, whose wants are of an entirely different kind. They desire and enjoy better houses, more warmth and protection from cold, gas, improved lamps, electric light, better and more varied food, books, magazines, newspapers, and postal services a much better *ménage*, extending, too, all over the house; music, and occasionally foreign travel while the richer ones desire and obtain costlier equipage, good art, a great deal too much sport, and two or three houses each, instead of one, not to mention long sojourns in foreign hotels.

Collectively, this modern society demands, and gets, good means of transport by land and by sea, rapid transmission of messages or news, and comfortable hotels at all centres of interest, whether in the streets of a metropolis or on a Swiss mountain. These are the demands of the burgher of the latter half of the present century for a great many of us no longer desire to lord it, baronially, with fire and sword, but are learning to live and let live; and a vast section of society now prefers to live honourably by the sweat of the brow, rather than screw rack-rents out of pauper peasants. The pluck, ingenuity, and industry of the designing and working class of our time has produced the article demanded, and has been liberally paid for it. True, the details of the articles so produced are in most cases as hideous as utilitarianism can make them but remember that it was not beautiful detail that was ordered, but material comfort and convenience and, beyond doubt, if beautiful leather for wall coverings, for instance, had been steadily asked for twenty years ago, some of us would have produced leather equal to the best the

Spaniards made, and by now better still. But the well-to-do burgher replies, "I do not care to pay a guinea a skin I would rather have an imitation at 5s. and spend the remainder in dogs, horses, yachts, Scotch shooting, a trip to the Riviera." We may be sorry for his choice and think it a mistake, but we have to deal with facts, and change our ideas with the changing times.

Perhaps you will say to me, "Well, but if the production of beautiful sixteenth century work were to be demanded again, say by an aristocracy who had ceased to think killing God's creatures the greatest pleasure to be enjoyed, you would merely copy old work: you would go to South Kensington and trace and copy and reproduce." Believe me, this has always been so. No architect, no painter, no craftsman in this world ever sprung by a stride into what was at once novel and good. And just as the beautiful Gothic of Beauvais and Bourges is merely developed through a thousand delicate gradations from a Greek temple, *so whatever work of mans is thoroughly fine and noble in the world, must always have been only a trifling advance upon a previous success*. There is absolutely no exception whatever to this rule. The more one looks into the history of the past, the more one feels that each art or craft must follow its own tradition. I know we live in an age when this is constantly forgotten, and numbers of young designers and architects are constantly springing up to show how they can make mighty leaps and astonish the ages. There were three or four specimens in a recent "Arts and Crafts Exhibition," where the modern gesso work was cracked and going to pieces within a few months of its production. The saving clause is that these crazes are of short duration, and we are constantly learning that tradition is the only safe foundation.

## Notes

1 *International Studio*, October 1897, p. 273.
2 *British Architect*, 12 March 1897, pp. 179–180.
3 *Saturday Review of politics, literature, science, and art;* 85, 1 January 1898), pp. 25–26.
4 Rue du Jerzual, is a preserved medieval street that leads down to Dinan's harbour. It is divided halfway down by the town walls and the massive Porte du Jerzual gateway.

# MARTHA CUTLER, 'WHAT TO AVOID
# IN HOUSE-FURNISHING' (1907)

## Editorial Headnote

Martha Hill Cutler (1874–1951) was a graduate of Smith College, Northampton, MA. She studied art in New York at the then recently established (1892) School of Applied Design for Women, and was associated with writing interior decorating columns for both *Harper's Bazaar* and *The Designer*. She later become editor of the Interior Decoration Department, of the Butterick Publishing Company. She contributed many illustrated articles on home decoration and art to these and other magazines, including *House Beautiful*. She was also one of a number of women that set up businesses to advise clients, purchase furnishings and furniture and arrange them in houses. In her case she had a studio at 34 Gramercy Park, New York.

Much of her work was undertaken in the early twentieth century, of which three early examples are noteworthy. The American Home Economics Association commissioned a Report (appointed in June 1919), to see what might be done to improve the character of the home interiors shown in moving pictures. Cutler was engaged to examine the issue and reported that "The interiors shown in the best class of moving pictures have improved one hundred per cent in three years. The artist and interior decorator have arrived in a world where they should have reigned supreme from the beginning."[1] Secondly in an issue of *The Delineator*, (April 1920) Cutler showed she was aware of technical developments. Writing on 'Linoleum Floors – Durable, Smart,' she said that 'linoleum has now "arrived" as an artistic as well as a practical possibility for every room in the house'.[2] Thirdly she discusses modern bathroom design in terms of beauty and practicality, saying that

> shining cleanliness is in itself beautiful, but when we add the attraction
> of white porcelain tiles, white woodwork, polished nickel-plated fix-
> tures, and the dainty light color of wall and furnishings in general which
> the sanitary laws encourage for the sake of cleanliness, we need not fear
> that we must sacrifice beauty to utility and hygiene in this case at least.[3]

The text below addresses a number of issues, but they are all linked by the idea of reducing clutter and creating an inclusive and harmonious visual style. The concerns about bric-a-brac, muddle and incongruity have resonances in other texts in this collection and reflect a concerted effort to move away from the perceived idea of an over-blown Victorian interior. There are clear references to William Morris's dictum 'Have nothing in your houses that you do not know to be useful or believe to be beautiful'. She also draws lessons from Japanese interiors along with the inevitable advice on colour scheming, but she also makes useful comments on the use of space and the idea of gradually furnishing, not just filling up spaces with unsuitable furnishings and decorations.

# 22

# 'WHAT TO AVOID IN HOUSE-FURNISHING'

*Martha Cutler*

Source: Martha Cutler, 'What to Avoid in House-Furnishing,' *Harper's Bazaar*, 41, May, 1907, pp. 484–8.

The miracle of miracles will have been brought to pass in interior decoration when we learn what to keep out of our homes. An unyielding determination to bring nothing new into them to-day that we believe to be ugly, and to banish from them as speedily as possible all relics of former degenerate taste or false sentiment, which we know in our innermost souls belong to this same category, will do more toward solving the problem of beautifying these homes than innumerable dreams of ideally beautiful things that we hope to have tomorrow. She who has the courage to attack the problem from this side first: to live, if need be, with bare floors, undraped windows, and almost empty rooms until she can afford to buy the right thing for the right place, rather than sacrifice her best knowledge of what is right for the sake of *filling space*, is very wise, and will have her patience and self-restraint rewarded. Empty spaces are not necessarily ugly. Unless bounded by objectionable wallpapers and woodwork, they are, on the contrary, restful, and may be beautiful. One can safely say that none of them are as full of ugly possibilities as the furniture with which an unwise person may fill them, when under the influence of the space-filling passion. The rule is that, unless necessity and utility demand it, no space shall be filled with anything less beautiful than the space itself. Some pieces of furniture we must have, if we are to live the life of civilized human beings, at least of American or European civilized beings. If we were Japanese, we would find our needs amply supplied with four walls and a cushion; even the cushion might be classified as superfluous. Being Americans, we must acknowledge our dependence upon tables and chairs, although we can fully appreciate the simplicity and beauty of the Japanese home. From the Japanese, however, we can learn the beauty and restfulness of empty rooms surrounded by beautiful walls, Without furniture, without draperies, without any "filling in" to make things "cozy," they depend entirely upon the beauty of the essential parts of the room-the walls, the floor, and the woodwork, their decoration, color, and perfect proportions to create an effect which we all envy, and from which we should learn a few valuable lessons; first, that the essential

DOI: 10.4324/9781003290490-28

parts of our rooms are the walls, floor, and woodwork; second, that if these are beautiful we need not fear empty spaces; and third, that superfluous furniture is distinctly not an addition to a room.

*A simple dignified mantel with artistic bric-a-brac.*

The new housekeeper, in her haste to "get settled," is beset by the temptation to buy everything at once, although her capital is small, and the number of things required according to her ideas large. Of course, the result is inevitable. Everything suffers from her financial limitations. All her furniture is cheaply made and probably unlike the woodwork. The new things do not harmonize with the few old things which she has, the cheap rugs are crude in color; in fact, although the house is full of furniture and "settled," nothing is satisfactory, while if she had laid out a definite plan and bought a few things at a time, all harmonizing with the general scheme and thoroughly good in construction and material, even at the sacrifice of comfort and necessitating some empty rooms for a time, she would have been much happier in the end, and her capital would have been better invested. Better

184

still if she had first invested a little of it in piecing out the amount allowed by her landlord for papering and painting so that her walls and woodwork had been first satisfactory. She would then not have had all her furnishings ruined in appearance by an impossible background to start with. This suggestion seems a reckless one for a house not one's own, but the results would have saved many a discouraged hour and sleepless night. The success of the entire house depends first upon the walls and woodwork. With so important a point in view, one can afford to invest a few extra dollars even on another man's house.

The first thing, then, to be changed, if it is not satisfactory in either a new or an old house, is undesirable paper and paint. Paper may be undesirable both on account of its color and on account of its conspicuous design. Plain or self-toned papers are best in every way. The wall of the room must be the background for its furnishings; consequently, it must be inconspicuous. The rococo designs, the large naturalistic floral designs, and the obtrusive new art designs, are all objectionable on this account. The wall, when covered with these papers, ceases to be a background. The figures in the paper stand out and concentrate attention upon themselves, while they should be absolutely unobtrusive. In color the paper should be quiet and soft, and should harmonize with the furnishings of the room. We should not use a bright yellow in a sunny room nor a blue in a north room. We should not use the dainty colors, light blue and light pink, in our living rooms, and dark browns and reds in our sleeping rooms. They are not appropriate. The colors should in all cases be soft, not crude or glaring. The cheap figured papers, the rococos and the floral designs, have this fault in common, and even the plain papers are frequently too bright; the yellows are inclined to have a disagreeable mustard tone, the greens a grass tone, and the reds a blue or magenta tone. It is better to try a roll of paper in the room where it is to be placed, living with it several days and testing its effect in this way, before deciding upon it, if these dangers are to be avoided.

The woodwork is also a part of the background, and should harmonize unobtrusively with the paper and furniture. It should not stand out boldly, making a disagreeable outline around the doors and windows. The furniture and woodwork should be alike, except in the case of white woodwork and mahogany furniture. These two belong, through custom, together. The fireplace and picture moulding are a part of the woodwork and should be like it. We should not have an oak mantel and white woodwork. It is not customary to paint woodwork light brown, green, or pink, as was the custom a few years ago. It is now either painted white or stained or painted some of the dark colors-browns, greens, or mahogany – to imitate the natural hard woods. The highly polished natural woods pine, ash, and light oak frequently ruin the entire color effect of a room. The conspicuous yellow tone does not harmonize either with the walls or with the furniture. It is particularly unhappy in its effect when combined with yellows. It is better, almost without exception, either to stain these woods soft dark browns or to paint them white. If one has control over the construction of the woodwork in a house it should not be elaborate. The lines of the mouldings should be simple and plain,

without carving, and without unnecessary crevices for dust. The finish should be dull, not highly polished.

If you find a want of color harmony in your home, if things do not "hang together," look at your floors and see if they are so light that the rugs all seem like dark spots. The floor color should be the darkest and strongest in the room, not the lightest, as so frequently happens with hard-wood floors. The floors should be the darkest part of our background, and the colors should be inconspicuous, although the rugs may be deep and rich in color. Do not have rugs of many different tones in the same room, thinking that because they are Oriental they must harmonize. Consider the color of the walls very carefully in selecting them. They should form a very important part of the color scheme of the room. They should not have too many colors in them, and the colors should not be crude, as is so frequently the ease. The design should be inconspicuous also. It is much wiser to get plain rugs, or to have them made of plain carpet, than to get any of the cheap Orientals. Some of the domestic weaves are very satisfactory in both color and texture, although some are extremely crude. One small rug that is off color will frequently throw out the entire color scheme of rooms – a small red rug, for instance, in a room where the color scheme is made up of browns and coppers.

*A badly proportioned mantel and a clutter of bric-a-brac.*

The necessary pieces of furniture must not be elaborate. They must not be covered with carving most of which is glued on. The proportions must be good. The legs of tables must be neither too slender nor too heavy; the back of a chair must not be too high or too narrow: rockers must not be too short: there should not be cheap ornaments of gilt or inlay, and upholstery materials must not be elaborate and conspicuous in design and color: the wood itself of which the chair is made must be strong and free from knots: the finish must not be highly polished, and the color inharmonious. In other words, all the furniture should be simple, plain, and well-constructed, depending for its beauty upon the proportions and the beauty and finish of the wood, not upon ornament or high polish. One should not have furniture of different woods in the same room. For instance, a yellow-oak table, a weathered oak rocker, and a Colonial sofa in mahogany are quite enough to destroy all effect of harmony in a room, although each is inoffensive in itself. Combine these with natural hard pine woodwork and the discord is complete. Curtains and portiéres should not be draped. The lines should be straight and simple. The materials should be as beautiful as one can afford, but the figures and colors should not be conspicuous. One should not use figured curtains or portieres with a figured paper. The result is a chaos of figures. If one adds figured upholstery to these the results are still more disastrous. With a plain wall one may have figured curtains and portieres, but very few colors should be used. The simplest curtains are generally the safest, plain or figured nets or fish-nets. Elaborate laces do not harmonize with simple furnishings. Inner curtains of silk sometimes strike an interesting color note, but are not necessary. The wash nets are inexpensive, attractive, and sanitary. Electric and gas light fixtures should not be of bright yellow brass in elaborate designs with colored globes. Dull brass is much handsomer and more harmonious, the plainest designs are much more beautiful, and the color of the globes should depend entirely upon the light effect one wishes to obtain in the room. It should harmonize with the color of the room and should not be noticeable in itself. Colored globes with gold figures and colored bead fringes are particularly objectionable. So, too, are the dead white globes, which give a hard, disagreeable light in a room. A lamp may be one of the most beautiful things in a room. It is one of the strictly useful pieces of bric-a-brac. It should not be elaborate, and the coloring should be considered very carefully in relation to the room. Elaborate gilt bases adorned with cupids and maidens' heads, or those of colored porcelain painted with heads and flowers, the shades equally elaborate and trimmed with the inevitable bead fringe of the season, are all equally objectionable and would not harmonize with any artistic room. The base should be of dull brass, copper, or dark rich pottery, with graceful lines and good proportions. The shade may be of gathered silk covering a wire frame, of a tone harmonizing with the base and with the room; or it may be of opalescent glass without decoration, the color adapted both to practical use for reading and to the general color scheme.

There should be no bric-a brac that is not either useful or unquestionably beautiful, and in harmony with the room in color and character. Brightly colored vases, elaborate brass picture frames, crude Japanese and French pottery, small brass

clocks, and a quantity of unframed personal photographs are all in poor taste. There should be very little of any kind of brie-a-brac. Here more than anywhere else, since the only excuse for bric-a-brac is its unquestioned beauty, one should be absolutely sure that it fulfils its requirements.

There should neither be too many pictures, nor should they be skied or hung in poorly arranged groups. When there are too many, the wall seems to be spotted with a collection of frames. The beauty of any individual picture is entirely lost. When poorly arranged, one is troubled with lines, with steps, and with all sorts of irritating geometrical figures. Have as few bright gilt frames as possible, and be sure that the frame is secondary in importance to the picture. Dull gilt frames are used for oil-paintings, narrow gilt or wooden frames for water-colors, narrow dark wooden frames for engravings and etchings, and dark wooden frames harmonizing with the darkest tone in the picture for photographs. It is better to have no pictures than poor ones, and not too many good ones.

It is with the pictures and bric-a-brac that one usually begins a critical weeding out of all that does not come up to one's highest standards, and it is here that some of the most surprising results may be obtained. When we try to play the part of an unprejudiced judge with one standard only in view, beauty per se, most of us will discover that two-thirds of our so-called ornaments are not ornaments at all. We have retained them purely through habit and want of thought: someone gave them to us Christmas; they were inherited from our mothers or aunts; they were among our wedding-presents; they simply happened in some involuntary way, and we are slaves to their presence. We were not responsible for their coming, but we certainly are responsible for their staying. So few of us are able to separate sentiment and artistic judgment, that one woman, at least, has recognized this feminine weakness and made herself a professional critic and judge. With her mind unclouded by personal feeling, she goes to those brave souls by whom she has been called, and ruthlessly pronounces sentence upon all their cherished possessions, "This must go. That may stay," etc. She has been very successful in spite of the wounded feelings which she inevitably leaves in her wake. When her victims have recovered, they appreciate the improvement. At first tables, mantels, bookcases, and walls seem empty and forlorn deprived of their clutter of ornaments, but in the process of reconstruction unknown treasures have been found, dragged from the shade of ugly neighbors, and given their proper value; the restfulness of empty spaces and harmonious colors is gradually felt, and the readjustment is found quite worth the necessary sacrifices. The interior decorator generally prefaces his work of construction in this way, making way for the improvements to follow; but even without buying anything new wonderful results may be brought about first by this simple method of elimination of the ugly, and then by the rearrangement of all that is left into harmonious groups: all the oak furniture in one room, all the mahogany in another; all the rugs with copper reds in them in one room, all those with magenta in another; all the etchings and water-colors with light frames in one room, all the dark photographs with dark frames in another; a chair with suspiciously carved arms and feet and cut velvet seat banished to the

store room: innumerable pictures sent to the framer's to be reframed, others sent to join the chair; and a motley collection of bric-a-brac dropped into an empty lot nearby after dark and the magic has been wrought. As our tastes improve the reformation will go on, but the first break will be the hardest one. If we but appreciated the wonderful tact shown by decorators in developing our taste by making one part of the house artistic and beautiful, and allowing the comparative ugliness of the rest to sink into our souls without indulging in unnecessary criticism, we would have hopes of improvement under similar treatment from our own hands, and realize that development after the first courageous step is inevitable.

*Graceful draping and artistic furniture.*

## Notes

1 "Report of the Committee on Home Interiors", *Journal of Home Economics*, 13, 11–12, 1921, pp. 41–2.
2 *The Delineator*, April 1920 p. 64. Linoleum had been invented in 1860, but was often seen as a utilitarian material.
3 M. Cutler, "Modern Bathrooms" *Harper's Bazaar*, 41:2, 1907, p. 165.

# Part 4

# CLEANLINESS AND HOUSEKEEPING

# CLEANLINESS AND HOUSEKEEPING

Two major concerns are addressed in these texts. The first concern relates to the need for cleanliness relating to health. Although the issue had been growing in importance throughout the period, the 1884 International Health Exhibition held in London was a pivotal moment. The exhibits were displayed under various headings: 'food, dress, the dwelling – its construction, and fittings; water supply and sanitation, heating, lighting, and ventilation; and the ambulance, the workshop, the school, and technical education'.[1] This celebration of the importance of health to society was clearly reflected in technological improvement in the home. The German architect and author, Hermann Muthesius, writing in 1908, recognized that the issue of sanitation and hygiene was of prime importance to the English interior and its wider influence.

Hermann Muthesius was unequivocal. He said in *The English House*

"More important even than the question of comfort in the process of the transformation of the house during the nineteenth century was the question of sanitation. . . . The development of all the devices connected with health and cleanliness forms no inconsiderable part of the fame that England has earned in the design of the interior."[2]

In a more direct message, Ellen Richards, the doyen of home economics writers, and an advocate of the 'science of controllable environment' wrote, 'sweeping and cleaning and laundry work are all processes of sanitation and not mere drudgery imposed by tradition, as some people seem to think'.[3] Reformers had already promoted wooden furniture as opposed to the fully upholstered; they encouraged painted instead of wallpapered walls; they endorsed wooden floors in place of dust-gathering carpets, and they promoted easily washed surfaces in kitchens and bathrooms.

Once the health issues had been addressed as much as practicable, the second concern related to housekeeping and respectability. The traditional phrase 'cleanliness is next to godliness' refers to the idea that people have a moral duty to keep themselves and their homes clean. This was achieved by either a housewife on her own or in conjunction with servants.

DOI: 10.4324/9781003290490-30

The processes of weekly laundry, polishing, cleaning and dusting as well as the semi-annual spring and autumn cleaning all needed advice and education. In some cases these matters were addressed as if they were battle plans that incorporated ideas for the efficient use of staff and equipment. The numerous advice books and articles that provided recipes, routines, housekeeping hints tips and other informa-tion were aimed at helping the housewife manage the home. The classic example is *Mrs Beeton's Book of Household Management*, which was first published in 1861 and became a standard for many decades to follow. Although the majority of the book contained meal recipes the remainder offered advice on fashion, child-care, animal husbandry, poisons, the management of servants, science, religion, first aid and the importance of fresh seasonal produce.

See also vol 4.59–4.62 'Home Management' and 4.54–4.55 'Sanitation'.

## Notes

1 *British Medical Journal*, 6 December 1884, p. 1116.
2 H. Muthesius, *The English House* [1908], (New York: Rizzoli, 1987), p. 162.
3 Ellen Henrietta Richards, *Sanitation In Daily Life* (Boston: Whitcomb & Barrows, 1907), p. 7

194

# CATHERINE ESTHER BEECHER, 'ON THE CARE OF PARLORS' *A TREATISE ON DOMESTIC ECONOMY FOR THE USE OF YOUNG LADIES* (1846)

## Editorial Headnote

Catherine Esther Beecher (1800–1878) was an American educator known for her encouragement of female education and home-making. Catherine devoted her life to education and in 1823 she opened the Hartford Female Seminary in Hartford, Connecticut, where she taught until 1832. Catherine also released *The Duty of American Women to their Country* (1845), *Miss Beecher's Domestic Receipt Book: Designed as a Supplement to Her Treatise on Domestic Economy* (1846) and *The American Woman's Home* (1869) with sister, Harriet Beecher Stowe (1811–1896). This latter publication offered a model home designed from a woman's perspective with a number of innovative suggestions. For example, the kitchen was inspired by a galley in a steamship, whilst a novel design of a movable partition on wheels provided flexibility and privacy in a small home, which could also serve as a wardrobe.

In this *Treatise* Beecher introduces three broad themes – gender, religion and American identity. She uses Alexis de Tocqueville's *Democracy in America* (1835/1840), to contend that woman's lesser place in American society is the eventual result of the application of democratic and Christian principles, that women were happy with. The idea behind this was that a woman's claim to possession of the home, (and the family and its management) was through it, a declaration of women's important place and necessary role in society.

To achieve this, Beecher argues for the study and practice of domestic economy as a critical part of a woman's learning. She explained her *raison d'être* for the work in the Preface: 'The author of this work was led to attempt it, by discovering, in her extensive travels, the deplorable sufferings of multitudes of young wives and mothers, from the combined influence of poor health, poor domestics, and a defective domestic education'.

First published in 1841 *A Treatise on Domestic Economy*, often called the first complete guide to house-keeping published in America, was planned to be used as a textbook in American female schools. It was dedicated to 'American Mothers', and fostered the idea that education was essential as part of women's roles as mothers and teachers, so that they could successfully influence the next generation. The book demonstrated her beliefs about the central responsibility of women in the home as mothers and educators, who raised children and created a shelter for their families. Considered as a manual on women's appropriate gender roles, the *Treatise* encouraged self-sacrifice, modesty, and frugality along with teaching about housekeeping, childcare and cooking. It was very successful and went through at least fifteen editions by the 1870s. The publication was also important

in that it offered standardized domestic working practices and reinforced the important role of women in establishing and maintaining domestic values,

This chapter 'On the Care of Parlours' was one of a number of detailed chapters devoted to the caring and cleaning of the various rooms of a house. This was a topic that was addressed in numerous domestic advice publications that tried to offer advice on the organisation of a household, its staff and the routines required to keep a house clean, tidy and safe.

Apart from the home-made recipes for cleaning particular surfaces there is an acknowledgment that it was also perfectly normal practice for a household to cut, sew and lay their own carpets rather than being professionally fitted.

# 23

# 'ON THE CARE OF PARLORS'

## Catherine Esther Beecher

Source: Catherine Esther Beecher, 'On the Care of Parlors', *A Treatise on Domestic Economy for the use of Young Ladies* . . . (New York: Harper & Bros., 1846), pp. 302–6

## ON THE CARE OF PARLORS

In selecting the furniture of parlors, some reference should be had to correspondence of shades and colors. Curtains should be darker than the walls; and, if the walls and carpets be light, the chairs should be dark, and vice versa. Pictures always look best on light walls.

In selecting carpets, for rooms much used, it is poor economy to buy cheap ones. *Ingrain*[1] carpets, of close texture, and the *three-ply* carpets, are best for common use. *Brussels*[2] carpets do not wear so long as the three-ply ones, because they cannot be turned. *Wilton*[3] carpets wear badly, and *Venetians*[4] are good only for halls and stairs.

In selecting colors, avoid those in which there are any black threads as they are always rotten. The most tasteful carpets are those, which are made of various shades of the same color, or of all shades of only two colors; such as brown and yellow, or blue and buff, or salmon and green, or all shades of green, or of brown. All very dark shades should be brown or green, but not black.

In laying down carpets, it is a bad practice to put straw under them, as this makes them wear out in spots. Straw matting, laid under carpets, makes them last much longer, as it is smooth and even, and the dust sifts through it. In buying carpets, always get a few yards over, to allow for waste in matching figures.

In cutting carpets, make them three or four inches shorter than the room, to allow for stretching. Begin to cut *in the middle of a figure*, and it will usually match better. Many carpets match in two different ways, and care must be taken to get the right one. Sew a carpet on the wrong side, with double waxed thread, and with the ball-stitch. This is done by taking a stitch on the breadth next you, pointing the needle towards you; and then taking a stitch on the other breadth, pointing the needle from you. Draw the thread tightly, but not so as to pucker. In fitting a breadth to the hearth, cut slits in the right place, and turn the piece under. Bind the whole of the carpet, with carpet-binding, nail it with tacks, having bits of leather under the heads. To stretch the carpet, use a carpet-fork, which is a long stick, ending with notched tin, like saw-teeth. This is put in the edge of the carpet,

DOI: 10.4324/9781003290490-31

and pushed by one person, while the nail is driven by another. Cover blocks, or bricks, with carpeting, like that of the room, and put them behind tables, doors, sofas, &c., to preserve the walls from injury, by knocking, or by the dusting-cloth.

Cheap footstools, made of a square plank, covered with tow-cloth, stuffed, and then covered with carpeting, with worsted handles, look very well. Sweep carpets as seldom as possible, as it wears them out. To shake them often, is good economy. In cleaning carpets, use damp tea leaves, or wet Indian meal, throwing it about, and rubbing it over with the broom. The latter is very good for cleansing carpets made dingy by coal-dust. In brushing carpets in ordinary use, it will be found very convenient to use a large flat dustpan, with a perpendicular handle a yard high, put on so that the pan will stand alone. This can be carried about, and used without stooping, brushing dust into it with a common broom. The pan must be very large, or it will be upset.

When carpets are taken up, they should be hung on a line, or laid on long grass, and whipped, first on one side, and then on the other, with pliant whips. If laid aside, they should be sewed up tight, in linen, having snuff or tobacco put along all the crevices where moths could enter. Shaking pepper, from a pepper-box, round the edge of the floor, under a carpet, prevents the access of moths. Carpets can be best washed on the floor, thus: First shake them; and then, after cleaning the floor, stretch and nail them upon it. Then scrub them in cold soap suds, having half a teacupful of ox-gall to a bucket of water. Then wash off the suds, with a cloth, in fair water. Set open the doors and windows, for two days or more. Imperial Brussels, Venetian, ingrain, and three-ply, carpets, can be washed thus; but Wilton, and other plush-carpets, cannot. Before washing them, take out grease, with a paste, made of potter's clay, ox-gall, and water.

Straw matting is best for chambers and Summer parlors. The checked, of two colors, is not so good to wear. The best is the cheapest in the end. When washed, it should be done with salt water, wiping it dry; but frequent washing injures it. Bind matting with cotton binding. Sew breadths together like carpeting. In joining the ends of pieces, ravel out a part, and tie the threads together, turning under a little of each piece, and then, laying the ends close, nail them down, with nails having kid under their heads.

In hanging pictures, put them so that the lower part shall be opposite the eye. Cleanse the glass of pictures with whiting, as water endangers the pictures. Gilt frames can be much better preserved by putting on a coat of copal varnish, which, with proper brushes, can be bought of carriage or cabinet-makers. When dry, it can be washed with fair water. Wash the brush in spirits of turpentine.

Curtains, ottomans, and sofas covered with worsted, can be cleansed, by wheat-bran, rubbed on with flannel. Dust Venetian blinds with feather brushes. Buy light-colored ones, as the green are going out of fashion. Strips of linen or cotton, on rollers and pulleys, are much in use, to shut out the sun from curtains and carpets. Paper curtains, pasted on old cotton, are good for chambers. Put them on rollers, having cords nailed to them, so that when the curtain falls, the cord will be wound up. Then, by pulling the cord, the curtain will be rolled up.

Mahogany furniture should be made in the Spring, and stand some months before it is used, or it will shrink and warp. Varnished furniture should be rubbed only with silk, except occasionally, when a little sweet-oil should be rubbed over, and wiped off carefully. For unvarnished furniture, use beeswax, a little softened with sweet-oil; rub it in with a hard brush, and polish with woollen and silk rags. Some persons rub in linseed-oil; others mix beeswax with a little spirits of turpentine and rosin, making it so that it can be put on with a sponge, and wiped off with a soft rag. Others, keep in a bottle the following mixture: two ounces of spirits of turpentine, four tablespoonfuls of sweet-oil, and one quart of milk. This is applied with a sponge, and wiped off with a linen rag.

Hearths and jambs, of brick, look best painted over with blacklead, mixed with soft-soap. Wash the bricks which are nearest the fire with redding and milk, using a painter's brush. A sheet of zinc, covering the whole hearth, is cheap, saves work, and looks very well. A tinman can fit it properly.

Stone hearths should be rubbed with a paste of powdered stone, (to be procured of the stonecutters,) and then brushed with a stiff brush. Kitchen-hearths, of stone, are improved by rubbing in lamp-oil.

Stains can be removed from marble, by oxalic acid and water, or oil of vitriol and water, left on fifteen minutes, and then rubbed dry. Gray marble is improved by linseed-oil. Grease can be taken from marble by ox-gall, and potter's clay wet with soapsuds, (a gill of each). It is better to add, also, gill of spirits of turpentine. It improves the looks of marble, to cover it with this mixture, leaving it two days, and then rubbing it off.

Unless a parlor is in constant use, it is best to sweep it only once a week, and at other times use a whisk broom and dust-pan. When a parlor with handsome furniture is to be swept, cover the sofas, centre table, piano, books, and mantelpiece, with old cottons, kept for the purpose. Remove the rugs, and shake them, and clean the jambs, hearth, and fire-furniture. Then sweep the room, moving every article. Dust the furniture, with a dust-brush and a piece of old silk. A painter's brush should be kept, to remove dust from ledges and crevices. The dust-cloths should be often shaken and washed, or else they will soil the walls and furniture when they are used. Dust ornaments, and fine books, with feather brushes, kept for the purpose.

## Notes

1 Ingrain: flat woven carpet with dominant weft as opposed to Venetian with dominant warp.
2 Brussels: lopped warp pile carpet
3 Wilton: cut warp pile carpet.
4 Venetian carpet: striped flat weave single ply floorcovering.

# ELIZA LESLIE, *MISS LESLIE'S LADY'S HOUSE-BOOK: A MANUAL OF DOMESTIC ECONOMY, CONTAINING APPROVED DIRECTIONS FOR WASHING, DRESS-MAKING, MILLINERY* (1850)

## Editorial Headnote

The *House Book* was first published as a companion to *Miss Leslie's Directions for Cookery* (1837). It was intended, like many other examples, for newly-wed wives who needed help in setting up a new home. Like a number of other authors, Leslie noted the significance of appreciating that the home was a 'functioning system'. This approach was based on a combination of overall managerial planning along with specific instructions for the varied tasks of running a home. The systematic method she uses seems to be an early form of 'scientific management' of the home, where everything is planned to work in an orderly fashion.

Philadelphia-born Eliza Leslie (1787–1858) not only wrote books on cookery and household management and etiquette, but also novels, short stories and articles for magazines and newspapers. Leslie's works were widely popular, as they were specifically aimed at American audiences, in a market that was dominated by British publications on these topics.

Leslie was clearly successful. She wrote in her autobiography:

> The works from which I have, as yet, derived the greatest pecuniary advantage, are my three books on domestic economy. The 'Domestic Cookery Book', [Ed: 'Directions for Cookery'] published in 1837, is now in the forty-first edition, no edition having been less than a thousand copies; and the sale increases every year. 'The House Book' came out in 1840, and the 'Lady's Receipt Book' in 1846. All have been successful, and profitable.[1]

Leslie's comment on women writers in her *Behaviour Book* is of interest as it links the skills of home-making with the attributes of writing:

> A large number of literary females are excellent needle-women, and good housewives; and there is no reason why they should not be. The same vigour of character and activity of intellect which renders a woman a good writer, will also enable her to acquire with a quickness, almost intuitive, a competent knowledge of household affairs.[2]

The extract refers to the ritual of general housekeeping and it is laid out like a battle plan. The staff required, the rooms and the processes for each are all described in detail.

# 24

# MISS LESLIE'S LADY'S HOUSE-BOOK: A MANUAL OF DOMESTIC ECONOMY, CONTAINING APPROVED DIRECTIONS FOR WASHING, DRESS-MAKING, MILLINERY

*Eliza Leslie*

Source: Eliza Leslie, *Miss Leslie's Lady's House-Book: A Manual of Domestic Economy, Containing Approved Directions for Washing, Dress-Making, Millinery* (Philadelphia: Parry & McMillan, successor to A. Hart, late Carey & Hart. 1850), pp. 336–43

## PREPARATIONS

In some families there is no general house-cleaning at stated periods, but the rooms are scrubbed, white-washed, &c., one at a time, as may be most convenient. But the usual custom in America is to have the house completely cleaned from top to bottom twice a year; late in the spring and early in the autumn. As the temperature of the season varies in different parts of the Union, it is a good rule not to commence house cleaning in the spring till the trees are all in full leaf; but to begin it in autumn as soon as the leaves become tinged with brown; having it entirely over before the 20th of September; at which time the equinoctial rains may be expected, fire will be necessary, and the house and furniture ought no longer to appear in the guise of summer. But at no season should house-cleaning be commenced when there is a prospect of bad weather. And the whole business may be deferred or anticipated a week or more, if there is a prospect of the master of the family having business to take him from home at the period so uncomfortable to all gentlemen. We would advise him, however, before he goes, to put his library-table in order himself, and to lock up (taking the key away with him) all his papers, &c.

Besides the assistance of your own domestics, you will find it necessary to employ at least three other persons a whitewasher, a scrubber, and a man to take charge of the carpets. You should bespeak their services a week or two beforehand, as at the usual house-cleaning seasons they are much in demand, and you may be disappointed in obtaining them. It may be well to make a stipulation with them

DOI: 10.4324/9781003290490-32

that they are not to undertake the white-washing or cleaning of another house at the same time with yours; a practice that is very common with them, rather than lose a job. The consequence is, that after doing a day's work (or perhaps only a morning's work) at your house, they will go off to another and work there a while; you, in the meantime, seeing nothing of them all the afternoon, or perhaps during the whole of the next day, to your great disappointment and inconvenience.

The cook is never required to assist in house-cleaning; as at that time she will have enough to do in preparing food for an additional number of persons, and in clearing things away after them. They should all have an early and substantial breakfast, and a luncheon between breakfast and dinner; they will work the better for it. And give them their tea before they go home in the evening.

The first thing is to remove most of the furniture from the rooms: the next is to take up the carpets. This will be done by the man you have engaged to attend to them, and by the assistants of his own that he will bring with him. In Philadelphia it is easy to procure a coloured man who, for about five dollars, will undertake all the carpets of a large house. He will bring a cart, into which he will put them all, after he has taken them from the floors and folded them loosely; and he will be provided with carpet-sticks, brooms, and whatever is necessary, including men to help him. Having taken the carpets to some one of the vacant lots in the skirts of the city, he will make them perfectly clean, by shaking and beating them first, and then laying them on the grass and sweeping them. He will then fold them neatly, and bring them home in his cart, ready to be put away, if they are not to be in use during the summer. It is well to give him, before he goes out with the carpets, a quantity of tobacco to lay among the folds, or a quarter of a dollar to buy some for the purpose.[3]

As soon as the carpets are gone, sprinkle the floors well, and sweep them twice over; as the first sweeping will only take off what is called the rough dirt. The looking-glasses, pictures, &c., should be taken down, dusted clean, and then laid upon their faces on the beds, or on large tables in the centre of the drawing-rooms, covering them with a sheet or blanket. The lamps, branches, vases, and all the ornamental articles belonging to the mantel-piece, centre-table, and pier tables, had best be collected all into one room, and cleaned while there by some careful person.

## White-Washing

The white-washing and scrubbing should always be commenced in the upper story, descending by degrees; the stair-case being done last. In a new house, no wall should on any account be white-washed or painted till after the plastering has been dry at least a year.

To make white-wash, put lumps of quick-lime into a bucket of cold water, and stir it about till it is all dissolved and mixed. It should be about as thick as cream. A pint of common white varnish, (which can be procured at a cabinet-makers for a trifle,) mixed in a bucket of white-wash, will make it stick like paint. Instead

of water to mix the lime with, skim milk (which must be perfectly sweet) will make the white-wash very white and smooth, and prevent it rubbing off easily. White-wash is put on with a very long-handled brush, made for the purpose; and it should be spread thinly, smoothly, and evenly. When it is quite dry, it must be gone over with a second coat; and if the wall has previously been very dirty, or coloured with yellow ochre, a third coat of white-wash may be necessary. For ceilings, instead of the common white-wash, it is best to give them a coat of what is called Paris white, (to be obtained at the paint-stores,) mixed with water.

All the closets should be cleared out, and their walls white washed, and the paint of the shelves and doors cleaned.

## Cleaning Paint or Wainscotting

Have ready two buckets of water, some hard soap, a flannel, a soft linen cloth, and some old, soft, linen towels. Paint will come off if cleaned with soft soap, pearl-ash, sand, or a scrubbing brush. In one bucket, rub the soap in the water till it makes light suds, dip in the flannel, and with it rub the paint well. Then, as you go along, rinse off the soap with the soft cloth dipped in the other bucket of water, and dry, as you proceed, with the old towels; hanging them to dry in the window as they become wet. In this manner clean the doors, (on both sides,) the window-frames, shutters, and whatever painted wood-work or wainscotting may be about the room; using the movable steps, when necessary.

If you find an ink-stain on the paint, wipe it with the wet corner of a cloth dipped in oxalic acid, (either in powder or dissolved.) This will remove the ink. Then, in a few minutes, wash off the oxalic acid with an old towel and clean water. If the paint is white, no trace of either the ink or the acid will be left. If it is coloured paint, rub the place with some hartshorn and water, and let it dry. The same application will take ink out of a floor, or remove its stain from a mahogany table, or from a carpet; the hartshorn and water restoring the colour that has been faded by the oxalic acid in expelling It is best to clean the paint directly after the white-washing, and before the windows are washed.

## Window Washing

Having taken down the curtains or blinds, wash the outside of the windows, raising the sashes, and throwing against them cold water from a tin mug; looking out first, to see that no person is passing below. For the inside, take a sponge dipped in luke-warm water, and rub each pane of glass till quite clean; finishing with a soft linen cloth. For the best windows, after washing the glass with luke-warm water, (as above,) rub every pane with a buckskin dipped in finely-powdered whiting, or prepared chalk; and then wipe it off with a soft linen, and finish with a silk handkerchief. This will make good glass look beautifully. To reach the top in cleaning the inside of windows, you must stand on the movable steps. If there are Venetian shutters, brush or wipe them well between all the slats. If there are Venetian

blinds, see that they are in good order before they are put up for the summer; and, if necessary, have them re-painted, and the cords renewed.

Many families are provided with platforms or stages, like those used by house-painters, to be fixed outside of the windows when cleaning.

## Cleaning Chairs

Painted chairs should never be scrubbed, as it takes off the paint. It is sufficient to wipe them well with a flannel dipped in luke-warm water, and afterwards with a dry cloth. If there is gilding on the chairs, do not wet them at all, but wipe them with a dry soft cloth. Chairs of curled maple may be washed with a flannel and luke-warm soap-suds, then rinsed with a cloth dipped in cold water, and then finished with a dry cloth.

Directions for cleaning other articles of furniture, will be found in preceding parts of this book.

## Scrubbing Floors

After the white-washing, paint-cleaning, and window-washing of each room has been completed, let the floor be scrubbed; first seeing that it has been well swept. For this purpose, have a small tub or bucket of warm water; an old saucer to hold a piece of brown soap, a large, thick tow-linen floor-cloth and a long-handled scrubbing brush. Dip the whole of the floor-cloth into the water, and with it wet a portion of the floor. Next, rub some soap on the bristles of the brush, and scrub hard all over the wet place. Then dip your cloth into the water, and with it wash the suds off the floor. Wring the cloth, wet it again, and wipe the floor with it a second time. Lastly, wash the cloth about in the water, wring it as dry as possible, and give the floor a last and hard wiping with it. Afterwards go on to the next part of the floor, wet it, scrub it, wipe it three times, and proceed in the same manner, a piece at a time, till you have gone over the whole; changing the dirty water for clean, whenever you find it necessary. For a large room, fresh warm water will be required four or five times in the course of the scrubbing.

When the floor has been scrubbed, leave the sashes raised while it is drying.

For scouring common floors that are very dirty, have by you an old tin pan with some gray sand in it; and after soaping the brush, rub on it some sand also.

In scrubbing the stairs, commence at the top, and come gradually downwards; doing one step at a time, and finishing each, before you begin the next. Use for the stairs a hand brush, instead of a large one with a long handle. You will require clean water at least once for every flight of stairs. For the kitchen-stairs, you may use sand as well as soap.

Before the steps of the staircase are scrubbed, the painted part of the bannisters should be cleaned. First sweep them well with a banister-brush, getting all the dust thoroughly out from between the rails. Then wash them with soap and flannel

and luke-warm water, rinsed off with plain water, and dried with a linen cloth. The mahogany part must be cleaned in the same manner as your other mahogany.

## Finishing the House-Cleaning

A house cleaning generally finishes with the kitchen, cellar, kitchen staircase, and yard. The closets in the kitchen should be all cleared out, white-washed, and scrubbed. So also should the dresser shelves and drawers, the tables, &c. The tin-ware, iron-ware, and all the utensils belonging to the kitchen and cellar, should have a complete scouring; though, of course, they ought to be kept clean at all times. If any entirely useless rubbish has been allowed to accumulate, let it be burnt, rather than occupy space to no purpose.

After the spring house-cleaning, (which, east of New York, had best be deferred till June, or till the damp, chilly weather seems entirely over for the season,) let the fire-place in one of the parlours be so arranged, that a fire can be made up there if necessary.

See that the curtains, carpets, and any articles of furniture that may not be wanted during the summer, are put carefully away.

Let all the books be removed from the shelves, well dusted, and regularly arranged.

Previous to the autumn house-cleaning, let all the chimneys be swept; at least, all those in which wood is burned. It will not be necessary to put up your winter curtains before November.

At each house-cleaning, let all the bedsteads be taken apart, examined, and the joints washed with cold soap suds.

If your house requires painting, papering, or other repairs, have them done just before the cleaning time. Previous to replacing the furniture in your rooms, let everything be mended that requires it.

## Notes

1  "The Female Prose Writers of America" /Eliza Leslie /Autobiography, accessed 16th August 2022.
2  Eliza Leslie, *The Behaviour Book*, (Philadelphia: Peterson, 1839), p, 262.
3  This was an anti-moth measure.

# SAMUEL WALL RICHARDS, 'THE INFLUENCE OF ORDER, METHOD, AND CLEANLINESS, IN FACTORIES AND WORKSHOPS, UPON THE HOMES OF THE INDUSTRIAL POPULATION OF LARGE TOWNS' (1877)

## Editorial Headnote

Samuel Wall Richards (1837–1908) was an engineer at button makers Green, Cadbury and Richards, Birmingham, who was also active in business and local government, with a particular passion for attempting to improve the welfare of the working classes in Birmingham. His own business tried to improve workers' conditions including the provision of a sick pay scheme and a library for the use of workers. He also wrote some of the Artisans' Reports on the Paris Universal Exhibition, 1867 and the Vienna exhibition 1873 in the Buttons and Small Wares categories. This paper was delivered to the first Domestic Economy Congress held in Birmingham in 1877.

The Congress was initiated by the design reformer Sir Henry Cole, who gave a paper titled "The Practical Development of Elementary Education through Domestic Economy". He proposed a National College of Domestic Economy. The Congress, which convened for a few years, was open to ridicule. Writing about the second Congress held in 1878 *The Examiner* commented that

> At present there is really too much zeal, too much thoroughness, too much tempest in a tea pot. Ladies and gentlemen of much information on many subjects have, apparently, quite independently of the world's experience before them, discovered that some of those subjects – such as chemistry, physiology, cloacal science, natural philosophy and so forth – have a direct bearing on everyday matters belonging to the business of the cook, the housemaid, or the 'matron of all works'.

They then mention some examples of superior practices and note that 'On these data they have set to work to invent a new science, and England is to be made regenerate under the auspices of Domestic Economy'.[1] It was also heartily mocked by Punch magazine.[2]

The *Saturday Review* in a light-hearted review of the Congress suggested that

> There was a great deal of clever nonsense and stupid absurdity in many of the speeches. But, notwithstanding all these circumstances, and perhaps even in consequence of them, some good work was done which will have more important results than any one merely reading an abstract of the proceedings would be likely to infer.[3]

Published as a pamphlet as *The Influence of Order, Method, and Cleanliness in Factories and Workshops Upon the Homes of the Industrial Population of Large Towns*, (Birmingham: M. Billing, Son & Co., 1877), the text was also reproduced in the *Journal of the Society of Arts*. An enthusiastic review of the paper was published in an unlikely journal titled *The Reliquary and Illustrated Archaeologist* subtitled 'A quarterly journal and review devoted to the study of early pagan and Christian antiquities of Great Britain'.

> To be healthy in mind as well as in body, it is essential that the surroundings both in the home and in the workshop and factory should be clean, pure, and wholesome, for though, as it is said, 'pigs thrive best in the dirt', human beings do not. A vast responsibility rests on employers of labour – the owners of manufactories and workshops in towns in this respect, for upon the cleanliness, good order, and healthfulness of the surroundings of the people while at their daily labour, depends their taste for those essentials in their own homes. . . . One of the most enlightened of employers, Mr. S. W. Richards, of the firm of Green, Cadbury, & Richards, of Birmingham. . . . His pamphlet is full of valuable information, and cannot be read without profit. We commend it to the notice of everyone interested (and who is not?) in the welfare of the human family, and we especially commend it to the careful notice of employers of labour in towns. If they will only carefully study its pages, and act on the excellent principles enunciated by Mr. Richards, they will indeed be doing good not only 'in their own day and generation', but in generations and ages to come.[4]

The concept of order, method and cleanliness was not new and many of the extracts in this volume do address versions of the 'problem' in one way or another. However, Wall's paper linked the cleanliness of the workspace with the home in an interesting way.

# 25

# 'THE INFLUENCE OF ORDER, METHOD, AND CLEANLINESS, IN FACTORIES AND WORKSHOPS, UPON THE HOMES OF THE INDUSTRIAL POPULATION OF LARGE TOWNS'

## Samuel Wall Richards

Source: Samuel Wall Richards, "The Influence of Order, Method, and Cleanliness, in Factories and Workshops, upon the Homes of the Industrial Population of Large Towns", *Journal of the Society of Arts*, 25, 17 August 1877, pp. 893–8

Among the subjects in which instruction is most urgently needed by the industrial population, and to which attention should frequently be drawn in any course of education on domestic economy, there are few more important than the one I have endeavoured to illustrate in the following paper.

Having had frequent opportunities of comparing workmen's homes in the textile districts of Lancashire and Yorkshire with workmen's homes in Birmingham and neighbourhood, I have been led to inquire into the cause of the differences between them.

Many of the houses of the operatives of the northern counties are characterised by an air of cleanliness, freshness, and an appearance of general comfort that is altogether wanting in a similar class of houses here.[5]

A different spirit seems to pervade the household, and is a striking feature to a resident of the Midland Counties.

There is no doubt in my mind that the superior manner in which houses are built, the more complete domestic arrangements that are made by architects and builders of this class of property in the North, has a great deal to do with the general cheerfulness of home life there.

But what are the influences at work that create the taste and demand for this class of house, influences not in operation here?

I have never seen ordinary workmen's homes here that would compare at all with those there.

In Yorkshire there is on the ground-floor living-room, with a second apartment in the rear, that serves the purpose of slop-kitchen and washhouse, being fitted

DOI: 10.4324/9781003290490-33

with open furnace or boiler also a good supply of water laid on, and what is very important, a current of air could pass through these two lower rooms.

The living-room is invariably fitted with what is known as the "Yorkshire range,"[6] with an open fire, and on one side a hot-water boiler, on the other side a large baking oven, large enough to bake a batch of bread: the fire-grate itself, with sufficient polishing surface to tempt a "Lancashire lass" that was house proud to try what "Baker's brilliant blacklead"[7] would do towards supplying a mirror for the use of the family.

But the marked features of the northern home do not end here; under the bars of the grate there is always to be seen a bright red glare; no accumulation of ash: no contrivance for hiding dirty sides running back to the chimney. Ashes are not allowed to accumulate, because the floor immediately underneath the bars is invariably whitened over with a brush and wet whitening, and the ash that falls is removed frequently.

Working men and working women in this neighbourhood have not the remotest notion of the attraction of a Yorkshire fireside. Whether the bright hearthstone is the complement of the general cleanliness of the walls, which are painted (not covered with a tawdry paper, as with us), or the whitened ceiling, a crowning feature of the whole, is a moot point.

The advantages of painted walls are well known by those who live in high-rented houses, where, as a rule, the best kitchens are always painted, and cleaned frequently with soap and flannel.

Well, the walls of the living-rooms of the northern dwellings have many of them an occasional cleaning with soap and flannel, and the ceilings are whitewashed twice a year.

I once remarked on seeing the ceiling of a living-room whitewashed at Christmas, that I had observed being whitewashed at Midsummer, "Why do you whiten them twice a year?" the reply was "We should be dirty people if we allowed them to go as long as the factories before they were done, that is, only once in fourteen months."

Happy operatives, indeed, are they who can speak of the factories they may work in being whitewashed once a year.

Now, what is the interior of the homes of the operatives in Birmingham? How compares it with the same class of house in the North?

A single living-room on the ground floor in a court of houses, a cul de sac, with no second apartment; a cramped room with a ridiculously small fire-grate, no hot-water boiler, a small baking-oven on one side only (nine or ten inches square) divided in two parts, a fire-grate, perhaps the cheapest, commonest, and most useless design ever made: no back apartment, wash or slop kitchen, no painted walls, but, instead, walls covered with a cheap, showy paper, that is never cleaned or changed for years, a contrivance for harbouring loathsome insects; and ceilings that are whitewashed at long intervals of years also.

That adjunct of comfort, and promoter of cleanliness and health, a good supply of water, the operatives here are also denied; a common pump in the centre of

the court, into which the sewage may percolate, and be of serious mischief, is the usual, and in most cases the only supply, and the wash-kitchen, or wash-house, available by the housewife, is a general one, common to the whole of the neighbours in turns, and used only on certain days, or portions of days, as when there are more than six houses to only one wash-house. Each tenant cannot have the wash-house for even one whole day out of the six.

This very slight sketch of the houses inhabited in Yorkshire and Lancashire by the operative classes, and of houses inhabited by the same class here, will, perhaps, enable those not having an acquaintance with either to form an idea of the conditions of home-life in the two districts.

The immense difference so much in favour of Lancashire and Yorkshire I attribute to the order, method, and cleanliness observed in factories there, and the entire absence of corresponding rules and regulations in factories and workshops here till recently.

Since the Act of Sir Robert Peel, in 1802,[8] and subsequent Acts of 1833 and 1844,[9] controlling and regulating labour in factories, and determining the conditions upon which it shall be carried on in the interests of the physical growth and health of children, young persons, and females, it may be said these northern districts had enjoyed advantages during the period represented between the dates 1802 and 1867 that have not been permitted to operatives here.

The magnificent factories, with every appliance and contrivance that could be suggested by human ingenuity for securing the most favourable conditions upon which the gigantic industries could be carried on, have aroused and kept alive the desire of the factory employees for clean, convenient houses. To these causes I attribute their growth and development; and, where they do not exist, something exceptional has come in the way.

What has been the rule, method, or custom here? Most factories in Birmingham may be said to consist of a series of workshops that have grown from month to month and year to year, without symmetry or design, that the largest of them are, with few exceptions, agglomerations of shops, all shapes and sizes, forming irregular masses of buildings (very frequently a *congeries*[10] of six or seven houses, communication with each other through two holes in the walls) with no principle observed, securing to the workers [n]either proper light, ventilation, or cleanliness. All these important considerations have been ignored, so that, as a rule, places are built subject to no supervision, and, in consequence, are in direct contravention of the laws of health, and sometimes even of decency.

Systematic cleanliness in workrooms is a term almost unknown, I regret to say, except in rare instances, observed, perhaps, in not more than 10 per cent. of the various trades of Birmingham, and, if a hundred workshops or manufactories were visited, I doubt whether, previous to the Factories Act Extension Act, 1867, more than 5 per cent. of them had been whitewashed in a decade, and since, from the relaxations embodied in that Act after the most persistent opposition by our Chamber of Commerce, and especially to the whitewashing clause, I doubt very much, up to the present time, whether the practice of whitewashing has by any means been general.

From the above outline of the different influences and surroundings of those occupied in daily labour in the North – and it must be remembered that females are more largely employed there than here; as many as 800,000 are computed to be engaged in the textile trades – it will be seen, and admitted, that the character of these surroundings is all-important.

The members of this Congress[11] will be able to account for the less favourable appearance here of operatives, generally in their dress, which partakes of the character of their homes-tawdry, not substantial, not what a Yorkshire lass would call wholesome or cleanly – and their contentment with a state of things that would not be tolerated in some parts of Lancashire and Yorkshire for 24 hours.

It is wearying to hear the working classes so continually rated for their shortcomings and preached to, whilst the class above, who have so many opportunities, and so many obligations to discharge, neglect both.

It has always appeared somewhat of a mockery to me that such efforts should be made by a community to erect hospitals to cure diseases, whilst so little is done by the same community to prevent them. Birmingham in every part of it is busily occupied in its thousand different trades daily, carelessly and thoughtlessly: aye! in the majority of workshops and manufactories preparing patients for the different hospitals and dispensaries, by its utter neglect and failure to observe the common rules of cleanliness.

It seems a sweeping charge to make, that our principal manufacturers, who live in suburban villas, surrounded with most of the luxuries of modern life, should be content to drive into town to their different places of business, and remain content when they see their workpeople occupied in the most loathsome of workshops, so unwholesome that they would be indignant if they were asked to use such workshops and hovels as stabling for their horses. Their stables and carriage houses, or even dog-kennels at their homes, are palaces compared with very many of their manufactories, and members of this Congress may, if they are so disposed, easily test it. Whilst they would be shown over the suburban establishment and have all the newest appliances explained to them, if they were anxious to penetrate the dirty hives that contain the sinful working bees some plausible excuse would be offered for not gratifying their curiosity.

I once knew a wealthy Birmingham brass founder who kept an expensive horse to ride backwards and forwards to his place of business; the horse was stabled at the manufactory during the day. The owner observing the horse was frequently unwell when in town, sent for a veterinary surgeon to examine the stable, and see if he could discover the causes of the animal's illness. This the "vet" soon did. "See," said he to the brass founder, "the fumes that pour out from the doors and windows of this casting shop, adjoining the stable, affect the horse's health; you must build him a stable in another part of the premises." This was done at once, the animal's health improved, but the brass-casters – who were only men, whose health was not considered, and whose lives were certainly not so valuable from his point of view as the life of a horse-worked on under the same unhealthy

conditions as before, and those of them not killed off by the noxious fumes continue working without a thought being given to them.

Till we have better influences pervading the towns generally – and I am sorry to say, Birmingham does not stand alone, all the towns surrounding Birmingham resemble us very much – till we have an "ideal" of what cleanly life should be, whether the ideal be created by our better educated and larger employers of labour, or whether the municipality set up the standard? till then, much of the philanthropic work of the many philanthropic institutions in our midst is neutralised. The late George Dawson once said, "What a famous thing it would be for this country if we could have a national annual scrubbing day."[12] A people lost in dirt are lost to much of their self-respect; lift them out of this dirt, and you elevate both man and woman in their own and general esteem. The elevating process is going on slowly. When women were prohibited from the degrading labour of working in coal mines, an immense advance was made in the home-life of the collier, and when they are prohibited from working on the pit banks another great step will be taken forward.

I have within the past year seen a pianoforte being taken into the cottage of a working collier in Bilston.

Again, Mr. Robert Baker, of Leamington, and Mr. George Smith, of Coalville, have done the greatest kindness to the wives of brickmakers in their efforts to limit the labour of females in the degrading occupation of brickmaking.[13]

Whenever a female loses her personal identity in the very dirty and repulsive occupations of some kinds of daily labour, from that moment one may expect self-respect to be on the decline. My experience of a quarter of a century amongst the various trades of Birmingham has taught me that the dirtiest shops in any trade are shunned till all others are solicited for employment and have failed: and that the dirtiest trades are only resorted to by females of the very lowest class, and only then from unfitness or disqualification, and all other occupations have been closed to them; and when once entered, they seldom are able to emancipate themselves.

To further restrict the employment of females in degrading labour I believe to be the surest means of improving their condition, physically, socially, and morally, the lady advocates for unrestricted employment of females notwithstanding.

Slow as all these changes are brought about, a change is coming over the habits of Birmingham industrial life; thanks to the unremitting efforts and untiring zeal, coupled with long experience, of Robert Baker, Esq., her Majesty's inspector of factories of this district.

When Birmingham trades were placed under the law in 1867,[14] license, liberty, and irregularity were rampant in many of them; men, women, and children were employed how and when some employers chose to employ them, and under any conditions. Mr. Baker kindly, but firmly, told the irregulars that this state of things would have to be altered, peacefully if they chose, but altered, nevertheless.

Happily, his tact and urbanity reconciled the most incorrigible to the change, and the improved physical appearance of children, half-timers consequent upon more wholesome factories and workshops, is largely owing to his labours.

There are other influences also at work new manufactories are being built more rapidly than at any former period. These new buildings are now constructed with some regard to health and to the requirements of kindly, exacting, and beneficent legal enactments.

When labour generally is carried on, and the conditions of it are influenced by a healthy public opinion, very many of the faults with which the working classes are now charged will have passed away. Give them these altered conditions, and they will not long remain content with the miserable shoddy houses that are provided for them by a sordid, soulless class of speculators notorious in this locality for the impunity with which they outrage, and cause to be outraged, the commonest decencies of life.

"House pride," a phrase in the North, that to most women belonging to the working class is and acts as a "talisman," is not understood or acted upon here.

Tens of thousands of our operatives, male and female, have never had any other school from childhood upwards, but the dirty, disorderly workshop, with its Saint Monday[15] devotees as exemplars; and its early and late hours as the week advanced, its grand device for recovering time lost in drunken bouts at the beginning.

The influences of the factory and workshop are undoubtedly the most powerful in the life of an operative; they may be good or bad; the employer is frequently the only person occupying a higher social position that the employed comes in daily contact with; how important then, that the influence should be of the right kind: what a powerful agency it may and could be made.

In these modern days, the large employer of labour occupies position relatively the same as that occupied in feudal times by the barons, when the welfare of those about them as retainers was a prime consideration.

We have had an Akroyd, a Crossley, and a Titus Salt,[16] to remind us that these great responsibilities are not universally ignored, but these noble representatives of the old love and care for dependents are too few and far between.

As a manufacturer, engaged in one of the staple industries of Birmingham, I maintain that there are not any insuperable difficulties to be overcome, by four-fifths of the trades here, in any endeavours employers may choose to make to bring about a better state of things. If they desire order, method, and cleanliness in their establishments, the reforms are easy of accomplishment, and the inclination for them exists. The great variety of trades, and large number of small masters – who are constantly with their workpeople, and, therefore, are supposed to have the influence of personal supervision – make the attempt easy.

If it is urged that reform may be brought about in the smaller establishments, whilst it would be difficult in the large ones, I still maintain that the will only is wanted to reach the desired end. My firm employ upwards of 400 operatives, three-fourths of whom are females; and I do not know of any beneficial change that suggested itself for our consideration, that we should hesitate to make.

The time-honoured institution of Saint Monday, for example, is not known with us. For many years the Saturday half-holiday is an institution that has been

observed. We should not tolerate absence from work on Mondays, through idleness, from the most skilled operatives we employed.

Again, we have a rule which is cheerfully obeyed, and it is this: that the floors of every room in the factory in which any persons arc employed be scoured with soap, soda, and hot water once the last week in every month. Some of the rooms are 150 feet in length. Every alternate month we have another rule, that the windows be cleaned throughout the works, and what is the result: why, an amount of cheerfulness and brightness not common in Birmingham manufactories.

It is scarce necessary to say that we have an annual whitewashing, so that each new year in the works is begun with clean rooms.

There is a library of upwards of 1,000 volumes which is free to all the employees; there is also a sick society, or club, in which for each penny paid as subscription, 2s. is received weekly in case of sickness, no one being allowed to subscribe more than 5d. per week.

We do not compel all who are in the works to become members; therefore, many who are seldom ill are not inclined to join.

The average sickness last year was four days for each member. Not having any knowledge of sick clubs that may be in existence in other manufactories, I cannot tell how it compares.

We had a very striking instance of how this habit of cleanliness in the workshops re-acted and stimulated to increased cleanliness. The works are heated by steam conveyed through 4-inch iron pipes, between one and two thousand feet, running through the different workrooms and warehouses. We never gave any orders about these pipes being kept clean at any time or in any particular manner, however, every month the females employed will laboriously blacklead them, and when asked why they do so, as some of them are partially out of sight, replied, "they looked so untidy against the clean walls and floors if not done." One day we noticed some girls industriously polishing the brass gas-pipes, quite a voluntary proceeding on their part. I mention these very small matters, but are gratifying and encouraging to those they desirous of cultivating a love of cleanliness and order in small things.

In conclusion, I would urge those employers who are sceptical of these good results to follow our example; the pecuniary outlay is not large for soap and flannel, or hot water, or for whitewash for the whole year. I would also urge these same employers willing, but doubtful, to try the experiment of meeting all their hands together annually at a social gathering. We have done it now for some years; the pleasure has been mutual. Working men and women are not surrounded by overwhelming refining influences, rather the contrary. An evening spent over a cup of tea with music and singing at intervals, a good supply of microscopic and other interesting objects, have an interest for those who have had as their only pleasure resort hitherto, the casino, the public house, or the gin-palace, and it demonstrates to them the possibility of spending an evening rationally and enjoyably without having resource to stimulants. It would be unjust to insinuate that these better influences were thrown away on them; it would to ourselves, as employers, be disheartening if it could be proved it was not productive of latent good.

These sanitary considerations and improvements affect the relations between employers and *employés* in many ways. They lengthen the service, and make that service a pleasure while it lasts. In our own establishment the feeling of attachment to us is shown by the following statistics of the length of service rendered by those at present in our employ:

|  |  | Per cent. |
|---|---|---|
| Under 3 years | | 30 |
| Over 3 and under 5 years | | 30 |
| "        5 | 10 | 20 |
| "      10 | 15 | 10 |
| "      15 | | 10 |

The business has only been in existence about 20 years.

At the present moment we have not a healthy public sentiment influencing the masses in the matter of cleanliness. The municipal authorities and other governing bodies of our town give little heed to it.

After our factories and workshops, the next dirtiest buildings belong to the Corporation and public bodies. Only last week the chaplain of the borough prison made formal application to have the rooms and passages of his residence (which belong to the town) whitewashed and coloured, pleading at the same time that they had not been done for six years.

Perhaps the most unwholesome public room that we have ever had in Birmingham is the lecture theatre of the Midland Institute; a room that is used periodically for the delivery of lectures on the laws of health. To my knowledge it has gone as long as six or seven years without a coat of whitewash. Again, our School of Art was whitewashed and cleaned down a year ago, the first time for eight or ten years.

If the governors of a town are so negligent on this subject, and practice at such long intervals the habits of cleanliness, it is sheer hypocrisy to upbraid the "governed" with their shortcomings. Dirt hangs like a pall over Birmingham, Wolverhampton, and Sheffield, and very many of our manufacturing centres, injuring the health of the mass of their several populations at the same time that it is degrading and debasing them. It is all the more remarkable that Birmingham, occupying such an advanced position in many matters, should be so indifferent to this momentous and vital question.

Finally, I attribute the more comfortable homes of the working classes in the textile districts to the wholesome influences that have been silently at work so many years, through the periodic and systematic observance of cleanliness in the manufactories there.

The homes of the same class here are as unlike as it is possible for them, and still be called by the same name. In the former, life is enjoyed; home comfort is a reality. In the latter, life is endured from necessity, so absolutely devoid

is it of the commonest appliances that should and do contribute to domestic enjoyment.

Employers of labour, many of whom

"From want of thought,
Rather than want of will,"

neglect to inculcate the love of order, method, and cleanliness, by not observing and not practising the same in their own workshops and manufactories. Municipal and other public bodies, whether literary, scientific, or educational, forget all the means of usefulness at their command, if they do not systematically, by their own example, inculcate the love for, by the practice of cleanliness. Corporate bodies should observe this in the scrupulous cleanliness of the public buildings in their charge, their various offices, &c. Other institutions of an educational character in their lecture-halls, classrooms, reading-rooms, libraries, &c.

As a large ratepayer of this borough, I should look upon the liberal disbursement of the rates for this purpose as one of the most legitimate items of outlay during the year,

If this paper should be the means of calling attention to a subject that has hitherto received but scant consideration, I think it may, another year, be taken up by abler hands, treated as a new branch of domestic economy, and form an interesting portion of the proceedings of your next Congress.

## Notes

1 "The Domestic Economy Congress." *Examiner,* no. 3675, 1878, pp. 844–845. The term domestic economy was not new, being first recorded in the OED in 1778.
2 "Domestic Economy Congress" *Punch,* 9 July 1881, p. 10–11.
3 "Domestic Economy In Birmingham" *Saturday Review of Politics, Literature, Science and Art,* 44, 1877, p. 102.
4 *The Reliquary and Illustrated Archaeologist* 18, April 1878, p. 251.
5 "Here" refers to Birmingham.
6 A Yorkshire range was a cast iron cooking range with the oven at a higher position that others.
7 Blacklead was a form of graphite used to clean and finish cast iron.
8 Health and Morals of Apprentices Act, 1802.
9 Factories Acts-various.
10 A disorderly collection; a jumble.
11 Domestic Economy Congress held in Birmingham in 1877.
12 George Dawson (1821–1876) was an English nonconformist preacher, lecturer and activist. He called for radical political and social reform in Birmingham, based on his philosophy known as the Civic Gospel.
13 Robert Baker (1803–1988) was a medical doctor and one-time chief inspector of Factories.
  George Smith, (1831–1895) persistently advocated the necessity of legislation on behalf of the brickmakers. He also lectured on the degradation, immorality, and ignorance of the workmen, and on the cruelties to which the children were subjected. (DNB)

14 Factory Act Extension Act 1867 that allowed the restrictions on working hours to be extended to workshops. It was from this year onwards that the majority of women in Birmingham were affected by these regulations.

15 Saint Monday. The tradition of taking Monday off (Saint Monday) had been common among craft workers who worked Monday to Saturday which was traditionally pay-day.

16 Lieutenant Colonel Edward Akroyd (1810–1887), English worsted manufacturer, Halifax. John Crossley and Sons, Carpet manufacturers Halifax, Titus Salt, textile manufacturer Bradford. All three were known to have a paternalistic view of working conditions.

# FLORENCE CADDY, *HOUSEHOLD ORGANIZATION* (1877)

## Editorial Headnote

Florence Caddy (1837–1923) was an English non-fiction writer who published a mixed collection of books including *Household Organisation* (1877), *Lares and Penates: Or the Background of Life* (1881), *Footsteps of Jeanne d'Arc* (1886), and *Through the Fields with Linnaeus; a Chapter in Swedish History*, 2 vols. (1887).

Mrs Caddy was married to a naval doctor who rose to become deputy inspector-general of hospitals and fleets. On his retirement it seems that financial difficulties encouraged her to turn to writing for some income. Her first published work, *Household Organisation* (1877), seems to reflect her reduced circumstances with its stress on budgeting and her claim that a lady should be able to turn her hand to any sort of work. In the Preface to the book, she argues for prudent home management:

> We do not hesitate to lay out money in improvements on our farms. Why, then, need we fear to arrange our dwellings in accordance with principles of true economy, so that the ladies of our families may be able to co-operate with us in advancing the benefit of all? Every family might be its own Economical Housekeeping Company (Limited), comprising in itself its shareholders and board of directors, realizing cent. per cent. for its money, because £200 a year would go as far as £400.[1]

Caddy reinforced this business-like model by commenting on the employment of servants: 'We have tried to keep ourselves as sleeping partners in the domestic concern; we have derived profit from our money invested in service, and we find that this is no longer a profitable investment'.[2] This concept of home management that mimicked the operations of commerce and industry ensured that homes could be made both profitable and successful for the later Victorian middle classes.

*London Society* noted the usefulness of this text in their review:

> Mrs. Caddy's work on household organisation is one of considerable value. The good sense that pervades it throughout will commend itself to every reader. Her attention has been drawn to the subject mainly by the prevailing want of good servants. Her main remedy is that people should wait upon themselves and each other. She is full of methods for abbreviating labour, and is of the opinion that each gentleman should empty his own bath, and the boys of the house should do their own boots.

The reviewer concluded by noting that 'There are few households where something may not be learned from a little book like this. The subject is one of the

weak points of English life'.[3] The issue of a lack of servants was a growing concern for many from this time.

Other reviewers agreed. The *Saturday Review* commented that: 'Meantime it is fair to say that, though the author of *Household Organization* may raise a smile now and then by her somewhat stilted style, still her practical hints and moral and economical advice are very far from being contemptible.'[4]

In a review of her other book on houses titled *Lares and Penates*, the *London Quarterly* also poked fun at her style but agreed her work was worth reading:

> What are we to say about Mrs. Caddy? When a lady calls one house a narcissus, and another a Florentine tulip, and when she says that in Mr. Fitzmaurice's London mansion 'the keynote is struck at once, the tone given; that tone is porphyry, with its major-third in gold, while each room is a distinct chord of colour – a grand theme, a Spanish organ strain, the music varied by sweetly – solemn bursts of trumpet-sound from its range of horizontal pipes', one is tempted to close the book and think of Postlethwaite in Punch.[5] What are the horizontal pipes? Does she mean the hot-water apparatus? But, in spite of a good deal of this rubbish, Mrs. Caddy is worth reading.[6]

This section from the book is a chapter on Bed and Dressing rooms which addresses a number of contemporary issues including the need for ventilation, the removal of 'clutter', the matter of fire risks and the need for men to consider the actual needs. This section is one of a number of topics addressed that include the usual rooms but also topics such as 'Lady-help', 'Education of Girls' and 'Sunday'.

# 26

# *HOUSEHOLD ORGANIZATION*

## *Florence Caddy*

Source: Florence Caddy, *Household Organization* (London: Chapman & Hall, 1877), pp. 155–75

We pass a third of our time in our bed-rooms when we are in health, and the whole of it when we are ill; therefore their ventilation and general arrangement demand our most earnest consideration.

Some bed-rooms are draughty, occasioning cold and neuralgia, but the more common fault is that they are not airy enough; for with our extreme attention to what is called "English comfort," we too frequently make our bed-rooms almost air-tight.

This causes restlessness by night and headache by day. It were far better to accustom ourselves to sleep with our windows open, as the night air is not at all injurious in dry weather, unless an east wind is blowing. We must be guided by the weather, and trim to the wind; our feeling will tell us whether we may, or may not, safely leave our windows open much more surely than the almanac. The time when windows should be shut throughout the house is when the dew is rising and falling; then the damp enters and saturates everything.

People seldom attend to this point, but keep their windows open too late in the afternoon, which in Italy is recognized as the dangerous time. We have but little malaria in England, but what little there is, is at work just before and after sunset. Many persons, too, who like myself have immense faith in fresh air, throw open their windows on leaving their rooms in the morning, regardless of whether the air be dry and warm, or whether a fog or bitter east wind will penetrate the whole house to damp or chill it. It is more prudent, in case of bleak or raw weather, to wait for an hour or two before opening the windows, ventilation from the door being sufficient for the room while it is empty.

It is useless to lay down laws as to the windows in our variable climate. We must work by our natural thermometer, and let our skin perform one of its most useful functions and tell us whether it is cold or hot; but if our feelings are uncertain, give judgment in favour of fresh air.

If your rooms have the old-fashioned long and narrow windows which are always found in houses built in the reigns of the early Georges, the Japanese paper curtains,[7] being very cheap, are as good as any, the intention being to drape a skeleton window, which curtainless is a dismal object.

DOI: 10.4324/9781003290490-34

But more modern windows should not, or at least need not, have long hanging curtains, but only just sufficient to cover the window without leaving a streak of light. The drapery may hang from one side or from both, according to taste; but unless you are very particular to admit no light in your bed-room, a mere valance, or some ornament at the top of the window, is enough. For instance, some pretty design in fretwork, as the tracery of an Arabian arch, made of deal an inch thick, cut out with a steam saw and stained or enamelled black, would be effective when lined with rose colour, or any drapery suited to your room; and you might furnish an appropriate design for the fretwork. This would be easily dusted, and is not expensive.

White blinds are clean and pleasant for bed-rooms, but dark-green ones are better for persons with weak sight; either these or Venetian blinds are very useful where there are no shutters.

Brass and iron bedsteads have almost entirely superseded wooden ones, and they are generally made without fittings for curtains. Indeed, in our well-built modern houses there are so few draughts to be guarded against that curtains are seldom necessary.

In bed-rooms of the present time valances to the beds are quite superfluous, as the bed-round is completely out of fashion. This was the name of the breadth of carpet which went round three sides of the bed, leaving the remainder of the floor bare. The fashion was healthy and economical, certainly, but it was tryingly ugly and cheerless.

For a bed-room, nothing is so good as the square carpet, with a broad margin of the floor stained and varnished, as this is very easily taken up for the floor and carpet to be cleaned. The carpet must be laid down the first time by a man from the carpet-warehouse, so that it may be evenly stretched, which is seldom done by a carpenter; but after that it is easily spread, as it remains in shape, and needs very few nails to keep it in position.

Bed-room carpets need not have brown paper laid under them, though this is an advantage in other rooms, as it keeps dust and draught from coming through the cracks of the floor, besides saving the carpet from being cut by the edges of the boards. Kidderminster carpets[8] are now made in very nice patterns, and are quite suitable for bed-rooms where Brussels carpets[9] may be thought too expensive.

A hearth-rug is more useful in a bed-room than elsewhere, as a bed-room fire should be of coal or wood, and not of gas, as this is injurious in a bed-room.

Take care never to let the head of the bed be placed before the fire-place. This is sometimes foolishly done, and unsuspecting sleepers get neuralgia from it. In summer a pretty pattern, cut out in tissue-paper so as to resemble lace, tacked on a slight frame covered with black tarletane,[10] and fitted into the fire-place, allows ventilation and keeps out the dust from the chimney. Little girls love to cut these fire-papers, and one of them, with care, lasts two summers, and often three.

When there are no bed-curtains, it is sometimes advisable to line the ironwork at the head of the bed, so that the sleeper may not be exposed to draught. Spring mattresses, with soft woollen mattresses upon them, are the most comfortable

beds of any; and Heal's folding spring mattresses,[11] though expensive, cannot be too strongly recommended. These spring beds are so easily made up, that this is a matter of very trifling consideration in any house where there are two pairs of hands, children's or grown-up people's. It is necessary to turn back the bed-clothes completely over the foot of the bed, and leave it to air for an hour, at least, after the window has been opened. There is a great fancy now for having trimmed pillow-covers, and pieces of ornamental needlework to spread over the bed after it is turned down; the fashion is pretty, but superfluous, as a nicely worked coun-terpane looks equally well, and need not be folded up at bedtime.

Towels may, and should be, ornamented, but not so much as to make them inconvenient for use. The collection of linen exhibited by the Duchess of Edin-burgh gave many of us an interesting lesson in things of this kind. One of the silliest pieces of finery seen in a bed or dressing room is the trimmed towel-horse cover. Towels cannot possibly dry if the evaporation is stopped, and even when the cover is made of thin muslin, it is only a troublesome frivolity.

Every lady has her own particular taste about her toilet-table, so that I only give a caution to let it be safe, and not liable to take fire. We frequently want candles on our dressing-tables; therefore it stands to reason that the veil often placed over the looking-glass is highly dangerous. This drapery is intended to keep the sun from scorching the back of the glass, but it is safer to stand the glass elsewhere than in the window when the room is exposed to the midday sun, although it will not be so pleasant for use.

The rose-lined white muslin petticoat which was once such a popular way of concealing a deal dressing-table is highly dangerous. Indeed, it is difficult to con-ceive any combination more inflammable than the veiled glass set in the midst of cotton window-curtains, and two candles standing on a cotton toilet-cover, with a frilled muslin pincushion between them, and full muslin drapery below.

The most convenient table allows the large square-seated stool, so comfortable to sit on while dressing the hair, to be pushed under it when not in use. When light ornaments are placed on a bed-room mantelpiece and exposed to a current of air, it is advisable to have two upright pieces of board, painted, cut out, or otherwise made ornamental, placed one on each side of the shelf to protect the knick-knacks from being blown down; and if these are numerous, one or two shelves may be put above the mantelpiece, forming a pretty little museum of curiosities which may be too small, or too trifling, to be placed with advantage in the drawing-room; and houses of the class I am describing seldom have a boudoir. If the mantelpiece is covered with cloth or velvet, the shelves and back might be covered with the same, and this would be very becoming to the ornaments. Tunisian or point lace forms a very good edging to a mantelboard, and when a foot deep, or nearly so, it is extremely handsome. Water-colour sketches should abound in a bed-room, sou-venirs of places we have visited, or of friends who have made the drawings, being doubly enjoyed when we are recovering from illness, or when we are awake early in the summer morning. Sketches are as pleasant as books, without the trouble of holding them up to our eyes. They should be carefully arranged so as not to look

spotty; and they must be hung flat against the wall by having the rings placed high in the frames, as, although it is becoming to the pictures, the effect of them hanging much forward makes many people giddy, and in an invalid will sometimes produce a feeling akin to sea-sickness.

Neatly made frames of the cheap German gilding (which will wash) answer very well for sketches hung in the less prominent situations in a bedroom, and bring a luxury within the reach of many who would not otherwise afford it.

Now I am come to the difficult part of my subject – the tug of war, in fact – for I want men to do something for themselves, and women to do without something dear to their hearts. I think I will speak of the latter clause first.

In bed-rooms especially is seen that truly English love of superfluous comforts which we mistake for civilization: it meets us everywhere, in and out of the house, but it abounds in our bed and dressing rooms.

The amount of toilet so-called necessaries is incredible, and the number of patent objects overwhelming. When we consider that seven things only are necessary to our personal neatness and cleanliness – soap, sponge, towel, and tooth-brush for washing, and brush and comb and nail-scissors for the rest of the toilet – and then count the other paraphernalia seen in our dressing-rooms, we shall discover how many frivolous trades our superfluities maintain, to say nothing of ingenuity misplaced in making advertisements of dressing-cases and hair-restorers conspicuously attractive.

The toilet-table is not alone to blame: the fault pervades the whole house and overwhelms the bed-rooms.

M. Taine, in his "Notes on England,"[12] amusingly describing an English house, says, "In my bedroom is a table of rosewood, standing on an oilcloth mat on the carpet; upon this table is a slab of marble, on the marble a round straw mat – all this to bear an ornamented water-bottle covered with a tumbler. One does not simply place one's book on a table: upon the table is a small stand for holding it. One does not have a plain candlestick: the candle is enclosed in a glass cylinder, and is furnished with a self-acting extinguisher. All this apparatus hampers; it involves too much trouble for the sake of comfort."

This was only a bachelor's room; what would the French critic have thought of the aids to reading in bed in an ordinarily well-appointed bed-room where the master indulges in that practice?

By the Englishman's bedside is also a small table standing on a mat, and on this table another mat supporting a patent stand which screws up and down, and on this another mat with a candlestick with a nozzle and a patent protector of the candle from the draught, a glass shield set in an ormolu frame which has an elaborate screw; and by the side of the candlestick-stand another mat, on which is a patent screw for shading the light from the aforesaid candle. Then, besides the extinguisher, also on a stand and a mat, and patent matches in a patent box, he is supplied with a book-rest which will turn in every possible way, with a patent leaf-turner and leaf-holder, and a variety of other little conveniences. He only lacks an electric communication between the fire-escape outside and the patent

night-bolt on his door, to prevent him being burnt in his bed, to make the thing complete.

We feel how difficult we have made life by having to put all these indispensables to their intended use. We have multiplied these patent gimcracks until we cannot move without being crushed by our comforts; and the keeping of all this in order obliges us to have under us a parlour-maid, an upper housemaid, and an under housemaid, to wait upon these inventions. Helps,[13] in one of his essays, says, "I have always maintained that half the work of the world is useless, if subjected to severe scrutiny. My idea of organization would be to diminish much of this useless work." The same remark applies to our luggage when we travel. We take things fancying. We may want them, forgetting that it is easier to do without an article once, than to have the trouble of packing it and looking after it every day; so we bury our pleasure under a heap of care.

I must give another extract from Taine's description of his bed-room before I proceed to my second great battle-field, where I fear a harder contest.

After describing his dressing-table, Taine goes on to say of his washstand: "It is furnished with one large jug, one small one, a medium one for hot water, two porcelain basins, a dish for toothbrushes, two soap-dishes, a water-bottle with its tumbler, a finger-glass with its glass. Underneath is a very low table, a sponge, another basin, a large shallow zinc bath for morning bathing. In a cupboard is a towel-horse with four towels of different kinds, one of them thick and rough. Napkins are under all the vessels and utensils; to provide for such a service, when the house is occupied, it is necessary that washing should be always going on. The servant comes four times a day into the rooms: in the morning to draw the blinds and the curtains, open the inner blinds, carry off the boots and clothes, and bring a large can of hot water with a fluffy towel on which to place the feet; at midday and at seven in the evening to bring water and the rest, in order that the visitor may wash before luncheon and dinner; at night to shut the window, arrange the bed, get the bath ready, renew the linen; – all this with silence, gravity, and respect. Pardon these trifling details, but they must be handled in order to figure to one's self the wants of an Englishman in the direction of his luxury: what he expends in being waited upon and comfort is enormous, and one may laughingly say that he spends the fifth of his life in his tub."

Men will do much for glory and for vainglory, even to using cold shower-baths in winter, and boast of breaking the ice in them; but I never yet heard of a man who would take the trouble to empty his bath after using it. Now I maintain that every man who has not a valet ought to do this. Few men consider the hard work it is to a woman to carry upstairs heavy cans of water; but that is trifling, compared with the difficulty to a woman of turning the water out of a large flat bath into a pail. A man would find little difficulty in doing this; his arms are longer, his back stronger, and his dress does not come in the way.

When a man likes to have his bath regularly – and who does not? – he should think of the labour that half a dozen or more baths entail, and in the evening prepare his can of water for tomorrow's use, place his own bath on his piece of

oil-cloth, enjoy his tub to his heart's content, pour away the water, put up his tub, and say nothing about it.

This disagreeable lecture over, we will go on and see how easy the general dressing-room arrangements might be made.

If, instead of our ordinary washstands with their jugs and basins, we had fixed basins with plugs in them and taps above, much of the water-bearing difficulty would be obviated. These washstands should be placed back to back, as it were, in every two rooms, having only the partition-wall between them, so that the same pipe would supply two taps.

I have three sorts of basins in use in my house: one kind has the ordinary tap and plug, another kind has handles for supply and waste, the water being sucked away on turning the waste handle. This is safe for careless people who let rings, or any other articles drop in the basin, and nothing but water can go down to choke the pipe. But the basin I find easiest and most pleasant to use, tilts out the water by lifting a handle, or rather finger-niche, in front of the basin; and when this is let fall it strikes on an india-rubber pad beneath the tap, so that the basin cannot be cracked. All these different basins are fitted into marble washstands with dishes for soap and tooth-brushes hollowed in the marble, with holes for drainage connected with the waste-pipe below. These conveniences, with a housemaid's-closet with sink and tap on the same floor, save all carrying up and down of pails and cans of water, and, in fact, the heaviest part of a housemaid's work.

Where the hall is warmed by hot-water pipes, water from the same source will supply the bedrooms. It will be warm if the first quart is allowed to flow away. Or the pipes may be connected with the kitchen boiler, which, in the case of our kitchen on the ground floor, will not be so expensive as where the pipes have to communicate with the basement.

Supplying the taps is perfectly easy when only cold water is required, and children and delicate persons may be indulged with jugs of warm water, which, however, every boy using should fetch for himself. We should thus be able to dispense with ewers and toilet-cans, which would at once pay for the fitting of the pipe and tap to each room.

It is better and nicer to use filtered water for the toilet-decanter, and not water drawn directly from the cistern, unless it has been tested and found pure. In such a case, which is rare, no decanter will be needed, unless we like to have a Venetian glass one for the sake of its beauty.

Let all persons, in dressing, replace the things they have used, and spread their towels on the horse to dry; then the rooms will be set in order for the day, only needing the daily dusting, which will be done after the beds are made. Boys and girls who go to school should make their beds before they go, so they must open them to air immediately they get up.

"These seem little things: and so they are unless you neglect them" (Sir A. Helps).[14]

Everybody should have his or her own wardrobe, and keep it in order. Men and boys and little children will have everything neatly made and mended for them,

and laid in its proper place; so all they have to do is to leave the drawers as tidy as they found them, taking heed not to lose their gloves and neckties; the larger things take care of themselves. The secret of keeping one's clothes tidy is not to have too many.

Of course, where there are no servants to provide for, the house has fewer rooms than a family of the same size requires in our present experience, and the uglier part of the house is abolished, or where not abolished, is converted from servants' bed-rooms and attics – unpleasant, dusty, and ill furnished; redolent of tallow candle, shoes, brushes, and stale perfumery; with closed windows and the floor strewn with old letters, hair-pins, half-empty matchboxes, and dogs-eared penny novels – into a bower-like study or morning-room, where a young lady may entertain herself and her own especial visitors. I have even known an attic in Baker Street so converted by the invention and taste of a young lady, as to live in one's recollection as pretty as a summer room as any country rectory could boast, by being papered with bright flowery paper all over its sloping roof, and its window made cheerful with climbing plants and flowers; tasteful draperies, a work-table and work-basket in embroidered green satin, book-shelves carved by friends, a piano just good enough for practising upon, and water-colour drawings on the walls.

I have known another room, cheaply fitted up in a French style by a French lady, as a dressing-room, with looking-glass wardrobe and painted furniture. A small bed in an alcove, in case the room might be wanted as a spare room, and lace curtains drawn over the alcove. The head of the bed and all its plain wood-work covered in quilted white cotton in large diamonds, and cross-barred with narrow blue satin ribbon, and large blue bows here and there. The walls papered with a paper resembling quilted muslin. The effect was soft, clean, and extremely pretty.

## Notes

1 Caddy, *Household Organisation*, Preface.
2 Ibid p. 3.
3 Review: *London Society*, vol 31, 1877, p. 477.
4 Review: *Saturday Review of politics, literature, science and art London*, 43, Mar 17, 1877, pp. 319–320.
5 Jellaby Postlethwaite an 'aesthetic poet' is a cartoon character drawn by George du Maurier for *Punch* from 1880.
6 Review: *London Quarterly and Holborn Review*, Vol. 56, 1881, Page 550. The house she is discussing here is the home of the millionaire Alfred Morrison at Carlton House Terrace, London.
7 Probably introduced into England at the London Exhibition 1872, they looked like chintz, and were very cheap. They had a short life and could not be used near fire sources so lost popularity. *The Furniture Gazette* (1890, p. 68) noted that: "The so-called Japanese paper curtains were for a time popular, but a more undesirable substitute for woven stuff can hardly be imagined, as no amount of ingenuity could produce graceful folds from these stiffened absurdities."
8 Two-ply ingrain carpet originally woven at Kidderminster.
9 Loop warp pile carpeting.

10 Tarletane: a fine open muslin, first imported from India and afterwards manufactured in Europe.

11 In 1860 Heals of Tottenham Court Road, London, patented their 'Sommier Elastique Portatif' which was a foldable sprung bed base.

12 Hippolyte Taine., *Notes on England*, (London: Strahan & Co., 1872), See 1.33 below.

13 Sir Arthur Helps, *Companions Of My Solitude. Essays Written In The Intervals Of Business*: (London: Smith Elder 1879), p. 382.

14 Sir Arthur Helps, *Essays Written in the Intervals of Business* (London: Pickering, 1843), p. 104.

# MRS MARY HAWEIS, *THE ART OF HOUSEKEEPING: A BRIDAL GARLAND* (1889)

## Editorial Headnote

Mary Eliza Haweis, née Joy (1848–1898) was a British author. She was the daughter of genre- and portrait painter, Thomas Musgrave Joy. In her youth, she developed skills in painting and drawing. However, after marriage to Rev. Hugh Haweis, she engaged with literature and history, particularly writing and illustrating editions of and about Chaucer.

She was adept at managing her own life, being not only a wife and mother but also as a socialite who managed to project an image which was really more than her income would allow. She was also a serious scholar, who later in life developed a close interest in women's causes especially the suffrage question.

Haweis was quite prolific in her output and published important works related to homes such as *The Art of Beauty* (1878), *The Art of Dress* (1879), *The Art of Decoration* (1881), *Beautiful Houses* (1882), and *The Art of Housekeeping* (1889). In relation to her publications, the *Dictionary of National Biography* noted that in 'endeavouring to establish some sound canons of taste in the minor arts, she embodied her views with vivacity and piquancy'.[1]

In the *Art of Decoration*, Mary Haweis had already suggested the idea of furnishing to a planned design or 'system', with the clear inference of the need for professional input from an artistically trained decorator rather than a fashionable vendor. She explained that

> To make a beautiful and artistic room it is not sufficient to collect a mass of good materials and mix them together. You may spend a fortune at a fashionable decorator's and make your house look like an upholsterer's showroom; or you may fill your house with antiquities of rare merit and calibre, and make it look like an old curiosity shop; but it may be most unpleasing all the same. The furnishing ought to be carried out on some sort of system.[2]

Haweis makes her meaning completely clear in this passage:

> It is the delicate, practised perception which places such a colour here, such another there – which feels how to craftily mingle richness with paucity of colour, so as not to tire the senses. . . . This discrimination divides the born decorator from the mere purveyor of reigning fashions, the artist from the upholsterer.[3]

*The Art of Housekeeping* was a very practical manual that was addressed to her own daughter to whom she wrote in the first chapter:

> DEAR CHILD. – This book is not intended for young ladies who marry for money, or who think it ridiculous to do anything for the home provided for them by an injudicious admirer, and vote it quite a disgrace to look at every sixpence before flinging it into the gutter.

She then goes on to explain how 'I shall draw your attention to the lowest details of elementary housekeeping, as the foundation for any superstructure which your own life experience may enable you to build'.[4]

*The Bookseller's* review was supportive:

> Mrs. Haweis not only conveys her information in a crisp, chatty style not often met with in these manuals, but has contrived to get into this small compass almost everything which a wife ought to know and practise. She discourses upon all that pertains to good housekeeping, recommends the most reliable tradespeople, and goes into matters so practically that the book may be specially recommended.[5]

She tried hard to disguise the need for her to publish as a source of income, but with *The Art of Housekeeping* she demonstrated some of the thrifty tips she no doubt practiced herself. For example, in a later part of the book dealing with cost management she wrote that 'The secret of good housekeeping is to have no waste',[6] and she demonstrated with various examples. This extract shows Haweis's approach to managing servants, their time schedules and work patterns with a bottom line that says keep as few servants as possible. The ideas expressed by Mrs Caddy twelve years earlier (see text 1.26) are also evident in this work.

# 27

# THE ART OF HOUSEKEEPING: A BRIDAL GARLAND

## Mrs Mary Haweis

Source: Mrs Mary Haweis, *The Art of Housekeeping: A Bridal Garland*
(London: Sampson Low, Marston, Searle & Rivington, 1889), pp. 79–86.

## ARRANGEMENT OF WORK

### Too Many Servants

Women collectively, no doubt, bring their own domestic troubles on themselves. But innocent individuals certainly suffer for the neglect and selfishness of others all the world over, and it by no means always happens that one's own troubles are one's own fault, though they may be. One of the causes of trouble with servants is because people keep too many. Another is, because a neighbouring registry office bribes them away as fast as they come. Here is a cause of multiplication, the sooner regulated by authorized committees of management, the better. I remember going through a phase of great trouble with servants. I think I had twenty men-servants one year, and three or four cooks. I felt SO grand. But I could have dispensed with this grandeur, and did after a time. No one ever came down in the world with a better grace.

People keep too many servants, chiefly because mistresses do not take the trouble to calculate how much work can be properly done by one person, and half the mischief, social and moral, which is the chronic result of a number of over-fed and under-occupied domestics being boxed up together in a very little space, and with very little exercise, is directly due to this ignorance, and an amiable (but feckless) wish not to overwork anybody.

Servants in decently-conducted houses are seldom over-worked. The men-servants in particular, very commonly suffer in health from the want of out-door exercise, and of anywhere to go, and anything to do, when they are off duty. Quarrelling, smashing china, flirting, with sudden and inconvenient changes soon after, are oftener due to the servants not having enough occupation to fill their lives, nor enough change to vary their lives, than to the horrors of "servitude." Pray, could our own sons and daughters do differently under similar circumstances

DOI: 10.4324/9781003290490-35

Servants generally rise at 7 (they call it 6), they breakfast at 8, they lunch at 11, they dine at 2 or before,. they have tea at 4.30., and they have supper at 9: Between these meals, for which about half an hour or more is allowed, there is hardly time for a strong man or maid to get very tired. In most well-conducted gentlemen's houses, the housemaids and their underlings are required to be dressed for their dinner, and as there is no very dirty work in the afternoon, the time between dinner and tea admits of sufficient rest – not necessarily idleness – to enable them to digest their many meals easily, and recover in time to close the house, and do the usual not very arduous afternoon duties. Most servants get off doing much in the evenings (unless much company is kept), which are therefore practically their own, and this is reasonable. It is not a hard life and the cook, who has kitchen maids to wait on her, the housemaid who has an under housemaid to do half her work, and the under-house maid who has a girl up and down "to save her", added to the butler, who has young footmen seething with repressed energy, learning to wait on him with velvet feet – these form a considerable crowd to sit in one kitchen (or one lower hall, if there is one). We experience nothing like it, except in a mixed boarding house, where the guests are expected to "join in conversation." What are they to do, but what they do do? In homes of their own they would have endless occupation, the daily anxiety of "business," good or bad, accounts to balance, unlimited children to rock, clothes to wash, rent and taxes to meet, the public to circumvent. Here nothing! Can we wonder that propinquity leads often to unfortunate adventures, that temptation and bad company for one communicates itself to the rest, because they cannot get away from each other – that they quarrel, because tongues run too fast, reading is well-nigh hopeless, and a general *laisser auter*, born of having no responsibilities, grows up? Servants have to give in to one another, back up one another for a variety of reasons. If one asks in a friend, the others must, or jealousy follows; if they are allowed to bring in good friends, they cannot keep bad ones out, and they have their social difficulties with a "mixed circle" which we do not always allow for. It is a ticklish position, service, with all its comfort and luxury and freedom from heavy cares, and I doubt if we were in similar circumstances, perhaps imperfectly brought up at home, trained haphazard in service, with no cares but those imported, we should do any better, or half as well.

Keep as few servants as you possibly can. If it can be arranged, let the men-servants sleep out, or all but one. Give the men a sitting-room distinct from the women, that there may be the possibility of privacy. Give every servant plenty to do, and see that it is done; give them meat only twice a day, and no beer. Replace the eternal beef and beer with sweets or some variety in food, such as we ourselves demand, and for drinks, water, lemonade (which is cheap enough), or the American fashion of tea. Give them opportunities of seeing exhibitions, theatres, museums. Show them that you take an interest in their individual comfort, without trying to enter into their affairs (which they detest), and they will be found, as a rule, a very kindly, self-controlled, and pleasant class of people.

## How Much Work

How much work can a healthy young servant undertake? The cook, if she has much cooking to do, and for many persons, can do nothing else. The washing-up takes a long time; the hot fire is enervating, the anxiety of "dishing-up" is exhausting – to a certain extent. If the cooking is only moderate in amount, as it is in most private houses, she ought to keep all her own departments clean without help, and do it well. If the cooking is but little, say for two upstairs and one, two, three, or even four downstairs, the cook can take care of the hall, front steps, and one small room, and do it well. She ought not to have to cook for the family breakfast much before 8.30. or 9. That gives her at least an hour for dusting and skirmishing, and half an hour for the kitchen breakfast, if she leaves her kitchen in perfect order overnight and a good clean cook scrubs her table, washes her hearth, and, in summer, blacks her grate before she leaves the kitchen.

The housemaid takes all the rooms above the hall, her pantry, plate, china and glass. She can take charge of from six to twelve or fourteen rooms, according to their size and contents, and according to the frequency with which she is expected to dismantle and "turn them out." A housemaid can easily clean one room a day; there are six days in a week; if she has to turn the rooms out weekly, she can only take five or six, unless she is allowed to clean them in the afternoon. If she has to turn them out once a fortnight (quite often enough when properly done, for it involves less wear and tear of carpets and curtains, and is less inconvenient to the family), she can take twelve, thirteen, or even fourteen, for some are sure to be small enough to take in couples, and yet there will be time for her to dress by one o'clock. As a rule, a room turned out every week is not very thoroughly done, the maid often argues, "it will be done again in a few days." When a room has to last a fortnight, every piece of furniture must be shifted out, the corners must be seriously tackled, else the housemaid is sadly disgraced in ten or eleven days by the accumulations of dust. It must be remembered that a fair-sized room takes fully three hours to clean properly, and the housemaid must not begin later than ten on such a morning, therefore her bedrooms must be actively discussed. All the ornaments have to be removed to another room or packed on a central table and covered with a clean dust-sheet, like the chairs, which should be rubbed and brushed before turning out of the room (some ladies prefer these packed in the middle of the room and covered up) then comes the sweeping, after which the housemaid will make time to run down for her "lunch" of bread and cheese and glass of let us hope not beer. The dust takes half an hour to settle, and during this process, a few ornaments can be washed or metal goods polished. Then comes the tidying and the beeswaxing, and last the dusting.

A mistress should peep at corners, high shelves, &c., *herself.*

With every servant, on arriving and leaving, go carefully over the list of things entrusted to her care, which is usually written in her book. Note breakages, cracks and damages, and replace losses before the new servant enters. This is a great trouble, but it must be done, or if not done, the housekeeper will rue her indolence. A good servant will insist upon it in justice to herself and her employer.

## List of Days for Cleaning

The following is a good list of days for work, if the rooms are cleaned out weekly.

### List A

Monday, 1 bedroom, and washing (dusters, odds and ends for self and mistress).
Tuesday, 1 bedroom, dressing-room and ironing.
Wednesday, Drawing-room.
Thursday, Library and bedroom (if both very small).
Friday, Dining-room (if not undertaken by cook) or another
Saturday, Bedroom and plate, castors seen to, &c.

The following is a better one, the rooms being turned out fortnightly, and here it will be seen are several reception-rooms, and about nine bedrooms.

### List B

Monday, Servant's bedroom and another (2).

Tuesday, Drawing-room (r).

Wednesday, Washing, stairs and rods.

Thursday, Best bed and dressing

Friday, One or two bed rooms (2).

Saturday, Upper passages.

Monday, 2 small bedrooms (2).

Tuesday, Library (1).

Wednesday, Washing, stairs and rods.

Thursday, Waiting, school, or room (2). odd room (1).

Friday, Bathroom or other required (2)

Saturday, central passages.

If much washing be done at home, a day should be reserved, otherwise two days a week are best devoted to personal and other 'washing,' and to shifting the stair carpets, with a little allowance for oversights I mean by that, a margin for forgetfulness, and possible toothache, headache, or something which may make the girl less active one day than another, should be allowed by making two of the days "light." It is unwise to openly admit or court such contingencies, but, of course, they will occur, as maidservants are but human. The above list includes one very heavy morning in each week, three moderate, and two light.

Every afternoon, if not too much occupied with answering the door, and if she has no plate or lamps to clean, the housemaid should be expected to give at least two hours to needlework, she must keep the table and household linen in order, and do odd jobs.

Some ladies find it a good plan where there is time and occasion, to have night dresses, chemises, and other tiresome work done by the housemaid and cook, if capable and willing, in the evening, *paying them for this* at a reasonably liberal

rate. It is wonderful how much work is sometimes then got through, and how few ink spots deface the kitchen tables!

## Notes

1 *Dictionary of National Biography*, 1912, Supplement.
2 Mrs Haweis, *The Art of Decoration*, (London: Chatto & Windus, 1881), p. 201.
3 Ibid. p. 69.
4 *Art of Housekeeping*, pp. 1–2.
5 *Bookseller*, 14 December 1889, p. 1365.
6 *Art of Housekeeping*, p. 121.

# SPENCER SILLS, *COMMON-SENSE HOMES: A PRACTICAL BOOK FOR EVERYBODY UPON THE ESSENTIAL EQUIPMENT AND TREATMENT OF THE HOME* (1912)

## Editorial Headnote

In July 1842, a most important publication, titled, 'Report on the Sanitary Condition of the Labouring Population of Great Britain' marked the beginning of attempts to improve the health of the populace, particularly in towns. Many of these improvements revolved around the nature of house building and equipment and there were numerous subsequent publications that addressed the problems. These critics were interested in both the public health of towns and the domestic health of homes. Numerous authors tried to tackle the problems that were all too evident. These included builders, architects, medical practitioner as well as domestic advice pundits. A small sample would include the following texts:

* William Hosking, *Healthy Homes: A Guide to the Proper Regulation of Buildings, Streets, Drains, and* Sewers . . . (London: John Murray, 1849).
* William Bardwell, *Healthy Homes, and how to Make Them,* (London: S.A. Gilbert, 1854).
* P. Thompson. *Healthy Moral Homes for Agricultural Labourers. Showing a 'Good Investment' for Landlords with Great Advantage to Tenants.* . . . (London: Longman, Green, & Co. 1863)
* Stanley Haynes, *Healthy Homes* (London: Bailliere, Tindall, & Cox, 1881)
* Robert Brudenell Carter, *Our Homes, and how to Make Them Healthy,* (London: Cassell, 1883).

Sills was one of this long line of sanitary reformers and advisors who tried to influence the design of houses and their internal planning to mitigate health related problems. Sills, one-time assistant surveyor of the town of Rochester, Kent, was a member of the Society of Engineers, the Royal Sanitary Institute and the Institution of Municipal Engineers.

In this text Sills implores readers to ensure their homes are healthy and avoid building faults that might cause insalubrious conditions

In 1913, the *British Architect* rather satirically reviewed the work saying it

is a common-sense book, evidently written for those unfortunate people who are lacking in both a practical and artistic sense. Those, alas! are the people who surely will not be the readers of this essentially practical book. To those who are endowed with their own ideas as to design and decoration, the book may be instructive, if not amusing. Mr. Sills leaves nothing to the imagination! The primary use of a bedroom, he tells us, is

for a bed! That is comforting. We might have thought that in Mr. Sill's love – nay, passion for the inclusion of sun and air, and the exclusion of germs, we should, perforce, be exhorted to keep the bedrooms as a means of scrubbing exercise for the servants, and sleep in a perforated zinc arrangement, hung in a through draught.

They went on to express some dismay at the degree Sills was proclaiming his war on diseases arising for poor domestic sanitation and management.

We like to see what the lady thinks about such a book as this, and handed it to a young married lady of our acquaintance. She writes: . . . I felt that possessing a house would be a lifelong war with every ill that flesh is heir to, and every disease that bricks, mortar, wood, glass yea, even china – can bring! If the author's object is to prevent people buying or renovating old places, he will perhaps achieve his wish, for the book is written in a peculiarly convincing style. If, on the other hand, he merely wants to lead us to be practical, I fear his time and trouble have been thrown away, as a common-sense person would be so alarmed with this common-sense book that he would close it with relief, soak both it and himself in a disinfecting fluid, and renounce homes for ever.[1]

# 28

# COMMON-SENSE HOMES: A PRACTICAL BOOK FOR EVERYBODY UPON THE ESSENTIAL EQUIPMENT AND TREATMENT OF THE HOME

## Spencer Sills

Source: Spencer Sills, *Common-sense Homes: a Practical Book for Everybody Upon the Essential Equipment and Treatment of the Home* (London: Cassell, 1912), pp. 1–7

## INTRODUCTORY AND GENERAL

"One may make the house a palace of sham, or he can make it a home."

MARK TWAIN[2]

Since those early days when Man, by reason of his physical weakness, sought rest and shelter in the trees or made himself a retreat within the recesses of the rocks, the home has become an integral part of our national and social life. But civilisation has bred in us a desire to make our place of dwelling something more than a mere shelter from the inclemency of the weather or an asylum from the molestation of our own species, and we have widened the significance of home immeasurably beyond the accepted definition of the word, which conveys no just appreciation of the many attributes that complete the sum of its charm and endearment.

So carefully are its portals guarded against the entrance of the undesirable that its sanctity has long been proverbial. Yet, with all our solicitude, the attack of disease frequently finds a weakness in the defences, and the insidious enemy enters into riotous possession. "The home beautiful" has been the subject of prolific writing, and art has been administered to us in very liberal doses as the panacea for the dullness and discomfort which, in spite of modern improvements, seem to cling with singular persistency to many of our abodes. On the other hand, many very able men have laboured to promote a more rational mode of existence by enunciating the principles which govern health, and by explaining the laws of life and the dangers of their infraction.

But despite the enthusiastic acceptance by the energetic and eccentric of all and every new health doctrine which happens to be freshly revealed them, the

unheeding thousands persist in looking upon such matters as trivial. A deeply rooted aversion to fads leads most men to put such things aside as really too troublesome and preposterous, or they mentally promise the question consideration at a future time, and promptly forget it. This is a peculiarity of human nature difficult to overcome, but it is responsible in a great measure for much which is avoidable.

A great deal of the disease with which we are afflicted, and much of the misery regarded as the inevitable heritage of mankind, are due to wilful neglect and gross ignorance, for which there is assuredly very little excuse. High and low, rich and poor, and even the sober middle class, show, as a rule, a serene disregard for simple facts and common-sense reasoning relative to matters which lie outside their own particular calling, the great majority being quite content to take things as they find them, without why or wherefore. The future lies on the knees of the gods! What need, then, to attempt to free ourselves from the bonds which fetter us to the habits of centuries, and the surviving practices of a savage ancestry? Our forefathers flourished in spite of their ignorance and squalor; but what of the pestilence and what of the plagues which until quite modern times were ever-recurring terrors?

The idleness and filthy habits of many of our poorer brethren, coupled with their destructive tendencies, impose a burden upon the house owner, in the nature of essential repairs, which precludes the possibility of desirable and necessary improvements, and the situation will present the same difficulties for all time, whatever may be accomplished in the way of provided dwellings, municipal or otherwise, unless some means can be adopted to bring home to this class the benefits of decent living.

The Socialist would tell us that the rights of private ownership, which hedge us in on every side, are responsible for much that is wrong in this respect; and many of us are quite willing to sit down and wait for the coming of those Utopian days which he tells us are at hand. But mean time, if such days are to come, can we not at least make an effort to lessen the instant evils by present action, and by so doing be the better prepared to appreciate fully that golden millennium when it dawns?

Each year the holiday season sees the migration of great numbers from our cities and towns in search of health and relaxation. Seaside and countryside resorts are thronged with humanity, crowded into lodging houses and hived in hotels, living, in many cases, under conditions which in ordinary circumstances would be regarded as insupportable. The resultant benefit of such a holiday would often be a minus quantity were it not for the entire change of scene and society and the temporary relaxation from the tension of business life, the fresh air and healthy surroundings being often more imaginary than real.

Then, too, we have the week-end habit, which of late years has impelled great numbers to get away from business cares into the quiet of the country at any cost and inconvenience. This has led to the transformation of the labourer's cottage into the bijou residence for more affluent occupancy, and the erection of innumerable bungalows, artistic and otherwise, in all sorts of sequestered spots and out-of-the-way nooks. The transformed cottage bears no trace of its one-time squalor but,

brave in its veneer of gentility, makes an alluring picture for the beguiling of the unwary. Under the glossy paint and showy plaster may still lurk the defects which but a few months before made this self-same abode, from a health point of view, an unfit habitation for the farm hand. From beneath its floors the thin, unwholesome vapours of earth may arise, as aforetime, to permeate the whole house. The walls have still no provision against rising damp, and are covered internally with ancient plaster tainted with the accumulated impurities of generations of sickly tenants. An archaic system for the disposal of waste still exists, although probably thinly disguised, and in the midst still stands the delightful (?) drinking-well, in all its charming simplicity! The situation altogether has perhaps but one redeeming feature the picturesque.

Much the same may be said of the bungalow, and the tenant of such is fortunate if the compensating influences of unlimited fresh air and outdoor exercise happen to counterbalance the effect of the untoward conditions. Cheap construction is frequently uneconomical, and the path of the amateur architect is strewn with pitfalls and lined with ambuscades planted by the man with something to sell. Indeed, it may be safely asserted that in the majority of instances little or nothing is gained from such experiences except the whimsical gratification of a hobby. Technical guidance in such matters as this is absolutely necessary. With some knowledge upon essential points, and a modicum of common sense, a start on a sound basis would be possible and a real chance of ultimate benefit to health assured.

The man who pins his faith to the primitive methods of an early civilisation loses sight of the fact that the country is now more crowded, and the human organisation more susceptible to disease by reason of its finer development and the greater demands made upon it in the more strenuous life we lead.

Zymotic diseases are due to the propagation and spreading of germs of such microscopic proportions that the finest dust may contain them in great abundance.[3] The essential elements which support life may be, and in all probability often are, contaminated with them, and the poison is taken freely into the body with the air we breathe, in liquids we drink, and in the food we eat. Our inability to avoid these tiny assailants is counter-balanced by natural provisions which enable the body to resist their attacks, provided the vital energies are not weakened by unnatural conditions of living, or that the growth of the disease has not assumed too great a virulence. Cleanliness and safety are as inseparable as dust and danger, and it is only the general recognition of this fact which will give us a greater freedom from the outbreaks which now so frequently disturb us.

There are always to be found numbers of people ever ready to decry the present times, especially with regard to building. Generally, those who know least about the matter are the most vociferous in the outcry at the decadency of the builder.

We are often told how much better things were done in the "good old days," "although, as a fact, our informants have but a misty idea of the precise period to which they would refer us for examples. Apparently, the notion is "The older the days the better the building." Such is the inference drawn from the observations of those who compare modern domestic building with the massive construction

of a Norman keep, built to withstand the shocks of war. Or it may be some surviving Elizabethan building, the remains of a semi-fortified country house, or the former abode of a merchant prince the massive detail of which they are so inclined to contrast with the constructive features of the tiny suburban villa of the present day.

Surely very little reasoning would suggest that the survival of a solitary example is due largely to special and costly work, the wealth of carving, the enriched plaster, the wainscoted walls, and a thousand details of ornament and construction, stamp the building as a place of one-time importance. The crazy farm-house, with its unceiled rooms and tottering walls, the almost unlighted labourer's cottage, and the dilapidated slum dwellings, are often contemporaries of these much-admired structures, but the poorer buildings escape admiring notice. Good sound building can be, and is, obtained, even in these degenerate days, upon exactly the same conditions as when these admirable models were constructed, viz. by paying the price for good work.

At no time in the world's history has there been a greater craze for cheap construction.

The architect is often cramped and restricted by the misconceptions of his client, in whose mind ostentation and parsimony are at variance. The builder is bound down by rigorous conditions and nailed to the smallest possible figure, the job being let in a species of Dutch auction to the lowest bidder.

Can excellency of workmanship be ensured, or even expected, in such circumstances? Again, in the matter of repairs the work is not infrequently entrusted to the ill-trained and ignorant handyman in preference to the skilled workman, because the former is thought to be cheaper.

This is the alphabet of jerry-building, and until common-sense reasoning displaces this cheeseparing economy better work cannot be expected, and the public health will continue to suffer as a consequence.

Aversion to light and air would appear to be characteristic of the British housewife, to judge from the external appearances of many of our dwellings. Not only is this remarkable with regard to the poorer neighbourhoods, but may be noted throughout Suburbia and among the best class of residential property. On a genial spring morning or, for that matter, in really warm weather, one may pass from end to end of many a street and observe nearly every window tightly closed, or, at the best, opened a meagre inch or two-usually at the bottom. The blinds are carefully drawn down so as to screen at least one-third of the window, and on the sunny side of the thoroughfare it is customary to veil the window entirely, to avoid the destructive bleaching effects of the sun's rays upon wall papers, carpets, and furniture. Other reasons sufficiently sane as an excuse for the custom are no doubt forthcoming, and the housewife cannot be persuaded that there is much to be gained by the wholesome admission of light and air at all times, even at the risk of the entry of dust and fading of carpets. Better this than the rigorous exclusion of these envoys of health for fear of such minor evils.

The microscopic organisms of disease are spread with such facility, and their growth is so rapid, that whole communities may be affected before the presence of disease is suspected.

The agency of the common house-fly in sowing disease broadcast has long been a known fact, but it is difficult to impress this sufficiently upon the public mind. The foot of the fly is provided with a gummy substance which enables it to walk upon smooth and inverted surfaces, and to this substance the minute germs of disease may cling in thousands, to be transferred to any food or liquid that may be exposed to its visits. The Medical Officer of Health for Woolwich, in a recent report, refers to the infant mortality in his district due to "zymotic enteritis," which recurs during each summer and early autumn, the spread of which he ascribes to flies.

Disease is also spread by exudations from the trunk or proboscis of the fly, bites from the flea, gnat, mosquito, etc. Bubonic plague, which devastated London and many other towns in 1665, and has of recent years been particularly troublesome in India, owes its virulence in a great measure to the rat flea.

Since the accumulation of garbage and lumber, and general uncleanliness in and about the house, encourages and breeds such pests, the need for greater exertion in attending to such matters cannot be too strongly advocated, nor the Gospel of Cleanliness too often preached. As a recent writer in a London daily paper says, "The national well-being depends very much upon the standard of comfort in the home," and an efficient standard cannot be maintained when the laws of health and reason are ignored.

## Notes

1 *British Architect* 21 February 1913, p. 165.
2 "In a word, one may make the house a palace of sham, or he can make it a home-a refuge." Quoted from a letter written by Twain to a young friend on the occasion of her début: See *The Review of Reviews*, Volume 5, January – June 1892, p. 43.
3 Zymotic: A 19th-century medical term for diseases which were thought to develop within the body following infection in a process similar to the fermentation and growth of yeast. These included acute infectious diseases such as typhus and typhoid fevers, smallpox, scarlet fever, measles, erysipelas, cholera, whooping-cough, diphtheria, etc. The Greek term for "ferment" was zumoun. The related concept of miasma is of interest.

# Part 5

# COMFORT

# COMFORT

It can be argued that increases in comfort and ease reflect social progress; however, comfort was, and is still culturally determined and is not a natural occurrence. As a specific vehicle of meaning, comfort is at the heart of the Victorian home. It not only serves a practical purpose, but it also acts as an element in the creation of meaning in the interior. The home as an ideal is therefore inextricably tied to the notion of comfort. For many middle class homes this meant the absence of noise, freedom from interruption, the safety of a private place and a sense of ease.

It was in the eighteenth century that the concept of comfort was fully established, albeit being mainly reserved for those who could afford it. During the nineteenth century, the obsession with domesticity, respectability and comfort reached its zenith. Nevertheless in this period, comfortable interiors were a sign of status, and this was recognized early in the nineteenth century: 'Who in the reign of Queen Elizabeth, would have planned a library, a music room, a billiard room, or a conservatory? Yet these are now deemed essential to comfort and magnificence'.[1] The concept of comfort for the Victorians was both material and immaterial, in the sense that is was both physical and emotional. To this end technologies were often able to supply material goods in such a way that they also reflected demonstrative needs for self-expression, for example. The architect Herman Muthesius looking back on the nineteenth century, remarked that 'The scientific spirit of the age addressed itself first to developing furniture in forms that perfectly suit the body and provide the maximum of comfort'.[2]

Robert Southey, writing in 1807 in the guise of a fictional Spanish visitor, neatly expressed a view of comfort that has become specifically associated with the nineteenth century:

There are two words in their language on which these people [the English] pride themselves, and which they say cannot be translated. Home is the one by which an Englishman means his house. . . . The other word is comfort; it means all the enjoyments and privileges of home.[3]

The terms 'home' and 'comfort' were finely drawn and hid many subtle variations in meaning. For example, comfort and neatness were still seen as

DOI: 10.4324/9781003290490-38

representative of morality as well as of bodily ease, but on the other hand too much physical comfort implied luxury and extravagance, and by extension, a lack of moral fibre. This dilemma was explored in much nineteenth century literature where the interior and its 'comforts' could put people at ease or conversely create a feeling of being ill at ease: where interiors represented the moral self, or where interiors reflected inappropriate luxury.[4]

By the mid-nineteenth century, the changes in home comforts for the middle classes were very noticeable. The comments below emphasise the distinction between a state of comfortless and the new-found luxury that had become commonplace. Writing in 1846 one commentator thought

> As one instance, it is not necessary to go back much beyond half a century [1795] to arrive at the time when prosperous shopkeepers in the leading thoroughfares of London were without that now necessary article of furniture, a carpet, in their ordinary sitting rooms: luxury in this particular, seldom went further with them than well scoured floors strewn with sand, and the furniture of the apartments was by no means inconsistent with the primitive, and as we should say, comfortless state of things. In the same houses we now see, not carpets merely, but many articles of furniture which were formerly in use only among the nobility and gentry.[5]

Much has been made of the rise of the middle class and their concepts of home comforts and cosiness. According to the contemporary architect Robert Kerr, it was a very particular form of comfort:

> What we call in England a comfortable house is a thing so intimately identified with English customs as to make us apt to say that in no other country but our own is this element of comfort fully understood; or at all events that the comfort of any other nation is not the comfort of this.[6]

## Notes

1 H. Repton *Observations on the Theory and Practice of Landscape Gardening* (London: printed by T. Bensley for J. Taylor, [1803] in a new edition by J. C. Loudon (London: Longman 1851), p. 311.

2 H. Muthesius, *The English House*, 1908, [1987], (New York: Rizzoli), p. 162.

3 *Letters From England: By Don Manuel Alvarez Espriella*. Translated From The Spanish. In Three Volumes. Vol. I. Third Edition (London: Longman, Hurst, Rees, Orme, and Brown, 1814), p. 180.

4 See for example P. Tristram, *Living Space in Fact and Fiction* (London: Routledge 1989).

5 George Richardson Porter, *The Progress of the Nation: In Its Various Social and Economical Relations, from the Beginning of the Nineteenth Century* London: John Murray, 1847), p. 532.

6 R. Kerr, *The Gentleman's House* (London: J. Murray, 1865), p. 69.

# MAX SCHLESINGER AND OTTO WENCKSTERN, *SAUNTERINGS IN AND ABOUT LONDON* – 'THE ENGLISHMAN'S CASTLE' (1853)

## Editorial Headnote

In 1786 Robert Burns wrote the immortal lines: 'Oh, would some Power give us the gift/To see ourselves as others see us!' There has been a long tradition of foreign visitors recording their impressions and experiences of visits to England. During the nineteenth century for example, Louis Simond published a *Journal of a Tour and Residence in Great Britain, During the Years 1810 and 1811*; Hermann Pückler-Muskau's *Tour in England, Ireland, and France* was published in 1832; in 1844 Frederick Engels wrote *The Condition of the Working-class in England;* and in 1853 Max Schlesinger's *Saunterings in and About London* was issued. Further examples are Hippolyte Taine's *Notes on England*, 1872 and Ralph Waldo Emerson's *English Traits* (1883).

Max Schlesinger (1822–1881) was Hungarian by birth but later lived in Prague, Berlin and London. At one time he was the English correspondent of the *Cologne Gazette*, Otto von Wenckstern (1819–1869) was the translator of this work. He was a German-born journalist who moved to London in 1846 and worked for a number of newspapers. Between 1851 and 1856 he wrote numerous articles for the literary weekly *Household Words* published by Charles Dickens.

This work was first published in Germany in 1852 and then translated by Otto Wenkstern and published in English in 1853. The author states in his Preface: 'The "Saunterings" were intended for the profit and amusement of my German countrymen; and I must say I was not a little pleased and surprised with the very flattering reception which my book experienced at the hands of the English critics'.

The work was indeed well received. In 1853, *Blackwood's Edinburgh Magazine* published an extensive article titled 'Foreign Estimates of England'. It was a very long and supportive analysis to the text explaining details including the author's working plan:

[The author] establishes himself in an English family, in the terra incognita of Guildford Street. The master of the house, Sir John, who is intended as a prototype of his countrymen, is a thorough John Bull – shrewd, sensible, intelligent, with a moderate allowance of English prejudices, a warm attachment to his country, well-founded conviction of its pre-eminence amongst the nations, and of the excellence of its institutions.

Dr Keif (the word signifies a grumbler), another inmate of the house, and an old friend of Sir John's, is an Austrian journalist, whose pen has taken liberties that have endangered his own, and who has sought refuge in England, which he begins good-humouredly to abuse almost as soon as he has landed in it.[1]

A further review in the *Examiner* commented upon the gracious approach taken by the author to his subject:

> M. Max Schlesinger, . . . has in these two clever volumes presented the German public with some notes upon London which are very lively, very sensible, and on the whole very free from those absurd mistakes into which foreigners, especially our French friends, fall when they are in too great hurry to pick up notions about us. The English reader of these volumes will find much amusement and some profit in following the researches of an inquisitive and intelligent German, who has evidently taken pains to understand properly the main points of his subject.[2]

The article takes a tour round the house and comments on various aspects of its building and furnishings, often making comparisons with German models.

# 29

# *SAUNTERINGS IN AND ABOUT LONDON*

## *Max Schlesinger and Otto Wenckstern*

Source: Max Schlesinger and Otto Wenckstern, *Saunterings in and About London* (London: N. Cooke, 1853), pp. 6–10

## CHAPTER I

### In Which the Reader Is Introduced to Some of the Author's Friends. – the Englishman's Castle

"ARE you aware, honorable and honored Sir John," said Dr. Keif, as he moved his chair nearer to the fire, "are you aware that I am strongly tempted to hate this country of yours?"

"Indeed!" replied Sir John, with a slight elongation of his good-humoured face. "Really, Sir, you are quick of feeling. You have been exactly two hours in London. Wait, compare, and judge. There are thousands of your countrymen in London, and none of them ever think of going back to Germany."

"And for good reasons too," muttered the Doctor.

"May I ask," said Sir John, after a short pause, "what can have shocked you in England within two hours after your arrival?"

"Look at this cigar, sir! It won't burn, has a bad smell, drops its ashes – and costs four times as much as a decent cigar in my own country. Can you, in the face of this villainous cigar, muster the courage to talk to me of your government and your constitution? This cigar, Sir, proves that your boasted civilisation is sheer barbarity, – that your Cobden[3] is a humbug, and your free-trade a monstrous sham!"

"Does it indeed prove all that? Very well, Sir German," cried Sir John, with a futile attempt to imitate the martial and inquisitorial bearing of an Austrian *gendarme*. "Come, show me your passport! Did anyone here ask for it? Did they send you to the Guildhall for a *carte de sureté*? Have the police expelled you from London? It's either one thing or the other. It's either sterling liberty and cabbage-leaf cigars, or real Havanas and all the miseries of your police. Take your choice, sir."

"But I cannot take my choice, sir!" cried Dr. Keif. "They have hunted me as you would hunt a fox, across all their fences of boundary lines to the shores of

the ocean, and into the very maw of that green-eyed monster, Sea-sickness, which cast me forth vomiting on this barbarous island, where men smoke lettuce and call it tobacco!" saying which, the doctor flung his cigar into the grate, and sung, "*Was ist des Deutschen Vaterland?*"[4]

But the reader will most naturally ask, Who is this comical doctor, and who is Sir John?

To which I make reply – they are two amiable and honest men who met on the Continent years ago, and who, after a long separation, met again in the heart of London, in Guildford-street, Russell-square.

Dr. Keif is an Austrian and a journalist. There is good in all, but none are all good. Dr. Keif makes no exception to the common rule. He was so far prejudiced as to write a batch of very neat *Feuilletons*,[5] in which he asserted that the Croats did not altogether conduct themselves with grace at the sacking of Vienna, and that the Bohemian Czechs are not the original race which gave birth to all the nations of the earth. He denied also that German literature and science have ever been fostered by the Servians;[6] he alleged that Göthe had done more for the advancement of science than the twenty-first battalion of the Royal and Imperial Grenadiers, and he was abandoned enough to avow his opinion that a bad government is worse than a good one. On account of these very objectionable prejudices, the Doctor was summoned forthwith to depart from Leipzig in Saxony, where he lived, and proceed to Vienna, there to vindicate his doctrines or submit to a paternal chastisement. But the Doctor objected to the fate of John Huss;[7] perhaps his mind, corrupted with German literature, was unable to appreciate the charms of a military career in the ranks of the Austrian army. Dr. Keif left Leipzig with all possible secrecy; nor could he be induced to return, even by the taunts of the official *Vienna Zeitung*, which justly accused him of cowardice, since he preferred an ignominious flight to a contest with only 600,000 soldiers, twelve fortresses, half a million of police officers, and the "*peinliche Halsgerichts Ordnung*"[8] of the late Empress Maria Theresa. Whether Dr. Keif lacks courage or not, and all other traits of his character will be sufficiently shown in the course of the Wanderings through London, which we propose to make in his company.

Dr. Keif and the author live in the house of Sir John –, a full-blown specimen of the old English gentleman, and one worthy to be studied and chronicled as a prototype of his countrymen. This house of ours is the centre of our rambles, the point from which we start and to which we return with the experiences we gathered in our excursions. And since an English fireside and an English home are utter strangers to the most ideal dreams of the German mind, we propose commencing our Wanderings through London with a voyage of discovery through all the rooms and garrets of our own house.

At the first step a German makes in one of the London streets, he must understand that life in England is very different from life in Germany. Not only are the walls of the houses black and smoky, but the houses do not stand on a level with the pavement. A London street is in a manner like a German high-road, which is skirted on either side with a deep ditch. In the streets of London the houses on

either side rise out of deep side areas. These dry ditches are generally of the depth of from six to ten feet, and that part of the house, which with us would form the lower story, is here from ten to twelve feet under-ground. This moat is uncovered, but it is railed in, and the communication between the house door and the street is effected by a bridge neatly formed of masonry.

Every English house has its fence, its iron stockade and its doorway bridge. To observe the additional fortifications which every Englishman invents for the greater security of his house is quite amusing. It is exactly as if Louis Napoleon was expected to effect a landing daily between luncheon and dinner, while every individual Englishman is prepared to defend his household gods to the last drop of porter.

You may see iron railings, massive and high, like unto the columns which crushed the Philistines in their fall; each bar has its spear-head, and each spear-head is conscientiously kept in good and sharp condition. The little bridge which leads to the house-door is frequently shut up; a little door with sharp spikes protruding from it is prepared to hook the hand of a bold invader. And it is said that magazines of powder are placed under the bridge for the purpose of blowing up a too pertinacious assailant. This latter rumour I give for what it is worth. It is the assertion of a Frenchman, whom the cleanliness of London drove to despair, and who, in the malice of his heart, got satirical.

A mature consideration of the London houses shows that the strength of the fortification is in exact proportion to the elegance and value of the house and its contents. The poor are satisfied with a wooden stockade; the rich are safe behind their iron *chevaux de frise*,[9] and in front of palaces, club-houses, and other public buildings, the railings are so high and strong as to engender the belief that the thieves of England go about their business of housebreaking with scaling-ladders, pick-axes, guns, and other formidable implements of destruction.

Every Englishman is a bit of a Vauban.[10] Not only does he barricade his house against two-legged animals of his own species, but his mania for fortification extends to precautions against wretched dogs and cats. To prevent these small cattle from making their way through the railings, the Englishman fills the interstices with patent wire-net work, and the very roofs are frequently divided by means, of similar contrivances. Vainly will cats, slaves of the tender passion, make prodigious efforts to squeeze themselves through those cruel, cruel walls, and vainly do they, in accents touching, but not harmonious, pour their grief into the silent ear of night. Vainly, I say, for an Englishman has little sympathy with "love in a garret"; and as for love on the roof, he scorns it utterly.

We now approach the street-door, and put the knocker in motion. Do not fancy that this is an easy process. It is by far easier to learn the language of Englishmen than to learn the language of the knocker; and many strangers protest that a knocker is the most difficult of all musical instruments.

It requires a good ear and a skilful hand to make yourself understood and to escape remarks and ridicule. Every class of society announces itself at the gate of the fortress by means of the rhythm of the knocker. The postman gives two loud

raps in quick succession; and for the visitor a gentle but peremptory *tremolo* is *de rigueur*. The master of the house gives a *tremolo crescendo*, and the servant who announces his master, turns the knocker into a battering-ram, and plies it with such goodwill that the house shakes to its foundations. Tradesmen, on the other hand, butchers, milkmen, bakers, and green-grocers, are not allowed to touch the knockers – they ring a bell which communicates with the kitchen.

All this is very easy in theory but very difficult in practice. Bold, and otherwise inexperienced, strangers believe that they assert their dignity, if they move the knocker with conscious energy. Vain delusion! They are mistaken for footmen. Modest people, on the contrary, are treated as mendicants. The middle course, in this, as in other respects, is most difficult.

Two different motives are assigned for this custom. Those who dislike England on principle, and according to whom the very fogs are an aristocratic abuse, assert that the various ways of plying the knocker are most intimately connected with the prejudices of caste. Others again say that the arrangement is conducive to comfort, since the inmates of the house know at once what sort of a visitor is desiring admittance.

As for me, I believe that a great deal may be said on either side; and I acknowledge the existence of the two motives. But I ought to add, that in new and elegant mansions the medieval knocker yields its place to the modern bell. The same fate is perhaps reserved for the whole of the remainder of English old-fogyism. There are spots of decay in these much-vaunted islands; and now and then you hear the worm plainly as it gnaws its way. I wish you the best of appetites, honest weevil!

We cross the threshold of the house.

Sacred silence surrounds us – the silence of peace, of domestic comfort, doubly agreeable after a few hours' walk with the giddy turmoil of street life. And with peace there is cleanliness, that passive virtue, the first the stranger learns to love in the English people, because it is the first which strikes his eye. That the English are capital agriculturists, practical merchants, gallant soldiers, and honest friends, is not written in their faces, any more than the outward aspect of the Germans betrays their straight-forwardness, fitful melancholy, and poetic susceptibility. But cleanliness, as an English national virtue, strikes in modest obstrusiveness[11] the vision even of the most unobservant stranger.

The small space between the street-door and the stairs, hardly sufficient in length and breadth to deserve the pompous name of a "hall," is usually furnished with a couple of mahogany chairs, or, in wealthier houses, with flower-pots, statuettes, and now and then a sixth or seventh-rate picture. The floor is covered with oil-cloth, and this again is covered with a breadth of carpet. A single glance tells us, that after passing the threshold, we have at once entered the temple of domestic life.

Here are no moist, ill-paved floors, where horses and carts dispute with the passenger the right of way; where you stumble about in some dark corner in search of still darker stairs; where, from the porter's lodge, half a dozen curious eyes watch your unguided movements, while your nostrils are invaded with the smell

of onions, as is the case in Paris, and also in Prague and Vienna. Nothing of the kind. The English houses are like chimneys turned inside out; on the outside all is soot and dirt, in the inside everything is clean and bright.

From the hall we make our way to the parlour – the refectory of the house. The parlour is the common sitting-room of the family, the centre-point of the domestic state. It is here that many eat their dinners, and some say their prayers; and in this room does the lady of the house arrange her household affairs and issue her commands. In winter the parlour fire burns from early morn till late at night, and it is into the parlour that the visitor is shewn, unless he happens to call on a reception-day, when the drawing-rooms are thrown open to the friends of the family.

Large folding-doors, which occupy nearly the whole breadth of the back wall, separate the front from the back parlour, and when opened, the two form one large room. The number and the circumstances of the family devote this back parlour either to the purposes of a library for the master, the son, or the daughters of the house, or convert it into a boudoir, office, or breakfast-room. Frequently, it serves no purpose in particular, and all in turn.

These two rooms occupy the whole depth of the house. All the other apartments are above, so that there are from two to four rooms in each story. The chief difference in the domestic apartments in England and Germany consists in this division: in Germany, the members of a family occupy a number of apartments on the same floor or "flat"; in England, they live in a cumulative succession of rooms. In Germany, the dwelling-houses are divided horizontally – here the division is vertical.

Hence it happens, that houses with four rooms communicating with one another are very rare in London, with the exception only of the houses in the very aristocratic quarters. Hence, also, each story has its peculiar destination in the family geographical dictionary. On the first floor are the reception-rooms; in the second the bed-rooms, with their large four-posters and marble-topped wash-stands; in the third story are the nurseries and servants' rooms; and in the fourth, if a fourth there be, you find a couple of low garrets, for the occasional accommodation of some bachelor friend of the family.

The doors and windows of these garrets are not exactly air-tight, the wind comes rumbling down the chimney, the stairs are narrow and steep, and the garrets are occasionally invaded by inquisitive cats and a vagrant rat; but what of that? A bachelor in England is worse off than a family cat. According to English ideas, the worst room in the house is too good for a bachelor. They say – "Oh, he'll do very well!" What does a bachelor care for a three-legged chair, a broken window, a rickety table, and a couple or so of sportive currents? It is exactly as if a man took a special delight in rheumatism, tooth-ache, hard beds, smoking chimneys, and the society of rats, until he has entered the holy state of matrimony. The promise of some tender being to "love, honour, and obey," would seem to change a bachelor's nature, and make him susceptible of the amenities of domestic comfort. The custom is not flattering to the fairer half of humanity. It is exactly as if the comforts of one's sleeping-room were to atone for the sorrows of matrimony, and as if a bachelor, from the mere fact of being unmarried, were so happy and

257

contented a being, that no amount of earthly discomfort could ruffle the blissful tranquillity of his mind!

It was truly comical to see Dr. Keif, when the lady of the house first introduced him to his "own room."

The politics and the police of Germany had given the poor fellow so much trouble, that he had never once thought of taking unto himself a wife. As a natural consequence of this lamentable state of things, his quarters were assigned him in the loftiest garret of the house. Dismal forebodings, which he tried to smile away, seized on his philosophical mind as he mounted stairs after stairs, each set steeper and narrower than the last. At length, on a mere excuse for a landing there is a narrow door, and behind that door a mere corner of a garret. The Doctor had much experience in the topography of the garrets of German college towns; but the English garret in Guildford Street, Russell Square, put all his experience to shame.

"I trust you'll be comfortable here," calls the lady after him, with a malicious smile; for to enter the bachelor's room, would be a gross violation of the rules and regulations of British decency. And before he can make up his mind to reply, she has vanished down the steep stairs.

And the Doctor, with his hands meekly folded, stands in the centre of his "own room." "Oh Bulwer, Dickens, and Thackeray" – such are his thoughts – and thou, "Oh Punch, who describest the garrets of the British bachelor! here, where I cease to understand the much-vaunted English comfort, here do I begin to understand your writings! If I did not happen to be in London, I should certainly like to be in Spandau. My own Germany, with thy romantic fortresses and dungeon-keeps, how cruelly hast thou been calumniated!"

There is a knock at the door. It is Sir John, who has come up for the express purpose of witnessing the Doctor's admiration of his room. He knows that the room will be admired, for to his patriotic view, there is beauty in all and everything that is *English*. His patriotism revels in old-established abuses, and stands triumphant amidst every species of nuisance. The question, "How do you like your room?" is uttered exactly with that degree of conscious pride which animated the King of Prussia when, looking down from the keep of Stolzenfels Castle, he asked Queen Victoria, "How do you like the Rhine?" And equally eager, though perhaps not quite so sincere, was the Doctor's reply: "Oh very much! I am quite enchanted with it! It is impossible to lose anything in this room, and the losing things and groping about to find them was the plague of my life at home in the large German rooms. A most excellent arrangement this! Everything is handy and within reach. Bookcase, washstand, and wardrobe – I need not even get up to get what I want – and as for this table and these chairs, I presume that the occasional overturning of an inkstand will but serve to heighten the quaint appearance of this venerable furniture!"

"Of course," said Sir John, "certainly! this is liberty-hall, sir. But mind you take care of the lamp, and pray do not sit in the draught between the window and the door."

He does not exactly explain how it is possible to sit anywhere except in the draught, for the limited space of the garret is entirely taken up with draughts. Perhaps it is a sore subject, for, with an uneasy shrug of the shoulders, the worthy Sir John adds: –

"But never mind. Comfortable, isn't it? And what do you say to the view, eh? Beau-ti-ful! right away over all the roofs to Hampstead!"

He might as well have said to the Peak of Tenerife; for the view is obstructed with countless chimney-pots looming in the distant future through perennial fog. Sir John is struck with this fact, as, measuring the whole length of the apartment in three strides, he approaches the window to enjoy the glorious view of Hampstead hills. He shuts the window, and is evidently disappointed.

"Ah! never mind! very comfortable, air pure and bracing; very much so; very different from the air in the lower rooms. And – I say, mind this is the 'escape,'" says Sir John, opening a very small door at the side of our friend's room. "If – heaven preserve us – there should be a fire in the house, and if you should not be able to get downstairs, you may get up here and make your escape over the roofs. That's what you will find in every English house. Isn't it practical? eh! What do you say to it?"

The Doctor says nothing at all; he calculates his chances of escape along that narrow ledge of wall, and thinks: "Really things are beginning to look *awfully* comfortable. If there should happen to be a fire while I am in the house, I hope and trust I shall have time to consider which is worst, to be made a male suttee of, or to tumble down from the roof like an apoplectic sparrow."

We leave the Doctor between the horns of this dilemma, and descending a good many more stairs than we ascended, we find our way to the haunts of those who, in England, live under-ground – to the kitchen.

Here, too, everything is different from what we are accustomed to in Germany. In the place of the carpets which cover the floors of the upper rooms, we walk here on strong, solid oilcloths, which, swept and washed, looks like marble, and gives a more comfortable aspect to an English kitchen than any German housewife ever succeeded in imparting to the scene of her culinary exercises. Add to this, bright dish-covers of gigantic dimensions fixed to the wall, plated dishes, and sundry other utensils of queer shapes and silvery aspect, interspersed with copper sauce-pans and pots and china, the windows neatly curtained, with a couple of flower-pots on the sill, and a branch of evergreens growing on the wall round them – such is an English kitchen in its modest glory. A large fire is always kept burning; and its ruddy glow heightens the homeliness and comfort of the scene. There is no killing of animals in these peaceful retreats. All the animals which are destined for consumption, such as fowls, ducks, pigeons, and geese, are sold, killed, and plucked in the London shops. When they are brought to the kitchen, they are in such a condition, that nothing prevents their being put to the fire. And then, in front of that fire, turned by a machine, dangle large sections of sheep, calves, and oxen, of so respectable a size, that the very sight of them would suffice to awe a German housewife.

Several doors in the kitchen open into sundry other subterraneous compartments. There is a back-kitchen, whither the servants of the house retire for the most important part of their daily labours – the talking of scandal *apropos* of the whole neighbourhood. There is also a small room for the washing-up of plates and dishes, the cleaning of knives and forks, of clothes and shoes. Other compartments are devoted to stores of provisions, of coals, and wine and beer. Need I add that all these are strictly separate?

All these various rooms and compartments, from the kitchen up to Dr. Keif's garret, are in modern London houses, lighted up with gas – and pipes conducting fresh, filtered, and in many instances, hot water, ascend into all the stories – and there is in all and everything so much of really domestic and unostentatious comfort, that it would be very uncomfortable to give a detailed description of every item of a cause which contributes to the general and agreeable effect. Indeed, such a description is simply impossible. Just let anyone try to explain to an Englishman the patriarchal physiognomy of a pot-bellied German stove; or let him try to awake in the Englishman's wife a feeling, remotely akin to sympathy, for the charming atmosphere of a German "*Kneipe*";[12] or make an American understand what the German "*Bund*" is, and what it is good for. To attempt this were a labour of Sysiphus[13] – toil toil without a result. Nothing short of actual experience will enable a man to understand and value these national mysteries.

## Notes

1 *Blackwood's Edinburgh Magazine*, 74, 1853, pp. 284–5.
2 *Examiner*, 26 February 1853, 134.
3 Cobden: Richard Cobden (3 June 1804–2 April 1865) was an English Radical and Liberal politician, manufacturer, and a campaigner for free trade and peace.
4 A German nationalist song by Ernst Moritz Arndt (1813), popular in the 19th century.
5 Feuilletons are a part of a European newspaper or magazine devoted to material intended to entertain the general reader.
6 Refers to a native or inhabitant of Serbia.
7 Jan Huss, (1370–1415), was an important 15th-century Czech religious reformer, whose work transitioned the medieval and the Reformation periods and set the path to the Lutheran Reformation. Deeply involved in the bitter controversy of the Western Schism (1378–1417) he was convicted of heresy at the Council of Constance and burned at the stake.
8 Body of penal law.
9 A moveable barrier of spikes, blades, etc, used to obstruct the passage of undesirables.
10 Vauban: A military engineer of King Louis XI. Vauban also played a major role in the history of fortification in Europe and on other continents until the mid-19th century.
11 noticeable.
12 A German bar or public house.
13 Labour of Sisyphus was an eternal punishment of forever rolling a boulder up a hill in the depths of Hades without result.

# HENRY MAYHEW,
## 'HOME IS HOME BE IT NEVER SO HOMELY',
## *MELIORA: OR BETTER TIMES*
## *TO COME* (1852)

## Editorial Headnote

*Meliora: Or Better Times to Come* was a collection of

> chapters or articles by different authors, of whom two are noblemen, six clergymen, two or three honourables, and the rest gaol governors, physicians, and men of letters. Each man deals with a single subject – but the subjects have no sequence or necessary connexion with each other, excepting in so far as they all bear on the state of society as at present existing.[1]

The editor's intention was just that. The topics in the collection range from the evils of beer shops to food adulteration, from lodging houses to education provision. It is noteworthy that three essays discuss aspects of the home.

Henry Mayhew (1812–1887) was an English journalist and sociologist, and a founder of the magazine *Punch* (1841). He was a prolific and intense writer best known for his work published as *London Labour and the London Poor*, 4 vol. (1851–1862). His evocations of the plight of London's underclasses influenced authors like Charles Dickens as well as reformers including Christian Socialists, such as Thomas Hughes and Charles Kingsley.

The public's unawareness and lack of knowledge about the state of other classes was a leading issue for reformers. Mayhew's publications were part of persistent attempts to draw attention to the predicaments of the poor and working classes. Mayhew's sociological research into the slum areas of London uncomfortably shows how accepted standards of comfort in middle class dwellings were completely missing amongst the working classes. To drive this home, he keeps emphasising the distinction between shelter and shelter plus ease and comfort which he sees as the essence of home.

Mayhew argued that the saying 'an Englishman's home is his castle' indicates that a family dwelling has always been believed to be a place for safety and sanctuary He also suggests that there is something inherently English about the concept of home. He says

> The word 'home' in the real English sense, is not more peculiar to the language, than is the word 'comfort' itself. The French people have no terms in their vocabulary to express either notion. The adjective *comfortable*, they have been obliged to borrow to the letter from us, and as for their phrases *à la maison* and *chez nous*, they stand for mere eating and sleeping places.

Mayhew wrote a letter to *The Morning Chronicle*, in September 1849, that gave particulars of a tour he made to Bermondsey (London). Mayhew subsequently suggested to the newspaper, that the paper commissioned an investigation into the living conditions of the working classes in England and Wales. This initiative resulted in at least one article appearing every day for the rest of the year and for most of 1850. The letters were subsequently collated into volumes but with only about a third of the *Morning Chronicle* material included in his *London Labour and the London Poor*. This essay in *Meliora* is an abridged version of some of the *Morning Chronicle* articles.

# 30

# 'HOME IS HOME BE IT NEVER SO HOMELY'

## *Henry Mayhew*

Source: Henry Mayhew, 'Home Is Home Be It Never So Homely', in Viscount Ingestre (ed.) *Meliora: or Better Times to Come* (London: Parker and Son, 1852), pp. 258–64

'HOME IS HOME, BE IT NEVER SO HOMELY.'
BY HENRY MAYHEW, ESQ.

This is one of the many foolish sayings which pass current as 'wise saws,' – a bit of tinkling brass with a glittering was – a worthless 'token' from some Brummagem mint, that good easy men accept as sterling truth, because it has something of a ring and sparkle with it. Your 'old saw'' generally, indeed, are none of the sharpest instruments – and require a deal of re-setting to render them in any way serviceable; but of all the blunt, toothless, and bad-tempered things which have been handed down as heir-looms in the human family, there is none perhaps so thoroughly worn out, and unfitted for the work of the present day, as that which has been adopted for the subject of this contribution.

To comprehend this, we must first understand definitely what we mean by the word *home*. Etymologically considered, the term expresses simply a place of shelter. The Saxon root *Ham*, from which our word is directly derived, signifies a mere *covering*, and, consequently, stands for not only a *roof* to protect us from the elements, but a *skin*, a *coat*, or, indeed, anything that answers the same purpose. The same root exists in our word, yellow-*hammer*, literally, the bird with the yellow covering; and *hammer*-cloth, the cloth which covers the box of a carriage. The Latin *Cam*-isia is a cognate term, though one would hardly think that there could be any point of resemblance between a house and a shirt; and yet, assuredly, the bricken and the linen case do us each a similar service, so that we may be said to be, as it were, etymological snails, carrying our homes on our backs.

The original idea, then, attached to the term home, appears to have been merely that of shelter, or protection from the weather and foes. Probably the first homes were caves or hollow trees – mere holes, into which to thrust and screen the body from the winds and animals. The Welsh adjective *cau*, which means hollow, and is the original of the Latin *cavus*, and our cave, means, also, *shut u – enclosed*,

DOI: 10.4324/9781003290490-40

while the verb *cau* signifies to *fence in – to cover*. This is closely connected with the Celtic *cab-in*, and the Teutonic *hov-el*;[†] so that, look which way we will, we find that the fundamental signification of home is that of a covering, or place of shelter.[‡]

But though this may have been the primitive sense of the word, assuredly it is not the signification which we now attach to it.

Home is with us something more than an hotel or an hospital, an archway, an umbrella, or a Macintosh each and all of which serve the purposes of covering and protection. The dry arches of Waterloo-bridge, or, more properly speaking, of the Adelphi, afford a nightly shelter from the winds and rain to many a houseless wretch; and yet which among the number who herd there would think of speaking of such a place as his home?

The Refuges for the Destitute are crowded, in the winter time, with the "vaga-bonds of all nations" – a kind of Beggars' Congress from every quarter of the world; for your true rogue returns to town for the winter as regularly as your nobleman or person 'of quality,' – the pleasure of 'shaking a loose leg,' (as those who prefer a 'roving life' term vagrancy) lasting only so long as the thermometer ranges above 40°, and it is possible, in case of an emergency, to 'skipper it,' that is to say, to sleep in the open fields. But never was one of the many thousands who avail themselves of the gratuitous warmth and leathern coverlets of the Nightly Refuges heard, except in bitter jest at his own destitution, to speak of the 'straw-yard' as his home.

Home, then, with us, stands for a very different idea from that which was origi-nally associated with it, – and this doubtlessly has been a necessity of the altered circumstances of the race inventing and still using the term. The Saxons were not always the inhabitants of a cold or variable climate. The most probable history derives them from the Axoni, who dwelt on the banks of the Euxine Sea;[2] and it is certain that in all warm countries, the desire and the necessity for a home, in the true English meaning of the word, is not felt so acutely as it is in less genial climates. In Italy and France, the people pass the greater part of their time in the open air; they are *al fresco* race – out-of-door nations – living in the sunshine and having mere dormitories rather than homes to retire to for the night. In this country, however, where there are 178 wet days out of the 365; and the quantity of rain that falls in the metropolis in the course of the year is just up to ones knees[§] (twenty-four inches per annum is the average of twenty-seven years), where one-fifth of the winds that blow are north-easterly – where, for three months out of every twelve, the thermometer ranges below 40°, and for another three months below 50° – where the domestic consumption of fuel is estimated at one ton per

† The Saxon *hof* is a house, a dwelling, cave, den.
‡ The words *house* and *hut* have a similar origin. These are philological cognates, being both derived from the old German, *hüten*, to cover, protect; whence the Anglo-Saxon *hydan*, and English *hide*.
§ The gross amount of the rain-fall in London, according to the Registrar General's limits, may be esti-mated, in round numbers, at 36,500 million gallons, or an average of 100,000,000 gallons per diem.

head, man, woman, and child (London alone consuming, for all purposes, not less than three-and-a-half millions of tons in the course of the twelvemonth) – in this country, I say, where the people pass at least seven-eighths of their time within doors, it is but natural that the word home should have extended itself into something more than a mere covering a bricken case for our bodies (like the Italian *casa*). Accordingly, we find many other ideas have grown to be associated with the term, so that it now expresses a place not only of shelter, but of ease, of peace, of comfort, and endearment – with us.

I cannot say which of the latter ideas enter most fully or essentially into the complex notion; but perhaps the Englishman's home is more particularly dear to him, as being the focus of his affections the abiding place of his family.

It is true, we hear much of an Englishman's fireside, but I doubt whether the comfort of our sea-coal fires enters so thoroughly into the essence of an English home, as does that of its being the spot where all that is dearest and nearest to the individual are concentred. Assuredly, the home of the bachelor must be very different from that of the Benedict – as different as the lair is from the nest. With even the middle classes, the single man's abiding place is generally a lodging – often only a bed – and consequently reverts to the primitive sense of the term. Ease and comfort appear, however, to be absolutely essential to complete the English idea of home. I doubt whether the titled and fashionable classes are imbued with that full home feeling which belongs to the middle and many of the humbler folk of this country. Among those who are not compelled to labour for their living, there is a less enjoyment of the ease of home; and, consequently, a greater love of society than is found among those who return to it after a heavy day's work: and it is probably the irksomeness of mere domesticity, to such as are unable to enjoy the ease with which they are surfeited, even to *ennui*, that induces that love of social display, which distinguishes the richer from the poorer classes of this country.

But if the idea of ease be essentially connected with the English notion of home, certainly that of comfort forms a special part of it. The word 'home' in the real English sense, is not more peculiar to the language, than is the word 'comfort' itself. The French people have no terms in their vocabulary to express either notion. The adjective *comfortable*, they have been obliged to borrow to the letter from us, and as for their phrases *a la maison* and *chez nous*, they stand for mere eating and sleeping places.

There is a vast deal of philosophy in words, rightly considered; and there is not, perhaps, a more apt type of the peculiar domestic turn of an Englishman's mind, than in the invention of that most characteristic and expressive word *comfort*. How difficult is it to analyze all the many feelings, negative and positive, which enter into that one term! – the utter freedom from all the petty disagreeablenesses and uneasinesses of life – the enjoyment of several of those minor pleasures of which our nature is susceptible. And yet it is strange that the ancient Saxons should have had no word to express any such feeling which plainly shows that they were strangers to the feeling itself. But when we come to compare the mode of living in this country in even the Middle Ages (the days of horn windows and

'reredosses' instead of chimneys) with that of the present time, it is evident that a sense of comfort is comparatively a modern development, and the word, therefore, one of recent invention, even with ourselves. Indeed, the existence of the term, and consequently of the sense itself, may be cited in proof of a high order of civilization on the part of our people; for if the dwelling in cities, and the development of that particular manner, respectful of a neighbour's feelings, which we term civility or politeness, be the essential distinction between the civilized man and the savage, certainly the dwelling in houses of a particular kind, possessed of greater conveniences, where all the requirements of a keener sense of decency, and a greater love of cleanliness and order may be observed – all of which are but so many proofs of the development of the sense of comfort in a nation – certainly these may be cited as infallible signs of a still higher order of civilization and refinement of that respect for all those minor graces, and sentiments, and affections, which add so much to the charm of life, and the happiness of the people.

Home, then, to an Englishman's mind, is a place not alone of shelter, but of ease, of comfort, and affection. The English, and indeed Saxon, law has always regarded a man's home as a place of special sanctity. The old word *hamsocn* meant simply 'protection from assault in one's house' – *domus immunitas*: and the German cognate formerly signified 'burglary and any violence or injury done to the owner of the house or its inmates.' The maxim that an 'Englishman's home is his castle,' though partaking too much of the warlike spirit of ancient times to agree with the more peaceful character of the present age, and making that a fortress and a stronghold against enemies which is now rather a place of quietude and the abode of friends, still shows that the dwelling of the family has ever been considered in this country as a kind of social sanctuary – a spot sacred to peace and goodwill, where love alone is to rule, and harmony to prevail, and whence every enemy is to be excluded by the strong arm of the law itself.

But if this be the archetype of the English idea of home, if it be essentially a place of special security, of ease, of peace, of comfort, and of affection, how can the dwellings of the poor possibly be homes to them when the majority hardly admit of the fulfilment of any one of these conditions; that is to say, when they are so very homely as to allow neither ease, peace, comfort, and hardly affection to be enjoyed in them? Those who have never known the want of a comfortable dwelling-place, and who have never contrasted the snugness of their own residence with the wretchedness of those of their less lucky brethren, may perhaps find it difficult to regard home even in its homeliest form but as a place whence all the cares and jealousies of life are excluded, where, let the world frown as it may, happy, smiling faces, and kindly voices are always ready to welcome them; where the honest love of children yields a rich compensation for the hollow friendship of men, and where the gracious trustfulness and honied consolation of woman, makes ample atonement for the petty suspicions and heartlessness of strangers, – to such, say, who have never known other than this, and who lack the imagination to conceive how a fireless grate – an empty cupboard – children peevish with hunger – wife weak, disconsolate, and querulous with long suffering, can strip

a dwelling-place of all the charms it borrows from affection and peace; how one small close room for all to sleep in, where each drinks in, the long night through, the breath of the others, can rob it even of its rest, and how the absence of the commonest requirements of decency, cleanliness, and even shelter – how the leaky roof, broken windows, damp walls, reeking drains, and wet clothes hung to dry on a string across the one apartment which has to serve as kitchen, nursery, workshop, wash-house, bed-room, coal-cellar, sitting room, larder, and all – can divest it of every touch of comfort, and so render it literally no home at all.

"But are there really such places?' the innocent and sceptical well-to-do will ask. 'It is not to be expected,' they will say, 'that the poor should be able to indulge in the luxury of double windows and doors; that their beds should be of goose-down, or their coverlets of eider-down; that hot and cold baths should be attached to their apartments: but surely this want of the commonest requirements of decency and cleanliness, the absence even of protection from the elements, is a stretch of the truth to its utmost limits.'

Assuredly it is not; and to convince you, Reader, of the fact, you shall, if you will, while you sit beside your snug sea-coal fire, in your cosy easy-chair, make a short tour with me to some few of the houses that I have seen during now two years inquiries into the condition of the humbler classes of the metropolis. You shall see them as I saw them, and as if you looked at them with your own eyes, in all their naked truth; some sketched by myself from notes taken on the spot, and others, painted far more vividly, by the owners of them, as I sat in their miserable homes, questioning them on their mode of life and merely reporting their replies . . . .

## Notes

1 *The Athenaeum*, 3 April 1852, p. 380.
2 Greek name for the Black Sea.

# [ANON] 'OUR HOUSEHOLD GOODS' (1864)

## Editorial Headnote

This text, by an anonymous author, considers the issues of possessions and ownership through a discussion of household goods. It reflects on this and particularly on 'the houses of the poor, the straightened, the sick, the solitary, the common place, the old', where 'furniture and household chattels', have an important role 'in educating and elevating their possessors'. The author also refers to the role of women in the home and their capacity to instil order, morality and taste through the furnishings of a home: 'feminine organization [is] all that is needed to develop character and stimulate exertion, to infuse the sense of weight and importance, to promote self-denial, to impart a sense of responsibility, and to cultivate taste'.

The author also points out how furniture and furnishing should not only be useful and practical but that they should also teach morality and respect.

Francis Jacox referred to this essay in his *Recreations of a Recluse* of 1870. He summed up the argument by noting that:

> the writer observes by the way that, happily, the feeling of ownership is strongest under the immediate survey of the senses, and that the things always under the eye, always within the grasp, always subject to treatment, are property in a stricter meaning than can attach to any one of a rich man's countless possessions. We are rightly said to respect the imagination which can invest movables with life, and can establish an actual community of mind with inanimate things: the appraiser's valuation has nothing to do with the worth of a poor woman's well-kept knick-nacks: they constitute to the owner and part creator of them a right to feel herself somebody: and to her they are, to all intents and purposes, wealth.[1]

This idea is rooted in the concept of sentiment in that any possessions found in a household; however meagre, represent the owner's self-identity and worth. Whether they have any financial value is irrelevant, it is the relationship between owner and object that is important.

# 31

# 'OUR HOUSEHOLD GOODS'

## *[Anon]*

Source: [Anon] 'Our Household Goods', *Saturday Review of Politics, Literature, Science and Art*, 18, 458, 1864, pp. 178–80

## OUR HOUSEHOLD GOODS

Some grace, or at least propriety of form, some harmony of colour, and some glance and shimmer of light, in the things near us and surrounding us, are one and all necessary, not only for the happiness, but for the respectability of humanity. The ascetic who excludes them from his cell sees them in vision; the prisoner who wholly misses them in his dungeon is less human for the privation. This being so, the difficulty is how to reconcile with our sense of justice the enormous disparity which exists between different ranks and classes in their power of providing themselves with these indispensable requirements. If poverty and scanty means and unfriendly circumstances stand in the way of their easy and liberal indulgence, surely these must be moral evils and direct causes of imperfection. If form, and light, and colour are necessary conditions of more than material happiness – if they cultivate, refine, and humanize – what is to become of the masses who have so few of these influences within reach? This light and beauty some men are born to as an inheritance. The proverbial silver spoon typifies their good fortune. Some snatch a full feast at intervals amidst new and strange scenes, mountain ranges, snowy peaks, gleaming lakes, harmonious distances, or in the splendour of cities, theatres, pictures, statues; some are brought in contact with beauty casually in the movements of daily life, in noble churches, illuminated streets, gay markets. Healthful and adventurous youth, whatever its class, brings itself in some way in contact with light, colour, and what at least it deems beautiful form. But there are multitudes, larger perhaps than all these classes united, whose lot it is never to see the beauties of nature, or the glories of art, or the graceful combinations of mam's grouping whose lives are solitary, or restricted to a routine of mechanical labour, who live in dull streets amid the disturbing confusion of machinery, who never see a river, or a green field, or an unbroken horizon, who know nothing of sunsets or dawnings, or the lights and shades of graceful architecture. How do such people sustain in themselves the idea of beauty without which taste dies, and happiness with it? What have they instead of parks, lakes, fountains, and gardens, gilding, hangings, mirrors, wax lights, diamonds, picturesque distances, soft

smooth surfaces, and all the crowning effects of form, light, and colour? With vast numbers, all their share of these good things, or rather of the properties that make them good, is centred within the narrow range of four walls. The shine and glitter that the eye hungers for, the colour, softness, and harmony that are necessary for peace of mind and growth of thought, are to be made out of materials inconceivably poor and seemingly inadequate, though rendered sufficient for their purpose under the mysterious influence of labour and possession. It is in the houses of the poor, the straightened, the sick, the solitary, the common place, the old, that we learn what in modern phrase we will call the "mission" of furniture and household chattels, and the mighty part they have to play in educating and elevating their possessors.

A writer of religious novels has given it as his opinion that the ideal Christian must possess landed property – that the whole man cannot be developed, nor self-denial cultivated with sufficient severity, without the exercise supplied by a large estate for every faculty and every grace. Considering the earth's very limited surface, and therefore the small number that can be trained heavenwards by this method, it is consolatory to observe how many persons a floor of twelve feet square supplies an analogous field, and constitutes this indispensable estate to woman directly, and to man through her instrumentality. There is indeed something infinitely soothing, when we are perplexed by the inequalities of fortune, in witnessing the moral effect that the possession of and control over creditable household goods will produce, and in noting how the charge of a few chairs, tables, chests of drawers, and bedsteads will supply to the active, notable feminine organization all that is needed to develop character and stimulate exertion, to infuse the sense of weight and importance, to promote self-denial, to impart a sense of responsibility, and to cultivate taste. And all this is mainly effected by care and labour to elicit from these unpromising materials those qualities of light, order, and colour which we have stated to be necessary to man's well-being. Happily, the feeling of ownership is strongest under the immediate survey of the senses, and the things always under the eye, always within the grasp, always subject to treatment, are property in a stricter meaning than can attach to any one of a rich man's countless possessions; while the beauty that men develop for themselves has a power, in its constant presence, which does not belong to the superfluities of the amply endowed.

We take the poor as an illustration of the happy influence of possession, and the duties of possession, in reconciling people to a limited share of this world's splendours, or rather in supplying them with the sense of beauty at a cheap rate. But the same effects are observed wherever the field of observation is contracted by circumstances; and since women have, as a rule, a narrower range than men, and much that is beautiful is cut off from them, whether as a daily indulgence or as a hope – for while the man travels the woman stays at home, while he labours in fields, in cities, on the seas, she keeps house – it is in them that we see the most usual and natural examples of what we mean. It is only the superficial or the cynical who will despise the relations of the respectable female mind towards her

own household effects. The thing is no doubt a mystery; it takes us sometimes by surprise; but the explanation lies, not in the frivolity of woman's nature, but in universal needs which are cut off from gratification elsewhere. We doubt whether even angelic foresight could have looked for this state of things in a world thrown open to the dominion and conquest of such a race as man – whether it could have anticipated that, even for the humblest, such scanty crumbs from the great banquet should furnish constant occupation for thought and action, that a few homely chattels should impart a sense of proud satisfaction and be contentedly accepted as a work and responsibility. We are tempted to wonder how it is that so much interest can be got out of them – such transitions of pain and pleasure, such exaltations and depressions, such life-long illusions. We respect the imagination which can invest moveables with life, which can establish an actual communion of mind with inanimate things; and we admire the effect on eye and feeling that can be drawn out of them. We own the whole to be productive of the most beneficial results; we see that this temper tends to the stability of households, to the rise of families to decency and order, not only external but fundamental; but in the abstract it is strange, and, in fact, needs some such mode of accounting for it as we are suggesting. The man who makes furniture an especial interest has to prove himself singular and cut off from the natural recreations of his class before we can respect his hobby. Whatever his success, the effect upon the observer is in no way elevating. It is when we see taste cultivated under difficulties, the mind impressing itself on untoward materials, some quaint show of harmony, grace, and brightness brought about by a need for order and beauty which can be indulged no other way, that we admire. It is not for their picturesqueness only, but for ideas and associations such these, that the household furnishings of the poor may become fit subjects for the painter's art. Artists may study antique cabinets, costly gildings, or carved oak for a special purpose but surely nothing in the long run rises so little above soulless upholstery work as the groupings from Wardour Street[2] that have in their day covered so much canvas. Nevertheless, the effects we admire are real, and vigilant care produces delightful results that are not due only to our moral approval. There is no brightness either of light or colour more in harmony with our human feeling than that which gleams from articles of homely necessity elevated into beauty by the hand that tends them – from iron, tin, and copper polished into the preciousness of silver, gold, and steel. There are no tints more charming than brick and hearth-stone, and many pieced coverlets, rich-toned earthenware, and solid wood rubbed and dusted into colour and brightness; while there is no taste that so touches our sympathy, no labour so graceful, as that which has made a home and created a veritable oasis in contrast with the dust and dreariness, it may be, of the outside world. The appraiser's valuation has nothing to do with the worth of such effects as these. They constitute to the owner and part creator of them a right to feel herself somebody; they are, to all intents and purposes, wealth.

Though no furnishings can have a favourable moral influence that are not good of their kind and adapted to their purpose, yet mere utility is by no means their highest moral end. Indeed, to have the value we have assigned to them, usefulness

must not be too rudely or unscrupulously enforced. The furniture which raises its owner in the scale of being is treated with respect; there is an acknowledged reciprocity of duty and obligation. We are not sure but that indications of this sense of duty in the proprietor are necessary to an honest pleasure in such things, even to the looker on. The rich hangings and luxurious appointments of club houses and French hotels certainly fail to excite the ideas we attach to some person's surroundings, let the form and colour be as pleasing, or the glitter as exhilarating, as skill can make them. Of course this sense of duty is easily exaggerated. When the servant becomes the master, the consequences are sufficiently irritating. The reader will recall Tom Tulliver's indignant feet wrapped in cloths that they might not soil Miss Pullet's hearth,[3] the bright stairs that risked the necks of those who ascended them, the carpets which no occasion was good enough to bring into use, the pokers and scrapers that did their duty by deputy. But young imaginations learn something even from this fanatical respect, and children who are taught no regard for even the drawing-room's soft brightness and graceful order lose a very important training in reverence and manners. A more extended sense of possession soon dispels the mystic part of the sentiment, as it is desirable it should, We point out household effects, and the care of them, as supplying multitudes with the means of a certain necessary moral training and happiness that are not furnished any other way.

While furniture, as representing the pleasures and duties of property, has always met high appreciation, there certainly has been, in all times, a jealousy of every new luxury which contributed to mere personal ease. Even Shakespeare has a sneer at easy chairs, as where he represents pursy Insolence in terrified fright, while

> Breathless wrong
> Shall sit and pant in your great chairs of ease.[4]

He delights to describe objects of splendour and *vértu*, and, we cannot doubt, knew how to make himself comfortable; but his was an age of housewives, and was full of the respects we attribute to certain classes among ourselves. Even now, when we have learned to regard such feelings as prejudices, our sentiment is regulated rather by the old standard than the modern one. Associations of mere ease cannot attach us if that ease has been inglorious. We like those things which have aided our work, or rested us after it. We do not willingly separate ourselves from tables, secretaries, pigeon-holes, drawers, well-arranged shelves amongst which we have worked and thought. They have positive control and influence over us. It is well, we think, for everybody to establish personal relations with the combination of wood and horsehair, wool and silk, without which, in our day and climate, home cannot be. Those who leave all to the upholsterer miss an opportunity of stamping themselves, as it were, upon dead matter, and imparting a kind of life to it. The man who, from no necessity, sells off his "effects" by auction, has cast away an anchor, and advertises his own tendency to disband and break loose

along with the dispersion of his movables. But furniture, to win the heart of its owner, must represent the age as well as the man. We have no faith in the attaching qualities of things chosen on consciously aesthetic principles as suiting our favourite architecture or our hobbies. Nobody can give his heart to what is cumbersome or fantastic except through the ties of long association. Nobody, for example, can be on more than the coldest visiting terms with a laboriously collected museum of lumbering carved oak. The subtle influences of these things must reach the mind through the body, not contrariwise. The notion of being at ease and at home with our furniture is not the first nor the most natural one; and while this is the one field for the cultivation of taste, it cannot be treated with absolute familiarity. However, the tendency to be comfortable, and facilities for looking about us, are reaching all ranks, and before long even the cottage housewife will have discovered other uses for her one armchair than to rub it into more flattering reflector than her looking-glass. The manufacturers of cheap ornaments are already repining at the influence of excursion trains, which, as they allege, make women care nothing for the adornment of their homes; and, of course, it is nothing to these huxters that the decay of their trade is due to the opening of a wider field of beauty to their customers, or that nature, even as seen from an excursion-train, teaches a refinement beyond the art of their most staring owls and their gaudiest Highlanders. Altogether we might begin to despond of our age, as given up to mere personal indulgence, but for a consideration or two. One is, that a fussy, striving generation like ours must have periods of more deliberate, not to say abandoned, repose than where the business of life is taken more easily. Another is, that after all we may plead a mere change in our times of ease and habits of luxury. When men sat upon hard stools they slept upon feather-beds, as the poor do still when they have them. Even Ariosto's untiring heroes tossed upon *le piume* at night.[5] Now-a-days, if we lounge in public, if we recline our lengths on down cushions in the drawing room, we at least sleep severely on mattrasses, and so may face the reproofs of our forefathers with the hope of still holding our own.

## Notes

1 Francis Jacox, *Recreations of a Recluse* (London: Richard Bentley, 1870), p. 102.
2 A London street once known for antique shops; some spurious.
3 Characters in George Eliot, *Mill on the Floss*, 1860.
4 *Timon of Athens* 5:4
5 Ludovico Ariosto wrote an Italian epic poem titled *Orlando Furioso* 1516. *Le piume* refers to feathers.

# ROBERT KERR, 'COMFORT'
## *THE GENTLEMAN'S HOUSE* (1865)

### Editorial Headnote

Robert Kerr (1823–1904) was an architect, architectural writer, and co-founder of the Architectural Association. Well-known as the author of the *Gentleman's House* (1864, revised 1871) he was also a council member of the Royal Institute of British Architects, and a professor of the arts of construction at King's College London. Kerr published *Newleafe Discourses on the Fine Art of Architecture* (1846) *The Consulting Architect* (1886) and *The History of Architecture in all Countries* (1891–1899).

Kerr clearly explains his approach to the design of a house:

> Let it be again remarked that the character of a gentleman-like Residence is not matter of magnitude or of costliness, but of design, and chiefly of plan; and that, as a very modest establishment may possess this character without a fault, all unadorned: so also the stately Seat of a millionaire may perchance have so little of it that the most lavish expenditure shall but magnify its defects. The qualities which an English gentleman of the present day values in his house are comprehensively these –

> Quiet comfort for his family and guests: –
> Thorough convenience for his domestics: –
> Elegance and importance without ostentation.[1]

This chapter deals with the concept of comfort. The modern notion of comfort (as opposed to simple forms of relief and sustenance) was well established by the time Kerr was writing. For example, the early nineteenth century author Robert Southey's *Letters from England: by Don Manuel Alvarez Espriella* was published in the summer of 1807. In it he 'discusses' the two words home and comfort, and goes on to explain that

> it [comfort] means all the enjoyment and privileges of home, or which, when abroad, make no want of home; and here I must confess that these proud islanders have reason for their pride. In their social intercourse and their modes of life they have enjoyments which we never dream of. Saints and philosophers teach us that they who have the fewest wants are the wisest and the happiest; but neither philosophers nor saints are in fashion in England.[2]

Kerr's own comments on comfort are founded in the ideals of rest, ease and a reduction in the cares of the external world. These ideals are established and maintained by the nature of the 'Gentleman's House' by prioritizing economy, restraint and well-being as the key to the state of comfortable domesticity. Kerr introduces various senses of the term 'comfort'. The obvious one is the avoidance of 'draughts, smoky chimneys, kitchen smells, damp, vermin, noise, and dust; summer sultriness and winter cold; dark corners, blind passages, and musty rooms'.[3] But he also argues for the concept that each room should be designed in relation to its use, so they were 'free from awkwardness, inconvenience, and inappropriateness, . . . as to be in every respect a comfortable room of its kind'.[4] More abstractly, Kerr offers the notion of comfort as a lifestyle that was more familiar and suited to Northern climes. He suggested that 'indoor comfort is essentially a more Northern idea, as contrasted with a sort of outdoor enjoyment which is equally a more Southern idea, and Oriental'.[5]

Nearly ten years after the publication of the *Gentleman's House*, Kerr wrote:

the arrangement of our houses of the better class, especially in the country, has become a science of delightful intricacy, which, when duly applied, even on the smallest scale, constitutes the edifice a thing of complete organisation, in which every part is assigned its special function, and is found to be contrived for that and no other; the express purpose of the whole being that exquisite result which is signified by our scarcely translatable phrase – *home comfort*.[6]

# 32

# THE GENTLEMAN'S HOUSE: OR, HOW TO PLAN ENGLISH RESIDENCES, FROM THE PARSONAGE TO THE PALACE; WITH TABLES OF ACCOMMODATION AND COST, AND A SERIES OF SELECTED PLANS

## Robert Kerr

Source: Robert Kerr, *The Gentleman's House: Or, How to Plan English Residences, From the Parsonage to the Palace; With Tables of Accommodation and Cost, and a Series of Selected Plans* (London: J. Murray, 1865), pp. 69–71

### CHAPTER III COMFORT

What we call in England a comfortable house is a thing so intimately identified with English customs as to make us apt to say that in no other country but our own is this element of comfort fully understood; or at all events that the comfort of any other nation is not the comfort of this. The peculiarities of our climate, the domesticated habits of almost all classes, our family reserve, and our large share of the means and appliances of easy living, all combine to make what is called a comfortable home perhaps the most cherished possession of an Englishman. To dwell a moment longer on this always popular theme, it is worth suggesting that indoor comfort is essentially a Northern idea, as contrasted with a sort of outdoor enjoyment which is equally a Southern idea, and Oriental. Hence the difference between the French habits, for instance, and the English. The French, like the modern Italians, represent the ancient Romans: while the English represent the old Goths by direct inheritance through the Saxons.

In its more ordinary sense the comfortableness of a house indicates exemption from all such evils as draughts, smoky chimneys, kitchen smells, damp, vermin, noise, and dust; summer sultriness and winter cold; dark corners, blind passages

DOI: 10.4324/9781003290490-42

and musty rooms.* But in its larger sense comfort includes the idea that every room in the house, according to its purpose, shall be for that purpose satisfactorily contrived, so as to be free from perversities of its own, – so planned, in short, considered by itself, as to be in every respect a comfortable room of its kind. This might be called convenience, as regards the Room, but we prefer to apply that term to another and more general quality presently, relating to the House at large.

It is too frequently considered, with respect at least to the more ordinary apartments, that almost any accidental proportion of form will do for a room, provided the door, windows, and fireplace, however accidentally placed, be not openly at variance, and provided space be adequate and height approved. But here lies the cause of incalculable shortcomings in respect of comfort. As a rule, no random arrangements of this kind ought to be tolerated. No room ought to pass muster on the plan until the designer has in imagination occupied it and proved it comfortable. It is not too much if he plots upon the drawing every important article of furniture which the room has to receive, and so establishes its capacities and qualities beyond all hazard. A little of this fastidiousness on paper will save much discomfort in the building. Take, for instance, the case of a Gentleman's Study of small size; and suppose, when the occupant comes to place his desk in it, he discovers that he must choose between three evils (not an unfrequent case), namely, whether to turn his back to the fire, or to the door, or to the window. He will be told, perhaps, that the reason of this awkwardness lies in the conflicting claims of a neighbouring apartment; or that it is the fault of the access, or the chimneybreast, or the prospect, or what not; but the simple fact is that it is the fault of the architect – the room has never been planned. It is true, it would be dangerous to assert that the architect is bound to provide for each individual apartment an arrangement as perfect and complete as if itself alone were the subject of design; questions of compromise must continually arise, and often they will prove hard of solution; but the skill of the designer has its chief task here, in reducing every compromise, by sheer patience of contrivance, to a minimum; and the plan can never be considered perfect whilst anything of the sort is so left as to provoke the perception of a radical defect or even a serious discomfort.

## Notes

1  Kerr, 1865, p. 66.
2  Robert Southey, *Letters from England*, Vol. 1, (London: Longman, Hurst, Rees and Orme, 1808) p. 182.
3  Ibid, p. 70.
4  Ibid 1864 edition, p. 77.
5  Kerr, 1865, p. 70.
6  R. Kerr, *A Small Country House*, (London: John Murray, 1874), p, 12.

*  It appears to have been matter of disappointment to some readers of our first edition that we do not deal with this class of questions in detail, by way of pointing out the means of prevention and cure; but a moment's reflection will show that, our subject being Plan only, these considerations as a class cannot come formally into our programme. Several of them, however, are frequently spoken of incidentally throughout the work.

# HIPPOLYTE TAINE, *NOTES ON ENGLAND* (1872)

## Editorial Headnote

Hippolyte Taine (1828–1893) was a French historian and writer on contemporary art and literature. In 1864 he was appointed to succeed architect Viollet-le-Duc as professor of aesthetics and of the history of art at the École des Beaux-Arts in Paris where he remained until 1883. Here he developed a reputation as one of the most major promoters of positivism. His efforts to apply the scientific method to the study of the humanities was one of his major legacies.

He was also one of an illustrious set of visitors from France that wrote about England and the English from a French viewpoint. He joins Voltaire, Stendhal, Morand and Tocqueville in this task that seems to have been welcomed by contemporary readers. The review in *Notes and Queries* pointed out that however fond people maybe of repeating Burn's couplet 'To see ourselves as others see us',

> their real wish is only to see themselves when in full dress and on their best behaviour. This wish they will not find gratified in the work before us for though he looks at us with friendly eyes, M. Taine does not shut them to what he considers our faults or our shortcomings, . . . [There is] a feeling of the truth of his translator's judgment, that M. Taine is sympathetic without stooping to flattery, and candid without lapsing into discourtesy.[1]

The *London Quarterly Review* were also impressed:

> On a smooth and polished mirror many aspects of our national life are minutely and accurately reflected. M. Taine is a careful and correct observer, and very skilful in delineation. All that his eye sees, and it must be very observant eye, he accurately records. . . . Intelligent discernment, accuracy and fairness characterise these letters. They will please the English reader, for they exalt our national advantages: they will abase, sadden, and instruct him, for they reveal our deplorable national vices.[2]

Amongst his observations Taine noticed that the English were more interested in country living than city dwelling as a source of comfort:

> Drives and visits in the wealthy quarter [of Manchester]. Here and at Liverpool, as at London, the English character is manifested in the buildings. The City man does his utmost to cast his city skin; he strives to have his country seat and country surroundings at the outskirts; he feels the

necessity of being by himself – of feeling that he is alone, monarch of his family and his servants, of having around him a piece of park or a garden as a relaxation from the artificial life of town and of business.[3]

This text is a description of a house, its layout and its comforts, especially in the guest bedroom which is described in detail. His point in relation to comfort(s) being supplied by servant staff links their work with the physical supply of comfort for the user.

# 33

# *NOTES ON ENGLAND*

## *Hippolyte Taine*

Source: Hippolyte Taine, *Notes on England* (London: Strahan & Co., 1872), pp. 181–3

The house is a large mansion, rather commonplace, solid in appearance, arranged in modern style; the furniture of the ground floor and of the first floor, recently renewed, cost four thousand pounds. Three rooms or drawing-rooms, sixty feet long, twenty high, are furnished with large mirrors, good pictures, excellent engravings, with bookcases. In front is a glazed conservatory, where one passes the afternoon when the weather is bad, and where, even in winter, one can fancy that it is spring. Bedrooms for the young ladies who come as visitors; fresh, clear, virginal, papered in blue and white, with an assortment of pretty feminine objects and fine engravings, they are well fitted for their amiable occupants. As for the rest, the picturesque sentiment of decoration and of the arrangement of the whole is less keen than among us; for example, the objects and the tones are rather placed in juxtaposition than in accord. But there is grandiosity and simplicity; no fondness for crowding and for old curiosities. They readily submit to large bare plane surfaces, empty spaces; the eye is at ease, one breathes freely, one can walk about, one has no fear of knocking against the furniture. Attention is given to comfort, notably to what relates to the details of sleeping and dressing. In my bedroom, the entire floor is carpeted, a strip of oilcloth is in front of the washing-stand, matting along the walls. There are two dressing tables, each having two drawers, the first is provided with a swing looking-glass, the second is furnished with one large jug, one small one, a medium one for hot water, two porcelain basins, a dish for toothbrushes, two soap-dishes, water-bottle with its tumbler, a finger-glass with its glass. Underneath is a very low table, a sponge, another basin, a large shallow zinc bath for morning bathing. In a cupboard is a towel-horse with four towels of different kinds, one of them thick and rough. Another indispensable cabinet in the room is a marvel. Napkins are under all the vessels and utensils; to provide for such a service, when the house is occupied, it is necessary that washing should be always going on. Three pairs of candles, one of them fixed in a small portable table. Wax-matches, paper spills in pretty little holders, pin-cushions, porcelain extinguishers; metal extinguishers. Whiteness, perfection, softest tissues in every part of the bed. The servant comes four times a day into the room in the morning to draw the blinds and the curtains, open the inner blinds, carry off the boots and

DOI: 10.4324/9781003290490-43

clothes, bring a large can of hot water with a fluffy towel on which to place the feet; at midday, and at seven in the evening, to bring water and the rest, in order that the visitor may wash before luncheon and dinner: at night to shut the window, arrange the bed, get the bath ready, renew the linen; all this with silence, gravity, and respect. Pardon these trifling details; but they must be handled in order to figure to oneself the wants of an Englishman in the direction of his luxury; what he expends in being waited upon and comfort is enormous, and one may laughingly say that he spends the fifth of his life in his tub.

## Notes

1  Review: 'Notes on England', *Notes and Queries*, IX, 6 April 1872, p. 291.
2  'Notes on England', *London Quarterly Review*, July 1872, p. 519.
3  Taine, 1872, p. 275.

# SAMUEL SMILES, *THRIFT* (1875)

## Editorial Headnote

A Scottish author and government reformer, Samuel Smiles (1812–1904) thought that progress in society was achieved through individuals developing personal attitudes (such as thrift) rather than relying on government legislation. His major publication, *Self-Help* (1859), was a text aimed at the poor, and was intended to encourage self-education and upward mobility. The idea of the 'deserving' poor meant that even those at the bottom of the social ladder should be able to improve themselves through hard graft and perseverance, as opposed to the undeserving poor who should be left to their own devices.

An example of Smiles's approach is seen in an early part of his book titled *Thrift* where he says:

> Time can be economized by system. System is an arrangement to secure certain ends, so that no time may be lost in accomplishing them. Every businessman must be systematic and orderly. So must every housewife. There must be a place for everything, and everything in its place. There must also be a time for everything, and everything must be done in time.[1]

The now rather overworked phrases regarding planning that are so familiar now, did have a bearing on the thinking of domestic planning in the century. These references echo the comment of other commentators (see texts 1.23–1.28).

*The Academy's* review of the book was supportive:

> He sketches the sanitary movement, unsparingly satirises the feminine follies of fashionable circles, and lastly concludes with an admirable essay on what may be called the aesthetics of common life. We all know what a book from Mr. Smiles is sure to be, anecdotical, practical, and abounding in good sense and every-day wisdom, a book that is sure to entertain the old and instruct the young. Whether thrift, any more than etiquette, swimming, or the art of conversation can be taught in a book is a doubtful matter, but there is no doubt that young people may reap some benefit from Mr. Smiles' good-natured sermons.[2]

This extract again considered domestic comfort as a primary concept for a 'happy home'. It does acknowledge that it is relative to an individual's station and also that it is women that manage and maintain the comfort of a home. Indeed, Smiles make the point that comfort in the home is not just a set of physical properties but that it is also rooted in morality which is aided by women's good management and thrift. He makes a lot of the concept of a 'comfortable person' and makes many references to aspects of this idea.

# 34

# *THRIFT*

## *Samuel Smiles*

Source: Samuel Smiles, *Thrift* (London: J. Murray 1875), pp. 359–62

The Art of Living is best exhibited in the Home. The first condition of a happy home, where good influences prevail over bad ones, is Comfort. Where there are carking cares, querulousness, untidiness, slovenliness, and dirt, there can be little comfort either for man or woman. The husband who has been working all day, expects to have something as a compensation for his toil. The least that his wife can do for him, is to make his house snug, clean, and tidy, against his home-coming at eve. That is the truest economy – the best housekeeping – the worthiest domestic management – which makes the home so pleasant and agreeable, that a man feels when approaching it, that he is about to enter a sanctuary; and that when there, there is no alehouse attraction that can draw him away from it.

Some say that we worship Comfort too much. The word is essentially English, and is said to be untranslatable, in its full meaning, into any foreign language. It is intimately connected with the Fireside. In warmer climes, people contrive to live out of doors. They sun themselves in the streets. Half their life is in public. The genial air woos them forth, and keeps them abroad. They enter their houses merely to eat and sleep. They can scarcely be said to *live* there.

How different is it with us! The raw air without, during so many months of the year, drives us within doors. Hence we cultivate all manner of home pleasures. Hence the host of delightful associations which rise up in the mind at the mention of the word Home. Hence our household god, Comfort.

We are not satisfied merely with a home. It must be comfortable. The most wretched, indeed, are those who have no homes – the homeless! But not less wretched are those whose homes are without comfort those of whom Charles Lamb once said, "The homes of the very poor are no homes." It is Comfort, then, that is the soul of the home – its essential principle – its vital element.

Comfort does not mean merely warmth, good furniture, good eating and drinking. It means something higher than this. It means cleanliness, pure air, order, frugality, – in a word, house-thrift and domestic government. Comfort is the soil in which the human being grows, – not only physically, but morally. Comfort lies, indeed, at the root of many virtues.

DOI: 10.4324/9781003290490-44

Wealth is not necessary for comfort. Luxury requires wealth, but not comfort. A poor man's home, moderately supplied with the necessaries of life, presided over by a cleanly, frugal housewife, may contain all the elements of comfortable living. Comfortlessness is for the most part caused, not so much by the absence of sufficient means, as by the absence of the requisite knowledge of domestic management.

Comfort, it must be admitted, is in a great measure *relative*. What is comfort to one man, would be misery to another. Even the commonest mechanic of this day would consider it miserable to live after the style of the nobles a few centuries ago; to sleep on straw beds, and live in rooms littered with rushes. William the Conqueror had neither a shirt to his back, nor a pane of glass to his windows. Queen Elizabeth was one of the first to wear silk stockings. The Queens before her were stockingless.

Comfort depends as much on persons as on "things." It is out of the character and temper of those who govern homes, that the feeling of comfort arises, much more than out of handsome furniture, heated rooms, or household luxuries and conveniences.

Comfortable people are kindly-tempered. Good temper may be set down as an invariable condition of comfort. There must be peace, mutual forbearance, mutual help, and a disposition to make the best of everything. "Better is a dinner of herbs where love is, than a stalled ox and hatred therewith."

Comfortable people are persons of common sense, discretion, prudence, and economy. They have a natural affinity for honesty and justice, goodness and truth. They do not run into debt, – for that is a species of dishonesty. They live within their means, and lay by something for a rainy day. They provide for the things of their own household, – yet they are not wanting in hospitality and benevolence on fitting occasions. And what they do, is done without ostentation.

Comfortable people do everything in order. They are systematic, steady, sober, industrious. They dress comfortably. They adapt themselves to the season, neither shivering in winter, nor perspiring in summer. They do not toil after a "fashionable appearance". They expend more on warm stockings than on gold rings; and prefer healthy, good bedding, to gaudy window-curtains. Their chairs are solid, not gimcrack. They will bear sitting upon, though they may not be ornamental.

The organization of the home depends for the most part upon woman. She is necessarily the manager of every family and household. How much, therefore, must depend upon her intelligent co-operation! Man's life revolves round woman. She is the sun of his social system. She is the queen of domestic life. The comfort of every home mainly depends upon her, – upon her character, her temper, her power of organization, and her business management. A man may be economical; but unless there be economy at home, his frugality will be comparatively useless. "A man cannot thrive," the proverb says, "unless his wife let him."

House-thrift is homely, but beneficent. Though unseen of the world, it makes many people happy. It works upon individuals; and by elevating them, it elevates society itself. It is in fact a receipt of infallible efficacy, for conferring the greatest

possible happiness upon the greatest possible number. Without it, legislation, benevolence, and philanthropy are mere palliatives, sometimes worse than useless, because they hold out hopes which are for the most part disappointed.

How happy does a man go forth to his labour or his business, and how doubly happy does he return from it, when he knows that his means are carefully husbanded and wisely applied by a judicious and well-managing wife. Such a woman is not only a power in her own house, but her example goes forth amongst her neighbours, and she stands before them as a model and a pattern. The habits of her children are formed after her habits, her actual life becomes the model after which they unconsciously mould themselves; for example always speaks more eloquently than words: it is instruction in action – wisdom at work.

## Notes

1 Smiles, *Thrift*, 1875, p. 13.
2 Review, *The Academy*, 10, 226, 1876, p. 304.

# Part 6

# DOMESTICITY

# DOMESTICITY AND
# THE CONCEPT OF HOME

The notion of home varies across place and time. It reflects the religious and cultural mores of the time, and is restrained by external factors including social and economic pressures. The idea of a home is also formed by the nature of various relationships as well as socially defined gender roles. The ideal of home for the Victorians was equated with respectability, contentment and security. John Ruskin's well-known portrayal reflects this ideal perfectly:

> The true nature of home – it is the place of peace: the shelter, not only from all injury, but also from all terror, doubt and division. In so far as it is not this, it is not home; so far as the anxieties of the outer life penetrate into it, the inconsistently-minded, unknown, unloved, or hostile society of the outer world is allowed by either husband or wife to cross the threshold, it ceases to be home; it is then only a part of that outer world which you have roofed over and lifted fire in.[1]

This idea had been expressed earlier in 1853 when a 'happy home' or rather a moral home was simply and effectively defined in the *Family Friend* as

> A dwelling comfortable furnished, clean, bright, salubrious and sweet . . . a small collection of books on the shelves – a few blossoming plants in the window – some well selected engravings on the walls . . . these are conditions of existence within the reach if everyone who will seek them – resources of the purest happiness, lost to thousands, because a wrong direction is given to their tastes and energies, and they roam abroad in pursuit of interest and enjoyment which they might create in abundance at home.[2]

The idea of incorrect 'tastes and energies' missing out on the benefits of home was an essentially middle-class idea which hinted at the need for education, self-help and commitment to the idea of 'home sweet home'. The Registrar General of the 1851 Census neatly summed up attitudes: 'The possession of an entire house is, it is true, strongly desired by every Englishman; for it throws a sharp, well-defined circle round his family and hearth the shrine of his sorrows, joys, and meditations'.[3]

DOI: 10.4324/9781003290490-46

In 1859 *The Art Journal* published a review of the engraving of *The Royal Family* painted by F. Winterhalter. Here the review considers why images of the royal family at home are so interesting to the public, and help to explain the fascination of the home.

> We English are unquestionably a domestic people; everything that partakes of home comforts and enjoyments is dear to us, no matter how elevated the position or how ennobled the rank of the possessor; for there is not a palace nor a mansion in the land in which the apartments where state and revelry receive their guests, are not gladly exchanged, on fitting occasions, for the less sumptuous but far more inviting chambers wherein the family circle is accustomed to gather. The interest universally felt in this subject is evident from the anxiety that is always expressed to see and know how they who occupy high places look and act in their "ain house at hame," when the trammels of external show and of fashion are laid aside, and the heart is of the world within and not of that without.[4]

The nature of the role of women as home-makers was still being contested in 1889. A Professor Roark argued that the 'woman movement, was a force, however undesignedly, antagonistic to the home. The rights of one home are greater and more sacred than the so-called public rights of any number of women'. He went on to say,

> it must be true that the mother is in the true and large sense the creator of the home. Around her in after years will cluster the children's thoughts of home; she is the essential attribute in any true concept of home. Nor can the mother delegate this business of home-making and home- (not house-) keeping to paid servants, any more than the husband can, if his business is to be successful, delegate the supervision of the business to employees.[5]

The texts all reflect how domesticity, and the concept of home were built around the wife or mother figure whether written by churchmen, reformers or women themselves.

(See also Part 7 'Gender and Identity'.)

## Notes

1 John Ruskin, *Sesame and Lilies: Two Lectures Delivered at Manchester in 1864* (London: Smith Elder, 1865), p. 148.
2 Cited in Adrian Forty, *Objects of Desire* (London: Thames and Hudson, 1986), p. 108.
3 *Report of the Registrar-General on the Census of 1851*, pp. xxxv–xxxvi; P.P. 1852/3, vol. 85.
4 *Art Journal*, XII, 1850, p. 235.
5 Prof. R. N. Roark, "Another say about Women", *The Statesman*, Chicago, January 1890, p. 199.

# JAMES ANTHONY FROUDE,
## *THE NEMESIS OF FAITH* (1849)

### Editorial Headnote

James Anthony Froude (1818–1894), was an English historian and biographer. Froude went up to Oxford and was influenced by a fellow student and future cardinal, John Henry Newman. After graduating in 1842, he broke with the Oxford movement and, with the appearance of the third of his novels, *The Nemesis of Faith* in 1849, he was obliged to resign his fellowship at Exeter College. In effect the novel was an attack on the established church.

The *Nemesis of Faith* is an epistolary novel that is partly autobiographical, in which are described the reasons for and the consequences of a youthful priest's crisis of faith. Numerous critics condemned it, including Thomas Carlyle. The *Bentley* magazine's report on the novel is typical.

> The spirit of the Work to which we refer is such – the venom spit at THE CREATOR so daring and incessant; the palliation of adultery so nauseous and revolting; that one is curious to know how the writer obtained his fellowship, and by what instrumentality he was admitted to holy orders.[1]

Amazingly, the book was publicly burnt, the outcry being so enormous. However, Froude did have his supporters including the novelists George Eliot and Mrs. Humphrey Ward.

This particular extract though is not so contentious, as it does reflect many of the Victorians' thoughts on the idea of home and family. Nevertheless, Froude denied the republication of work after its second edition, and in 1858 he formally retracted it.

The nostalgia for the 'old home' is fully evident in this sentimental passage which is preceded by a passage explaining how 'there is one strong direction into which the needle of our being, when left to itself, is for ever determined, which is more than a catchword, which in the falsest heart of all remains still desperately genuine, the one last reality of which universal instinct is assured'.[2] Froude declared that this talisman was home.[3]

# 35

## *THE NEMESIS OF FAITH*

### James Anthony Froude

Source: James Anthony Froude, *The Nemesis of Faith* (London: Chapman, 1849), pp. 102–4

The fish struggle back to their native rivers; the passage birds to the old woods where they made their first adventure on the wings which since have borne them round the world. The dying eagle drags his feeble flight to his own eyrie, and men toil-worn and careworn gather back from town and city, from battle-field or commerce mart, and fling off the load where they first began to bear it. Home – yes, home is the one perfectly pure earthly instinct which we have. We call heaven our home, as the best name we know to give it. So strong is this craving in us, that, when cross fortune has condemned the body to a distant resting-place, yet the name is written on the cenotaph in the old place, as if only choosing to be remembered in the scene of its own most dear remembrance. Oh, most touching are these monuments! Sermons more eloquent were never heard inside the church walls than may be read there. Whether those hopes, written there so confidently, of after risings and blessed meetings beyond the grave, are any more than the "perhaps" with which we try to lighten up its gloom, and there be indeed that waking for which they are waiting there so silently, or whether these few years be the whole they are compelled to bear of personal existence, and all which once was is reborn again in other forms which are not there anymore, still are those marble stones the most touching witness of the temper of the human heart, the life in death protesting against the life which was lived.

Nor, I think, shall we long wonder or have far to look for the causes of so wide a feeling, if we turn from the death side to the life side, and see what it has been to us even in the middle of the very business itself of living. For as it is in this atmosphere that all our sweetest, because most innocent child memories are embosomed, so all our life along, when the world but knows us as men of pleasure or men of business, when externally we seem to have taken our places in professions, and are no longer single beings, but integral parts of the large social being; at home, when we come home, we lay aside our mask and drop our tools, and are no longer lawyers, sailors, soldiers, statesmen, clergymen, but only men. We fall again into our most human relations, which, after all, are the whole of what belongs to us as we are ourselves, and alone have the key-note of our hearts. There our skill, if skill we have, is exercised with real gladness on home subjects. We are

DOI: 10.4324/9781003290490-47

witty if it be so, not for applause but for affection. We paint our fathers' or our sisters' faces, if so lies our gift, because we love them; the mechanic's genius comes out in playthings for the little brothers, and we cease the struggle in the race of the world, and give our hearts leave and leisure to love. No wonder the scene and all about it is so dear to us. How beautiful to turn back the life page to those old winter firesides, when the apple hoards were opened, and the best old wine came up out of its sawdust, and the boys came back from school to tell long stories of their fagging labours in the brief month of so dear respite, or still longer of the day's adventures and the hair-breadth escapes of larks and blackbirds. The merry laugh at the evening game; the admiring wonder of the young children woke up from their first sleep to see their elder sisters dressed out in smiles and splendour for the ball at the next town. It may seem strange to say things like these have any character of religion; and yet I sometimes think they are themselves religion itself, forming, as they do, the very integral groups in such among our life pictures as have been painted in with colours of real purity. Even of the very things which we most search for in the business of life, we must go back to home to find the healthiest types. The loudest shouts of the world's applause give us but a faint shadow of the pride we drew from father's and sister's smiles, when we came back with our first school prize at the first holidays. The wildest pleasures of after-life are nothing like so sweet as the old game, the old dance, old Christmas, with its mummers and its mistletoe, and the kitchen saturnalia. Nay, perhaps, even the cloistered saint, who is drawing a long life of penitential austerity to a close, and through the crystal gates of death is gazing already on the meadows of Paradise, may look back with awe at the feeling which even now he cannot imitate, over his first prayer at his mother's side in the old church at home.

## Notes

1 "Mr. Froude and 'The Nemesis of Faith,'" *Bentley's Miscellany*, 25, (1849), p. 443.
2 Froud, 1849, p. 101.
3 "Froude never felt comfortable at home, and it is poignant to find Markham Sutherland, the main character in The Nemesis of Faith who so clearly represents Froude himself, extensively idealizing home as the fostering-ground for the affections and the religious sensibility." F. Korsten, "Froude and Bunyan," *Neophilologus* 77, 3, 1993, p. 489.

# JOSEPH WATTS LETHBRIDGE, 'THE HOME PARADISE' (1858)

## Editorial Headnote

*The Englishwoman's Review* was published from 1866 to 1910. The magazine's feminist publishers supported an approach that was to chart and discuss the emerging emancipated middle-class woman and her opportunities. These included economic independence from men, occupation selection, involvement in the professions, commerce and government, access to higher education, and equal suffrage. The editors of *Good Housekeeping* wrote in 1890 that the *Englishwoman's Review* 'had always retained as distinctive character as a record of *women's progress in social and industrial questions in all parts of the world'*.[1]

Joseph Watts Lethbridge (1817–1885) was a dissenting cleric, who held a number of posts across England. He published *Woman the Glory of Man*, (London, 1856), which was sub-titled 'Showing the Relations of her Physical, Social, Intellectual, Moral and Religious Superiority Over Man'; *Loving Thoughts for Human Hearts*, (London, 1860); and *The Idyls of Solomon: the Hebrew Marriage Week arranged in Dialogue*, (London, 1878).

An idea of his approach is seen in his *Woman the Glory of Man* where he states*:*

> How often may it be said, and by how many too, the home she has constantly blessed and cheered, – the home which but for her were only a few rooms, and pieces of furniture, and discontented solitude, a barren, miserable hermitage; but through her it has been made, sacred, morning, noon, and night.[2]

As the author was a cleric it is not surprising that the text reads rather like a sermon emphasising the Victorian ideas and values of a home as a bastion of truth, faith, hope and love. During the century the home ceased to be simply a shelter and took on a greater connotation. The commentators, often clergymen, developed an ideology that connected the basic need for shelter to a higher moral order. These attitudes helped to form revised cultural and religious attitudes. The commentators particularly fostered the idea of a home as a hallowed symbol in and of itself, so that religion became more domesticated.

The passage is introduced and concluded with extracts from the well-known poem *Home Sweet Home*, (John Howard Payne, 1791–1852).

# 36

# 'THE HOME PARADISE'

## Joseph Watts Lethbridge

Source: Joseph Watts Lethbridge, 'The Home Paradise', *The Englishwoman's Review: A Journal of Woman's Work*, 45, 22 May 1858, pp. 629–30

"Mid pleasures and palaces tho' we may roam,
Be it ever so humble, there's no place like home.
A charm from the skies seems to hallow us there
Which, seek through the world, is ne'er met with elsewhere.
Home! home! sweet, sweet home!
There is no place like home.

As the radii of a circle come from and go to a common centre, so all the social influences of good and evil may be seen to proceed from the centre of every individual's daily life, namely, the home.

Here springs up unceasingly the social living water which supplies the streams of good that flow through the channels, washing, refreshing, rendering fruitful, and beautifying the banks of society. Here, too, is spun the material which soothes sorrow, clothes the naked, binds the criminal, and hangs the murderer. Home is the world's, society's enclosure of virtue and vice.

The first home of man was wrecked through the unskilfulness of the pilotage tossed about like the barque of Eneas, when sailing from the coasts of Troy for Italy and the Lavinian shores.[††3]

Stranded on the quicksands of temptation, wrecked upon the rock which had been for bidden, every plank lost but one; and on that one the sin-beaten mariners sailed to land; and with that one made for themselves a refuge; and in that refuge a hearth; and around that hearth, a HOME.

Every man and every woman who has a home has, socially speaking, a recovered plank from the good old ship "Paradise."

This recovered fragment is a remembrancer of what the home should be to its inmates, – a garden where beauty and sweetness are; an Eden, a pleasant

††  . . . . . . . . . . . . . . . . . . . . . . . . . . . Ab oris
   Italiam, fato profugus Lavinia venit
   Littora, – AN., B. I.

DOI: 10.4324/9781003290490-48

place, paradise of happiness. To some, from the earliest childhood. it has been a memento of life to body and soul; while to others, from the dawn of consciousness, it has been nothing but the memento of misery and death. parents, and mothers more especially, would leave a pleasant impression on their children's minds, they must make their homes a family garden, a sacred pleasure ground, an enclosure, paradise.[4]

And the mother should begin where nature begins, that is to say, with the infant. Infant mortality is anything but maternal morality. Sin against physical laws is as much sin as the transgression of moral laws. To drive back the waves and prevent the flowing out of the *spring-tide* of the infantine developments, is to sin against the freedom which God and nature have given to the first manifestation of the human form. To bind up the limbs when they ought to be unbound, is to clip and maim sensation and to take away its strength. To imprison the innocent and fasten with prison chains those who are marked with no social sin, charged with no social crime, is again to tread forbidden ground, again to pluck forbidden fruit, to perpetrate upon the infant race a desperate crime, which sooner or later will overtake the community with the destroying elements of a fearful penalty.

Statistics tell us that infants die at the rate of forty per cent. before they are five years old, and disease strips a great many more of their strength and physical beauty, and leaves them but of stunted growth, very much like useless trees in the possession of useful ground.

What would society say if forty per cent. of the useful produce of the country were lost to the community? If forty grains of wheat were lost out of every hundred grains, or forty ears per cent. of other grain, or forty sheep, cows, or horses out of every hundred head, would there not be an inquiry made. Say if forty shillings per cent. were lost to the money market, or if forty per cent. of gold were to go down the gulf as lost, would not the evil be traced out and a remedy provided!

For the recovery and salvation of the insensible, insentient, irrational things, what an impulse and agitation would move society to its foundations! How human souls, like ocean waves, would roll, and rise, and bellow forth their hollow sounds! What man that shall have a sheep and it fall into a pit, will not lay hold on it and lift it out?[5] How much, then, is an *infant* better than a sheep?

What would trade and business say if forty hours out of a hundred, or forty days per cent, were lost to the counting-house or shop counter? Would not the merchant and the tradesman look about and bestir themselves, and give no rest to their tongues and their limbs until they had recovered the loss? May it not be said in this case as on another occasion – "Ye pay tithe of mint, and anise and cummin, and have omitted the weightier matters of the law: these ought ye to have done, and not to leave the other undone."[6]

Time and property are looked up and found, untied, liberated, and multiplied; but the weightier matter – to make time more valuable and give to property wings to fly to more extensive regions – the strength and sinew of the infant limbs, the muscle and growth of the human constitution, are left in bondage only to sicken,

and in the noisome dungeons of infected air and the killing influences of vitiated food, to wither and to die. The work of mothers must be first to learn the way to save and not destroy forty per cent. of the infant race, for the good of society and the glory of God.

HOME, the recovered paradisical fragment, should be a standing memorial of happy influences.

The happiness or misery of home consists in the recognition of the sacred tree of duty, on which grow the fruits of good and evil, obedience and the contrary. Within the sacred enclosure is forbidden ground. Stinging serpents, wriggling snakes, hypocrisy and lies, flattery and deceit, and company, attempt to enter and desecrate it. Tread not on the forbidden path, for the footsteps will be seen and traced. Touch not the sacred thing which duty guards, for duty, sinned against and violated in any way, will become a revenging angel with flaming sword, and turning every way a citadel of strength of fiery ammunition to revenge the insulted law and outraged justice. See to it, all whom it may concern, that the sanctities of home be respected with a virtuous jealousy.

How will some men work and toil to erect for themselves a monument of fame, in order that posterity may look upon a representation of their form in bronze or stone? And how many among such men are disappointed in the object of their laudable ambition? The noblest representation any man or woman, or both, can erect is a virtuous home. And such a place has special advantages attached to it the husband and wife are their own designers and their own builders, not left to the benevolent whim or sullen caprice of other parties to construct or not, as popular opinion or otherwise may determine. And such an erection is not delayed until life is over, when no personal happiness can be experienced; but the home constructed upon a virtuous basis, carried up with the materials of a virtuous development, the last stroke will be received with a virtuous acclamation.

The truly virtuous home has four evergreens growing in its midst – plants which never die, flowers which never fade: winter frosts and chilling blasts do not kill these plants, for they are ever-green. *Truth* is found in such a home and where can be found such congenial Soil? *Faith* finds a resting-place, a scene of repose, a prop to lean upon. The parents and children of such a home have faith in one another believing all things, for if such have not faith in each other here, where is faith to be found. Here *Hope* looks round, and out, and on and on, and up with sunny smiles and golden expectations, hoping all things. And here, too, *Love* lives and grows, the ever active divinity, the perpetual motion of the place never tired, although bearing all things. Reader, act well thy part in securing to thyself and those around thee the blessedness and happiness of a virtuous home.

The place where vice reigns is a desecration. Truth is withered, dead, lost, a lie occupies its place. Infidelity is where faith should be. Hope there is none. Despair has come and brought idleness, wretchedness, and recklessness in its train, love has retired weeping; passion and hatred hold their court rule. Reader, if such a

home be thine, summon all the powers of heart and feeling, and turn it upside down by turning the present inmates out.

> An exile from home splendour dazzles in vain;
> Oh! give me my lovely thatch'd cottage again
> The birds singing gaily, that came at my call,
> Give me them, with a peace of mind dearer than all,
> Home! home! sweet, sweet home!
> There is no place like home.

## Notes

1 *Good Housekeeping* [US] 13 September 1890, p. 233.
2 J. Watts Lethbridge, *Woman the Glory of Man, Dedicated to the Ladies of England* (London: Thomas Richardson and Son, 1856), p. 52.
3 Aeneas, the hero of Virgil's *Aenid*, after many years trials and tribulations, finally arrives in Italy and meets his bride Lavinia and settles down.
4 Virgil, Aeneid, "From the coast of Italy, Lavinia, a fugitive from fate, came to Litora."
5 Matthew Gospel, 12:11.
6 Matthew 23:23.

# ELIZA COOK, 'THREE HUNDRED POUNDS A YEAR' (1872)

## Editorial Headnote

Eliza Cook (1818–1889) was a self-educated writer and poet who at the age of seventeen published her first poetry collection, *Lays of a Wild Harp: A Collection of Metrical Pieces* (John Bennett, 1835). Her hugely popular poem, 'The Old Armchair' (1838), promoted her in both England and America. The poem describes an ideal mother who has passed away but left valued memories behind in the 'old armchair'. In the same year she published her second collection, *Melaia and Other Poems*. Cook also published poems in magazines such as *Metropolitan Magazine, New Monthly Magazine*, and *Weekly Dispatch*.

Cook was an advocate of political and sexual freedom for women, and she addressed questions of class and social justice, believing strongly in the ideology of self-improvement through education. This was in line with other commentators of the time such as Samuel Smiles. In 1849, Cook started a penny-biweekly called *Eliza Cook's Journal*, which contained poems, reviews, and social essays written mostly by her for a female audience. This audience was the comparatively well-educated working-class or lower middle-class family and included many items found in traditional women's magazine. Nevertheless, she included some radical discussions in support of her beliefs. The title ceased publication in 1854.

Cook's Chartist sympathies meant that the idea that women took over the home as a response to the viciousness of the outside world, made this an important aspect of her poetry. In her poem 'The Room of the Household', she explains her approach to the constraints of social etiquette. The room frees up its users from social conventions and becomes a real living space rather than a location for displays.

> The romp may be fearlessly carried on there,
> No 'bijouterie' rubbish solicits our care;
> All things are as meet for the hand as the eye,
> And patchwork and scribbling unheeded may lie;
> "Black Tom" may be perch'd on the sofa or chairs,
> He may stretch his sharp talons and scatter his hairs;
> Wet boots may 'come in,' and the ink-drop may fall,
> For the room of the Household is 'liberty hall'.[1]

The poem in this chapter also addresses a number of issues including class pretentiousness, the ridiculousness of following fashion, and the flamboyant expenditure of the English middle classes. The particular thrust of the poem addresses the issue for men lacking the necessary income to marry successfully, and the reasons for staying single were clearly outlined. It also outlines the expectations of middle

England and their homes and seems to reflect Cook's disdain for them. It was accepted that men were expected to keep their wives in the style to which they aspired, and this accounts for why many middle and upper-class men married comparatively late in life.

# 'THREE HUNDRED POUNDS A YEAR'

## *Eliza Cook*

Source: Eliza Cook, 'Three Hundred Pounds a Year', *The Poetical Works of Eliza Cook*, (London: F. Warne, c. 1872), pp. 601–3

### 'Three Hundred Pounds a Year'

My Angel sweet! my dove of doves!
Oh! who shall ever tell
How much your Charles Adolphus loves
His Florence Isabel?
As for my heart! oh! do believe
That I, this very minute,
"Would carry it upon my sleeve,
While you stuck hair-pins in it.
Thou art the dearest of the dear;
My fate! my soul! my life!
But on "three hundred pounds a year"
How can you be my "wife?"
Love, now, is an expensive thing
When once we lodge and board it;
And though I long to buy the ring;
I really can't afford it.

Sweet girl! you know three hundred pounds
Would prove a slender axis
For household wheels to run their rounds
In yearly rent and taxes.
You see, dear, that our home must be
Out West, about the squares,
With good reception rooms – full three –
And servants' flight of stairs.
You must have "soirees" now and then,
(Though I can't see their use);
And I must often have some men

DOI: 10.4324/9781003290490-49

To dinner – "a la Russe"
I've asked my uncle for his aid;
Of course, he won't accord it;
And so our bliss must be delayed,
For means, love, wont afford it.

A housemaid, cook, and liveried boy
We must, at once engage;
One of the two we must employ –
A footman, or a page.
I cannot well resign at "Lord's,"
And you, dear Flo, of course,
Must go to balls and make your "calls"
With decent brougham and horse.
I must keep up my name at "White's,"
Despite all uncle says;
You still must have your opera nights
And show on Chiswick days.
Now, if I had three thousand, dear,
You know I would not hoard it;
But on three hundred pounds a year!
I really can't afford it.

My tailor's bills are long, but yet,
They cannot well be less;
And Madame Folie Mantolette,
You know, can charge for dress.
Your gloves and trinkets take some cash,
And then, sweet Isabel,
My "weeds," which uncle reckons "trash,"
Cost more than I dare tell.
I wish my heart were made of rock,
To bear this heavy woe –
Just ring, love, for a glass of Hock;
I really feel quite low.
To think with love so warm and dear
That marriage can't reward it;
But on "three hundred pounds a year,"
How can a man afford it?

## Note

1 Eliza Cook, 'The Room of the Household' in *The Poetical Works of Eliza Cook* (London: Frederick Warne and Co, 1870), p. 184.

## ANNIE. S. SWAN, 'THE IDEAL HOME', *COURTSHIP AND MARRIAGE: AND THE GENTLE ART OF HOME-MAKING* (1893)

### Editorial Headnote

A prolific Scottish journalist, novelist and story writer (1859–1943) Annie Swann was for many years the editor of the 'Love, Courtship, and Marriage' column for the journal *Woman at Home*. For over sixty years she published work in the sentimental magazine, *The Peoples' Friend*, but at the same time managed to engage with issues such as feminism and Scottish nationalism. Swan's prolific output included at least one hundred book titles, one hundred and fifty magazine serials and many hundreds of short stories and articles. Under the pseudonym of David Lyall she made considerable contributions to the *British Weekly*. As Mrs. Burnett Smith, she had a personal life as wife and mother.

A bookseller's catalogue recommended the volume 'to all young men and young women who are contemplating marriage'. The notice continued by pointing out how "The writer denounces the artificialities of life, the prevalent ignorance of the details of house-keeping, and the indifference of mothers, as some of the causes which bring about ultimate discord and misery in households'.[1]

Jerome K. Jerome's *Today* magazine briefly reviewed Swan's *Courtship and Marriage* saying

> it is a trifle platitudinarian for an audience accustomed to Oscar Wilde and John Oliver Hobbes, but it is the well-written book of a good woman, who has many thousands looking to her for advice, especially in Scotland. Twenty thousand copies sold in a few weeks. Her magazine is said to have a circulation of 100,000.[2]

Swan wrote about women and the idea of home saying:

> In the heart of almost every woman there is a house of remembrance, one which she holds specially dear. Perhaps it is only a cottage on a hillside or in some country lane, the house where she was born and lived with her parents perhaps in her careless happy childhood, it may even be only in a room in a tenement to which she came as a young wife and where little children have been born. But it is a house she never forgets and to which her heart never grows cold.[3]

Like other authors in this section, beneath the apparent sentimental domesticity of this passage these are elements of a longing for a lost time in the loving home of one's youth.

# 38

# 'THE IDEAL HOME'

## *Annie S. Swan*

Source: Annie S. Swan, 'The Ideal Home', *Courtship and Marriage: And the Gentle art of Home-making* (London: Hutchinson & Co., 1893), pp. 56–64

## THE IDEAL HOME

A house is not a home, although it has sometimes to pass as such. There are imposing mansions, replete with magnificence and luxury, which if realised would provide the outward trappings of many modest domiciles, but which offer shelter and nothing more to their possessors. Home is made by those who dwell within its walls, by the atmosphere they create; and if that spirit which makes humble things beautiful and gracious be absent, then there can be no home in the full and true sense of the word.

While each member of the household contributes more or less to the upbuilding of the fabric, it is, of course, those at the head whose influence makes or mars. A lesser influence may be felt in a degree great enough to modify disagreeable elements, or intensify happy ones, but it cannot, save in very exceptional circumstances, set aside the influence of those at the head.

It is to them, then, that our few words under this heading must be addressed; and, to reduce it to a still narrower basis, it is the woman's duty and privilege, and solemn responsibility, which make this art of home making more interesting and important to her than any other art in the world. Her right to study it, and to make it a glorious and perfect thing, will never be for a moment questioned, even in this age of fierce rivalry and keen competition for the good things of life. In her own kingdom she may make new laws and inaugurate improvements without let or hindrance, and as a rule she will meet with more gratitude and appreciation than usually fall to the lot of law-givers and law-makers. She will also find in her own domain scope for her highest energies, and for the exercise of such originality as she may be endowed with. I do not know of any sphere with a wider scope, but of course it requires the open eye and the understanding heart to discern this fact.

It seems superfluous, after the chapters preceding this, to say again that the very first principle to be learned in this art of home-making must be love. Without it the other virtues act but feebly. There may be patience, skill, tact, forbearance, but without true love the home cannot reach its perfect state. It may well be a comfortable abode, a place where creature comforts abound, and where there is much

DOI: 10.4324/9781003290490-50

quiet peace of mind; but those who dwell in such an atmosphere the hidden sweetness of home will never touch. There will be heart-hunger and vague discontents, which puzzle and irritate, and which only the sunshine of love can dispel.

Home-making, like the other arts, is with some an inborn gift, – the secret of making others happy, of conferring blessings, of scattering the sunny largesse of love everywhere, is as natural to some as to breathe. Such sweet souls are to be envied, as are those whose happy lot it is to dwell with them. But, at the same time, perhaps they are not so deserving of our admiration and respect as some who, in order to confer happiness on others, themselves undergo what is to them mental and moral privation, who day by day have to keep a curb on themselves in order to crucify the "natural man."

It is possible, even for some whom Nature has not endowed with her loveliest gifts, to cultivate that spirit in which is hidden the whole secret of home happiness. It is the spirit of unselfishness. No selfish man or woman has the power to make a happy home.

By selfish, I mean giving prominence always to the demands and interests of self, to the detriment or exclusion of the interests and even the rights of others. It is possible, however, for a selfish person to possess a certain superficial gift of sunshine, which creates for the time being a pleasant atmosphere, which can deceive those who come casually into contact with him; but those who see him in all his moods are not deceived. They know by experience that a peaceful and endurable environment can only be secured and maintained by a constant pandering to his whims and ways. He must be studied, not at an odd time, but continuously and systematically, or woe betide the happiness of home!

When this element is conspicuous in the woman who rules the household, then that household deserves our pity. A selfish woman is more selfish, if I may so put it, than a selfish man. Her tyranny is more petty and more relentless. She exercises it in those countless trifling things which, insignificant in themselves, yet possess the power to make life almost insufferable. Sometimes she is fretful and complaining, on the outlook for slights and injuries, so suspicious of those surrounding her that they feel themselves perpetually on the brink of a volcano. Or she is meek and martyred, bearing the buffets of a rude world and unkind relatives with pious resignation; or self-righteous and complacent, convinced that she and she alone knows and does the proper thing, and requiring absolutely that all within her jurisdiction should see eye to eye with her.

It is no slight, insignificant domain, this kingdom of home, in which the woman reigns. In one family there are sure to be diversities of dispositions and contrasts of character most perplexing and difficult to deal with. She needs so much wisdom, patience, and tact that sometimes her heart fails her at the varied requirements she is expected to meet, and to meet both capably and cheerfully. If she has been herself trained in a well-ordered home, so much the better for her. She has her model to copy, and her opportunities before her to improve upon it.

Every home is bound to bear the impress of the individuality which guides it. If it be a weak and colourless individuality, then so much the worse for the home, which must be its reflex.

This fact has, I think, something solemn in it for women, and it is somewhat saddening that so many look upon the responsibilities that home-making entails without the smallest consideration. Verily fools rush in where angels fear to tread! If they think of the responsibility at all, they comfort themselves with the delusion that it is every woman's natural gift to keep house but housekeeping and home-making are two different things, though each is dependent on the other.

This thoughtlessness, which results in much needless domestic misery, is the less excusable because we hear and read so much about the inestimable value of home influences, the powerful and permanent nature of early impressions, even if we are not ourselves living examples of the same. Let us each examine our own heart and mind, and just ask ourselves how much we owe to the influences surrounding early life, and how much more vivid are the lessons and impressions of childhood compared with those of a later date. The contemplation is bound to astonish us, and if it does not awaken in us a higher sense of responsibility regarding those who are under the direct sway of our influence, then there is something amiss with our ideal of life and its purpose.

## Notes

1 Henry Sotheran Ltd., *The Christmas Bookseller*, 1893.
2 *Today*, 16 December 1893, p. 11.
3 M. R. Nicoll, *The Letters of Annie Swan*, (London: Hodder & Stoughton 1945), p. 87.

# HELEN KINNE AND ANNA M. COOLEY,
## *SHELTER AND CLOTHING: A TEXTBOOK OF THE HOUSEHOLD ARTS* (1913)

### Editorial Headnote

Helen Kinne, (1861–1917) Professor of Household Arts Education and Anna M. Cooley, (1874–1955) Assistant Professor of Household Arts Education at the Teachers College, Columbia University were the joint authors of this textbook. In the book, the authors argue that harmony and accord will be the defining result of the home in proportion to the homemakers' concern for the plan, ideals in organization, sanitation and decoration of the house. These topics were included in the curriculum of home economics classes. Indeed, in *Domestic Arts in Woman's Education* (1911), Cooley argued for the importance of home economics in elementary, secondary, and college curricula and wrote that it merited a greater place than the liberal arts in women's colleges, being 'so vital an expression of [woman's] nature'.[1]

In their *Preface* the authors note two audiences.

> This book and the companion volume, *Foods and Household Management* by the same authors, are intended for the girl pursuing any type of high school or normal school course, as well as for the home maker. They cover the course in household arts for the general high school.

In relation to the importance of women's roles in a changing society, the authors suggested that the 'Woman is the chief purchaser, and upon her rests the responsibility in household affairs of making each dollar procure full value'.[2] This of course meant that she should know and understand the practical aspects of the material culture found in a home. In relation to this they also said

> Too many homes are furnished simply for show without relation to health or pocketbook. Beauty in house decoration depends upon the harmonious relation of parts and of each part to the whole. The aim should be to make it as simple as possible, and appropriate, in that it is adapted to one's mode of living.[3]

A homely atmosphere was also a desirable part of making a home through sensible material choices. The authors noted this was when a housewife

> tries to work out the ideals and standards of the home that will create the real home atmosphere and bring about the development of all members of the family. The material things of the home express the real spirit of the family and exert an untold influence on its moral and intellectual life.[4]

More than the practical issues though, were the ideals necessary to create a home. The authors saw these, as many other writes did, as being rooted in simplicity, morality, harmony, cleanliness, orderliness and godliness. They said:

> A home based on the right principle will be simple. There will be simplicity of living, honesty in the expression of what is offered in the home. No ostentation or living beyond one's means; simplicity in entertainment in offering freely of what one has to friends without apology or explanation; simple furnishings, simple, healthful food, simple, artistic clothing.[5]

Without all these, they suggested that the very democracy of nations was in peril.

# 39

# *SHELTER AND CLOTHING: A TEXTBOOK OF THE HOUSEHOLD ARTS*

## *Helen Kinne and Anna M. Cooley*

Source: Helen Kinne and Anna M. Cooley, *Shelter and Clothing: A Textbook of the Household Arts* (New York: Macmillan Co., c. 1913), pp. 1–5

## THE HOME

Upon the privacy and sanctity of the home rests the strength of American democracy. The English and German nations are noted for the deep-rooted attachment of their people to the home and for their skill as home makers. They have fought through centuries for the preservation of their home ideals, and have realized the nobility of the profession of home making. The words "house" and "home" are often confused. The home expresses the family life which is lived within the house. The house is the place where the home maker surrounds herself with artistic and harmonious furnishings and where she tries to work out the ideals and standards of living that will create the real home atmosphere and bring about the development of all of the members of the family. The material things of the home express the real spirit of the family and exert an untold influence on its moral and intellectual life. The home should stand for rest, for peace, for comfort, health, and inspiration, for the true spiritual development of each member of the family. There should be unity, with a chance for each individual to express himself, a democracy in the best sense of the term.

A house may have had every thought and care expended upon its furnishing and equipment, every device for convenience and comfort, and yet fail to be a home. The home atmosphere is created by the ideals of the family or of her who is to lead in its administration and management. It is her artistic sensibility that brings about this atmosphere, a something that cannot be bought, but that is the result of thought and training. Each real home should be an institution of society so managed that the best and most efficient citizens may be given to the community. Every girl, then, in preparation for home building should consider carefully this aim. The home is the place where the members of the family retire apart from the world and where children receive training that will help them to meet the problems of

life outside the home. The household machinery should be so arranged that there is time left for the higher life of the home and for child training, as the main aim is the production of happy, healthy, useful human beings. The home makers of the ideal home are not so worried and overtaxed that there is little time left for the family and the real joys of family life. The true aim cannot be achieved if more thought is given to the care of the house than to the physical, spiritual, and mental development of the children – character building is the aim of home making. In the ideal home the father unites with the mother in the aims to be attained. The home should satisfy the many-sided needs of all the members of the family, and it should be a place of refuge which each delights to seek, where the troubles and worries of life are shared and the burdens carried together. It is the character and ideals of those within the home that will make this ideal a possible achievement, not the mere formal walls and living together of a group of people.

Each home has an individuality that is strongly its own, and expresses to the world the ideals and standards of life of those within. As long as there are men and women and life lasts, there will be homes. The girl should so prepare herself for home administration with a view to improving present conditions of home life that her home will minister to all that is good and beautiful and best in the personal health and happiness of the lives of her family – and not to dissatisfaction, unrest, overelaborateness, expensive living, discord, and unhappiness. The home, when it is rightly developed with all things in proportion, works entirely for good and is uplifting. The family should not be a disorganized group with no regard for privacy, individual rights, or the good of others. If this condition exists, the home is based on wrong ideals. No community is better than the average home in its midst, and no institution outside of the home – church, state, or school – can compensate for the neglect of home training. Professor Giddings[6] defines the home as "the place of development of the social, individual, economic, and cultural."

**Ideals in establishing a home**. – Much thought, therefore, must be given, by those who expect to establish the right kind of home, to working out the ideals upon which the life of the home is to be based. These standards of life must be clear, in order that they may be 'the guiding principles that direct the activity of the home. Order, contentment, hospitality, godliness have been called the house blessings. The home maker must early realize that "man does not live by bread alone," and the other needs must be as carefully considered as food, clothing, and shelter.

A home based on the right principles will be *simple*. There will be simplicity of living, honesty in the expression of what is offered in the home. No ostentation or living beyond one's means; simplicity in entertainment in offering freely of what one has to friends, without apology or explanation; simple furnishings, simple, healthful food, simple, artistic clothing, all help to simplify life and give the home makers more time for the family joys and intercourse. It sometimes requires much courage and independence of thought and action to achieve this ideal when one's neighbors give elaborate dinners

which are paid for with difficulty, seek the excitement of moving-picture and vaudeville shows when they can scarcely be afforded, and neglect the allurements of woods and fields and streams, which offer more healthful and simpler pleasures. Modern life has brought much that is complex, but a well-organized home with right ideals will be run so as to plan the spending of the family income to the best advantage of all and to consider the spiritual as well as the material needs of the family. Simplicity of living will add much to the independence and freedom of the group.

A home with right ideals will be *harmonious*. The members will be kind, loving, and forgiving as well as thoughtful of one another. The religious life of the family will have expression in the acts of kindness to one another and altruistic expression outside the home. No home is well planned which omits to place as one of its foundation rocks the thought of relationship and responsibility to the Creator. Godliness is the crowning blessing of the home.

*Cleanliness and orderliness* should be fixed ideals, for upon them the health and comfort of the whole family depend. Mrs. Richards[7] used to speak of the beauty of cleanliness as the most costly of all beauty. Cleanliness in the preparation and handling of foods, cleanliness in the care of clothing, rooms, and furnishings leads to happiness and a more healthful family life. Sanitary science demands that thought be given to the care of the household furnishings in order that disease may be prevented. Simplicity in furnishings will help the housewife to achieve this aim. It is her duty to her family to see that refuse is quickly removed and the house kept free from dirt and dust, that the plumbing is in order, that the heating fulfils the requirements of the family. The best investment made by the family is that which goes to promote the health of the family. Upon orderliness in the household depends much of the family pleasure. In the ideal home, the housewife will be so systematic in her management that there will be little friction in the machinery of administration. A time and place for everything will help. Simplicity, orderliness, cleanliness, honesty, godliness, will lead to harmony in the life of the home.

The home maker in planning must strive for standards that will develop all sides of the individual and fulfil the needs of all the members of the family. Health of mind should be sought as well as health of body. Consideration should be given to questions of entertainment, to the savings which give a feeling of security, and to opportunities for the exercise of altruism in various forms of charitable and religious expression. Home makers have a wonderful duty to perform in the education of their children so that all sides of their natures may be fully developed.

No one can estimate the influence of a home that is so organized that, the life of all its members is centered there. From it inspiration, cheer, and comfort radiate to guide and help those who enjoy its life daily. The friends who come and go carry with them the memory of the inspiration and refreshment offered. There is no element so vital in character building as the influence of a well-ordered, godly home where parents have united in the thoughtful training of their children.

# Notes

1 Frederik Ohles et al. *Biographical Dictionary of Modern American Educators* (West-port, Conn: Greenwood Press, 1997).
2 Kinne & Cooley, p. 38.
3 Ibid p, 55–6.
4 Ibid p. 1.
5 Ibid p. 3.
6 Franklin Henry Giddings, (1855–1931) was an American sociologist and economist.
7 Mrs Richards: Ellen H. Richards was a chemist, founder of the home economics move-ment, and the first woman admitted to the Massachusetts Institute of Technology.

# Part 7

# GENDER AND IDENTITY

# GENDER AND IDENTITY

Within the home, gendered divisions of styles were based on concepts of femininity or masculinity and were usually associated with particular styles and room use. One example will suffice. In *The Gentleman's House*, Robert Kerr wrote, 'the dining room should have an air of "masculine importance" and the drawing room should be "entirely ladylike"'.[1] Underneath all these ideas were the stereotypes of gender that were clearly acknowledged and understood by manufacturers, retailers, consumers and commentators.

John Ruskin's essay 'Of Queen's Gardens' is regarded as epitomising the conservative Victorian ideal of femininity which defined women as passive and belonging to the private sphere of the domestic home – in comparison to the man who was 'the doer, the creator, the discoverer' of the public sphere. Ruskin's ideal is evident in this passage:

> And wherever a true wife comes, this home is always round her. The stars only may be over her head; the glow-worm in the night-cold grass may be the only fire at her foot; but home is yet wherever she is; and for a noble woman it stretches far round her, better than ceiled with cedar, or painted with vermilion, shedding its quiet light far, for those who else were homeless.[2]

For much of the nineteenth century, the onus was on women, mainly of the middle class, to live up to these ideals and to also manage the everyday 'cult of domesticity', which necessitated a shared process of transforming ideas about home into objects and rooms. Francis Power Cobbe writing in 1881, considered the powerful role of home-making for women:

> The making of a true home is really our peculiar and inalienable right; – a right, which no man can take from us; for a man can no more, make a home than a drone can make a hive. … It is a woman, and only a woman, – and a woman all by herself, if she likes, and without any man to help her, – who can turn a house into a home.[3]

DOI: 10.4324/9781003290490-53

This role was ambiguous as it was intended to insulate and separate women from commerce but was in fact intimately tied to it via goods and services that were required to make and run a home. The intervention of taste professionals in this process, whether retailers or writers, was an important link which connected the home to the outside world. If anything, there were increasing pressures on women to apply their artistic endeavours to decorate and enhance the home for the family, as they become consumers and managers rather than producers.

However, control over the choice, arrangement and purchase of goods indicates a potentially important role for women. Although Eastlake was vociferous in his comments: 'the faculty of distinguishing good from bad design in the familiar objects of domestic life is a faculty which most educated people – and women especially – conceive they possess'.[4] He goes on to suggest that 'It is scarcely too much to say that ninety-nine out of every hundred English gentlewomen who have the credit of dressing well depend entirely upon their milliners for advice as to what they may, or may not, wear'.[5] This argument might also be applied to the retailers of home furnishings, although one at least was not going to admit superiority in matters of taste. John Oetzmann said in his *Hints on House Furnishing and Decoration* that 'in our remarks upon furnishing and decoration, our aim will be to give a general idea of what should be the governing principle. . . . The selection of most of the items requiring special good taste may be safely left to the ladies'.[6]

## Notes

1 R. Kerr, *The Gentleman's House*, (London: J. Murray, 1865), p. 107.
2 J. Ruskin 'Of Queens' Gardens', *Sesame and Lilies* (London: Smith Elder, 1865).
3 Francis Power Cobbe, *The Duties of a Woman,* (Boston: Geo. H. Ellis, 1881), p. 139.
4 Charles Locke Eastlake, *Hints on Household Taste*, (London: Longman, 1868), p. 7.
5 Ibid.
6 John Oetzmann, *Hints on House Furnishing and Decoration*, (c. 1871), p. 294.

# [ANON] 'DECORATING ART AS AN EMPLOYMENT FOR LADIES', (1874)

## Editorial Headnote

This text was published with an anonymous by-line, but is an adaptation of the article on 'Decorative Art and Architecture in England', by Moncure D. Conway from the November 1874 edition of *Harper's New Monthly*. This article was ultimately derived from Conway's publication *Travels in South Kensington*.

In 1857 Eliza Warren a well-known author of needlework as well as household management books, became editor of the *Ladies' Treasury*, which had a verbose subtitle: being an 'Illustrated Magazine of Entertaining Literature, Education, Fine Art, Domestic Economy, Needlework, and Fashion'. The publication ran successfully for nearly forty years.

The topic of suitable employment of middle-class women in the decorative arts was widely discussed in the latter part of the century. (See texts 1.45 and 1.48) The decorative arts often provided women with economic freedom at a time when they had few other options. This freedom was central to the fight for political rights because it brought women nearer to economic independence. The Society for Promoting the Employment of Women was established in 1859 with the objective of 'Promoting the training of women and their employment in industrial pursuits, such as decorative art, painting on glass and china, wood-carving and engraving, plan tracing'. Interior decoration was clearly an extension of these.

This article considers early examples of female decorators and discusses the role of businesses such as Minton in promoting the decorative artwork of females. It then explains how the well-known Garrett sisters learnt the decorating and designing trade and set up business on their own account. The example of another business established by Mrs Hartley Brown and Miss Townshend is used to demonstrate a successful enterprise. The essay then moves on to consider clothing fashion and an analysis of British middle-class taste. Ancient Chinese texts are then invoked in a discussion on ornament. The article then moves to an in-depth description of the home of the American artist George Boughton. In line with many other famous interiors, contemporary books and journals 'wrote up' the interiors for publication. In addition to the text in this chapter, other publications included essays on famous interiors by Cosmo Monkhouse, Mary Haweis and Joseph Hatton.[1]

# 40

# 'DECORATING ART AS AN EMPLOYMENT FOR LADIES'

## *[Anon]*

Source: [Anon] 'Decorating Art as an Employment for Ladies', * *The Ladies' Treasury: An Illustrated Magazine of Entertaining Literature*, 1 Dec. (1874), pp. 291+.

Miss Jeykl, who was one of the first to take up this kind of work [decoration], attracted the attention of Mr. Leighton, Madame Bodichon, and other artists by her highly artistic embroidery, and has since extended her work to repoussé or ornamental brass-work-especially sconces-and many other things. She has, I hear, acquired not only distinction but wealth by her skill, some specimens of which were exhibited in the International Exhibition at South Kensington this year. There also could be seen the work of other ladies who have followed in her footsteps, some of the finest being by a Miss Leslie, a relative of the celebrated artist of that name. Indeed, there has now been established in Sloane Street a school for embroidery, which has succeeded in teaching and giving employment to number of gentlewomen who had been reduced in circumstances.[2] Miss Phillott, whose paintings have often graced the walls of exhibitions, and have gained the interest of Mr. Ruskin, has of late been painting beautiful figures and flowers on plaques, which, when the colours are burned in by Minton, make ornaments that are eagerly sought for. A Miss Coleman has also gained great eminence for this kind of work. Miss Levin, the young daughter of well-known artist, has displayed much skill in designing and painting pots, plates, &c., with Greek or Pompeian figures. Many of these ladies have begun by undertaking such work as this for personal friends, but have pretty generally found that the circle of those who desire such things is very large, and that their art is held in increasing esteem among cultivated people. It is even probable that the old plan which our great-grand mothers had of learning embroidery will be revived in more important forms, and, with the painting of China, be taught as something more than the accomplishment it was once thought.

We find, too, that artists, architects, decorators, and the numerous workmen Messrs. Minton employ, have great respect for any woman who can do anything

---

* From the article on 'Decorative Art and Architecture in England', by M. D. Conway, in *Harper's New Monthly*, November 1874, pp. 784–79.

DOI: 10.4324/9781003290490-54

well, which contrasts favourably with the jealousy which the efforts of that sex to find occupation in other professions appear to have aroused. One example of this is particularly striking. Nearly twelve years ago I heard of a young lady of high position who was making almost desperate efforts to win her way into the medical profession. She had taken a room near one of the largest hospitals in London, to which she was not openly admitted, that she might study cases of disease or injury, but where, through the generosity of certain physicians, she was able, as it were, to pick up such crumbs of information as might fall from the table of the male students. By dint of her perseverance, means of information and study increased. visited her room near the hospital, and found this young lady surrounded by specimens such as are conventionally supposed to bring fainting fits on any persons of that sex at sight. I found that, being excluded from the usual medical and surgical schools, she had been compelled to employ lecturers to teach her alone. Fortunately she had the means of doing this, but it amounted to her establishing a medical college, of which she was the only student. That lady is now known as Dr. Elizabeth Garrett-Anderson, an eminent physician, who has done not her sex alone but this entire community a great benefit, by showing that a woman's professional success is not inconsistent with her being a devoted and happy wife and mother. By the side of the long struggle through which she had to go to obtain her present position – a struggle in which many a woman with less means and courage has succumbed – I am able to place the experience of her younger sister and of her cousin, Agnes and Rhoda Garrett, who have entered into a partnership as decorative artists. These young ladies, it may be premised, have by no means been driven to their undertaking by the necessity of earning a livelihood. They belong to an old family of high position, and are as attractive ladies as one is likely to meet in the best society of London. But like the better-known ladies in the same family, Dr. Garrett-Anderson and Mrs. Professor Fawcett. they are thinkers. and they have arrived at conclusions concerning the duties and rights of their sex which forbid them to emulate the butterflies. A few years ago, when the decorative work of such firms as Messrs. Morris and Co. began to attract general attention, it appeared to them that it offered opportunities for employment suitable to women. They determined to go through a regular apprenticeship; and though they were met by looks of surprise, they did not meet with any incivility. One gentleman allowed them to occupy a room at his offices, where they might pick up what knowledge they could in the art of glass-painting, and here they awaited further opportunity. The architect who had been connected with this glass-staining firm separated from it, and, having begun a business of his own, accepted the application of the Misses Garrett to become his apprentices. They were formally articled for eighteen months, during which time they punctually fulfilled their engagement, working from ten to five each day. Of course there were good stories told about them. Some friend, calling upon them, reported that though the interview was interesting, the ladies could not be seen, as they were up on a scaffolding, lying flat on their backs close to a ceiling which they were painting. From that invisible region their voices descended to carry on the

conversation. The ladies themselves were quite able to appreciate all the good humoured chaff attending their serious aim. When their apprenticeship reached its last summer they went on a tour throughout England, sketching the interiors and furniture of the best houses, which were freely thrown open to them. They have now started in business for themselves at No. 3, Cornwall Terrace, Regent's Park, with fair prospect of success. Mr. J. M. Brydon, of Marlborough Street, is the architect who has the honour of having had these ladies for apprentices: and they assure me that during their stay there and in their work since they have met with no act of incivility. Occasionally the workmen may stare a little at the unaccustomed sight of ladies moving about with authority, but they are most respectful when they find that there is intelligence behind the authority. From a friend of these ladies I heard a significant anecdote. They directed that a certain kind of mixture with which paint is generally adulterated should not be used. When they came to look at the work, they found that the mixture had been used, though it is what no untrained eye could detect. They called the painter to account, and he said he had used very little of the mixture indeed.

"That is true," said one of the ladies, "but we told you not to use a particle of it."

The painter was amazed, and at last said,

"Will you be kind enough to tell me how you knew that mixture had been used?"

It is precisely this knowledge which everywhere secures respect. The Misses Garrett have made themselves competent decorators: they undertake the wall decorations, upholstery, furniture embroidery, &c., as fully as any other firm. Nor are they the only firm of women engaged in this business. Two ladies of high position and education – Mrs. Hartley Brown and Miss Townshend (the former a sister of Chambrey Brown, Esq., a very accomplished architect) – have set up in the same business at 12, Bulstrode Street, a quaint and interesting old house, by-the-way, built by the famous Adamses, with a frieze representing some of Aesop's fables. These ladies, who have been employed to decorate the interiors of the new Ladies' College (Merton) at Cambridge, have not only devised a number of new stuffs for chairs, sofas, and wall panels, but also for ladies' dresses. In the ancient code of Mann, it is said, "A wife being gaily adorned her whole house is embellished; but if she be destitute of ornament, all will be deprived of decoration."[3] It is not a little curious to find the remote descendants of those whom Mann thus instructed including female dress among the concerns of decorative art. This is, indeed, theoretically done in the lectures given at South Kensington, and Charles Eastlake has interspersed some valuable hints concerning ladies' dress in his work on "Household Taste." But the practical way in which Mrs. Hartley Brown and Miss Townshend have taken up the matter indicates, if I mistake not, a quiet revolution which has been for some time going on in certain London circles. It is said that the artists of England once thought of getting together and making some designs for dresses, which they would recommend to ladies; they did not do so formally, but they have certainly availed to modify very materially the costumes visible in thousands of English drawing-rooms. The "pre-Raphaelist lady" with her creamy silk, short-waisted and clinging – at once child-like and great-grandmotherly – is

now a well-known figure in evening companies. But there is no uniform for ladies anymore. At a fashionable party lately, I was unable to pick out any two ladies out of a hundred whose dresses were cut alike, and the variety of colours suggested a fancy-dress ball. Yet these colours were all of moderate shades, and Hippolyte Taine himself must have admitted that very few of them were "loud." It would not at all surprise me if the world which has so long laughed at the English woman's dress should some fine evening glance into one of these quiet Queen Anne interiors and feel as if the ladies in their Queen Anne costumes – and the other rich but also quiet variations of it now becoming frequent – are among the most agreeably dressed of woman kind. But I must return from this digression.

The Misses Garrett appear to have an aim of especial importance in one particular. They tell me that they have recognised it as a want that a beautiful decoration should be brought within the reach of the middle-class families, who are not prepared or disposed to go to the vast expense which the very wealthy are able and willing to defray, thereby occupying the most eminent firms. They believe that with care they are able to make beautiful interiors which shall not be too costly for persons of moderate means, This can surely be done, but it can only be through a co-operation between the owners of the house and the decorators which shall make it certain that there shall be nothing superfluous. If an individual wishes for a beautiful home, especially in dismal London, it is first of all necessary that he or she should clearly understand what is beautiful, and why it is desired. The decoration will then, in a sense, be put forth from within, like the foliage of a tree. In each case the external beauty will respond to an inward want, and be thus invariably an expression of a high utility. Nowhere more than in the homes of the great middle classes is there need of beauty. Their besetting fault is a conventionality which often lapses into vulgarity, and their thoughts (so called) are apt to be commonplace. The eye is often starved for the paunch. The pressure of business sends every man engaged in it home fatigued, and yet it is only when he enters that home that his real life, his individual and affectional life, comes into play. On the exchange, in the office or shop, he has been what commerce and the world determine; he has been but perfunctory; but now he shuts the door behind him, and his own bit of the day is reached. What is the real requirement for this person? Does the house that furnishes him bed and board suffice him? or, which is of greater importance, does so much alone suffice others who dwell habitually in it?

In the ancient Chinese Analects[4] we read that Kih Tsze-Shing said, "In a superior man it is only the substantial qualities which are wanted; why should we seek for ornamental accomplishments?" Tsze-Kung replied, "Ornament is as substance; substance is as hair." It would be difficult to find in literature a finer or more philosophical statement of the deep basis of Beauty than thus comes to us from a period of near three thousand years ago, and from a race whose applications of decorative art to objects of every-day use are models for Europe. The spots of the leopard are the sum of its history; its hair is the physiognomy of its passion and power; it bears on its back the tracery of' the leaf and sunshine amidst which it hides, and the purpose of the universe hides with it. Transferred to

floor or sofa in a room, the coat of that cat is a bit of the wild art of nature, full of warm life, purely pictorial; more beautiful than the skin of our domesticated cats, because these have been adapted to other purposes, and reduced to an environment of less grandeur. But strip the two of their hair, and they are only larger and smaller pieces of leather, and the depilated hide of a dog is the same. All of which confirms Tsze-Kung's dictum that ornament is substance, and it at the same time suggests the converse truth that throughout the universe there must be substance to insure true ornament. When we ascend to the region of finer utilities – those, namely, which are intellectual, moral, spiritual, social – we discover that household art is another name for household culture. What germ in the child's mind may that picture on the wall be the appointed sunbeam to quicken? What graceful touch to unfolding character may be added by much falsehood and unreality have been shed through the life and influence of' individuals by tinsel in the drawing-room and rags upstairs?

Just now we are the victims of two reactions. Our ancestors made external beauty everything, and the starved inner life of man rebelled. Puritanism arose with grim visage, turning all beautiful things to stone. From it was bequeathed to us a race of artisans who had lost the sense of beauty. A reaction came, in which the passion for external beauty displayed itself in an intemperate outbreak of gaudiness and frivolity. We are sufficiently surrounded by the effects of that reaction, sustained by wealth without knowledge or taste, to make Charles Eastlake's description appropriate to ninety-nine out of every hundred English homes. "This vitiated taste pervades and infects the judgment by which we are accustomed to select and approve the objects of everyday life which we see around us. It crosses our path in the Brussels carpet of our drawing rooms: it is about our bed in the shape of gaudy chintz; it compels us to rest on chairs and to sit at tables which are designed in accordance with the worst principles of construction, and invested with shapes confessedly unpicturesque. It sends us metal work from Birmingham which is as vulgar in form as it is flimsy in execution. It decorates the finest possible porcelain with the most objectionable character of ornament. It lines our walls with silly representations of vegetable life, or with a mass of uninteresting diaper. It bids us, in short, furnish our houses after the same fashion as we dress ourselves, and that is with no more sense of real beauty than if art were a dead letter. It is hardly necessary to say that this is not the opinion of the general public. In the eyes of materfamilias there is no upholstery which could possibly surpass that which the most fashionable upholsterer supplies. She believes in the elegance of window-curtains of which so many dozen yards were sent to the Duchess of and concludes that the dinner service must be perfect which is described as 'quite a novelty.'"

Mr. Eastlake well says, also "National art is not a thing which we may inclose in a gilt frame and hang upon our walls, or which can be locked up in the cabinet of a virtuoso. To be genuine and permanent, it ought to animate with the same spirit the blacksmith's forge and the sculptor's atelier, the painter's studio and the haberdasher's shop."[5] Under the influence of such scornful words as these persons

331

of taste and culture have risen in reaction against the reaction, and the result is that there are now in London several thousands of homes which have filled themselves with those old shreds of beauty which Puritanism cast to the winds. Most of these are the homes of artists or virtuosi, and as they have thus set the fashion, a still larger number have tried to follow them. A genuinely old thing is competed for furiously, and as it is apt to go with the longest purse rather than the finest taste, we find the past as often reappearing in a domestic curiosity-shop as in a beautiful interior.

Now Puritanism in its day was one of the most useful of things, and if we do not see the traces of beauty which it has left, the fault is in our own eyes. The artists know very well that if it had spared the old tapestries and furniture for the main uses of our present society, the effect would be as unlovely as if our homes were all buttressed and turreted in feudal style. Feudalism and Puritanism have alike left to us just as much of the styles of their ages as we need – enough to give, as it were, a fair fringe to the appropriate vestment of to-day. A house made up of antiquarian objects is a show-room, a museum, but not a home. We have fallen upon an age when cultured people know that external beauty is but one means to integral beauty, and when the prophets of that higher end can see that the very flowers of the field are ugly if they drink up that which ought to turn to corn and wine. Much is to be said for the antiquarian taste if it does not run into an antiquarian passion. It may safely be admitted that our churches need not be sombre nor our services gloomy, that a few good pictures would not harm the one, nor more poetry and music the other; but what is to be said of those who find in albs and chasubles[6] and incense-burners the regained Paradise of man.

But if there can be no real beauty secured by building for a life that is to be lived in one century a mansion that grew out of another, as little can a high taste be satisfied by the conventionality of its own time, which admits of no relation between the individual and his dwelling place. In a normal society each man would be able to build his house around him as he builds his body, and to task the past, the east, the west, for his materials as much as brick or stone. "Let us understand," says the wisest adviser of our time, "that house should bear witness in all its economy that human culture is the end to which it is built and garnished. It stands there under the sun and moon to ends analogous and not less noble than theirs. It is not for festivity, it is not for sleep; but the pine and the oak shall gladly descend from the mountains to uphold the roof of men as faithful and necessary as themselves, to be the shelter always open to good and true persons a hall which shines with sincerity, brows ever tranquil, and a demeanour impossible to disconcert; whose inmates know what they want; who do not ask your house how theirs shall be kept."[7]

One residence particularly has connected itself in the course of my observations with the high place given, in this extract from Emerson's chapter on "Domestic Life," to the individuality so essential to a home, and so difficult to obtain. Those who have found delight – as who has not? – in the paintings which the American artist, Mr. George S. Boughton,[8] has given to the world will not be surprised to learn that he has built up around him a home worthy of his refined taste and his

delicate perception of those laws of beauty which enable it to harmonise with individual feeling without ever running into eccentricity. Few of those who have enjoyed the fine hospitalities of Grove Lodge, Kensington, can fail to recognise that the much-admired residence is as unique a work of the much-admired artist as any of those charming pictures of his which so tenderly invest the human life of to-day with the sentiment and romance of its own history. Passing lately through his hall, touched everywhere with the toned light of antique beauty, to his studio, the picture which he was just finishing for the Royal Academy appeared as a natural growth out of the aesthetic atmosphere by which he was surrounded – some girls of Chaucer's time beside an old well and a cross, filling the water-bottles of pilgrims on their way, amidst the spring blossoms, to the shrine of St. Thomas a Becket, "the holy, blissful martyr," at Canterbury. The embowered English landscape closed as kindly around the figures and costumes and symbols of the olden time as they do now about the features of a new age; and no less harmoniously do the ornaments and decorations of this beautiful home surround the cultured society which the young host and hostess gather to their assemblies. The house is, as I have intimated, remarkable for the impression it gives of being the expression of individual taste. It might well enough bear on its threshold that signature which bears such increasing value, so truly does it represent the man-as free from ostentation as from conventionality.

Entering the door, we find ourselves in a square vestibule, separated from the main hall by rich and heavy curtains of greenish-blue tapestry. The walls are here, for distance of one-third of their height from the floor, covered with a panelled wainscot coloured in harmony with the hangings. For the rest, the walls are covered with a stamped leather papering of large antique scrolls, outlined in gold. A rich light fills this little apartment by reason of the quaint and deep-hued glass of the door and side window. In these both roundels and quarries are used. In the door there are roundels above and quarries beneath, furnishing a neat border to larger stainings representing marguerites and clover blossoms on a blue ground. Above the door is a curious horizontal glass mosaic, set in lead, as indeed are all the squares and circlets of both window and door, with bees and butterflies at the angles of the irregular lines. The zigzag flight of the little winged symbols of industry and pleasure required that the pieces of glass should be irregular, and this result was secured by an odd device. The decorator having come with his oblong pane of precious glass, asked how he should cut it up. The artist promptly ordered him to let it fall on the door-step, and then gather up the fragments. This was done, and as the pieces came of the fall, so were they put together, with the bees and butterflies at their angles. The effect of this irregularity is very fine indeed, as setting off the precision of the patterns in the rest of the door.

Passing through the curtains, we enter a hall running about two-thirds of the depth of the house to the dining-room. The hall is lined with fine old engravings and cabinets, with here and there an old round convex mirror, The general colour of the walls of the dining room is sage green, thus setting off finely the beautiful

pictures and the many pieces of old china. There are several cabinets which have been designed by Mr, Boughton himself. And 1 may here say that Mr. Boughton's art has enabled him to make his many beautiful cabinets, the antique ones as well as those designed by himself, particularly attractive by introducing small paintings on the panels of their doors or drawers. These figures are generally allegorical and decorative, and are painted upon golden backgrounds. They are of rich but sober colours, and usually female figures with flowing drapery, great care being taken that their faces shall have dignity and expression. In some cases, an old cabinet has small open spaces here and there which will admit of medallion busts and heads being painted, and if care be taken that the colours shall not be too loud, and especially that the designs are not realistic, the beauty and value of the cabinet are very much enhanced. The buffet to which I have referred has a curtain over the arch beneath, and such an addition may be also made to a cabinet which rests upon legs with good effect as well as utility, if care be taken that the colour of the curtain shall not be obtrusive.

This dining-room is lighted by a large window set back in a deep recess, curtained off from the main room with hangings of red velvet, and exquisitely environed by original designs. The window is composed of the richest quarries, holding in their centres each its different decorative flower or other natural form, and these being collectively the frame of large medallions of stained glass representing Van Eyck, Van Orley, and the burgomaster's wife from Van Eyck's picture in the National Gallery.

It is a notable feature of the ideas of glass decoration, and, indeed, of paper decoration, in houses where English artists have superintended the ornamentation, that realism in design is severely avoided. In this respect I cannot doubt that we are in London far more advanced in taste than those decorators of Munich and some other Continental cities who try to make the figures, in their glass at least, as commonplacely real as if they were painting on canvas. Even if the material with which the glass-stainer works admitted of a successful imitation of natural forms, the result could not be beautiful. No one desires roses to blossom on his window-panes, nor butterflies to settle on the glass as if it were a flower. The real purpose of the glass can never be safely forgotten in its decoration: it is to keep out the cold while admitting the light; the colour is to tone the light, and prevent its being garish' and if, further, any form is placed upon the glass, it is merely to prevent monotony by presenting an agreeable variation from mere colour. But the form must be in mere outline, transparent, else it suggests an opaque body, which were a denial of the main purpose of the glass, i.e., to do away with opaqueness. Even when the ornaments on the little panes are thinnest, they are hardly suited to the English sky, which sends us little superfluous light.

The drawing-room at Grove Lodge is adorned on the theory that its function is one which requires a degree of richness bordering on brilliancy, which were out of place in a study, or studio, or sitting-room. Here are to be happy assemblies of light-hearted people in gay dresses, and the room must be in harmony with the purpose of pleasure which has brought them together; but then

the drawing-room must not obtrude itself, it must not outshine their lustres nor pale their colours; rather it must supply the company with an appropriate framing, and set them all in the best light. have rarely seen a more picturesque drawing-room than that at Grove Lodge, and none that has seemed to me a more purely artistic creation of beautiful out of a rather unpromisingly constructed room. A paper of heraldic pink roses, very faint, with leaves in mottled gold, makes a frieze of one width above a wall-paper of sage-gray, which has no discernible figures at all on it. 'This sage-gray supplies an excellent background to the pictures-which are moderate in quantity, charming in quality – and for the picturesque ladies, who are too often fairly blanched by the upholsterer's splendour, as they might be by blue and silver lights in a theatre. At the cornice is a gold moulding and fretting, making an agree able fringe to the canopy (as the star-spotted ceiling may be appropriately called). The ceiling is not stellated, however, with the regularity of wall-paper designs, but with stars of various magnitude and interspaces. It must be, of course, a room in which the deep tones of colour preponderate which could alone make such a ceiling appropriate. In this instance it is rendered appropriate not only by the character of the hangings of the room, at once rich and subdued, and by the carpet, which Mr. Boughton has had made for this room, the basis of whose design is the greensward, touched here and there with spots of red, but also by the fact that it is a double drawing-room, lighted in the daytime only at the ends, and requiring therefore a bright ceiling. There are two old Japanese cabinets: one is richly chased, but with nothing in relief except the gold lock-plates, and some twenty-eight hinges (themselves a decoration): the other is more complex, and has figures in relief. In addition to these there are two cabinets of unique beauty, designed by Mr. Boughton – one possessing a bevelled mirror running its whole width at the top, the other with panels on which the artist has painted Spring and Autumn in gold.

Before leaving this charming residence, I must mention that some of its best effects have been produced by the extraordinary lustre of colour and quality of surface in the stuffs used for curtains, furniture covers, and upholstery. These are such as are not ordinarily manufactured, and can be procured in London only by searching for them. Manufacturers in this country, and no doubt in America also, are in the habit of bleaching their stuffs as white as possible, and the consequence is they will not take rich and warm dyes. The secret of those Oriental stuffs upon whose surface, as they appear in our exhibitions, English manufacturers are so often seen looking with despair, is, that they never bleach to whiteness anything that is to be dyed. If the Eastern dyers should put their deep colours upon a surface bleached to ghastliness, their stuffs would be as ghastly as our ordinary goods speedily become. The Oriental dyer simply leaves the natural colour of the wool or cotton creamy and delicate, and the hues never turn out crude and harsh, as do those of English stuffs. This bleaching, moreover, takes the life out of a natural material, which is the reason of the superior durability of coloured Oriental fabrics.

# Notes

1 See Cosmo Monkhouse, "Some English Artists and Their Studios." *The Century Illustrated Monthly Magazine,* XXIV, 1882, pp. 553–68. Mary Eliza Haweis, *Beautiful Houses* (London: Sampson Low, 1882), p. 45. Joseph Hatton, "Some Glimpses of Artistic London", *Harper's New Monthly,* November 1883, p. 840.
2 The Royal School of Needlework was originally based in Sloane Street, then it was moved to a purpose-built building along Exhibition Road Kensington.
3 J. E. Padfield, *The Hindu at Home* (London: Simpkin 1908), p. 264.
4 *The Analects of Confucius* is an ancient Chinese book composed of a collection of sayings and ideas attributed to the Chinese philosopher Confucius.
5 Charles Locke Eastlake, *Hints on Household Taste in Furniture, Upholstery,* 1868, p. 4.
6 Liturgical vestments.
7 Ralph Waldo Emerson, "Domestic Life" in *Society and Solitude and Other Essays* (Boston: Osgood, 1871), pp. 106.
8 George Henry Boughton (1833–1905) was an Anglo-American landscape and genre painter, illustrator and writer.

# JACOB VON FALKE, 'WOMEN'S AESTHETIC MISSION', *ART IN THE HOUSE: HISTORICAL, CRITICAL, AND ÆSTHETICAL STUDIES ON THE DECORATION AND FURNISHING OF THE DWELLING* (1879)

## Editorial Headnote

Jacob von Falke (1825–1897) was a German-Austrian cultural historian and museum curator. Like numerous other reformers and thinkers on design, Jacob von Falke was a serious scholar who, in 1860 published *Das Kunstgewerbe*, (*The Arts and Crafts*) which reflected English ideas and writings, often echoing the ideas found in the *Journal of Design and Manufacture*. In 1864, Jacob von Falke joined Rudolf von Eitelberger-Edelburg at the newly founded Kaiserliches Königliches Österreichisches Museum für Kunst und Industrie (now the MAK) in Vienna, which was based on the concepts Cole established in the South Kensington Museum. In 1866, Jacob von Falke published *Geschichte des Modernen Geschmacks* (*History of Modern Taste*). Although a Renaissance scholar, Jacob von Falke had a wide range of interests in applied art and design and had already published widely on the topics of art, culture fashion, design and art-industry.

Jacob von Falke thought that an aesthetically good design reflected an object's function. He considered art and design as objects, which he saw through the lens of industrialism and the ambitions of the middle classes. In his *Art in the House*, he stated that using the considerations of function, material and appropriate production process, the best products would occur. In terms of interiors an emphasis on colour and form as opposed to the slavish following of styles was his belief.

Jacob von Falke also derided the mis-use of historic revivals. Writing on the International Exhibition in Vienna 1873, Jacob von Falke made an amusing commentary"

> In so far as style is concerned the modern Frenchman dwells in the eighteenth century, he sleeps in that century likewise, but he dines in the sixteenth, then on occasion he smokes his cigar and enjoys his coffee in the Orient while he takes his bath in Pompeii.[1]

A little later, Jacob von Falke, writing in his important work, *Art in the House: Historical, Critical, and Aesthetical Studies on the Decoration and Furnishing of the Dwelling*, explored the counter position: 'A design, a form of decoration, a piece of furniture may have style without belonging in style to any one of the famous art epochs, either as original or copy'.[2] He continued by discussing furniture design. Furniture had style, he said, 'when it is exactly what it ought to be, when it is suited to the purpose for which it is intended, and it has the purpose unmistakeably inscribed upon it'.[3]

First published in 1871, *Die Kunst im Hause* (Vienna) was based on articles he had previously published since around 1860. It had six German editions, the American edition featured in this chapter, as well as Swedish and Hungarian versions.

The American title was *Art in the House; Historical, Critical, and Aesthetical Studies on the Decoration and Furnishing of the Dwelling*, subtitled 'by Jacob von Falke, Vice-Director of the Austrian Museum of Art and Industry at Vienna. Authorized American edition translated from the third German edition, Edited with notes by Charles C. Perkins, M.A. Illustrated by Chromo Lithographs, Albertotypes, and Typographic Etchings', 1879.

Jacob von Falke starts this chapter by stating that

> The subject of Household Art cannot be said to have been adequately treated, even after the most exhaustive discussion of every decorative and useful object in the house, so long as we have not considered woman, its mistress, in her relation to it, and her artistic work. We must therefore endeavor to discover the aims as well as the limits, of her aesthetic mission.[4]

A reviewer in *The Nation, A Weekly Journal Devoted to Politics*, published in 1878, responded:

> The book winds up with a chapter on 'Woman's Aesthetic Mission', which contains a discussion of what the women of a family can do to beautify its home. It seems to us that no discussion on that subject is of much value which does not take account of the one great disturbing element, the evil influence which prevents women from doing anything great to help in the artistic movement – their life-long subjection to the rule of fashion. Changing fashions affect men as well, and so far as to prevent any good thing coming out of even the best workshops; but still there are men who are indifferent to la mode. Are there any women who can say as much as that of themselves?[5]

# 41

# 'WOMEN'S AESTHETIC MISSION'

## *Jacob von Falke*

Source: Jacob von Falke, 'Women's Aesthetic Mission', Art in the House: Historical, Critical, and Æsthetical Studies on the Decoration and Furnishing of the Dwelling (Boston: L. Prang & Co. 1879), Chapter X, pp. 330–6

It is hardly necessary for me to point out in detail where and how universally the hand of woman can make itself felt in the embellishment of the house. There can be no doubt that every lady desires (although there may often be reasons which prevent her from doing so) to decorate the rooms in which she lives with the work of her own hands, and to make otherwise vacant places attractive to the eye by some pleasing object. We know also from daily experience that the feminine mind is very intelligent in such matters. In spite of all this our dwellings continually show us mistakes committed, toil and labor expended upon useless and unmeaning knickknacks, or wasted, often on a large scale, in wrong places. I will not again speak of offences against style in embroidery, but will content myself with citing such examples only as lamp-mats and footstools, to which artistic decoration is applied in places where it either cannot be seen at all, or else is condemned to be ignominiously soiled and destroyed. Artistic productions of this class are made to be seen; their end and aim is beauty of outward appearance, and appearance is for the eye. On the other hand, we must not forget that domestic utensils are for practical use and not for show, and that they must therefore combine utility with beauty.

It also seems to me, generally speaking, that embroidery is used altogether too little in the decoration of the dwelling, and that, whenever it is so employed, it is hampered by unnecessary difficulties, resulting from the tedious technical methods adopted. This might easily be avoided. As an example of it, take those comparatively large rugs worked in cross-stitch with Berlin wool, whose delicate nature, want of thickness and strength, make them ill adapted to the purposes for which they are intended; for, although diligent and nimble fingers have been at work upon them for months, and sometimes even for years, they are rapidly worn out. One cannot help regretting the time, toil, and labor expended upon them, when he considers that rugs which are artistically as well as practically superior to them can be woven with less trouble and in a much simpler manner. Embroidery is a delicate art, unfit for the decoration of large surfaces. When, however, it

undertakes such a task, it must do so in a certain sense from the point of view of monumental art, and instead of spreading pieces of embroidery on the floor and under our feet, must adapt them to places where they will be protected.

Even for small mats, back-cloths, pillows, cushions, and chair-covers, cross-stitch and point-work are, as a rule, too tedious and time-consuming processes. Think only of the variety of objects which might be executed in the time saved by the adoption of some simpler technical method, capable of yielding equally satisfactory artistic results! How easy to decorate lambrequins, curtains of all kinds, rugs and covers, beautifully and yet simply, by means of colored borders, braids, and cords; how rich the effects that may be produced on them by applied embroidery, provided only that we know what is wanted, and are convinced that it is not the labor expended upon an object which determines its artistic value, but its beauty as a result.

It is, however, absolutely necessary that in all cases there should be perfectly clear comprehension of the aim to be reached, for in work of this kind nothing must be done for its own sake, no pattern selected simply for its beauty, and no color because it happens to please, for otherwise it will often happen that the pattern or the color, when fixed in its place, not being in harmony with its surroundings, will ruin all our good intentions. It is evident, therefore, that to attain good result all things must be selected and made with reference, not only to the places they are intended to decorate, but with reference also to the complete artistic harmony of their surroundings. This, of course, demands an artistically trained eye, capable of taking in at a glance the aesthetic possibilities of a given space, and of using them so as to make them conduce to the general artistic harmony. It is not sufficient to know that red harmonizes with green, and orange with blue, but we must also be able to say, in this place we shall need red, in that yellow, in that blue, so as to fill the void, to relieve and light up what is sombre, and to produce everywhere the best and most appropriate effect.

Such an eye for harmony and for color is, of course, not very often to be met with, and to this fact may perhaps be attributed a very common error noticeable in our dwellings, the preponderance, namely, of white. We do, indeed, upholster our furniture with costly, lustrous, and richly colored fabrics, but we conceal them under white covers. Of what use is a thing of beauty to its possessor if its beauty is to be so hidden that it cannot be enjoyed? For this reason, the white "tidies" which we spread out on the backs of chairs and sofas, though useful, are objectionable, as they for the most part hide the color of the furniture under white spots which destroy all aesthetic effect. Their destructive power is greater in proportion to the deeper or stronger tones of walls and furniture. As we have given up color in other objects, so also have we banished it from our household linen, and especially from that used on the table. It is indeed true that neatness and cleanliness in the house are good things, and that in this they find their highest expression; but nevertheless it is not necessary to carry puritanism about color to the extent to which it has been carried in this particular. There are aesthetic reasons enough why we should do well to use color for the decoration of linen, as in past times. We might adorn

table and bed in a variety of charming ways, and thus provide constant employment for female hands, whose works would be a daily source of fresh delight to the eye. The lady of the house will more especially have need of an aesthetically trained eye and an all-embracing judgment, where she does not work with her own hand, but is called upon to act in matters where selection and artistic direction are concerned, such as in the decoration of walls, the selection of colors, of furniture, and of carpets, as well as the arrangement, position, and distribution of the various household objects. As the mistress of the house, she must accustom herself to look upon her rooms in all their details as pictures in which all things are so placed and combined as to contribute to the general artistic effect. Symmetry should not be too pronounced in a picture, and yet a conscious arrangement should make itself felt through main groups and subordinate groups, balance of masses, distribution of light and shade, harmony of colors, united by the predominance of a general hue. So should it be in a dwelling. There, also, no one object exists for itself alone, but in reference to all other objects. If the lady of the house has accustomed herself to view things in this light, she will soon perceive where there is a discord and where perfect harmony is attained: she will be able to recognize the chief place which ought to dominate the rest; to see where there is too much or too little; where there is gap needing to be filled up with some object or work of art; what object is superfluous, or ought to be removed because it is out of proportion with its surroundings; where and how this or that piece of work may be used for best advantage. She will soon become capable of deciding which hues and tints she may select in harmony with her individual taste for walls and furniture, and which other hues may be contrasted with these fundamental colors of the decoration so as to produce the best possible effect. This is by no means an easy task, for whose success or failure the mistress of the house must be held responsible. The different impressions which house interiors make upon us are mainly due to the presence or the absence of this capacity of the eye, this feeling for harmony, this sensibility to artistic effect. We enter a sumptuously furnished drawing-room, wanting neither in gilding, in heavy silks, nor marbles and alabasters, and lo! the atmosphere seems as heavy as lead, a chill runs through our veins, and the hand, or rather the fingers, stretched out towards us, appears to be offered in compliance with the laws of politeness and the customs of society, but not from any prompting of the heart. We enter another dwelling which has no trace of the wealth and luxury of the first, and yet a sense of comfort steals over us; we feel the hearty pressure of the hand even before it touches our own, we are convinced that we are welcome, and cannot bear to depart. Why is this? It is because a poetical, intelligent mind has been at work here, and has united warm, pleasant hues of color in cheerful harmony, gentle, amiable person, who has the faculty of making herself and others comfortable, has so arranged the chairs and other pieces of furniture that they invite to conversation; has agreeably filled corners, walls, and tables with flowers and plants and with works of love and of art, modest though they may be. There, on the contrary, fashion only has been consulted; the upholsterer has undertaken to furnish the house, he has followed his usual insipid routine without consulting

the wishes and feelings of the gentleman and the lady of the house, who have had nothing to say in the matter, either because they did not understand it, or did not think it worth the trouble to consider it. This latter mode of proceeding may be said to be the rule in the furnishing of the more pretentious class of apartments, By adopting it, however, we not only deprive ourselves of an agreeable and pleasurable occupation, but we also renounce all certainty of success, as the artisan and the decorator are dependent upon fashion, and the fashion of to-day, at least, is indifferent to beauty.

It is true that there are upholsterers and decorative artists who rise above fashion and can both understand and carry out artistic intentions. But if we are not ourselves able to appreciate them, to recognize and to value that which is truly good and tasteful, we shall find, like a certain lady whom we have in mind, that even with the best of will, with good intentions and copious means, our efforts have ended in nothing but annoyance and vexation. This lady desired to accomplish something in the decoration and furnishing of her new grand drawing-rooms which should rise above the ordinary level of modern tastelessness, and for this purpose addressed herself to the best workmen, and unfortunately not only to one but to several. Being herself without knowledge and judgment in such matters, and incapable of deciding between different views and aims, now taking advice from one and then from the other, and following neither, she was in a perpetually discontented, wavering state of mind. Having caused the costly painted ceiling to be taken down because it did not suit the wall-paper, and changed the wall-paper because the furniture did not harmonize with it, she finally reached an unsatisfactory result, which gave pleasure neither to herself nor to others.

This illustration shows us that the ideal mission of woman, as a promoter of the beautiful, has also its practical subjective side. The want of a feeling for beauty occasionally brings heavy retribution, and this is another reason, which, added to those of an ideal nature, should lead us to develop it with special care. We now know, if we remember what has been said, that modern culture indispensably demands the fostering of a sense of beauty in ourselves; that it is necessary for the sake of the education of our children, whose aesthetic perceptions are generally corrupted from early infancy by bad picture-books and tasteless surroundings; we know that in cultivating this feeling for beauty we are doing our part towards working out the civilization of the future, little as the part may be which any individual can contribute towards it; and finally we know that it will open up to us a source of pleasure and of enjoyment during the whole of our lives. These are surely reasons enough to make us attach the highest importance to woman's aesthetic mission. Let us not, however, be led to suppose that the comprehension of the beautiful will come of itself; on the contrary, toil and practice will be required, and this all the more for the reason that we do not grow up in the midst of beautiful things as our predecessors did, who lived in happier art-epochs, and because our taste is perverted by the present fashions in dress, in industries, and even in art. The beautiful has a language of its own, and this language must be learned like any other. He, however, who has learned it, and knows how to use it, has to

borrow the language of Goethe – tasted of that nectar which Minerva brought down from Heaven to her favorite Prometheus, and thus has his part in the highest happiness, – in Art.

## Notes

1 Cited in Peter Thornton, *Authentic Décor*, (Weidenfeld and Nicolson, 1984), p. 308.
2 Jacob von Falke, *Art in the House* (Boston: Prang, 1878), p. 171
3 Ibid.
4 Jacob von Falke, Chapter 10, p. 311.
5 *The Nation, A weekly Journal devoted to politics,* 12 December 1878, 702, p. 370.

# LEWIS F. DAY, 'HOW TO DECORATE A ROOM' (1881)

## Editorial Headnote

Establishing his own studio in London in 1870, Day designed for a wide variety of mediums and supplied numerous manufacturers. He wrote prolifically on design, and his readership included professional and amateur designers, students of design and manufacturers. He addressed the technical aspects of pattern making and its correct application in books such as *Instances of Accessory Art* (1880), *The Application of Ornament* (1888), *The Anatomy of Pattern* (1889) and *The Planning of Orna*ment (1889), while his other books discussed specific mediums, such as *Art in Needlework* (1900) and *Stained Glass* (1903). Day was a founding member of the Art Workers' Guild and the Arts and Crafts Exhibition Society. However, he also embraced modern technology and advised on how to achieve good design through industrial processes; an issue which is well demonstrated in his debate with Walter Crane in *Moot Points: Friendly Disputes on Art and Industry Between Walter Crane and Lewis F. Day* (1903).

This journal article is simply an exposition of how to decorate a room through examples. It also sets out some principles that can be applied to other rooms. There is an implicit gender bias in the text as the client is considered a male who, in particular, must not have any 'millinery about the window'. Lewis Foreman Day was quite disdainful about women as decorators, perpetuating the apparent clash between the work of female amateurs and male professionals. Discussing upholstery, he said 'it is only natural, however unfortunate, that the lady of the house should resort to the expedient of trimmings, fringes, valances, and the like'. He goes on to say in a similar vein:

> She knows nothing of decoration, and something about millinery, and in every difficulty she faces back accordingly upon feminine choices. There is no such excuse for the decorator. His is a manly art and remains for the most part in the hands of men. Why he should treat it in a womanish fashion is hard to understand, except that he has come at last to regard it from a woman's point of view.[1]

This essay was later reproduced in Day's *Everyday Art* (London: Batsford 1882).

# 42

# 'HOW TO DECORATE A ROOM'

## *Lewis F. Day*

Source: Lewis F. Day, 'How to Decorate a Room', *Magazine of Art*, 1881, pp. 182–6

The superiority of example to precept is proverbial. Perhaps, then, the simplest way of inculcating the principles on which a house should be decorated will be to take some one room as an instance, and proceed to work out a scheme for its decoration from the very beginning. In the first place the question is, Who is to inhabit it? What manner of man is he? What are his tastes and habits? For what purpose does he intend the room? We will imagine him a man under middle age, married some eight or nine years, his income sufficient for modest comfort but not adequate to anything like display or even luxury, His days are spent away from home in the counting-house or office. On his return he dines, and his evenings he usually spends quietly with his wife in their sitting or living room. This is the room that it is proposed to make pleasant. It is a room for rest and quiet. A number of guests is such an unusual event with him that it need not be taken into consideration. The atmosphere of a large party is no more congenial to him intellectually than it is physically, although once or twice in the year his wife and he do their best to be gracious to a number of worthy people with whom circumstances compel them to be on friendly terms, but with whom they have not sufficient sympathy to ask them to spend an evening at their house alone. The two or three who often do pass the evening with them are friends, familiar because of mutual sympathies. In arranging his room after his own fashion, therefore, he will probably be consulting their comfort as well as his own, and if not, he will surely make them more comfortable by carrying out his own idea than by aiming vainly to fulfil theirs.

It is intended that the room should be adapted to the habits of its inmates, and in particular to their evening occupations. These are various. Sometimes the owner returns from business fagged, and wants rest; or worried, and wants soothing; or depressed, and wants rousing. Sometimes the day's work has scarcely taxed his energies, and he wants to be doing something. His tastes are perhaps not very pronounced. He is fond of reading, but not such an eager reader as to pursue that pleasure under difficulties. He is no musician, but he has great pleasure in music, and he delights, especially when he is in the passive mood, to sit and listen to his wife at the piano. Neither art nor science has any strong

DOI: 10.4324/9781003290490-56

attraction for him, but he does like photographs – notwithstanding that his painter friends tell him that it is very bad taste on his part – and he has acquired a considerable collection of them. It is assumed, of course, that the wife is in sympathy with the husband, or if there are little differences of idea between them, this is the room in which his wants prevail, as hers do elsewhere. (It is simpler to speak always of one person than two.) Now that we know something of the man and his habits, it becomes possible to suggest a reasonable scheme for the arrangement of his room.

As it is chiefly in the evening that this room will be inhabited, we must beware of making it too dark. That would involve difficulty in the way of illumination, which means gas, which means heat, foul air, heaviness, and general discomfort. If a moderator or duplex lamp$^2$ (or two, if the room is rather large) will not sufficiently illuminate it, it is too dark. On the other hand, it must not be too light, or we shall lose the feeling of repose that we most want. Call to mind the cosiest rooms you can think of, and you will find that none of them are in a very light key. They are not white-and-gold drawing-rooms, but sober morning-rooms, or dining-rooms so called) that are really living-rooms. The tone of the room then is determined, not so dark as to necessitate gas, not so light as to appear cold or naked the tint is a matter of choice, to be settled according to preference, or perhaps with reference to the other rooms; one does not want to have all the rooms in the house of one colour. Before the distribution of the colour and its general arrangement can be determined, we must have some notion of the general character of the room itself, and of the more important articles of furniture. It is of no use, for example, to lavish work on that part of the wall which will be hidden by furniture or covered with pictures. Very frequently, too, there will be some marked feature in the room an arched recess perhaps, moulded ceiling, or a prominent chimney piece that of itself suggests a certain scheme of decoration: or the furniture may do the same. Since this one room, at least, is to be homely, let us boldly accept the photographs as worth a prominent place, if only on account of the owner's liking for them (just as we would accept his coins, his minerals, his butterflies, or any other collection in which he was deeply interested), and let these be the starting-point of the decoration. Let us choose enough of these for our purpose, selecting the best of course, but not only the best; considerations of proportion, scale, and general effect will almost certainly make compromise in the less important pictures desirable. The photographs should all be framed alike or nearly alike, the difference in proportion being rectified as much as possible by more or less of mount. It is impossible to arrange pictures of all shapes and sizes on a wall with complete satisfaction. The mounts, by the way, may be of wainscot or tinted cardboard, or of common brown paper of whatever they may be, the tone should harmonise with the photography. The thing to be most certainly avoided is a white mount. Unless the walls themselves are uncomfortably light, the white mounts of pictures catch your eye directly you enter a room; in other words, they murder repose. Now, as these pictures are

to be hung because the owner has pleasure in them, let them be hung where they can be seen-on the eye-line, in fact. They may, if there are enough of them worthy of the position, form a compact band all-round the room, inter-rupted only by the doors, windows, and taller furniture. A further precaution against monotony may be taken by allowing here and there one of the most important frames to rise above the upper most important frames to rise above the upper line of the picture-band. The lower line will be horizontal, and will correspond, in fact, with the rail of the dado, which for reasons partly of use and partly of effect we will keep considerably darker than the walls above. The darker colour will wear better (and this is the portion of the walls that suffers most from wear), and it will help to connect the furniture and make the place compact and snug. Economy being an object, we will use paper for this dado, choosing a pattern somewhat severe or stiff in style, partly because it seems fit that the base of a wall should be rigid, and partly in order that we may with propriety break out into freer and more flowing forms in the wall above. If we began at the bottom with flowers and scrolls, what should we arrive at by the time we reached the ceiling? The wall above the pictures is the place for freer ornament, and here again we may as well adopt paper as the simplest, cheapest, and most effective means of giving interest to a wall space. This may be finished off immediately below the cornice by a frieze, deeper or shal-lower according to the height of the room, very similar in tone (and perhaps in character too) to the wall-paper. It is commonly believed that such a frieze lowers the room in appearance. If it do so, it is the fault of the contrast in colour or of the strength of the pattern. A frieze, fitly chosen, only serves to prevent the lines of the wall-paper from seeming to run behind the cornice. There is no reason whatever why it should draw attention to itself. It may even, by connecting the wall surface with the cornice, draw the eye up to the ceiling, and so give the appearance of greater height to a room. On the cornice we will waste no labour in "picking out"; all that is wanted is a few shades of intermediate colour to connect the wall with the ceiling. If the mouldings are in themselves bald and uninteresting, some stencilled pattern-work may be necessary in order to make up for the shortcomings of the plastered work. The ceiling is most easily distempered or papered, the colour in either case being much paler echo of one or two of the colours prevailing on the walls. Crude white is in favour with housewives – "It looks so clean." That is just its fault. It looks so clean, even when it is not, that it makes all else look dirty, even though it may be clean. To paint the flat ceiling of a moderate-sized room by hand is simply a waste of labour. It is only at great personal inconvenience that one can look long at it, whilst as a matter of fact no one cares to do so. You see it occasionally, by accident, and for a moment, and, that casual glimpse should not be a shock to the eye, it is as well to tint it in accordance with the room, or even cover it with a simple diapered paper, which will to some extent withdraw the attention from the cracks that frequently disfigure the ceilings of modern houses. What hand-painting we can afford may best be reserved for

the panels of the doors, window shutters, and the like, where it can be seen; these doors and the other woodwork being painted in two or three shades of colour, flat or varnished, according as we prefer softness of tone or durability of surface. Perhaps it will be best in this instance that the woodwork should fall in with the tone of the dado, but this is not a point on which any rule can be laid down. The decoration of the panels should be in keeping with the wall-paper patterns. It may be much more pronounced than they, but still it must not assert itself. One great point of consideration in the decoration of a room is the relation of the various patterns one to another. It may often be well to sacrifice an otherwise admirable design simply because you can find nothing else to go with it. A single pattern, once chosen, will often control the whole scheme of decoration.

The carpet shall be Persian or, better still, there shall be no carpet but a sufficiency of Persian rugs, distributed as comfort may suggest, the floor of the room being polished, if it is good enough, or if not, stained and varnished or even painted. It is advisable always to have as little carpet about the room as is consistent with warmth. The worst thing one can do is to nail a carpet down over the whole area of the room. There is nothing like a carpet to hold dust. But the rugs can be taken up daily and shaken; and thus, moreover, the wear of brushing is saved. In the pattern of the carpet the chief thing to be sought is unobtrusiveness; colour, too, if it is to be had, but the more barred and broken the better-anything like definite form is more than dangerous. Often a plain colour would answer every decorative purpose, but plain surfaces tell too many tales.

Now we may begin to ask what furniture is wanted, and let us be sure that we consult our actual wants and not other people's prejudices. We must have a table large enough for use, and firm enough on its legs to work at, and not a shaped table or a round one; the former is made to be looked at, not to be used, and the latter is fit only for meals or a round game. A great proportion of furniture is made only for the show-room.

On each side of the fireplace is a low book-shelf, so arranged that as one sits by the fire one can always reach book without effort – a perpetual temptation to reading. The books are of all kinds, for all moods; some books of reference in particular, and these especially close at hand; in short, there is no excuse for indolence. On the top of the book-cases will stand candles or a reading-lamp ready. On the further side of the room is a cottage piano, music in this case not being of sufficient importance to warrant the sacrifice of space as well as beauty involved in the admission of a "grand." It appears to be an accepted fact (is it really a fact, I wonder?) that the fittest shape for a piano is the most hideous. For other furniture we have two small cabinets, one for music and another for photographs; a small movable table that will serve either as work or card table; at least four substantial chairs (of the "dining-room" type), in case of a rubber, or if one would do anything at the table: a music chair; a sofa; and half-a-dozen easy chairs, all different in shapes

These last are for passive enjoyment. If you are really in a lazy mood, no one chair is comfortable for long, and your greatest chance of rest is to change the chair you sit in. The seats are covered with stuffs of rich and warm effect, all of them different, but all of them in harmony; none of them, however, of velvet, like the curtains. The effect of velvet is perfect; it falls admirably too, and wears well enough, but it clings too much to answer the purpose of a comfortable cushion. Another provision is that none of the material used shall be so costly as to need covering up. The curtains hang from a brass pole just stout enough to bear them, and fall in straight folds nearly to the ground. They are not looped up; there are no superfluous cords, tassels, or fringes anywhere; in particular, there is no millinery about the window. It may be noticed that in this room there is no looking-glass. The perpetual nuisance of seeing oneself reflected at every turn in a mirror more than outweighs any convenience there might be in it. If such an article had been necessary, the best thing would have been to frame it something like the photographs and hang it like a picture, only out of the way, so that one could not see oneself in it without "malice prepense".

The clock, which hangs in the corner, is of brass, and so are the door-handles and other little fittings, the fender, fire-irons, and coal-scuttle. It so happens that the candlesticks and one or two other objects on the mantelpiece are also of brass. Not that it follows because one thing is brass that all the other things should be of the same; but even the little knick-knacks in a room should go together; they should not look as if they had come together by accident. So with the style of the furniture in our typical apartment. It does not all come from one workshop, and certainly it is not what is commercially called "a set" or, more magnificently, "en suite;" but whether it be light or heavy, florid or severe, it has some character, and that character pervades everything. All is substantial too, and well made, the first expense of good workmanship being counterbalanced by the saving effected in doing without all that was not really wanted. Even the most economically disposed of "those about to furnish" start with a preconceived idea that they must have many things for which they have no use and no excuse but custom. Nowhere is there in our apartment any sham construction or stuck-on ornament. The chairs and sofa show their framing, and are comfortably padded; they are not overgrown bolsters with iron entrails. It is a popular superstition to suppose that the most apoplectic-looking chairs are the easiest; but, in truth, it is the *form* of a chair, and not its padding, that has most to do with its ease. From the maker's point of view the preference for formlessness is easily explained; it hides all sins of construction, and good joinery is costly. It may have happened to some of my readers to come in contact with a dressmaker whose panacea for everything was padding; but will any amount of padding supply the place of a good cut?

Little now remains to complete the furniture of the interior I have attempted to sketch. Even such a room will not look quite homely at first – it will want a few weeks' wear. The occupants will soon find that there are some further contrivances

for comfort that have been overlooked. If, when these have been supplied, and the different members of the scheme have had time to mingle together and be on friendly terms all round, the effect should be still unsatisfactory, it must be that I made a false start at the beginning, and quite misunderstood the wants of my imaginary employer. But of this I am certain, that if he is once satisfied with a room furnished on the principles here advocated, it will continue to grow in his affections, and he will become more and more loth to make any serious alteration in it as the years go on.

These principles, let me say, are capable of the widest possible application, Suppose, for instance, the owner of this room had been of a more bookish turn of mind. It would have been easy to modify the same scheme to suit his tastes. On the preceding page I have shown something of the sort. In place of the photographs, books occupy the most important place in the room. The shelves form a decorative feature all round the room, fixed at a level most convenient for use, high enough to allow the chairs to be set back against the wall under them (in that way economising space), and low enough to form a broad shelf, available either for useful or ornamental purposes, The wall-space above still affords room for a few pictures, more particularly if they are bold enough in style to look well at a certain distance from the eye; and over the mantel piece, where the book-shelves could not conveniently be carried, would be a place of honour more worthily filled by a work of art than by a sheet of looking glass. In the framing of the picture in my illustration the simple plan has been adopted (for the sake of economy) of carrying on the lines of the somewhat commonplace mantelpiece that one finds in ordinary houses; but with greater outlay a much more important feature might have been made of this "over-mantel." The corner of the room, where some space would be wasted if the shelves were allowed to meet at right angles, is just the place for a useful cupboard, and the door-panel of such a prominent piece of furniture is just the place for a decorative figure, inlaid or painted, as the ease may be, for it faces the owner as he sits in his easy-chair by the fire, his feet on the fender which, by the way, has a bar arranged at a convenient height, so that he can toast his toes in comfort instead of scorching his instep, as he would if the fender were too low. His back is to the light, and he can read with comfort. On the table at his left is a movable desk, in case he should want to make a note, and at his right hand the book-case is carried, for once, nearly down to the ground, so as to accommodate the larger books of reference which he likes to have near him. The inscription on the frieze of the book-case is introduced to show that there is always an opportunity somewhere in a room for the whim or fancy of its inmate.

Further description is unnecessary, and might be tedious; the illustration explains itself. It is, however, only one out of any number of schemes that might have been built upon a man's personal ideal. My argument is that that ideal should be the basis of his domestic decoration, whatever that ideal may be.

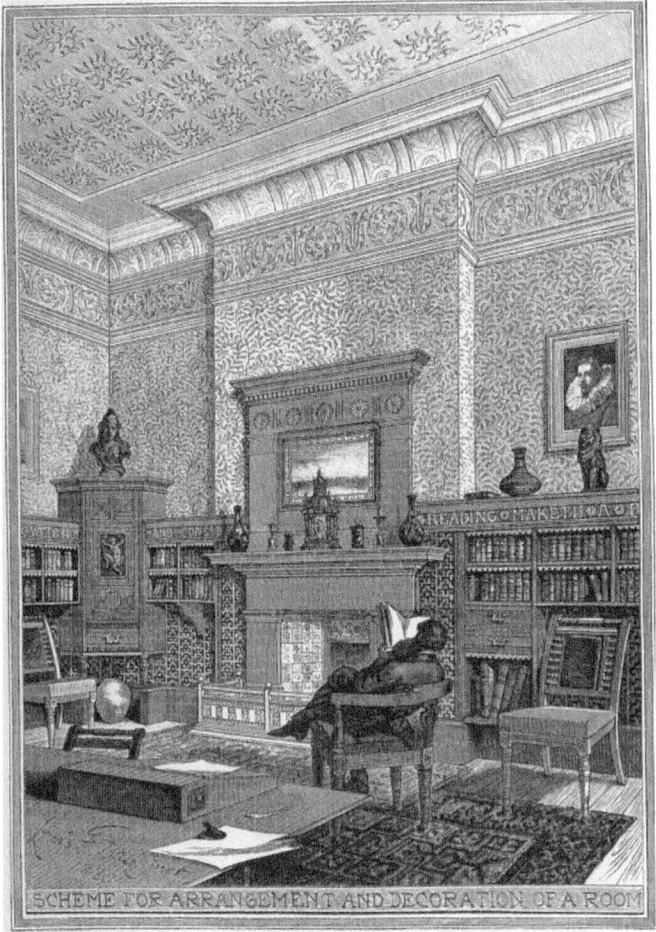

## Notes

1 L. F. Day, 'Modern Upholstery', *The Cabinet Maker and Art Furnisher*, July 1892, p. 20.
2 The Moderator lamp has the oil forced up the wick by means of a spiral spring, pressing on a disc immersed in the oil which is located below the wick, so as to avoid shadow.

# FRANCES POWER COBBE, *THE DUTIES OF WOMEN:*
## *A COURSE OF LECTURES* (1882)

### Editorial Headnote

Frances Power Cobbe (1822–1904), was an Anglo-Irish author, social reformer and theorist, particularly involved in women's rights, the franchise as well as animal welfare. Her duty-based moral theory also extended to women and animals. Cobbe's analysis of duties included relationships, contracts, being mistress of the house, being a member of society and finally a citizen of the state. Her lectures changed the nature of discussion on women's domestic duties towards establishing agency for them in a wider context. Cobbe's stress on duties as opposed to rights may seem strange, but she sees these developments as a woman's responsibility to be men's equivalents but not equals. She argued that women should remain proud of their gender, and use it to achieve power in a male-dominated world. Cobbe emphasizes that the home sphere is the place where future possibilities will materialise. She sees the home as a point of access to greater and more widespread influence. Home spaces allow personal duty to be developed into social duty, through the power of influence.

In her paper titled "Female Education", read at the Social Science Congress, held in London, in 1862 she expressed her ideas about the traps for women:

> All of us know enough of those hapless households where the wife, having no children and few home duties, undergoes the most deplorable depreciation of character for want of employment of heart and mind; and her nature, if originally weak and small, shrivels up in petty vanities and contentions.[1]

A review in the Boston-based publication *Unitarian Review and Religious Magazine* was appreciative of the 'latest work of an able and thoughtful Englishwoman'. They particularly commented on Cobbe's consideration the role of women in the home:

> Attractive passages are too numerous to be quoted, but none is more refreshing than the one in which this womanly woman pounces with good-humored vigor on the failure of some of her sisters to appreciate the worth of home. She belabors such delinquency with right good-will, and her words are assuredly as much needed here [USA] as in England. . . . She brings out all that is implied in the idea of a home, recognizing every claim of every living creature within it, human or beast, and closes thus: 'One word in concluding these remarks on woman's duties as a Hausfrau. If we cannot perform these well, if we are not orderly enough, powerful enough, in short, to fulfil this immemorial function of our sex

well and thoroughly, it is somewhat foolish of us to press to be allowed to share in the great housekeeping of the State. . . . Having shown ourselves incapable in little things, nobody in their senses will trust us with great ones.'"[2]

# 43

# THE DUTIES OF WOMEN: A COURSE OF LECTURES

## Frances Power Cobbe

Source: Frances Power Cobbe, *The Duties of Women: A Course of Lectures* Authorized ed. (Boston, Mass.: G. H. Ellis. 1882), pp. 136–48 [Extracts]

## DUTIES OF WOMEN AS MISTRESSES OF HOUSEHOLDS

After treating of Duties arising from Blood Relationship and from the Contract of Marriage and Friendship, we come to treat of the Duties which concern us women, when we are MISTRESSES OF HOUSEHOLDS; and, to begin, I must say at once that I have no sympathy at all with those ladies who are seeking to promote co-operative housekeeping, in other words, to abolish the institution of the English Home. There may be, indeed, specially gifted women, artists, musicians, literary women, whom I could imagine finding it an interruption to their pursuits to take charge of a house. But, strange to say, though I have had a pretty large acquaintance with many of the most eminent of such women, I have almost invariably found them particularly proud of their housekeeping, and clever at the performance of all household duties, not excepting the ordering of "judicious" dinners. Not to make personal remarks on living friends, I will remind you that the greatest woman mathematician of any age, Mary Somerville,[3] was renowned for her good house-keeping, and, I can add from my own knowledge, was an excellent judge of a well-dressed *déjeuner* and of choice old sherry; while Madame de Stael, driven by Napoleon from her home, went about Europe, as it was said, "preceded by her reputation and followed by her cook."

Rather, I suspect, it is not higher genius, but feeble inability to cope with the problems of domestic government, which generally inspires the women who wish to abdicate their little household thrones. Some sympathy may be given to them, but I should be exceedingly sorry to see many women catching up the cry and following their leading to the dismal *disfranchisement* of the home, – the practical homelessness of American boarding-houses or Continental pensions. I think for a woman to fail to make and keep a happy home is to be a "failure" in a truer sense than to have failed to catch a husband.

DOI: 10.4324/9781003290490-57

Assuredly, the Englishwoman's home is the Englishwoman's kingdom; and those homes, with all their faults and shortcomings, are the glories of our country, better glories, I think, than if we could transport the Louvre and Saint Mark's, or St. Peter's itself, across the Channel. Out of the English home has sprung much of that which is most excellent in the national character; and with the abolition of it would follow, I cannot doubt, a dissipation of childhood and a loosening of family ties, whereof the evil consequences would be measureless. Let we entreat you, then, while doing all you can to amend the many and serious defects which cling around our home system, to lift no hand to break it down. Make your homes better and happier and freer than they are, but do not even speak of the alternative of forsaking them and turning ourselves into Bedouins of the lodging-house. For Englishmen, such change would be very injurious, for Englishwomen it would be simply disastrous.

The making of a true home is really our peculiar and inalienable right, a right which no man can take from us; for a man can no more make a home than a drone can make a hive. He can build a castle or a palace; but – poor creature! – be he wise as Solomon and rich as Croesus, he cannot turn it into a home. No masculine mortal can do that. It is a woman, and only a woman, – a woman all by herself, if she likes, and without any man to help her, – who can turn a house into a home. Woe to the wretched man who disputes her monopoly, and thinks, because he can arrange a club, he can make a home! Nemesis overtakes him in his old bachelorhood, when a home becomes the supreme ideal of his desires; and we see him – him who scorned the home-making of a *lady* – obliged to put up with the oppression of his cook or the cruelty of his nurse!

But it is our privilege, our faculty, to turn any four walls, nay, even a tent under which we take shelter as we wander about the plains of the East, into home, if we so please. And shall we relinquish the use of this blessed faculty, and be content henceforth, like *mere men*, to be only quartered here or there, not to be at home anywhere? Why, even the little beavers, left in a drawing-room, set about making a dam, – a beavers' home, out of the coal-scuttle and the rug and the fire-irons! Shades of our grandmothers, keep us from such degeneracy.

But, not to pursue this spectre, let us take our stand *pro aris et focis*,[4] and see what duties belong to us in right of our home-rule. (We women are the true home rulers: Parnell and Co.[5] are impostors.)

In the first place, if home be our kingdom, it must be our joy and privilege to convert that domain, as quickly and as perfectly as we may, into a little province of the Kingdom of God; for remember what I have said all along: that we may look on all our duties in this cheering and beautiful light, – first, to set up God's Kingdom in our own hearts, making them pure and true and loving, and then to make our homes little provinces of the same kingdom, and, lastly, to try to extend that kingdom through the world, – the empire of Justice, Truth, and Love. We are entirely responsible for our own souls, and very greatly responsible for those of all the dwellers in our homes; and, in a lesser way, we are answerable for each

widening circle beyond us. How shall we set about making our homes provinces of the Divine Kingdom? . . .

[discussion of the role of morality and then happiness follows]

When the mistress of a house has done all she can to *prevent the suffering*, mental or physical, of any creature, human or infra-human, under her roof, there remains still a delightful field for her ability in actually *giving pleasure*. We all know that life is made up chiefly of little pleasures and little pains; and how many of the former are in the power of the mistress of a house to provide, it is almost impossible to calculate. But let any clever woman simply take it to heart to make everybody about her *as happy as she can*, and the result I believe will always be wonderful. Let her see that, so far as possible, they have the rooms they like best, the little articles of furniture and ornament they prefer. Let her order meals with a careful forethought for their tastes and for the necessities of their health, seeing that everyone has what he desires, and making him feel, however humble in position, that his tastes have been remembered. Let her not disdain to pay such attention to the position of the chairs and sofas of the family dwelling-rooms as that every individual may be comfortably placed, and feel that he or she has not been left out in the cold. And, after all these cares, let her try not so much to make her rooms splendid and aesthetically admirable as to make them thoroughly habitable and comfortable for those who are to occupy them, regarding their comfort rather than her own aesthetic gratification. A drawing-room bright and clean, sweet with flowers in summer or with dried rose leaves in winter, with tables at which the inmates may occupy themselves, and easy chairs wherever they are wanted, and plenty of soft light and warmth, or else of coolness adapted to the weather, this sort of room belongs more properly to a woman who seeks to make her house a province of the Kingdom of Heaven than one which might be exhibited at South Kensington as having belonged to the Kingdom of Queen Anne!

## Notes

1 Frances Cobbe, *Female Education, and How It Would Be Affected By University Examinations. A Paper Read at The Social Science Congress, London*, 1862. (London: Emily Faithfull, 1862) Third Edition, p. 4.
2 *Unitarian Review and Religious Magazine*, (Boston), March 1881 p. 256.
3 Mary Somerville (1780–1872) was a Scottish scientist, writer, and polymath. She studied mathematics and astronomy, and published widely on a range of topics.
4 Latin: "For our hearths and our homes".
5 Charles Stewart Parnell (1846–1891) was an Irish nationalist politician who served as a Member of Parliament from 1875 to 1891. He formed the Irish Parliamentary Party in 1882, whose legislative agenda was Irish Home Rule and land reform.

# [ANON] 'RELATIONS OF INTERIOR DECORATION WITH COSTUME AND COMPLEXION' (1883)

## Editorial Headnote

The anonymous author in this article for *The Art Amateur* journal discusses the relation between decoration, costume and complexion. This article is an edited extract from a longer version given by J. D. Crace to the Conference of Architects in 1881. The lecture was reproduced in various edited forms in *The Art Amateur* (below) and later in the *Furniture Gazette*.[1]

This issue was not a new concern. In 1854 the links between colour and complexion were addressed by Mary Merrifield:

> We have also shown that the colors worn by ladies should be those which contrast or harmonize best with their individual complexions, and we have endeavored to make the selection of suitable colors less difficult by means of a few general rules founded upon the laws of harmony and contrast of colors.[2]

There were numerous references to the problem of complexion in relation to interior colour schemes in the magazines and journals of the latter nineteenth century, often in response to specific questions in advice columns. An example from a publication devoted to training children noted:

> True taste, therefore, is the observance of philosophical laws; and it is these laws that determine what colors are as 'becoming to' certain complexions; also, which colors harmonize in the decorations of a room. As illustrations of this law, we will mention the effect of a few colors in dress upon the complexion of the wearer.[3]

In 1893 an American trade journal published a lecture on colour given by a Mr Barbier to the Pratt Institute, Brooklyn, where he was clear about the nature of this issue and is value: It is really a triumph of the decorator's art to be able to evolve a scheme of color, as a background, that will enhance the dresses and complexions of the ladies.[4]

Not surprisingly the topic was raised in books on etiquette and home making. Maud Cooke wrote:

> Another important item in the decoration of the home is considering the choice of ground tones with reference to the complexion of its hostess. Guests appear there but casually. She is always there, and no one should elect to occupy a room, whose color tones either totally efface what little color one may possess, or else, by an exaggeration of natural ruddiness, be made a rival of the setting sun.[5]

Interestingly it was still a concern in the 1920s. Bernard C. Jakway wrote that 'it must always be remembered that the colors of floor, hangings and furniture coverings, and especially of the walls, are certain to affect for good or ill the colors of complexion, hair and costume'.[6] The introduction of electric light also had a great impact on this issue.

The text's main thrust is to challenge the colour theories of Chevreul in relation to the complexion and the effect of interior colours on it. There is a particular emphasis on the colouring of spaces dedicated to dancing, no doubt because the effects of colour in these rooms were influenced not only by light but also by movement.

# 44

# 'RELATIONS OF INTERIOR DECORATION WITH COSTUME AND COMPLEXION'

## *[Anon]*

Source: [Anon] 'Relations of Interior Decoration with Costume and Complexion', *The Art Amateur*, 10:1, 1883, pp. 13–16

A great deal has been said and written about the coloring of theatres but, so far as coloring goes, the theorists, when they have differed from accepted practice founded on experience, have been wrong. Chevreul[7] proves to his own satisfaction that crimson is a bad color for the interior of the boxes, as tending to give the complexion a tinge of the complementary green. He advocates a pale green, therefore, for the interior of the boxes as enhancing the rose tints of the complexion. He thinks that the fronts of the boxes have a much more remote effect in this respect; but that the cushions should be covered in green velvet. Mr. J. D. Crace,[8] an English architect, declares, however, that experience tells that Chevreul is absolutely wrong from first to last; as he is, indeed, constantly wrong when he is discussing the effects of color on "complexion." In this very matter he appeals to results of experiments made on flat surfaces with uniform tints; and he is, therefore, in no position to judge of effects in which one color is in deep shadow, another in strong light, the object to be influenced being of quite uncertain quantity as to depth of complexion, color of costume, and degree of shade. Green lining to the boxes, and particularly green cushions on the front, would be fatal to four out of five complexions and costumes. There is no color at all equal to red-and especially red in shadow-for setting off to advantage a variety of complexions and costumes. The too red complexion is toned down by contrast; the pale borrows color by "sympathy" a very important factor where the human face is concerned. Besides this, the shadows are all warmed by reflection, and it is cold shadows, not cool lights, which are detrimental to a face. Then Chevreul underrates the value of the box-fronts as color. The arguments which he brings to bear on the interior are really applicable to these. Consequently, a light color which shall not either be so light or so pure as to injure, by contrast, the whites of the costumes, and which shall yet set forth the coloring of the faces (which are in the same plane), will be found best. This may be relieved by gilding, and by

neutral tints or colored ornament sufficiently broken up to afford only a neutral result – a soft and light contrast to the darker interior.

For rooms devoted to music or dancing, Mr. Crace points out that the conditions of coloring are not so similar to those for theatres as might at first appear. In the theatre the lighting of the audience is direct, the background being in shadow. In the ball-room or concert-room the light is to a great extent reflected from the walls, and will partake more or less of their tone, unless the sources of light are distributed pretty equally around the walls themselves. In a room hung with green silk, for instance, and lighted only, or mainly, by a central chandelier, all that side of the face which is in shade from the chandelier will be tinged with the green light reflected from the walls. It is, therefore, always desirable to distribute the sources of light, both to obviate these reflected tints, and to diminish all shadow. It is also very desirable to employ such tones of color as readily reflect light, and light rather warm than cold. It must, however, be remembered that many of the tints which are best for this, such as rather pure pale buffs, are apt to be very trying to portions of the costumes, especially to whites of transparent material, such as laces or gauzy fabrics, which against them become smoky in tone. A large preponderance of white (not too raw), with a liberal use of gilding, and some red (as drapery or otherwise) for the gilding to reflect, are always good. Probably no background is so effective for a ball-room as tapestry in pale tones of fairly pure color, which the texture of the fabric always softens below the coloring of the complexions or dresses. But in a public room so costly a decoration can rarely be expected. The beautiful variations of quiet tints exhibited by natural marbles are, again, admirable. If the cost allowed of it, Mr. Crace says he would desire nothing better than to have the lower walls, to a height of some six or seven feet, lined with various marbles, and the upper walls in subdued white relieved with gilding, and divided at intervals with pilasters of colored marble. The draperies and portieres should in this case be of rich and deep colors. This again, however, is a costly decoration, and we should consider what is possible with moderate means. Very gray tones of green, broken up by soft white, and set off by reds in the draperies, are becoming if the lighting is well distributed. The whites in this case may either be softened by tinting, or by some form of delicate arabesque ornament in mixed coloring painted thereon. The reds of the draperies must, of course, be recalled, in somewhat reduced tone, in the decorations, either as margins, lines, or medallions, or by any means which may appear appropriate.

If the proportions of the room allow of it, a good system of decoration for a ballroom or concert room would be one by which the color intended as background to the company would be carried only high enough to serve that purpose, and the larger surfaces of wall from which light would be reflected would be kept in light and somewhat warm tones.

In the case of smaller rooms used for similar purposes (only occasionally) in private houses, the great point to attend to is the even distribution of light. A wall with some depth of color, if not too gay, may be made a very effective background. But care must be taken, in that case, to light up the company, and not so

much the walls. For a dinner-party, a dark wall, relieved with pictures, is much the most effective and becoming, because the table being well lighted, the faces are all well lighted; the reflection from the white cloth prevents all heavy shadows on the features, and the dark background purifies the tones of the complexion. Moreover, the alternation of the black coats of the men performs the same service with very great advantage to the ladies at table.

## Notes

1 *Furniture Gazette* Vol 15, 1881, pp. 358+ 374+ and 390+.
2 Mary Merrifield, *Dress As A Fine Art* (Boston: Jewett And Co, 1854), p. 10.
3 Norman Allison Calkins, *Primary Object Lessons for a Graduated Course of Development* (New York, Harper & Brothers, 1861) p. 111.
4 *Painting and Decorating*, April 1893, p. 690.
5 Maud C. Cooke, *Social Life, or, The Manners and Customs of Polite Society Containing the Rules of Etiquette for All Occasions* etc. (Buffalo: Northrup, 1896), p. 484.
6 Bernard C. Jakway, *The Principles of Interior Decoration* (New York: The Macmillan company 1922), p. 216.
7 M. E. Chevreul et al., *The Principles of Harmony and Contrast of Colours and Their Application to the Arts: Including Painting Interior Decoration Tapestries Carpets Mosaics Coloured Glazing Paper-Staining Calico-Printing Letterpress-Printing Map-Colouring Dress Landscape and Flower Gardening Etc.* Second ed. Longman Brown Green and Longmans 1855.
8 J. D. Crace was a member of the illustrious firm of decorators-Crace and Co. London. See also text 1.57.

# [ANON] 'WOMEN AND MEN: WOMEN AS HOUSEHOLD DECORATORS' (1886)

## Editorial Headnote

In an American plea for women to engage with the craft of interior decoration through art school training and then the establishment of their own business, the author of this piece argues that this will eventually alleviate many of the problems facing those setting up home and also improve the general level of taste.

From the mid-1870s on, journals and newspapers started to publish articles on the topic of women's employment and especially mentioning house decoration, china painting and needlework as suitable examples. Candace Wheeler's contribution (see text 1.48) was a discussion of the profession of interior decoration and an example of the training that it demanded.

The opportunities for training of women in interior design and decoration, especially in the United States, grew into a diverse range of approaches. It ranged from self-education and apprenticeships to attendance at designs schools, university fine art or architecture courses, and later, home economics degrees.

Some professionals did not see this development sympathetically. In 1881 the British designer Lewis Forman Day noted:

> But it must be said that, as a rule, even the skilful amateur is anything but a useful assistant to the practical decorator, and the ladies who apply for 'art-work', as it is called according to the cant current, apply too late; they are too old, and probably too well satisfied with their capacities, too anxious to earn something, too ignorant of the slight commercial value of such labour as they have to sell. . . . Few of them will be able to do so by means of decoration or any other art or trade to which they have not served some sort of apprenticeship. But there are many branches of decoration by any one of which they might live in comfort if they had seriously studied it whilst yet there was no need of making profit of it.[1]

It is interesting to read the critique of interiors from the recent past in the text. The reference to the furnishings earlier in the century as being from the 'iron age' and the following 'glacial period' are derided, and the then contemporary Japanese style is not seen as an improvement. It is argued that these faults can be remedied by trained ladies who apply themselves to the art of decoration.

This essay was later reproduced in Thomas Wentworth Higginson, *Women and Men*, (Harper, 1888).

# 45

# 'WOMEN AND MEN: WOMEN AS HOUSEHOLD DECORATORS'

## [Anon]

Source: [Anon] 'Women and Men: Women as Household Decorators', *Harper's Bazar,* 19, 27 February 1886, p. 138

It once happened to me to spend a day or two in a country house where the different rooms gave unconscious object-lessons to show the gradual change of taste in household decoration. One room the sitting-room of an elderly invalid represented what might be called the iron age of furnishing; everything was dark mahogany and hair-cloth; there was not a chair or a sofa on which you could retain your seat without struggle, so polished and so slippery were they all. The walls were hung with dark portraits in dark frames, or smaller daguerreotypes in circles of black walnut; the only spots of color were found in one faded sampler, and in the gilded circular frame of a very small mirror hung too high for use. It was curious to pass from this sombre abode into the bedroom occupied, which had been fitted up by an elder sister, long since married, and whose girlhood fell in what might be called the glacial period of thirty years ago. Here everything was white instead of dark – white Parian statuettes, white fluffy embroideries, a white cross cut in complicated fashion out of paper, surrounded with white flowers and hung in a white frame against a white wall. On the mantel-piece stood a pair of cut-glass vases, bearing great clusters of dried grasses, bleached almost colorless by time. The furniture was of straw, and the counterpane was of white damask. If the room of the iron age was depressing, this was almost more so; it was like passing from an under-ground cave into a chilly world of ice. But third experience was offered on proceeding to the parlor, which had been given over to the charge of the youngest daughter, fresh from an art school. From this room every article of pure white or jet black had been banished; the eye wandered from one half tint to another, or if any bit of positive color arrested the gaze, it was some unexpected stroke of bold yellow or regal red. No two chairs were alike; nothing was paired; the carved marble mantel-piece was concealed by lambrequin; there were screens, fans, a knot of some Oriental stuff at the back of every chair, three various vases of bulrushes, and seven Seltzer water jars painted by the young lady herself, This room did not belong to the iron age, nor yet to the glacial, but to the

DOI: 10.4324/9781003290490-59

recent or Japanese formation. Considered as a step forward from the earlier stages represented in that house, it indicated a great advance. Considered as a finality, it was calculated to appall the human heart.

Now all these successive transformations were the work of women, and they suggest the question, If woman is thus the born and appointed decorator of the home, why should she not be trained to do it artistically and professionally? It is not truly artistic to plunge at once into the most exclusive extreme of the present fashion, whether it lead to black, or white, or a multiplicity of hue, but to take what is truly the best of each period and adapt it gracefully to modern use and to the needs of each separate family. In many houses this is now exquisitely done; no one can deny the great improvement in our "interiors" within twenty years. But if it is to be done systematically for the community, it is impossible to leave it wholly to amateurs. The modern decoration implies architects, designers, and artificers of its own. In the foreman of an art blacksmith's shop, I found the other day one whom I had previously known as a working jeweller; he had simply transferred his energy and skill from gold and silver to brass and iron, and was laboring with hands harder than before, yet no less cunningly, upon graceful gas fixtures and in-door ornamentations of his own designing. It must be the same with women; they must undergo professional training to do their best. Here is this whole continent waiting to be made graceful and beautiful in its in-door homes. It is said by dealers that, outside of a few large cities, there is absolutely no organization to supply this demand – no one who can give to a young couple setting up their housekeeping more than that amount of information possessed by the average furniture dealer, which is very little. For want of this, many young pair, as their wedding day approaches, sit down and ponder helplessly over some book on *The House Beautiful*, or *In-door Decoration*, until their souls are filled with despair. Where are they to find these charming portieres, these aesthetic wall-papers, these delightful Russian wash-bowls that are lighter and prettier and cheaper and more durable than any china! And the dealers receive unavailing letters from thousand miles away, asking for the wrong things or under the wrong names, and ending in failure. What is the remedy?

The remedy is for few women first, and then a good many women, after training themselves properly, to take up decoration as a profession. Let any two bright and capable girls who have wearied themselves in painting water-colors that people do not want, or Christmas cards for which the market is waning, try another experiment. Let them, after studying in the art schools of New York or Boston or Cincinnati, make also a careful study of the markets and workshops of those cities, so far as they relate to decoration; and then go, armed with circulars, price lists, plans, and patterns, to establish themselves as household decorators in some interior city to which the wave of modern improvement has come only as a matter of intelligent interest, not of systematic supply. They will have to wait awhile, no doubt, to command public confidence, or even to make their mission understood, but they will not have to wait so long as their brothers will wait for clients or for patients. They will need to be very practical, very accurate, very efficient, and

very patient. The great dealers in the larger cities will gladly make them their agents, give them letters of introduction, and pay them a commission on sales. With a little tact they can learn to cooperate with the local dealers, to whom they will naturally leave the coarser supplies, devoting themselves to the finer touches. If they succeed at all, their circle of clients or correspondents may extend through whole States, and they will help to refine the life and thought of the nation. By all means let us see women take up household decoration as an educated profession.

## Note

1 L. F. Day, "The Woman's Part in Domestic Decoration", *The Magazine of Art*, 4, 1881, pp. 457–63.

.

# J. MOYR SMITH, 'AMATEUR AND ARCHITECTURAL AMATEUR DECORATORS' (1887)

## Editorial Headnote

Scottish architect and designer Moyr Smith studied at Glasgow School of Art and became a member of Alexander Thomson's circle, which at that date included William Leiper, Bruce Talbert and Daniel Cottier. In 1866, Moyr Smith moved to London to be assistant to George Gilbert Scott. By about 1867 he was on 'temporary service' for Christopher Dresser and was supplying designs for the Arthur Silver design studio. From around 1870 he was developing an extensive commercial practice in the decorative art. Major clients included the cabinetmakers Collinson & Lock and Cox & Son, the piano-maker Broadwood & Son and the tile and ceramic manufacturers Minton & Co (later Minton Hollins & Co), W B Simpson & Sons, and Maw & Co. He also published four books: *Studies for Pictures: A Medley*, 1868; *Album of Decorative Figures* (1882); *Ancient Greek Female Costume* (1882) and *Ornamental Interiors, Ancient and Modern* (1888). He also illustrated a great many others.

*Ornamental Interiors Ancient and Modern*, was an important book that stressed the role and nature of decorative ornament in interiors. Moyr Smith discusses the history of ornament from ancient Assyria to the 1880s, but the work also has practical chapters on decorative arts practices as well as examples of modern work.

The book's reviews were mixed. The *British Architect*, noted that

> Mr. Moyr Smith, in his new work on 'Ornamental Interiors', treats architect decorators and lady decorators very much as two little side groups of workers who have no very great part to play in the practice of interior decoration. Now, we have a very great contempt for that architectural practice which contents itself with the designing of the general fabric, and leaves untouched the finishing, furnishing, and decoration of a building, if the way to carry that out be by any means possible.

The ongoing argument of the role of architect in relation to the decorator or furnisher continued in this review:

> In order to be fully competent, the architect must see to it that he endeavours to place himself on a level with the ability of those who usurp his functions. We all of us know that architects' furniture is apt to err on "the side of heaviness," as Mr. Moyr Smith tells us, but we also know that furnishers' furniture is apt to err on the side of over-refinement, and lack of breadth and scale appropriate to the building.[1]

See also text 1.18

# 46

# 'AMATEUR AND ARCHITECTURAL AMATEUR DECORATORS'

## *J. Moyr Smith*

Source: J. Moyr Smith, 'Amateur and Architectural Amateur Decorators', *Ornamental Interiors Ancient & Modern*, (London: Crosby Lockwood. 1887), pp. 76–80 (Extract)

About thirty years ago the chief rooms in many good houses were furnished with a wooden dado rail, which if it had no other use, served to keep chair-backs from injuring the walls. But a change was impending. The first thing a high-class decorator did when he got into a room of that kind was to wrench off the dado rail and cover the walls from skirting to cornice with a French paper of light and cheerful aspect. For dining-rooms the colours might be rich and dark, but for drawing-rooms both decorators and the ladies agreed that there was nothing so refined as enamel white and gold.

In those days acknowledgment of the intuitive superiority and delicacy of feminine taste was looked for as a matter of course from all the novelists, and lovely woman reigned supreme in the choice of colours for house decoration.

But this intuitive delicate feminine taste has been dealt with rather harshly of late years. Some cynical being of the masculine sex discovered, and worse, made public his discovery, that woman is a mere imitator and does not possess original any taste at all. She could, it was said, imitate a fashionable taste in millinery, dress, furniture, music, and cookery, but as a rule she originated nothing. The ladies' dresses that lead the fashion, the furniture and decoration of the rooms she lives in, the music she plays, and the mode of cooking the food she eats had, it was said, all been originated by that tasteless creature, man.

The cynic, moreover, said that although many women have devoted a great deal of time to playing music and to cooking, there has not yet appeared a great composer or a great cook of the feminine sex. It was conceded, however, that her gifts in the way of placing anti-macassars where they would make the clumsy male being most uncomfortable, almost amounted to genius. It was likewise granted that she could choose vases of the slightest known degree of stability as ornaments for a mantelpiece, and that she could crowd incongruous though perhaps expensive trifles on unstable furniture so cunningly that ordinary persons of the clumsy masculine order, when in her drawing-room, were impressed with the

DOI: 10.4324/9781003290490-60

feeling of her too exquisite refinement, and at the same time taught the much-needed lesson of self-repression.

For the decoration of the drawing-room walls she at that time firmly believed there was nothing so chaste or so elegant as white and gold. Perhaps she was right in her belief; but unfortunately it was also the belief of every other lady who had the slightest pretensions to fashionable taste. The effect, therefore, produced by the combined fashionable feminine taste of the civilised world was rather monotonous.

The doors were white, or grained to represent satinwood or some other precious timber; the carpet was light in the ground and spangled with roses or garlands of other gay flowers.

But since that time there have been great changes; noble, high-souled men have come forward boldly and shown the awful iniquity of graining doors in imitation of oak, satinwood, or maple; they have denounced the sin and imposture deliberately perpetrated by demons in the guise of wall-paper manufacturers and carpet makers, who put attractive imitations of real flowers on walls and floors where no real flowers were likely to be.

We, however, have not yet reached that transcendently high standpoint which would enable us to denounce imitations of real flowers as soul-destroying shams, or graining of doors as glaring immorality. For while thinking there are better and truer modes of decoration, we do not think it worthwhile to waste good indignation on such harmless fashions.

If we ask the noble denouncers of graining why it is so very wicked to grain a door in imitation of oak, they will probably reply that it is intended to deceive, and all deception is wrong.

But, say we, you yourselves use flowers as decorations for walls.

"Yes, but *our* flowers are conventional renderings, and are not intended to deceive."

Well, we reply, the ordinary builder and decorator's oak graining is quite as conventional as your flowers, and even a blind man would not mistake it for real oak.

But is not all art founded on imitation? We have sham effigies giving the forms of men and women – that is sculpture; we have flat surfaces which pretend to give the roundness and colour of human figures – that is painting.

Art is conventional imitation; and what is decoration of the pure, good, exalted sort favoured by the denouncers of sham graining but a conglomeration of shams? They would cover the walls with paper-hangings-that is, sham hangings-on which there would be sham leaves and flowers; they would gild mouldings which the wicked builder has thoughtlessly made of wood instead of solid gold; they would use veneer of wood or marble; they would probably stain floors dark in some places, so that though plain deal they would look like walnut or ebony.

It seems to us only a question of degree, and in spite of the elaborate distinctions and explanations as to the rights and wrongs of imitation given by denouncers of graining, who have followed each other with sheep-like regularity during

the last twenty years, we persist in believing that graining is only terribly wicked because it is at present so very unfashionable.

Many amateurs, especially ladies, feeling a call to convert the nations to the practice of high-toned decoration, expounded their true principles of Art at Home with as much innocent confidence as if the subject had been the trimming of a dress. Of course, their delicate feminine instinct led them to advocate the style of decoration with which they had most acquaintance, and everyone aspiring to a name for taste had her mantelpiece befrilled, draped, and furnished with a convenient apron or curtain to hide the emptiness of the fire-place. Japanese fans were spluttered over the walls, sometimes on the ceilings as well, and the soul was cheered everywhere with the delectable sight of plates and other articles of crockery adorning the chief points of the apartment.

Mrs. Haweis, who is the author of a book called the "Art of Decoration," however, is entitled to a higher place than that usually accorded to the amateur author who attacks a subject that requires technical as well as practical knowledge. Her information seems to be very extensive, and her conclusions, which are shrewd, are given in her book in a very lively and entertaining manner. She shows up in her book the absurdities of some of the lady decorators in the following fashion: "One of my strongest convictions, and one of the first canons of good taste in house decoration, is that our houses, like the fish's shell or the bird's nest, ought to represent our individual tastes and habits, never the habits of a class. There is nothing so foolish, nothing so destructive to the germination of real taste and art feeling in England, as the sheep-like English inclination to run in a flock. No thoroughly bad fashion would ever take a firm hold on society were it not for the indolence of those who can, but will not, think for themselves, and the timidity of those who dread what is new. For instance, one hears ladies laying down the law in this style: "You must have old point on your mantel-shelf; it is indispensable; everyone has it!?" Yet good sense tells us that a delicate fabric designed to adorn a lady's dress is as unsuited to the rough and dusty service of furniture close to the fire as a pearl necklace or ostrich plumes. Why, therefore, 'must' we adopt a freak of luxury, founded neither on good sense nor good taste? Again we hear, Fire ornaments are quite gone out; you must stick a Japanese parasol in the stove, or fill it with tinsel and waterlilies.' It matters not how outrageous the notion primroses planted in the fender, a rockery of ferns, a scent fountain playing up the chimney, or a white satin bow from the register-the argument is always the same: I am telling everybody of it, and they are all doing it!"

Besides the amateurs, however, some architects have endeavoured of late years to show that they were masters of the art of decoration. If he has a thorough knowledge of his profession, an architect is likely to make the interior decorations in harmony, as to scale at least, with his building; but it is perhaps too much to demand that a modern architect should mix all the tints and draw all the details of ornamentation with his own hand, although the best ancient work was probably done under such conditions.

The modern architect has, moreover, sometimes to be brother to the keenest of hucksters, so as to be more than a match for the wiliest of builders on the one side, while on the other he claims to rub shoulders with the immortals who designed the Parthenon and gave Europe its grand cathedrals. Everything, from the construction of a kitchen sink to the building and decorating of a St. Peter's, is supposed to be well within the powers of that combination of modern practical science and of genius made to order – the modern architect.

## Note

1 *British Architect*, 27, 4, 28 January 1887, p. 73.

# MARY TEMPLE BAYARD,
## 'HOW TO BEAUTIFY A HOME', (1894)

## Editorial Headnote

Mary Temple Bayard (1853–1916) was an American author and journalist. Her published work was generally written for newspapers and magazines, often on topics related to women's social reform and philanthropy. Her approach is clear in her strident lecture on 'Woman in Journalism' given to the Congress of Women at the World's Columbian Exposition in 1893:

> I don't like the petticoat or trouser differentiation which my subject seems to imply. Women in journalism today in no way differ from men in journalism. Sex is neither a disqualification nor a recommendation. Much discussion of women in any particular line of usefulness, in these free and equal days, when they can hem ruffles or engineer locomotives equally without comment, is too much like discussing them as a species instead of a sex. . . . Neither is there a royal road especially prepared or made smooth for either sex. A fair field and no favor must suffice for women in journalism. There is no claim to be set forward on the basis of sex. Women who have succeeded in journalism have succeeded as journalists and not as women, and this along the same lines on which men have succeeded.[1]

The *Canadian Magazine* was founded in 1893 as a monthly magazine dedicated to Canadian interests and was intended to challenge the supremacy of the foreign press.

Although the text mentions the possibility of women making a career out of decorating, the main thrust of the advice is to the home-maker and their own needs. The journalistic tone does not hide the common-sense attitude to decorating that Bayard suggests. Although many of the arguments around the topic were, by the time of publication, well-aired, Bayard had a way with words that encouraged and educated her readers without being 'preachy'.

There is a fascinating mention of the possibilities of women taking to the study the art of furnishing and decorating with London firms. Serving an apprenticeship of between three and five years they were educated in the 'mysteries and technicalities of the profession', but were required to pay one hundred pounds premium for the privilege.

# 47

# 'HOW TO BEAUTIFY A HOME'

## Mary Temple Bayard

Source: Mary Temple Bayard, 'How to Beautify a Home', *The Canadian Magazine of Politics, Science, Art and Literature*, 111, 1894, pp. 168–72

Pre-eminently this is an age when every woman is possessed of the decorative fad. And granted that out of broom-handles and bread-toasters she does create marvels, and that many an otherwise cheerless home has been brightened by the little patches of color with which she has dotted the walls and tied the furniture, yet is it not well to call a halt, while we consider the danger of over-doing, of our being surfeited with cheap splendor and the products of faulty taste and false luxury. From the time Eve commenced house-keeping, a beautiful house has been the most deeply grounded desire of every feminine soul (be it in its normal state), and is manifested as early as doll days, when we played "keep house."

Man builds the house, but it is woman who makes the house. That sounds more or less platitudinal, we know, but nevertheless it is full of the living truth. Next to the deep-seated love of home (which women still possess, the croaking of all pessimistic cranks to the contrary, notwithstanding), is the feminine characteristic – a desire to lavish time and money on its fitting adornment. Given a free hand to banish and replace, what can she not do to beautify and adorn the home – if only she knew how.

But there is the rub. How few seem to know how? There is a decorative sanity in choosing colors, styles and methods. To make a proper choice is not always intuitive, and in consequence mere display is too often substituted for beauty and good design, and we have a flimsy exhibit of interior ornament with which it is really degrading to live. Many women who have just picked up the decorative fad, think they have grasped the whole idea when they have put petticoats on their lamps, flounces on foot-stools, trousers on the piano's legs, neckties on vases, and aprons on the radiators. and have swathed flower-pots in silk scarfs, until they look as if the intention was to prevent sore throat, and what with draperies, tidies, pillow-shams and "things," have made the whole place about as much of a bore to the man of the house as it could possibly be, and in the minds of all people with the insanity of the fad not yet upon them, furnished him with good and sufficient grounds for serious dissatisfaction.

DOI: 10.4324/9781003290490-61

In general, a man hates these things, but will make no fuss about them unless they interfere with his personal comfort. Artistically, they do not offend, for it seldom happens that he knows right from wrong in regard to general effect. He only notices, with commendable pride, that his wife has surrounded herself with as much "trumpery" as has Jones' wife, and is well pleased, until he falls over the same hassock a dozen times, because it is the exact shade of the carpet, and always in the only bit of space in the over-crowded room where a man could reasonably expect to get a foot hold; or until the silken fringe of a "throw" sticks to his unlucky coat sleeve and he drags it off, smashing the most costly bit of bric-a-brac in the room: or until he goes down town with a tidy on his back, or gets roundly "blown up" for desecrating the lace pillow-shams with his stupid head, into which no idea of genteel living can be drilled. At such moments he feels fully qualified to give "pointers" in household decorations. and his verdict is: To perdition with all such "flummery," while he resolves all over again, and for the one thousandth time, to found an asylum for incurable faddists – with his wife a charter inmate.

Now, what is it that is wrong with his wife's ideas in regard to beautifying the home? Is it not simply the fault that many others have; the failure to understand that the floor is intended to be walked on, and is not to be considered only as so much space upon which to crowd spider-legged chairs, unsteady stands, and easels which topple over almost at breath: that the ceiling is to reflect light, and is not merely a something from which to suspend an expensive chandelier, and that the wall is to serve as a background or setting for guests as well as pictures, and therefore should be subdued in color, so as not to obtrude itself upon one's notice, and should not be over-crowded with pictures, or brackets with draperies, or cabinets filled with bric-a-brac.

It is the excess of ornament, no less about a house than a person, that fatigues the eye and distracts the mind. About half of the useless lumber in the way of fragile brackets, cheap ornaments, conglomerate pictures, throws, tidies and flimsy scarfs, now disfiguring our houses should be relegated to the attic; the good etching or water-color or engraving is worth a van-load of common stuff, and would cost no more. A few exquisite forms and fewer colors, a restriction of cheap and lavish ornamentation, a chaste individuality in selecting every article of furniture and decoration for its fitness for its environments and its use, and we shall begin to understand the true art of decorating the home. That which, of all industries among women, none is of more importance.

As I have already stated, such knowledge is not intuitive, but is easy to be obtained by an actual study of the technicalities of the profession, or by a habit of observation that amounts to the same thing – in a woman at any rate, who acquires so much by absorption. The woman's building at the Columbian Exposition (the design of a woman and the best expression of elegance, harmony and beauty, with its exhibition limited to work done by women alone),[2] was in itself, in the region of art, a great inspiration and incentive for women.

Since that Exhibition, women, generally, are giving more attention to decorative art, and the women of our country are taking it up as a profession, but unfortunately, they so far have been obliged to go abroad for study. It has, for some years, been the custom with London firms to receive women to study the art of furnishing and decorating, the apprentice to remain from three to five years with the firm: and, in consideration of the time and trouble taken by employers in conscientiously educating their pupil in the mysteries and technicalities of the profession, one hundred pounds premium is required. This seems an unreasonable exaction on the part of such firms, for the experiment of teaching women has proven that they are more apt than men; that they have a keener moral sensitiveness; to beauty, a quicker eye for color; that their sense of artistic proportions is equal to man's: and that they have, with these qualifications, an unbounded and unflagging enthusiasm, which, carried into the pursuit of any trade or profession, and coupled with the persistent effort said to be closely akin to genius, is almost certain to bring success.

Women studying decorating and art furnishing are required to learn all about the various materials used for all kinds of artistic work. They must know the newest designs for wallpapers of both home and foreign productions; they have to familiarize themselves with furniture of all kinds and styles, including mantel-pieces, the fitting up of grates with tiles and brasses: they must know everything knowable about carpets and draperies, art embroideries, bric-a-brac and about pictures, and hanging them, how to place marbles, in short – how to artistically cover the lifeless skeleton of a house with beauty and interest. More than all else, since it is one of the most important questions of decoration, they must study harmony of colors, about which little enough is yet known: for, notwithstanding the immense progress that has been made in art in the last four hundred years, our knowledge of the properties of color is still in its infancy.

But it is not of decorating as a profession that I want to write, though I do think that it is an occupation for which woman is pre-eminently fitted by reason of her love of home, her delicate manipulation, and her great patience in detail. But it is for the home maker – the woman who has for the object aimed at the beautifying of her own home – that this article is particularly intended. The world is full of people with whom a lavish use of money is impossible: and the question of the hour is how to obtain artistic results at a low cost: how to do something durable and decorative in the production, at a trifling outlay, of articles of convenience and beauty. This is not impossible, though many with limited means suppose that it is: their idea of correct furnishing being the relegating of the work to a professional, who, as often as otherwise, puts in a collection of enormities and makes the whole place look like his own show-rooms, and of course unsuited to the family which is to live amidst these environments.

Undoubtedly there should be a harmony between the house, the furnishings and the people in the house: and this is only obtainable when one knows what one wants: when, through observation and thought, one has cultivated the eye and

exercised a little common sense. Wealth does not always bring good taste: but rich people who will not take the trouble to study pure style themselves, would run less risk in giving a decorator carte blanche than in juggling with the art themselves, in the way in which many people of means in these faddy days do. We have all been in houses of the wealthy where the furnishings had been collected and placed simply because fancied, and without their proper harmony, in regard to style or fitness, being in the least understood. Violations of this kind are perpetrated every day, and it is to be hoped the time is coming when wealthy people who will not study pure style for themselves, will place the decoration and furnishing of their houses in the hands of competent decorators, who will at least do better for them than they can do for themselves.

Art shops and dealers in household decorations, lead the mind, and a score of ideas and adaptations to one's own particular needs, follow in train. But we must apply the test of fitness and use to the novelties that attract with their prettiness and brightness, and we must determine how much of time or money they are worth. A little sifting soon creates a capacity for clear analysis, A woman can learn to distinguish, at the glance of an eye, between truth and trash: and in a work in which she has so much at heart as the beautifying of her own home, she should ever he willing to pay a fair compensation in time, labor, and thought where there is to be such value received.

Trumpery "nothings," in their uselessness, are dear even as gifts. "Decorate the useful, but avoid mere useless decoration," is a good motto, particularly for the moderately rich and the comparatively poor. Pretty and tasteful things are within the reach of all. It is a great mistake to believe such things are for the rich only, and to be bought with a price. One clever woman of my acquaintance, whose home, though inexpensively furnished, is most artistic, has made one of the most exquisite set of portieres have ever seen. For this purpose, she utilized some old rose silk curtains, which had been purchased at an auction sale, and which were faded. These she ripped and turned, and they were found to be as fresh and rich in color as if new. Next, she looked up some cast-off lace curtains, laundried them herself, cut out the heavy figures and appliqued them on the silk, after gracefully arranging them on that fabric. The result was a pair of beautiful portieres that attract the attention and command the admiration of everyone. Their manufacture took time, patience and thought, as we can well understand, but there was the value received for all this. This woman has furnished her entire house along the same lines, She is in the habit of saying that it was furnished out of the rag bag, but it certainly looks as if the fairies did the furnishing.

"Nor is her case a solitary one." We all know of other women who, by the exercise of good sense and such knowledge of art as they happen to have, cast a glamor over the most unpromising of rooms. They weave potent spells of witchery by making unusual arrangements of furniture, placing everything just where it belongs, where it is least likely to interfere with anyone's personal comfort, and where it shows to the best advantage. For instance, the black screen has a large pot of orange lilies, or golden foliage, to light its gloom: the tall mirror has a slight

drapery of canary phoolkari:[3] and a hanging, yellow-shaded lamp is fixed across a corner, so as to reflect a pretty window: a couch has fat yellow cushions: there are a few chairs not too elegant nor yet too cheap; fewer pictures, but these well hung, etc., etc., – nothing valuable after all, but everything has that strange, undefinable charm of being just like the woman who owns it.

People cannot always create, outright, the place in which they are compelled to live, and they often find themselves in houses or rooms entirely opposed to their individual fancies. But that is their opportunity! As Lady Barker has said: "So long as a woman has a pair of hands, a work basket, a hammer and brass tacks, she need not live in an actually ugly house."[4] In this, I am sure Lady Barker is quite right. We cannot all have costly pleasures, such as really good pictures, statuary, bronzes, old silver, and old embroideries; but nothing save our want of knowledge, or want of taste, can withhold us from the daily, hourly delight of being surrounded by beautiful harmonious color. But a really good eye for color is not found as often as might be supposed. Indeed, there seems to be, generally, but little thought given to it and yet the tonic effect of harmony in colors is, upon some natures, as strong as that of music.

Many of us have only a smattering of color-knowledge – just that little knowledge which is a dangerous thing. For instance, we know that a crude purple, a magenta and a blood-curdling shade of green are "really quite too dreadful," as a combination: but we are slow to understand how a certain shade of yellow wallpaper cries aloud for velvet curtains of a special tone of russety green: we would be more likely to insist upon having hangings of that most bourgeoise color, peacock blue, because blue and yellow go together, you know.

There are a few cardinal principles of truly artistic decoration which every woman can know without apprenticing herself to a furnisher or draper, and which it is gross laziness or carelessness not to know.

The prime object of house-furnishing is to, through the senses, rest both body and mind and the realization of this idea is attained by supplying impressions that are totally alien to those generated in the struggle in the business world for the almighty dollar.

A room should declare its purpose or nature of occupancy, and should also declare its logical relation to the rest of the house. It should harmonize with those rooms which adjoin it, thereby exerting a pleasant influence upon the person passing through them. It should be an expression of the individuality of its inmates. The condition of individuality makes the room express the nature of the decorator. If the owner leads an intellectual existence, and loves soft lights or warm glowing colors, then if she does her own thinking she will, of course, betray this existence in the things with which she has surrounded herself. The rare literary contents of the bookcases, the statuary, if she can afford it, (but all weird and symbolical effects.) rather than the presence of things hard and practical, reveal a poetic personality. Such a scheme admits the widest possibilities of decorative art: is rich in a thousand practical suggestions. The individuality of the master and mistress of the house, whose tastes can be made identical, becomes the soul of the

arrangement, transforming what might at first appear a heterogeneous gathering of disconnected parts into harmonious composition. The style is the decorator himself or herself, and not any conception of a dead past. The subject is worthy of the consideration of every house-maker. It is a fad quite worth pursuing, since, through the medium of the home, the coming generations will be taught to admire what is best in form and color.

It might be well to consider seriously what we are teaching in the way of "mother wit," as revealed in art. There has been much ridicule on our part thrown upon the "good old times," as being more uncomfortable and fanatical than the present. But it must be acknowledged that there is one thing in which our ancestors were superior to ourselves, and that is that decorative art, with them, did not mean an endless covering of the wall or ceiling spaces with a prodigality of patterns and colors which "swore at each other" as the French say. Neither did they try to hide their poverty with sashes and silken draperies, nor fling so-called Indian rugs here and there to hide grease spots. Homes made up of handkerchiefs and remnants were less common, and as emporiums of misfits were unknown. There was much less of those cheap splendours and mock luxury which abhors the use of furniture really well made, and chairs that are comfortable and solid, and bureau drawers that open and shut well. In fact, there was a relish of those healthful ideas which, in decorating a home as in everything else, consist in appearing that which one is and not what one might wish to be thought. In this age when financial progress goes rapidly ahead of education in art, are we not in some danger of falling into degeneracy?

## Notes

1 *The Congress of Women Held in The Woman's Building, World's Columbian Exposition, Chicago, U. S. A., 1893* (Conkey: Chicago, 1894), p. 435.
2 The Woman's Building was designed by Sophie Hayden with interiors by Candace Wheeler, for the World's Columbian Exposition held in Chicago in 1893.
3 Poolkhari refers to the folk embroidery of the Punjab.
4 Lady Barker (1831–1911) was a prolific author on a variety of topics. She published her *The Bedroom and Boudoir* (1878), but this quote is untraced.

# CANDACE WHEELER, 'INTERIOR DECORATION AS A PROFESSION FOR WOMEN' (1895)

## Editorial Headnote

Candace Wheeler (1827–1923) was an important figure in America's design world, being both an interior and a textile designer. In April 1892 Wheeler published her first articles on interior decoration in the *Christian Union* journal. She also published a number of other articles and books including contributions on the 'Philosophy of Beauty applied to House Decoration' to *Household Art* (New York: Harper & Brothers, 1893) and her own *Principles of Home Decoration* (New York: Doubleday, Page & Company, 1903). This was apparently successful as a second edition came out in 1908, and a third in 1913. This book offered advice to middle-class women on all facets of house decoration, from exterior architecture to interior designing.

Wheeler was an amateur painter until around 1871, when she became a member of the Ladies' Art Association, a New York-based group founded in 1867. In 1876 she was inspired by the Royal School of Needlework's exhibit at Philadelphia Exposition to establish a similar organization in the United States. In 1877 she founded the Society of Decorative Arts of New York City as well as the self-help organization New York Exchange for Women's Work. She was keen to raise the profile of crafts associated with women, especially art needlework, and to make them profitable. Branches in other cities were soon established. In 1879, Wheeler joined forces with her friend Louis Comfort Tiffany, Samuel Colman and Lockwood de Forest to form Louis C. Tiffany & Associated Artists, which soon became a very influential New York decorating business. Wheeler designed Japanese-influenced floral embroideries, textiles, and wallpaper for the company. In 1883, when this partnership ended, she took the name Associated Artists and continued to operate the business on her own until 1907. While still handling private commissions, she was asked by textile manufacturers to produce designs for the large-scale manufacture of fabrics such as printed cottons. As well as designing in the Japanese idiom, she was also inspired by traditional American visual culture.

Later on in 1918, she wrote an autobiography titled *Yesterdays in a Busy Life*, and in 1921 she published *The Development of Embroidery in America*, which was the first book on the subject.

# 48

# 'INTERIOR DECORATION AS A PROFESSION FOR WOMEN'

## Candace Wheeler

Source: Candace Wheeler, 'Interior Decoration as a Profession for Women',
*The Decorator and Furnisher*, 26, 3, 1895, p. 87

Possibly there is no profession that, at first thought, seems so natural and appropriate a one for women as that of interior decoration; but perhaps the very appropriateness of it to a woman's usual capacity may be misleading and mischievous, since it is very likely to prevent the serious and comprehensive study without which no profession can be worthily followed or its practice genuinely respected.

Interior decoration, at its best, certainly demands very varied and exact knowledge. A man or woman may paint pictures or model statues which deal with the emotions of nature or the vicissitudes of life, and the work may be absolutely complete as a picture or statue, appealing to human feeling and gaining entire approval from art lovers, even where the author of it has the gifts or genius of the artist without the wider education demanded by other professions. But the decorative artist must have the artistic gift or ability in all its phases; must understand form, and be able both to draw and model it; he must have what is called the color sense very highly developed, and, in addition to these gifts and their attendant knowledge, he must have an exhaustive familiarity with the literature of the art, and a knowledge of its practice extending back through all the varied styles – of centuries and periods and generations.

I am often asked the question, "Is decoration a good field for profession for women?" and I can readily answer, "Certainly it is! if women will educate themselves for it." But what would you think of a painter who proposed to paint a picture without preliminary training, not only in drawing and perspective, but in methods and mediums? And yet he could do this far more easily, because his work is individual and independent, than the decorator can make a good interior without wide knowledge of well-directed study. And this is because the work of the latter must supplement and follow, must in fact be a part of that of the educated architect.

DOI: 10.4324/9781003290490-62

*Design No. 3.* Scheme for Decorating a Bay Window

It is necessary for the decorator to be cultivated in the same line with the architect to properly follow and combine the work, for where the two stand as widely apart as education and ignorance might place them, the work must necessarily be incongruous and unworthy.

Of course I am speaking now of real excellence, of decoration as an art and not as a pretty arrangement of curtains, carpets and furniture, which are more or less in harmony with each other in color, and more or less good in shape, design and manufacture; this sort of thing means interior arrangement, and not interior decoration, or decorative art.

Any ordinarily clever woman can arrange her own home in a way to "make the most of it"; she can bring pictures and books and personal and household belongings in an agreeable *ensemble* and, if she is blest with what is popularly known as "an eye for color," she will be able to make a home interior enjoyable to her friends and good to live with. But that is quite another thing from an interior containing treasures of art in every line of human capacity, so disposed of as to

make a perfect mosaic of excellence; or even from an interior in which there are a few such things, and which must be on a plane of superiority with a successful effort of the architect.

Every man who builds a house wishes to employ the best architect within his reach or means – the man who knows the most of his art, and knows how best to adapt it to the particular problem presented to him. If it is a grand house, or a small domestic nest, the cleverest architect will make the clearest distinction in his treat-ment of these two widely different requirements, and he will do it because he is the cleverest man. So the decorator, who follows him in his work, should know how to adapt his treatment to the same conditions.

Now, truth compels me to confess that the man decorator – if he is not a mere man of trade, as many of them, alas! are – will follow the purpose of the archi-tect more understandingly or conscientiously than the woman. Perhaps this is because he is more widely educated, and is less interested in and impressed by individual things; he has less enthusiasm for objects, he feels them less strongly. This latter fact, which should result in an immense advantage to the woman, is an absolute disadvantage until she has learned to generalize and not to particularize; and practical generalization comes from knowledge and training – from power to subordinate things to effects.

There is no doubt that interior decoration is a true field for the woman artist, but it requires the gifts of the artist as well as those of the woman, and it requires much special training.

The apparently instinctive knowledge which women have of textiles, and which men have hot; the intimate knowledge of the conveniences of domestic life – con-veniences which may also be used as factors in a scheme of beauty – are great advantages to women who make this choice of a profession. The difficulty is that it is chosen by many who have not the remotest idea of its ultimate requirements, and who fancy that a little gilding here and there, and a little touch of harmonizing color in curtains and carpets, make up the whole duty and business of the decora-tor; when, in fact, the real decorator should be competent to compare and apply all the interior ornament of the house, to draw the detail of frieze or cornice or ceiling, to design chandeliers and fixtures, to select and direct the metal-work required for chimney-places, the hardware of locks and keys and doors, and the thousand and one details of a house after the work of the architect is completed and it stands in effect a finished building. And when these details are complete, there is the question of color and appropriate decoration for ceilings and walls – for treatment which will distinguish each room and commend it to its own proper use, giving dignity to halls and drawing-rooms, ease and cheerfulness to the family rooms, and the suggestive-ness of their several uses to the dining-room and library.

Some of the furniture may have to be designed, and all must be selected to suit the styles or periods indicated by the architect in the fashion of the house as well as the pecuniary ideas of the house-owners.

It will be seen that here is a large demand for educated ability outside of the artistic feeling, which women are apt to consider the only necessary stock-in-trade

necessary for the interior decorator. It is not to be wondered at that this idea that natural good taste is the only necessary equipment of the decorator obtains so largely, because it is only very recently that the thorough decorative artist has made his appearance. Before that the paper-hanger and painter, the cabinet-maker, upholsterer, and the carpet salesman divided the honors between them, and made interiors not always or perhaps often to the satisfaction of the refined householder, but quite as good as could be expected without unity of purpose or guiding skill or knowledge.

Now, with the improved results of what are rightly called artistic manufactures, both in wall-papers and general house-furnishings, and with the general diffusion of art knowledge, and the instinctive color sense of Americans, many a house is made beautiful by the selection and choice of someone in the family who possesses in a high degree the feeling for harmony and subordination which makes the perfect home. This is what occurs in most homes of moderate cost where the family are characterized by general cultivation; but there are a large number of homes belonging to the "well-to-do" members of society who have none of this general cultivation, and are well aware of their own lack of it. They can appreciate what they see in other houses, but how the result is attained is and remains a profound mystery to them.

Here is the natural field of the woman decorator. The woman with cultivation and taste and an instinct for arrangement, even without special education, is entirely competent for this limited field. But why should she not be educated for wider work, since even this easy duty would be so much more easily and satisfactorily performed with wider and more comprehensive education? The larger always includes the less, and the woman whose knowledge is founded upon principles instead of small facts and experiments does her work far more safely and successfully.

But how to get this wider knowledge is the question; and here comes in a serious difficulty. There is a general want of serious preparation among women for professions of any kind, and this want of serious preparation is caused by sex – by the uncertainty of continuance in any work other than that of general manager of family interests. A girl may throw herself heartily into a profession for two or three years, but just as it is becoming something which requires energy, persistence, and determination, she has to choose between making – this difficult road in life, over which she may finally walk in ease and safety, or taking advantage of the safe and accustomed path of wife and mother in the companionship of someone who promises to share with her, and, as far as possible, to lighten, all of life's difficulties.

It is natural and well for her to choose this companionship. The question, as I see it, is not at all of renouncing this natural exercise of woman's ability, but of being thoroughly trained in some one direction, in addition to the natural capacity which every woman possesses for family direction and family life; of being prepared for life's vicissitudes, of thoroughly understanding a subject which, in all its ramifications and enlargements, may make the woman ten times more of a woman even in a purely domestic capacity.

But girls do not often look at the subject in this way. They do not realize the length of life's road, and that, although it may seem to be entirely fulfilled when one enters the gate of marriage, one-third of a woman's life is usually lived after her children are grown up and have taken their place in the world, and that the education and use of the early part of life determine the aspect of this latter third, decide whether it is to be interesting and useful in its relation to the world, dignified and honorable in its relation to the family, or wearisome and dependent to one's self, to the world, and to the family. A capable and growing woman, one who has had the seed of growth planted in her youth by thoughtful education, will find the "latter days" as full of enthusiasm and enjoyment as are the early ones.

We all recognize the detriment to development and character which the expectation of a fortune is to a young man, but we do not always recognize the fact that the confident expectation of marriage operates in the same way upon the development of character in a young girl; it discourages her proper preparation for any other place in life. But since special education and earnest study cannot unfit her for marriage, it seems to me a great misfortune to have it act so universally as it certainly does against the painstaking acquirement of a profession. This whole subject of professional education among women needs to be much more carefully and thoughtfully considered both by parents and young women themselves, since at present the attitude of the general mind toward it is one of uncertainty and doubt, and tends to make all professional study inoperative and incomplete.

But suppose this question is well settled in the mind of a girl, and she determines to adopt decoration as a profession and to prepare herself thoroughly for it, the next question is, How is she to acquire this thorough preparation? There is no course of decorative study in any of our colleges, as there is of architecture, and no school of art which carries this preparation further than the acquisition of different elements which must be afterward combined in a whole, and carried forward as a whole, if the student wishes to master the art in its entirety.

It is as if a boy who had chosen architecture as a profession could study only certain parts of his profession under competent teachers, could learn the different requirements of construction only by bits, and was obliged to bring them all together and calculate their effect upon each other by experiments, each one of which might exhibit a new and undoubted flaw, for want of the master-teaching which is really so happily within his reach. And yet this is the way in which at the present time a woman must study decoration.

# MRS OLIVER BELL BUNCE, 'MRS. KATE COLLINS, THE ARTIST DECORATOR' (1897)

## Editorial Headnote

Mrs Oliver Bell Bunce was the wife of the eponymous author. After his death in 1890, she published articles and recipes under the name Mrs Oliver Bell Bunce. In the early 1890s, *Good Housekeeping* magazine printed a series of articles by her on the proper maintaining of a household titled 'What to Do With my Lady's House'. She also published an etiquette manual titled *What to Do; a Companion to Don't*, in 1892.

*The Decorator and Furnisher* journal was a monthly magazine published in New York City from 1882 to 1897. It addressed all aspects of interior decoration. Bunce was an associate editor of the journal. Here she published a variety of articles including 'The Season's Draperies' (November 1894), 'The Decorative Don'ts' (May, 1896), 'Draperies for the Autumn' (October 1896) and 'Dainty Spring Furnishings', (February 1897) amongst a number of others on a wide range of topics related to art and interiors.

This text introduces Mrs Kate Collins, an artist-decorator, her clients and interestingly her showroom, which is described in some detail. There is also an emphasis on the design and making of souvenirs or 'favors' which were clearly a feature of the decoration of tables and spaces in the grand houses of the New York area.

Although little seems to be known about Kate Collins, she is representative of the new profession of 'lady decorator'. These women gradually transformed the decoration of the home from an unpaid amateur activity into a potential career path for women.[1] Women were employed as professional, independent interior decorators in England from the 1870s and similar approaches gradually developed in the USA. For example, in 1869 home economist Catharine Beecher had already published her ideas for a rational kitchen. Later, the education of young girls in domestic science or home economics developed these ideas in a more professional framework.

# 'MRS. KATE COLLINS THE ARTIST-DECORATOR'

*Mrs Oliver Bell Bunce*

Source: Mrs Oliver Bell Bunce. 'Mrs. Kate Collins the Artist-Decorator', *The Decorator and Furnisher*, 30: 4, 1897, pp. 102–4

The time was when the woman in business was an unusual thing, a marvel, and a wonder that she should so demean herself by entering an employment fitted only for men.

But for those souls who need the wherewithal, who depend solely on their own exertions to procure for themselves a livelihood the shop now has no terrors, and although it is a place where articles are made, where pretty fabrics are converted into accessories for rooms and the like, in many cases this same shop becomes a studio for the holding of artistic effects in the way of satins, silks and every other texture known as house decorations. This idea has been well carried out by Mrs. Kate Collins, the artist-decorator, a woman well known for her distinctive talent in clever ornamentation and a helper of social functions in the fashionable set.

Kate Collins when a little girl naturally had a decided taste for the putting together of certain materials in different colors, and so when completed, formed decorative place in the household. In fact, she came from an artistic family so that she only brought out as she grew to womanhood the ideas that had been born within her and when a line of business was absolutely necessary she put her clever perceptions to the test and went regularly into trade. At the outset she timidly made a calendar, a pretty affair which she submitted to a publisher, and so artistic was the design that he accepted at once the first attempt of this novice in decorative specialties, At that time the Yale boys gave their yearly dance, and of course to give it in first rate style a souvenir or memento was needed for their class. It was then that Mrs. Collins was pressed into service, and so capable was she in this direction that she became after some months the designer of favors[2] for the "smart set." Favors for the cotillons,[3] favors for the German, favors for luncheons and dinners, and a furnisher of trifles made in excellent taste and in the best manner, Everyone knows that the woman of fashion when in town is an up-to-date creature, especially when balls, receptions, parties and the like are on the tapis, That, when the season commences her first consideration is for the introducing at

DOI: 10.4324/9781003290490-63

her social functions some special favor, some artistic design which has not been thought of by any other woman in her set. A device which when created is hers alone and then banished forever. So a decorator is sought to aid in this plan, a woman full of artistic leanings like Mrs. Collins, who knows her business in every detail, so suggestions are made, and a line of ornamentation followed, that when finished is considered a genuine success.

Mrs. Collins has many patrons, among them are the Astors, Bradley Martins, and a host of fashionable folk, who are ladies well equipped in all directions, particularly in art matters, and are quite willing to pay for anything that is peculiarly unique and attractive.

At the Bradley Martin ball[4] this artist decorator had full charge of the souvenirs made for that social event. For one of the favors of the German, for the gentlemen whose costumes were so widely discussed there were walking sticks in shape like an alpine, over which was an excellent coating of gold paint, On the top was a figure in china of Sévres make of Louis the Fourteenth, in a costume of splendid tones most minutely copied in all its historical tints while some three or four inches below was a silken cord with tassels in a delicate light blue. For the queens of the occasion was an elaborate affair in which green satin and an abundance of gold formed the charming plan. Another was a tabard horn with a small banner decorated in a sort of heraldic effect made of Venetian red satin and trimmed with a fringe of gold bullion.

At a social function given by Mrs. John Jacob Astor there was designed by Mrs. Collins an immense sedan chair covered well with smilax and other tender greens, At each point was fastened innumerable bouquets of choice flowers. This magnificent decoration was brought in by the footman and deposited in the centre of the ball-room, and afterwards the flowers were distributed to each dancer. For another figure there were bannerettes made in superb effects of red and yellow satins on which were decorations that for finish and completeness could not be equalled.

When Miss Pauline Whitney became Mrs. Paget,[5] it was this clever artist who made the wedding cake boxes, exquisite and dainty affairs, on which were embroidered three wreaths gracefully combined, each one in different delicate colors, with raised work in gold which formed the outside decoration, and tied together by narrow white satin ribbon. On each side of the box was a conventional design in gold ornamentation and So finished in detail that they looked like a bit of rare faience of long ago. This clever woman has made pretty devices for evening entertainments in the shape of muffs made of crépe paper – also top hats, butterfly nets, and butterflies in all their gorgeous tints. Every conceivable plan is put forth by this untiring worker who is now acknowledged as one of the best decorators in this great city.

Mrs. Collins declares that the colors and shadings of brocade and satin are to her like beautiful music; that when she wishes an inspiration she collects about her some lace-satins, silks and the like and then waits till an idea takes possession of her, which she works out. Sometimes: whole day passes without a new device being conceived or a design formulated, but when that is accomplished, the task is an easy one. Besides doing work for leaders of society here she goes

ART FURNITURE DESIGNED AND MANUFACTURED BY
MRS. KATE COLLINS.

to Washington to make favors for the Chevy Chase, German Embassy, and Metropolitan Club.

As one ascends the stone steps to the Collins studio, which is on one of the great thoroughfares of this big town, the window, which is a broad one, claims your attention. It is a mass of beautiful articles for house decoration. At the farther end is a curtain, and nearby a chair in forest green on which rests a pillow of brilliant stripes. A little way on is a table and against it a bracket – one of the new kind which has only one small shelf for the placing of photographs. Beyond it are some silken stuffs, then a drapery, and a little further on a tulle of cream matting set off by a finishing of forest green. Over this a lace, and a number of accessories in cut glass, all in a harmony of delicate colors. From this is some four rooms, the largest being the workshop, where a number of employees are busily engaged in the embroidering of curtains, the designing of pillows, making of cushions, favors and small articles that make up a home and its atmosphere. The studio proper faces the street. It is square, with a wonderful array of objects. At one end is a couch, on which there are pillows for inspection, made in every conceivable shape, of every known material, and special ornamentation, of which Mrs. Collins's ideas were the happy thought. Odd pieces in furniture, a toilet dressing glass with chairs to

match, enameled and then painted in Dresden style. As a corner decoration there is a tall candlestick some four feet in height, in which is a candle of extra length, the whole well adorned in bold tones of rich flowery designs. Another piece well worthy of mention is a massive table elaborately carved, a splendid device of Mr. Frank Keeble, the decorative architect of the Collins studio. On this table rests a fiddle case in a highly-finished satin box, another artistic plan of this clever young Englishman. One can see special bookcases, quaint screens in burnt wood, and a host of materials scattered everywhere which could not fail to please any student who loves that great art – interior decoration.

Beyond this are two smaller rooms for the holding of finished draperies and special designs partly under way, half completed schemes which are aids to other artistic devices. Articles which have just arrived from the other side of the water, grotesque bits of Japanese ware which are to form a favor for a Newport dinner or aid in a luncheon somewhere else either in the East or West, In fact, Mrs. Collins asserts that in the production of any piece she hardly knows herself the beauty of the design until the work is nearly completed; that her desire is always to produce a harmony, and so she rather feels her way in the making of artistic effects. To her it is good deal like painting a picture. That to one plan delicacy should be given to another a broadness and strength. That each in its way should stand alone, making for itself a completeness in every detail. That the best materials should be used in the provision for all work however simple, and that colors should be carefully chosen and wisely selected.

Mrs. Collins each season designs novelties which are not found in the market, Of course the decoration and furnishing of rooms are her special forte, yet there are numberless bits of artistic additions which naturally grow out of a business like hers. This season it is the photograph rail or shelf, merely of different sizes made of pure white wood, remarkably simple in form, in some two or three artistic curves. This affair is undeniably plain when not ornamented.

But by the aid of a brush and a little water color there is a background given in the way of a pastoral scene – a horse racing or bit of flower garniture which makes this simple novelty a beautiful focus as a corner ornamentation. Others there are in a fine grain of mahogany, highly polished and bordered with a lighter wood, which has much the appearance of a fine marquetry. Pillows whose top covers represent the fruits of the season in all their natural colors. There are screens in leather, ornamented by burnt work. On the middle panel is an early French design of a peasant dressed in the time of 1730. On the other two, are strong conventional plans of a most artistic character. At one time a mantel covering was desired by a patron of wealth. It being needed for an old-fashioned marble shelf, a means had to be devised. From the ceiling on a brass pole was hung a red satin curtain, here and there cleverly outlined. For the shelf a board was covered with the same red tints, which had for a finishing touch a small brass pole, From this hung a deep curtain that reached to the floor, embroidered like the one over the shelf and trimmed with crescents which hung in graceful rows on each side. This affair caused much comment among people who saw it for the first time.

A CORNER OF MRS. COLLINS'S STUDIO.

Some weeks ago, a council was held, and a plan formed for the decorating of the fine yacht belonging to Mr. Percy Chubb.[6] With the usual taste of the Collins shop there were a number of materials gathered together and an arranging of decorations was commenced. In the main saloon was a floor covering of deep red velvet carpet, almost solid in color. On the walls was a cretonne whose background was a light cream, in which a delicate green leaf and large conventional flowers formed for this place a very attractive scheme. For the cushions there was a tapestry in wood colors, in which dark red leaves and a quaint design in pattern was the excellent plan. In this room there was a balancing table so well weighted that whichever way the ship turned it was always level.

In Mrs. Chubb's stateroom there was for the floor carpet of splendid warm blue in which there was only a blending of these tints. As a wall covering there were leaf effects in delicate green set off by a yellow narcissus. These lovely hues were on a background of charming blue, while the cushions were in a tone of very light old rose. This combination, as an artistic effect, was peculiarly suitable for a lady's stateroom. The guest cabin was in another blue, but darker in tones of bluish green, and here and there a branch of small yellow blossoms. The cushions for the chart room were in a pattern of pomegranates of very dark reds, blues, and splendid browns. A heavy material in silk and wool that would stand the sea air and the ocean spray.

There is one thing to be said about Mrs. Collins that the rooms she furnishes have at least a liveable atmosphere. They look as if they have been lived in, and are not places where a lot of artistic furniture has been set down and in which there is a great deal of show but very little comfort.

Mrs. Collins is a fine distinguished looking woman well built, with large dark expressive eyes, and a manner that is womanly in speech and agreeable.

When asked about her work she will tell you she is never satisfied with herself, that there is much to be acquired before one really knows the art of interior decoration. She believes that women are as good in lines of business as men. And above all they have one quality which ensures for them many successes and that is a steadfastness of purpose, which never fails when a necessity is to be made. This clever woman also asserts "that simplicity in form is one of the true laws in decoration. That all principles in colors should be treated like those given by the able artist who understands the mixing of tints and blending of hues."

## Notes

1 See also Mrs Bunce, "Virginia Brush, the Able Decorator" *The Decorator and Furnisher*, 28:6 September 1896), pp. 168–169.
2 Favors; a small gift given to the guests at a party as a gesture of thanks for their attendance, a memento of the occasion, or simply as an aid to frivolity.
3 Cotillon; a social dance.
4 On 10 February 1897, the Bradley Martins threw a famous costume ball at the Waldorf Hotel. 800 of New York's elite society spent about $400,000 imitating kings and queens.
5 Pauline Payne Whitney Paget (1874–1916), was an American heiress and a member of the prominent Whitney family. She married Englishman Almeric Hugh Paget (1861–1949) in 1895.
6 Percy Chubb (1860–1930), Australian-born senior member of Chubb & Son, marine underwriters and insurance brokers, was a famed sportsman and yachtsman.

# MARQUISE DE FONTENOY, 'A BEAUTIFUL WOMAN'S HOME' (1897)

## Editorial Headnote

Marquise de Fontenoy was the pseudonym for Marguerite Cunliffe-Owen (1859–1927), an English-born writer. She moved from France to the United States in 1885, where she and her husband began their writing careers. Frederick wrote newspaper editorials and society columns, while Marguerite published a series of biographies and novels as well as articles. She was particularly well-known for her writings on the machinations of the royal courts of Europe. Her major publication was *The Marquise de Fontenoy's Revelation of High Life Within Royal Palaces: The private life of emperors, kings, queens, princes, and princesses* (1892). Due to their supposed exposés of the activities of high society, these were published anonymously or under the *nom de plume*, La Marquise de Fontenoy.

The work this extract is taken from was called *Eve's Glossary*. It is a collection of sketches and articles which initially appeared in the press and were then published in book form. They mainly refer to the apparatus for a woman to maintain her beauty, but also to teach techniques of etiquette and acceptable social behaviour in general. Particular chapters are devoted to the dressing room, the hair, other body parts, the complexion, clothes and accessories as well as sections on servants and this chapter on the home.

# 50

# 'A BEAUTIFUL WOMAN'S HOME'

## Marquise de Fontenoy

Source: Marquise de Fontenoy, 'The Beautiful Woman's Home', in *Eve's glossary: [The Guide-Book of a 'Mondaine']* (Chicago: H. S. Stone. 1897), pp. 175–83

## A BEAUTIFUL WOMAN'S HOME

The question of the "nest" is fully as important to a truly elegant woman as is that of clothes and beautifiers; and when I say "nest," I do not mean merely the more personal boudoir or sleeping-room, but also every nook and corner of the house. It is from the way in which our entire home is arranged that people can judge not only the amount of taste which we possess, but our very innermost nature. A woman of refinement and delicacy will naturally – whatever her social position or her financial situation – surround herself with pleasing objects gracefully arranged and especially characterized by the most scrupulous cleanliness. Womanly influence should be felt in every detail, from the artistic draping of a curtain to the coloring of a pincushion, the grouping of cut flowers, or the folding of the dinner napkins. There are half a hundred small "nothings" easy to make or to procure, and very inexpensive, which yet wonderfully improve the homelike aspect of a household, and which are in themselves sufficient to denote the interest taken by the lady of the house in her *ménage*. It is not by any means always the wealthiest establishments that are the best furnished, and I have frequently seen comparatively humble dwellings which delighted every sense of comfort and every artistic inclination of the on-looker. I propose to give a few hints as to the manner in which the principal rooms of a moderately large house should be furnished and decorated, steering clear of too much luxury as also of too great parsimony. In France, women whose income is moderate use their bedroom during the day as a kind of *boudoir*; and this accounts for the well-known saying that a Parisienne's sleeping apartment is invariably more luxurious than an Englishwoman's drawing-room. But even when money is no object, and when the mistress of the house can afford to have an entire suite for her own personal use, including *boudoir*, dressing-room, bath, and separate library, yet her bedchamber ought always to be the best-feathered comer – if I may thus express myself – of her entire domain. Is it not, *par excellence*, the casket made to contain the pearl, – a peaceful, fragrant retreat wherein she is certain to retire undisturbed, and where

DOI: 10.4324/9781003290490-64

she can occasionally retire when tired or out of sorts, without fear of intrusion on the part of other members of the family?

Even the husband should not be allowed to treat his wife's sleeping apartment as if it were conquered territory, or to enter it unbidden, – alas! as is too often the case, with his hat on his head and perhaps a cigar in his mouth. It is oftener than one imagines just such a lack of decorum between husband and wife that creates or precipitates matrimonial dissensions. Among the poorer classes, where, for want of space, husband, wife, and children are forced to crowd together into one or two tiny rooms, like so many herrings in a tub, the famous proverb about familiarity breeding contempt, has fair play; and the result of this deplorable state of affairs is that love flies away through the cracked ceiling and leaves nothing behind but disgraceful squabbles and subsequent blows. Let us who have been blessed with the possibility of so doing, maintain a little poetry and delicacy in our conjugal relations by the observance of these many little courtesies and *politesses du coeur* which are the "small change" of good breeding. And now that I have moralized to my heart's content, let us proceed with our planning out of a comfortable and at the same time elegant bedroom.

## The Bedroom

I must begin by warning my fair readers against encumbering the walls, bed, windows, and doors with too many curtains, *portières*, etc. The craze for heavy and profuse plush draperies, and endless knickknacks of more than questionable taste, has died a natural death, and fashionable women now adopt a far more classical and simple style of decoration throughout their homes. For this let us praise the Fates, as such an abnormal quantity of drapery was a microbe-breeding death-trap, even when the utmost care and cleanliness were observed. Wool, plush, or velvet, should be strictly banished from the bedroom, not alone because these materials are too heavy in appearance, but also on account of the all-important question of germs, which they readily harbor. Smooth-faced linen or silken stuffs are far preferable, more pleasing to the eye, and should therefore be adopted in preference to any others.

Here is the description of a typical bedroom, that of young French duchess, which is a marvel of dainty luxury. It is octagonal in shape, and contains three windows. Walls and ceilings are covered with a highly-glazed silk of a pearly shot hue, varying from pale-pink to delicate willow-green. Curtains of the same material, lined with pale sea-shell pink taffetas, hang down in straight folds on each side of the windows and doors. The gondola-shaped bed, the lounges, armchairs, and chairs are of dull ebony wood inlaid with mother-of-pearl and upholstered in the pink and green shot silk; and in one corner – the duchess is devoted to music – stands an old spinnet of the fifteenth century inlaid by Martin Pacher of Brauneck.[1] A pale-green Smyrna carpet, powdered with a design of pink and lilac sea-anemones, covers the floor, and point d'Alençon[2] blinds lined with pink taffetas tone down the glaring daylight. The high mantelpiece is of superbly carved

black marble surmounted by a Venetian mirror which reflects the nodding blossoms of an onyx, silver-mounted *jardinière* filled daily with pale-green and pale-pink odorless orchids. Of course, such a bedroom can only be enjoyed by a very wealthy woman, but still the idea might be carried out to suit a far lighter purse than that of the *Petite Duchesse*, as she is called in Paris. There is a material called linen taffeta, or *toile de Jouy*, obtainable at any first-class dry-goods store in beautiful colors and designs, which might be used instead of silk. The furniture would be very pretty if made of Indian bamboo, light oak, or pitchpin,[3] upholstered in the same material, and the mantelpiece in this case would look well if it were in corresponding wood surmounted by a plain crystal square *jardinière* containing small ferns and pink cyclamens.

It is impossible to deny that even the most luxuriously appointed European or American houses are never one-half as comfortable to live in as are the homes of Oriental people of high degree. It is impossible to conceive anything more barbarous than the ordinary dining-room chairs, which are usually the most uncomfortable in the entire establishment. A moment's thought will suffice for anybody to realize how unfeasible it is to appreciate the merits of culinary *chefs d' oeuvre* if seated on an uncomfortable chair; for instance, one of those abominations with straight, high, narrow backs and equally narrow and hard ledges. Strange as it may appear, I must confess that I prefer the Oriental method of dining in a recumbent position with my legs on a level with the remainder of my body. The position of the body when seated in a chair is neither natural nor healthy, and is bound to cause the blood to concentrate itself in the lower portion of the legs and to send it coursing to the head by way of restoring normal circulation. No better illustration of the evil effect of a sitting position at meals can be found than in the prevalence of gout among those noted for sitting the longest over their dinner; namely, the English. A lady to whom I was propounding these theories a few days ago put forward the objection that recumbent attitudes, although possible when arrayed in Oriental garb, were rendered exceedingly difficult by the exigencies – may I add the exiguity – of the dress imposed upon the women of the world by the famous couturiers of Paris. In this she was mistaken, for most of the wealthy Levantines and a great many harem women of high rank obtain all their gowns from Paris nowadays, and their dresses invariably represent *le dernier cri de la mode*. And yet they never seem to prevent their wearers from lounging on huge divans with their feet not on the floor, but on the cushions beside them, in attitudes that constitute the quintessence of graceful ease and repose. As an illustration thereof, I would cite Her Excellency Madame Nubar Pacha, the Armenian wife of the most famous Oriental statesman of the age. She is no longer young, and she is not beautiful, but she is wonderfully graceful and stately. Graceful in her very movement, she is delightfully so when seated on a broad, low divan smoking a *papillette*, with her feet on the cushion at her side. I am at a loss to describe just how she manages to curl herself up in this peculiar yet charming manner. I can only describe the result, which is eminently pretty, and conveys the impression of the most perfect ease and comfort.[4]

407

The philosophy of chairs is a science that has not yet, so far as I can see, been explored to any extent in America. Hardly anywhere does one meet with a very low, very deep, very broad, and delightfully soft armchair with the back sloping just enough to rest every portion of the body when reclining in it. Chairs such as this are to be found in every well-equipped English or French household, and contribute materially to the maintenance of the equanimity and imperturbability of our temper. It is simply impossible to retain any vestige of ill-humor when the seated, and the most wooden-jointed and awkward of individuals will unconsciously lapse into a pose of graceful ease when ensconced in one of these exquisitely comfortable armchairs

## The Boudoir

A pretty French marquise, who reigns over one of the best regulated households in Paris, has caused her boudoir to be in furnished entirely à *l'orientale*. The walls are painted a deep soft crimson, and a covered from floor to ceiling with superb latticed *Moucharahib*[5] woodwork. All round the room runs a broad low divan, upholstered in heavy Persian silk cashmere thickly embroidered with tender hued silks, gold and silver threads, and strands of burnished red copper. This divan is littered by big and small square cushions filled with the softest down, encased in embroidery, lace, silk, foulard, Turkish gauze, etc. The three windows of this poetical retreat open upon a balcony, which has been transformed by screens and colonnades of fretted cedar-wood into a perfect semblance of a Cairene-harem *patio*, seen through the wrong end of an opera-glass as it is only eighteen feet long by ten broad. Great brass perfume-burners and hanging mosque lamps add to the far-eastern illusion produced by this *tout ensemble*; and the finishing touches are given by silken hangings, low inlaid stools, and carved cabinets of sandal and lime wood, glittering with mother-of-pearl and turquoises, – rare bits of furniture, for which the marquise sent all the way to Cairo and Constantinople, that they should be absolutely genuine.

A *boudoir* being *par excellence* the unconventional corner of a house, the proprietress thereof can give full swing to her imagination regardless of hard and fast rules. I will therefore pass on to a description of a hall or ante-room *selon mon coeur*. This apartment, being the first which one enters in either house or flat, should be fully as carefully and prettily furnished as the others. But of course much depends on its size and shape. In the case of a large hall, especially when it opens on one of those double Dutch staircases which have of late years become so fashionable for both town and country residences, it should be very luxuriously furnished. The hall and staircase should be carpeted, let us say in dark blue or crimson velvet pile, and the arched recesses of the staircase filled in either with bronze caryatides, supporting on their head great Satsuma or bronze vases wherein are palms or flowering shrubs, or again with square boxes of Delft also containing plants. In the hall, between the two branches of the staircase, a bronze fountain with a miniature jet of water, falling in sparkling sprays on a bank of

aquatic plants, adds greatly to the beauty of the decoration. Along the walls, divans covered with dark blue or crimson sixteenth-century brocade, flecked with gold or silver, should be placed; while the middle of this beautiful antechamber should be occupied by a huge square table of carved dark-colored wood, whereon two gigantic dishes of rare china and a Venetian vase for cut flowers stand. For a small and unostentatious hall, the walls should be covered with some dark cloth bordered with wooden *baguettes* the furniture consisting of an oblong table, an umbrella and hat stand surmounted by a mirror, a couple of high-backed chairs, and a *jardinière* supporting a few green plants, whilst the carpet is in corresponding colors to that of the wall drapery, curtains, and *portieres*. A brass lantern should hang from the ceiling, and if desirable, a few trophies of arms can brighten the walls. Of the library, writing-rooms, studios, etc., I will say nothing, for these apartments must be left entirely to the individual taste of the master and mistress of the house. It would be impossible for me to lay down the law in so far as they are concerned. The dressing-room and bath-room I have described in the opening chapters, and I am now at liberty to sketch the two *pièces de résistance* of house or flat; namely, the drawing- and dining-rooms.

## The Drawing-Room

Like the bedroom, the drawing-room must at a glance reveal the taste and refinement possessed by the mistress of the house. There are very few really well-understood and daintily furnished drawing-rooms, for even when a great deal of money has been expended on furniture, – nay, even on art treasures, – most of them are wont to betray the vulgarity which is the besetting sin of our age. Thirty years ago, the most punctilious of *mondaines* was satisfied with a yellow, red, or blue drawing-room, where everything was of the same color and where the furniture was stiffly disposed around the walls in utter disregard of all artistic rules. To-day a really elegant drawing-room must give the impression of being half a museum and half a conservatory. It is filled with costly bric-a-brac brought from every part of the world, hung with priceless pictures, and decorated by upholsterers who are fully entitled to pose as artists. In this fad for curios lies, however, the snare for those unwary beings who, without possessing the means to gratify their longings, yet attempt to substitute for the genuine *objets d'art* for which they pine a lot of cheap and tawdry knickknacks and draperies bought mostly at some great dry-goods emporium, which, without deceiving anybody as to their actual value, create a most distressing impression of one's being ushered into a dentist's waiting-room or the parlor of some second-rate boarding-house. Moreover, it by no means suffices that a vase, a statue, or a cabinet should have come from India, China, Japan, or Egypt for these decorative pieces to have a real value; for one must still be sufficiently a connoisseur to distinguish the genuine article from the thousand and one bits of crockery, ivory, bronze, or wood which are manufactured by the gross in the far East for what is called there "the European market." I will classify in the same category the more or less spurious imitations of antique

furniture with which we have been deluged ever since the time when Louis XIV., Louis XV., and Louis XVI. styles, Breton sideboards, and Dutch credences came into fashion. Beautiful and refined as the models undoubtedly are, the copies are painfully undeceptive, for they exaggerate, so to speak, every defect of these different periods, and involuntarily remind one of stage furniture meant only to dazzle the eye without captivating the taste. It must not be forgotten that, in the days to which I have just referred, a workman, whether sculptor or cabinet-maker, thought nothing of devoting the efforts of many weary days, weeks, and even months to the production of one chair, one table, or one consol. Now everything is done by machine, wood is stamped with a given design and then sawn by steam-power, and anybody wishing to procure hand-made carvings must be ready to pay an absolutely exorbitant price for it, I am therefore of the opinion that, excepting when money is absolutely no object, a truly refined woman should confine her-self to such a class of furniture as can be bought from conscientious dealers who would scruple to palm off on their customers bogus antiquities or loud *meubles* of which they will become thoroughly weary after possessing them for six months.

A very tasteful and pretty arrangement for a drawing-room, when the lady of the house does not wish to spend a small fortune thereon, is to have the walls and ceiling draped with some of this delightful, soft-toned antique-looking cretonne which is easily obtainable at any first-class upholsterers. Let us, for instance, sup-pose that this cretonne is of a mellow ivory hue, the design in old rose, delineated by a clever hand with, a slim gold cord. Instead of the humdrum and ever com-monplace-looking gas chandelier, which vulgarizes the prettiest rooms, a pendant of Venetian glass representing clusters of morning-glories in pale-pink and blue, should hang from the centre of the ceiling, each pink flower containing a blue candle and vice-versa, Beware, above all things, of the stilted sofas and armchairs which most upholsterers take a fiendish delight in recommending to you, and order a couple of graceful lounges, three or four low armchairs, an ottoman, and some piles of cushions to be made for you. They can either be upholstered in the gold-delineated cretonne or be made of silk in harmonizing colors. In such a drawing-room I would not put a carpet on the floor, but conceal the latter under one of those exquisitely fine rice-straw Japanese mats painted with strange birds and exotic flowers. A table – for there must be a table – although this is rarely a graceful adjunct, should be of violet wood, lacquered bamboo, or, if the top notch of elegance is to be attained, of ebony, richly engraved and inlaid with mother-of-pearl, ivory, and copper. On the mantelpiece, in lieu of that abomina-tion of desolations, a clock and accompanying candelabra, a handsome statue of Florentine bronze or of terra-cotta, signed by some well-known master, should be placed, backed either by green palms and ferns or by vases of scrupulously fresh-cut flowers. If really good pictures seem too expensive, abstain from hang-ing any on your walls, and replace them by a few perfect etchings, or water-colors above reproach. If this description should appear too simple, I will add thereto a few words about the salon of a well-known Austrian great lady who is renowned throughout Europe for her exquisite and original taste. This salon is also draped,

ceiling and walls alike with soft, shimmering, willow-green silk embossed with silver unicorns. In the centre of the room stands a round ottoman, from the centre of which emerges a gigantic, flute-shaped vase of rock crystal filled summer and winter with superb long-stemmed cut flowers. The grand piano of *marqueterie* is partly concealed by an artistically draped altar-front of cloth of silver fastened here and there by authentic old miniatures rimmed with pearls, the high, white-marble mantelpiece being decorated in the same fashion and surmounted by a unique group of nymphs carved by Clodion,[6] which emerges from a mass of flowering plants. All the seats in this ideal room are low and inviting. The floor is covered by a marvellous faint-green Aubusson rug, whereon wreaths of Bengal roses and of apple-blossoms are scattered in a thoroughly unconventional design. At night light is afforded by several silver hanging lamps shaded by antique lace over almond-green silk.

## The Dining-Room

Let us now cast a look on the dining-room as it should be. I need not say that it must be thoroughly in keeping with the drawing-room as far as luxuriousness is concerned. Otherwise, your house would look like one of those walls painted to represent a gorgeous stone colonnade or some other pompous architectural design, but which are only intended to conceal the poverty of whatever lies behind them; and the visitor who, after having admired the beauty of your salon, would be suddenly ushered into a painfully contrasting dining-room, would form but a poor opinion of your breeding. To continue this simile, I may add that when every room in a house is not in keeping with one another, this is as much a fault of education, I would almost say principle, as if a woman donned an elaborate silk dress over some plain, cheap, and ill-cared-for underclothing, It must be borne in mind that a dining-room decoration should be as much as possible dark and magnificent rather than light and cheery, for in this instance the table being *the* object (rather like an altar where the daily sacrifices are offered), it is necessary that the surroundings of this nucleus should not intrench through too glaring an ornamentation upon its brilliancy. It goes without saying that hand-carved wainscotings and Gobelin tapestries are what suit a dining-room best; but as most people cannot afford to go in for such costly furnishings, I would suggest high oak, pear, or ebony wainscotings topped by panels of Spanish embossed leather and finished off with a dado of either dark crimson, royal blue, or Russian-green velvet furnished with a narrow wooden shelf, whereon is disposed a collection of old Delft, Satsuma, or Hungarian dishes, plaques, and platters. This will be quite sufficiently elaborate, especially if your sideboards boast a certain amount of plate. Naturally, the table, sideboards, and high-backed chairs must invariably be of the same wood as the wainscoting. Round tables have gone entirely out of fashion and have been completely superseded by square ones. I have seen in my day many a handsome dining-room, but I cannot remember any which could compare with the great dining-hall

in Prince Dondoukow-Korssakow's Castle of Polonaja, in Russia.[7] The prince was an old friend of mine, and many are the beautiful banquets which I have witnessed in this beautiful apartment panelled in oak and hung with Gobelin tapestries of inestimable value. So grandiose in fact was this hall that it was not used excepting on state occasions; and when we were only a small house party the meals were served in a much smaller room disposed like a winter-garden, where camellias and azaleas, orange trees and mimosa bushes, formed fragrant bowers of blossoms and verdure. At either end of this pretty *salle à manger* there was a fountain of pink marble with carved basins filled with blossoming water-lilies, among which goldfish swam, and the marble columns supporting the roof were garlanded with purple and white passion-flowers. The table was always set in Louis XVI fashion, the service of old Meissen china of a pale-pink hue, and Watteau figures of the same priceless ware upheld large shells containing flowers, fruit, and bonbons in superb profusion. This room, which was, however, in an entirely different style from the one which I advocated in the beginning of this chapter, formed, nevertheless, a truly charming picture, the table littered with Venetian glass and gold plate, the wines sparkling in their fantastically shaped Grecian ewers and Bohemian jugs, the pretty women with diamonds glittering on their white throats and in their hair, all grouped among the blossoming plants. In one word, everything looked like an eighteenth-century picture, and made one think of Versailles and Trianon. But this can only be considered in the light of a millionaire's fantasy, and can therefore not be used as a model for any of my readers excepting for the very wealthy ones whose circumstances permit them to satisfy their every caprice. Let me add that people even in the humblest of circumstances can render their dining-room both attractive and pleasant to inhabit by the use of a little judgment in its decoration and furnishing. For instance, what can be at the same time cheaper and prettier than a papering of plain Pompeian red, relieved by a four-foot wainscoting of equally plain cherry wood matching the table, chairs, and unostentatious sideboard? Curtains of red military cloth and a red ingrain rug on the floor will complete this "natty" *gout ensemble*, which can be enhanced by a few chastely framed engravings and a *jardinière* or two, filled with homelike ferns and plants.

A point on which I will be inexorable, however, is the table linen, which must always be of snowy whiteness and as dainty as if fairies alone had touched it. The wealthy are able to indulge in rare china and dazzling cut-glass, Baccarat or crystal; but it is within the reach of all housekeepers who take to heart the internal arrangements of their homes to afford neat, well-laundered, and prettily disposed tablecloths and napkins.

## Notes

1 See Nicolò Rasmo, *Martin Pacher* (tr. P. Waley), (Phaidon: New York, 1971).
2 This lace format has a mesh ground and incorporates pattern motifs with a raised outline of closely packed buttonhole stitches, an outer edge decorated with picots, and open areas with decorative fillings.

3  Pitch pine.
4  Helena Petrovna Blavatsky wrote that "Madame Nubar Pasha is an Armenian, a well-educated and well-read woman, speaking French like a Parisian, a real grande dame." *The Path,* Volume X, New York, July 1895, pp. 105–108.
5  A mashrabiya is a projecting second-storey window or balcony enclosed with latticework.
6  Claude Michel (1738–1814), known as Clodion, was a French sculptor who worked in the Rococo style.
7  *The Aberystwyth Observer* 6 April 1893 p. 3, wrote: "An interesting account of the country seat of Prince Dondoukow-Koresakow, in the Pskowsk Government of Russia, is given in the *New York Tribune*. . . . Almost awe-inspiring are the great sombre courts and porticoes and the long galleries and halls, the antique walls of which are covered with Byzantine paintings like those of a church, while the exquisite salons are filled with costly modern bric-a-brac, artistic furniture, superb pictures, flowers and palms, These salons the late Princess planned herself, and she caused them to be decorated by a celebrated French artist",

# CHARLOTTE PERKINS GILMAN, *THE HOME, ITS WORK AND INFLUENCE* (1904)

## Editorial Headnote

An American author, feminist and social reformer, Charlotte Perkins Gilman (1860–1935) was born in Hartford, Connecticut, and raised in straitened circumstances by her single mother, Mary Perkins. Her family's struggles shaped Charlotte's views and engendered her lifetime interests of writing and crusading. Gilman was a forerunner of the American feminist movement and an early advocate for women's suffrage, divorce, and euthanasia. Her most well-known publication is *The Yellow Wallpaper* (1890) which describes the descent of a woman's mental health while she is taking a prescribed "rest cure" on a rented summer country estate with her family. Her obsession with the yellow wallpaper in her bedroom symbolises her deterioration into psychosis deriving from her depression.

Gilman began a course at the Rhode Island School of Design in 1878, and then found employment as an art teacher and illustrator. Her book *The Home: Its Work and Influence* is a work that examined the role of the home as an institution in society, that was of major importance to women and their role in life. Her feminist approach meant that she saw the home as not only a place of refuge and comfort for the family but also a space for individuals, especially women, to be productive. She also argued that this was an ideal that her contemporary society had fallen short on. The book explores a range of topics including domesticity, cooking, entertainment, and child rearing thus identifying the gendered roles that males and females undertake. Her important message was that a well-run and managed home would benefit not only the occupants but also be a beneficial influence on wider society. She argued that woman's role in the home and family was important but needed to balance that role against her creative and productive potential in other areas.

This particular chapter deals with the issue of beauty in the home that indicates Gilman's engagement with the issue of domestic aesthetics. She says, 'So long as the lives of our women are spent at home, their tastes limited by it, their abilities, ambitions, and desires limited by it, so long will the domestic influence lower art'. She concludes by saying that through education and opportunity, a 'larger womanhood, a civilised womanhood, specialised, broad-minded, working and caring for the public good *as well as the private*, will give us not only better homes, but homes more beautiful'.[1]

Gilman's view was that the monotonous labour with which women engaged in the home should be challenged in the cause of creating economic independence for women. This could then open up other forms of work which were more productive, socially useful and more fulfilling. She suggested that the whole concept

of home needed to be completely restructured, to engage with socialist rather than capitalist approaches. Although this section deals with art and taste, she also advocated increased efficiency, division of labour and socialization as methods towards her goals.

# 51

# THE HOME, ITS WORK AND INFLUENCE

## Charlotte Perkins Gilman

Source: Charlotte Perkins Gilman, *The Home, Its Work and Influence*
(London: William Heinemann, 1904), pp. 143–60

## VIII

### Domestic Art

One of the undying efforts of our lives, of the lives of half the world, is "to make home beautiful." We love beauty, we love home, we naturally wish to combine the two. The rich spare no expense, the æsthetic no care and pains, in this continuous attempt; and the "home" papers, or "home departments" in other papers, teem with instruction on the subject for the eager, but untutored many.

In varying fields of work there is a strong current of improvement, in household construction, furnishing, and decoration; and new employments continually appear wherein the more cultured few apply their talents to the selection and arrangement of "artistic interiors" ready-made for the purchaser. Whole magazines are devoted to this end, articles unnumbered, books not a few, and courses of lectures. People who know beauty and love it are trying to teach it to those who do not, trying to introduce it where it is so painfully needed – in the home.

Why does it not originate there? Why did the people who cared most for beauty and art, the Greeks, care so little for the home? And why do the people who care most for the home – our Anglo-Saxons – care so little for beauty and art? And, in such art-knowledge and art-growth as we have, why is it least manifested at home? What is there in home-life, as we know it, which proves inimical to the development of true beauty? If there is some condition in home life which is inimical to art, is that condition essential and permanent, or may it be removed without loss to what is essential and permanent?

Here are questions serious and practical; practical because beauty is an element of highest use as well as joy. Our love of it lies deep, and rests on truest instinct; the child feels it passionately; the savage feels it, we all feel it, but few understand it; and whether we understand it or not we long for it in vain. We often make our

DOI: 10.4324/9781003290490-65

churches beautiful, our libraries and museums, but our domestic efforts are not crowned with the same relative success.

The reasons for this innate lack of beauty in the home are not far to seek. The laws of applied beauty reach deep, spread wide, and are inexorable: Truth; first, last, and always – no falsehood, imitation, or pretence: Simplicity; no devious meandering, but the direct clear purpose and result: Unity, Harmony, that unerring law of relation which keeps the past true to the whole – never too much here or there – all balanced and at rest: Restraint; no riotous excess, no rush from inadequacy to profusion.

If the student of art rightly apprehends these laws, his whole life is richer and sounder as well as his art. If the art he studies is one under definite laws of construction, he has to learn them, too; as in architecture, where the laws of mechanics operate with those of æsthetics, and there is no beauty if the mechanical laws are defied.

Architecture is the most prominent form of domestic art. Why is not domestic architecture as good as public architecture? If the home is a temple, why should not our hills be dotted with fair shrines worthy of worship?

We may talk as we will of "the domestic shrine," but the architect does not find the kitchen stove an inspiring altar. If it did inspire him, if he began to develop the idea of a kitchen – a temple to Hygeia and Epicurus, a great central altar for the libations and sacrifices, with all appropriate accessories for the contributory labour of the place – he could not make a pocket-edition of this temple, and stick it on to every house in forced connection with the other domestic necessities.

The eating-room then confronts him, a totally different *motif*. We do not wish to eat in the kitchen. We do not wish to see, smell, hear, or think of the kitchen while we eat. So the domestic architect is under the necessity of separating as far as possible these discordant purposes, while obliged still to confine them to the same walls and roof.

Then come the bedrooms. We do not wish to sleep in the kitchen – or in the dining-room. Nothing is further from our ideals than to confound the sheets with the tablecloths, the bed with the stove, the dressing table with the sink. So again the architect, whose kitchen-tendency was so rudely checked by the dining-room tendency, is brought up standing by the bedroom tendency, its demand for absolute detachment and remoteness, and the necessity for keeping its structural limits within those same walls and roof.

Then follows the reception-room tendency – we do not wish to receive our visitors in the kitchen – or the bedroom – or exclusively in the dining-room. So the parlour theme is developed as far as may be, connected with the dining-room, and disconnected as far as possible from all the other life-themes going on under that roof.

When we add to these the limits of space, especially in our cities, the limits of money, so almost universal, and the limits of personal taste, we may have clearly before us the reasons why domestic architecture does not thrill the soul with its beauty.

418

Whenever it does, to any extent, the reason is as clear. The feudal castle was beautiful because it had one predominant idea – defence; and was a stone monument to that idea. Here you could have truth, and did have it. Defence was imperative, absolute; every other need was subsidiary; a fine type of castle could give room for unity, simplicity, harmony, and restraint; and stirs us yet to delighted admiration. But it was not a comfortable dwelling-house.

A cottage is also capable of giving the sense of beauty; especially an old thatch-roofed cottage; mossy, mouldy, leaky, damp. The cottage is an undifferentiated home; it is primarily a kitchen – with a bedroom or two added – or included! Small primitive houses, like the white, square, flat-roofed dwellings of Algiers, group beautifully, or, taken singly, give a good bit of white against blue fire, behind green foliage.

But as a theme in itself, a thing to study and make pictures of, the castle, the temple of war, is the most beautiful type of dwelling place – and the least inhabitable. In our really comfortable homes we have lost beauty, though we have gained in comfort. Would it be possible to have comfort and beauty too; beauty which would thrill and exalt us, delight and satisfy us, and which the art critic would dwell upon as he now does on temple, hall, and church?

Let us here take up the other domestic arts; surrendering architecture as apparently hopeless. We cannot expect our composers in wood and stone to take a number of absolutely contradictory themes and produce an effect of truth, unity, harmony, simplicity, and restraint; but may we not furnish and decorate our homes beautifully? Perhaps we might; but do we? What do we know, what do we care, for the elementary laws which make this thing beautiful, that thing ugly, and the same things vary as they are combined with others!

In the furnishing and decoration of a home we have room for more harmony than in the exterior because each room may be treated separately according to its especial purpose, and we can accustom ourselves to the æsthetic jar of stepping from one to another, or even bring them all under some main scheme.

But here we are confronted by the enormous unrestricted weight of the limitation which is felt least by the architect – personal taste. We do not dictate much to our builders, most of us; but we do dictate as to the inside of the house and all that is in it. The dominating influence in home decoration is of course the woman. She is the final arbiter of the textures, colours, proportions, sizes, shapes, and relations of human production. How does she effect our output? What is her influence upon art – the applied art that is found, or should be found, in everything we make and use?

We may buy, if we can afford it, specimens of art, pictorial or sculptural art, or any other, and place them in our houses; but the mere accumulation of beautiful objects is not decoration; often quite the contrary. There are many beautiful vases in the shop where you bought yours; there is but one in the Japanese room – and there is beauty.

The magpie instinct of the collector has no part in a genuine sense of beauty. An ostentatious exhibit of one's valuable possessions does not show the sense of

beauty. A beautiful chamber is neither show-room nor museum. That personal "taste" in itself is no guide to beauty needs but little proof. The "taste" of the Flathead Indian, of the tattooed Islander, of all the grades of physical deformity which mankind has admired, is sufficient to show that a personal preference is no ground for judgment in beauty.

Beauty has laws, and an appreciation of them is not possessed equally by all. The more primitive and ignorant a race, or class, the less it knows of true beauty.

The Indian basket-makers wove beautiful things, but they did not know it; give them the cheap and ugly productions of our greedy "market" and they like them better. They may unconsciously produce beauty, but they do not consciously select it.

Our women are far removed from the primitive simplicity that produces unconscious beauty; and they are also far removed from that broad culture and wide view of life which can intellectually grasp it. They have neither the natural instinct nor the acquired knowledge of beauty; but they do have, in million-fold accumulation, a "personal taste." The life of the woman in the home is absolutely confined to personal details. Her field of study and of work is not calculated to develop large judgment, but is calculated to develop intense feeling; and feeling on a comparatively low plane. She is forced continually to contemplate and minister to the last details of the physical wants of humanity in ceaseless daily repetition. Whatever tendency to develop artistic feeling and judgment she might have in one line of her work, is ruthlessly contradicted by the next, and the next; and her range of expression in each line is too small to allow of any satisfying growth.

The very rich woman who can purchase others' things and others' judgment, or the exceptional woman who does work and study in some one line, may show development in the sense of beauty; but it is not produced at home. The love of it is there, the desire for it, most cruelly aborted; and the result of that starved beauty-sense is what we see in our familiar rooms.

Being familiar, we bear with our surroundings; perhaps even love them; when we go into each other's homes we do not think their things to be beautiful; we think ours are because we are used to them; we have no appreciation of an object in its relation to the rest, or its lack of relation.

The bottled discord of the woman's daily occupations if quite sufficient to account for the explosions of discord on her walls and floors. She continually has to do utterly inharmonious things; she lives in incessant effort to perform all at once and in the same place the most irreconcilable processes.

She has to adjust, disadjust, and readjust her mental focus a thousand times a day; not only to things, but to actions; not only to actions, but to persons; and so, to live at all, she must develop a kind of mind that does *not object to discord*. Unity, harmony, simplicity, truth, restraint – these are not applicable in a patchwork life, however hallowed by high devotion and tender love. This is why domestic art is so low – so indistinguishable.

When our great Centennial Exhibition[2] was given us, a wave of beauty spread into thousands of homes, but it did not originate there. The White City by the lake[3]

was an inspiration to myriad lives, and wrought a lovely change in her architecture and many other arts; but the Black City by the Lake is there yet, waiting for another extra-domestic uplifting.

The currents of home-life are so many, so diverse, so contradictory, that they are only maintained by using the woman as a sort of universal solvent; and this position of holding many diverse elements in solution is not compatible with the orderly crystallisation of any of them, or with much peace of mind to the unhappy solvent.

The most conspicuous field for the display of the beauty sense – or the lack of it – in our home life, is in textile fabrics and their application to the body. The House is the foundation of textile art. People who live out of doors wear hides if they wear anything. In the shelter and peace of the house, developed by ever-widening commerce, grew these wonderful textile arts, the evolution of a new plane for beauty. We find in nature nothing approaching it, save in the limited and passing form of spreading leaf and petal. To make a continuous substance soft as flowers, warm as furs, brilliant as the sunset – this was a great step in art.

Woven beauty is a home product, and in the house we are most free to use and admire it. The "street dress," even the most unsophisticated, is under some restrictions; but the house dress may be anything we please. There is nothing in the mechanical limitations of house life to pervert or check this form of loveliness. We are free to make and to use the most exquisite materials, to wear the most pleasing of textures and shapes.

Why, then, do we find in this line of development such hideously inartistic things? Because the discords of domestic industries and functions prevent a sense of harmony even here. Because the woman, confined to a primitive, a savage plane of occupation, continues to manifest an equally savage plane of æsthetic taste.

One of the most marked features of early savage decoration is in its distortion and mutilation of the body to meet arbitrary standards of supposed beauty. An idea of beauty, true or false, is apprehended, its line of special evolution rapidly followed, and there is no knowledge of physiology or grasp of larger harmonies of bodily grace to check the ensuing mutilation.

The Zulus decorate their cattle by cutting the dewlap into fringe, and splitting and twisting the growing horns into fantastic shapes. Some savage women tie the gastrocnemius muscle tightly above and below, till the "calf of the leg" looks like a Dutch cheese on a broomstick. Some tie strings about the breasts till they dangle half detached; some file the teeth or pluck out the eyebrows.

In the home, among women, still appear these manifestations of a crude beauty-sense, unchecked by larger knowledge. Our best existent examples are in the Chinese foot-binding custom, and ours of waist-binding. The initial idea of the corset is in a way artistic. We perceive that the feminine form has certain curves and proportions, tending thus and so; and following the tendency we proceed to exaggerate those curves and proportions and fix them arbitrarily. This is the same law by which we conventionalise a flower for decorative purposes, turning the lily of

the field into the *fleur-de-lis* of the tapestry. The Egyptians did it, to an extreme degree, in their pictorial art, reducing the human body to certain fixed proportions and attitudes.

The application of these principles to living bodies is peculiar to the savage, and its persistence among our women is perhaps the strongest proof of the primitive nature of the home. As women enter the larger life of the world these limitations are easily outgrown; the working-woman cannot make a conventionalised ornament of her body, and the businesswoman does not care to; the really educated woman knows better, and the woman artist would be bitterly ashamed of such an offence against nature; only the home-bound woman peacefully maintains it.

To the scientific student, man or woman, the sturdy reappearance of this very early custom is intensely interesting; he sees in the "newest fashion" of holding and binding the body a peculiar survival of the very oldest fashion in personal decoration known to us. The latest corset advertisement ranks ethnologically with the earliest Egyptian hieroglyph, the Aztec inscriptions, and races far behind them.

The woman's love of beauty finds its freest expression along lines of personal decorations, and there, as in the decoration of the house, we see the same crippling influence.

She loves beautiful textures, velvet, satin, and silk, soft muslin and sheer lawn; she loves the delicate fantasy of lace, the alluring richness of fur; she loves the colour and sparkle of gems, the splendour of burnished metal, and, in her savage crudity of taste, she slaps together any and every combination of these things and wears them happily.

A typical extreme of this ingenuous lack of artistic principles is the recent, and still present, enormity of trimming lace with fur. This combines the acme of all highly wrought refinement of texture and exquisite delicacy of design, a fabric that suggests the subtleties of artistic expression with a gossamer tenuity of grace; this, and dressed hide with the hair still on, the very first cover for man's nakedness, the symbol of savage luxury and grandeur, of raw barbaric wealth, which suggests warmth, ample satisfying warmth and crude splendour in its thick profusion! We cut up the warmth and amplitude into threads and scraps which can only suggest the gleanings of a tan-yard rag-picker, and use these shabby fragments to *trim lace*! Trim what is in itself the sublimated essence of trimming, with the leavings of the earliest of raw materials! Only the soul which spends its life in a group of chambers connected merely by mechanical force; in a group of industries connected merely by iron tradition, could bear a combination like that – to say nothing of enjoying it. Domestic art is almost a contradiction in terms.

The development of art, like the development of industry, requires the specialisation, the life-long devotion, impossible to the arbitrary combinations of home life. Where you find great beauty you find a great civic sense, most clearly in that high-water mark of human progress in this direction, ancient Greece. Within the limits of their cities, the Greeks were more fully "civilised" than any people before or since. They thought, felt, and acted in this large social contact; and so developed a sufficient breadth of view, a wide, sweet sanity of mind, which allowed of

this free growth of the art-sense. Great art is always public, and appears only in periods of high social development. The one great art of the dark ages – religious architecture – flourished in that universal atmosphere of "Christendom," the one social plane on which all met.

The Greeks were unified in many ways; and their highly socialised minds gave room for a more general development of art, as well as many other social faculties.

Household decoration was not conspicuous, nor elaborate attire; and while their women were necessarily beautiful as the daughters of such men, it was the men whose beauty was most admired and immortalised. The women stayed at home, as now, but the home did not absorb men, too, as it does now. When art caters to private tastes, to domestic tastes, to the wholly private and domestic tastes of women, art goes down.

The Home was the birthplace of Art, as of so many other human faculties, but is no sufficing area for it. So long as the lives of our women are spent at home, their tastes limited by it, their abilities, ambitions, and desires limited by it, so long will the domestic influence lower art.

"So much the worse for art!" will stoutly cry the defenders of the home; and they would be right if we could have but one. We can have both.

A larger womanhood, a civilised womanhood, specialised, broad-minded, working and caring for the public good *as well as the private*, will give us not only better homes, but homes more beautiful. The child will be cradled in an atmosphere of harmonious loveliness, and its influence will be felt in all life. This is no trifle of an artificially cultivated æsthetic taste; it is one of nature's deepest laws. "Art" may vary and suffer in different stages of our growth, but the laws of beauty remain the same; and a race reared under those laws will be the nobler.

These more developed women will outgrow the magpie taste that hoards all manner of gay baubles; the monkey-taste that imitates whatever it sees; the savage taste that distorts the human body; they will recognise in that body one infinitely noble expression of beauty, and refuse to dishonour it with ugliness.

They will learn to care for proportion as well as plumpness, for health as well as complexion, for strength and activity as essentials to living loveliness, and to see that no dress can be beautiful which in any way contradicts the body it should but serve and glorify. We do not know, because we have not seen, the difference to our lives which will be made by this large sense of beauty in the woman – in the home; but we may be assured that, while she stays continually there, we shall have but our present stage of domestic art.

## Notes

1 Gilman, p. 60.
2 Worlds Colombian Exposition, Chicago, 1893.
3 The "White City," was the nickname for the fair's Neoclassical buildings that were planned as a cohesive whole in a landscaped setting.

# AVERIL SANDERSON FURNISS, DOROTHY SANDERSON AND MARION PHILLIPS. 'THE VIEWS OF THE WOMAN IN THE HOME', *THE WORKING WOMAN'S HOUSE* (1919)

## Editorial Headnote

The important post-war (1918) housing agenda was a major catalyst in developing housing 'fit for heroes' in Britain. Amongst those involved in the discussions were The Women's Labour League and the Women's Co-Operative Guild. These worked together to seek working-class women's opinions on matters related to post-war housing. Their credo was that 'unless the working woman's point of view is understood, no housing schemes can be really successful'.

In October 1917, the Women's Labour League formed a Women's Housing Sub Committee under the chairmanship of Mrs Sanderson-Furniss. Through its investigations and questionnaires the Committee had some effect on the well-known Tudor-Walters Report, although the emphases were different.

In 1919, Averil Sanderson Furniss and Marion Phillips published *The Working Woman's House*, being an illustrated booklet complete with plans and photographs. The two authors, Lady Averil Dorothy Sanderson Furniss (1873–1962) and Marion Phillips (1881–1932) were both members of the Labour Party and deeply involved in the debates around post-war housing. Furniss was an architect, while Phillips was a Member of Parliament.

The feminine perspective on housing matters addressed two opposing ideas about the nature of the home. These two ideas were (1) a woman's place was to create and manage the home and (2) a more recent masculine adoption of domestic spaces as 'fit for heroes to live in'. The authors argued that these two positions were not exclusive, and it was possible to provide good housing for heroes but at the same time release women from the drudgery of past housing problems and the associated gendered roles.

*The Bookman's* review highly commend the authors efforts:

> Large numbers [of houses] must be built as speedily as possible. Hence there is a splendid opportunity for discovering the best and most convenient type of house, and that desired by women who have to live in them and run them for their families. Inquiries have been conducted among working women as to what kind of house they really want, and what improvements will embody their long experience of house-running. The results of these inquiries are brought together and amplified in this most valuable little book, along with plans of houses meant to meet the requirements indicated, and many most useful hints and descriptions of labour-saving methods of construction and furnishing. At the present

moment many people are vitally and urgently interested in the whole question, and this book admirably sums up the most important elements and details therein.[1]

*The Architectural Review* was also supportive:

A handsome booklet issued by the Swarthmore Press gives the woman's view of housing under three heads. First, it deals with the internal arrangements; secondly, with the possibilities of co-operative house management; and thirdly, with the environment of the home, and hence with the need for considering the lay-out of towns and villages that is to say, the need for town planning, or, as some prefer to say, with town development.[2]

The chapters in the book include 'The Views of the Woman in the Home', 'The Inside of the House', 'Cooperative House Management', 'The Healthy Town' and 'The New Housing Act and Women's Needs'.

# 52

# 'THE VIEWS OF THE WOMAN IN THE HOME'

## Averil Furniss, Dorothy Sanderson and Marion Phillips

Source: Averil Furniss, Dorothy Sanderson and Marion Phillips. 'The Views of the Woman in the Home', *The Working Woman's House* (London: The Swarthmore Press Ltd. 1919), pp. 9–21

### THE WORKING WOMAN'S HOUSE

### Part I

#### *The Views of the Woman in the Home*

For many generations, and with special emphasis in the last fifty years, we have been told that woman's place is the home. If women are to accept this position, they must also claim a right to have that home built according to their own desires. The war gave rise to a new phrase when the Prime Minister[3] made his declaration that with the coming peace houses must be built fit for heroes to live in. In this book we propose to combine these two ideas. We admit frankly that for most women the home is the chief centre of activity, and we give here the woman's own view as to what that home should be like. She wants her house to be fit for a hero to live in, but she wants also to free herself from some of that continuous toil which is the result of the bad housing conditions of the past, and has prevented her from taking her full share of work as a citizen, wife and mother.

Though it has been so largely the concern of women to *keep* the house, the working woman has had very little to say in the past as to the *kind* of house that she should keep. When a well-to-do family build their own house, the architect consults, not only the husband, but also the wife. But the working woman, to whom it is so infinitely important to secure a comfortable and convenient home, has never been consulted at all. In the main, working-class housing has been in the hands of builders, and of jerry builders at that, who have considered cheapness as far more important than health or comfort. Even when housing has been a matter of municipal concern instead of private enterprise, no effort has been made to learn the opinion of working women before deciding upon the plans.

DOI: 10.4324/9781003290490-66

Two years ago the first step was taken to correct this mistake. Organised women of the Labour Party, encouraged by the political power which had just been placed in their hands by the grant of the Parliamentary franchise, decided to conduct an inquiry into the kind of house a working woman wants. Since that inquiry began, similar efforts have been made in other quarters to record women's opinions; of these the most notable was the formation of the Women's Advisory Committee of the Ministry of Reconstruction, which published two important reports on this subject. Both these reports drew a considerable share of their information from the Labour Party's inquiry, and one of the authors of this volume was included on the Committee. The various housing resolutions, which have from time to time been passed by conferences of working women of the Labour Party, have reiterated the demand that in all housing schemes the opinions of the women for whom the houses were being constructed should be taken. The inquiry itself has very much strengthened our opinion that, unless the working woman's point of view is understood, no housing schemes can be really successful. From direct personal experience a housewife knows, in a way that no other section of the community can know, the most pressing needs for the establishment of a healthy home life.

In this book we have embodied the chief results of this inquiry, setting forth the almost unanimous opinion of women with regard to the inside, the outside, and the general environment of our homes. We believe that these results show conclusively that working women in all parts of the country are not only interested in the question of housing, but that they have thought out very closely many of its chief problems. On all important questions opinion has been practically unanimous, and the unanimity has not been confined to urban or rural populations, but has included both. Townswomen and the women of the villages take very similar views; the essentials of a good house are the same for both, and the scope of our inquiry was sufficiently wide to include a substantial number in all parts of the country. The method pursued was a very simple one. A four-page leaflet was prepared, which gave in the following words the object of the inquiry:[4]

'Woman's chief task is to make a home. To do this well the house in which her family lives must be so constructed as to give opportunities for health, comfort, leisure, and social well-being. The house must be not merely a roof for shelter, but must be sufficiently well-planned, well-built, and well-furnished to make life pleasant and beautiful.

'The working woman spends most of her time in her home, and yet she has nothing to do with its planning. It is time that this state of things ended. After the war there will be urgent need of a million new houses, and as great a need for the re-modelling of those we have. The working woman with a home of her own will be a voter. *Let her first effort of citizenship be to improve this home.* She alone has the necessary knowledge and experience, and if she can do nothing, her case is hopeless. The Labour Party is giving an opportunity to working women all over the country to express their views, and the first step is to consider two questions:

1. What is wrong with your house now?
2. What sort of house do you want in the future?

'This is not the time for making the best of a bad job. Let us make up our minds exactly what we do want in an ideal house.

'In such a house there would be the healthiest and most convenient arrangements for cooking, bathing, and cleaning; there would be enough space and sufficient rooms to give healthy sleeping and living accommodation for all; the house would get the full benefit of sunshine and yet give protection from excessive cold and wet. But the home must not be just a place to live in; it must provide a centre for social life and for the reasonable use of leisure; and still more, it must be a good setting to the lives of those who inhabit it, and nourish the best qualities of their characters – in five words, it must be a *pleasure to live in it.*

'In these pages we have plans – an architect's plans – of an ideal house for a family of five or six. What we ask of women is that they shall consider whether it is a woman's ideal house as well. On page 14 a few questions are asked, but these are only a few of the points which will occur to every woman. What we ask of you who read this is that you should answer the questions and add further comments. Please send your answers to Mrs. Sanderson Furniss, Secretary of the Women's Housing Sub-Committee, Labour Party, 33 Eccleston Square, S.W.1, and please send them soon. We want to have the views of women and to bring them before all those authorities throughout the country who are concerned with the housing of the working people.

'Do not consider the question of rent. We must make up our minds as to the sort of house we want, and see if we can get it at the price we can pay: that is where the *building expert* comes in. Women ought to be the *housing* experts and consider what they want, and leave compromises on one side. Do not carry your flag too low. Is there any reason why all children should not have the best homes that the nation can provide?'

Some 50,000 copies of this leaflet were sold, and a very large number of replies received. The number of replies does not represent the number of women who contributed to their compilation, since most of them were filled in as a result of discussion at meetings of Women's Sections of the Labour Party, of Women's Co-operative Guilds, or at conferences, and not by individuals. Many hundreds of letters were received dealing with special points of importance, and the variety of the inquiry may be gauged by the following list of organisations which held special meetings or conferences:

Women's Labour League. Local Labour Parties. Women's Co-operative Guilds. Women Citizens' Associations. Adult Schools. Federations of Girls' Clubs. Women's Fellowships. Women's Municipal Party. Homeworkers' League. Infant Welfare Centres. Baptist Sunday School Union. W.E.A. Branches. London Theosophical Society. National Council of Women. Association of Teachers in Domestic Subjects. Garden Cities and Town-Planning Association. Girls' Clubs. Women's Institutes.

These meetings were all arranged at the request of the organisations by the Women's Housing Sub-Committee of the Labour Party, and they include twenty-four conferences and over forty meetings. In addition to these there were a very large number arranged locally without consultation with the Committee, and from these full accounts were received of the wishes of the women present Some of the areas covered will be seen from the following list of conferences and meetings,

almost all of which were convened by organisations of Labour women, and all of which were addressed by Mrs. Sanderson Furniss, who acted throughout as secretary of the Sub-Committee:

Conferences. – Central London, Barking and Ilford Fulham, Cardiff, Leicester, Newport, Finchley, Todmorden Hebden Bridge, Cleckheaton, Swindon, Abertilleiy, Machen Maescymmer, Tre-Thomas, Bargoed.

Meetings. – St. Pancras Women's Liberal Association North Kensington Health Association, Stockwell Green Women's Fellowship, Ilford Co-operative Society, Wood Green Adult School, Lewisham Hill Sisterhood, King' Cross School for Mothers, Camden Town Women's Fellow ship, Bayswater Women's Christian Association, Princes Club, Leytonstone Sunday School, Kelmscott Women' Education Association, Ascott Women's Education Association, Burford Women's Institute, Walthamstow Adult School.

Other members of the Party who took part in addressing meetings which were arranged by the Committee were Mrs. John Baker, Mrs. Lowe, Miss Heckford, Mrs Salter, and Mrs. Chettle, and a number of conference and other meetings were addressed by Dr. Marion Phillips.

The leaflet which formed the basis of discussion contained the following list of questions:

'1. What are the chief defects of your house?
'2. Which do you think is the most convenient place for the bath – upstairs or down, in kitchen or separate room?
'3. Do you want hot water laid on?
'4. Do you want a bath even if hot water is not laid on?
'5. Do you like a house with –

(a) One living room and a scullery-kitchen?
(b) A small kitchen and a scullery separate from it?

'6. Do you like the parlour and living room about the same size; or a large living room and a small parlour?
'7. Do you think it best to have most of the cooking done in the scullery with the use of gas or electricity, or do you prefer it to be done in the living room?
'8. What kind of flooring do you like in your scullery – tiles or other material?
'9. Do you like to have fittings for cooking by gas, electricity, or coal?
'10. Where do you think the larder should be?
'11. Do you like –

(a) A well-fitted wash-house, with all appliances, for several houses?
(b) A copper of your own in the scullery?
(c) A copper in an open shed outside?

'12. What rooms do you want cupboards in, and what kind of cupboards?
'13. What fittings or labour-saving appliances would you like to have?
'14. Do you like sash or casement windows?

'15. Do you want an outside shed for bicycles, prams, &c.?

'16. Do you prefer –

    (1)  A cottage?

    (2)  Cottage flats (one upstairs and one downstairs)?

    (3)  Tenement flats?

'17. Would you like a garden to yourself, or a big garden attached to several houses?

'18. Do you like a garden in front of the house?

The interest of the questions was greatly increased by the plans of two houses which were included in the leaflet and are reprinted here on pp. 16, 17. These gave a living form to the conception of a decent dwelling, and their details raised many fresh points for discussion

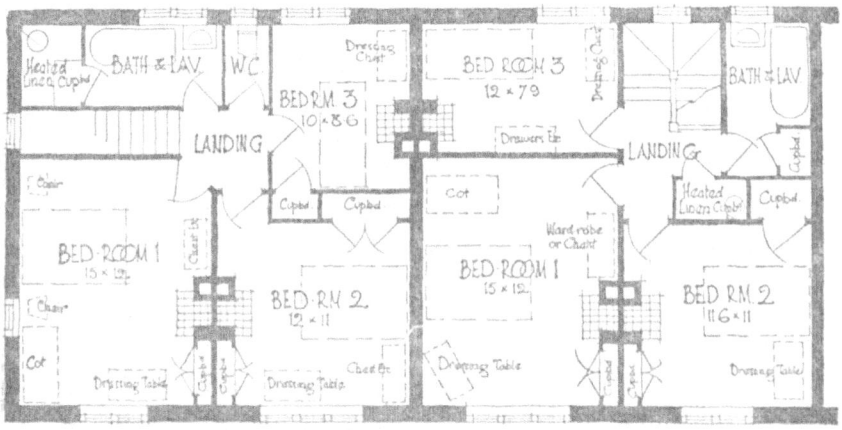

*Plan of First Floor of Two Houses.*

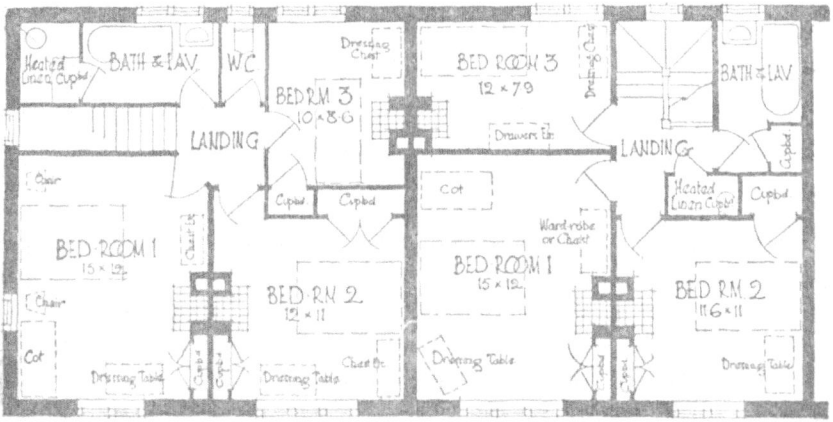

*Plan of First Floor of Two Houses.*

From talking of cupboards and sinks, the housewife turned to consideration of sunlight and gardens, streets and playgrounds, and from labour-saving devices within to the consideration of co-operative services outside. The general lay-out of urban and rural areas was dealt with, as well as the possibilities of co-operation in house management, in the pages of 'The Labour Woman'[5] from month to month, and the plans and articles published therein raised still further discussion amongst women members of the Party.

The importance of pleasant surroundings was recognised, and women declared that a house ought to welcome happiness by its exterior beauty as well as make provision for cleanliness and comfort inside. The design, by Miss Dorothy Hutton,[6] on the cover of this book shows how a six-roomed house may, by its simplicity and its air of sheltering comfort, give a feeling of home and rest which it is impossible to gain from the box-like cottages in long monotonous lines built straight upon the roadway which disfigure so many industrial areas.

We have endeavoured in this small volume to give attention to all the points which have been raised. Undoubtedly the first and most important is the question of the internal arrangements of the house, and women look at this from three points of view. First, there is the matter of health and decency. The house must be large enough to enable a woman to bring up her family properly, and attend to their reasonable requirements, both physical and moral. In this connection, the demand for a cottage, and not a flat, is very definite. A flat may be approved as convenient for old people or childless people, but never for a family with children. Secondly, there is the question of housework. The present demand for shortening the hours of labour is not only found in the workshop, the factory, and the mine; the woman in the home desires to see her work curtailed in order that she may preserve her health, widen her mental resources, and attain a higher standard of life herself. She therefore seeks to have a house in which she can reach a high level of cleanliness and comfort without working continuously at the drudgery which has been her common lot. In the third place, the home should make possible the social amenities of civilised life, and with that purpose in view, and not merely the need of providing a shelter for a family, it should be large enough to be a social centre as well. This is why her demand for a parlour is so definite, for if the home is to be the social centre of family life there must be the opportunities for the quiet which any sort of intellectual work necessitates, as well as a room for recreative purposes. Just as her desire for shortening the hours of work leads her to think of co-operative means of house management, so her desire to raise the social level makes her seek for a better general environment. For many women the chief task of life has been to gain a series of victories in the constant struggle against dirt. From day to day the working woman has fought a constant battle with the poorest weapons against this foe. She looks now for something better, and seeks in her home a fitting framework for the development of good citizenship, and aims at gaining for her children as well as herself an environment which will aid development of the best qualities of mind and body, instead of being a constant handicap, hampering and stunting both physical and intellectual growth.

As this inquiry has proceeded working women have been found more and more eager to take a share in solving housing problems. There has been no lack of discussion, especially in the case of meetings of self-governing working women's organisations, and amongst organised working women many active steps have been taken to secure that full consultation with them shall take place before the Local or Central Authorities decide upon the plans for new houses. There is an opportunity to-day which is unique in the country's history, since never before has there been so urgent a need of houses, and never the prospect of building in such large numbers for the benefit of the public and not of the private landlord. A scheme of housing carried out by public authorities assisted by public funds gives an enormous opportunity for the building of houses such as the working woman wants, and it is universally recognised that if the present housing famine is to be reduced little less than a million houses are required. Bad housing means constant ill-health, the occurrence of dangerous epidemics, a low level of morals, and a continuous waste of national force, and no one suffers from that loss so much as the woman whose work lies within the home. With this great opportunity before her the woman of to-day is eager to place before the community the demand she makes in the interests of the whole nation. The reconstruction of society must depend very largely upon the energy and wisdom with which the housing problem is met) and in putting forward the results of this inquiry the women of the Labour Party feel sure that they are contributing to the welfare, not only of the present, but of future generations.

The book falls naturally into three divisions, and of these the first is that which deals with the internal arrangements of the house. In treating this, we have given no: only our opinion as to future building, but our criticism of working-class housing of to-day. The next part deals with the possibilities of co-operative house management. Here there is very little experience to guide us, but there is a very wide field for experimental work. This is followed by a discussion on the environment of the home itself, and the need for considering the whole lay-out of towns and villages, and ending the haphazard scheme of building houses as closely together as possible, and neglecting to provide healthy and beautiful surroundings for the community. Finally, we have dealt with practical questions of administration, emphasising those matters in which we believe that women should specially concern themselves, and suggesting lines of development, so that their opinions may have full force in gaining practical results.

## Notes

1 *The Bookman,* 58, April 1920, p. 44.
2 *The Architectural Review,* 47, 282, 1920, p. 138.
3 David Lloyd George.
4 *The Working Woman s House.* Four-page Leaflet. To be obtained from the Labour Party. Price Id., or 1½d. postage paid.
5 *The Monthly Journal for Women,* issued by the Labour Party. Price Id., or 2s. a year, posted.
6 Dorothy Hutton (1889–1984) was an English painter, calligrapher and printmaker.

# Part 8

# ROLE OF ARCHITECTS, DESIGNERS AND DECORATORS

# ROLE OF ARCHITECTS, DESIGNERS AND DECORATORS

Attempts at professional distinction for architects in Britain were realized early on in the nineteenth century. In 1834 architects established the Institute of British Architects to distinguish themselves from the 'building trade' especially, but they also seem to have alienated themselves from work in the interior. Only four years after the establishment of the Institute of Architects a commentator could write

> It is too much the practice with the architects of this country to neglect that branch of their profession which is chiefly concerned with internal embellishment, to such degree, in fact, that they seem hardly to recognize its title to be considered as belonging to their province, but willingly relinquish it to upholsterers and decorateurs, which latter class of artistes would not exist separately as an intermediate grade between architects and upholsterers, but for either the pride or the supineness of architects themselves, who leave others to find the taste, which, be it good or bad, must ultimately manifest itself within the buildings they have merely planned and constructed.[1]

The anonymous author of an 1847 article entitled 'The Architect versus the Cabinet Maker and Others' summed up this issue:

> There cannot be refused the man of taste [architect], when he looks on to his Architectural-work marred and distracted by the wretched Decorator or Upholsterer, the justice of his complaint that the Decorator or Upholsterer ought to be at least his subjects, if not practically as regards design, incorporated in himself.[2]

Clearly, there was a considerable problem not only with roles, but also with the question of appropriate taste and education. One critic did consider the role of the interior decorator to be valuable. It was the American architect and landscape designer A. J. Downing who saw interior decorators as a complement to the architect. In 1850 he wrote

DOI: 10.4324/9781003290490-68

When a villa is designed by an architect, he generally superintends and directs the finishing of the interior; and in villas of considerable importance, interior decorators, who devote themselves to this branch of the profession, are called in to complete the whole, as the builder leaves it. Some of these possess talent enough to take an apartment or a suite of apartments, design and execute the decorations, and color, and furnish them throughout in any style.[3]

Nevertheless, the professional journals harked back to the past and lamented the architect's loss of control over the interior design work. In 1863, *The Builder*, forcefully suggested that

every opportunity should be taken to demonstrate the importance of interior decoration as a subject for the attention of architects themselves. All decoration is part of architecture; coloured decoration is predominantly concerned in the effect of most interiors; and architects should never have allowed the study and control of it to escape them.[4]

The texts in this section show a variety of approaches to the issue of the roles of architects, decorators, designers and tradesman in creating an interior.

## Notes

1 'On architectural decoration' *The Foreign Monthly Review and Continental Literary Journal* 1, no. 1, June 1839, p. 142.
2 'The architect versus the cabinet maker and others', *The Fine Arts Journal*, 13 February, 1847, p. 228.
3 Andrew Jackson Downing, *The Architecture of Country Houses Including Designs for Cottages, Farmhouses, and Villas* (New York: D. Appleton & Co., 1850), p. 405.
4 'The architectural exhibition', *The Builder,* 4 April, 1863, p. 237.

# [ANON] 'THE ARCHITECT VERSUS THE CABINET MAKER AND OTHERS' (1847)

## Editorial Headnote

*The Fine Arts Journal* was a very short-lived (November 1846–June 1847) publication that had as its subtitle 'a weekly record of painting, sculpture, architecture, music, the drama, and polite literature'. According to *The Newspaper Press Directory and Advertisers' Guide,*

> This Journal differs from *The Literary Gazette* and *The Athenaeum*, as it consists chiefly of original papers on subjects connected with art, – the reviews occupying a very small portion of each number. The writers do not appear to belong to any class or party, but write con amore, as their feelings prompt; and certainly, at times, they are betrayed into rather eccentric positions.[1]

This may be one reason for the magazine's very short life. They clearly intended to act as mediators, as the first editorial offered their pages to those prepared to dispute the opinions published therein.

The subject of this article was topical. Although particular architects such as A.W.N. Pugin and William Burges had designed complete buildings and interiors, the anonymous author of this article summed up the issue:

> There cannot be refused to the man of taste [i.e. architect], when he looks on his Architectural-work marred and distracted by the wretched Decorator or Upholsterer, the justice of his complaint that the Decorator or Upholsterer ought to be at least his subjects, if not practically, as regards design, incorporated in himself.[2]

There were clearly issues around the employment of eminent architects and the lack of designer training within the trade, as Matthew Wyatt explained in 1856:

> The principal impediments to the progress of the manufacture of elegant cabinetmaker's work in this country are caused by a great want of designers, draughtsmen, and modellers; in fact, of all the directors of art. The very few who can assist, demand and are paid such excessive rates, that their services are dispensed with, except upon important occasions.[3]

The argument of this article was particularly based around the need for education in design (something lacking in the 'mere table and chair maker') and an understanding of the principle of unity so that the decoration of an interior and its furnishings should reflect the building in which they are located.

Writing in 1869, Charles Eastlake commented upon the changes that were beginning to occur in the design and supply of furniture and furnishings:

> Fifty years ago an architect would probably have considered it beneath his dignity to give attention to the details of cabinet-work, upholstery, and decorative painting. But I believe there are many now, especially among the younger members of the profession, who would readily accept commissions for such supervision if they were adequately remunerative, and that they might become so is evident from the fact that the furniture of a new house frequently costs as much if not more than the house itself. And when clients lead the way, we may be sure that manufacturers will seek assistance from the same source.[4]

Of course, the situation was never fully resolved, as trade designers continued to work anonymously for the industry, and architects would work for specific clients or businesses, as required. Even by the near end of the century, the author and dealer, Frederick Litchfield, writing in 1892, returned to the issue of the role of the architect and the consequences of a loss of control over furniture design:

> About the early part of the nineteenth century, the custom of employing architects to design the interior fittings and the furniture of their buildings, so as to harmonize, appears to have been abandoned . . . furniture therefore became independent and beginning to account for herself as Art, transgressed her limits and grew to the conceit that it could stand by itself as well as its betters, went a way of its own.

# 53

# 'THE ARCHITECT VERSUS THE CABINET MAKER AND OTHERS'

## *[Anon]*

Source: [Anon] 'The Architect Versus the Cabinet Maker and Others', *The Fine Arts Journal*, 13 February 1847, p. 228

That the division of labour is a good thing is, in the abstract, established long ago. But when applied to practice, like everything else, it has its disadvantages as well as its advantages. The good principle has its limit – beyond this it becomes evil.

There are many in our day to whom the division of labour is a source of very grievous continual complaining. They may be old-fashioned people, – they will say, – perhaps they are, – nay, they will acknowledge they are, – but they cannot help wishing the good old days were come back again. Among these, our friend the Architect has of late taken up a very forward position. He does not know what the world is coming to at all; things were very different indeed in the olden time; he only wishes he could hope to see the olden time return. And he is not unable, either, to give you details in his complaint. The Engineer has encroached scandalously: the Builder – he has not words to tell how much: the Decorator, the Upholsterer, the Cabinet-maker, and more, they are all very wicked people, and, what with the one and the other, he is a very ill-used man.

But there is one part of his complaint in which we cannot but agree with him heartily. Taking him to have his true own province as an artist in the Design of Buildings, we certainly lament that this province is so much kept from him, occupied by the incompetent. There cannot be refused to the man of taste, when he looks on his Architecture-work marred and distracted by the wretched Decorator or Upholsterer, the justice of his complaint that the Decorator and Upholsterer ought to be at least his subjects, if not practically as regards Design, incorporated in himself. Whatever we may think of the Architect when he is inveighing against the depredations of the Engineer, we assuredly must support him when his suit is against the Cabinet-maker.

The practice of Design demands education. The principle that *taste* is inherent, cannot be imparted, and needs not to be cultivated, is essentially fallacious. The man of the most excellent imagination that could be possessed must be trained before he can be an able man in design. The world has been advancing generation

DOI: 10.4324/9781003290490-69

by generation; education is the imparting of this advancement to the mind. Uneducated, it could but assume it standing on a level with the far back beginning. The complaint of the Architect against the Furniture-man is that he is miserably uneducated. Were he of a properly-trained judgment, he could be depended upon, – he would be entitled to demand consideration in the province of his training: but it happens that there is scarcely, if at all, any one of the class who can truthfully claim to have been educated in design, and that all the while the design of a branch of Architecture (we will call it so) of the most essential value in itself, and holding in addition a most important power to aid or destroy the work of other branches, is entrusted to his care. The man is permitted to do artist's work who has had none of the education which the artist needs.

The principles upon which the design of the Cabinet-maker, Decorator, and Upholsterer proceeds are the same in fundamental nature with those of Architecture, – the Use, the Construction, and the beauties and harmonies of form and colour. The present condition of this department of Art is exceedingly unsatisfactory. The most unprincipled precedents govern; and design, fancy, when it comes into play, is unregulated and false, principles completely lost sight of, or ridiculously misapplied. The design is done by men who have no education in design. Were they not thus uneducated, it might be different, – we might have less cause, as we certainly should have less liberty, to complain. The Architect, on the other hand, much as we have denounced him for ignorance, is not thus ignorant. At least, we may say so of all respectable practitioners, – their power of design, although it ought to be greater than it is, assuredly is not so small as that developed by the Decorator-assistant. Even although the reason should be merely that the Architect is confined by principles which keep him more strictly to propriety, and that the Decorator and Furniture-designer have not the benefit of such favourable control, yet the fact is still the same that the present Architect as an Artist is certainly superior, in points where he comes in contact with him, to the present Furniture-man as an Artist; and that thus the Architect has good reason to complain of the other, as an offence to him, and it detractor from the beauties and satisfaction of his work.

Thus much as regards the inferiority of the Furniture-work to the Architecture. The case is still stronger when we look on the Decorator and Cabinet-maker as positively destroying the Architect's design by the incongruity of their own. And this is by no means an uncommon occurrence, – it is perhaps more nearly a universal grievance. However perfect the architectural design may be as itself a whole, – when the furniture design is thrown into it, a new whole is formed of which it is but a part, – and a part, as it happens, frequently completely marred by the other. It is not perhaps so very observable, but the critical judgment can detect in the elegancies of the upholsterer and cabinet-maker in our drawing-rooms sins against art no less decided and absurd than the famous Corinthian screens in our old Gothic Churches, or Sir Christopher Wren's notable "restoration" of the Westminster towers.[5] It is one of the first principles of design that when two works form one, they must harmonize. That the design of the furniture ought to correspond in style and spirit with that of the architecture with which it is put in

combination is but self-evident among requirements. If it so corresponds, it aids; if not, it directly destroys. Even although the one part and the other part may be each good and beautiful separate, yet if the essences of their beauty are contrary or even incongruous, the result can only be distraction – two tunes played together. And it really is worth being wondered at that a man should, as is so very commonly the case, put himself to all the trouble and cost of careful and rich architectural design and commit it so thoughtlessly into the ruthless hand of the Decorator – the art-work of a Barry, a Soane, or a Chambers[6] to be "decorated" by a tradesman-paper-hanger or a mere table and chair maker.

No one who will take the trouble to look at the matter with a little attention can avoid being struck with our singular want of good, or even inoffensive, designs in common furniture. Devices the most intolerably absurd are elaborated in all the solicitude of sandpaper and polishing, and all the extravagance of costly materials, enough to make us almost suspect the beautiful a mere conventionality, and no fixed principle, or even commonly determined system. The beautiful in this, which might be so beautiful a department, is almost utterly supplanted. It is nearly an absolute principle that the more elaborate the cabinetmaker becomes the farther does he wander from the right and the true. No vagary is too absurd for him, no inconsistency too marked. The common carpenter by his little practice of moulding work in doors and skirtings and windows has ten times the taste of almost any cabinetmaker you will find. He would be ashamed to cut a moulding-plane, with such 'fat' and broken curves and ill-proportioned parts. So much is a little education superior to none.

To confine our attention, therefore, mainly to the design of furniture, – it cannot but be manifest how sadly deficient we are in this respect, and all the while how extremely valuable a department of design is involved. The beautiful in our furniture might even be fairly claimed as more valuable than the beautiful in architecture. And also, perhaps, more extensive as a province of art, – there is so large an admission for varieties, elegancies, delicacies, enrichments, and characters. And all the more surprising is it that this opportunity should be so unimproved, – the result, not even so little of the good, but so much of the reverse.

One of the most necessary departments, therefore, for the action of the good effect of the Schools of Design which are now happily rising up, is this of cabinetmaking and upholstery. We might even venture to prefer a pretty lady in a beautiful chair to a pretty lady in a beautiful gown. At all events the chair ought not to be forgotten when the gown is receiving so much attention. And the more especially at present, when we see how very much the one design is generally inferior to the other.

We have before promulgated the idea that the designer of the house ought to govern also in the design of the furnishing. The architect ought to be able to take responsibility in furniture design, and ought to be entrusted with it. Even at present we cannot but think that the Architect might take authority in cabinetmaking with very valuable results; and this both as regards his own satisfaction in his work, and the beauty-value to the employer in his property. The drawing boards of

an architects' office could surely turn out better sideboards and tables and chairs than we at present possess: and perhaps even the cabinetmaker himself would be glad of the aid, and would make them all the better, and with all the more pleasure, for someone else designing them.

## Notes

1 C. Mitchell, *The Newspaper Press Directory and Advertisers' Guide* (London: C. Mitchell: Benn, 1846) p. 94.
2 'The Architect versus the Cabinet Maker and Others', *The Fine Arts Journal*, 13 February 1847, p. 228.
3 M. D. Wyatt, *Reports on the Paris Universal Exhibition Part I* (London: H.M. Stationery Off., 1856), p. 311.
4 Charles Locke Eastlake, *Hints on Household Taste* (London: Longmans, Green, and Co. 1869), (2nd ed) Preface, p. x.
5 Sir Christopher Wren, the architect, was appointed Surveyor of the Fabric at Westminster Abbey in 1698.
6 Barry: Soane: Chambers: Sir Charles Barry FRS RA (1795–1860) British architect; Sir John Soane RA FSA FRS (1753–1837) British architect; Sir William Chambers RA (1723–1796) British architect.

# MARTHA JANE LOFTIE, (MRS)
## 'DOING UP ONE'S HOUSE' (1879)

### Editorial Headnote

Martha Jane Loftie was a successful author, best known for her work *The Dining Room* (1878) published in the Macmillan *Art at Home* Series. She began to contribute anonymous articles on the topics of housing, interior decoration and furnishings to the English newspaper *Saturday Review*, from 1874. These were later published by Macmillan as *Forty-six Social Twitters* in 1879. One article on 'Furnishing' neatly expressed Loftie's concerns about the design of a home. In this article she discusses an imaginary young couple who put their faith in a retailer with no taste in design matters:

> The house is to be done up in all the proper tints, to have dados, wainscotings, and varnished floors. 'Elizabethan easy-chairs with cabriole legs' and an 'elegant walnut Louis-Quatorze lady's cabinet writing-table, handsomely inlaid with marquetrie.' are ordered for the drawing-room; Cromwell chairs and 'antique carved oak book-cases' for the library. There are to be 'baronial' coal-vases with medieval mountings, an 'Athenian hip-bath', an 'Eastlake' breakfast service, and Minton tiles in all the fire-places.[1]

Despite the seemingly sensible advice to avoid this mish-mash of designs, there were misgiving about the quality of the guidance. In 1878 the *British Architect and Northern* Engineer published an article titled 'Mrs. Loftie in Excelsis'.[2] This diatribe was typical of the attacks on contemporary taste that flourished in the period that were supposedly being addressed by advice books, magazine columns and articles. They wrote:

> do the publishers – Messrs. MACMILLAN and Co. – think that their reputation is too great to be affected by such foolishness and such weakness as these little books exhibit? In the one before us the only merit of it is in certain advice, which might well have been put into a tract of half the compass, and called *The Housekeeper's Guide*. To put forward a book like this as a contribution to art knowledge or culture is either the act of folly or pretence.

The seeming inconsequentiality of her work was also mentioned in a later review in the *Examiner* of her *Forty-Six Social Twitters*, where it was noted that

> when Mrs. Loftie attempts the heavily practical or the seriously moral, she reads but to very little advantage. To discuss the merits of garden

parties, windows gardens, or the decoration of a drawing room mantel shelf, Mrs. Loftie is always equal to the occasion.[3]

The *Examiner*'s put-down was partly alleviated by the review in *The Athenaeum*. Its brief notice of the same book said: 'Mrs. Loftie's *Forty-Six Social Twitters* are certainly better written than the rather silly title would lead one to expect. Many of these essays are bright and pleasant, and extremely sensible remarks are scattered through the book'.[4]

This particular rant by Loftie against the nature of workmen employed in house decoration, their habits and the lack of quality in their work is laid squarely at the door of trade unionism.

# 'DOING UP ONE'S HOUSE'

## M. J. Loftie

Source: M. J. Loftie, 'Doing Up One's House', *46 Social Twitters* (London: Macmillan, 1879), pp. 33–9

### DOING-UP ONE'S HOUSE

The mere sight of the words "Builder and Decorator" is sometimes enough to arouse in a person of really sweet temper those angry passions which Dr. Watts only permits to bears and lions.[5] They seem at first sight harmless words, but the experienced householder knows their full import. He knows that under them lurks the terrible phalanx of plumbers, slaters, gasfitters, bellhangers, blacksmiths, paper-hangers, whitewashers, and plasterers, at whose approach we all fly, and at whose bills many of us quake. The overhoused young doctor who has a strict painting clause in his lease and yet can see a paint-brush without a shudder must be the most insensible of men. He must be without recollection of the things which he has suffered; without that dread of the future which his past experiences ought to supply. Many a lady of refined taste but scanty means sits day after day in a room where the pattern of the paper offends her eye, and the shabbiness of the woodwork is a constant source of annoyance to her. Five shillings would buy all the paint needed to freshen up the doors and shutters; five times five shillings would not pay a London work man for putting it on. Pretty wallpapers can certainly be bought for fabulously small sums, but the expense of having them hung more than doubles their cost. This is much to be regretted, and there seems at present no way out of the difficulty, unless Mrs. Crawshay would organize a band of lady painters. Miss Faithfull might also persuade some of the women who earn two shillings a day by laboriously working sewing-machine for ten hours, to take to the not unhealthier occupation of common house painting. It is surprising that some enterprising emigration agent has not brought over a band of Chinese coolies, or persuaded a few Japanese designers to brighten our walls with their gay chrysanthemums and graceful storks. In Japan the paint-pot seems as constantly in use as the scrubbing-brush is in Holland, and quite as necessary to the comfort of the inhabitants as soap and water is to us. Besides the expense of painting and papering there is the trouble of it. It is most difficult, either in town or country, to get a small job executed in a reasonable time. Perhaps three days would be quite sufficient to give for the work to be done, say the

DOI: 10.4324/9781003290490-70

papering of a room. Messrs. Copal and Oak promise to send their men early on Monday morning. Everything is cleared out on the previous Saturday. The men do not appear till Friday. They spend the day in making a mess and whistling. At twelve o'clock on Saturday they disappear, to be seen no more until the following Wednesday at noon. Meantime the stair carpets must remain up, and a board be left along the hall, over which our friends and our servants have the privilege of tumbling as many times a day as they think expedient. We are not of course now speaking of the rich people who can at any time leave their houses, and can afford to put them into the hands of an experienced and well-known firm, who can give *carte blanche* with regard to the spending of money, and do not interfere with such details as carpets, curtains, or furniture. They, too, have their troubles, into which we need not here enter, but they are not the troubles connected with careless workmen who scamp their work. The foreman in such establishments is the sufferer and the person held responsible. Unhappily there are people in the world who like to have their houses nice, yet who cannot afford to spend much money upon them. When making additions or alterations they are therefore obliged to endure the smell of paint, and must remain at home to superintend second-rate workmen and see their fancies carried out.

But the principal reason why so many people dread having their houses done up is that the object of each tradesman employed seems to be to make work for some other tradesman. The whitewasher forgets to cover up the steel grate in the drawing-room when he is doing the ceiling; The housemaid is so busy flirting with him and listening to the words of the last comic song which he is trying to teach her that she neglects to remove the fender and fire-irons. Grate, fender, and fire-irons are completely spoilt, and have to be sent away and repolished at considerable expense. The whitewasher also manages to clog the bell-wires so that the bells will not ring. The bell-hanger must therefore be sent for. He leaves dirty finger-marks upon the cornice where he has loosened the cranks, and round the china-handles where he tries the bells. Perhaps he breaks one of the handles. It cannot be matched, so two new ones must be bought, and another tradesman brought in to put them on. The paperhanger possibly uses bad size on the wall, and makes his paste of damaged flour, consequently when the room is again inhabited it has a mysterious but most offensive smell. Perhaps he does not take the trouble to remove the old paper before putting on the new one, in which case pastilles may be burnt and windows opened, but all in vain – the smell will remain. The painter does not sufficiently rub down or burn off the old paint before he puts on the new. He sometimes even covers the old doors with size to save himself trouble and make a surface. He is almost always careless with his first coat – a carelessness he cannot afterwards repair. It is not uncommon, as soon as the new paint is quite dry, and has been under the influence of either sunshine or a hot fire, to see it starting off in pieces at the slightest touch, and leaving the light under-colour visible. If not carefully watched, the painter will put his pots on one of our best tables, making on it a fine confused pattern of circles, great and small. In consequence of his carelessness the French-polisher has to be called in. The painter is quite

satisfied, having done his part towards the encouragement of trade. In giving the hall-door a fresh coat, he lets drops fall on the step which no French-polisher or English house-maid could, with any quantity of fuller's-earth, whiten or remove. He walks up and down the oilcloth in the hall with nailed boots, and gives it the appearance of having recently recovered from a severe attack of smallpox. His sympathies are with the makers of oilcloth, not the buyers thereof, so he is rather pleased. It is not uncommon for a bill to be sent in charging for four coats of paint when only two have been put on; perhaps in some cases there may have been three thin paintings and a little chalk mixed with the white lead. Common oak varnish will be charged as best copal,[6] and the bad cotton rope with which the window sashes are mended as best hemp line.

Strange to say, there are people who honestly love the house-painter and his paint, who like to be constantly "restoring" their rooms, who would scarcely take a present of a set of decorative panel pictures from Mr. Leighton,[7] or find place for hangings of "cloth of Arras." A great art collector who has lately remodelled his house paid as much for having some doors done in imitation of mahogany as would have procured the doors in the real wood, whilst another gentleman had his splendid century-old mahogany woodwork painted white. The excuse for this last piece of barbarism we have never discovered; perhaps he was a Queen-Anne-ist, and they looked too ruddily comfortable to match his furniture. Fortunately, he did not replace the egg and dart mouldings in the shutters by stop chamfers, which we saw done on another occasion. Men of supposed taste still have their hall-doors grained in a bad imitation of oak or maple, and would scarcely care for natural wood even if it were to be had easily. The reason why builders so love paint and varnish is that it hides bad wood, and ensures to them and their successors work for ever. If some substitute for whitewash in ceilings could be found which would wash, they would lose thousands a year. They set their faces against the varnished papers which some people have adopted, and which are certainly a help to cleanliness at small cost, because they bear cleaning. They detest marquetry floors with rugs, as there are not then heavy carpets to take up and nail down, and tear the corners out, as we know to our cost.

The stupidity of apparently intelligent workmen is sometimes very puzzling. You arrange on leaving home for the painting and papering of your dining and drawing rooms. When you return, the papers are transposed, but not the paints, so you have a thick flock in the drawing-room with French grey and gold mouldings, while in the dining-room you find a white and gold paper with dark brown and black doors. You left some Japanese crape pictures for a frieze, and find most of them either upside down or sideways. In one a Chinese lady is standing on her head supported by a fan, which she holds in her hand. In another a bird which ought to be skimming the air, is lying on its back apparently in its death agonies. In a third the snow is rising instead of falling. You draw a number to be put on the hall-door; the piece of paper on which you draw it happens not to be straight. The number is put on according to the paper, and suggests that a visit was paid to the "Harp and Crown" round the corner before it was sketched.

It is amusing to see some poor lady bitten with a love of peacock blues, trying to make a country workman unaccustomed to such eccentricities, mix the proper colours with which she wishes her rooms redecorated. It is heartrending to see the fearful pigments he produces from her descriptions, and the poor lady's helpless despair. For this sort of stupidity Trade-Unions are to blame. They give no encouragement to individual talent. They put no premium upon industry and rapid work. A man who belongs to a Trade-Union is like a soldier; his pace must be regulated by that of the weakest man in the regiment. He earns no more wages by being able to do his work in half the time and twice as well as the man beside him. He is not allowed to remain a quarter of an hour after twelve on Saturday when he could in that quarter of an hour finish a most important job. Perhaps some invalid is waiting for a room to be completed; perhaps some real damage will be done by the delay; but the workman must sacrifice himself, his talents, and his desire to be obliging, to the inexorable law of his Trade-Union. The noble working man learns to lounge to his work as if he were going to his club in Pall Mall. He employs a considerable part of his time in looking out of the window at the expense of the British householder. He can bet on the Derby and drink like a lord. Now that Trade-Unions have been accepted as necessary organizations, it is a pity that all trades should not be divided into guilds as of old. The men would then have an inducement to improve themselves by study, and some reward to look forward to from special industry or cultivated intelligence.

## Notes

1 Mrs. Loftie, 'Furnishing', *Social Twitters* (London: Macmillan, 1879), p. 61.
2 "Mrs. Loftie In Excelsis", *British Architect and Northern Engineer,* 9, 8, 22 February 1878, p. 83.
3 *Examiner*, 23 November 1878, p. 1497.
4 'Our Library Table' *The Athenaeum*, 2 November 1878, p. 560.
5 'Let Dogs Delight to Bark and Bite,' by Isaac Watts (1674–1748).
6 Copal is any of various varnish resins, produced from the exudates of various tropical trees.
7 Sir Frederic Leighton, (1830–1896), was a British painter, draughtsman, and sculptor.

# LEWIS FOREMAN DAY, 'THE RELATION OF THE ARCHITECT TO THE DECORATOR' (1883)

## Editorial Headnote

The issue about architects and their relationship with craftsmen had already been raised over thirty-five years previously in the *Fine Arts Journal*.[1] Following the apparently widespread abrogation of responsibility for interior decoration and furniture design by architects early in the nineteenth century, certain retail furnishers and decorators, in their role as middlemen within a creative economy, acted as co-ordinators of interior design projects, and crucially had overall responsibility and control of the works undertaken.

The professional journals often harked back to the past and lamented the architect's loss of control over interior design work. In 1863, *The Builder*, forcefully argued that:

> Every opportunity should be taken to demonstrate the importance of interior decoration as a subject for the attention of architects themselves. All decoration is part of architecture; coloured decoration is predominantly concerned in the effect of most interiors; and architects should never have allowed the study and control of it to escape them.[2]

In 1869, *The Building News* discussed the decorations of the contractor and politician Sir Morton Peto's Kensington home, and chastised the upholsterers Jackson and Graham for the quality of their interior decoration work. Even though the firm employed distinguished designers, the architectural press still played out the arguments about the loss of control of work from the architect to the 'upholsterer'. They wrote scathingly that:

> The decorations were unfortunately taken out of the architect's hands and given, together with the furnishing, to Messrs. Jackson and Graham, a firm of upholsterers whose reputation for the quality and artistic excellence of their goods stands deservedly high, but whose notions of decoration appear to consist in the indiscriminate application of Mr. Owen Jones's objectionable crudities.[3]

Following this demolition of Owen Jones's designs, they then wrote:

> Had a firm essentially decorative, such as Messrs. Crace, for instance, been employed, the beauties of the internal architecture would have been brought out by the decorative treatment, while the furniture would probably have been quite as good as that actually supplied.[4]

They made the distinction between the upholsterer and the decorator very clear.

An artist, critic, and industrial designer, Lewis Foreman Day (1845–1910) played an important role in the Arts and Crafts Movement, particularly in his efforts to relate the movement to industrial productions. He was one of the organizers of the Arts and Crafts Exhibition Society and a one-time master of the Art-Workers' Guild. From 1897 to his death, Day remained a member of the council of the Royal Society of Arts. He also gave lectures on ornamental art to the Society of Arts and the Royal College of Art, South Kensington, and acted as an inspector on ornamental work in provincial art schools.

Day's ideas were important, in that he argued that designers should accept industry and industrial methods of production, and indeed, he practiced what he preached. This is borne out by his involvement with several major manufacturers including ceramics firms Maw and Pilkington, wallpapers suppliers, such as his long association with Jeffery and Co., and by the 1880s, he was the artistic director on the board of textile company Turnbull and Stockdale.

Day published many important articles and volumes on ornament and decoration, including *Instances of Accessory Ornament* (1880), *Every-Day Art* (1882), *Anatomy of Pattern* (1887), *The Planning of Ornament* (1887), *Lettering in Ornament* (1902), *Pattern Design* (1903), *Ornament and its Application* (1904), and *Nature and Ornament* (2 vols, 1908–1909). His books were important as texts for design students, with one being updated as late as 1930 by Amor Fenn. Other more specialised works included *Windows: A book about stained and painted Glass* (1897) with three editions by 1909, *Alphabets Old and New* (1898), *Lettering in Ornament* (1902), and *Stained Glass* (1903). His work was also published in journals including the *Magazine of Art*, the *Art Journal*, and the *Journal of Decorative Art*.

*The British Architect* was founded in 1874 to act originally as a platform for the work of Manchester architects as opposed to the London-based *The Builder*. Eventually in 1919 it merged with *The Builder*. It had several various sub-titles including: a journal of architecture and its accessory arts; *The British Architect and Northern Engineer*, and a national record of the aesthetic and constructive arts; and business journal of the building community. Its first number explained its aim: 'The usefulness of this publication to gentlemen of taste, clients, public men, and the building community may be its great merit; the advancement of the aesthetic and constructive Arts in this kingdom will be its higher aim'.[5]

See also text 1.53.

# 55

# 'THE RELATION OF THE ARCHITECT TO THE DECORATOR'

*Lewis Foreman Day*

Source: Lewis Foreman Day, Friends in Council No. 74. 'The Relation of the Architect to the Decorator', *British Architect*, 16 March 1883, pp. 125–6

It may be as well to preface the remarks that I have to make concerning "the relation of the architect to the decorator," by saying that a recent contribution of mine, under the title of "Contradictory Decoration" though it touched the subject, and has been referred to by a "Friend"[6] in connection with it, was sent to the editor in the usual way, before there was, so far as I know, any thought of a discussion on the question other than might arise out of it. It was meant simply to assert the right of a man to act, under certain circumstances, for himself. As an expression of the relationship under discussion, it would have been ludicrously inadequate.

The able introductory paper by Mr. Aitcheson[7] leaves little, if anything, to be said against it; and it is not without significance that this generous recognition of the claims of the decorator comes from an architect who has especially distinguished himself in decoration. Were the architect more generally disposed to ask, "only that his building should not be dwarfed by the figures being too large, and that the parts he wanted to keep unobtrusive were not made prominent, and that the parts be wanted to be striking were not subdued," no decorator would be likely to deny him the prerogative. Nor would there be any other feeling than that of grateful recognition of the architect whose interference with the sculptor was limited to insisting that in the capitals of columns he should "confine himself to the outline desired by the architect," and that he should not cut into his "material so deeply as to endanger the stability of the structure," or even "give a look of insecurity."

In reference to the question "whether it is right that the architect of the building should have his view of the effect carried out – i.e., that it should be light or dark, warm or cold" that right will be readily conceded to Mr. Aitcheson by decorators no less than architects. That the "master of a subject should have his own way," to quote once more his words, is all that the wildest hope could wish and as a matter of *practice* all depends upon the relative mastery of his subject by the architect and the decorator. If, on the one hand, some knowledge of decoration is necessary

to architecture, on the other, at least some superficial acquaintance with the laws of architecture is necessary to decoration.

In the discussion, thus far, in the *British Architect*, what diversity of opinion there is appears rather to be diversity of conception as to what is meant by the term decorator. Mr. Aitcheson, for example, assumes that the decorator is an artist who is also specialist in the decorative craft. Mr. Salmon considers him as an "employee" whilst Mr. Brooks bluntly calls him his "servant," It is quite clear that these writers are speaking of quite different men when they speak of decorators. The relation between the architect and the decorator, which Mr. Penrose describes as "a very complicated one," is only so inasmuch as it is confused by the use of the same word to express two different functions. The mere house-painter, who dignifies himself by the name of decorator, is of course wholly subordinate to his employer, no matter whether he be employed by the architect, the decorator, or the amateur. But where the assistance of the decorative artist is invited by the architect, it must be in the capacity of *collaborateur*, and not of "employé" or "servant."

More than one "Friend" has alluded to stained glass as a *specialité*, admitting that it at least is a branch of decoration of which the architect cannot be expected to be master. But it seems to me that decoration on *any important scale* is equally beyond the range of the architect proper. An architect may turn his attention to decoration, and he will be, in many respects, the better decorator for his previous architectural training but it may well be doubted, in the words of Mr. Penrose, "whether an architect could with advantage have so given his mind to decoration as to be able to dispense altogether with the assistance of a specially trained decorator." That there was a time, as Mr. Sedding reminds us, when things moved so slowly that the architect was able to do all his work himself, and decorate that which he had constructed, does not alter the fact that we live in days when all things make for specialism and subdivision of labour. There may be room for limited number of architects who prefer to work in the old leisurely way, perhaps more congenial to the artistic temperament; but they will have to make up their minds to forego the worldly advantages that accrue only to those who move with the times, and the times make specialists of most of us. "An architect is expected to be an all-round man," says Mr. Robins. Is not rather too much expected of him? When we think of all that is comprised in the practice of architecture, it is obvious that no one human being can be master of the whole. Indeed, one may be permitted to doubt his wisdom in accepting such a position of presumed omniscience. He has already had to recognise the position of the engineer, and he will come to acknowledge that of the decorator – notwithstanding that in the Middle Ages engineering and decoration were both included under the head of architecture. One may even see grounds to suppose that yet further subdivision will take place, when constructor, sanitarian, and artists (not one but many) may work together, each responsible for his own work only; and this, not as Mr. Colling fears, "at the expense of the character of the work," but to its immeasurable gain.

Still, however minute the subdivision of architectural labour, the question will remain as to the order in which the various labourers shall take rank. Even in a band of brothers one must take the lead. Which? Logically, it would seem as if decoration must be subordinate to architecture. But these are not the days of feudalism, and it is really not so much a question of subservience as of association; and amongst associates the leader will always be the stronger man. He who is strongest in one direction will naturally take the lead in that; others will lead, in turn, in the direction in which their strength lies. As an actual fact, architects, with the exception of a few who practically identify themselves, as Owen Jones did, and as Burges did, with decoration, depend, not only for the execution, but also for the design of their decorative work, to a great extent upon the unacknowledged help of decorators, who are subordinate to them only in name; many a one of whom not only "calls himself" artist, but has every bit as much right to the title as Mr. Wyatt Papworth[8] himself. Whatever it is that makes the artist, it is *not* the T square.

It is assumed, rather gratuitously, that the decorator, left to himself, would be sure to go contrary to the intention of the architect. But surely, it is quite as possible for the decorator to know something of architecture as for the architect to be proficient in decoration. A knowledge of the lines upon which architectural decoration should be based is not beyond the reach of the ordinary mind. If the decorator is really in danger of ignoring the architect, is there no danger of the architect omitting to make due provision for the proper decoration of his work?

Doubtless the man who schemes a building knows better than any other being can know what he meant to do, and how he meant to do it; but it is conceivable that he might not know where to stop. He might be a great architect, without being gifted with a refined sense of colour, and such of us as love colour might prefer even to sacrifice something (if sacrifice wore necessary) to harmony.

Mr. Owen Davis[9] proves too much when he asserts that, "the sculptor is a sorry hand at his pedestal," and that "few artists can design frames for their pictures." He lays himself open to the retort that, in like manner, few architects are to be trusted with the decorative detail and the colouring of their buildings. Assuming, however, that the architect is to direct, a consultation with him as to his notion of the distribution of enrichment, its character and its tone, scarcely constitutes the decorator his subordinate. Mr. Boult, who rejects the supremacy claimed for the profession, compares the architect to the general, the statesman, and the editor. Now, the general or the statesman, however dependent upon the support of others, is yet presumably the master-mind. The editor is not necessarily so; he is rather the administrator – a valuable, a most necessary functionary, but not always the superior of those who work under his editorship. Waterloo was not the work of any one man, but we justly ascribe the victory to Wellington. A statesman of the rank of Mr. Gladstone or Lord Beaconsfield is the veritable head of his party, all of whom are more or less subordinate to him, as generals of division are subordinate to the commander-in-chief. But the distinguished writers who contribute to the pages of *The Nineteenth Century*, are not in any intelligible sense the subordinates of Mr.

Knowles;[10] and that able editor would be the last to claim more than the credit due to his energy, enterprise, and administrative skill. In many cases, the architect might with propriety be compared to the learned editor of some great work the past, himself neither poet nor philosopher. Of the vast quantity of labour of various kinds which the architect is accustomed to edit, there is much in the way of decoration with which he has, and can have, no more to do than deciding who shall do it. One of the worst features in connection with the modern profession of architecture is the anonymous character of some of the more artistic contributions to the work for which the architect is responsible – responsible, that is, inasmuch as it bears his name.

Mr. Owen Davis suggests that there is room for specialists, who shall be consulted by the architect in reference to decorative matters; and he assumes that this consulting artist must be an architect. We have, indeed, architects among us well qualified for such a position, but we have at least as many qualified artists who have not graduated in architecture. The difficulty in the way of association, whether between the architect and the consulting specialist, or between the architect and associates to whom he is "bound by mutual respect, arising out of their relative merit" is (and this controversy goes to prove it) that the architect is too often loth to admit another to his fair share in the credit of the work to be done, and thinks it due to his prestige to pretend that all contributors to his undertaking are his subordinates, if not his "servants." It is gratifying to find this pretension to autocracy disowned by more than one of our "Friends in Council."[11]

I do not underrate the dignity nor the scope of architecture. On the contrary, it seems to me so vast and comprehensive that no one man can be proficient in every branch of it. The branches spread further than they did. Constructive and sanitary science, beautiful building, and all of art that is not comprised in painting pictures, are more than a man can hope to master. Even the "subordinate" section of decoration is in itself more than any, but a giant can overcome. There has only been one Alfred Stevens[12] in our day.

If decorative art divides itself into figure work and ornament (not to mention further subdivisions which are in practice inevitable), still more certain is it that architecture and decoration, twins though they be, are two.

## Notes

1  Anon, 'The Architect Versus the Cabinet Maker and Others', *The Fine Arts Journal*, 13 February 1847, pp. 228–229.
2  'The Architectural Exhibition', *Builder*, 4 April 1863, p. 237.
3  'Interior Decoration – The Drawing Room', *The Building News and Engineering Journal*, 16, 1869, p. 121.
4  Ibid.
5  Introductory, *British Architect*, 1, 1, 2 January 1874.
6  The title of the series of articles was 'Friends in Council'.
7  George Aitchison 'The Relation of the Architect to the Decorator', *British Architect*, 16 February 1883, pp. 78–79.

8  Wyatt Papworth (1822–1894) an English architect, surveyor and antiquarian. He is best known for his editorial work on the part-published *Dictionary of Architecture*, appearing 1853 to 1892, and the 1867 edition of Joseph Gwilt's *Encyclopædia of Architecture*.
9  Owen Davis (1838–1913) architect and designer.
10 James Knowles founded *The Nineteenth Century* as a British monthly literary magazine in 1877.
11 'Friend in Council' refers to authors of the texts published in this journal. They explained how "A large number of our leading professional brethren have readily responded to our invitation, and offered us the benefit of their counsels during the past two years, under the heading of "Friends in Council." *British Architect* 5 January 1883.
12 Alfred Stevens (1817–1875), was an important British sculptor and designer.

# CHARLES FRANCIS ANNESLEY VOYSEY, 'THE AIMS AND CONDITIONS OF THE MODERN DECORATOR' (1895)

## Editorial Headnote

The architect Charles Francis Annesley Voysey (1857–1941) was an important and influential figure at the turn of the century. Although trained as an architect, in 1883 he began to design two-dimensional patterns for wallpaper and textiles, often distinguished by their flowing, twisting, plant like forms. Voysey's growing standing as an architect and designer meant that his work was widely published in British and European architectural and design journals. Voysey followed the thoughts of Augustus Pugin and John Ruskin and applied them to his design work that is in an arts and crafts tradition. Voysey also wrote two books, *Reason as the Basis of Art* (1906) and *Individuality* (1915).

Voysey, delivered this text as a lecture on 15 February 1895 at the City Art Gallery, Mosley-street, Manchester, in connexion with the Manchester and Salford Association of Master Plasterers and Painters, upon art in decoration and design. It was published in *The Journal of Decorative Art: An Illustrated Technical Journal for the House Painter, Decorator, and all Art Workmen*. This was the publication that was associated with the National Association of Master House Painters of England and Wales. Published monthly it contained detailed reports on contemporary technical matters and design trends in the decorative arts, as well as trade news.

*The Builder* journal précised the lecture noting how

> [Voysey] urged that the decorator must be free from the bondage of imitation, and that to secure the best results the decorator and designer must express living emotions. . . . Too often the decorator became a kind of head foreman, and was expected to carry out the desires of those who had no experience in the matter whatever. Under modern conditions the decorator's life was a very hard one. It was partly, however, brought on by himself, in consequence of his readiness to supply anything, to do anything, and to be pulled by the nose, for the sake of the pounds, shillings, and pence to be got out of the public by whom he was employed. Individualism, Mr. Voysey insisted, should be made the foundation of all art. Each man's productions would then be invested with a personal character, and would possess qualities entirely his own and when that principle was recognised the patrons of art would generously give a fair field to the craftsman, and take a pleasure in placing confidence in his pride and enthusiasm for his work. To arrive at a higher state of art in their work they must modify their spirit of commercialism, The sacrifice must be real, or the reverse, selfish greed, would reign supreme, to the

destruction of true and lasting art, They must do their utmost to raise the colour sense from morbid despondency to bright and hopeful cheeriness. Let them have crudity, if they would, rather than mud and mourning. Every attention, again, should be paid to the qualities of simplicity and harmony.[1]

# 56

# 'THE AIMS AND CONDITIONS OF THE MODERN DECORATOR'

*Charles Francis Annesley Voysey*

Source: Charles Francis Annesley Voysey, 'The Aims and Conditions of the Modern Decorator', *The Journal of Decorative Art*, 15, 1895, pp. 82–90

Eleven years ago, when beginning to turn my attention to designing wall papers and fabrics, I felt that the decorators were my natural enemies – that their tastes and interests were diametrically opposed to my own as a designer.

Ignorance and ambition led me to the belief that the public could be coerced into buying what the designer thought best, and that it was the duty of the decorator and designer to lead the public, and *not* their duty quietly to supply the market to suit any debased taste that might happen to be in vogue.

Time has revealed that the greatest consideration and sympathy are due to the decorator, when one remembers his liabilities, and the number of hungry mouths dependent upon him, and last, but not least, the universal commercial instinct of the general public, who assume that they have a right to do what they like with their own money. and that, if they pay for anything, that fact gives them the right to determine exactly what that thing shall be.

Thus the labours of the decorator and designer are reduced to a commercial commodity, like so much butter or cheese. The flavour of which is to be regulated to suit the palate of the purchaser.

Hence, we have acres of pattern designed by experts and applied by decorators to suit the taste of persons the bulk of whom never designed a pattern nor gave a moment's thought to the laws of decoration and fitness – a public swayed to and fro by fashion, and demoralised by excessive luxury and excitement in a world almost dead to the sense of dignity and repose. Must we decorators and designers for ever follow such a public?

In the fact of your kind indulgence and courtesy in inviting me to address you tonight I feel great hope and encouragement.

I rejoice to think the decorators are ready to hold out the right hand of friendship to the designers and unite with them in a mighty endeavour to lead the public for Art's sake, and cease to be content only to follow them for commercial ends.

When once we make up our minds that the demand shall not always and for ever govern the supply, we may be sure the supply will in time govern the demand.

To bring about this state of things, some of us must be prepared to make sacrifices, for nothing worth having is to be had without some pain or loss.

The task of trying to influence public taste must be a very hard and arduous one, attended with much anxiety and heartache, as many of you know from your own experiences. Still it is not generally recognised as a duty. For countless lives are wasted in trying to find a *via media* in endeavouring to sneak up to a leading position without suffering for it.

No doubt it will be retorted that he can preach courage who stands alone, and, therefore, suffers alone: but for men who have many workers dependent upon them the case is different. For they rightly refuse to bring suffering on others for the sake of an idea not too obviously a duty. And so the question is one which must be left to each individual to decide as his own conscience prompts him. For my own part I would say that *that* man serves his fellows best who is most courageous in his pursuit or the highest and best impulses within him.

Taking it for granted, then that the highest position the decorator and designer can take up is that of a leader or public taste what does this position involve and how can it be upheld?

First, we must purify our motives, and seek to discover true principles as far as it is possible. Of course it is clear that if the decorator is to have motives higher than the mere making of money, he must needs devote much lime and thought to the study of colour, form, and texture. and be in close communion with the designer, who in his turn should help the decorator on artistic lines. And most important is it to avoid at all times the lazy and contemptible practice of relying upon precedent for justification of what is done.

The revivalism of the present century, which is so analogous to this reliance on precedent, has done more to stamp out men's artistic common sense and understanding than any movement I know. The unintelligent, unappreciative use of the works of the past. which is the rule, has surrounded us at every turn with deadly dullness, that is dumb alike to the producer and the public.

This imitative, revivalistic temper has brought into our midst foreign styles of decoration totally out of harmony with our national character and climate. Also the cultivation of mechanical accuracy, by close attention to imitation, has so warped the mind and feelings until invention to many is well-nigh impossible. Technically excellent imitations arc still unduly applauded, to the exclusion or forgetfulness of the nobler powers of thought and feeling. The decorator must be freed from the mechanism of dull imitation, and be allowed to exercise his God-given faculties: at the same time reverently respecting and gaining inspiration and help from all faithful workers who have gone before him. Not for the sake of being original should men so work, but to fulfil the universal law in the exercise of their best and noblest faculties. Free men from the bondage of imitation, and they *must* at once express living emotions. Turn a man on to any ordinary house to colour the wood and the walls without regard to tradition, and he will inevitably

462

express, by his work and choice of colour. either unhealthiness or healthiness, sadness or joy. Some expression of thought and feeling there is sure to be, and thus may be imparted that human element which adds such immeasurable charm to all noble works of art.

Emerson says: "In the sculptures of the Greeks, in the masonry of the Romans, and in the pictures of the Tuscan and Venetian masters, the highest charm is the universal language they speak. A confession of moral nature, of purity, love, and hope breathes from them all. That which we carry to them, the same we bring back more fairly illustrated in the memory, The traveller who visits the Vatican. and passes from chamber to chamber through galleries of statues, vases. sarcophagi, and candelabra. through all forms of beauty, cut in the richest materials, is in danger of forgetting the simplicity of the principle out of which they all sprang, and that they had their origin from thoughts and laws in his own breast. He studies the technical rules on these wonderful remains, but forgets that these works were not always thus constellated; that they are the contributions of many ages and many countries: that each came out of the solitary workshop of one artist, who toiled, perhaps. in ignorance of the existence of other sculpture, created his work without other model save life, household life, and the sweet and smart of personal relations, of beating hearts and meeting eyes, of poverty and necessity, and hope and fear. These were his inspirations, and these are the effects he carries home to your heart and mind. In proportion to his force, the artist will find in his work an outlet for his proper character . . . Art has not yet come to its maturity, if it does not put itself abreast with the most potent influences of the world: if it does not stand in connection with the conscience: if it does not make the poor and uncultivated feel that it addresses them with a voice of lofty cheer."[2]

In this passage Emerson shows clearly that there is a spiritual as well as a physical aspect of Art. A fact which we shall do well to remember in this materialistic age. For likeness to physical nature is the almost universal gauge or artistic worth.

Once remove the strait-jacket of convention, and place beauty of thought and feeling above beauty of expression, and the hands of men will soon find the cunning with which to represent their thoughts: and, once again, Art will be a living power amongst us. To what extent the decorator and designer can reason with, and persuade, and sometimes learn from and lead the public, it is impossible to say. A kind readiness to reason, rather than a gluttonous civility, which aims only at securing orders, will do much to clear the air of prejudice. Surely, in some such way might be broken down the unreasonable. unhealthy. and insane opposition to the conventional application of *animal* life to decoration.

The realistic treatment of birds has very properly been denounced as a painful spectacle when plastered round angles, or cut in half by cornices. But can it not be justly argued that when conventionally treated the bird is merely a flat symbol, and if repeated quickly, the mutilation is scarcely felt? And, again, what reason can be assigned for grieving over a bisected symbol of a bird, more than over a bisected symbol of a flower? No doubt strong popular prejudices generally have some foundation in fact, and it may be, there is some justification for the

cruel boycotting or the sweetest, most suggestive, interesting, and telling forms or decoration. Perhaps, when the public have given up telegraphing the rise and fall of railway shares. there will be left a little more sympathy for the poetic and imaginative sense, and our playful delight in bird life and strong joyful colour will not meet with so much indifference and disdain. At present it is idle to look among the many for the appreciation of pleasures enjoyed only by the few.

The multitude associate bird-life with the shooting season and bread sauce. But what real delight in bird-life – what belief in individual existence of bird spirits is there? Surely, it is most uncommon to find among men and women any signs of keen interest in animal life: for do not their own pleasures depend less and less on simple Nature, and more and more on Eiffel Towers, Infant Prodigies, and Mahatmas? In countless ways the decorator is hemmed in and hampered by the *Vox populi*.

We seldom hear now of the client sending for his decorator and instructing him to decorate his house or a portion thereof, limiting him only as to cost, but otherwise leaving him free to work to the best of his ability and for his own credit; but if this practice were revived, the decorator would be put upon his mettle, he would take a deeper interest in his work, and would carry it out with a unity of idea which might render harmony possible – good result meaning for him the foundation of a wide and honourable reputation: but now too often the decorator becomes a kind of head-foreman, who opinion is not always asked, and indeed is often scornfully rejected. He is expected to carry out the ideas of others, although he has probably spent his life in the study and practice of his craft. His client – often the lady of the house – does not consider this but will rather turn (fresh from the mysteries of millinery, and with a head full of notions begotten of Paris fashion books) to her daughters for counsel and suggestion. And the decorator, with his years of experience, has to stand patiently by and listen to verbose feminine dogmatism upon a matter to which in many cases his client brings neither knowledge nor aptitude, but often, what is worse, will quote canting little catechisms, and handbooks in defence of the views put forward.

Again. think of the hardships the decorator has to endure, who is at the mercy of the present generation of upholsterers, and furniture makers. Does not the presence in nine thousand out of every ten thousand houses of bastard French, German, Italian, English furniture of the Renaissance persuasion, foredoom the decorator's labours? Can it be possible to produce grace, dignity, repose or cheerfulness in the presence of such vulgar, ostentatious lumber? or when surrounded with the museum of useless and often gimcrack ornaments and nick-nacks?

We must not forget that only a few years ago Art was believed to belong exclusively to the picture and the statue; till at last the traveller returning home conceived the vain delight or displaying objects as witnesses or his extended culture and experience. Vulgar boastfulness and pride began the domestic museum: and there are to be found to this day often most exquisite examples of lovely design and workmanship in company with the very worst and most debased furniture and fittings about the house. These good people, who will often spend their

hundreds on curios, will go to any universal provider and purchase the typi-cal, hideous, carved coal-box, or a three-legged standard lamp with tiers upon tiers of silk petticoat and the like monstrosities. Will these people be induced by their decorators to put away some of their museums, and show their taste in the selection of their furniture and fittings? Truly under modern conditions the decorator's life is a very hard one. It is, as I said before, partly brought on by himself; by his immoral readiness to supply anything, do anything, and, in fact, be pulled by the nose by the public, for the sake of the pounds, shillings, and pence he can got out of them.

One of the difficulties we have to meet, and unfortunately, a very common one, is to be required to produce an effect, or series of effects. present in the mind of another and emblazoned by countless associations. Association plays such an important part in controlling and governing our taste that it is often very difficult to justify effects by reason; and the result of giving up reason and following the lead of association will often make us parties to unruly outrage against the funda-mental principles of artistic fitness. As, for instance. happy memories. associated with crude and ugly form and colour will quite blind our eyes and warp our judg-ment, and our affection at once goes out to those wicked forms that accompanied those happy moments.

Events in history, political, religious, and social bias all affect our taste to an extraordinary degree but are, in fact a most unsound foundation for it. Hence the never-ceasing importance of continual cross-questioning. Why do I like that? Why is this right, and that wrong?

If each will scrutinise his own taste in this way, the handbooks and articles on decoration will do less harm, and we shall all feel the danger of binding up our minds in old-world traditions as new-world theories.

The habit or presenting a scheme on paper accompanied by an estimate, and the ridiculous notion that any but an expert can judge of its ultimate effect before it is carried out, is all a natural outcome of the revivalism of this century. We hear too much about styles and the fashions which live and grow fat on them – as if decoration were capable of being dispensed like drugs from hieroglyphic pre-scriptions. A most admirable condition of things if men were automatic machines, without a semblance of emotional feeling or personal characteristic. But they are *not;* there is a depth of interest in every human creature natural and peculiar to him. And this individualism, I contend, should be made the foundation of all Art. Each man's productions will then depend largely on his personal character, and in that way possess a quality entirely his own, which no man can either give or take away. When this principle is recognised. the patrons of Art will generously give a fair field to the craftsman. and take pleasure in placing confidence in his pride and enthusiasm.

If the painter needs freedom to express the best in him, why not the decorator? Admit this, and the decorator is forced for the sake of his reputation, to study the artistic side of his craft, and to add the fulness of his nature to his life work; and in that way live a real life.

465

What a contrast such a state would be to the common treadmill struggle for money, which is robbing us of all healthy pleasure and pride in work, and is making beasts of men. If the craft of the decorator is raised from the position of commercial enterprise to that of an art, it will cease to be necessary for men to strain every nerve and fibre to advertise themselves. The modern system of advertising is degrading and pestilential, and the leading professions recognise this by obedience to the unwritten law against self-advertisement. And why? Simply because the reputation of a professional man depends so largely upon his personal character. It is this same quality of individualism which raises them from being mere vendors of materials to creators of human thought and feeling. Sculptors, painters, decorators, designers, and architects must join hands one with the other over a common object, not to make money out of each other, but to further artistic knowledge and feeling. For, surely you gentlemen could do much to use the skill and artistic powers of the picture painters and sculptors. Could not such a society as yours undertake among yourself to demand from the manufacturers metal-work designed by known sculptors of experience? For why should our door-furniture, furniture fitting, bell-pulls, letter-plates, and chimney-pieces be so deadly dull, vulgar, and degraded?

The arts of picture painting and sculpture are in a sorry plight, the reasons for which we need not here investigate. The fact remains the same, and so the sculptor must come down off his pedestal and learn architecture enough to co-operate with the architect in producing front doorways and fireplaces: and the painter must light his fire with his easel, and study from the same book as the decorator, and *vice versa*. Surely, men trained to appreciate fine line, colour, texture, light and shade, and composition, should be able to turn their faculties to good account in house painting and decorating, in fittings and furniture! Are not these the very qualities all decorators acknowledge they *most need?*

Often, when picture painters have tried their skill at decoration, the result has been appalling and hopeless. Still, I venture to say that their failure is due to a pre-conceived notion that they must follow some precedent – reproduce some decoration already tried. They fall back upon precedent and association, not having experience or practice in applying the rules of fitness and laws or beauty to anything outside a gold frame. Still, I cannot but believe that these crafts might be united with your own, to the common benefit of all, and that there are painters who might be induced to join hands with you in producing charming combinations or poetry, colour, and form in wall papers and tapestries, or in furniture daintily ornamented with colour.

There must be unity among you, and determination to use only the best you can get, rather than that upon which you get the most money profit: and I cannot but think that the true art-worker will not measure your commissions by the price you pay, nor demand the extravagant prices paid for pictures. In return for this you gentlemen must modify your commercialism, for it must be a loving sacrifice on all sides; or the reverse, which is selfish greed, will reign supreme, to the utter destruction of all true and lasting art.

I hope I am not expected to suggest a number of different plans and methods of decoration, and give you my opinion on them, in the manner or the handbooks on art, for in that way much mischief may be done. Theories are so satisfying and yet so unsatisfactory in practice: and I am more and more impressed by the difficulty, nay, the sin of trying to dogmatise about matters or Art. While I feel convinced in my own mind that it is right for me to do certain things, and not to do others, I feel it might be quite the reverse in many cases with other individuals. As each man's moral sense varies in detail and degree, so does our artistic sense vary, and, moreover, we are none of us in the possession of the whole truth. But in spite of this prefatory caution, there are some leading ideas which, if expressed, may result in very useful discussion. and so clear our reason and shed new light on the subject. Therefore, let us take a few ideas as they occur.

Say, the walls of ordinary living-rooms should be treated as backgrounds, subservient to pictures, furniture, and people, which, if admitted, inevitably leads to the conclusion that the utmost flatness is essential. This proposition at once puts out of court all those realistic flowery papers, in which there is a display of light and shade, and prospective of a naturalistic character.

These papers, we all know, sell better than any others, because their villainy harmonises with the brutality of the furniture and architecture which they accompany. By the same argument, friezes may be treated with less flatness, because they seldom, if ever, appear in the position of backgrounds, and are so separated from pictures and furniture as to call for specially interesting treatment.

Likewise, the ceiling is in no sense a background, and should therefore not be treated with any flat decoration suitable for a wall. And unless the room is very lofty and large, no decoration of an interesting and engaging character should be put there at all; or, let us say, unless the ceiling can be easily seen obliquely without straining the neck, no interesting ornament should be placed on it. This, of course, is mainly a matter of personal feeling, although I remember many fine old painted and plaster ceilings, to be seen in this country, the beauty of which, by-the-way, is due to their treatment and execution rather than to their position.

An additional reason for aiming at flatness in wall-coverings is to be found in the fact that any attempt at realism provokes comparison with nature, which is distressing in proportion to the beholder's appreciation of the subtle beauties or real life: whereas, in conventional ornament, the life of the designer is brought in, and should form a very living and additional attraction.

Nature has decreed that it is absolutely impossible to copy her in her completeness, and in this way has ruled that human work shall be creative in so far as it is a selection of some truths, some characteristics in the light of human thought and feeling. There are many subtle forms of imitation, and efforts to delude and deceive, against which we must earnestly struggle. In this category must be placed marble papers and graining, which in their origin were undoubtedly immoral; but it is questionable how far the use of such can he justified by the plea that the deception no longer exists.

Too little attention is paid to architectural proportion in these days, and the possibility of improving the proportions of rooms is often lost sight of. It is painfully common to find in an ordinary room, 18 feet by 21 feet or thereabouts, 12 feet high, a miserable border 10½, inches wide at the top of the wall, as it were creating a precipice. This room is as bad in proportion as it can well be; yet the chance of improving it by putting a picture rail and deep frieze is missed. It is, l hope, becoming more and more common to find doors, shutters, and panelling treated in one colour. and not picked out with contrasting colours or varying shades, or gold, to the utter destruction of breadth. The use of one colour, as you all know, produces a simplicity and a breadth which are an immense relief to the motley collection of forms and colours with which most rooms are crowded. Moreover, the common door and window shutter are not pleasantly divided up into panels. Like a long-bodied man with very short legs, the long panels are at the top, producing an effect the very reverse of that of dignity. so that to emphasize the fact by picking out the uninteresting machine-made mouldings, is an aggravation of one's sorrows.

Lastly, let us do our utmost to raise the colour sense from morbid sickly despondency to bright hopeful cheeriness. Crudity, if you will, rather than mud and mourning.

It is amazing that for outside painting, in large towns, people still paint their houses, as they would have them be, instead of several tones higher and brighter, to allow for dirt and age. Consequently, our streets are deadly melancholy.

Experience has led me to the conclusion that light, bright cheery colours, for outside work, wear better and *please longer* than more sombre hues.

Surely there is enough misery and depression in the world without adding to it by gloomy drabs and chocolate or dirty black greens.

One appeal must be made for the sense of repose. Let us not ignore the immense value of horizontal bands and lines, and the simple reposeful effects so produced. In this noisy world of angularity and turmoil we need all the peace and repose we can get in our homes. Simplicity in decoration is one of the most essential qualities without which no true richness is possible. To know where to stop and what not to do is a long way on the road to being a great decorator.

It is well to pay particular attention to this quality of simplicity. For it is more often than not scoffed at. We hear it on the lips in tones of disparagement, and many are afraid of it. For well they may be, as its presence lays bare the true qualities of things. Simplicity requires perfection in all its details, while elaboration is easy in comparison with it. Take what art you will, and you will find only that the greatest masters can be simple or dare to be simple.

As a matter of education, we ought constantly to strive for simplicity in all we do, and encourage it among our clients; and I am sure. if we do, there will grow up an appreciation of *quality* rather than *quantity*.

Let the several craft, unite in sympathy with and devotion to the one great aim of slaying the arrogant demon Commercialism, and then may we encourage each other to cultivate that self-reliance and self-sacrifice which will stimulate our efforts to pursue the noblest artistic ideals, regardless of ridicule and loss.

I can picture the vision produced in many minds by the contemplation of the individualism herein advocated. Th multitude of egotistic mannerists, the eccentricities insanities, and views of each individual having been let loose to romp and rave on the housetops and under the very nostrils of sober-minded modest people. What a ghastly pantomime it presents! But picture what abuses you will, the principle of encouraging the cultivation or all the faculties is a right principle, and one impossible to practise while Revivalism and Commercialism reign supreme.

## Notes

1 *The Builder,* 23 February 1895, p. 151.
2 Ralph Waldo Emerson, "Art" in *Essays by R.W. Emerson,* (London: Fraser, 1841), p. 265.

## 'CRACE COMPANY', *WYMANS COMMERCIAL ENCYCLOPÆDIA OF LEADING MANUFACTURERS OF GREAT BRITAIN*, (1888)

### Editorial Headnote

John Gregory Crace (1809–1889) was an English interior decorator and author. Part of the well-known Crace family that had been in the decorating business since 1768, Crace commenced work as an assistant to his father in 1825, working on projects such as the Royal commissions at Windsor Castle and Buckingham Palace. In 1830, he became a full partner in the family business

Crace travelled to Europe on occasion between 1825 and 1830, where he became interested in eighteenth-century French decorative arts. He was later appointed to decorate (along with Pugin) the interiors of the new Houses of Parliament. This association with Pugin continued when they decorated of the Medieval Court in the Great Exhibition of 1851. James Ward was supportive of Crace's work there. Writing in his comprehensive review of the displays in the Exhibition he noted that

> In this class [of English decorators] we may safely assume that Crace holds the highest position; though there are others, eminent in their peculiar styles, whose taste is equally conspicuous. Messrs. Crace were the first, we believe, who elevated decoration to a branch of the fine arts; for they alone, on an extended scale, have introduced order, harmony, and uniformity of character in their works.[1]

The rationale for the publication of the commercial encyclopaedia was explained in the preface.

> There has thus long existed an unsupplied demand for a Work which should prove a trustworthy Guide to Buyers, or in other words, which should bring under their special notice the productions of some of the best houses in different branches of industry. Such a work has been attempted in the present volume. In its pages will be found descriptive accounts of the business carried on by many leading firms throughout the United Kingdom, and of the specialties produced by them.

Only three furnishing businesses listed, these being Gillow, Crace, and Wylie and Lochhead (Glasgow).

This eulogistic commentary on the firm, its history and products is really an extended advertisement for the business, but it does help to give an idea of the scope and development of a high-end decorating business.

471

# 57

# 'CRACE COMPANY'

Source: 'Crace Company', *Wyman's Commercial Encyclopedialike of Leading Manufacturers of Great Britain* (London: Wyman, 1888), pp. 144–6.

JOHN G. CRACE & SON, Art Decorators, Wigmore Street, Cavendish Square, London.

The Firm of Messrs. Crace & Son have, for nearly a century and a half, held a leading position among decorative painters, without ever admitting a partner of different lineage within their circle.

Edward Crace, the founder of the business, was born in the year 1725, during the reign of George I. His father was Thomas Crace, described as "citizen and coachmaker" of Westminster, and his grandfather on his mother's side had been surveyor of Westminster Abbey. When about sixteen years of age, young Crace was bound apprentice to an artist, and he thus obtained a training well calculated to fit him for the business of house-decorating, which he entered upon in 1750. Two years previously he had been admitted to the freedom of the Painter Stainers' Company, and in 1752 he was admitted to the livery. A year or so later he married an artist's daughter, a circumstance which helps in some measure to account for the artistic taste which his descendants have displayed.

In those days James Wyatt was the leading figure in the architectural world, and about the year 1773, or a little earlier, he adapted the Pantheon, in Oxford Street, for dramatic performances. One of the principal tasks which Edward Crace undertook, and successfully accomplished, was the decoration of this building but perhaps better testimony to the reputation he acquired was his appointment, in 1780, to the responsible post of Curator of the pictures in the Royal Palaces. This important office he held for many years, until at length he died, in 1799, at an advanced age, and his place at the head of the Firm was taken by his son, Mr. John Crace.

Born in 1754 this gentleman had long been associated with his father in the business, although at one time a split had been brought about between them by the runaway marriage of the son. John Crace had then started on his own account. He was noted for energy and other desirable qualities, as well as for intense love of art. Among the great architects with whom he was contemporary were Sir Robert Taylor, Sir William Chambers, who built Somerset House, James Stuart, the well-known classic architect, and Sir John Soane, whose house and valuable collection of antiquarian treasures, bequeathed for the use of the public, are now

DOI: 10.4324/9781003290490-73

known as the "Soane Museum." Each one of these celebrated architects entrusted John Crace with important work, as did also George III. and the then Prince of Wales. Besides other public buildings, he helped to decorate the Opera House, Drury Lane and Covent Garden Theatres, and Carlton House. At the age of sixty-five he died, and was succeeded by his son Frederick Crace, grandson to the founder of the business. Under the superintendence of this third head of the Firm the uncompleted work at Carlton House was finished, and the celebrated Brighton Pavilion was decorated for the Prince Regent, afterwards George IV. A good deal of decorative work was done in Windsor Castle also during the reign of the last of the Georges, who apparently was well pleased with the manner in which Mr. Frederick Crace accomplished the task. Concurrently with the execution of these and other commissions for Royalty, the private connexion of the Firm rapidly increased, and the mansions of many of the chief among the nobility are indebted for much of their decoration and ornament to one or other of the Crace family. Mr. Frederick Crace was born in 1779, and died in 1859, at the age of eighty. From 1806 to 1812 he lived and conducted his business at 34, Curzon Street; but subsequently he resided out of town, while carrying on business at 51, Great Queen Street, in partnership with a younger brother. During the latter part of his life, he gave much of his time to forming a collection of maps and views of London and so important did this collection become, that, in 1881, it was purchased on behalf of the nation by the trustees of the British Museum.

About the year 1826 the business had grown to such proportions that the assistance of Mr. John Gregory Crace, the present head of the Firm, and son of Mr. Frederick Crace, was called in by his father. At this time, also, the Great Queen Street premises were relinquished, and fresh ones taken in Regent Street; but another move followed almost immediately, and the premises in Wigmore Street were then taken, which have ever since been occupied. Mr. J. G. Crace was born in the year 1809, and after 1826, in conjunction with his father, carried on the business for many years on the old lines. He began to perceive, however, that this country was not taking her proper position in the world of art; and in 1840 he determined to travel on the Continent in order to examine into the artistic styles and schools of Germany and Italy, as well as into those of France, with which he was already, to some extent, acquainted. In these countries he made a careful study of the best examples of art-work, both ancient and modern. On his return to England, he engaged the most skilful artists he could obtain, and commenced to carry out work of higher class than either he or others had previously attempted. English art was at that time in a very backward state, the British public were content with the most commonplace colouring and designs, – and to indulge in white and gold was considered the very height of aesthetic refinement. It will easily be understood, therefore, how great stir was created in art circles when Mr. Crace began to introduce French and other foreign ideas into his work. A profound impression was made on the minds of the cultivated classes, especially by Mr. Crace's decorations in the style of the early French Renaissance; and his ideas being taken up and his example followed by others, a great impetus was given

to the tendency, just beginning to show itself, to indulge in a more attractive and truly artistic style of decoration. The principal show-room in the Wigmore Street establishment was then decorated in the style just mentioned – that of the French Renaissance.

About the same time, also, Mr. Crace made an important addition to his business in the shape of a furnishing department. He had observed, what others must often have observed too, that when the decoration and the furnishing of a fine building are in different hands, the result is often far from satisfactory, owing to the want of harmony between the ornamentation of the building and the furniture. It was, therefore, a wise move on his part to bring together under one management the business of decorating and that of furnishing. Nor was he content merely to act as a dealer in furniture, and to select his goods from the stocks of other manufacturers which might not always be exactly to his taste. Accordingly, he started his own workshops, and began the manufacture of furniture that harmonised with his decorations.

In 1843 and following years several magnificent mansions belonging to the nobility were beautified by the taste and judgment of Mr. John G. Crace, who at that time was still but the junior partner in the business. Among these edifices were Chatsworth – the palatial residence of the Duke of Devonshire – and Devonshire House, belonging to the same family. The Marquess of Breadalbane also called in his services at Taymouth and in London; and among the many public buildings which the Firm decorated about this period may be mentioned St. James's Theatre.

Another tour to the Continent was undertaken in 1846, on which occasion Mr. Crace gave most of his attention to the restored Sainte Chapelle in Paris, and the chateaux of Blois, Chambord, and Chenonceux. The chateau of Blois was then undergoing repair, and he obtained permission to carefully inspect the designs and colouring of the decorations. On his return he gave the public the benefit of his tour of inspection, by reading before the Royal Institute of British Architects two papers containing the results of his travels.

No trifling distinction was conferred upon Mr. Crace when, in 1848, he was selected by the Government, on the recommendation of Sir Charles Barry, to execute the coloured decorations in those magnificent buildings beside the Thames at Westminster – the Houses of Parliament. His father who, as we have said, lived until 1859, was now becoming old; and the management and direction of this important and extensive work fell entirely to the lot of the son, Mr. John G. Crace. Under the influence of Pugin, with whom he became acquainted while engaged on this work, he began to be much interested in the "Gothic revival," and took the matter up in his hearty and thorough-going way. Nothing would satisfy him until he had mastered in detail the styles of decoration in vogue in the Middle Ages, and had applied his knowledge of those styles to the manufacture of furniture. Specimens of the medieval work which, with Pugin's aid, were turned out from the workshops at this time are still thought highly of, notwithstanding the general progress which has been made since then in the manufacture of furniture

475

in artistic styles. Of the many important buildings which the Firm were engaged in decorating about the middle of this century, we may mention a house in Hyde Park Gardens for the brother of Sir Robert Cockerell; the mansion of the Duke of Hamilton, in the Isle of Arran, of Sir Norman Lockhart at Lanark, and of the Duke of Devonshire at Lismore; Chirk Castle in North Wales; Sherborne Minster, and many other churches; Leighton Hall at Welshpool and to add another to the list of buildings which they decorated for the Duke of Devonshire – the mansion belonging to that nobleman at Chiswick.

We are now arrived at the time of the Great Exhibition of 1851, in promoting which Mr. John G. Crace was one of the first to take an active part. In conjunction with Pugin he decorated the Medieval Court; and, along with Lord Ashburton, Mr. Jackson, Mr. Webb, Mr. Snell, and Mr. Aubert, he was deputed to adjudicate on the furniture and works of decoration in the Exhibition. His name was included also on the list of Special Commissioners. On the removal of the Exhibition buildings to Sydenham, where they have since been known as the Crystal Palace, Mr. Crace was selected as one of the architects to superintend the internal adornment of the structure and it was he who designed the Queen's private apartments in the building, which, unfortunately, were afterwards destroyed by fire. Two or three years after the date of the Great Exhibition, he was commissioned by Prince Albert to furnish a suite of rooms in Windsor Castle, set apart for the reception of Napoleon III. and the Empress Eugénie during their visit to the Queen. While this work was in hand, Mr. Crace had the misfortune to be taken seriously ill; but even when laid on a bed of sickness and in danger of losing his life, he continued to make the necessary arrangements for the furnishing and adornment of the royal apartments. By this time his son, Mr. John Dibblee Crace, was old enough to take some share in the business; and, with the help of his son and his aged father, Mr. J. G. Crace was able to get through the work he had undertaken.

In 1857 the "Art Treasures Exhibition "was held in Manchester, and Mr. Crace was engaged to design and execute the coloured decorations for the building. Some three or four years later, Prince Albert, who had been specially struck with the Manchester decorations, again secured his services to beautify the "Waterloo Chamber," as the great banquet-hall of Windsor Castle is called.

In 1859, when the Great Eastern was nearing completion, the decoration of the saloon of that celebrated vessel was entrusted to Mr. J. G. Crace. The greatest care and skill were bestowed on this work. While the vessel was on her trial trip, a terrific explosion occurred on board, which caused much loss of life, and utterly wrecked the magnificent saloon so tastefully decorated by Mr. Crace. He himself on this occasion very narrowly escaped with his life.

It was in this year, 1859, and within a few days of the explosion on the Great Eastern, that the aged Mr. Frederick Crace breathed his last. In the same year, also, Mr. J. D. Crace, then quite a young man, undertook a journey to Italy, for similar objects to those which had taken his father, Mr. J. G. Crace, there. He carefully studied the Italian styles of art, and brought back with him fresh ideas and

numerous sketches, as the result of which there has been a touch of the fine Italian character about the work of the Firm since that time.

The important buildings on which the Firm have been engaged in recent years are far too numerous to be all mentioned here; but among them we may name Bestwood, belonging to the Duke of St. Albans; Ickworth, the seat of the Marquess of Bristol; Longleat, the seat of the Marquess of Bath; the Mercers' Hall; and Grosvenor House, belonging to the Duke of Westminster. They have also done notable work for Viscount Gough, Sir John Amory, Mr. Snowdon Henry, and many other gentlemen of distinction. The fame of the Firm, which has lasted through so many generations, is to be attributed to the great artistic judgment, administrative ability, and care for detail which the members of the Crace family have so persistently exhibited. Mr. John G. Crace is now advanced in years; but the son, Mr. J. D. Crace, has abundantly proved his ability as well as his determination to conduct the business in such way as to sustain the reputation of his ancestors. His latest work is the decoration of the new rooms and Grand Staircase of the National Gallery, now about to be thrown open to the public.

## Note

1  J. Ward, *The World in its Workshops: a practical examination of British and foreign processes of manufacture, with a critical comparison of the fabrics, machinery, and works of art contained in the Great Exhibition*. (London: Williams S. Orr and Co 1851), p. 171.

# Part 9

# ROLE OF RETAILERS AND PURCHASING PRACTICES

# ROLE OF RETAILER AND PURCHASING PRACTICES

Important retail and contract furnishing businesses in many major cities offered full house furnishing and decorating services and were responsible for many interiors during the nineteenth century. During the second half of the century, department stores also began to offer similar services to a less affluent group of consumers.

The retailer's role, not only as supplier but also as arbiter and advisor, was only gradually usurped by the rise of the decorators, of amateur specialist advisors and professionals. Only when these advisors became consultants rather than trades-people did the process of change from retail control to the professional interior designer begin.

The influence of retailers on the nature of house furnishing is evident in a study of trade catalogues and estimates. It is clear that there was a hierarchy of designs (based on cost) designated as appropriate to particular rooms: for example, the rococo revival for parlours, gothic style for dining rooms, and renaissance for libraries and so on. What is also interesting about the various company estimates is that they illustrate a considerable homogeneity of styles across financially vary-ing levels and house sizes that were deemed appropriate for typical life-styles, thus endorsing the idea of a common understanding of an established taste.

Interestingly, in 1869 the *Building News* suggested that:

> The best and most truly economical plan for anyone about to decorate and furnish is to go to some respectable house combining both branches, give an idea of what he likes (having an estimate if he wishes) and wash his hands of the whole till it be finished.

Even so there were distinctions. The article went on to say

> it will generally be found advisable, when anything beyond simple paint-ing and papering is intended, to employ men whose prime business is that of decoration rather than upholsterers who have added decoration to their original occupation, for it requires a much higher art-education to produce a good decorator than a good upholsterer.[1]

DOI: 10.4324/9781003290490-75

The distinctions were important to this journal and the role of education as a characteristic of a profession was already clearly indicated. This education was not only in terms of interior work but was also related to the understanding of the client and their needs, wants and aspirations.

In December 1900, an article *in The Illustrated Carpenter and Builder* pointed out that

> Until recently when a man wanted to furnish, he would visit all the dealers and select piece by piece of furniture. Today he sends for a dealer in art furnishings and fittings who surveys all the rooms in the house, and he brings his artistic mind to bear on the subject.[2]

This set of comments looks like an acknowledgement of the growing professional status of the interior decorator/designer or indeed the retailer who could rise to this demand.

## Notes

1 *Building News*, 12 February 1869, p. 143.
2 *The Illustrated Carpenter and Builder*, 7 December 1900, Supplement, p. 2.

# M. B. H. *HOME TRUTHS FOR HOME PEACE, OR 'MUDDLE' DEFEATED, A PRACTICAL INQUIRY INTO WHAT CHIEFLY MARS OR MAKES THE COMFORT OF DOMESTIC LIFE. ESPECIALLY ADDRESSED TO YOUNG HOUSEWIVES* (1854)

## Editorial Headnote

*Home Truths* was first published in 1851 by the anonymous female author M. B. H. The book was clearly successful, as it went into six editions between 1851 and 1854. The dedication was clear as to the book's audience: 'To the young wives and housewives of the middle classes; this attempt at the exposure and destruction of their most insidious and deadly enemy, is affectionately dedicated and inscribed, by their sincere friend, the author'.

This extract considers the issue of furnishing a home.

See also text 1.17.

# 58

# HOME TRUTHS FOR HOME PEACE, OR 'MUDDLE' DEFEATED, A PRACTICAL INQUIRY INTO WHAT CHIEFLY MARS OR MAKES THE COMFORT OF DOMESTIC LIFE. ESPECIALLY ADDRESSED TO YOUNG HOUSEWIVES

## M. B. H.

Source: M. B. H. *Home Truths for Home Peace, or 'Muddle' Defeated, A Practical Inquiry into what Chiefly Mars or Makes the Comfort of Domestic Life. Especially Addressed to Young Housewives* (London: Longman, Brown, Green, & Longmans, 1854), 6th Edition, pp. 78–85

So many various circumstances must regulate the furnishing of the residence of each young housekeeper, that any attempt at *particular* directions would be useless. But the following general observations made in different families of the class for which I am writing, and approved by their practice and experience, will, I trust, be found acceptable.

*Let all the articles of furniture with which you begin housekeeping be strong, – well-seasoned, – as elegant as is compatible with strength –, not too large; such as are easily moved, easily cleaned and dusted, and suitable to the places and purposes for which they are intended. Prefer having enough plain things, to being scantily supplied with fine things; and, as a rule, choose such articles as will not only be of the most use, but will require the least care, and, consequently, give the least work.*

These suggestions of common sense are but too frequently disregarded, and that, under manifold pretences, Some account for the unsuitable size and costliness of the furniture in their miniature abode, by the hope and expectation of "not *always* living in such a band-box;" others excuse the obvious extravagance they have committed, by the consideration that, *if* they did not get such things at *first*, they should certainly have no money for them afterwards; – and thus, many remain encumbered and out of pocket, the whole of their married career, by purchases which need an apology to themselves and others, as often as they are felt to be in the way and out of place, that is to say, *continually*.

DOI: 10.4324/9781003290490-76

To the *uncertain* expectants of a more considerable establishment, I would suggest, that, as the largest furniture with which it is practicable to cram a "bandbox," will be insufficient to fill or to adorn a mansion, and taking a *larger house* can only be a salutary measure, with the larger income that would allow of fresh purchases suited to its dimensions, – it is much wiser, in the meantime, to be contented with such things as, whilst they would not look amiss in the smaller rooms of a more spacious dwelling, will leave their possessors space to move in, and air to breathe, in the "band-box" to which they are at first confined. For those who, acknowledging the unsuitableness of their furniture to their *present* condition, as well as to their *future* prospects, were anxious *to make sure* of this disadvantage whilst they could, there is nothing but the trite observation that "there is no accounting for taste." I would, however, recommend all who prefer room in their houses, money in their purses, and good sense in their understandings, *not* to follow their example.

An opposite, but equally unfortunate, mistake is theirs, who, with the intention of "getting better some day," and, under the impression that anything is good enough for "a first turn in," – throw away the money that would have procured them lasting comforts, on ill-made or veneered furniture, and transparent druggets, the freshness and availability of which scarcely survive the honeymoon, – whilst the day of procuring "something better," suffers an indefinite prorogation.

Housekeepers who furnish in the spirit of the observations at the beginning of this chapter, will avoid both extremes. Should increasing means allow them to occupy a larger house, the chaste and solid furniture with which they began housekeeping, will be no discredit to the new establishment; or, if sold, will fetch a reasonable price in most markets should they, on the other hand, remain in their first abode, that which was useful and suitable originally, will continue to be so still; each year that takes something from its fashion, will add to its value and associations; and if a well-deserved compliment is bestowed on its freshness or durability, the owners may reply with innocent exultation, "We have had it ever since our marriage, and have never regretted the money that it cost us." The fact is, that *good thing*s cannot be made for nothing, even in these days of miraculous cheapness, and that, especially in the article of furniture, "the dearest is often the cheapest in the end," and "*vice versa.*"

The following remarks, in regard to some of the most essential articles in daily use, may be found useful to the inexperienced.

TABLES. – Tables with drawers take no more room than tables without drawers, and drawers, in these closetless times, are more than ever needed and acceptable; it is well, therefore, to have drawers in the greater number, if not of all your tables. Even where they are shallow, they will be useful for papers, a table-cloth, etc.; and for *some* purpose or other, they will be constantly voted *comforts* by most persons. The want of drawers in toilet-tables or in wash-stands, is a great impediment to tidiness in a bed-room, or comfort in dressing: as anyone who has encountered the pink petticoated dressing-tables in sea-side lodgings, will

easily comprehend. Where there is a lady's-maid to set out a toilet, or to pack and unpack a dressing-case, the inconvenience of the petticoated table may not be felt; but for the numbers who must wait upon themselves, the having comb and brush at hand, and being able to screen them from dust and observation, as soon as they are done with, will be found highly desirable.

For the many housekeepers whose small sitting-rooms open one into the other, and who seldom or ever give dinner parties, two oblong tables of similar and moderate dimensions, that might be used *together*, if requisite, and will look well *apart*, generally answer better than the expensive *sets of dining-tables*, the rarely used parts of which have to be carried up and down, and which, if not in constant use, are often put together with consider able difficulty, and not more easily separated. A third smaller table of the same height and width, but half or one-third of the length of the larger, will be most available for an additional guest; and when not wanted to serve the purpose of an extra flap at dinner, may be useful for something else. Three such tables, that may be joined together in different ways, or employed separately, will likewise be more readily disposed of than others, should a change of circumstances demand a change of furniture, and this is also a consideration.

Although rather in anticipation of the requirements of future years, I cannot forbear mentioning what is so valuable in a large family of little children, A LOW FIRM TABLE WITH FOUR DRAWERS, in which slates, pencils, and pictures may be kept by each young proprietor, and which may serve for their amusement and occupation on rainy days. Such an article, either in a regular or irregular nursery, will tend greatly to their happiness and comfort, and save them from their unsteady and uncomfortable position at the tables of the "children of a larger growth," where, with dangling legs and sprawling arms, the poor wee men and women, in their eager struggle for light and room enough, generally end by knocking themselves or their contemporaries over, and sometimes by being dismissed as nuisances by their unsympathising seniors, who, with feet floor-rested and their arms at liberty, have not "the most distant notion what upon earth can make these *little things* so troublesome." At a table suited to their dimensions, some of the hours during which the poor "little things" might be annoying or annoyed, will be the happiest of the twenty-four. A table for four will suffice in most families, as it is to be hoped that when that number is exceeded, number one may be already promoted to the bigger table, with a footstool, whilst numbers six, seven, or eight can hardly be candidates for any intellectual sedentary employment whatever. At a "little tea or dinner," such a table always *stretches, or else* the largest guests will shrink to its proportions.

The pretty compact CHIFFONIER of modern days, is a great improvement upon the heavy and expensive sideboard, which I can remember as taking up so considerable a portion of many a small dining-parlour, or, rather, living-room. In some of its numerous varieties, the chiffonier will be found amply sufficient for the daily use of those for whom I am writing, and will ornament many a recess, in which no sideboard could be placed.

For those who employ their bed-room otherwise than for repose and dressing, and who are, consequently, in want of a table, etc., therein, there is no piece of furniture so available as the old-fashioned BUREAU, with its commodious drawers below, and its invaluable partitions and pigeon-holes above; its table-flap let down or put up at pleasure, and its chief treasures thus covered up and secured at the shortest possible notice, and with the least possible trouble. Especially in the apartment of single brothers or sisters, is something of this kind an inestimable comfort; and if any young lady, who cannot command a modern *sécrétaire* on her marriage, is requested by her grandmother to accept of one of its respectable predecessors, I do not think she will ever regret giving house-room to what, in all the changes of taste, must certainly be *useful*, and, in *some* of them may, under the name of "rococo", become *the very height of fashion.*

In these days of general luxury and convenience, a sitting-room without a sofa for the lady and an easy chair for the gentleman, is so rare an exception, that it would be almost superfluous to recommend them where they can be procured.

But supposing these articles are matters of course in the sitting-room, I would suggest to persons who have to purchase *everything* new, that whilst extra *chairs* in a *bed-room* are rather in the way than otherwise, A SIMPLE COMMODIOUS COUCH is, on many occasions, especially in illness, when a nurse must sleep in the room, of the greatest comfort and utility. A frame of cane, or even of wood, and a separate mattress and bolster, are all that is requisite; and, covered with chintz or dimity, such a couch will not only be a most convenient, but a pretty piece of furniture.

Anyone acquainted with the superior warmth, lightness, and durability of the EIDER-DOWN COVERLET or "DUVET," will readily adopt it, in preference to additional blankets. Time was, perhaps, when English prejudices would have revolted from lying "under a feather-bed," as the untried *duvet* was designated; but since John Bull has resided so much abroad, he is fain to confess, in his more candid moments, that in the items of bed and bedding, *some* of his continental neighbours have the advantage of him, and that, as regards both cleanliness and comfort, his children might, in some few particulars, take useful lessons from them. The eider-down coverlet, which is so portable, so easily purified by exposure to the air and sun in summer, and so efficient in winter, will not only give the warmth of *several* blankets, but, when contemporary blankets are worn and discoloured, will be as warm and as good as ever, and no despicable possession for posterity.

Housekeepers, who set little value upon occasional display, but have, on the contrary, a great regard for habitual convenience and equanimity, will never cumber their closets or their consciences with a second or *best* set of china or dinner-service. The china and earthenwares in common use are now so pure and even elegant, that the most fastidious guest could hardly demand anything better than what serves the family in general; so that consideration for our company is needless. There being but *one* set, will insure its being treated with more respect by the servants; and, as the chief fractures to which treasured cups and saucers are liable,

488

occur in getting them down and putting them up again – and the most valuable is ever the most unlucky – the services which are always "out," and which may be easily replaced if broken, are, consequently, much less liable to accident than all which cost a "mint of money, and cannot possibly be matched in town or country."

Stronger ware, then, for the kitchen, if you please; but, unless you have a *careful housekeeper* instead of a *careless housemaid*, do not add useless and expensive breakables to your possessions.

Besides the larger and more obviously necessary articles of furniture, there are many small objects and implements wanted in a house and garden, such as hammer, sieve, garden tools, etc. etc., which young housekeepers would do well to procure at first, so as to avoid the singular and inconvenient borrowing-system not unfrequently maintained in regard to such trifles. Mutual and neighbourly assistance on rare and unexpected emergencies, is both allowable and pleasant; but to be always: "on the parish"[1] for corkscrews, spades, and hammers, is certainly unbecoming in persons who "have two gowns, and everything (apparently) handsome about them."

In conclusion, I would recommend all about to furnish a residence for themselves, to profit by the experience of others, to procure what they know will be serviceable and comfortable, and to avoid whatever is likely to be felt a mere encumbrance.

NOTE. – Petticoated tables may be contrived so as to furnish a roomy bag, fixed in a sliding frame, and calculated to hold bonnets or light things; but they are not agreeable to sit against.

## Note

1 Informal word for being inadequately supplied: from the practice of receiving charity from local authorities.

# JOHN V. HOOD, 'AN ART ROOM', (1887)

## Editorial Headnote

This article is a description of the showrooms of the antique dealers Bailey, Banks and Biddle who started business in 1832 in Chestnut Street, Philadelphia. Initially, the partners were Joseph Trowbridge Bailey and Andrew B. Kitchen. They were manufacturing and retail jewellers and silversmiths but also sold a wide range of luxury domestic goods including furniture, porcelain and bronzes. In 1878 J. T. Bailey's son, Joseph Bailey II formed a new partnership with George Banks and Samuel Biddle thereby creating the new name of the company.

The firm produced their own in-house journal – *The Connoisseur Bailey, Banks & Biddle's Illustrated Quarterly of Art and Decoration* – that was first published in 1886 and ceased publication after ten issues in 1888. Their own advertorial explains the raison d'être for the publication:

> The CONNOISSEUR is edited with a view to securing the interest and support of the intelligent general reader avoiding equally the tendency of many of the costly foreign art-publications to be too technical for those not professionally devoted to art, and the fault more usual in this country of fostering amateur work without proper discrimination. While encouraging American artistic progress, it will lay before its readers only the best on the subjects within its range, which will embrace painting, sculpture, interior and exterior decoration, art metal-work, glass, ceramics, and bric-a-brac generally, wood-carving, book making and illustrating, jeweling, art needle-work, etc.[1]

John V. Hood was a late nineteenth century American art critic about whom little seems to be known. Hood wrote articles for the journal on a variety of topics related to the firm's business. These included 'Modern Silverware', the 'Art of Bronzes', 'Precious Stone' and 'The Art of Jewelling'.

With its emphasis on the role of colour and sparing layout, this essay tries to teach the reader some basic principles of interior design practice. The staged photograph of the interior shows a range of antiques and art works with an apparent emphasis on ceramics and furniture.

See also text 1.60.

# 59

# 'AN ART ROOM'

## John V. Hood

Source: John V. Hood, 'An Art Room', *The Connoisseur*, 2:2, 1887, pp. 80–5.

In proportion as a higher culture is banishing the old weakness and passion for large instead of home-like houses, and simplicity and chastity are being substituted for flashy exterior ornamentation, so in the decoration of the interior of American houses the same changes are noticeable, and warm and cheerful colors are found taking the place of meretricious and glaring designs, which attract only by the bizarre effects that they produce, and leave behind them no impression of harmony and completeness. It is the fashion to date this renaissance in decoration back to our Centennial year; but, although the great object-lesson which was then set up in our midst had an effect in influencing our artistic taste, the true reason is undoubtedly to be found in the working out of the process of natural development. The changes which have taken place in our methods of education, freedom from the tyrannical rule of precedent and tradition, an earnest desire to train the eye and the hand as well as the purely mental faculties, and by that technical training to direct into the channels of the various arts and industries the activities of intellect which were at one time allowed to operate chiefly in literature, in science, and in utilitarian inventions, have all had a share in raising the standard of household art and decoration, and in making the dwellings even of those not wealthy, but belonging to the great producing classes, homes in the truest sense of the word.

It has been said that if a man wishes to gain some knowledge of a language other than his own, he can do so simply by reading and re-reading the pages of one book written in that particular tongue, so that in the end their meaning sinks into his mind, and he begins to comprehend somewhat of their significance. It may also be safely said that a knowledge of art can be gained after the same fashion, and without the education of the schools. A constant contemplation of great statues and pictures, of marvellously moulded bronzes, or of porcelains the tints and textures of which range from Tyrian purple to the delicate beauty of the rose, and from the iridescent blue of the sky after rain to the changing green of grasses and of leaves, must have an effect in developing the color-sensations, in increasing their activity, and in preparing the eye for a better realization of what constitutes beauty and harmony. Looked at in this light, the tastefully arranged windows of every store, each exhibition of painting and sculpture, and even the casual glimpse which the passer-by may

snatch of a well-lighted interior, with its warmth and richness of color, the artistic disposition of its furniture, and the harmonious juxtaposition of dissimilar things which blend by contrast, is a lesson which will prove valuable, not in creating, but in widening our knowledge of color-effects and tones.

The natural weakness of almost everyone who first begins to attempt the carrying out of any plan of interior decoration is to overcrowd, just as a young and ambitious poet will burden his lines with a redundancy of metaphor or imagery, forgetting that real effect can be reached more by delicate and subtle suggestions than by direct appeals either to the eye or to the brain. The danger in succumbing to this weakness lies in the fact that the contrasts thus produced are apt to be too sharp and well defined, instead of having the appearance of gradually melting, so to speak, into one another and forming a united whole. Any person who has ever analyzed his color-sensations will readily admit that his greatest pleasure is due to tonings, markings, gradations, and cloudings, which are essentially variations of darkness or of light. When once, therefore, this weakness for overburdening the eye by too much massing of separate and distinctive colors has been overcome, the way is clearer for indulging in the carrying out of bold effects in shading and for exemplifying ideas which, even if striking and original, do not violate any of the well-established and accepted canons of art. And besides this it should never be forgotten that a certain artistic carelessness and naturalness in arrangement will charm more quickly than can any labored effort at detail, and that, to use the lines of old Robert Herrick, such things

"Do more bewitch me than when art
Is too precise in every part."[2]

No better illustration could be afforded of the soundness of these principles and their application to the decoration and art-furnishing of homes than the art room which now forms a part of the establishment of Messrs. Bailey, Banks & Biddle, in this city; and that innovation on commercial methods is here referred to because of the possibilities which it suggests, and the influence which a careful study of it is certain to have on a rapidly growing artistic taste. The first thing in it which strikes the eye is that, even with the widely varied character of the surroundings, there has been no attempt to subordinate any one of the art-objects to the other. Each is presented as a type of a certain era or school; but, although thus individualized, all of them are merged into one complete whole, the mechanical side of the plan of design not being apparent, while the artistic side is revealed in its full beauty. The background, on the color and arrangement of which so much depends either in painting or in decoration, has been touched with so skilful a brush and with such harmonious colors that the foreground, while it stands out in bold relief, takes on changing hues from the applied and natural light, and is seen to be rich in the most varied and delightful effects. These color-effects thus harmonized influence the eye just as the color-tones of an exquisitely balanced orchestra affect the ear. In the one case the deep diapason of the brasses and the mellow notes of the woods form a tone-picture, the beauty of which is added to by the deli cate broidery of the violins; in the other, the massive beauty of bronze is shaded by the delicate radiance of porcelain, while the rich warmth and

glow of rugs and hangings are tempered by the colder and more neutral colors of the carver and designer in wood and leather. The La Barre vase, with which readers of THE CONNOISSEUR are familiar, is of itself a gem, the softest effects being produced by the painting of the figures on pate tendre instead of on hard glaze, so that the flesh seems almost to yield to the touch of the finger. There are also two porcelain vases, exact reproductions of those which were made for Louis XV. to commemorate the battle of Fontenoy, and which were purchased at the Double sale by the Duc d'Aumale. The paintings on them represent incidents of the battle. Here is a reproduction of a Louis XIV. escritoire, with porcelain panels and Watteau painting; there, a dark-browed Judith in bronze, with a grim resolve on lip and in eye; nearby, a cabinet filled with the smallest of designs in ivory and Dresden; plates with a cream colored and jewelled border, the white centre adorned with a painting as rich in colors as if it came from the brush of a Turner or a Claude Lorrain; Crown Derby with designs built up on successive layers of gold; Royal Worcester which imitates ivory; onyx, the parti-colored veins in which catch the tints that flash from masses of color glowing on every hand; and, above all, a beauty and a harmony pervading the atmosphere, which come not from a single object, no matter how pure and delicate, but from the suggestion of perfect art which the eye obtains in its grasp of all. If it be argued that the standard here set up is too high to reach, it may be answered truthfully that the higher the ideal the greater the room for development. Nothing but the best and the fittest in art will live; many may only be able to nurture a single rose, while others can build for themselves a conservatory; but it is through an adherence to the principle of beauty that the love of art will grow until it goes with us in our daily duties and makes the world brighter and purer.

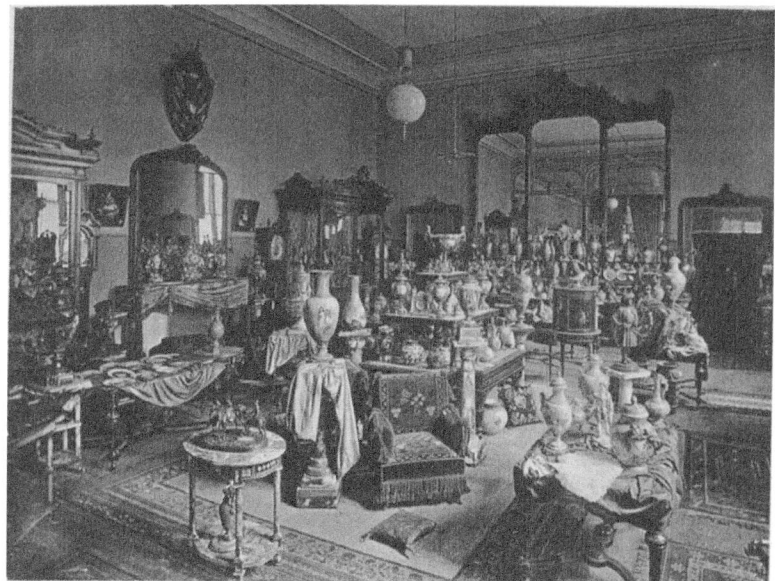

MESSRS. BAILEY, BANKS & BIDDLE'S NEW ART ROOM.

# Notes

1 *The Century Illustrated Monthly Magazine*, 1887, p. 14.
2 Robert Herrick, 'Delight in Disorder", 1648.

# R. RIORDAN, 'A VISIT TO BAILEY, BANKS & BIDDLE'S ART ROOMS' (1888)

## Editorial Headnote

This second article on the showrooms of antique furnishers and decorators, Bailey, Banks & Biddle's emporium in Philadelphia is again published in their in-house journal *The Connoisseur*.

The tone and the references in the text confirm the audience as being the 'intelligent general reader' as there are numerous classical and art references therein. In addition, there is a theme that 'everything in the interior furnishings of a house should be in accordance with women's tastes, [and] should be adapted to feminine manipulation'.

# 60

# 'A VISIT TO BAILEY, BANKS & BIDDLE'S ART ROOMS'

## R. Riordan

Source: R. Riordan, 'A Visit to Bailey, Banks & Biddle's Art Rooms', *The Connoisseur*, 3:2, 1888, pp. 61–73

At No. 53, Boulevard Montmorency, is a house which may be distinguished at a distance by the medallion, in gilt bronze, of Louis XV. inserted in the iron-work of its balcony. Some passers-by look upon the medallion with an evil eye, but we have the proprietor's word that no political preferences are expressed by it; that it simply denotes his taste for the artistic productions of the eighteenth century, with which the house is filled.

It is the residence of Edmond de Goncourt,[1] the man who of all others has done the most to bring the industrial art of the last century into vogue once more. From its door, surmounted by a grille in wrought iron, to the last landing of its stairs, it is packed with terra-cottas, bronzes, and porcelains of the "siecle aimable par excellence," of the period of the Pompadour and of Marie Antoinette, the time of Clodion and Gouthiere, of Boucher and Watteau; when, it may be truly said, Art first became domestic, and turned from public and semi-public functions to the appropriate adornment of the houses of ordinary citizens.

This was, above all things, a homage to woman, and shows that the gallantry of the time was not wholly superficial for the male of the period was very seldom to be found at home, and, so far as his own gratification was concerned, had little reason to care about its decoration. Woman's taste reigned supreme. It was for her, and in great measure by her, that all these charming things were designed; and she succeeded in creating the most beautiful style of interior decoration (its purpose considered) that has ever been imagined; a style which, after an interregnum of masculine bad taste, is now again paramount throughout the civilized world.

This art of pre-revolutionary days, of which our own colonial style was the faint and distant echo, was born at a lucky moment. Pompeii had been laid bare, and sufficient was already known of the true classic principles to disgust people. with the rigidity and pomposity of the style of Louis XIV. and with the meaningless contortions of the Rococo. Japan and China had already sent much of their most beautiful work westward, and it had been imitated in a hundred manners. But the

DOI: 10.4324/9781003290490-78

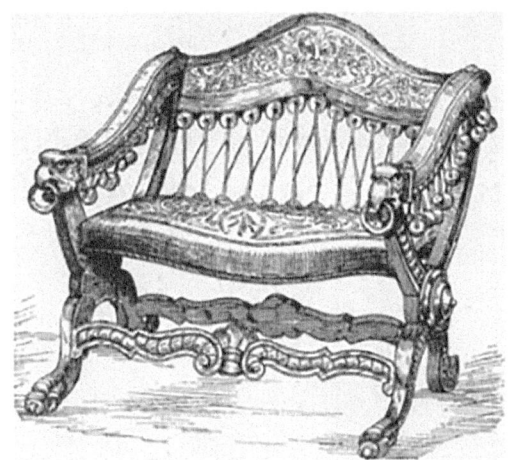

CARVED LEATHER CHAIR IN THE ART ROOM.
From model in Munich Gallery.

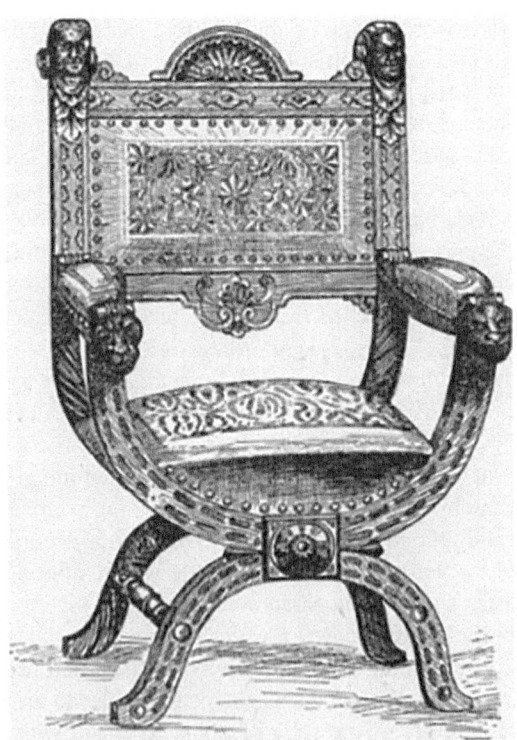

CARVED LEATHER CHAIR IN THE ART ROOM.
Both leather and wood carved by hand. In the style of pieces in
the Historical Furniture Collections of the Munich Galleries.

spirit of the age was too strong to be subdued to mere imitation. No one thought of copying for mantel-ornaments the friezes of Roman temples, or of designing carpet-patterns after Japanese foukousas,[2] but from every source were absorbed new ideas of the beautiful, to be expressed in original work bearing the stamp of the time and of the nation. Nothing has since appeared to supplant it permanently. The heavy Empire style, the weak and uncomfortable Victorian Gothic, have had their day and disappeared. Not all the efforts of the dealers in modern antiques can bring them in fashion again. But there is not of our day who does not draw inspiration from the things of the last century. In regretting the past and in gathering up its vestiges the connoisseur of the Boulevard Montmorency has done better than he knew. He has not merely set the fashion for collectors, but for the world at large. So that now, were a chevalier or a marquise of the old régime, Lafayette or a Rochambeau, or any of the fair Philadelphians of their acquaintance, to return to this planet and their accustomed haunts, they would find things less seriously changed, as regards the pleasure of the eyes at least, than twenty or even a dozen years ago.

Descendants of these last, inheritors of their tastes, well know where they may find the means of beautifying their homes, a need now become common to both sexes. In the art rooms of Bailey, Banks & Biddle there is gathered the largest and best-selected stock of objects for home decoration in Philadelphia. Some of these are copies of eighteenth-century models, such as the Fontenoy vases, the originals of which cost the Duc d'Aumale, at the Double sale, 150,000 francs, and the splendid eighteenth-century table, inlaid with porcelain medallions of Louis XVI. and the ladies of his court.

THE FONTENOY VASE
In Sèvres pâte tendre, executed in duplicate for King Louis XV. on the occasion of the Fontenoy victory. The medallions represent episodes of that celebrated battle. An artistically executed facsimile pair is shown in Messrs. Bailey, Banks & Biddle's Art Rooms.

Others, while not direct copies, are full of the charm of the style. Here are cabinets in vernis Martin, half-round, oval, rectangular, triangular, mounted with chiselled and gilt bronze, painted with Watteau like groups, and filled with rare and costly bric-a-brac. There is a collection of miniatures, on porcelain and on ivory, of powdered, patched, and painted beauties. Here, again, is a lot of Dresden figurines, charming little shepherdesses, and yet more charming gallants, the delight and the solace of the late Mr. Vanderbilt. And in another case are East Indian figurines in Worcester ware, equally animated, but much more sober in color.

But this gives hardly an idea of the variety of objects and of styles, of shapes and colors and materials, all, nevertheless, brought into harmony by the one prevailing idea which we moderns have borrowed from the eighteenth century, the idea that everything in the interior furnishings of a house should be in accordance with women's tastes, should be adapted to feminine manipulation. No sharp angles, no discordant colors, no forms too heavy or too rude. From end to end of the rooms this idea rules. Whether one listens to the musical chimes of the tall, old-fashioned clocks in carved oak or mahogany cases, or examines the sets of table-ware in rich blue and gold Crown Derby, or in Doulton ware specially decorated with floral designs of poppies, arrow-heads, and brambles, or Minton game plates, painted by Mussill[3] with pheasants, grouse, and kingfishers, or admires the novel combination of Mexican onyx and Limoges enamel in some mantel-ornament, or the pleasant contrast of celadon ware and gilt bronze in a library inkstand, the same influence is everywhere apparent. Within the prescribed bounds there is no end to the variety; but it never oversteps these bounds. One may even come upon a Rococo clock in ormolu and pink marble, but its curves are not so extravagant as usual or an example of the Empire, in gold and onyx, but it has somewhat of the unexpected grace of a design by Prud'hon.[4] One of the crazes of the Empire, that for tall lamps "a la Romaine," developed and modified to meet modern requirements, is fully exemplified. There are perhaps a dozen different styles, in iron, old silver, bronze, with shades of porcelain or opaque or opalescent glass, or – latest Parisian fantasy – of silk and guipure. Here are Renaissance aiguières and snuffboxes of the Directory, flambé ware from the Royal Berlin factory, and colored bronzes by Amaties[5] and by Picault,[6] but not an object which is not sure to be especially pleasing to women.

In a charming little book, which should be in everybody's library,* the genial litterateur, best known, perhaps, as Bachelor Bluff, points out that good taste is as much within the reach of modest as of liberal incomes.

"But" he adds, "let me not be misunderstood. Nothing can be done worthily without some money. Let no man or woman put trust in the devices set forth in various books, under the name of household art, by which inferior things are made to put on the seeming of better things." To make a house pretentious by means of shams, he hints, were easy enough; but trickery is not art, and the only

---

* Oliver B. Bunce. *My House: An Ideal.*

ROYAL BERLIN PORCELAIN VASE.
In same time as vase shown on page 89, the two being the original and only ones executed by the Royal Berlin Porcelain Works for the Munich Exhibition, 1888. Also owned by Bailey, Banks & Biddle, Philadelphia.

way to secure a good result at a moderate expense is by choosing and combining intelligently. A few hints as to how to do this may not be considered out of place in the present article. It is true that much trouble has been saved to their custom-ers by the firm in absolutely banishing shams, and in refusing to admit anything, however real, which would be decidedly out of keeping. But it may a be set down as an axiom that where a choice is possible it is necessary: and a wide choice is certainly possible here.

It is well not to try for too much splendor or magnificence in any one room. Any considerable number of showy objects are little likely to be harmonious. This is the fault that is oftenest committed in furnishing a drawing-room; so often that some sensitive people will not have a drawing-room at all, for fear they might fall into this mistake. "If" they will say, "we have this onyx and gilt centre table, we must have a gilt and onyx mantel-set; and then the furniture must be in gilt wood, to correspond, and, oh dear! there is no having any sort of drawing-room but the regulation one in white and gold." Now, this is all wrong. It is the fact that a light key of color is the mode, and is in itself desirable. But one may imagine a scheme, all in light tints, which shall lead up step by step to some few points of

greater brilliancy than the rest. Let a beginning be made with some delicate tint, not white, for the walls, and porcelains will be found to tell against that, and gilt bronze even against the porcelains. The more brilliant the light or the color, the less space should it fill. But with due attention to the qualities of various textures, some reflecting the light, some absorbing it, quite a high key of color may be maintained throughout a room without garishness, and without loss of harmony.

Similarly, it is not necessary, because one may wish a few very elegant and. costly articles, to keep up the same scale of expense throughout. A certain graduation is possible here also; and it always leads to a better result than mere uniformity. Harmony does not imply absolute monotony, but simply an avoidance of crude tones and shocking contrasts. Because one would not put cloth of gold by cloth of frieze, it does not follow that the former alone must be used. Attention should be paid, in the first place, to the size, the lighting, and the general appearance of the room which it is proposed to furnish. Then, as a painter begins with his highest light and purest color, a particular object will be chosen to which everything else is to be in some degree subordinate. It may be (if the room is to be of extreme magnificence) one, or a pair, of the large Berlin vases from the German National Exhibition of this year in Munich. Their light grounds of cream and gold, with figures and flowers in bright colors, might furnish the key note for a very brilliant scheme of decoration.

CREAM-AND-GOLD DECORATED VASE.
Light ground, flowers and figures in color. This and the vase represented on page 6y the original and only ones executed by the Royal Berlin Porcelain Works for the German National Exhibition held in Munich, 1888. Owned by Messrs. Bailey, Banks & Biddle, Philadelphia.

Or it might be the vase in old Vienna style, made to order from drawings of Mr. Joseph T. Bailey. Or a marble by Albano[7] or by Cambi[8] may be chosen, – lovely female figures with flowing drapery. If other statuettes or groups are considered desirable, a terra cotta by Carriere-Belleuse or a colored and gilt bronze by Guillemin[9] may lead the eye to lower tones and less costly ornaments.

VASE, OLD VIENNA STYLE.
The scheme of decoration in blue and gold with bronze mountings originated by Mr. Joseph T. Bailey. Paintings from the originals by François Le Moinière, " Diana and Iphigenia" and "The Rape of Europa." Owned by Bailey, Banks & Biddle.

The hall, being, like the drawing room, semi-public, had best be considered at the same time with it. It is customary to treat it in rather sombre tones; but they should not be too sombre. Old tapestries make a suitable wall-covering, and against them nothing can be more in place than one of the old-fashioned "grandfather's" clocks already mentioned. In some of these one might sink a small fortune. Seven hundred dollars will buy one in carved oak case with elegantly-chased brass mountings, sounding the hours on metal tubes the tones of which recall the chimes of an English cathedral.

Others, handsome, but not so beautifully carved as this, can be had for one third the price; and a handsome hall clock, "The Colonial," with fine English movement, for one hundred dollars. There are also hall clocks in Buhl-work of ebony and brass, and mantel clocks of every variety of shape and material. Let us mention just one of these, in a case of repoussé and chased silver, with figures in gold on a dark-blue enamel face, whose cost is only two hundred and fifteen dollars.

Suitable for either hall or dining-room are some very handsome chairs in carved and incised leather. This sort of work, which was brought to a high pitch of perfection during the late Middle Age and the Renaissance, has only recently been revived in Europe. Naturally, the workmen follow, to some extent, the old designs, which are bold arabesques intermixed with flowers, fruits, and foliage. All of these are carved with the knife in thick sole leather, with little or no aid of stamps, rollers, or punches. The forms affected by the seats are in keeping with the bold and somewhat masculine character of the work. Several are modelled upon the antique folding chairs, and all are rather too severe for use in other parts of the house than those indicated.

Having mentioned the dining-room, let us pass in review the things belonging to it. Baudelaire, in one of his "Little Poems in Prose", has compared a good conscience to a bright and orderly display of cooking-implements; and certainly they have this much in common, that the former may frequently be said to depend on the latter. But still more truly may it be said that all the faculties of the mind and soul are stimulated over a well-laid board in a properly-appointed dining-room, and that they are correspondingly depressed among surroundings of the opposite sort. Nothing distinguishes the civilized man from the savage more than the manner of his taking food. And it is not necessary to be a Brillat-Savarin. The true gourmand is one who "eats with his eyes," as the saying is. Yet in nothing is the American housewife so often deficient as in her appreciation of these facts. It is quite commonly the case that the dining-room is the dreariest in the house. The temptation is irresistible to describe a dining-room of no alarming costliness, but agreeable and comfortable. The walls have a dado of dark stained oak in large and simple panels. Above this is a paper of an orange-brown tint studded with golden stars. The ceiling is ivory-white, with large geometrical compartments in two tones of gray, and a very small and sparse patterning in gold. The window-curtains are of brown Holland, edged with écru lace. A shelf runs around the room at the height at which the frieze usually commences. It sustains a few pieces of porcelain and faience of rich colors and striking designs. Besides the buffet, there is an old-fashioned corner cupboard containing some delicate glass and china. For the rest, the show of silver, porcelain, and glass for every-day use sufficiently enlivens the room. There are no steel engravings of dogs and birds, no chromos of fruits and flowers, no atrocious English hunting-scenes. Here and there is an exquisite Minton plate fastened to the wall as a plaque, or a piece of some other decorative ware similarly displayed. Here, again, are no beams of bog-oak carved and gilded: no enormous mantel, reaching to the ceiling no windows of stained glass. Nothing could well be simpler; yet when filled with company no room

looks better adapted for its purpose, and when empty none so insinuatingly suggests it.

The ceramic art of our time hardly receives from amateurs the consideration it deserves. It scarcely ever strikes them that the cups out of which they drink, the plates off which they eat, are, or may be, products of artistic skill and taste and invention. Yet every new shape and color and pattern of decoration implies the exercise of artistic faculties of no ordinary sort. It may not often occur to our theorists and writers upon art, but it is the case nevertheless, that the men who superintend and direct the work of the principal modern potteries are often men of great natural abilities and of broad and enlightened views, as well as of a highly-specialized education.

The Worcester Royal Company is particularly fortunate in having as director of its porcelain works Mr. R. W. Binns, F.R.S., of whom his friend Mr. Bailey well says that no other man has done so much in our time for the advancement of English porcelain. At Bailey, Banks & Biddle's are some of the most beautiful Worcester pieces of the year. Next to these the decorated Doulton faience is noticeable.

In a set of plates decorated by Alcock, of the Copeland Company, each plate bears, for central subject, a classical figure – Thetis, or Oenone, or Galatea – in the faintest tones of white just tinged with color. The margins have jewelled borders recalling those necklaces and other personal ornaments of ancient Greek ladies recently disinterred by Schliemann at Mycenae and in the Troad. Some of the Minton game plates may be classed with these. To give an idea of the brilliancy of their coloring, one must liken them to water-color drawings of which the tints have not yet dried. And this will not do them justice, for the beautiful quality of the material must be taken into account, and also the special difficulties of the art. It is, indeed, no small triumph when one draws from the furnace a piece of work which is in every way what it was intended to be, form regular, glaze even and brilliant, color not over or underfired, perfectly vitrified, adherent, rich of tone, and sharp of outline. When one considers the risks which each of these drawings must run, one cannot but admire the boldness and the skill of the artist. Why, then, should we not make as much of his work as of that of the water-colorist, whose technique is so much easier, whose results are seldom finer? Why should we not decorate our dining-rooms, at least, with these brilliant paintings, fixed forever upon porcelain, rather than with less permanent and less appropriate decorations?

To turn, however, from these *capi d'opera* of the potter's art, can one imagine a more smiling picture than that presented by a table fitly set with any one of these pretty services in light pink, or blue, or creamy yellow? Here are bouillon-cups with their covers, salad-bowls, dessert-plates worthy of fruit from the Hesperides. And, for breakfast, what an aroma the coffee must have which is drunk from such dainty cups!

Is it too much to ask that the library, also, be made cheerful and beautiful? Surely not. While looking at this multitude of things, many of them designed for use in a book-room, one cannot help thinking of the libraries he has been in which

were only less desolate than their owners' dining-rooms. What sort of intellectual nourishment can a man obtain from volumes pent in black-walnut cases ranged against a bare white wall with a row of dusty plaster casts above? And what a life it must be when both the body and the mind have to be fed amid such surroundings! Let us listen once more on this point to Bachelor Bluff.

"We do not, in my house", he says, "connect literature with the stately solemnities of life. We do not see why a library must, perforce, be furnished gravely; we see no necessary connection between heavy oak and the light fancies of the poets; and we are disposed to believe that the grave speculations of the moralists are more acceptable under cheerful than under uncheerful surroundings."

And he pleads for some bits of faience, bronze, and Limoges enamel to brighten the wall above the bookcases. De Goncourt, as regards books, less catholic in his tastes, agrees with him in this, or rather goes far beyond him. For what would Bachelor Bluff say to a study ceiling covered with Japanese embroidery in gold and colors on a ground of black silk? And what of his *bibliotheque de Boule*? But, apropos! why not, for a few cherished volumes, have a case in Buhl (or Boule, spell the name as you will)?[10] or, say one of these cabinets in vernis Martin? And what would be better suited to enliven a library than this little vitrine a la Marie-Antoinette, with its collection of curious snuff-boxes, patch-boxes, and powder-boxes, themselves illustrating the history of their time, and their miniature paintings the mythology of the ancients?

In a library so fitted, need we say it? THE CONNOISSEUR[11] would be received no longer as a missionary, as a pioneer, but as an old and tried friend. And not in the library alone: for the influence of the doctrines which it teaches would pervade the house.

## Notes

1 Edmond de Goncourt: (1822–1896) was a French connoisseur, writer, literary critic, art critic, book publisher. Together with his brother Jules, they combined their art-historical knowledge with journalism that greatly influenced French taste in the second half of the 19th century. See also vol 2.58 THEODORE CHILD, 'AN ARTISTS HOUSE' (1884)

2 Foukousa: A piece of decorated silk used to cover gifts in the Japanese tradition.

3 William Mussill (1828–1906); Painter and designer he was born near Carslbad in Austria and studied painting in Paris. After working at Sèvres he came to England in 1870 to work for Minton

4 Pierre-Paul Prud'hon (1758–1823).

5 Louis Amateis (1855–1913) American sculptor born in Italy.

6 Émile Louis Picault (1833–1915) French sculptor.

7 Salvatore Albano (1841–1893) was an Italian sculptor.

8 Ulisse Cambi (1807–1895) was an Italian sculptor.

9 Émile Coriolan Hippolyte Guillemin (1841–1907), was a French sculptor.

10 André-Charles Boulle (1642–17320 famed French cabinet maker and marquetry worker.

11 *The Connoisseur* refers to the company's house magazine which published this review.

## JOHN HENRY CARDWELL, *TWO CENTURIES OF SOHO: ITS INSTITUTIONS, FIRMS, AND AMUSEMENTS* (1898)

### Editorial Headnote

John Henry Cardwell, (1842–1921) the son of a Sheffield coal merchant, was ordained in the Church of England and became rector of St. Annes in Soho, London. While there, he carried out the restoration of the Church, and converted the Churchyard into a public garden. Cardwell wrote three books on aspects of life in his Soho parish.

*Two Centuries of Soho* was one of a number of works that traced the history and heritage of London. This publication deals with the religious, general and medical institutions, amusements, as well as a wide range of businesses located in Soho. It is no surprise to find furniture stores listed and discussed, as Soho had been an important centre for furniture making since the eighteenth century. Cardwell makes the point in his Introduction:

> The long connection of Soho with Silver Smiths, Fiddle Makers and Dealers, Curriers, Furniture Makers, and Dealers in antique furniture and articles of vertu, besides Booksellers, Dealers in pictures, engravings, and works of Art, should render the stories of the Firms engaged in these trades interesting reading.

Three of the furnishing firms – Edwards and Roberts, Sinclair Galleries and W and J Wright are discussed in some detail and give a good idea of retail practice at the time. Particular emphasis is made on the trade in antiques, real and spurious, as it was Soho, and Wardour Street in particular, that was a centre of this trade.

Edwards and Roberts were established around 1845. The 1854 Kelly's Post Office Directory of London lists them as 'antique and modern cabinet makers and importers of ancient furniture' The firm exhibited at the 1878 Paris International Exhibition and at the 1889 Paris Exhibition

The Sinclair Galleries were established by Frederick Litchfield (b.1851) who was one of the leading antique dealers of the later 19th century, as well as an author of books on the history of furniture and ceramics. The Sinclair Galleries were in operation by 1896, They closed in 1903.

W and J Wright were antique furniture dealers, and importers of antique oak panelling, carving and marquetry furniture. They were also gilders and carvers.

The extract not only mentions the nature of the business, but also comments on the demand for antique furniture and the trade in spurious antiques which was a feature of this area during the century.

# 61

# *TWO CENTURIES OF SOHO: ITS INSTITUTIONS, FIRMS, AND AMUSEMENTS*

## *J. H. Cardwell*

Source: J. H. Cardwell, *Two Centuries of Soho: Its Institutions, Firms, and Amusements* (London: Truslove and Hanson, 1898), pp. 188–96

## LV. MESSRS. EDWARDS AND ROBERTS, WARDOUR STREET, CHAPEL STREET, DEAN STREET, & CARLISLE STREET

Mr. Wood commenced this business in a small way 70 years ago. In 1845 it became the firm of Edwards and Roberts, and rapidly developed into what it is now, one of the leading businesses of the kind in England.

Wardour Street at the earlier part of this century was quite the well-known resort of those interested in old furniture and works of art, and to a large extent still retains the same character. We are informed that in the earlier days of the business, the aristocracy were the principal customers, and the demand for old things was not so great as it is now. People are now better educated in matters of art, and old furniture and pictures have four times the value they had sixty years ago. Old oak though it still fetches a good price, is not so much in demand as it was, and the 'rage' during the last twelve years has been for furniture by "Chippendale," "Sheraton," "Hepplewhite," and "Adams," which was produced about the middle of last century, a great period in the history of furniture.

A fine and complete library of the works of these old designers is to be seen at Messrs. Edwards and Roberts. The old French styles of the period of Louis XIV. XV., XVI., and of the "Empire" are much in request, especially of the period of Louis XV. The productions of this period are largely due to the encouragement given by Royalty to the manufacture of beautiful furniture in the great age of French luxury, There is a perfection of design and workmanship about the furniture of this time which cannot now be obtained. The Jones collection at the South Kensington Museum[1] comprises some of the best examples of the old French style. As to the frauds said to be perpetrated in the production of imitations of old furniture, a representative of the firm told us that articles of furniture got up in a rough way,

were sometimes offered to them for purchase as old furniture but were not likely to deceive any but the most inexperienced. He also said that high class imitations of old furniture were very costly. He believed that very little fraud was practised.

We were amused with one story which we were told during our visit as to the strange uses to which old furniture is sometimes put. The firm had an order a short time back, to take out the inside of a beautiful tortoise shell tea-caddy, and fit it with an airtight box and a Chubb lock of the best kind. A silver plate with three initials and the date was also placed upon the lid. When completed the customer consigned the cremated ashes of his wife to the tea caddy.

Amongst their customers Messrs. Edwards and Roberts number H. M. the Queen, the Duke of Saxe Coburg-Gotha, the Duke of Cambridge, the late Archbishops of Canterbury and York, and the present Emperor of Russia and a large number of the Aristocracy.

Messrs. Edwards and Roberts occupy as part of their premises Carlisle House, in Carlisle Street, which was erected soon after the Restoration, and was the family mansion of the Earl of Carlisle. It still contains beautiful marble mantle pieces and ceilings. The old carving has been sold. Before it came into the hands of Messrs, Edwards and Roberts, twenty-seven years ago, it was Whittaker's Hotel, well known for many years as an hotel which was largely used by clergymen when they visited London.

The present proprietor, E. Loibl, has, until lately, taken an active part in parish matters, having for some time filled the offices of Vestryman and Overseer.

We can recommend the show-rooms of Messrs. Edwards and Roberts as one of the most interesting "things to see" in this interesting parish, and the lovers of the antique in furniture and articles of vertu will be able to satisfy their utmost desires.

## LVI THE SINCLAIR GALLERIES, 55 SHAFTESBURY AVENUE

Standing on part of the Glebe land of St. Anne's with a bold frontage on Shaftesbury Avenue, and its back windows looking over St. Anne's Public Garden, stands the somewhat imposing block of buildings known as the "Sinclair Galleries." The five large floors are entirely devoted to Art, and to those whose delight it is to render their homes tasteful and beautiful, these Galleries have a decided advantage over the ordinary Museum. You can touch and handle, you can obtain any information you require about what is exhibited, and more than this if you have a good banking account, you can by the trifling exertion of signing a cheque, add to the "Lares and Penates"[2] of your household.

Here are tapestries of the 15th, 16th, and 17th centuries, suites of carved and gilt furniture, with Beauvais and Aubusson coverings of the time of the Louis of France; commodes, consoles, escritories, which have graced the boudoirs or salons of the old nobility of France in the times of the *Grande Monarque*, the unfortunate Marie Antoinette and the ambitious Napoleon, chimney-pieces in stone and marble, many of which are from famous houses, e.g., three from

Arundel Castle before the present Duke of Norfolk pulled down and partly re-built it; one from Chesterfield House in the old days of the Magniacs;[3] and one at least from the old house in Golden Square where rumour says Ralph Nickleby lived in the early days of Charles Dickens.

Like many other large businesses in our famous old parish, the Sinclair Galleries had a very modest beginning. George Sinclair was a skilful marble mason, rising from journeyman to master, and beginning business on his own account about the time the Queen came to the throne, in a little shop in Wardour Street. He had taste beyond those of his class, and gradually attracted the notice of connoisseurs of wealth and position, and by making the best of his opportunities, he educated himself by his constant employment in removing, altering, and re-constructing the fine old marble chimney pieces of the old mansions to which he was called by his customers. The late Mr. George Cavendish Bentinck, M.P., became a liberal patron, recommended him to the late Duke of Portland and many members of the Bentinck family, and assisted him with capital with which to build the present premises in what, twenty-five years ago, was King Street, Soho. When some ten years ago Shaftesbury Avenue was formed, and many of the old houses were pulled down, old King Street disappeared, and George Sinclair's King Street Galleries became part and parcel of the new street.

Mr. Bentinck had a partiality for travelling in Italy and collecting more old furniture and *objets d'art* than he could himself find room for, and many of his treasures he placed with Mr. Sinclair for sale, and hither he brought many of his friends, so that the business grew to considerable dimensions. The death of Mr. Bentinck seriously crippled Mr. Sinclair's resources, and the want of abundant capital caused him constant anxiety and worry. When George Sinclair followed his patron in 1893, it was found that he had left an enormous but unrealisable stock of expensive works of art. In order to make the best of the estate, the Court of Chancery appointed a Receiver, and after two years the building, or rather the greater part of it, and all its valuable contents, was purchased by Mr. Frederick Litchfield in 1895. At this time the idea was to form a Public Company to take over and work the business, making Mr. Litchfield the Managing Director, but instead, Mr. Litchfield made an offer which the Court of Chancery accepted. We have been glad to make the acquaintance of our new parishioner, for previous to his coming among us we had known something of his writings on art subjects, and we have culled from the pages in his "Illustrated History of Furniture." some of the information which we have endeavoured to impart in our notice of Art Business in these pages. This is a book of considerable literary merit, and would well repay the perusal of those who want to understand the mysteries of the Wardour Street trade. Mr. Frederick Litchfield has from his earliest days been associated with the commercial as well as the literary side of art. His father, the late Mr. Samuel Litchfield, was at one time buyer to the famous Mr. Baldock,[4] the doyen of dealers in bric-a-brac, and sixty or seventy years ago, his gallery in Hanway Street, which was then known as Hanway Yard, was visited by all the wealthy collectors of the time. He retired with an ample fortune, and Mr. Litchfield succeeded to his business and connection in 1838, the year of our Queen's

Coronation. He in his turn retired on a well-earned competency, and after becoming a member of the first Hertfordshire County Council and filling many other public offices, died at a ripe old age some few years ago at Cheshunt. When Mr. Frederick Litchfield purchased the Sinclair Galleries he transferred his business from his old-established premises in Hanway Street to Shaftesbury Avenue.

Mr. Litchfield numbers among his clients Her Majesty the Queen, the Emperor of Russia, the Empress Frederick of Germany, and several members of our English and foreign Royal Houses, the Rothschilds and a large number of the plutocracy of England as well as many of the older aristocratic families. His later literary work has been the editorship and revision of Chaffers's standard work on "Ceramics, Marks and Monograms on Pottery and Porcelain," a rather ponderous Cyclopadia of some thousand pages or so.

## LVI. – MESSRS. W. AND J. WRIGHT, 144 WARDOUR STREET

At the end of last century Mr. W. Thrale Wright, carver and gilder to H. R. H. Princess Sophia Matilda, occupied the present premises and began to import oak panelling, carving and marquetry. At that time, he and a man named Hall had the business almost to themselves. For more than a century the business has been carried on with little or no change in its character, and "Old Curiosity Shop" is still the most appropriate description of the business, as nothing modern seems to be admitted. The show-rooms at the back occupy a large space behind Carlisle House which was formerly the site of a famous riding school kept by a Mr. Angelo during the latter part of the eighteenth century.

From enquiries we learn that strictly speaking the word "Antique" should only be used when alluding to the Greek and Roman works of at least 2000 years ago: but it has become a term which is most casually applied, and is used in a most elastic sense as describing furniture which cannot have been made a hundred years, if genuine, and also as describing work which is quite modern. In no class of old work, however, is the word more generally or more inaccurately used than when speaking of those darkly stained, ill carved and much varnished pieces of furniture called "Antique" work. Seriously speaking, if we consider what was the furniture of a room some two or three hundred years ago what should we find? a dresser perhaps, or a court cupboard, an armoire, a table, a chair for the master of the house, some benches for the rest of the family, but that is all, and very few of these remain to tell the tale of the past. When there is a demand, there will be a supply, and therefore we find a vast amount of carved oak, some of which has been made a sufficient time to acquire a tone and appearance of venerable age, while some has been "treated" in such a way as to deceive the unwary purchaser. Very often the so called "Antique" oak cabinet is made up of old pieces of work adapted to its new form and the whole stained to a dark "black oak" to hide the differences of tone and colour. A practised eye can generally detect in an old oak chimneypiece the different component parts. The front of an old chest perhaps

forms the frieze. Two figures which formerly did duty as the ornamental supports of a cabinet are on each side, and the rest has been made more or less to correspond. If these compound pieces are well arranged and carefully composed by the adept, they have considerable merit and value, because the real connoisseur knows perfectly well that the genuine old article is almost impossible to obtain, and when such work has been made or arranged for thirty or forty years a good tone is acquired which is acceptable to all but the hypercritical.

We are now referring to the more ornate kind of oak carvings. Occasionally one may still find in old houses some of the plainer oak chimney pieces and cabinets of the time of James I to Charles II, such as are in the South Kensington Museum from the houses pulled down in the City a few years ago. This is termed the Jacobean period of carved oak, and although not so ornate as the so-called Elizabethan, it is in better taste. There is a good example of Elizabethan carved oak work in part of the interior of the Charterhouse immortalised by Thackeray, and in the Hall of Grays' Inn, built in 1560, and in the Middle Temple Hall built in 1570–2. At Hardwicke Hall and at Knole there are fine specimens of the Jacobean period. In the Halls of the City Guilds too, old carved oak at different periods may be studied.

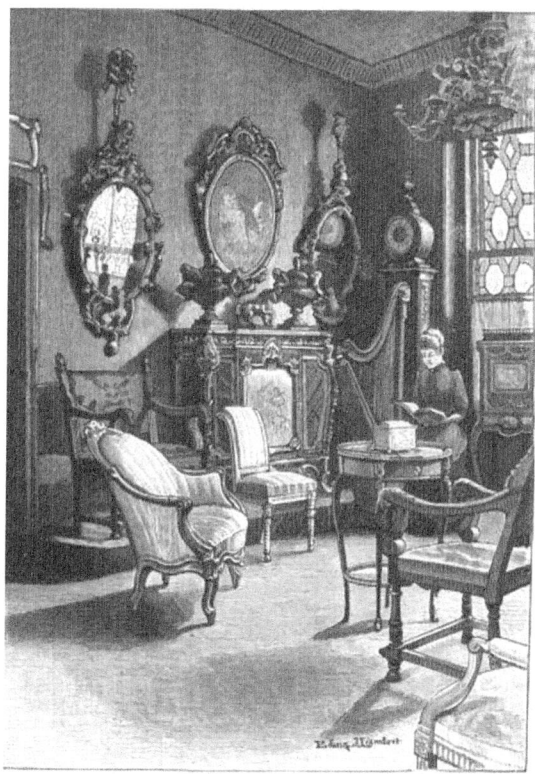

*The Sinclair Galleries*

## Notes

1 Jones Collection: John Jones was a businessman who in 1882 left his large collection of fine and decorative arts to the Victoria and Albert Museum 'for the benefit of the nation'. This included 105 paintings, 137 miniatures, 147 pieces of porcelain, 52 bronzes and gilt-bronze objects, 135 pieces of furniture, 109 sculptures, and 313 prints. His collection of books, which numbered around 780 volumes, included the first three Shakespeare folios.

2 The household deities of ancient Rome, respectively overseeing the family and its house and storerooms. It was a popular literary term in the nineteen century for the domestic goods and chattels of a home.

3 Magniac: Charles Magniac (1827–1891) was a British financier and Liberal politician.

4 Edward Holmes Baldock (1777–1845) was an important London furniture and antique dealer.

# LEWIS FOREMAN DAY, 'DECORATION BY CORRESPONDENCE' (1893)

## Editorial Headnote

An artist, critic, and industrial designer, Lewis Foreman Day (1845–1910) played an important role in the Arts and Crafts Movement, particularly in his efforts to relate the movement to industrial productions. He was one of the organizers of the Arts and Crafts Exhibition Society and a one-time master of the Art-Workers' Guild. From 1897 to his death, Day remained a member of the council of the Royal Society of Arts. He also gave lectures on ornamental art to the Society of Arts and the Royal College of Art, South Kensington, and acted as an inspector on ornamental work in provincial art schools.

Day's ideas were important, in that he argued that designers should accept industry and industrial methods of production, and indeed, he practiced what he preached. This is borne out by his involvement with several major manufacturers including ceramics firms Maw and Pilkington, wallpapers suppliers, such as his long association with Jeffery and Co., and by the 1880s, he was the artistic director on the board of textile company Turnbull and Stockdale.

Day published many important articles and volumes on ornament and decoration, including *Instances of Accessory Ornament* (1880), *Every-Day Art* (1882), *Anatomy of Pattern* (1887), *The Planning of Ornament* (1887), *Lettering in Ornament* (1902), *Pattern Design* (1903), *Ornament and its Application* (1904), and *Nature and Ornament* (2 vols, 1908–9). His books were important as texts for design students, with one being updated as late as 1930 by Amor Fenn. Other more specialised works included *Windows: A book about stained and painted Glass* (1897) with three editions by 1909, *Alphabets Old and New* (1898), *Lettering in Ornament* (1902), and *Stained Glass* (1903). His work was also published in journals including the *Magazine of Art*, the *Art Journal* and the *Journal of Decorative Art*.

This text is an attack on ladies' advice columns published in popular magazines and journals. Aimed at a female audience, Day is suspicious of the continual references to a particular set of suppliers and also critiques the nature of the advice given. As can be seen from the biographical detail above, Day was in a strong position to denounce the often amateur advice that was often supplied in very general or simplistic terms.

This condemnation of female advice publications was not new. Fifteen years earlier, the *British Architect and Northern Engineer* had also ridiculed the advice books, often written by women, in a piece entitled 'Mrs. Loftie in Excelsis'.[1]

517

# 62

# 'DECORATION BY CORRESPONDENCE'

*Lewis Foreman Day*

Source: Lewis Foreman Day, 'Decoration by Correspondence', *The Art Journal*, 55 1893, pp. 85–8

It occurs to one sometimes, to wonder who it is that really pulls the strings of fashion. A glance at the ladies' papers helps to explain, to some extent, the vogue of certain things, which, one might have thought, no one would ever dream of buying. There is one column in particular, that dealing with Art in the home, which is a perpetual source of annoyance or amusement, according as you take it seriously, or for what it is worth. Not a paper but seems to have its lady adviser; and this multitude of counsellors is out of all proportion to their collective wisdom. Who writes these columns? Who reads them? Occasionally the mentor appears to be a practical decorator, in which case, she writes, if not always wisely, somewhat to the point: more often it is an amateur, perhaps with artistic connections, or of some social position, who gossips easily enough about shops and shopping. But it matters less who these writers are, seeing that they write, for the most part, obviously without conviction, not so much with any thought of raising the taste of the class to whom they address themselves, as with the determination to gratify it, such as it may be.

The class of readers may be surmised from the pseudonyms under which they write for advice "Mavourneen," "Butterfly," "Romany Lass," "Gazelle," "Dolores," "Seraph" or "Wild Myrtle," "Bluebell," "Asphodel," "Maidenhair," "Daisy," and suchlike flower names, with here and there a "Prince Charlie" or "Jack Evergreen," posing, it may be presumed, as a male. To tell these sentimental young people a stern truth or two in answer to their wild queries, would be, no doubt, to frighten them away; but it is too bad to fan their simple faith in the ease with which the problem of decoration is to be solved, and to encourage them to spend their scanty means (of which perhaps they little understand the scantiness) upon mere frivolity and fuss. It may answer the purposes of the paper – doubtless it does – but to the anxious inquirers it is not kind, nor yet quite fair.

There is a curious similarity in the methods of proceeding on the part of these arbiters of taste, as though they had all founded themselves upon the same model, and one of them (the real source and fountain-head of all this stream of gossip, no

DOI: 10.4324/9781003290490-80

519

doubt) pettishly implies as much on more than one occasion. The answers begin usually with a word of welcome to a new correspondent (especially warm if the sheep be by chance from the other fold), a little flattery as to the taste displayed by Rose; a word of congratulation to Angelina upon her good fortune in possessing "such an antique jewel of a residence" an expression of satisfaction that Nita is so pleased with the writer's new book; a regret that the "dear correspondents have to wait such an age for a reply," and so on.

Then follows the advice. It would not be true to say that these authorities on art will tell you anything you want to know, for they will occasionally refer you to the lady who writes the column on cookery or domestic pets; but they will tell you where to live, what to spend in housekeeping, and how to spend it, the hour to dine and what to have for dinner, and will even go into particulars relating to the disposal of the scrag end of a neck of mutton, and the trimmings of the cutlets. Do you want the address of a clergyman with whom you can board, or of a fish sales-man at Grimsby, of an architect to advise as to the stability of your house, of a cabinetmaker to carry out the repairs, of a lady who will make you "lovely" table covers, you have only to ask. You can have advice as to the choice of a school for your children, and how to dress them; as to the wisdom or unwisdom of the mar-riage you contemplate, and the way undue indulgence in early strawberries will "run up" the weekly bills; as to the legal agreement on which you shall take your house, or where to get "glacier" window decoration; as to the claim a worthless father may have upon his offspring, or how to remove stains from the carpet when pet "transgresses" – all this, enlivened with little scraps of information by the way concerning the tastes of the writer's own children, her sufferings from influenza and consequent "dumps," the pleasure her friends take in her "little dinner parties of eight," her personal dislike for black-edged paper, and the annoyance it is to her to have her ideas stolen by rival advisers, or to find that a correspondent has dared to consult some other authority as well as herself.

All this is mentioned only by way of showing the mingled pretentiousness and triviality of which these columns are made up. The practical advice given on decoration and furnishing, good or bad, is much what any young lady who claims to know something of the subject (and who is there that makes no such claim?) would be likely to give. There is a certain vague talk about "a haze of Eastern colours," "blue Art serge," "Arab brown paint," and such like. "In the corner," you are told, "you should contrive one of my favourite amateur cosy corners," and for the mantelpiece a drapery of "Tadema brown plush"; for chairs you are allowed a choice between the Dagobert, a beautiful Charles 1. throne chair, Peter the Great's old oak chair, which is "simply delightful," and "of course" Shake-speare's chair, "the woodwork must be painted impressionist oak." Heavens! was there ever such jargon? Some persons might be puzzled to know what is meant when an "Art square" or "a Kensington Art square" is recommended, until it is explained "that if Mr, So-and-So's Arbela is too expensive, he could show you some Brussels make in the same tone of colouring, or you might content yourself with an Art square." That explains it; one knows now what an Art square is – the

cheapest, if not necessarily the nastiest thing to be had in the way of carpets: our instinctive distrust of that word "Art" was well-founded.

There is more talk about saving than advice as to true economy. It is pretty generally assumed that it is wise to buy what is cheapest: there is seldom any serious suggestion that persons of small means should restrict their wants, it is taken for granted that folks must have things they could very well dispense with, and things are recommended to them which are quite unnecessary, if not frivolously absurd.

There are recommended to you such things as "tray cloths for invalids, which are constant joy to me," and towel shams (at eight shillings each) to put over the towels to keep them tidy – "I am sure you could not help being delighted with them." In the way of a present to give to a man, what could be more useful than "demon sealing-wax sets"? If you happen to have two corner tables, "they would be better for curtains of coppery red plush placed on the wall at the back of them, and headed by little balcony rails."

When evils cannot easily be cured at least they can be covered up; and the lady adviser is quite herself in discoursing of drapery and trimmings. What with curtains for the fire-place, mantel frills, ball-fringe, and "lovely weeping-willow muslin," one need never be at a loss. "Why not cover your chairs and tables with art muslin? is the sage advice to "a worker," of all people.*

"Rose-coloured serge muslin" is recommended for "a curtained dado," and if you can't afford to repaint the entrance hall, you are given to suppose that it would be an economy to have four heavy portieres and a deep dado of handsome printed arras. The piano must of course be draped, and "a Chinese mandarin jacket" will make "an absolutely perfect piano back for an Anglo-Chino-Japo apartment"! Another panacea is pottery. Every room must be strewn about with pots, "Benares," "repousse," or whatever may be the newest thing; although no one goes quite so far as to make it a rule that when in doubt you should introduce a pot. One lady, who has almost the courage of her opinions on this point tells us, indeed, that it is "a little joke of hers," that if she were town legislator, she would issue a sumptuary law to the effect that every house should be adorned with turquoise blue pots outside all the windows – it would be no joke for us!

The advice is always buy, buy, buy! One sees a gleam of hope when it is suggested that a table should "be deported off," and a whatnot also "bundled off," to leave a corner free: but it turns out that is only to be left "free for an easel, enamelled green, upon which your husband's portrait, draped with a golden brown scarf, might stand." When, peradventure, you are told that "you can do very well without a border of any kind" it is only because "the use of it is no longer one of Dame Fortune's inexorable laws." Here at least there is no doubt left as to the teacher's criterion of taste.

* This extract is from a cheap paper in which you are further told that it will save much time and labour if you paint your oak furniture all over with stain but for the rest, the extracts in this article are taken from the higher-priced and more fashionable journals.

It is presumably in obedience to those "inexorable laws," that "Smith's Arcadian suites of trumpet vases and brackets" are instanced as "a most lovely and unique decoration for a bazaar." "Arcadian glasses," we are informed, are "a number of trumpet-shaped vases in pale green glass connected together with arches of crystal, from which are suspended little brackets." One is not surprised to find that in connection with them you may make use of artificial foliage plants, since they are "so wonderfully well-made now as almost to defy detection;" the all-important thing is, of course, that you should not be found out in your little deceptions.

If fashion is the standard, surely we want no lady guides. The advertisements will tell us that for Christmas decorations we can buy letters of cardboard and cover them with white wool, or that "quaint stuffed birds," to say nothing of monkeys (as shown in the lady's accompanying sketch) "can be added ad libitum." It will be no news to even the most newly married "that she can hang trophies of old-fashioned swords or armour in the hall," though her husband may be startled at being asked "to paint some shields with coats of arms, crests, and mottos" to accompany them. The drainpipe "which will make a good umbrella stand for your hall" is another old friend. It is interesting to learn that "it should be painted with bold decorative flowers on a shaded background," but the caution that it needs to be "duly fitted with tin inside," reminds one that this is not after all so much as a convenient pipe into which to drain umbrellas.

But for the artless reference to fashion, one would have been puzzled to imagine the point of view of those who recommend by turns a "lovely Louis XV. rose-coloured stripe" for one middle-class Victorian room, a "cheap Moorish arch to outline the recess," in another, a ready-made cosy corner for the landing on the stairs, and a stuffed bear to serve as a dumb-waiter.

All this, it may be urged, is [a] matter of taste: correspondents may expect, at any rate, sterling advice as to the judicious outlay on furnishing: they may rely at least upon due warning as to the practicality of the vague ideas they may have on the question asked. Marguerite accordingly writes in faith, enclosing her coupon, and her inquiring mind is relieved by the information that "old oak furniture is by no means an impossible possession nowadays, even for folks with shallow purses, and you may certainly indulge your fancy in this respect, as the Penshurst suite which So-and-So sell for nineteen guineas, is all that modern eyes can desire for the starting of a well set-up little ménage." Alas, for nineteenth-century eyes! There must be a strange cast in them.

This is a single instance; but there is not much difference in the character of the advice given by the various authorities. One is comparatively business-like and to the point, another goes out of her way to let you know how an old friend of hers, "a baronet," invariably went to the butchers to choose his own meat; but, apart from the more or less charmingly chatty way of giving it, the advice is mainly to the same purpose, They are, on the whole, remarkably in accord. On one point they are absolutely unanimous: they have one infallible resource in common they all advocate Aspinall.[2] "As regards old furniture, you can restore it perfectly by the aid of Aspinall's invaluable enamel; the suite in your room would look lovely

painted with electric turquoise:" or again, "by all means use Aspinall's enamel all over the house," and so on, with terrible iteration.

And this brings us face to face with the important consideration of advertisement. These counsellors cannot so much as tell you to get a clothes-basket, without advertising a vendor of such things. It is rather a suspicious circumstance that a prescription should be habitually accompanied by the address of the chemist where you must get it made up; it may be accounted for, more or less, by a desire on the part of the doctor to save the patient trouble; but it cannot be explained away – the fact remains that, for whatever reason, a certain limited number of tradesmen are recommended again and again throughout the columns to correspondents, to the exclusion of others who, to put it moderately, are by no means second to them, whether in respect to the quality of their goods, the moderation of their prices, the taste they display, or the reliance that may be placed upon their capacity and trustworthiness. Are these firms unknown to the advisers? If so, it behoves them to extend their range of investigation, and not pretend to pronounce what is best without knowing what there is.

If we are to believe what we are told, "This – man's inexpensive brass brackets" are not only "quite fit for a bedroom," but, "indeed, the only ones you could use to look nice:" that – man's writing-tables, registered number X, are the only ones that will serve your turn; the other man's rugs "are simply perfect, have never seen anything I like so much." The argument last adduced is unanswerable. The writer may, or may not, have seen all that there is to be seen in the way of rugs or what not, but she is safely entrenched behind that saving clause as to her liking. She may recommend the Curtain Road where we should have thought Bond Street more promising, Oxford Street where we should have imagined Tottenham Court Road would do better, Bond Street when we should have pronounced in favour of Holborn; but what then? She may be right or wrong. As to the soundness of her judgment there may be dispute: as to her opinion she may claim to speak with authority not to be disputed.

But the honest expression of personal opinion, whatever weight we may attach to it, will not account for the specification of the names of tradesmen in no way identified with the particular thing specified. The recommendation of certain "dear old Watteau paper" expresses very likely, if not the lady's own leaning towards the style of Louis XV, her readiness to lean that way.

"Most of the things recommended are specialities," says one lady, of the various shops to which she refers, and the others imply as much, if they do not in so many words say so. In some cases that may doubtless be. "The Arcadian suite of trumpet vases" is probably unique – let us hope it is; in others it all depends upon what is meant by specialities. If we are to understand that the firm mentioned keeps a certain thing in stock, that is very likely so; but if it meant that the thing is only to be had of that firm (and that is what the expression is calculated to convey), then it is hard to reconcile the statement with what one *knows* of certain things specified. It is possible there may be no direct relation between the things specified over and over again in the column of advice, and the advertisements at

the foot of it, or elsewhere in the paper. But the names so frequently recurring are not always such as to inspire with confidence those who know what is being done in the way of good work and who are doing it. They can but draw their own conclusions, one of which is that the editors never by any chance glance through this smaller print.

There is room enough for advice to those about to marry, and others, on the furnishing and fitting of their houses, but to be of any use it would need perhaps to be so little palatable as scarcely to suit the purposes of a ladies' paper. What is provided suits, apparently, the palate of the paying public. The editor and his contributors, very likely, know their business better than the reviewer who takes art seriously: they see what is wanted, and supply the want – remorselessly. It is difficult to have patience with those who want this kind of thing, or esteem for those who can bring themselves to provide it. That there should be a demand for it, that it should even be endured, points to a condition of taste (to say nothing of common-sense) among one section at least of the rising generation, which must very seriously discount the hopes we may have for the art of the immediate future.

## Notes

1 *British Architect and Northern Engineer,* 9, 8, 22 February 1878, p. 83.
2 Aspinall's enamel paint business was established around 1885 and was a very successful business not least because of its advertising styles. A publication prepared by 'A Lady' titled *Guide to Aspinalling – Instructions for the Use of Aspinall Enamel Paint,* was published in 1889. This empathises the DIY aspect of the products.

# JANE ELLEN PANTON, 'PARLOURS', IN *SUBURBAN RESIDENCES AND HOW TO CIRCUMVENT THEM* (1896)

## Editorial Headnote

Mrs Jane Ellen Panton, (1848–1923), was the daughter of the artist William Powell Frith. She married businessman James Albert Panton. She was a journalist and author who worked between 1881 and 1900 on *The Lady's Pictorial*, and wrote thirty-three books between 1887 and 1923, publishing novels as well as tracts on domestic and furnishing topics. These included *From Kitchen to Garret: Hints for Young Householders* (1887) *Nooks and Corners; being the Companion Volume to 'From Kitchen to Garret'* (1889), *Homes of Taste: Economical Hints* (1890), *Within Four Walls: A Handbook for Invalids* (1893) and *Suburban Residences and How To Circumvent Them* (1896). Some of these were very successful with *From Kitchen to Garret*, going through eleven editions in a decade.

She was a pioneer of engaging women in the profession of interior decoration as she explained in the preface to her *Kitchen to Garret*. Note that she also had suggestions for men's involvement in the business.

> From my correspondence I have evolved quite a new profession, which I commend to any lady who has taste and may wish to earn her living. I go to people's houses and advise them about their decorations, and tell them the best places to go to for different things; I buy things for country ladies, and write them long letters on every subject under the sun for a set fee, and have made some of the nicest friends possible through this means; and I feel sure that any lady who cares to take up the profession, and is of *sufficient social status to be above the suspicion of taking commission or bribes from tradespeople to advertise their wares*, and who above all possesses a quick eye and a certain amount of taste, can make a good and steady income in a remarkably pleasant way, while a great future would be before any gentleman possessed of the same qualifications, for he could see to estimates for painting, repairing, &c., and could act as a buffer between the purchaser and the workman, and, being thoroughly acquainted with his business, would soon become the boon and benefactor, to the ordinary person who requires his house done up and furnished, who is much wanted, and that no lady can be, because of the necessary fighting powers and technical knowledge.[1]

She also noted in the same preface a commercial development that offered women employment opportunities in soft furnishings:

In connection with my work, we have now started a society for the employment of ladies who will either decorate a house entirely, make the chair-covers and curtains I recommend, or work at ladies' houses at dressmaking and upholstering, so that I may justly pride myself on the fact that at least my particular column in the 'Lady's Pictorial' has been of some small practical good already. The address of the 'Workers' Guild' is 11 Kensington Square, W.

The numerous references to retailers in this text was common practice in these sorts of texts and perhaps puts her comments about commission and bribes into a different context. It was this sort of advice that Lewis F. Day was complaining about in the text at 1.62.

# 63

# 'PARLOURS'

## *Jane Ellen Panton*

Source: Jane Ellen Panton, 'Parlours', *Suburban Residences and how to Circumvent Them* (London: Ward & Downey, 1896), pp. 128–58.

### CHAPTER V PARLOURS

Anything less like a parlour than the drawing-room of an ordinary suburban residence I can hardly imagine; but there is no earthly reason why it should not be turned into a semblance of one especially in those more favoured spots where the architect has artistic leanings, and where the speculative jerry-builder has not had everything his own sweet way. Here we may often come across quite delightful little picture houses, bearing the stamp of Mr Ernest Newton's[2] genius, and if the structure does not equal the design in merit, we can always circumvent any errors if we are clever, while the deep, charming windows and really lovely mantels over-mantels and grates provided for us, make our task of decoration a comparatively easy one from the first. Generally, these houses are built with gables, and are half-timbered in a most picturesque manner, and maybe appear at first sight to be over-windowed and unduly ornate, and open vistas before us of swift ruination in the matter of blinds and curtains. But, on reflection, we discover that not only is there not one window too many, but that the very simplicity of the treatment of them as regards the curtaining as described in the last chapter, makes them far less expensive to deal with than the ordinary sash or French window, which one finds awaiting one in the dreadful houses of the older suburbs, or in those which have not yet advanced beyond the tastes of the day before yesterday. Let us therefore contemplate having a pretty room to deal with before we think of the ordinary chamber with its heavy and fearsomely-decorated cornice, its gaping grate, its 'statuary marble' mantelpiece, and its many other drawbacks to decorative happiness. For if we have, as I said before, the task before us is a comparatively easy one, unless of course, we are handicapped by the possession of a ghastly chiffonier brother in fearfulness to the massive sideboard, a grand piano for a room 15 feet square, or a 'suite' of furniture and a round table, which said possessions really do still exist and have often to be dealt with when a move from one house to another is contemplated. If they have, there is only one word for it, and that is sell. The greater encumbrances must go for whatever they will fetch, and the

DOI: 10.4324/9781003290490-81

owners must be contented with a much simpler style of furnishing. The chiffonier is impossible, the round table may be relegated to the dining-room, and the old-style table there sold: and fortunately these tables are always worth a certain sum in the market: while the grand piano should be exchanged for either a cottage grand or an ordinary upright piano, and the suite of furniture effectively disguised in new cretonne frocks which cover the chairs and sofas entirely, and so hide faulty lines and construction, turning heavy, ugly encumbrances into quite charming possessions at once. These covers, however, must be made very carefully indeed, and must fit easily. The small chairs are finished off with a 3-inch frill from the seat of the chair not in any case put into a band. A band spoils the look of the frills at once, and gives them a most comic and inconsequent appearance, and the frills on the sofa and big arm-chairs must be arranged on the same lines, though these should of course be very much deeper and should just, and only just, clear the floor. In any case there must be no attempt to adapt old curtains from long windows to these small and artistic ones, for that can never be a success, and materials nowadays are so cheap there can be no necessity for such economy, especially if the house-mistress has the smallest idea of sewing, or knows of a good upholstress, or has daughters who are equal to an emergency. By the way, the very best upholstress I know is Mrs George Bacon, of West Street, Wareham, Dorset.[3] It seems a long way off, but it really is not, and she is such an admirable worker and so quick and industrious, that one saves her fare over and over again, and her keep too, as of course save in London, where she has married daughters, she can stay with, she has to be put up. But then she has all my patterns, and think of the inestimable value those must be to my numerous friendly readers! Once more then, if we proceed on these lines, all we shall have to consider is the carpet, and we must take the most prominent colour in that, and do our best to live up to it. But on no account must we attempt either to ignore or shirk the fact that there is a prominent colour to be considered. We must make that the key-note, and wall-papers, cretonnes, and curtains must all be chosen with a remembrance of the one thing that we are bound to recollect if we wish for any decorative harmony at all.

When, I wonder, will the dreadful muddled browny-blue-yellow carpets cease to trouble us? When, oh when will the 'magnificent designs and handsome patterns fade away into the ewigkeit?[4] and leave only the charming unobtrusive designs in the same colour, but a shade or two lighter than the ground of the carpet, which are all that should be found in any house in the land? One only wants a warm bit of harmonious colouring on the floor, after all; one does not want the carpet to arise and call aloud to the entering visitor, 'Look at me! See what I cost! Recognise these exquisite touches and tints, these fearsome leaves and flowers, this magnificent and gorgeous pattern which covers me, and renders me so unduly conspicuous.' But rather should it never be noticed at all, thus taking its right place in the harmony of the decorative design, and becoming merely the floor covering that it is undoubtedly only meant to be.

If we are rich, we can have pile; if not, let us have either the three-ply Kidderminster, or the satisfactory 'Dunelm' carpets, recently brought out by Wallace, or

one of the carpets kept by Hewetson, Smee & Cobay and Wallace, at my earnest request, where the pattern only shows sufficiently to break up the plain surface. No doubt entire absence of pattern would be the more correct, did that not mean that every atom of fluff, dirt and dust showed at once, and fidgeted the owner all day long. For these atoms seem to accumulate mysteriously the moment any plain-surfaced material is selected, and though I much prefer to see whatever dirt is present, with an eye to getting it removed at the earliest possible moment, one cannot have a room swept and dusted more than once a day, and some rooms cannot be swept as often as that, although undoubtedly they ought to be. Of course my ideal floor covering will always be matting and rugs, and from that I shall never depart. I am devoted to the new 'Isis' matting, sold by the Abingdon Carpet Company, and also to the plain string coloured matting sold by Shoolbred, Treloar, and Liberty at about 2s. 8d. to 2s. 10d. a yard; this, of course, has to be supplemented with rugs, and, therefore, is not as inexpensive as even a good pile carpet: that is to say, if we buy good rugs, and inexpensive ones cannot please, because of the crudity of their colouring and the manner in which they wear. Hewetson's and Liberty's rugs are simply perfect, and can be bought by the tyro in artistic matters without the smallest qualm, for at neither establishment will he or she be given anything which is not just what it ought to be. But given the rugs, it must be once more remembered that there is a certain art in placing them about the floor, which all house-mistresses do not, it seems to me, recognise. The rugs must not be put down in straight lines and close together, but given the ordinary room, should be placed as a rule at right angles to one another. Of course this is merely a hint, and can be improved upon in any way my readers prefer. That such a hint is necessary I know, because I have often gone into a room where there are plenty of beautiful rugs, spoiled entirely by being placed in long lines close together, in a manner that would be painful indeed, were it not utterly absurd. As a rule such a room has one rug straight along in front of the fireplace, another straight in front of the window or windows, while the rest are placed in the same painful positions by the door and by the wall opposite the fire, in a manner which makes me long, no matter where I may be, to oust the furniture on the instant, and to put those rugs myself in the manner in which they should most certainly go. If we must have new curtains, quite the most dainty and charming arrangement can be made from using the new coloured linens, sold by Walpole Brothers, and by Murphy & Orr and Harris & Company. These linen curtains should be full and short, should be double, if there be very much sun, and should have an insertion of Torchon lace laid on about 2 inches from the edge of the curtain where should come a softly-falling frill of similar lace, about 3 or 4 inches wide. These frills should go round the bottom and up each side, and the tops of the curtains should be finished by being slightly gathered on a narrow tape, on which the hooks should be sewn which fasten into eyes on the slight brass rods, which are all that are required in these special windows. The hook-and-eye arrangement is much to be preferred to the old manner of sewing rings on the curtain itself; one can unhook a curtain in a minute and shake it out of doors in another. If one has rings only, it means taking down the rods too

and that means trouble, which a lazy housemaid will most surely shirk, if she can in any way manage to do so. By the way, the structural faults dwelt upon in former chapters will most certainly be found in this room, as in all the others, and must be rigorously treated in a similar style, while the portières must be placed inside and outside the door, and a screen must not be forgotten. Unless one has a screen the whole of the room is exposed to view the moment the door is opened; we can have no sense of privacy at all while in such a chamber. If the door opens inside to the left, it should be turned round and opened to the right. If this is not done no one can sit by the fire without being almost blown up the chimney, by reason of the draught which will come in at the opening, and make as a matter of course for the unsheltered and gaping grate.

If, once more, the would-be suburban resident enters on her possession of the house entirely free and unshackled by any encumbrances in the way of furniture, and can really set about making such a room as we describe charming; a beautiful parlour can be made by panelling the room for about 7 feet, and having a soft and very pretty paper above. This sounds reckless work in a house that is merely rented, but one can buy panelling sometimes extremely cheaply. Bartholomew & Fletcher have some oak an inch thick, ready to fix, at 1s. 10d. a square foot, while Godfrey Giles's 'Goehring' material[5] is cheaper much than that, and can, moreover, be painted any colour preferred. If the oak is chosen, the fireplace should be finished off with a very light and simple mantel in the same material. It must not be carved or unduly ornate, but be quite plain, and distinguished only by its graceful lines. I do not here advise the regulation overmantel, but I should hang above the fireplace the small Chippendale mirror sold by Hewetson for about 27s., supplementing it each side with ring-sconces to hold three candles. The real old ones are very expensive, but very good copies can be had from Oetzmann in the Hampstead Road. Above the oak the paper should be undoubtedly a really good blue. The right blue, which is always pleasant to live with, and does not go black at night or a dull grey or any other unpleasant hue, can always be had from Smee & Cobay; and I am also very fond of their gold and blue Japanese leather paper. Still this is expensive, and therefore not to be lightly recommended for it cannot be removed. The panelling can, which is one reason why I speak of what may seem out of the reach of the ordinary suburban resident, who will make his house three times as warm and comfortable if he panels his walls, and will moreover have always something delightful at which to look. The floor should be covered with matting and rugs, and the curtains should be the same blue as the paper, in linen and lace, printed damask and lace, all in plain colours, or else in plain blue linen plush edged fan edging; and the furniture should be simple, graceful and charming. In the bow window we could have a low broad seat or else a writing-table, placed rather across one side of the window. In the centre could be the flower-table, and on the other side we could put a low, corner window-seat, which might be a fixture and part of the panellings. The rest of the room can be furnished as shown in the sketch on page 131, [See below] but great care must be taken to have nothing but comfortable chairs and one good deep sofa; and the chairs must

not be chosen without due reflection and without being sat in in several attitudes. A really good chair is a possession which lasts one's lifetime, and one that is in the least degree uncomfortable should never be tolerated for one moment. A good reason that for refusing utterly to buy or countenance the detestable and out-of-date suite where none of the chairs are even decent, and where the sofa may be ornate but cannot be a place to rest upon try how we will. If we have this panelled room, we should try and find a Sheraton writing-table at Hewetson's, which has no high back, a thing, by the way, to remember about all writing-tables, which have to stand in a window. The flower-table can be bought at Wallace's, as can the smaller tables and chairs. A sofa and corner cabinet, can be had of Smee, while a 'grandfather' chair is to be had at Hewetson's, and Bartholomew & Fletcher's 'Seabright' armchair must never be forgotten. These are by far the most comfortable chairs in the whole furniture world. If we cannot rise to the oak panelling, a charming parlour may be made from plain 'goehring,' painted some soft colour, either sea-green, electric turquoise or real ivory, and above the panelling should be a paper in the same shade as the paint; if either green or blue is used; and with very little pattern, only enough to break the expanse of plain colour, while if the paint be ivory a dainty floral paper on an ivory ground should be chosen. In this case we should have cretonne covers to our chairs to match the paper, and the curtains could be of the same, or else of my pet invention the plain linen edged with softly falling lace. If we are able to indulge in the panelling, we should have one of the really beautiful anaglypta ceilings kept by Smee & Cobay; or if the ceiling is mapped out into patterns, the moulded parts should be simply coloured cream, and the panels should be filled in with the ivory-coloured anaglypta one buys at about 1s. a yard. I myself never believe in furnishing entirely from one establishment, and think if one does one can never get a real or individual home. It is also much more interesting to develop our own tastes and search about until we find what we want, and not take recklessly whatever Messrs Jones and Smith choose to sell us. If we do, our house will be the house of Jones and Smith, not ours. And is there not one special firm, which shall be nameless, whose taste or want of it rides rough shod over the suburbs, and makes one house the exact counterpart of the one next door: nay, and the one next door to that! Of course, there are many good firms which can rise above the conventional and become individual, and I am thankful to say that their numbers increase and multiply daily. At the same time, a house cannot be really enjoyed or be really our own unless we have ourselves searched and found what we want for it, recollecting all the time that on no account should we spend all our money until we have lived through a winter and summer in it. Otherwise we shall repent as in sackcloth and ashes, because we are sure to discover some terrible need, which we are powerless to supply because we have not the wherewithal to purchase what would make us comparatively if not completely happy.

Hitherto I have been dealing with the house which is out of the common run, and which is pretty to look at, and repays us over and over again for any outlay we may make, the house wherein we are certain to find good grates and simple

mantelpieces, and where, though we may not find our special tastes consulted, we may be quite sure that taste and art exist, though neither need be what we actually consider such ourselves.

Alas! and alas again! that I should have to show a darker side of the picture, and one that would most certainly paralyse any unfortunate tenant who has neither money nor an accommodating landlord. But then I say, let no considerations allow anyone to take such a house, for if it be hideous, and the owner is really poor as well as the tenant, nothing can be done for it because there is nothing to spend, and without money all are powerless. An impecunious landlord should never for one moment be allowed to exist. He is a danger to the community. He cannot and will not repair his roof, see to his drains, or keep the outside of his house in order; and though in some places, notably Brighton, the local authorities can give him notice to put his house in order, and should he fail to do so, can proceed to do the work themselves, sending him in the bill and seeing that it is paid; this power is, I fancy, rather the rule than the exception, else should we not see the fearfully insanitary houses we constantly come across, and are as constantly and continually condemning. I go as far as to say that if a landlord cannot cultivate his land, or keep his houses in good order, the State should have full power to buy at once at a regulation price; but I expect that is too Socialistic a move for most people to endorse. Still, I do most unhesitatingly implore my readers, first never to take a house on a repairing lease, and secondly to make sure that the landlord can spend, if he ought, whatever may be necessary to keep the place in really proper repair.

I have suffered from an impecunious landlord, who, while willing to do his utmost, yet really had nothing to spend; therefore I know how disagreeable this state of things can be; more especially if he is, as he generally is, a nice man. Then one can't bear to trouble him, yet why should we replace his tiles and chimney-pots, and sink our money in his drains, or why should we replace his hideous grates with our charming ones, or his worn-out kitchener with our new and superior 'Eagle' range?[6] Yet, if we do not have these things done, we are wretched and unhealthy too, and a good landlord is always willing to improve his property, if we are willing to pay him a proportionate interest on whatever capital he may lay out. If we not only find an impecunious but a crusty landlord, all negotiations must be broken off at once and without delay. It is bad enough to have to pay for improving another man's property, it is unbearable to have our improvements called 'dilapidations,' and treated with scorn and contumely.[7] Strange as it may appear, there are men whose ideas of the beautiful include grained panels, heavy and ornate cornices, and the preservation of the plaster excrescence in the very middle of the ceiling. If one finds such a man we can be quite sure he will allow no tamperings with his doors or his beautiful marble mantelpieces, and that we shall have to keep the house as we find it, or incur endless expense and litigation when we leave, as leave we undoubtedly shall, – thus bringing on ourselves the expense and trouble of a move, – because we are prevented from settling comfortably into a house, into which we should never for one moment have been weak enough to have gone. In the suburb where we do not find the pretty houses I have written of

532

just now, we generally discover the houses to be high and light, and glaringly vulgar and hideous in every way. They have the orthodox three rooms on the ground floor, and have above that, in a couple of stories, from six to eight bedrooms and dressing-rooms and a bathroom, while all the terrible ingenuity of a vulgar mind has been taxed to produce striped paint, heavily moulded and odiously-tinted cornices and vast glaring windows, which drive the artistic woman wild, because she feels almost powerless to cope with them. But she must do it, and at once. She must seek out the landlord himself, flatly refusing to leave matters to the agent; and dealing in these matters direct, must obtain the landlord's written permission to deal with the horrors to the best of her powers. Let us hope that the decorations may not be new and freshly done. In this case the house must not be taken, and I am sure that houses would let twice as fast as they do, if when one family leaves, the walls could be stripped and left bare, the woodwork being either left as it is or merely primed for painting. As a rule, no one likes another's taste, and even if the taste be good, it may not suit the next tenant's belongings, neither should she be about to furnish, may she care to adapt her new possessions to the colours and styles she finds ready for her in the fresh house. Fancy the anguish of being forced to make and inhabit a green drawing-room, after one has longed for years for a yellow one; or pining for a blue hall to find a terra-cotta one one's portion! That it is not ugly is its worst fault, it is only 'inoffensive,' 'unnoticeable,' too clean to touch. A thousand times better had it been hideous, or so black, that questions of hygiene could be raised at once, and the way opened to secure, what everyone should have, an artistic and beautiful home. If the drawing-room cannot be made into a charming parlour, if we must keep the heavy cornice and the frightful mantelpiece, we must e'en do the best we can for the wretched thing. Anyhow we must secure a simple, tiled hearth and surround, and a slow-combustion stove, and we must disguise the mantelpiece by painting it, if we can, to match the rest of the paint in the room, and putting on it the simplest drapery in the world, which is known as the 'Gentlewoman,' after the paper of that name, and which is made by taking a plain strip of material 24 inches wide, and 24 inches longer than the mantelpiece itself. This is trimmed round the sides and front with ball fringe or cord. If cord is used, a bunch of pom-poms should hang from each of the front corners, and the corners are lined on the cross with thin silk or sateen the same colour as the material, and this is simply put on the shelf and drapes itself. It is so simple that people cannot understand its virtues until they have seen it, then they understand at once what a valuable help it is to circumvent the ordinary marble mantelpiece of badly-designed houses. Mind, I am not saying one word against the beautiful old mantelpieces one finds in really splendid and venerable houses; these are often lovely and rightly placed enough. But the usual monstrosity is not like these or to be spoken of in the same book, and can only be treated as I have just described. The tiles of the grate should never be anything save severely plain and of one colour, for anything else is out of place and generally most expensive, and also more frightful than I can say. If the room is glaringly light it must be toned down, and much as I dislike green, it is the only colour one

can have. The 'green ash' paper always kept by Smee & Cobay is a delightful colour to live with, and should have paint the same shade of green as the palest in the paper; and one should moreover have some kind of floral frieze with pink in it. I like the 'Magnolia' bought of the same firm, but both Knowles & Haines always keep beautiful floral friezes, and should both be asked to supply or show designs if the 'Magnolia' were not liked, or were out of stock, as might be the case. The frieze-rail from which the pictures should hang from hooks on copper wires, should be coloured the same as the rest of the paint, and should come in an ordinary room about a couple of inches below the top of the door. Now, just one word of explanation in *re* the matter of a frieze, for strange as it may appear, everyone is not yet acquainted with what is meant when the word frieze is used. First of all, it is not a border and should never be treated as such; it should never be less than 16 inches wide, and can be as much wider as circumstances will permit, and it should never, under any circumstances whatever, be put on in strips like ordinary wall-paper is, but should be run round the room the length of the roll, not the width. Most floral friezes are so designed that one would imagine such treatment to be impossible, but I have actually known of cases where a 'festoon' frieze, which one would have thought no one ever could possibly make a mistake about, was cut in lengths and hung sideways in snippets, and even then, the owner only thought the design 'queer:' She could not see how absolutely idiotic had been the treatment of the unfortunate thing. Then there is another thing to mention: all too often the wry prettiest friezes designed as such, are disfigured with two or three straight lines which suggest to some vague, chaotic and inartistic minds that they replace the most necessary frieze-rail. They do nothing of the kind; a frieze-rail must be had if a frieze is used at all, and I trust that paper-stainers and makers may someday eliminate those lines altogether, and so no longer give a hint that it is possible to do without the real wooden rail. Even on the score of economy those lines are a mistake. One must hang one's pictures from something, and the frieze-rail is cheaper and far more effective than the usual brass picture-rod provided for this purpose. If we have pink in our frieze, we can have a pink or green carpet, or else a dull green one, just flecked with pink, which I think Morris has, or yet again can we have the entirely satisfactory green 'Isis' matting and rugs. I advise the 'Isis' most strongly, for not only is it beautiful and cleanly in itself but it is a home manufacture, and being made from the rushes in the higher Thames, should certainly claim our patronage. If we want a pink carpet, nothing surpasses Wallace's pink 'Iris,' while Smee's soft green carpet, made on purpose to match the 'green ash' paper, is a great success. If the room is very light it is well to keep to the same shade of green as the carpet for curtains and coverings. This does not go black at night, but keeps its colour well. All drawing and dining-room papers and materials should be chosen at night as well as by day, for great may be the disappointment that awaits the woman who only makes her selections in the upholsterer's shop, and by daylight alone. I have seen two materials which are absolutely the same by day become quite contrasts at night; notably in some shades of green, which turn brown in some materials, while in others they retain their colour, and

the result can be imagined if this mischance occurs when two materials, such as plush and serge are used together: or when a fringe is used which turns brown at night, on a material which does nothing of the kind! Of course, the windows all through the house should be treated alike, and in all should be the double or single sets of frilled muslin curtains, according to the amount of sunshine which the special window in question admits. Every care must be taken too in all the rooms to keep out draughts, and to let in a certain amount of fresh air, and the rooms must be ventilated in some manner at the top of the wall. In some cases, a brick can be removed and the opening covered within wire-netting, the space between being filled with cotton-wool, which is supposed to filter the incoming air; while if possible, there should be a moveable ventilator in the windows. Then Tobin's tubes[8] should not be forgotten, albeit the expense of this patent is an item one should not lightly incur. The drawing-room must be lighted by one good duplex lamp in beaten iron or copper, from Benson in New Bond Street, or from Strode, and the wise will have a transparent globe or shade, and will refuse to grope about in the semi-darkness of silken-shaded light. But the amount of further light must be determined by the owners of the room and their pursuits, and may consist of properly weighted Standard lamps: procurable at Benson's, or at Bartholomew & Fletcher's: or by one or two movable lamps placed on steady tables. In any case great care must be taken to ensure perfect safety; a very small table, or one that has no double tray, should never be selected as a lamp-carrier, for if it is, an accident is almost certain to occur. Great care should be taken in selecting the small table-cloths which should be on all tables, and these can be procured at Colbourne's, Godfrey Giles, and the Cavendish House Company Cheltenham, ready to use; and equal care should also be taken to secure proper pictures and ornaments, which must not be overdone in any way; while it is well to recollect that the dreadful 'chair back' is no longer with us, and has been completely ousted by the Liberty frilled pillow, which is as useful as it is undoubtedly beautiful and comfortable.

If we cannot have a new mantelpiece, let nothing induce us to have a regulation overmantel, for never can we procure one which shall in any way harmonise with a marble mantel; so there is no good trying to get one, for we can't. It is best to repeat instead the Chippendale mirrors spoken of before, and equally good to possess oneself of the round glasses with the eagle and ball at the top, which one often is able to pick up in the shops in Great Portland Street along with charming bits of real blue china, if one understands the craft of bargain-hunting, not unless. Under any circumstances nothing but severe simplicity is permissible. A real overmantel, which may be beautiful in itself, will only emphasise the misery below it, in the shape of the mantelpiece, by displaying its evident contrast to what should be a component part thereof; while either the 'Eagle' or the 'Chippendale' has frankly 'no connection with the party next door,' and is existent on its own merits alone, and is therefore all it should be. Now one last word only, and that is about the position of the piano. If it be a cottage grand, it can be placed like the one in the room illustrated. A piece of brocade should be put carelessly on the end of the piano, and kept

in place by a few books, and a tall palm should be placed on the table in the bend. No other decoration must be allowed at all. If we have a cottage piano, it is well to put it in one of the recesses by the fire, straight out into the room, and to conceal its hideous back by a simple curtain on a rod, sold by Shoolbred. We should have in a small room a piano stool to hold music, as well as to sit upon, and in the other recess we could place either the grandfather chair or one of the charming courting settees sold by Hewetson. But let me implore my suburban readers, when placing their pianos to do so with a kindly remembrance of their possible neighbours, to select an inside wall in preference to an outside one, and to practise whenever they can with the windows closed and carefully fastened. I have once been near enough to other folks to suffer the tortures of the lost from my neighbour's piano. I cannot, therefore, impress too much upon my readers that a good deal of real pain may be inflicted on one's neighbour simply because the question of the piano has never been duly and properly weighed and considered. I suppose it is too much to suggest that no one should play and sing who has neither taste, nor voice, nor knowledge, so I will only content myself with remarking that the farther the piano is placed from one's neighbour the better, and that some consideration on this subject is due from everyone who may possess and will manipulate that which in some hands may be as much an instrument of torture as the wretched barrel-organ itself!

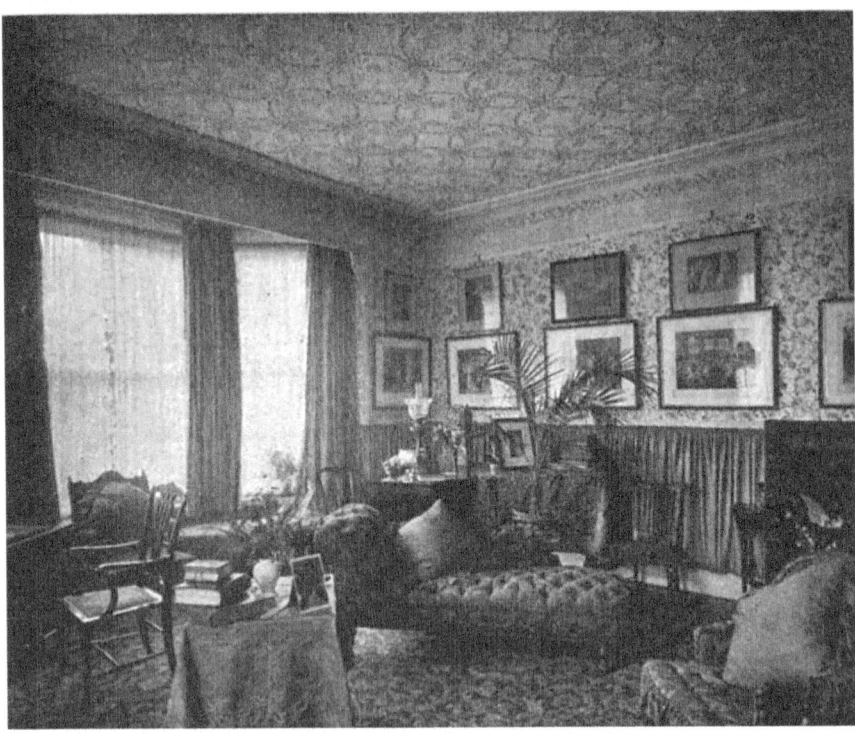

# Notes

1 Mrs Panton, *Kitchen to Garret*, Preface.
2 Ernest Newton RA FRIBA (1856 1922) was an English architect, President of Royal In-
stitute of British Architects and founding member of the Art Workers' Guild. His obitu-
ary noted that "His eminence as an architect of unexcelled skill in a class of work that
constitutes England's chief or sole claim to supremacy – the capture and apt embodiment
of the very spirit of the home . . ." *Architect's Journal*, 1 February 1922, p. 187.
3 Panton lived in Wareham, Dorset for a while.
4 *Ewigkeit*; Eternity (German).
5 The "name given to designate the cutting out of mouldings and sunk patterns in wood
by means of Dr. C. L. Goehring's geometrical wood-moulding machinery. By its means
great facility is offered for decorating woodwork in a legitimate and sensible manner."
*British Architect*, 17 February 1893, p. 124.
6 Eagle Range and Foundry Company, Regent Street, London. The feature of the 'Eagle
Range' was that it was manufactured with iron flues and required very little masonry
work to install.
7 Archaic term for abuse or insult.
8 'Tobin's Tubes'; were invented in 1874 by a Mr Tobin. They consisted of rectangular-
section tubes that enter into a room from an outside wall and curve upwards to about
shoulder height. The tubes draw in air from near ground level through airbricks, and
expel it in the higher parts of a room, obviating direct drafts. They are illustrated in *Cas-
sell's Book of the Household* (Cassell, 1889).

## JOHN H. ELDER-DUNCAN, 'HINTS TO PURCHASERS', *THE HOUSE BEAUTIFUL AND USEFUL: BEING PRACTICAL SUGGESTIONS ON FURNISHING AND DECORATION* (1907)

### Editorial Headnote

John H. Elder-Duncan (1877–1938) was trained as an architect, editorial secretary of the *Architectural Review* from 1900 to 1910 and later a civil servant in the Ministry of Agriculture, (1919–1937), as well as secretary of the Architecture Club. Elder-Duncan was also author of many articles on architectural topics, as well as books on similar subjects.

In this work he comments on the value of education in terms of taste and design, and at the end of the introduction, he notes that 'I have endeavoured to avoid being didactic in the notes on the various branches of our subject, merely striving to point out certain desirable tendencies, or to indicate certain qualities of artistic fitness that commend themselves'. The old desire to establish principles of 'good taste' and appropriate design were still in evidence.

In his preface to this book, he comments on the potential changes that could occur in the new century to benefit modest homes:

> The great revival of the arts and crafts during the last quarter of a century, not here alone, but also on the Continent, and a higher standard of general culture, have now brought about a reasonable partnership between Art and Commerce, so that the enlightened manufacturer, co-operating with the talented Craftsman, is able to produce furniture and decorations at a price which the man of moderate means can afford. There is no reason, therefore, why the most modest home should not be a model of artistic fitness.[1]

In a later article titled 'The Possibility of an Ideal Home', Elder-Duncan promoted the Modernist ideas of convenience, labour saving, and efficiency in house design.[2] However, Duncan's discussion around the furnishing and decoration of libraries, morning rooms, billiard rooms, and breakfast rooms seems a little at odds with his professed aim to discuss the furnishings of modest homes for the mass of people who could not afford their own architect.

Reviews were innocuous, with *The Athenaeum* commenting that

> this is the work of a competent journalist who, while not possessing expert knowledge, has been brought into close contact with his subject to which he has, moreover, evidently given a good deal of thought and study. In matters of taste it is a tolerably safe guide.[3]

Lawrence Weaver's review in *Architectural Review* was much more generous.

> The success of Mr. Elder-Duncan's earlier volume on *Country Cottages and Week-end Homes*, uniform with this, has prompted the preparation of a similar book on furnishing and decoration. It is primarily intended for the general public, but will be none the less useful to those whose work runs in these directions. In an introductory chapter the decorative achievements of last century are dealt with clearly and pleasantly, and the author tilts merrily at the now dis-credited but not yet wholly damned vagaries of 'L 'Art Nouveau'.

Weaver goes on to mention Elder-Duncan's commentary on antiques and their use in the home.

> On the subject of 'Antique' furniture Mr. Elder-Duncan discourses very sanely: 'For those who desire old furniture, it is only sound advice to say, never worry about the maker. Satisfy yourself that the piece is really old (and this is difficult enough in all conscience!); satisfy yourself that it is really beautiful; see if its beauty plus utility sufficient recompense for the price is you are called upon to pay for it, and if so, buy it. All else is chimera and or supposition'.

Finally Weaver noted:

> Were it not that Mr. Elder-Duncan is Editorial Secretary of this REVIEW, we should write with fuller praise; but, after all, 'good wine needs no bush,' and we can at least wish this popularly conceived handbook all the success it deserves.[4]

# 64

# 'HINTS TO PURCHASERS'

*John H. Elder-Duncan*

Source: John H. Elder-Duncan, 'Hints to Purchasers', *The House Beautiful and Useful: Being Practical Suggestions on Furnishing and Decoration* (London: Cassell, 1907), pp. 221–4

## HINTS TO PURCHASERS

ONE or two warnings may be timely in the matter of buying furniture. Everyone about to get a home together is fated to meet that knowing individual who talks largely about sales. "Ah! the furniture sales are the thing, my boy; you can pick things up dirt cheap. You know my house? Well, I furnished the whole of it for such-and-such a sum mentioned." If the end and aim of one's furnishing is to fill rooms with tables and chairs much as a caterer calculates for a rout dinner or ball, this is, no doubt, excellent advice: but if the intention is to gather round one beautiful and serviceable things, I have no hesitation in saying that furniture sales are the very worst places to find them. Then the lover of old furniture is advised to wander round the quaint little second-hand furniture shops in Wardour Street and elsewhere. Ten or twenty years ago, before old furniture was as much sought after and as highly prized as it is now, it might have been possible to secure bargains, but your second-hand dealer of to-day knows to the last penny what the value of his stock is; and if the unsophisticated buyer imagines, in the flush of his inno-cence, that he is getting things miraculously cheap, let him compare the prices paid with the prices asked by one of the straightforward prices-marked-in-plain-figures' dealers like, say, Messrs. W. & E. Thornton-Smith. It may be possible to pick a good piece now and then at some little dealer's in, say, Islington or Camden Town (I mention these as typical, not special, neighbourhoods), where the homes of one, two and three rooms are continually being set up, and as continually com-ing to grief, and where the dealer has no real knowledge of furniture, which he buys and sells as he might firewood, sweets or tobacco. But even such shops as these are few and far between.

Another warning is against the big advertising "cash or credit" firms. "No deposit required," "You marry the girl, and we furnish the home," are two of their catch phrases, and the advertising columns of any paper will give others. Do not base this warning on any question of terms. If one enters into an agreement to pay certain sums at stated intervals, and for any cause whatever fails to do so, it is hardly fair or reasonable to abuse the other party to the agreement if he or they

DOI: 10.4324/9781003290490-82

541

exact the penalties that a breach of the arrangement entails. The trouble is that the generous terms, in the shape of small payments, offered by these firms induces many people to commence house-keeping without an adequate appreciation of these responsibilities, and without a clear prospect of being able to complete the arrangement. To the man in a good position, drawing a fair salary, a hire-purchase agreement may be a very satisfactory solution to the difficult problem of finding a large lump sum for furniture; but for the clerk on a small salary, or the workman, it is hardly wisdom to embark on a scheme of payment extending over years, when in six months or a year he may be out of employment, or have to move to the other end of the kingdom to take up a fresh job.

My chief complaint against the big credit furnishing firms is, however, not only that they stock some of the most meretricious trash ever sold under the guise of furniture, but they charge three or four times its market value, and thus furnishing with them means a prodigious outlay for a very small result. If anyone contemplates furnishing with one of these firms let him compare, as I have done, the prices in their catalogues with the prices in the catalogue of one of the big West end houses. Of course the answer is obvious: furniture dealers are not philanthropists, and if they have to wait three or four years for their money they must get their interest somehow. Moreover, the period over which repayments, according to published scales, have to be made is uncertain. I note that one firm offers one hundred pounds' worth of furniture for £2 5s. per month. Simple multiplication shows that payments would have to be continued for four years before the sum was paid off-to be precise, £108 would then have been paid. Unless we are to assume that the odd £8 is interest, and that the dealer is satisfied with 2 per cent. per annum, the payments must be continued for even a longer period. The key to this enigma was afforded by an unwary an announcement of a "three years" system by one firm, but the scale of repayments showed that they could not possibly get the selling price of the goods in the stipulated time, let alone interest. Doubtless the advertisement was loosely drawn up. The explanation is that the selling price bears no relation whatever to the price the credit firm pays the wholesale dealer or manufacturer, and doubtless in eighteen months or two years, possibly less, they have received the price paid for the stuff and are making profits, and if the hire purchaser defaults at the end, say, of three years, the credit firm has not only received back the money they paid for the furniture and made a handsome profit, but they can claim the whole of the stuff into the bargain.

At the same time this credit furnishing question is so important to the major part of the community that I feel it is hardly to be dismissed summarily or as a method of purchasing that is to be condemned off-hand. Many of the other better class houses will, believe, make terms of repayment to suit their customers' convenience, but in all these questions I can of course give no guarantees, merely recommending readers thoroughly to investigate matters for themselves, and if necessary, take such legal or other advice on the wording of the agreement as may be necessary to safeguard themselves.

One of the worst methods of buying furniture is to start off to some furniture dealers with the vaguest notions of things one wants, of the size of the rooms, or of the colour schemes one desires in them. Furniture showrooms are necessarily big places, and to trail up and down long rows of furniture and go up and down several flights of stairs an unnecessary number of times because one's ideas and requirements have never been formulated, is calculated to tire out any assistant and make him indifferent and inattentive. It is advisable, therefore, to set down a list of the articles desired in each room, with any details as to size and colour, and further to collate some of the items, as carpets, curtains, fenders, &c., so that when you have arrived at the carpet department you have together all the particulars for all the carpets you require, and so on. This saves much needless running about. Another point to remember is that many firms do not stock the minor accessories of furnishing, though the majority undertake "complete house furnishing." Thus, I purchased my bedding of the same firm that supplied the bedsteads, but the bedding had "to be made," or, in other words, had to be procured from a bedding dealer, and I found it cost me much more than if I had gone to a firm of specialists in bedsteads and bedding like Messrs. Heal and Son. In the same way not many furnishing firms stock knives and forks, saucepans, kitchen utensils, brooms, &c.; and if purchased from the sample articles kept at most shops it will probably be found (except, perhaps, at Messrs. Oetzmann & Co.'s) that they are much dearer than if bought at an ordinary hardware shop. All these things it is advisable to buy beforehand. I know I had all plate, household linen, cutlery, and saucepans, &c., before I thought about tables and chairs; and this course is to be recommended because, while these items seem insignificant in themselves, they mount up considerably, and too often after buying the large and more solid articles the balance left is insufficient for things as necessary in a home as the chairs and bedsteads.

## Notes

1 Elder-Duncan, *The House Beautiful and Useful*, Preface.
2 "The Possibility of an Ideal Home", *Quiver*, 48, 8, June 1913, pp. 774–7.
3 Review, *Athenaeum*, 29 February 1908, p. 265.
4 Review, *Architectural Review*, 1 December 1907, p. 303.

# WALTER SHAW SPARROW, *HINTS ON HOUSE FURNISHING* (1909)

## Editorial Headnote

This practical analysis of the various methods available to prospective persons about to furnish their homes offers some practical advice as to the various options available. They include the scorned hire purchase system; the direct cash purchase from a showroom; the antique collector's market; the direct purchase from a craftsman; and the ordering of a reproduction style to one's own choice.

Walter Shaw Sparrow (1862–1940) was born into a comfortable lifestyle in Wales. His early interest in drawing and watercolour led him to attend the Slade School of Fine Art in London. In 1880, he went to the Académie Royale des Beaux-Arts in Brussels, where he worked and lived for seven years. In 1899 Sparrow produced publicity for the sixth exhibition of the Arts and Crafts Exhibition Society in *The Studio* magazine after which he was appointed assistant art editor for the magazine. He was a prolific author on both sporting artists and architecture and topics around the home. These publications included *The British Home of To-Day* (1904), *The Modern Home* (1906), *Flats, Urban Houses and Cottage Homes* (1907), *The English House* (1908), *Our Homes and How to Make the Best of Them* (1909).

*The Atheneum's* review took issue with some points but was clear as to the value of it overall:

> We cannot share his whole-hearted condemnation of the hire-purchase system, for the simple reason that without it many middle-class houses would never be started. Moreover the system has been taken up and established in trust-worthy quarters.
>
> Mr. Shaw Sparrow is sprightly and caustic at times, and he can even be rhapsodical. . . . But our author is perhaps most useful when he comes to apply his principles to the house in detail and supply practical advice. He mentions names of firms who supply different fabrics and the names of designers, from which the reader may pick at his pleasure. He leans heavily on certain accepted authorities, and shows discretion in his quotations from them. There is a special chapter on furniture designed by Mr. Baillie Scott: and a section is devoted to hints on the construction and size of rooms. Altogether the volume forms a miscellany of information into which one can dip with advantage, if it be only for the purpose of obtaining an address or the name of a particular patent grate.[1]

A review in *The Bookman* was also supportive of Sparrow's approach:

> The author has managed somehow or other to make his book very good reading. He has a number of dislikes, and does not scruple to pour out the vials of his scorn on many of the modern 'methods' and styles in house furnishing. Entirely apart from this, he gives the best of practical advice. Above everything the book is practical, and the author has not spoilt it by a morbid fear of giving gratuitous advertisements.[2]

The scorn is evident in the text below, but Sparrow's practical advice was clearly in support of the consumer in the face of some alleged dubious trade practices. He suggested in a chapter on 'Cheapness' that he knew of 'but three ways in which the public could be safe guarded:

1. That the law should make it an indictable offence for any person to sell a thing for a given purpose when it is not fitted for that object.
2. That there should be a yearly National Congress of the British Home at which all real grievances of house holders should be formulated and discussed.
3. That householders should form a league, establish a great central office in London, and defend their interest under legal advice and in a business-like way, issuing month by month a printed record of the work done

Meantime, let everybody make use of his common sense'.[3]

# 65

# *HINTS ON HOUSE FURNISHING*

## *Walter S. Sparrow*

Source: Walter Shaw Sparrow, *Hints on House Furnishing* (London: Eveleigh Nash, 1909), pp. 29–39.

## CHAPTER III

### Systems or Methods of Furnishing

There are a good many ways in which furniture may be got for a home, and it will be well to review them one by one, so that a fair choice may be given carefully.

### *A. The Hire-Purchasing System*

Let us have faith in the old maxim: "Buy always what you can afford to need and pay for it at once."

What you can afford to *need*, not what you can afford to *desire* or *want*. For there is a very real difference between wants, desires, and needs. Desires and wants stimulate enterprise; they are needs undeveloped. If we desire this or want that, we must strive for it, and have character enough to win it fairly without help from mean shifts and compromises. But when we need something, we stand at once as choosers between right and wrong; if we call the tune, we must pay the piper; needs demand both acts, payment with purchase, because purchase without payment dulls self-respect. Needs are fatal to honour if men trifle with them. The hungry steal, the impulsive run into debt, the ambitious risk their families rather than moderate their schemes.

These reflections belong to the old Puritan spirit, which reigned in England from Elizabethan times to the long days and years of Queen Victoria. Then a new industrialism took for its aim the turning of public wants and desires into urgent public needs. Temptations to spend money hurriedly, without feeling at once the full result of that transaction, were held up persuasively in many forms of advertisement. Thrift was looked upon as a foe to business; and we are now beginning to see that an over-stimulated demand in trade weakens the national character and begets an unrest of mind without will-power. Artificial needs are manufactured by advertisements, and then glutted with cheap commodities and pleasures, from patent medicines to seaside trips. It is time to remember that Debt, Penury, Thrift-lessness are three detectives that never fail to strike home.

DOI: 10.4324/9781003290490-83

For these reasons, if you need a hundred pounds-worth of furniture, buy it outright; do not pay for it in monthly instalments of £2 5s. Business of that kind is without character; and character is strength and wealth.

Have you read with care the advertisements that boom the hire-purchasing system? It is worthwhile, for they talk like popular philanthropists.

Buy always what you can afford to need, and pay for it at once.

But in saying this I do not condemn all the furniture issued by the hire-purchasing system. One firm has equipped nearly 150,000 houses during the last forty years, a long record of business not to be supported by bad workmanship; for people are always exceedingly critical when they pay for things little by little. All systems of "easy payments" so called, breed long after-thoughts; and hence they need help from free life insurances, free fire policies, and other things not usually connected with buying and selling.

I have dwelt upon this matter for two reasons. A book on furnishing should try to be a guide, and the public should resent the bad methods of advertising which are now so common. Advertisements belong to the cost of production, and the public pays for them; hence the paymaster should be critical and the advertiser discreet.

## B. The Stock Furnishing System

That is to say, you go to a reputable firm and choose what you need from the stock, paying for it immediately. Discount should be asked for and allowed, at least in most cases. This system can be recommended. There are firms in Great Britain that cater for all incomes with judgment and fairness.

One warning may be given here: that persons with moderate incomes should not go to a large furnishing shop until they have definite ideas as to what they need. If they go there with vague ideas, they are certain to buy too much. Draw up a list of things for each room, reduce them to the lowest possible minimum, and do not be tempted to add even one item to the list. Discuss the matter thoroughly, come to decisions and be loyal to them. If you decide that four ordinary chairs are enough for your dining-room, do not buy six or eight, a clever salesman charming you with the word "suite," a word which some men and many ladies find irresistible, not understanding that it means a set of no definite number. A suite of chairs may consist of two armchairs and four ordinary ones, if that be the number you want. Indefinite aims account for most bad shopping; there is scarcely a house which has not too much furniture. Small tables are bought in pairs not because they are needed, but because "they match," another phrase that tricks the unwary into spendthrift habits. "It will be useful" is another pitfall. "Will" implies futurity; and if you have no books and prefer golf to reading, why purchase a bookcase on the chance that it will be useful one day? In other words, buy nothing more than you will need daily in your rooms. If this rule were kept in mind and followed, poor families could afford to have furniture such as they would be proud to hand on to their children; for it is the waste of money on too many things

that prepares a market for jerry-made inutilities. Cheap pianos are bought by those who cannot play them; and occasional letter-writers give more thought to their bureaus than do journalists and novelists. "How do you like my writing-table?" asks Mr. A., whose hobby is golf, or cricket, or billiards at the club. When persons of this kind furnish a house, the bills are at least one third higher than they need be or should be.

### C. The Collector's System

I have already spoken about this way of furnishing a home. It is amusing, it has many advantages, but even in the hands of experts it is likely to produce a museum rather than a dwelling. I have never known a collector who kept his rooms uncrowded. One buys so many pictures that a great many have to be put in piles against the attic walls; while another has so much costly furniture that you think of the reserves of gold in the Bank of England and feel uncomfortable. There is a real danger in collecting, for (as a rule) it becomes an obsession, a mania. But if you care to run the risks, many a good thing may be purchased at second hand.

### D. The Craftsman's System

At the present time there are many artist-craftsman who design special furniture for their clients. Some are well-known architects like Mr. Mervyn Macartney, Mr. Walter Cave, Mr. Charles Spooner, Mr. Baillie Scott, Mr. C. F. A. Voysey, and Mr. R. S. Lorimer; others have their own workshops, like Mr. C. R. Ashbee, Mr. Sidney H. Barnsley, Mr. Ernest W. Gimson, and Mr. A. J. Penty; while one at least – Mr. Frank Brangwyn, A.R.A. – is better known as a great painter. I need not say that it is a delightful honour to have furniture either designed or made by these and other artists; and you will understand that they do not compete against the manufacturers, nor pretend to do work at popular prices. We may say of them what William Morris said of the leading members in the Arts and Crafts Exhibition Society; namely, that their cultivation of art is an attempt to interest persons of taste by calling special attention to that really most important side of art, the decoration of utilities by furnishing them with genuine artistic finish in place of trade finish. Now all the higher aims of art cost time – indefinite time; no excellent work was ever done in a hurry; and it is only the final result that counts when a creditable piece of work is to be a thing of beauty. As a consequence, if you go to an artist-craftsman for a special suite of furniture, you must give your commission in good time, refrain from hurrying him, and pay the price he is accustomed to receive. It will not be higher than the skill and the labour merit, you may be well assured. The mouldings will be cut by hand, not by machinery, every scrap of wood will be thoroughly seasoned, the polish will not be overdone, and you will have a suite of furniture by a man of name, a Gimson, for instance, whose art is not inferior to Sheraton's or Chippendale's.

Three things in furniture determine both its value and its beauty: fine wood, quiet and good design, and thorough craftsmanship. This last quality may be harmed, and is so frequently, in one of several ways. Sometimes the polishing is bad, and this defect is always serious. In old times a cabinetmaker polished his own work, partly by exposing it to the light till the surfaces darkened and partly by rubbing it with oil and beeswax. This method is the earliest and by far the best, but it gave place to a mixture of shellac and naphtha, which, though inferior to the beeswax, formed a lasting polish with a hard surface. The next downward step was the introduction of a French polish, a shiny and detestable thing; and goodness knows what other abominations are used to-day, bringing trouble into a million households. Who does not know the anxiety of housewives lest hot plates and dishes "mark" the tables?

This example of technique is given here to illustrate the ways in which all artist-craftsmen are called upon to be honest. If they shirk difficulties, they save time and lessen the cost of production; but if they decline to do that, they must needs ask a higher price for their commodities; and in this we find the real difference between the craftsman's art and the manufacturer's trade. An artist makes his own conditions and obtains his own price, while a tradesman cannot do more than his average customer will deem reasonable in price, though his workmen can do better if you commission a special job and state in plain words what you need and must have.

I have now offered for consideration four different methods of furnishing, but there is yet another, namely:

### E. The Reproduction Method

That is to say, you commission a reputable firm to make your furniture in accordance with certain old styles and models. Perhaps you may choose Sheraton for your bedrooms, Chippendale for the dining-room, &c., and select definite designs by those masters. Much excellent work has been done in this way. Messrs. Druce & Co. of Baker Street, London, made for me a suite of chairs from a Chippendale model, at a price of 37s. for each chair. The workmanship is excellent; but the wood, of course, has not yet the patina given by time, use, and rubbing, and its colour is not yet transparent and rich like that of old furniture. Further, when ordering such replicas, definite instructions should be given and summed up as an agreement, the main points being the following:

1.  The wood. The woods mainly used for furniture work are oak, walnut, rose-wood, satin-wood, cedar, sycamore, plane, deal, and mahogany. Walnut, with its even texture and its pleasing grain, is very popular. Its colour is improved by age and careful treatment. The Italian variety is grayer than English walnut, it is less subject to the attacks of worms, and it looks charming, but carvers speak of it as brittle. As to mahogany, the Cuba variety is the very best wood in the world for furniture, but its price has become so high that Cuba

550

mahogany is rarely used now except as a veneer and to decorate the surface of cabinets. The mahogany employed to-day comes from Honduras, and is known as Bay Wood. It is more useful than rosewood, its colour being less purple. Finally, remember always that beech, holly, and sycamore, are often stained to resemble both rosewood and walnut.

2. Whether the moulding is to be machine-cut or hand-cut.
3. The polishing in its relation to different articles. Let the polishes be named and their constituents given. Try to dislike brilliant surfaces because they mirror so many things that the beauty of the wood is obscured.
4. The choice of styles.

There are beautiful styles in furniture which are too elaborate to be in keeping with our simple daily needs. To see them is to know how their design was influenced by rich velvets, beautiful laces, glorious silks, and elaborately pleated ruffs. The best way to study this matter, I believe, is to pass some pleasant hours with "The Mansions of the Olden Times" by Joseph Nash;[4] but after the Stuart reigns we find plenty of furniture from which to choose a style. There is, perhaps, only one exception, and that is the gold and white furniture by Pergolese, a form of art too rococo for England. Sheraton in his decline did some absurd things, but so bad that no sane man would copy them now. He designed with pride a chair composed of a griffin's head, the neck and wings united by a transverse tie of wood, over which a piece of drapery was thrown and tacked behind. The good man made other chairs in which he introduced dogs, lions, camels, dromedaries, and other animals, nor did he seem to know what a poor figure he cut, A.D. 1807.

For the rest, whatever system of furnishing a young couple may decide upon, they must give ample time for their hard and anxious work, which ought really to be finished before they are married.

What happens, as a rule, is an adventure in hurried last days, hours, and minutes. Engaged couples put aside practical duties, live in islands of dreams, and then try to make up for lost time by wasting it on a flurried gallop in housekeeping. They start with enthusiasm, rushing from one house agent to another, only to be told, with the same chilling politeness, that really they have come to a wrong part of the town.

"Rents are rising here month by month," the agents say blandly; "this neighbourhood is very select, few lodgings and no cheap flats. If you want such low rents as you name, our advice cannot help you much, because the whole town improves and rents go up as a matter of course. Still, some neighbourhoods are not in fashion, and we'll look at our books and send you some addresses."

It is thus that agents form a league with landlords and squeeze the last possible shilling from a tenant's income. Even the rich are now invited to pay three thousand guineas a year for a pied-a-terre in London, just because they may live in splendid flats on a great thoroughfare, and be charmed by the music of motorcars and buses.

But as the pleasures of imagined things are worth cultivating, let us suppose that our engaged couples have found their houses and signed their leases. In three weeks' time they will be married. Trousseaus have to be finished meanwhile (for these are not left till the last moment, though the long last details may be as bad as a demurrage scare in shipbuilding). Yet custom says that a few magical half-hours of thought may yet be found for other important duties, so the actual furnishing is not entirely neglected.

It needs some courage to equip a house in a rapid scampering fashion; but there are traditions to help us if we wish to experiment. One tradition – and it seems to swallow up all the others – may be mentioned here: Bewilder your mind, dazzle your eyes, and then do the best you can. Surround yourself with catalogues of all sorts and conditions, perhaps a dozen on furniture, another dozen on kitchen utensils, eight or ten on carpets, and so forth; but to complete the disorder you need a large supply of pattern-books, giving samples of the latest achievements in wallpapers, in textile fabrics, in table linen, and what not besides. Rival manufacturers send you these things partly by request, and partly because your house agent has a kind interest in your welfare and wants a commission from certain firms. At first you are surprised when catalogues arrive, like volunteered contributions to an editor's daily work; but they help to make a confusion which is quite necessary to failure when a house has to be furnished. If the catalogues and pattern-books are few in number, and time enough is given to master their contents, who can be certain that he will fail?

## Notes

1 *The Athenaeum*, 10 July 1909, p. 49
2 *The Bookman*, 36: 211, April 1909 p. 15
3 Sparrow, *Hints on House Furnishing*, p. 21
4 Originally published in 1849 it was reissued as Joseph Nash and Charles Holme. *The Mansions of England in the Olden Time by Joseph Nash New Edition Edited by Charles Holme with an Introduction by C. Harrison Townsend*, Studio, 1906.

# Part 10

# SPIRITUAL MATTERS

# SPIRITUAL MATTERS, RELIGION, MORALITY

As the nineteenth century progressed, for many it appeared to be increasingly more disaffected and disordered, so that the home was perceived more and more as a foundation and a source of sanctuary in a turbulent society. This encouraged the growth of domestic religious practices which were closely linked to Victorian concepts of morality. A. J. Downing in his preface to *The Architecture of Country Houses* published in 1850 wrote:

> That family, whose religion lies away from its threshold, will show but slender results from the best teachings, compared with another where the family hearth is made a central point of the Beautiful and the Good. And much of that feverish unrest and want of balance between the desire and the fulfilment of life, is calmed and adjusted by the pursuit of tastes which result in making a little world of the family home, where truthfulness, beauty, and order have the largest dominion.[1]

To achieve this state of affairs, the home was seen as a sacred symbol and the domestic interior should reflect this. In 1861 an American clergyman wrote:

> In itself the home is a sacred place. Its founder is God. Its gifts, its possibilities are his. The things sacred to the soul and life are of it. It is the place of birth, of growth, of death, – and these three great mysteries, these processes in our being, sanctify it unto us. Distinctively religious then should the home be made by us, and every father and mother be known as the priest and priestess of the domestic altar.[2]

Andrew Boyd in his chapter titled 'Concerning the Moral Influences of the Dwelling', in *The Recreations of a Country Parson*, (1862), explained how he considered that domestic circumstances, and by inference their standard of decoration had an impact on man's moral compass: 'I do not hesitate to say that the scenery amid which a man lives, and the house in which he lives, have a vast deal to do with making him what he is'.[3]

DOI: 10.4324/9781003290490-85

This was reinforced by the Reverend W. J. Loftie in his final chapter of *Art in the House* where he discusses art and morals. Here he argues for a religious basis for home decoration:

> If we follow Bishop Butler in speaking of this life as a state of proba-
> tion, and if we allow that home life is the highest ideal type of the life in
> heavenly 'mansions', we find ourselves forced to go a little further, and
> to contemplate our own houses, our fire-sides, our sitting rooms, our sur-
> roundings in the house, or, in a word, all those things which go to make up
> our notions of home, with a kind of moral and even a religious reverence.[4]

To establish and maintain this state of affairs, it was in many cases the mother who was seen as the 'Angel in the House'.[5] The American educator Hiram Orcutt emphasised the importance of the mother in the home:

> The mother is [the father's] 'helpmeet', his honored queen, and the
> sharer of his authority and responsibility in the important work of edu-
> cation: indeed, she is the central light and animating spirit of every true
> home; and hence from her emanates the educating and moulding power
> in every family.[6]

It is important to remember that the working classes were not able to engage with these middle-class models of domestic motherhood in the same way. Nevertheless this did not mean that poorer households were not religious. However there were continuing concerns over the issue of morality in regard to the living conditions of the working classes that were exacerbated by poor quality housing, overcrowding and insanitary conditions. (See Volume 2: Working-Class Spaces.)

The texts here offer a variety of aspects of religious and moral approaches to the interior during the century ranging from concepts of the 'ideal home' through issues of class position and the avoidance of excess, to the use of symbols of piety in the home.

## Notes

1  A. J. Downing, *The Architecture of Country Houses* (New York Appleton, 1850), p. vi
2  Rev. J. F. W. Ware 'The Sunday at Home', *The Monthly Religious Magazine*, Boston, August 1861, pp. 92–3.
3  *The Recreations of a Country Parson* (London: Alexander Strahan & Co., 1862), p. 279.
4  W. J. Loftie, *A Plea for Art in the House* (London: Macmillan 1878) p. 89.
5  Coventry Patmore, wrote 'The Angel in the House' about his wife. The poem was origi-
   nally published in 1854, then revised through 1862.
6  Hiram Orcutt, *Home and School Training* (Boston: Thompson, Brown, & Co. 1874),
   p. 10.

## JESSE E. DOW, 'THE HAPPY HOME' (1840)

### Editorial Headnote

This sentimental poem, depicting the idyllic nature of a happy and Christian home, was published in *The Ladies' Cabinet of Fashion, Music and Romance*, in March 1840. This British journal was an illustrated monthly women's magazine aimed at the middle-class market. It was first published by a mother and daughter Beatrice and Margaret de Courcy in 1832. Like many other similar publications, it included extracts from novels, short stories, reviews, aphorisms, songs, philosophical discussions, and detailed descriptions of the latest clothing fashions from London and Paris.

Slightly shortened versions of the poem had already been published as anonymous in *The Church Magazine* as 'The Christians Happy Home' (1839, p. 349) and also in the *American Masonic Register and Literary Companion* (February 1840, p. 192) The American journal *Subterranean* (25 October 1845) also published the poem and identified the author as Jesse E. Dow, a friend and confidante of Edgar Allan Poe.

Jesse Erskine Dow (1809–1850) was born in Connecticut USA and worked as a naval officer until he was subsequently employed in various government posts (Dow was at one time the doorkeeper of the House of Representatives). He also published works of poetry and journalism which was sometimes critiqued as being uneven and sometimes careless:

> Mr. Dow is well known as a correspondent of the 'Democratic Review', the 'Lady's Book', and various other periodicals. His verse is often unequal in character – the same article exhibiting passages of decided beauty and others of careless versification. He is peculiarly happy in his political poems. He is evidently a warm politician, and when his theme is one in which his feelings are deeply interested, his verse glows with ardor, and is highly spirited.[1]

This poem is typical of the numerous sentimental approaches to the concept of 'home' as being rooted in Christian values.

# 66

# 'THE HAPPY HOME'

## *Jesse E. Dow*

Source: Jesse E. Dow 'The Happy Home', *The Ladies' Cabinet of Fashion, Music and Romance*, 1 March 1840, p. 184

### THE HAPPY HOME

For there the father sits in joy,
And there the cheerful mother smile
And there the laughter-loving boy,
With sportive tricks, the eve beguiles;
And love, beyond what worldings know
Like sunlight on the purest foam,
Descends, and with its cheering glow,
Lights up the Christian's happy home.

Contentment spreads her holy calm
Around her resting-place so bright,
And gloomy Sorrow finds a balm,
In gazing at so fair a sight;
The world's cold selfishness departs,
And Discord rears its front no more,
There Pity's pearly tear-drop starts,
And Charity attends the door.

No biting scandal, fresh from hell,
Grates on the ear, or scalds the tongue;
There kind remembrance loves to dwell,
And virtue's meed is sweetly sung;
And human nature soars on high,
Where heavenly spirits love to roam,
And Vice, as stalks it rudely by,
Admires the Christian's happy home.

DOI: 10.4324/9781003290490-86

Oft have I joined the lovely ones
Around the bright and cheerful hearth,
With father, mother, daughters, sons,
The brightest Jewels of the earth:
And while the world grew dark around,
And Fashion called her senseless throng,
I've fancied it was holy ground,
And that fair girl's a seraph's song.

And swift as circles fade away,
Upon the bosom of the deep,
When pebbles, tossed by boys at play,
Disturb its still and glassy sleep,
The hours have sped in pure delight,
And wandering feet forgot to roam,
While waved the banners of the night
Above the Christian's happy home.

The rose that blooms in Sharon's vale,
And scents the purple morning's breath,
May in the shades of evening fail,
And bend its crimson head in death;
And earth's bright ones amid the tomb,
May, like the blushing rose, decay;
But still the mind, the mind shall bloom,
When time and nature fade away.

And there, amid a holier sphere,
Where the archangel bows in awe,
Where sits the king of glory near,
And executes his perfect law,
The ransomed of the earth, with joy,
Shall in their robes of beauty come,
And find a rest without alloy,
Amid the Christian's happy home.

## Note

1 Charles Everest, *The Poets of Connecticut*, (New York: Gates and Steadman 1847), p. 375.

# SIR GEORGE GILBERT SCOTT, *REMARKS ON SECULAR AND DOMESTIC ARCHITECTURE, PRESENT AND FUTURE* (1857)

## Editorial Headnote

Sir George Gilbert Scott RA (1811–1878) was an important English Gothic Revival architect, who was mainly associated with the design, building and restoration of churches and cathedrals, although his secular work include workhouses, offices, hotels and private residences.

This, Scott's second book, *Remarks on Secular and Domestic Architecture, Present and Future*, was published by John Murray in 1857, with a second, slightly amended edition, in 1858. He dedicated the book to Alexander Beresford Hope, a well-to-do and influential Gothic devotee and co-founder of the *Saturday Review*.

Scott begins his book by asking:

> Are we, as Englishmen, satisfied with the state of domestic architecture amongst us, or ought we to be so? I am not asking whether our dining-rooms are comfortable, our drawing-rooms brilliant, or our parlours snug, we are pretty sure to take care of ourselves as to comfort, but are our houses pleasant things to look upon, as well as comfortable to live in?[1]

He then proceeds to discuss aspects of house building and fitting out as well as topics around design, materials choice and restoration, all from an architectural point of view.

*The Athenaeum* gave a substantial review to the book initially noting that

> His [Scott's] principles are 'The revival of our own national branch of Christian art as the basis of future development,' and the making use of other branches, not to supersede, but to enrich our own. This is practical, and to be understood. We heartily agree with Mr. Scott's starting-points.

The journal then points out that

> The book itself is a mere bundle of lecture-papers, memorandum notes, and shows no constructive principles: but that is by-the-bye; for the book is a sound and useful one, full of healthy thought, by a man who knows what can be and what should be done.

The nub of this extract here is noted in the same review: 'The enemies of the Gothic are the lovers of the Renaissance, – that fantastic, prodigal, luxurious, gorgeous style which sprang from the decline of faith and the revival of Pagan learning'.[2]

The connection between 'Christian art' and its opposite 'Pagan learning' is reflected in Scott's frequent use of the word 'Providence' meaning the protective care of God as a spiritual power. In this context it is used in relation to the home. Scott also argues that residences should reflect the status of the owner, but at the same time have a certain dignity which should come for the mind of the designer.

The idea of one's position in society, and linked to this the notion of reflecting this position in the design of a house and home, was a continual theme in the nineteenth century. It was clear that to be out of one's class was an offence to decency and worse. Numerous references to this concept appear throughout these texts, ranging from moralising writings such as this, to the commercial retail estimates that were designed to enable those to furnish tastefully and appropriately but within their means.

# 67

## REMARKS ON SECULAR AND DOMESTIC ARCHITECTURE, PRESENT AND FUTURE

*George Gilbert Scott*

Source: George Gilbert Scott, *Remarks on Secular and Domestic Architecture, Present and Future* (London; J. Murray, 1857), pp. 140–4

It appears a somewhat startling transition to pass suddenly from the cottages of the poor to the mansion of the nobleman or great landed proprietor, and this was not the order in which I had intended to have taken them; yet it may not be an unwholesome thing thus to bring into immediate contact the rude and confined habitation of the labourer – and our plea that his sense of decency may not be outraged by making him and his family all sleep in one room with the enormous requirements of his neighbour at the mansion, who has not, perhaps, a larger family than himself.

I do not wish to place the two cases in invidious comparison. Providence has ordained the different orders and gradations into which the human family is divided, and it is right and necessary that it should be maintained; yet it is well, from time to time, to fall back upon first principles, as a check upon the extremes into which these differences are apt to run, and as a wholesome suggestion to the rich man, that his luxuries and his state cease to be morally right if he has not first provided for the just and reasonable requirements of his dependants; and that they become actually immoral if their cost prevents his performing to the full the duties inherent upon his position.

As Pugin says, "every person should be lodged as becomes his station and dignity;"[3] and the first consideration in building a house is that its scale, both as to size and character, should be in just proportion to the means and position of its occupant.

The position of a landed proprietor, be he squire or nobleman, is one of dignity. Wealth must always bring its responsibilities, but a landed proprietor is especially in a responsible position. He is the natural head of his parish or district, in which he should be looked up to as the bond of union between the classes. To him the poor man should look up for protection; those in doubt or difficulty for advice; the ill-disposed for reproof or punishment; the deserving, of all classes,

DOI: 10.4324/9781003290490-87

for consideration and hospitality; and all for a dignified, honourable, and Christian example. The maxim of his life should be, "A good man sheweth favour and lendeth; he will guide his affairs with discretion. He hath dispersed, he hath given to the poor: his righteousness endureth for ever; his horn shall be exalted with honour."[4]

It is a great misfortune to our country that the landed gentry are in many districts so reduced in numbers. The prodigious accumulation of land in the hands of a few is, perhaps, as injurious as its extreme subdivision.

I well recollect a district in which nearly all the ancient estates had, by a series of fortuitous circumstances, come into the hands of one noble family. Every village had some remains of its ancient manor house – sometimes the house itself, now inhabited by a farmer; in others, perhaps, only the entrance-gates, the dove-house, or the stables: in others, only some mounds, plantations, or fish-ponds, to mark its site while in each the parish church contained tombs of every date, commemorative of the old proprietors; and perhaps some aged peasant would delight to tell you his reminiscences of good Judge this, or old Lancelot that, who, when he was a boy, retained the ancient patrimony. All, however, was now swept away; the villages had no secular head, and all influence was concentrated in one dominant family, whose mighty palace lorded it over the whole neighbourhood. Misfortune came upon that family, and half a county was left without a head.

I am, however, wandering from my subject: – what I aim at by my picture of what I imagine a landlord should be, is to suggest the kind of sentiment his residence should express.

He has been blessed with wealth, and he need not shrink from using it in its proper degree. He has been placed by Providence in a position of authority and dignity, and no false modesty should deter him from expressing this, quietly and gravely, in the character of his house. His position demands of him a certain reasonable degree of hospitality, not confined to his rich neighbours, but extended to others, and especially to his tenants and poorer dependants; his house should be so planned as to render this practicable. His lot has, perhaps, been cast in one of Nature's choicest spots, and he should cultivate and improve its natural beauties, both for his own enjoyment and that of his neighbours. All this, however, he should do in moderation, and in just proportion to his position and means; neither letting modesty induce him to lodge himself in a manner more suited to the order below him, nor ambition lead him to exceed what is proportioned to the means placed by Providence in his hands; and (as a general rule) as it will ever be the ease that large numbers of the poor will be provided for far below their just requirements, he should keep his own enjoyments rather below than in excess of his means, so as always to leave a surplus in hand for the extra and unexpected demands of public or private charity, and for supplying the wants, whether temporal or spiritual, of those whom Providence has placed in a less favoured position.

It is not easy to define wherein the dignity of an architectural work consists, much less to give rules for its attainment. No doubt there are external and material conditions conducive to the noble effect of building. We fancy we can see in the

majestic towers and frowning gateways of the Edwardian castle the elements of its stately grandeur; and may feel that, deprived of these lordly features, we might seek in vain to give dignity to our modern houses, whose conditions are so essentially utilitarian and domestic. I do not, however, think that we need despair. True dignity does not necessarily lie in those external conditions which are, in fact, but the means – and truly very fitting ones of its expression. It lies rather in the mind of the designer. Dignified architecture cannot be produced by a low and narrow mind. The sentiment and tone of thought of the designer will always influence the design, and the first step, I am convinced, towards producing noble architecture, is to cultivate a corresponding tone of thought and feeling. . . .

## Notes

1 *Remarks on Secular & Domestic Architecture,* 1857, p. 1.
2 "Remarks on Secular and Domestic Architecture. Present and Future," *The Athenaeum,* April 17, 1858, pp. 502–503.
3 Augustus Welby Northmore Pugin, *The True Principles of Pointed or Christian Architecture,* 1853, p. 50.
4 Psalm 112:5

# 68. [ANON] 'LUXURY IN HOUSE DECORATION' (1878)

## Editorial Headnote

From the middle of the century, a group who could afford to indulge in purchasing luxury goods was seen as an elite that were based on apparently superior aesthetic sensibilities and tastes, which took precedence over breeding and nobility. The deliberate use of luxury goods to create a lifestyle was built around this new taste-led elite, who used stylish objects to invent a self-image that was specific to them. The products they purchased evidenced the hedonistic or self-indulgent aspect of domestic luxury. This attitude was exclusive, being based on an information system that was limited to this group and reinforced by specialist publications and retail outlets.

This anonymous article on the impact of fashion and particularly the new 'aesthetic' style suggests that economy is no match for changes in fashion. The author raises concerns about the need to spend money on luxury goods, firstly on dress fashions and secondly on house furnishings that are likely to cause financial harm to households. Despite this approach a comparison of the new aesthetic styles with the designs of earlier furniture finds them far more satisfactory, but more expensive. There is no moral argument here, simply a plea to be aware of the nature and cost of contemporary furnishing practices.

# 68

# 'LUXURY IN HOUSE DECORATION'

## *[Anon]*

Source: [Anon] 'Luxury in House Decoration'. *Saturday Review*, 7 September 1878, pp. 307–8

## LUXURY IN HOUSE DECORATION

It seems that it is the destiny of our fast-living age to be finding out fresh fields of extravagance. And the worst of it is that modern luxury is so often synonymous with the most severe good taste, and with all that tends to refine the intellect and elevate the manners. People who never made a bet in their lives, who regard the pursuits of the turf with a holy horror, and would as soon betake themselves to habitual opium-eating as to heavy play, launch out into the realms of "the aesthetic" with the most inconsiderate recklessness. For aestheticism has come to be word of singularly vague and comprehensive meaning. It covers all that is suggestive of richness and elegance combined, so long as you are careful to avoid any flagrant extreme. It is intolerant of everything like sham in any shape; if you wish to be safe in following its dictates you must make sure that your materials are of the best, and that they are manipulated by artists of conscience and genius. Consequently, in the end it becomes horribly expensive. Perhaps you have fondly pleased yourself with the notion that your wife is disposed to sobriety in dress; that she is not one of those gaudy butterflies who must be perpetually changing the tints in which they flutter about the pet haunts of society. And no doubt it is easy to form some faint conception of what these gaudy butterflies cost to the unfortunate gentlemen who have the privilege of paying for their glitter. We know that the mere price of the stuff of the simple summer toilet is a bagatelle compared to the cost of the make and the trimming; and that our English Worths[1] would be thrown over as unfashionable were their charges to be anything short of enormous. But we doubt whether it is not dearer still when a lady dispenses with colour and spangle and seeks striking effects in the austere and sublime. Then her silks are like the flounced brocades of her ancestors, and would stand alone if she slipped herself out of them. Her muslins are miracles of ephemeral gauze, and she might almost pass a tight-fitting dress of them through her wedding ring. It is to be remarked, too, that, after all, the most durable dress lasts little longer than the most destructible of fabrics; for it is all the more easily recognized, and so the occasions of its appearance are numbered. We need not add that indulgence

DOI: 10.4324/9781003290490-88

in the very quietest morning jewelry may be an ugly pitfall for the engulphing of superfluous income. Costly sets of Egyptian, Etruscan, Hellenic, and Persian designs may be multiplied indefinitely without making much show; and should your wife have the mania of lace-collecting, you had need be Croesus. It is a most perishable material, that may, however, be preserved by extreme care, accumulating value as it looks really more and more disreputable. We know, of course, that this is blasphemy and we admit that we are sensible to the real beauty of some of those exquisite patterns of graceful intricacy which are reproduced in the volumes of M. Seguin or Mrs. Bury Palliser,[2] but it must be exasperating, nevertheless, to husband or father to see so much of his available resources locked up in old Point de Venise or modern Limerick:[3] Nor is it much of a comfort to know that, should he come to be sold up, those coffee-coloured garnishments may have a chance of fetching their fanciful value.

But dress and lace have led us wide of our mark, which happens at this moment to be modern furniture. We are all aware to our sorrow that the cost of living has gone up very generally in the course of the last twenty or thirty years. Public servants on fixed salaries have been bitterly complaining of increasing pressure. The metropolitan police force has been threatening a strike because its responsible duties are inadequately remunerated; while highly-educated physician's time should be doubled or tripled in the reign of Victoria. There were, however, till of late, one or two points in which the present afflicted generation had to confess that it had decidedly the better of its ancestors. One point was economy in the garments of the male sex, and the other was the cheapness of household furniture.

The furniture which our fathers and grandfathers had to buy was generally as expensive as it was ingeniously uncomfortable. Visitors to the Paris Exhibition[4] may get a very fair idea of its shapes and cost as shown in its more archaic simplicity by an inspection of the specimens of a Renaissance movement in retreat which the Misses Garrett[5] are apparently endeavouring to set on foot. Furniture of the highest class used to be built to endure to eternity, while all inferior imitations were conspicuously unsatisfactory. Who does not remember the heavy constructions of solid mahogany that came to be handed down as heirlooms with the massive walls that contained them? There were the ponderous four-post bedsteads that encroached upon the better half of every bedroom of moderate dimensions; the stiff high-backed chairs, ironically misnamed 'easy', the sofas that would hardly have been shaken on their sturdy legs by the shock of an earthquake; the dining-room tables of the best Honduras,[6] that assumed the shade and the shimmer of polished ebony under the indefatigable hands of generations of butlers. That style of furniture became one of the necessary conditions of the youthful householder who aspired to any social position; above all, it was indispensable to struggling professional men. A doctor on his promotion could never hope to fill his consulting-room unless the pedestal of each table weighed something like a hundredweight; while a mother would deplore the *mésalliance*[7] of her daughter if she were not welcomed on her first matrimonial visit into a bedchamber whose hangings might have reminded her of a hearse. The enterprise of a modern school of upholsterers

wrought some eminently beneficial changes in this respect. Certain enterprising monster establishments in Tottenham Court Road[8] and elsewhere rapidly added house to house as they accelerated the diffusion of their advanced ideas. The sombre austerity of decoration which delighted our ancestors was gradually replaced by sweetness and light. Draperies were curtailed within reasonable compass; bedsteads with slight brass frames replaced the Spanish mahogany; you had chairs that might be moved without straining your muscles, and which, moreover, were infinitely more luxurious to sit upon. In short, you could purchase sets of furniture that were pleasing in appearance yet sufficiently strong; and, best of all, you could buy them at an exceedingly moderate price. The boon was inestimable to "parties desiring to marry" who looked forward to making both ends meet on a tolerable income, but who had little ready money at starting.

This system of economical furniture for ready money is still in the ascendant, yet we see the signs of a distinct reaction. At the Vienna Exhibition[9] one had the opportunity of admiring the marvellous artistic advance made by some of the leading London upholsterers. But one regarded some of the masterpieces of furniture that were exhibited as curiosities rather than anything else. The material of course left nothing to be desired. The most exquisite woods of home and foreign growth were inlaid with specimens of those curious Central American products which are christened after their manifold tints rather than by regular botanical names. But the price set on the material was a trifle, compared to the outlay on the workmanship bestowed upon it. It was not only that the mere mechanical part of the labour was executed almost to perfection, but the minutest details of the forms and the graceful elaboration of the carving gave evidence of really artistic imagination. The value of the results that were reached might be a question of taste, but the services of these clever designers had evidently to be lavishly remunerated, And now, again, at Paris one cannot help being struck by the extraordinary progress that has been made in this direction. The best-known London firms have been striving hard to hold their own, and so far, perhaps they have succeeded. But they are being hard run by younger rivals in the country and elsewhere who are sparing neither thought nor expense. And it is significant that some of the houses that have made their reputation by the cheapness of their goods have been boldly breaking in upon this new ground, and are making most costly appeals to amateurs of "the aesthetic." We hear everywhere that the times are hard, and possibly many of us may have personal reason to know that they are so; but at all events general pecuniary pressure, Turkish repudiation,[10] or the dullness of trade has done little to check the new fashion. If you make any pretension to entertaining in society, and desire to have some outlet for your taste, you can hardly help putting yourself into the hands of a fashionable upholsterer and giving him something like *carte blanche* to the interior of your residence. If money is really a matter of indifference to you, everything is plain sailing enough; you have only to give him a general notion of what you desire, and may leave yourself to his discretion with considerable confidence. But then it is idle to ask for exact estimates in advance, and you must be prepared to show a superb indifference to the sum total of the

bill. The suites of oak and ebony, of walnut or cedar, must have surroundings that will show them off to the best advantage. You must buy Persian rugs and Aubusson carpets; you must procure the right specimens of china to display on your side tables and buffets, and the appropriate vases or even statuary to figure in the corners of your rooms. *Cloisonne* and *Champlevé* and oxydized metal-work threaten to become almost as common as Britannia ware.[11] Formerly there were wealthy nobles or landowners who felt bound to keep up the reputation of their ancestral mansions by liberal investments in contemporary decoration; and there were new-made millionaires, who, being either ostentatious or intelligent, set themselves up as generous patrons of the arts. Now, it would seem, judging at least by appearances, as if everybody must more or less follow suit; and, though this development of the upholstery business may be admirable in the abstract, we fear that it may have very serious consequences in many households hanging on to the skirts of the fashion.

## Notes

1 English fashion designer Charles Frederick Worth (1825–1895) who established his couturier shop in Paris in 1858.

2 J. Seguin, *La Dentelle: Histoire, Description, Fabrication, Bibliographic*. Illustrated. (Paris: Rothschild.)
   Mrs Bury Palisser, *History of Lace, with numerous illustrations*, London, 1865; 3rd edit. 1875.

3 Types of lace products.

4 Paris Exposition Universelle, 1878.

5 Refers to the Garrett sisters – Agnes and Rhoda who set up an interior decorating and furnishing business in London.

6 Honduras was a source and name of a species of mahogany.

7 A marriage with a person thought to be unsuitable.

8 Tottenham Court Road, London was a well-known centre for furniture and furnishing shops, as well as makers. See Clive Edwards "Tottenham Court Road: The Changing Fortunes of London's Furniture Street 1850–1950", *The London Journal*, 36: 2, July, 2011, pp. 140–60.

9 International Exhibition, Vienna, 1873.

10 Probably a reference to the Russo-Turkish War, 1878.

11 *Cloisonne* and *Champlevé:* Varieties of enamel work.
   Britannia ware: A type of pewter alloy, favoured for its silvery appearance and smooth surface first produced c. 1770.

# JAMES RUSSELL MILLER, 'THE ETHICS OF HOME DECORATION' (1880)

## Editorial Headnote

James Russell Miller (1840–1912) was a popular Christian author, editorial super-intendent of the Presbyterian Board of Publication, and pastor of several churches in Pennsylvania and Illinois. He was ordained and installed as minister to the First United Presbyterian Church of New Wilmington, Pennsylvania on 11 September 1867. He was also the general field agent for the United States Christian Commission, an organization established by the Young Men's Christian Association after the First Battle of Bull Run. Miller had begun contributing articles to religious papers while a student. This continued while he was at the First United, Bethany, and New Broadway churches. In 1880, Miller became assistant to the Editorial Secretary at The Presbyterian Board of Publication, also in Philadelphia. He authored nearly one hundred books and articles.

A number of texts encouraged people to visually demonstrate their piety with displays of religious trappings in the home. These included family bible stands, crucifixes, statuary and paintings depicting religious topics.

The authors of *Household Elegancies* (1875) noted how 'in these pages all may find a stimulus for new thoughts, more active work, with pretty fancies, and aesthetic beauty to gild the days for years to come –

> Bright moments shall still brighter grow,
> While Home becomes our Heaven below'.

They went on to discuss examples of pious work including carved brackets suit-able for holding a Bible or prayer-book, and mention that 'it is always desirable to have an appropriate table or desk upon which to place the "Family Bible"'.[1]

This text was one a number of chapters in Miller's book titled *Weekday Religion*. It was clearly successful as it was in its thirteenth edition by 1911. Miller in his Preface to the volume states that the book's aim 'is to help young Christians especially to take the religion of Christ out of closet and sanctuary and creed, and get it into their daily lives of toil, temptation and care'. This was the main mes-sage of the chapter: to put religion into the home and in this case through interior decoration that was pure and pious rather than coarse and vulgar.

In 'The Ethics of Home-Decoration', (one of thirty-two chapters) Miller addresses the connection between interior decoration and morality. He was partic-ularly concerned about the visual imagery that might corrupt. For example, 'The display of undraped figures on canvas, must exert a harmful influence, especially in the minds of the young'. A Christian home that had chaste and tasteful interior decorations both helped children's religious development and also signified the family's ethical position. Interior decoration was therefore intended to build the

moral character of children, as it had an educating effect on them. Miller argued that a home decorated with virtuous and worthy artworks was not only a support to an individuals' spiritual development was also a display of the family's Christian character for all to see.

In 1882 Miller published another work on the topic in a book titled *Home-Making* which proclaimed that it

> is written in the hope that its pages may carry inspiration and a little help, perhaps, to those who desire to do faithful work for God within their own doors. Its aim is to mark out the duties and responsibilities of each member of the household, and to suggest how each may do a part in making the home-life what God meant it to be.[2]

# 69

# 'THE ETHICS OF
HOME DECORATION'

## *James Russell Miller*

Source: James Russell Miller, 'The Ethics of Home Decoration', *Week-day Religion*
(Philadelphia: Presbyterian Board of Publication, 1880), pp. 265–74.

"Each man's chimney is his golden milestone,
Is the central point from which he measures
Every distance
Through the gateways of the world around him;
In his farthest wanderings still he sees it,
Hears the talking flame, the answering night-wind,
As he heard them
When he sat with those who were, but are not."

LONGFELLOW[3]

This is not an essay on household taste on the art principles which relate to the adornment of homes, but there is an ethical side to this subject on which I have a suggestion or two to offer. It is trite to say that every home influence works itself into the heart of childhood, and then works itself out again in the subsequent development of the character. None of us know how much our homes have to do with our lives. When one's childhood home has been true and tender its memories can never be effaced. Its voices of love and prayer and song come back like angels' whispers, like melodies from some far-away island in the sea, when the lips that first breathed them have long been silent in the grave. No one can ever get away from the influence of his early home. Good or bad, it clings through life. Homes are the real schools and universities in which men and women are trained, and fathers and mothers are the real teachers and makers of life. The poet's song is but the sweetness of a mother's love flowing out in rhythmic measure through her child's life. The lovely things men build in their days of strength are but the reproductions of the lovely thoughts that were whispered in their hearts in the days of tender youth. The artist's picture is but a touch of a mother's beauty wrought out on the canvas. A grand manhood or womanhood is only the home teachings and prayers woven into life and form.

DOI: 10.4324/9781003290490-89

It is proven that even the natural scenery in which a child is reared has much to do with the tone and hue of its future character. Those who are cradled among the grand mountains or by the shore of the majestic sea carry into their mature years the mystic influence of those scenes and there is no feature of a home itself or of its scenery and surroundings that does not print itself on infancy's sensitive heart like the images on the photographer's prepared plate, to be brought out again in the future character.

This truth is not properly appreciated. The educating effect of home-decoration has not received that attention which it deserves, nor has its moral value come into general and thoughtful consideration. The subject has been discussed from the view-point of art, but not from that of character culture. Much has been said and written of books, good and bad, vulgar and refining, and of the importance of putting such only as are pure and elevating into the hands of the young. In like manner, the importance of their early companionship has received much attention. But the moral effect of home adornment needs to be considered just as thoughtfully and carefully as that of either books or associations.

It is important that in the education and training of children we throw around their sensitive lives all of beauty, purity and inspiration that we can. The sites of our homes should be selected with reference to this. In this regard the country has usually wonderful advantages over the city. Its lovely natural scenery is a gallery hung with the rarest beauties, and yet there are many builders of homes who seem never to give a thought to this. They choose sites for some temporary convenience or on the ground of inexpensiveness in the midst of unlovely, or even repulsive, surroundings, when at a little additional cost they could have placed their homes in the midst of picturesque scenery and refining surroundings. Apart altogether from the question of taste, the moral influence of the scenery on which the doors and windows open is of immeasurably more value than any difference in money cost. There is no refining and purifying power like that of true beauty.

Then the ornamentation of the grounds about a home furnishes another opportunity not only for the display of taste, but for the choice of important educating influences. These may be permitted to remain without any adornment whatever, open to passing hoof, trodden down, void of any trace of beauty. Former improvements may be suffered to fall into decay, leaving broken gates, tottering fences, unpainted buildings, grounds overgrown with weeds, with not a lovely walk or an inch of green grass, and not a tree or shrub, not a vine or flower. Or they may be made tasteful and beautiful, with neatly-painted palings, gates in order, bright green lawn, shade-trees, pleasant walks, lovely plants and beds of flowers. In the mere education of taste the influence of these different surroundings is obvious, but there is a moral effect that is vastly more important. Holiness and beauty lie very close together, and the influence of all repulsiveness is toward evil.

The moral effect of interior home-decoration is still greater. We should make the rooms in which our children sleep and play and live just as bright and lovely as our means, directed by wisest skill and purest taste, can make them; and not only should the adornments and decorations be pleasing to the eye, but it is of

importance that we give the most careful heed to their moral character. There are many pictures found in even Christian homes whose influence is toward impurity. There are other pictures whose influence is toward gloom, and there are those again whose chaste beauty, bright cheerfulness and rich suggestiveness make them continual inspirations toward refinement and moral excellence. They frame themselves into young hearts and become a joy and comfort for ever.

A young artist once asked a great painter for some word of advice which might help him in all his after-life. Having noticed on the walls of the young man's rooms some rough and coarse sketches, he advised him, as a young man desirous of rising in his profession, to remove these, and never to allow his eye to become familiar with any but the highest forms of art. If he could not afford to buy good oil paintings of the first class, he should either get good engravings of great pictures or have nothing at all upon his walls. If he permitted himself to become familiar with anything in art that was vulgar in conception, however perfect in execution, his taste would insensibly become depraved; whereas, if he would habituate his eye to look only on that which was pure and grand or refined and lovely, his taste would insensibly become elevated.

This advice is of perfectly pertinent application to the use of pictures and statuary in home-decoration. Children from their earliest years are naturally fond of pictures. Their eyes rest much upon them, and insensibly they have much to do not only with the formation of their taste, but also in giving moral tone and color to their minds. Familiarity with vulgarity and coarseness will inevitably deprave, and looking upon pure and beautiful things will imperceptibly, yet surely, refine, elevate and inspire.

Lovely pictures in a home have a wondrous and subtle power in the education and refining of child life. They may be but wood-cuts or chromos or steel engravings, but let them be chaste and pure. Let us hang nothing in our parlors or play-rooms or bedchambers or dining-rooms that would bring a blush to the sweetest modesty or start a suggestion of anything indelicate in any beholder's mind. Every picture, engraving or print will touch itself into the soul of each child reared in the home. That which is impure or gross will leave a stain, and that which is refined and lovely will become a sweetening memory for ever.

The whole question of what is modest and pure in art is one that few Christian moralists have had the courage to meet. It is the custom to characterize as "prudish" any criticism based upon ethical grounds, or any judgment of a picture or a statue which considers its moral influence. But as Christians we are bound to look at everything from a moral point of view. A painting may rank very high as a work of art, both in conception and execution, and yet its influence be toward impurity, If this is the case, it is not fit to hang on the wall of any home. In the adornment of our homes, so far as works of art are concerned, Christian people cannot properly overlook this principle.

The display of undraped figures on canvas must necessarily exert a harmful influence, especially upon the minds of the young. The religion of Christ is chaste, and condemns everything in which lurks even the faintest suggestion of impurity.

Whatever, then, may be the merits of pictures or statuary as works of art, true Christian refinement must fix its standard along the line of perfect purity. The same principles that we apply to books, to speech and to behavior we must apply unflinchingly to the selection of pictures for the walls of our homes.

I know that this principle is denied. Men tell us that it is only a prurient imagination that sees impurity on canvas or in marble. They call it prudery and quote the motto, "Evil to him who evil thinks," or the Scripture aphorism, "Unto the pure all things are pure." They taunt us, too, with ignorance of high and true art, and begin to chatter learnedly about nature. The ability to be shocked, they say, by any representation of simple nature is an evidence of an evil imagination. Such things have been said so often, and modesty has been so much laughed at, that pure and delicate souled people do not dare to seem to be shocked: they think they ought to be able to look at anything in art. The figures introduced in parlors and drawing-rooms wax more and more wanton as the petrified impurity of ancient heathenism is dug up and brought to fill the niches of a pure and chaste Christianity. How will this affect the purity of our households?

Ignoring utterly the charge of prurience and over-delicacy, pleading for the utmost purity in the influence of the homes in which our children are growing up, I must reassert the principle that nothing which would be indecent in actual life can be proper in art. No sophistry can make anything else out of the laws of perfect purity which religion inculcates. The least indelicacy or wantonness in any picture or statue in a home cannot but exert a subtle influence for evil over the minds and hearts of the children. We admit this principle in reference to all other things. We believe that every shadow and every beauty of the mother's character prints its image on the child's soul – that the songs sung over the cradle hide themselves away in the nooks and crannies of the tender life, to sing themselves out again in the long years to come. We believe the same of every other influence, and must we not of pictures and statuary as well?

A godly man said that when quite young an evil picture was shown to him on the street. He saw it only once and for a moment, but he had never been able to forget it, and it had left a trail of stain all along his years.

I plead for most earnest consideration of this whole question of the morals of home-decoration. A dew-drop on a leaf in the morning mirrors the whole sky above it, whether it be blue and clear or whether it be covered with clouds. In like manner the life of a child mirrors and absorbs into itself whatever overhangs it in the home-beauty and purity or blemish and stain.

## Notes

1 Mrs C. S. Jones & Henry T. Williams, *Household Elegancies,* (New York: Henry Williams), 1875.

2 J. R. Miller, *Home-making,* (Philadelphia: Presbyterian Board of Publication, 1882), p. 5.

3 Henry Wadsworth Longfellow, "The Golden Milestone".

# LAURA C. HOLLOWAY, *THE HEARTHSTONE, OR LIFE AT HOME: A HOUSEHOLD MANUAL CONTAINING HINTS AND HELPS FOR HOME MAKING: HOME FURNISHING; DECORATION; AMUSEMENTS* (1887)

## Editorial Headnote

Mrs. Laura Carter Holloway (1848–1930) grew up in a world of privilege based in the southern states of America. Not too long after her early marriage, she went to Washington, DC, and lived with fellow Tennesseans, President and Mrs. Andrew Johnson at the White House. While there, she wrote *The Ladies of the White House*, probably her best-known and most successful publication. She also wrote articles, edited for the *Brooklyn Eagle*, and published other books. She also delivered public lectures on a variety of subjects as varied as women's rights to the works of Charlotte Brontë. One of her most well-known lectures was 'The Perils of the Hour' (1870), that concerned 'the obstacles that check the advancement of woman'. She belonged to the International Council of Women and was a member of Madame Blavatsky's Theosophical Society.

First published in 1883, *The Hearthstone* consisted of a cookery book as well as the standard chapters on room use, health, house operations and various help and hints on home making. This text is from a reprint of 1887. The selected chapter reads like a religious tract based on the idea of home as an ideal. In her preface Holloway sums up the essence of the chapter:

> Surely a word so potent [as home] has a deeper significance than any other in our language. To have a home in the fullest sense is to be blessed; to be in heaven while yet on earth. From out of happy homes come all the true men and women the world possesses. The noblest and best of the race have been and can only be the products of happy homes. The fetters that bind us to home are the cords that connect us with all true progress and right development. The happiness of a well-organized home is reflected in the lives of all men and women who come in contact with its inmates . . . when we have passed from the earthly home, it may be to find the spiritual one a *facsimile* of that which we have wrought in fancy here, and loved and longed to attain; a veritable Hearthstone, about which will be gathered the friends of old, the memories of the past, the essence of every aspiration and anticipation.

This extract that links the earthly with the spiritual home sums up the essence of many Victorian attitudes to the home. The words that refer to home as 'to be in heaven while yet on earth' set a very high standard that was so important to numerous homemakers of period.

# THE HEARTHSTONE, OR LIFE AT HOME: A HOUSEHOLD MANUAL CONTAINING HINTS AND HELPS FOR HOME MAKING: HOME FURNISHING; DECORATION; AMUSEMENTS . . . TOGETHER WITH A COMPLETE COOKERY BOOK

*Laura C. Holloway*

Source: Laura C. Holloway, *The Hearthstone, or Life at Home: A Household Manual Containing Hints and Helps for Home Making: Home Furnishing; Decoration; Amusements . . . Together with a Complete Cookery Book* (Chicago: L.P. Miller. 1887). pp. 25–35

What's a house? You may buy it, or build it, or rent,
It may be a mansion, a cottage, a tent;
Its furniture costly, or humble and mean
High walls may surround it, or meadows of green;
Tall servants in livery stand in the hall,
Or but one little maiden may wait on you all;
The table may groan with rich viands and rare,
Or potatoes and bread be its costliest fare.
The inmates may glitter in purple and gold,
Or their raiment be homely and tattered and old.
'Tis a house, and no more, which vile money may buy;
It may ring with a laugh or but echo a sigh.
But a home must be warmed with the embers of love,
Which none from its hearthstone may ever remove,
And be lighted at eve with a heart-kindled smile,
Which a breast, though in sorrow, of woe may beguile.
A home must be 'Home,' for no words can express it –
Unless you have known it, you never can guess it;
'Tis in vain to describe what it means to a heart

DOI: 10.4324/9781003290490-90

Which can live out its life on the bubbles of art.
It may be a palace, it may be a cot,
It matters not which and it matters not what;
'Tis a dwelling perfumed with the incense of love,
A beautiful type of the home that's above.[1]

There are some perfumes so aromatic that one need not uncork the bottle that contains them to have our clothes and rooms and furniture made fragrant by them. They find their way through thick glass and wood, and yet do not evaporate or decrease, but remain the same in bulk, although fragrance is always distilling from them and sweetening everything around them. So it is with the word Home. There is no other word in any dictionary that is so precious, so all-pervading and so full of tenderest memory and affection. If there be any nation that is without a word for home in its vocabulary, then we may be sure that it has no name for God, for heaven, and for those unselfish virtues and mutual influences which make the crown of our humanity. Indeed, so intimately is the idea of home associated with that of God, on the one hand, and of humanity on the other, that the ancient heathen had their gods in their homesteads, like family relics and heirlooms. At the siege of Troy, Aeneas and his father, Anchises, are chiefly anxious to save and carry away with them, in their exile from the ruined home, their Penates, or household gods, as soon as they have seen to it that the little lad Iulus[2] is safe. All religions worthy of the name have had home as their subjective, and God as their objective, basis. So intimately are these two ideas interwoven that it is quite as true to define man as a home-building and home-loving as a God-fearing or worshipping being. The original idea that the ancients had in building temples and churches was to make a home for God, or the gods among whom they divided the attributes of Creator and Protector. David is no sooner called away from the sheepfolds than he is possessed with the grand enterprise of the temple on Mount Zion. The palace, the splendid home for himself, does not satisfy him, so long as the Deity to whom he owes his life and fortunes has no national sanctuary. He resolves to take no rest for his eyes nor slumber for his eyelids until he has found out a home for his Lord, a "habitation" for the God of Israel. And when his son Solomon completed the grand cathedral which his father had begun, his aspiration is that God will accept it as an earthly cottage not worthy, of course, of Him who dwelleth in the heavens, but still well furnished and complete, having in it the perpetual fires and incense of home and the voices of prayer and joy and sadness that sound so home like. David even rejoiced at the thought that its very minarets and towers would be homes for the birds that were wanderers in the sky. Its altars were to afford the swallow a home and the sparrow a nest for her little ones.

Home is written on the heaven above us and the earth beneath. Said Rowland Taylor, as he walked from London to his dear parish of Hadley, within whose limits he was to be burned alive for his religious opinions in the dark days of Mary and of Bonner, "There are but one or two stiles more for us to climb over and then I shall be home."[3] It cheered the good man's heart that since he had to die,

he was to die near home. To be away from home, either when full of life or when expecting death, is to be lonely and to feel a void in one's heart. Hence, in one of the most beautiful of modern hymns or sacred poems, "Lead, kindly Light, amid the encircling gloom," John Henry Newman gives expression to this loneliness of feeling when he says,

"The night is dark and am far from home."[4]

Who of my readers has not felt the magic influence of John Howard Payne's world-famous song of "Home, sweet home"?[5] The secret of its popularity is not in any special excellence of meter, or even originality of thought. Rather it is the utter absence of originality that makes it universal. It merely voices in simple strain the melody of every human heart since the first home was built on earth till now, It is a subject that never tires, but has eternal memory and hope in it. Home is a talisman, and we whisper the word in our own hearts and wear the thought of it about us like a charm or amulet. Like a spring gushing through hard rocks it sparkles with constantly renewed freshness, and our hearts yearn toward it,

"As for some dear familiar strain
Untired we ask and ask again,
Ever, in its melodious store,
Finding a spell unheard before."[6]

Whenever the time comes to a young man that he ceases to love the home of his parents and his childhood, he may be sure that there is something wrong with him, and that morally he is on a downward track. The first symptom of the loss of purity of heart in a youth is when he begins to speak disparagingly or unfilially of home. The greatest men in the history of this and every other country have been and still are those who cling with the strongest affection to the scenes and memories of their childhood. The good old patriarchal or domestic sentiment can afford to be sneered at, for its power is confessed by all of us at last. The prodigal son may take his portion of the common stock and turn it into money, which he finds to be very hard cash indeed when he has squandered it in dissipation, but when he comes to himself, and his better nature and real manhood assert themselves, he feels that the best thing he can do is to go home. Too often, however, regret is felt too late, or it is too late to reinstate himself. He enters the old village with sad misgivings, and when he looks at the old home he finds it changed, and instinct tells him that other hearts than those he loved inhabit it, and that other hands than those that once caressed him have changed ins style and aspect. He asks, like Joseph, if the old man is yet alive, and soon learns that all there is remaining of his home is beneath the mounds in the village churchyard. Fiction has never exceeded in description the real despair and solitude of the homeless man.

We can remember such a case, which is but typical of many thousands of others. A young lad who had been gently born and nurtured contracted the youthful

fever of love of adventure and dislike of regular living. Like ambition the adventurous spirit is not to be condemned, for without it where would have been the discoverers and heroes of the world? But with many lads it is a mere mock heroism, and only shame prevents them from turning back, and confessing as much, before they have got fairly out of sight of the curling smoke of the home chimney. For once that the voice of one's good angel whispers

> "Turn again, Whittington,
> Lord Mayor of London!"

obedience to which leads on to fortune, there are a thousand cases where the voice says, "Turn again," in another sense, and bids us retrace our footsteps and go home again. The wilful, generous-hearted lad we have in memory was touched with the contagion of adventure, and, in spite of all advice and kinden treaty, would go to sea.

But of the sea he tired after one outbound voyage, and then ran off "to the diggings" in Australia. Next, he was a sheep farmer, but he lost all that he made. Sadder and wiser he worked his way home again before the mast. But what did he find? His father and mother both dead, murmuring the wanderer's name with their last breath, and the old homestead pulled down to make way for a railroad. The bronzed and weather-beaten man, not yet much past thirty, visited his parents' graves, and no doubt shed tears as he recalled their looks and voices and all their goodness to him in his early years. From the churchyard he strolled a mile to the grammar school where he had learned his mother tongue on paper and the elements of Latin and mathematics. The old porch and the dormitories and the long school-room and the playground were all there: but all the living associations were gone. The old Head Master was dead; his assistant teachers were all gone and scattered none knew where. He might have sighed with gentle Charles Lamb:

> I have had playmates, have had companions,
> In my days of childhood, in my joyful school-days;
> All, all are gone, the old familiar faces.
>
> Ghost-like, paced round the haunts of my childhood,
> Earth seemed a desert was bound to traverse,
> Seeking to find the old familiar faces.
>
> How some they have died, and some they have left me,
> And some are taken from me; all are departed;
> All, all are gone, the old familiar faces.[7]

Afterward, when his thoughts grew calmer and he was able from one source or another to glean some personal intelligence of his companions and schoolfellows, he found that one was a great Senator, another a bishop, and another chief-justice,

while he himself had but given another example to the proverb that "a rolling stone gathers no moss," and that "the lane called "By-and-By leads to the house of Never."

Sometimes, however, the spirit of adventure is not mere restlessness and impatience, but is the true outcome of a brave heart and steadfast will. But in such cases, there is no eagerness to get away from home. That is a hard wrench, and is only undergone as a painful duty. Indeed, the test of its being one's duty to leave home is often the pain it costs us to do so. If we wish to go away, we ought to make quite sure that we are right in going; but if it almost breaks our heart to part from all that has made our past life dear to us, we should listen attentively when duty bids, or seems to bid us go. In such cases even the wide ocean does not part us wholly from our home, either by night or day. The dying soldier on the distant battle-field, the shipwrecked sailor, the merchant in a foreign land, all think lovingly of the old home. There is nothing more worthy of admiration in the scantily educated domestic servants who come to this country from Germany or Ireland than the self-denying affection with which they save their little earnings that they may send help to "the old folks at home." Statistics show that the money sent by hard-working servants through the post-office amounts to a very large sum every year. Surely these faithful hearts deserve and will one day possess "a home of their own."

There is a class of persons, although not, it is to be hoped, a very large one, who are without natural affection, to use a Pauline phrase, and so are incapable of loving or caring for a home. As the Latin proverb describes the man who is "never less alone than when alone," so one may describe such misanthropic members of the human family as never less at home than when at home. And not only are such cross-grained creatures never at home themselves, but they prevent others from feeling at home in their presence. One ill-conditioned and sour-tempered inmate can blight the peace and happiness of a home. As "one touch of nature makes the whole world kin," so the touch of ill-nature can make everything unkind.

Do we sufficiently instill into our children the love of home and all that home connotes and stands for? The best way to make the young ones love it is to make it as cheery and pleasant for them as we can. It is a fact which the student of social life can scarcely avoid noticing, that the sons of particularly pious and straight-laced parents are generally much worse behaved when they get their liberty than those who have been brought up in an atmosphere of rational liberty and candor. One may see many a gray head being bowed down in sorrow towards the grave on account of the disgrace and anxiety brought upon a family by a son's profligacy or dishonesty. Some of these unworthy sons of Christian parents have gone so far in criminality as to pull up suddenly inside of a prison; but others who have been smart enough to avoid legal consequences have none the less branded themselves for life with a mark upon their foreheads as indelible as that of Cain. Surely there is some show of reason in the suspicion that the being compelled to be, or feign to be, "righteous overmuch" in their boyhood, has made them when they were able

585

to throw off the mask of hypocrisy stand out the more conspicuously in their real character.

Some social philosophers have argued from such cases that to instill the principles of religion into a child is to make him a hypocrite in the nature of things, and hence they have condemned the habit of attendance at public worship, and still more that of domestic worship or "family prayer." This seems to us to carry the argument too far, for if there are dozens, or even hundreds, of cases where the apparent effect of early religious training upon the subsequent conduct has been bad, there are thousands where it has strengthened the will, kept guard over the passions, and preserved the body and mind in purity and integrity. Who can think that such home religion and daily prayers and study of Scripture as those in William Wilberforce's household had a pernicious effect upon his children? In religious belief most of them ran to the opposite extreme from that of their father, but in conduct they never disgraced their early training.

It should be the ambition of every youth to be a successful home builder, and to earn by early industry a home of his own. It is dreary work to spend all one's life in sowing that others may reap. It is quite true that

> He who by the plough would thrive,
> Himself must either hold or drive.[8]

but the converse is not less true that he who holds or drives the plough ought also himself to thrive by it. This is the great social difficulty and problem that is shaking society to its centre. Alien proprietorship and a tenantry of serfs have had their day, but that day is passing away we trust forever. Education is now within the reach of all, and it was only the want of education on the one side that made them the social bondmen and mere hirelings of the other. The troubles in Ireland are the result of centuries of this unfair and unnatural inequality. The distinctions of rich and poor must always exist, because riches and poverty are relative, not absolute, conditions; but that the rich should be idle and have luxuries, while the poor work hard and want for bread, is an atrocious and rotten state of things, and one that cannot last in an age of such decisive progress and prompt action as our own. The day cannot be distant when every cultivator of the soil will have a home of his own; but agrarian outrages and murders postpone rather than hasten that good time.

The Germans and the English have been, of all nationalities, the most conspicuous for their love of home. In a newer country, whose extent is so much greater and where travel is so much longer and more frequent, the home and its central fires are not so easy to preserve. Americans have to make new homes far distant from each other. But perhaps this necessity of frequent migration makes them cherish the ideal of home the more. It is a restless, homeless, and unsatisfying way, that of living in hotels. Strange faces, however pleasant and kindly, do not fill the place of the old familiar faces. The banquet of a palace in which one is a guest by courtesy never tastes as sweet as the social meal in our own home does. We hear men

boast of travel and having no continuing city, and flitting from place to place and seeing new sights and mixing with strange people; but to be a citizen of the world is not so good as the citizenship of the home circle and the home fireside. Those who get tired of housekeeping live with less trouble in a boarding-house. But what they save in trouble they lose in comfort. Chiefly, they miss that privacy which is the sacred heritage of family life. The old English proverb that "a man's house is his castle" expresses this. In his own home he is safe from intrusion, "monarch of all he surveys," master of his own times and ways. Republicanism is good in national government, but not at meal times, or when one is reading, writing, or resting, and needs quiet and security from intrusion. Hence, of the All-Father it is said that "He setteth the solitary in families," and "maketh Him households like a flock of sheep," and sheep love their own company and their own shepherd, and know not the voice of a stranger. There are social marks and ways by which one can soon distinguish the man, woman, or child who has a happy home, from those whose life is all spent in publicity, amid noise and glare, without a parenthesis of introspection, reflection, private study, and home surroundings.

If the home-building and home-sustaining man develops nobler traits of character and is of kindlier mould than the human bird of passage, however rich his plumage, so the woman who finds a field for her affections and unselfishness in home is truly beneficent and beautiful. If it be the man's part to lay the foundations and erect the building, it is hers to beautify the walls and enshrine music and the kindly arts within them. It is his to build and hers to beautify. If there be some "lost arts" which adorned ancient homes, but in which modern homes are wanting, it is hers to restore and bring them back. It is woman who informs the home with light and life. Her hand it is that decorates and adorns, that culls and twines the flowers and leaves, and lets in "sweetness and light" into the rooms. Her hand it is that is cunning in the needlework and makes even the homeliest fare tempting in look and taste. Her touch is that of a purifying, transforming, and beautifying angel in the home, or like the magic wand of Cinderella's fairy godmother that transfigured the neglected and ill clad child into a maiden "fair to see," decked with taste and loveliness, to grace a palace and to win a prince.

Palace and prince, however, are both superfluous in the true fairy tale of home. Genuine aesthetics have their place in the simple cottage not less than in the mansion which oppresses one by its splendor. The touch of the Master of Life could raise the poor man's as well as the nobleman's child to renewed life and strength. There is often more true life as well as more true love in a cottage than in kings' houses, and the true aesthetic touch does not need the purple and fine linen for a fabric.

Amid a great deal that is trite and threadbare in Mr. Oscar Wilde's lectures, there is one remark which, although it has been uttered and thought a thousand times, cannot be repeated too often.[9] It is that our American stoves and furnaces are destructive of the perfect ideal of a home. One might fill a volume instead of a page with the reminiscences and associations that gather around the old grate fire, or the still older log upon the hearth. But one cannot by any stretch of imagination

conceive a happy thought or genuine inspiration to have been suggested by, or derived from, the modern stove or heater. It is "an abomination of desolation standing where it ought not." Who does not recall, with never fading pleasure, the dear old home-fires of the "auld lang syne." We see ourself in memory's mirror as we write, a musing, solitary child, looking and never tired of looking, at the nursery fire. Those were the days of unleavened bread, when life had not fermented, and all the chambers of imagery were filled with visions bright and beautiful. In the twilight, seated on our hassock, and with folded hands, we saw the angels and the fairies, the "cloud-capp'd towers and gorgeous palaces" of a world all our own, in which sin and sorrow were not, nor evil persons nor evil thoughts. But there is no augury in a stove; divination is in the fire, not in the heat. There were poems and romances, Jacob's ladders, and radiant mountains in the dear old fire; but one might as well seek inspiration in the lid of a tin kettle – we shall be told that James Watt found it there – as in the coldly-warm, inclemently-heating stove of the parlors and nurseries of to-day. Truly has the eccentric young Irish lecturer told us that there is nothing aesthetic in such severe domestic comforts as the stove.

But the old Fire was Home itself in essence and in miniature. We must not now dilate upon its cheerful glow, its kindly warmth, its visions of the ideal future that was not to be, lest our readers fall asleep, or into it. When we think of it, we can understand how men of old "fought for their altars and their fires," especially the firesides of home. The picture of the circle round that fireside never grows dim or fades.

> "Dark shadows of approaching ill
> Fall thick upon life's forward track.
> But on the past they stream not back,
> What once was bright remains so still."[10]

And the centre of all that once was bright was the home fireside. What stories were told by its red glow and flickering flame! What books and magazines were read aloud beside it! How much sweet talk of absent ones! The wind that shrieked amid the leafless trees, or round the corners of the street, made us draw closer to it. Then the heroic story, the pathetic poem, the narrative of hairbreadth escapes, the ghost story or tale of highway robbery, would hold us spellbound. But neither winds nor waves, nor ghosts nor robbers scared us till we went to bed, for we felt safe from physical and spiritual harm so long as we could see the live coals burning on the altar-hearth of Home.

## Notes

1 Unknown author but reproduced in a number of religiously-based journals in the 1850s and oddly in the *Federal Architect*, February 1938.
2 Iulus or Julus was also called Ascanius – a character in Roman mythology.

3  Rowland Taylor (1510–1555) an English Protestant martyr.
4  Cardinal John Henry Newman, "Lead kindly light . . ." *The Pillar of the Cloud.*"
5  John Howard Payne (1791–1852) American actor and poet.
6  John Keble "*Morning*"
7  Charles Lamb, "The Old Familiar Faces"
8  Benjamin Franklin *Poor Richard Improved* (1758)
9  Thomas Nast, Artist. "Oscar Wilde on our cast-iron stoves. Another American institution sat down on" *Harper's Weekly,* 1882.
10 Richard Chenevix Trench, D. D. Archbishop of Dublin. "O happy days, O months, O years", 1865.

# BIBLIOGRAPHY

## PRIMARY SOURCES

### Official Documents

Great Britain, *Census: Report of the Registrar-General on the Census of 1851*, Volume 85 (P.P. 1852/3), pp. xxxv–xxxvi.

Great Britain, *Report of the Department of Science and Art of the Committee Department of Science and Art* (London, 1854).

Great Britain, Board of Education, *Special Reports on Educational Subjects. Volume 15: School Training for the Home Duties of Women. Part 1: The Teaching of "Domestic Science" in the United States of America* (London: HMSO, 1905).

Great Britain International Exhibition 1851, *Reports By the Juries on the Subjects in the Thirty Classes into Which the Exhibition Was Divided*, Volume 2 (1852), class XXX.

Great Britain, Parliament, House of Commons, *Report from the Select Committee on Arts and Principles of Design and Their Connexion with Manufactures: With the Minutes of Evidence, Appendix and Index; Ordered to Be Printed, 16 August 1836* (London, 1836).

Great Britain, Parliament, House of Commons, *Royal Commission on Technical Instruction Second Report* (London, 1884).

### Other

An Admirer of Flowers, "On the Cultivation of Plants in the Windows of Living Rooms, Showing Their Tendency to Promote Health, with Their Poisonous Effects When Introduced into Sleeping Apartments", *Floricultural Magazine*, 1, 10, March (1837), pp. 217–19.

Aitchison, G., "The Relation of the Architect to the Decorator', *British Architect*, 16 February (1883), pp. 78–9.

Alcock, R. S., *The Capital of the Tycoon* (London: Longman, 1863).

———, "Japanese Art", *Art Journal*, 1, 37 (1875), pp. 337–9.

———, *Art and Art Industries of Japan* (London: Virtue, 1876).

Alford, M., *Needlework as Art* (London: Sampson Low, Marston, Searle, and Rivington, 1886).

Alison, A., *Essays on the Nature and Principles of Taste* (1790), 2nd Edition, 2 Volumes (Edinburgh: Archibald Constable and Co., 1815).

Allen, G., "Science of Taste", *Examiner*, 18 October (1879), pp. 1348–9.

———, "Cimabue and Coal Scuttles", *The Cornhill Magazine*, 42–43 (1880).

———, "Philosophy of Drawing Rooms", *Cornhill Magazine*, 41, March (1880).

Anon, "Improvement of Taste in the Decoration of Houses", *Penny Magazine of the Society for the Diffusion of Useful Knowledge*, 5, 301, 10 December (1836), pp. 484–5.

———, "On Architectural Decoration", *The Foreign Monthly Review and Continental Literary Journal*, 1, 1, June (1839), p. 142.

———, "Architect versus the Cabinet Maker and Others", *Fine Arts Journal*, 2, 13 February (1847), pp. 228–9.

———, "On the Use of Papier-Mache in Interior Decoration, &c", *Decorator's Assistant*, 1 (1847), p. 41.

———, "Consulting Decorator", *Art Journal*, 5 (1859), p. 93.

———, "The Architectural Exhibition", *The Builder*, 4 April (1863), p. 237.

———, "Fashion of Furniture", *Cornhill Magazine*, 9, March (1864), pp. 337–49.

———, "Arts in the Household", *Blackwood's Magazine*, 105, March (1869), pp. 361–78.

———, "Interior Decoration: The Drawing Room", *Building News*, 5 February (1869), p. 122.

———, "Mr. Poynter on Decorative Art", *The Sphinx*, 11 February (1871), p. 42.

———, "Art-Furniture Fever", *Tinsleys' Magazine*, 12 (1873), pp. 648–52.

———, "Queen Anne' Revival in London", *British Architect*, 3, 64, 19 March (1875), pp. 155–6.

———, "Coloured Light in the Treatment of the Insane", *British Medical Journal*, 25 March (1876), p. 382.

———, "Decorative Art in Britain: Past, Present, and Future", *Art Journal*, 39 (1877), pp. 327–8.

———, "Drawing-Room Furniture", *The Furniture Gazette*, 9 February (1878), p. 73.

———, "Mrs. Loftie in Excelsis", *British Architect and Northern Engineer*, 9, 8, 22 February (1878).

———, "Houses, and How to Furnish Them", *Englishwoman's Domestic Magazine*, 26, 171, 1 March (1879), p. 120.

———, "Some Critical Observations on Furnishing", *Furniture Gazette*, 12, 362, 5 July (1879), p. 2.

———, "Some Lessons on Japanese Art", *Cabinet Maker and Art Furnisher*, 1 August (1881), p. 34.

———, "Woman's Part in Domestic Decoration", *Magazine of Art*, 4 (1881), pp. 457–6.

———, "Travels in South Kensington", *Saturday Review of Politics, Literature, Science and Art*, 18 November (1882), p. 676.

———, "Relation of the Architect to the Decorator", *British Architect*, 16 February–6 April (1883), pp. 125–6.

———, "Colour in the Dwelling", *The Building News and Engineering Journal*, 25 July (1884), p. 113.

———, "A List of Official Publications Issued by the Executive Council of the International Health Exhibition", in *The Health Exhibition Literature* (London, 1884), pp. 3–6.

———, "The Furnishing and Decoration of the House. I: Ceilings and Floors", *Art Journal*, 54 (1892), p. 25.

———, "Leading Lady Journalists", *Pearson's Magazine*, 2 (1896), p. 106.

———, "Woman Bachelors in London", *Scribner's Magazine*, June (1896), pp. 600–11.

———, "Woman Bachelors in New York", *Scribner's Magazine*, November (1896), p. 634.

———, "Home and Garden", *Saturday Review of Politics, Literature, Science and Art*, 89, 2315, 10 March (1900), p. 300.

———, "Japanese Domestic Interior", *Architectural Review*, 7, January–June (1900), p. 15.

———, "An Artist and His Home", *The Worlds Work*, 2, September (1903).

———, "L'Art Nouveau: What It Is and What Is Thought of It", *Magazine of Art*, 2 (1904), pp. 377–81.

———, "Colour-Training and Colour Museums", I, *Art Journal*, 70, November (1908), pp. 328, 331 and 357–60.

———, "The Possibility of an Ideal Home", *Quiver*, 48, 8, June (1913), pp. 774–7.

———, "Report of the Committee on Home Interiors", *Journal of Home Economics*, 13, 11–12 (1921), pp. 541–2.

Appleton, *Artistic Houses* (New York: Appleton, 1883).

Argus, *A Mild Remonstrance against the Taste-Censorship at Marlborough House, in Reference to Manufacturing Ornamentation and Decorative Design* (London: Houlston & Stoneman, 1853).

Arrowsmith, H. W., *The House Decorator and Painter's Guide, Containing a Series of Designs for Decorating Apartments, Suited to the Various Styles of Architecture* (London: Thomas Kelly, 1840).

*Art Journal Illustrated Catalogue of the International Exhibition* (London: J. S. Virtue, 1862).

Art-Manufacture Association, *Catalogue of the First Exhibition of the Art-Manufacture Association in the National Galleries, Edinburgh, 1856* (Edinburgh: Printed by Thomas Constable, 1856).

Arts and Crafts Exhibition Society, *Catalogue of the First Exhibition: The New Gallery, 121 Regent St.* (London: Chiswick Press, 1888).

Bascom, J., *Aesthetics, or the Science of Beauty* (Boston: Crosby and Nichols, 1862).

Beckford, W., *Life at Fonthill 1807–1822: With Interludes in Paris and London from the Correspondence of William Beckford*, ed. B. Alexander (London: R. Hart Davis, 1957).

Beecher, C., *A Treatise on Domestic Economy* (Boston: Thomas Webb, 1843).

Beecher, C., & Stowe, H. B., *American Woman's Home* (New York: J. B. Ford, 1869).

Benn, R. D., "Why Not a 'Wigwam' Style?", *The Decorator and Furnisher*, 26, 5 (1895), pp. 165–7.

Bernan, W., *On the History and Art of Warming and Ventilating Rooms and Buildings* (London: Bell, 1845).

Berry, W., "The Decoration of Houses", *Bookman*, 7 April (1898), pp. 161–3.

Bielefeld, C. F., "On the Use of the Improved Papier Mâché in Furniture", in *Interior Decoration of Buildings and in Works of Art* (London: The Author, c. 1840).

Bing, S., *La Culture Artistique En Amérique* (Paris, 1896).

Blanchard, B., "Home Decorations", *Table Talk*, July (1888), p. 305.

Blashfield, E. H., "House Decoration", *Book Buyer*, 16, March (1898), pp. 129–33.

Bourget, P., *Essais de psychologie contemporaine*, Volume 1 (Paris: Plon, 1887).

Boyd, A., *The Recreations of a Country Parson* (London: Strahan, 1862).

Britton, J., *The Union of Architecture, Sculpture, and Painting* (London: The Author, 1827).

Burges, W., "The International Exhibition", *Gentleman's Magazine and Historical Review*, June (1862), pp. 663–76 and July (1862), pp. 10–11.

————, "The Japanese Court in the International Exhibition", *Gentleman's Magazine and Historical Review*, September (1862), pp. 243–54.

————, *Art Applied to Industry* (Oxford and London, 1865).

————, "Why We Have So Little Art in Our Churches", *Ecclesiologist*, 28 (1867), pp. 150–6.

————, "On Things in General", *The Architect*, 14, 25 December (1875), p. 367.

Calkins, N. A., *Primary Object Lessons for a Graduated Course of Development* (New York: Harper & Brothers, 1861).

Campbell, H., *Household Economics: A Course of Lectures in the School of Economics of the University of Wisconsin* (New York: G. P. Putnam's Sons, 1896).

Candee, H. C. H., *How Women May Earn a Living* (New York: Grosset & Dunlap, 1900).

Carter, R. B. (ed.), *Our Homes, and How to Make Them Healthy* (London: Cassell, 1883).

Cash, J., "The Home and Its Decorative Essentials", in *The British Home of Today* (London: Hodder and Stoughton, 1904).

*Cassell's Household Guide* (London: Cassell, Petter, and Galpin, 1869).

Caulfeild, B. C., & Saward, S. F. A., *Dictionary of Needlework* (London: L. Upcott Gill, 1887).

Chevreul, M.-E., *The Principles of Harmony and Contrast of Colours, and Their Applications to the Arts* (1855), tr. Charles Martel, 2nd Edition (London: Longmans, 1854).

Church, E. R., *How to Furnish a Home* (New York: Appleton, 1881).

Clarke, A., *The Effect of the Factory System* (London: G. Richards, 1899).

Cobbe, F. P., *Female Education, and How It Would Be Affected By University Examinations: A Paper Read at the Social Science Congress, London* (London: Emily Faithfull, 1862).

————, *The Duties of a Woman* (Boston: Geo. Ellis, 1881).

Cobbett, W., *Rural Rides* (1830) (London: Penguin, 1967).

*The Congress of Women Held in the Woman's Building, World's Columbian Exposition, Chicago, U. S. A., 1893* (Conkey: Chicago, 1894).

Conway, M. D., "Decorative Art and Architecture in England", *Harper's*, 49 (1874), pp. 617–32, 777–89, and 50, pp. 40–9.

————, *Travels in South Kensington* (London: Truber & Co., 1882).

Cook, C., "Our Furniture: What It Is, and What It Should Be", *The New Path*, 2, 4, April (1865), pp. 55–62.

————, *The House Beautiful Essays on Beds and Tables, Stools and Candlesticks* (New York: Scribner, 1878).

Cook, E., *The Poetical Works of Eliza Cook* (London: Frederick Warne and Co., 1870).

Cook, M. W., *Tables and Chairs: A Practical Guide to Economical Furnishing* (London: Routledge, 1876).

Cooke, M. C., *Social Life, or the Manners and Customs of Polite Society Containing the Rules of Etiquette for All Occasions Etc.* (Buffalo: Northrup, 1896).

Cousins, V., *The Philosophy of the Beautiful Translated with Notes and an Introduction by Jesse Cato Daniel* (London: William Pickering, 1848).

Crace, J. D., "Decorative Use of Colour", *Journal of the Society of Arts*, 36 (1887).

Crane, L., *Art and the Formation of Taste* (London: Macmillan, 1882).

Crane, W., *The Claims of Decorative Art* (London: Lawrence and Bullen, 1892).

————, *The English Revival in Decorative Art: William Morris to Whistler* (London: Bell, 1911).

Croker, T. C., *A Walk from London to Fulham* (London: W. Tegg, 1860).

Cutler, T. W., *A Grammar of Japanese Ornament and Design, with Introductory, Sescriptive, and Analytical Text* (London: Batsford, 1880).

Davidson, H. C., *Book of the Home* (London: Gresham, 1900).

Day, L. F., "The Woman's Part in Domestic Decoration", *The Magazine of Art*, 4 (1881), pp. 457–63.

———, *Every-Say Art: Short Essays on the Arts Not Fine* (London: B. T. Batsford, 1882).

———, *Anatomy of Pattern* (London: Batsford, 1887), pp. 52–3.

———, *Some Principles of Every-Day Art* (London: Batsford, 1890).

———, "Modern Upholstery", *The Cabinet Maker and Art Furnisher*, July (1892), p. 20.

———, "A Kensington Interior", *Art Journal* (1893), pp. 139–44.

———, *Nature and Ornament* (London: Batsford, 1908).

———, *Pattern Design: A Book for Students, Treating in a Practical Way of the Anatomy, Planning and Evolution of Repeated Ornament*, 2nd Edition, Revised and Enlarged by A. Fenn (London: Batsford, 1930).

De Wolfe, E., *After All* (New York: Harper, 1935).

Downing, A. J., *The Architecture of Country Houses* (New York: Appleton, 1850).

Dresser, C., *Art of Decorative Design* (London: Day, 1862).

———, "Hindrances to the Progress of Applied Art", *Journal of the Society of Arts*, 20, 12 April (1872), pp. 435–43.

———, *Principles of Decorative Design* (1870) (London: Cassell, Petter, Galpin, 1873).

———, *Studies in Design* (Cassell, Petter and Galpin, 1876).

———, *Japan, Its Architecture, Art, and Art Manufactures* (London: Longmans, Green & Co, 1882).

———, "The Decoration of Our Homes", *The Art Amateur*, 13, 2, July (1885), pp. 33–4.

Dunn, H. T., & Pedrick, G., *Recollections of Dante Gabriel Rossetti and His Circle (Cheyne Walk Life)* (London: E. Mathews, 1904).

Eagar, E. I., "The Servantless House", *The Architectural Review*, 55, 327 (1924), pp. xl, xlii.

Eastlake, C. L., *Hints on Household Taste in Furniture, Upholstery, and Other Details* (London: Longmans, Green, 1868).

———, *Hints on Household Taste*, 2nd Edition, Revised (London: Longman Green, 1869).

———, *Hints on Household Taste in Furniture, Upholstery, and Other Details*, 3rd Edition (London: Longmans Green, 1872).

———, *A History of the Gothic Revival* (London: Longmans, Green, 1872).

Edinburgh, *Catalogue of the First Exhibition of the Art-Manufacture Association: In the National Galleries, Edinburgh, 1856* (Edinburgh: Printed by Thomas Constable, 1856).

Edis, R., *The Decoration and Furniture of Town Houses* (London: Kegan Paul, 1881).

———, *Healthy Furniture and Decoration* (London: William Clowes and Sons, Limited, International Health Exhibition, 1884).

Elder-Duncan, J. H., *The House Beautiful and Useful* (London: Cassell, 1907).

Elliott, C. W., *Book of American Interiors Prepared by Charles Wyllys Elliott from Existing Houses* (Boston: James R. Osgood & Co., 1876).

Elmes, J., *Lectures on Architecture* (London: Priestley & Weale, 1823).

Emerson, R. W., "Art", in *Essays by R.W. Emerson* (London: Fraser, 1841).

———, *Society and Solitude and Other Essays* (Boston: Osgood, 1871).

Engels, F., *The Condition of the Working-Class in England in 1844* (London: Swan Sonnenschein, 1845).

Everest, C., *The Poets of Connecticut* (New York: Gates and Steadman, 1847).

Falke, J., "Chinese and Japanese Art and Its Importance for Modern Art Industry", *The Workshop*, 21 (1870), pp. 321–4.

———, *Art in the House: Historical . . . and Æsthetical Studies on the Decoration and Furnishing of the Dwelling . . . American Edition, Translated from the Third German Edition: Edited, with Notes, By C.C. Perkins . . . Illustrated, Etc.* (Boston: Prang & Co, 1879).

Fergusson, J., *The Illustrated Handbook of Architecture Being a Concise and Popular Account of the Different Styles of Architecture Prevailing in All Ages and All Countries* (London: J. Murray, 1855).

Fitzgerald, W. G., "A Curious and Interesting 'Fad' in Furniture", *The Decorator and Furnisher*, 29, 2 (1896), pp. 42–3.

Forney, J. W., *Letters from Europe* (Philadelphia: Peterson, 1867).

France, L. A., "Furnishing on the Frontier", *Art Amateur*, November (1883), p. 124.

Frederick, C., *The New Housekeeping: Efficiency Studies in Home Management* (Garden City, NY: Doubleday, Page, 1913).

———, *Household Engineering: Scientific Management in the Home* (Chicago: American School of Home Economics, 1915).

Galton, D., *An Address on the General Principles Which Should Be Observed in the Construction of Hospitals* (London: Macmillan, 1869).

Garrett, R. A., *Suggestions for House Decoration in Painting, Woodwork, and Furniture*, 2nd Edition (London: Macmillan, 1877).

Gengembre, H. P., *Liberty and a Living; the Record of an Attempt to Secure Bread and Butter, Sunshine and Content, by Gardening, Fishing, and Hunting* (London: G. P. Putnam's Sons, 1889).

Glasse, H., *The Art of Cookery Made Plain and Easy* (first published in 1747).

Goncourt, E. de, *La maison d'un artiste*, Tome 1, Préambule (Paris: Charpentier, 1881).

Goodwin, F., *Domestic Architecture* (London: The Author, 1834).

Gordon, A. M., "The Development of Decorative Electricity", *Fortnightly Review*, 49, 340, February (1891), pp. 278–84.

Gough, C., *The Cruet Stand: Select Pieces of Prose and Poetry, with Anecdotes, Enigmas, Etc.* (London: J. S. Hiron, 1853).

———, "Women as Students in Design", *Fortnightly Review*, 55, 328 (1894), pp. 521–7.

*Grace's Guide to British Industrial History*, www.gracesguide.co.uk.

Hall, H. B., *The Bric-à-brac Hunter: Or Chapters on Chinamania* (London: Chatto and Windus, 1875).

Hamst, O., *Aggravating Ladies* (London: Bernard Quaritch, 1880).

Harrower, I. M., *John Forbes White* (Edinburgh: Foulis, 1918).

Hart, J. S., *The Female Prose Writers of America*, New Edition, Revised and Enlarged (Philadelphia: Butler, 1855).

Haussez, Baron D'., *Great Britain in 1833*, Volume 1 (London: R. Bentley, 1833).

Havard, H., *Dictionnaire de l'ameublement et de la décoration depuis le XIIIe siècle jusqu'à nos jours*, 4 Volumes (Paris, 1887–90).

Haweis, M. E., *The Art of Beauty* (New York: Harper & Brothers, 1878).

———, *The Art of Dress* (London: Chatto and Windus, 1879).

———, *The Art of Decoration* (London: Chatto & Windus, 1881).

———, *Beautiful Houses* (London: Sampson Low, 1882).

———, "Smashed Birds", *Belgravia, an Illustrated London Magazine*, May (1887).

Hay, D. R., *The Natural Principles and Analogy of the Harmony of Form*, 3rd Edition (London: W. Blackwood and Sons, 1842).

————, *Proportion: Or the Geometric Principle of Beauty Analysed* (London: W. Black-wood and Sons, 1842).

————, *The Laws of Harmonious Colouring Adapted to Interior Decorations, with Observations on the Practice of House Painting* (Edinburgh: W. Blackwood & Sons, 1844).

Hayward, A., "Samuel Rogers", in *Selected Essays in Two Volumes*, Volume 1 (London: Longmans, 1878).

Helps, A., *Essays Written in the Intervals of Business* (London: Pickering, 1843).

————, *Companions of My Solitude: Essays Written in the Intervals of Business* (London: Smith Elder, 1879).

Hibberd, S., *Rustic Adornments for Homes of Taste* (London: Gollingridge, 1895).

Holly, H., *Country Seats* (New York: Appleton, 1863).

Hook, T., "The English Cottage", *The Spirit of the Times*, 1–2 (1825).

Hope, T., *Household Furniture and Interior Decoration: Executed from Designs by Thomas Hope* (London: Longman, 1809).

Hubbard, E., *The Notebook of Elbert Hubbard* (New York: W. H. Wise, 1927).

Hunt, R., "Papier-Mâché Manufacture", *Art Journal*, November (1851), pp. 277–8.

Hunter, G., *Inside the House That Jack Built (The Story, Told in Conversation, of How Two Homes Were Furnished)* (New York: John Lane Company, 1914).

Hussey, E. C., *Home Building: A Reliable Book of Facts* (New York: Leader & Van Hoesen, 1876).

Huxley, T. H., *Lay Sermons, Addresses, and Reviews* (New York: Appleton, 1880).

Jacobs, N. W., *Practical Handbook on Cutting Draperies* (Minneapolis: Harrison and Smith, 1890).

Jacox, F., *Recreations of a Recluse* (London: Richard Bentley, 1870).

Jakway, B. C., *The Principles of Interior Decoration* (New York: Macmillan, 1922).

Jarves, J. J., *A Glimpse at the Art of Japan* (New York: Hurd and Houghton, 1876).

Jennings, H. J., *Our Homes and How to Beautify Them* (London: Harrison & Sons, 1902).

————, *Chestnuts and Small Beer* (London: Chapman & Hall, 1920).

Jones, Mrs. C. S., & Williams, H. T., *Household Elegancies* (New York: Henry Williams, 1875).

Jones, O., *The Grammar of Ornament: Illustrated by Examples from Various Styles of Ornament* (London: Bernard Quaritch, 1868).

Kerr, R., *The Gentleman's House: Or, How to Plan English Residences, from the Parsonage to the Palace with Tables of Accommodation and Cost, and a Series of Selected Plans* (London: John Murray, 1865).

————, *A Small Country House* (London: John Murray, 1874).

King, T., *The Upholsterer's Accelerator; Being Rules for Cutting and Forming Draperies, Valences, Etc. Accompanied by Appropriate Remarks* (London: The Architectural Library, 1833).

le Duc, V., *Dictionnaire Raisonné Du Mobilier Français De L'époque Carlovingienne À La Renaissance*, Tome 1 (Paris: Veuve A. Morel et Cie., 1873).

Leslie, C. R., *Memoirs of the Life of John Constable* (London: Longmans Green, 1845).

Leslie, E., *The Behaviour Book* (Philadelphia: Peterson, 1839).

Leslie, G. D., *Our River* (London: Bradbury Agnew, 1881).

Lethbridge, J. W., *Woman the Glory of Man, Dedicated to the Ladies of England* (London: Thomas Richardson and Son, 1856).

Lidstone, J. T. S., *The Seventh Londoniad: (Complete in Itself) Giving a Full Description of the Principal Establishments . . .* (London: The Author, 1860).

Loftie, Mrs., *The Dining Room* (London: Macmillan and Co., 1878).

———, "Furnishing", in *Social Twitters* (London: Macmillan, 1879).

Loftie, W. J., *A Plea for Art in the House: With Special Reference to the Economy of Collecting Works of Art, and the Importance of Taste in Education and Morals* (London: Macmillan & Co, 1876).

Loudon, J. C., *Encyclopaedia of Gardening* (London: Longman, 1835).

———, *The Suburban Gardener and Villa Companion, Comprising the Choice of a Villa Residence, or of a Situation on Which to Form One, the Arrangement and Furnishing of the House, and the Laying Out . . . of the Garden and Grounds* (London: Longman, 1835; 1838; 1839).

———, *Encyclopaedia of Cottage Villa and Farm Architecture* (London: Longman, 1839).

Loudon, Mrs., *Domestic Pets* (London: Grant and Griffiths, 1851).

Maslen, T. J., *Suggestions for the Improvement of Our Towns and Houses* (London: Smith, Elder, 1843).

Mayhew, H., *London Labour and the London Poor: A Cyclopaedia of the Condition and Earnings of Those That Will Work, Those That Cannot Work, and Those That Will Not Work* (London: Griffin, Bohn & Co., 1861).

McClure, A., and Eberlein, H., *House Furnishing and Decoration* (New York: McBride, Nast & Company, 1914).

McFall, H., "English Illustrators of Juvenile Books", *Good Housekeeping*, 51, 5 November (1910), p. 528.

Merimee, M. J. F. L., *The Art of Painting in Oil, and in Fresco: Translated from the Original French Treatise of M. J. F. L. Merimee* (London: Whittaker & Co., 1839).

Merrifield, M., *Dress as a Fine Art* (Boston: Jewett and Co, 1854).

Miller, F., *Interior Decoration a Practical Treatise on Surface Decoration with Notes on Colour Stencilling and Panel Painting*, 2nd Edition (London: E. Menken, 1892).

———, *The Training of a Craftsman* (London: J. S. Virtue & Co. Limited, 1898).

Miller, J. R., *Home-Making* (Philadelphia: Presbyterian Board of Publication, 1882).

Mitchell, C., *The Newspaper Press Directory and Advertisers' Guide* (London: Mitchell, Benn, 1846).

Monkhouse, C., "Some English Artists and Their Studios", *The Century Illustrated Monthly Magazine*, 24 (1882), pp. 553–68.

More, L. B., *Wage Earners' Budgets* (New York: Henry Holt, 1907).

Moreland, F. A., *Practical Decorative Upholstery* (Boston: Lee and Shepard, 1889).

Morris, W., *The Decorative Arts: Their Relation to Modern Life and Progress; an Address Delivered before the Trades' Guild of Learning* (London: Ellis and White, 1878).

———, "Some Hints on Pattern Designing", *The Architect*, 24 December (1881), p. 410.

———, "The Lesser Arts", in *Lectures on Art Delivered in Support of the Society for the Protection of Ancient Buildings by R S. Poole, Prof. W.B. Richmond and Others* (London: Macmillan & Co., 1882).

———, "Beauty of Life", in *Hopes and Fears for Art: Five Lectures Delivered in Birmingham, London, and Nottingham, 1878–1881*, 3rd Edition (London: Ellis & White, 29 New Bond Street, 1883).

———, *A Dream of John Ball* (London: Reeves and Turner, 1888).

Moyr Smith, J., *Ornamental Interiors Ancient and Modern* (London: Crosby and Lockwood, 1887).

Murray, R., *Warne's Model Housekeeper* (London: Fredrick Warne and Co., 1879).

Muthesius, H., *The English House* (1908) Reprint (New York: Rizzoli, 1979).

Nicoll, M. R., *The Letters of Annie Swan* (London: Hodder & Stoughton, 1945).

Nicolson, A. (ed.), & Adam and Charles Black, *Memoirs of Adam Black*, 2nd Edition (Edinburgh: A. and C. Black, 1885).

O'Grady, W. L. D., "Indian Metal Work, and How It May Be Applied to Present Decoration", *The Decorator and Furnisher*, 4, 4 (1884), p. 140.

Orcutt, H., *Home and School Training* (Boston: Thompson, Brown, & Co., 1874).

Orrinsmith, L., *The Drawing-Room: Its Decorations and Furniture* (London: Macmillan & Co., 1878).

Padfield, J. E., *The Hindu at Home* (London: Simpkin, 1908).

Panton, J. E., *Nooks and Corners* (London: Ward and Downey, 1889).

———, *From Kitchen to Garret*, 7th Edition and Revised Edition 1893 (London: Ward, 1890).

———, *A Gentlewoman's Home: The Whole Art of Building, Furnishing, and Beautifying the Home* (London: 'The Gentlewoman' Offices, 1896).

Parkes, S., *Flower Shows of Window Plants for the Working Classes of London* (London: Victoria Press, 1862).

Percier, C., & Fontaine, P., *Recueil de Decorations Intérieures* (Paris: Pierre Didot l'ainé, 1812).

Philostrate, "Sincerity versus Fashion", *The Magazine of Art* (1878), p. 92.

Poe, E. A., "Philosophy of Furniture", *Burton's Gentleman's Magazine and Monthly American Review*, 6, May (1840), pp. 243–5.

Ponsonby, M., *Mary Ponsonby; a Memoir Some Letters and a Journal* (London: J. Murray, 1927).

Porter, G. R., *The Progress of the Nation: In Its Various Social and Economical Relations, from the Beginning of the Nineteenth Century* (London: John Murray, 1847).

Poynter, E., *Ten Lectures on Art* (London: Chapman and Hall, 1879).

Pückler-Muskau, H., *Tour in England, Ireland and France in the Years 1828 and 1829 by a German Prince* (London: Effingham Wilson, 1832).

Pugin, A. W. N., *The True Principles of Pointed or Christian Architecture: Set Forth in Two Lectures Delivered of St. Marie's, Oscott* (London: Weale, 1841 and 1853).

———, *An Apology for the Revival of Christian Architecture in England* (London: J. Weale, 1843).

Quennell, C. H. B., *Modern Suburban Houses* (London: Batsford, 1906).

Quinn, M. J., *Planning and Furnishing the Home, Practical and Economical Suggestions for the Homemaker* (New York: Harper Bros, 1914).

Reade, C., *Readiana: Comments on Current Events: Selections from the London Edition* (Germany: Bernhard Tauchnitz, 1882).

———, *Memorials of Old Herefordshire* (London: Bemrose, 1904).

Redgrave, R., "Supplementary Report on Design", in *Reports of the Juries*, Volume 2 (London, 1852).

Reid, D., *Essays on the Intellectual Powers of Man* (Edinburgh: John Bell, 1785).

Reid, T., *An Inquiry into the Human Mind, on the Principles of Common Sense: By Thomas Reid, D.D. Professor of Philosophy in King's College, Aberdeen* (Edinburgh, 1764).

Repton, H., *Observations on the Theory and Practice of Landscape Gardening* (London: Printed by T. Bensley for J. Taylor, [1803] in a new edition by J. C. Loudon; London: Longman, 1851).

*Revue Générale de l'architecture et des Travaux . . .*, Volume 15 (1857).

Richards, E. H., *Sanitation in Daily Life* (Boston: Whitcomb & Barrows, 1907).

Richardson, B. W., *Hygeia a City of Health* (London: Macmillan, 1876).

———, "Woman as Sanitary Reformer", *Fraser's Magazine*, 22, December (1880).

———, "Health in the Home", in S. F. Murphy (ed.), *Our Homes, and How to Make Them* (London: Cassell & Co., 1883).

Richardson, C. J., *The Englishmen's House* (London: Chatto and Windus, 1869).

Roberts, H., *The Dwellings of the Labouring Classes: Their Arrangement and Construction* (London: Society for Improving the Condition of the Working Classes, 1850).

Rogers, S., *The Poetical Works of Samuel Rogers* (London: Bell, 1892).

Rood, O. N., *Modern Chromatics: With Applications to Art and Industry* (London: C. Kegan Paul & Company, 1879).

Rothery, G., *Decorators' Symbols, Emblems & Devices* (London: Trade Papers Publishing, 1907).

———, *Ceilings and Their Decoration, Art and Archaeology* (New York: Frederick A. Stokes Company, 1911).

Rothschild, F., "French Eighteenth Century Art in England", *The Nineteenth Century*, 31 March (1892), p. 390.

Ruskin, J., *The Seven Lamps of Architecture* (London: Smith, Elder & Co., 1849).

———, *Stones of Venice* (London: Dent, 1851).

———, *Sesame and Lilies: Two Lectures Delivered at Manchester in 1864* (London: Smith Elder, 1865).

———, "Elements of Drawing", in *The Works of John Ruskin*, Volume 2 (New York: Alden, 1885).

———, *The Two Paths: Being Lectures on Art and Its Application to Decoration and Manufacture* (London: George Routledge & Sons, 1907).

———, *The Crown of Wild Olive & the Cestus of Aglaia*, ed. E. Rhys (London: J. M. Dent & Sons, 1915).

Ruutz-Rees, J. E., *Home Decoration* (New York: D. Appleton & Company, 1882).

Sanitary Reformer, *Cottages: How to Arrange and Build Them to Ensure Comfort, Economy, and Health* (London: Bemrose, 1879).

Scott, G. G., *Remarks on Secular & Domestic Architecture, Present & Future* (London: J. Murray, 1857).

Scott, W. B., "Ornamental Art in England", *Fortnightly Review*, 8, 46, October (1870), pp. 395–410.

Scott, W. B., et al., *Familiar Letters of Sir Walter Scott* (Edinburgh: David Douglas, 1823).

———, *The Letters of Sir Walter Scott 1821–1823*, Centenary Edition (London: Constable, 1934).

Sharp, G., *The Gilbart Prize Essay on the Adaptation of Recent Discoveries and Inventions in Science and Art to the Purposes of Practical Banking* (London: Groombridge and Sons, 1854).

Sheraton, T., *The Cabinet Dictionary* (1803) (New York: Praeger, 1970).

Simond, L., *Journal of Tour and Residence Great Britain, during the Years 1810 and 1811*, Volume 1, 2nd Edition (London: Longman, Hurst, Rees, Orme, and Brown, 1817).

Smalley, G. W., *London Letters: And Some Others in Two Volumes*, Volume 2 (New York: Harper & Brothers, 1891).

Smith, G., *A Collection of Designs for Household Furniture and Interior Decoration* (London: J. Taylor, 1808).

Smith, J., & Butcher, W., *Smith's Art of House-Painting Improved by W. Butcher Etc.* (R. H. Laurie, 1821).

Society for the Encouragement of Arts, Manufactures, and Commerce. Special Committee on the Statistics of Dwellings Improvement in the Metropolis, *Report [of the] Society for the Encouragement of Arts, Manufactures & Commerce . . . Addressed to the Council* (London: Printed by Simpkins, 1864).

Sotheran, Henry, Ltd., *The Christmas Bookseller* (London: Southeran, 1893).

Southey, R., *Letters from England: By Don Manuel Alvarez Espriella*, Translated from the Spanish in 3 Volumes, Volume 1, 3rd Edition (London: Longman, Hurst, Rees, Orme, and Brown, 1814).

Spofford, H. E. P., *Art Decoration Applied to Furniture* (New York: Harper & Brothers, 1878).

Staffe, B., *The Lady's Dressing Room*, Translated from the French by L. C. Campbell (London: Cassell, 1892).

Statham, H. H., "Is the Prevalent Taste for 'Art Furniture' and Bric-a-Brac Indicative of a Sound and Healthy Aesthetic Culture?", in *Transaction of the National Association for the Promotion of Social Science* (1878), pp. 762–4.

Stevenson, J., "On the Recent Reaction of Taste in English Architecture", *Builder*, 32, 27 June (1874), p. 540.

———, *House Architecture* (London: Macmillan, 1880).

Sturt, G., *The Wheelwright's Shop* (Cambridge: Cambridge University Press, 1923).

Sylvester, C., *The Philosophy of Domestic Economy* (London: Longman, Hurst, Rees, Orme and Brown, 1819).

Taine, H., *Notes on England* (London: Strahan & Co., 1872).

Tavenor-Perry, J., "The Pryor's Bank, Fulham", *The Antiquary*, 5, 10 (1909).

Tipping, H. A., "Lockleys, Hertfordshire, a Residence of Sir Eveline De La Rue, Bt", *Country Life*, 10 July (1920).

Topham, E., *The Life of the Late John Elwes Esquire Member in Three Successive Parliaments for Berkshire* (London: J. Ridgway, 1805).

Tressel, R., *The Ragged-Trousered Philanthropists* (London: Grant Richards Ltd., 1914).

Vallance, A., "Good Furnishing and the Decoration of the House", *The Magazine of Art*, 2 (1904), pp. 16–23.

Varney, A., *Our Homes and Their Adornments* (Detroit: J. C. Chilton, 1882).

Walsh, J. H., *Manual of Domestic Economy* (London: G. Routledge & Co., 1857).

Ward, J., *The World in Its Workshops: A Practical Examination of British and Foreign Processes of Manufacture, with a Critical Comparison of the Fabrics, Machinery, and Works of Art Contained in the Great Exhibition* (London: Williams S. Orr and Co., 1851).

———, *Ward and Lock's Home Book* (London: Ward Lock, 1882).

Ware, Rev. J. F. W., "The Sunday at Home", *The Monthly Religious Magazine*, Boston, August (1861), pp. 92–3.

Webb, S., "Furniture", in *Arts and Crafts Essays by Members of the Arts and Crafts Exhibition Society with a Preface by William Morris* (London: Rivington, Percival, & Co., 1893), pp. 89–98.

Webster, T., & Parkes, Mrs. W., *An Encyclopædia of Domestic Economy* (New York: Harper & Brothers, 1845).

Wharton, E., & Codman, O., *The Decoration of Houses* (New York: Scribners, 1897).

Wheeler, C., *Yesterdays in a Busy Life* (New York and London: Harper Bros, 1918).

Wheeler, G., *Rural Homes* (New York: Charles Scribner, 1851).

———, *The Choice of a Dwelling* (London: Murray, 1871).

Whitaker, H., *The Practical Cabinet Maker & Upholsterer's Treasury of Designs: House Furnishing & Decorating Assistant, Etc.* (London: Peter Jackson, 1847).

White, J. W. G., "The Epoch-Making House", *The Studio*, 56, November (1897), pp. 102–12.

White, W., *Aesthetical Sanitation* (London: Stanford, 1883).

Whitworth, J., & Wallis, G., *The Industry of the United States in Machinery, Manufactures, and Useful and Ornamental Arts: Compiled from the Official Reports of Messrs: Whitworth and Wallis* (London: G. Routledge & Co., 1854).

Wilkinson, G., *On Colour and on the Necessity for a General Diffusion of Taste among All Classes* (London: John Murray, 1858).

Williams, H. T., *Window Gardening: Devoted Specially to the Culture of Flowers and Ornamental Plants, for Indoor Use and Parlor Decoration* (New York: The Authors, 1877).

Wright, T., *Wanderings of an Antiquary Chiefly Upon the Traces of the Romans in Britain* (London: J. B. Nichols and Sons, 1854).

———, *Our New Masters* (London: Strahan, 1873).

Wyatt, M. D., *Reports on the Paris Universal Exhibition Part I* (London: H. M. Stationery Office, 1856).

Yapp, G. W., *Art Education at Home and Abroad: The British Museum, the National Gallery, and the Proposed Industrial University. Second Edition: With a Postscript* (London, 1853).

———, *Art Industry Furniture, Upholstery, and House-Decoration* (London: J. S. Virtue & Co., c. 1876).

## SECONDARY SOURCES

Allen-Emerson, M., Choi, T. Y., Hamlin, C., Crook, T., & Leckie, B., *Sanitary Reform in Victorian Britain* (London: Routledge, Taylor & Francis Group, 2016).

Benton, T., & Sharp, D., *Form and Function* (St. Albans: Granada, 1975).

Burke, D. B., *In Pursuit of Beauty: Americans and the Aesthetic Movement* (New York: Metropolitan Museum of Art, 1986).

Dickerson, V., *Keeping the Victorian House* (London: Routledge, 1995).

Edwards, C., "Complete House Furnishers: The Retailer as Interior Designer in Nineteenth-Century London", *Journal of Interior Design*, 38 (2013), pp. 1–17.

——— (ed.), *Nineteenth Century Design*, Volume 1–4 (Abingdon: Routledge, 2021).

Emery, E., *Photojournalism and the Origins of the French Writer House . . .* (London: Routledge, 2012).

Ferry, E., "'Any Lady Can Do This without Much Trouble . . .': Class and Gender in '*The Dining Room*'" (1878), *Interiors*, 5, 2 (2014), pp. 141–59.

Forty, A., *Objects of Desire* (London: Thames and Hudson, 1986).

Gilbert, C., *English Vernacular Furniture 1750–1900* (London: Yale, 1991).

Karcher, C. L., *The First Woman in the Republic a Cultural Biography of Lydia Maria Child* (Durham: Duke University Press, 1994).

Korsten, F., "Froude and Bunyan", *Neophilologus*, 77, 3 (1993).

Lindfield, P., *Georgian Gothic: Medievalist Architecture Furniture and Interiors 1730–1840* (Woodbridge: Boydell Press, 2016).

Long, H., *Victorian House and Their Details (The Role of Publications in Their Building and Decoration)* (Oxford: Architectural Press, 2002).

Mallgrave, H. F., *Architectural Theory*, Volume 2 (Oxford: Blackwell, 2008).

Newton, D., & Lumby, J., *The Grosvenors of Eaton* (Eccleston, Cheshire: Jennet Publications, 2002).

Nicoll, M. R., *The Letters of Annie Swan* (London: Hodder & Stoughton, 1945).

Nunn, P., *Victorian Women Artists* (London: Women's Press, 1987).

O'Brien, K. H. F., "'The House Beautiful' a Reconstruction of Oscar Wilde's American Lecture", *Victorian Studies*, 17, 4 (1974), pp. 395–418.

Ohles, F., et al., *Biographical Dictionary of Modern American Educators* (Westport: Greenwood Press, 1997).

Rasmo, N., *Martin Pacher*, tr. P. Waley (Phaidon: New York, 1971).

Symonds, R., & Whineray, B., *Victorian Furniture* (London: Country Life, 1962).

Thornton, P., *Authentic Décor* (London: Weidenfeld and Nicolson, 1984).

Tooley, M. J., *Gertrude Jekyll: Artist, Gardener, Craftswoman: A Collection of Essays to Mark the 50th Anniversary of Her Death* (Witton-le-Wear, Co. Durham: Michaelmas Books, 1984).

Tristram, P., *Living Space in Fact and Fiction* (London: Routledge, 1989).

Wilkinson, A., "The Preternatural Gardener: The Life of James Shirley Hibberd (1825–90)", *Garden History*, 26, 2 (1998), pp. 153–75.

## JOURNALS AND NEWSPAPERS

*Aberystwyth Observer*

*Academy and Literature*

*American Architect and Building News*

*American Art Review*, Boston

*Annual Review and History of Literature*

*Appleton's Journal: A Magazine of General Literature*

*Apprentice*

*Architect*

*Architectural Review*

*Architecture*

*Art Age*, New York

*Art Amateur*, New York

*Art and Decoration*, New York

*Arthur's Illustrated Home Magazine*

*Art Interchange*, New York

*Artist and Journal of Home Culture*

*Artizan*

*Art Journal*

*Art Journal* (Appleton's), New York

*Art Pictorial and Industrial*

*Art-Union*

*Art-Worker*, New York

*Athenaeum*

*Baily's Magazine of Sports and Pastimes*

*Bazaar Exchange and Mart, and Journal of the Household*

*Bentley's Miscellany*

*Bibliophile: A Magazine and Review for the Collector, Student and General Reader*

*Biograph and Review*

*Blackwood's Edinburgh Magazine*
*Bookman*
*Bookseller*
*Bow Bells Weekly*
*British Almanac*
*British Architect*
*British Medical Journal*
*British Metropolis*
*Builder*
*Building News*
*Burlington Magazine*
*Cabinet Maker and Art Furnisher*
*Carpentry and Building*, New York
*Carpet Trade Review*, New York
*Century Illustrated Monthly Magazine*, New York
*Christmas Bookseller*
*Civil Engineer and Architects Journal*
*Connoisseur*
*Cornhill Magazine*
*Cosmopolitan*
*Country Gentleman: Sporting Gazette, Agricultural Journal, and the Man about Town*
*Country Life Illustrated*
*Craftsman*
*Critic*, New York
*Crockery and Glass Journal*, New York
*Daily Graphic*
*Decorator and Furnisher*, New York
*Delineator*
*Dunstan Times*
*Ecclesiologist*
*Edinburgh Review*
*Elegant Arts for Ladies*
*Eliza Cook's Journal*
*Engineer*
*English Mechanic and World of Science*
*Englishwoman's Domestic Magazine*
*Examiner*
*Express*
*Federal Architect*
*Figaro in London*
*Fine Arts Journal*
*Fraser's Magazine for Town and Country*
*Fun*
*Furniture and Decoration*
*Furniture Gazette*
*Furniture Trade Review*, New York
*Furniture World and Furniture Buyer and Decorator*, New York
*Galignani's Magazine and Paris Monthly Review*

*The Gardener*
*Gentleman's Magazine*
*Globe and Traveller*
*Good Housekeeping*
*Good Words*
*Graphic*
*Hampshire Advertiser*
*Harper's Bazar*
*Harper's New Monthly Magazine,*
*Harper's Weekly*
*Hearth and Home*
*House Furnisher*
*The Hub*
*Igdrasil (Journal of the Ruskin Reading Guild)*
*Illustrated Carpenter and Builder*
*Illustrated London News*
*The Imperial Magazine*
*International Studio*
*John Bull*
*Journal of Decorative Art*
*Journal of Design and Manufactures*
*Journal of Indian Art*
*Journal of Psychological Medicine and Mental Pathology*
*Journal of the Royal Dublin Society*
*Journal of the Royal Institute of British Architects*
*Journal of the Society of Arts*
*Kunst und Kunsthandwerk; monatsschrift herausgegeben vom Österreichischen museum fuer kunst und industrie*
*Ladies' Treasury*
*Lancaster Gazette and General Advertiser for Lancashire, Westmorland, and Yorkshire*
*Leeds Mercury*
*Le Follet: Journal Du Grand Monde, Fashion, Polite Literature, Beaux Arts &C. &C.*
*Lippincott's Magazine of Literature, Science and Education*
*Literary Chronicle and Weekly Review*
*Literary World: A Monthly Review of Current Literature*
*London Gazette*
*London Quarterly and Holborn Review*
*London Society*
*Lowell Ledger*
*Magazine of Art*
*Manchester Guardian*
*Manufacturer and Builder*
*Mechanic's Magazine*
*Metropolitan Magazine*
*Monthly Critical Gazette,*
*Monthly Journal for Women*
*Monthly Review or Literary Journal*
*Morning Post*

*Musical World*
*Myra's Journal of Dress and Fashion*
*Nation*
*Nature*
*New Monthly Magazine*
*New York Evening Post*
*Notes and Queries*
*Pall Mall Gazette*
*Parthenon*
*The Path*
*Penny Magazine of the Society for the Diffusion of Useful Knowledge*
*Portfolio*
*Prospective Review*
*Punch*
*Quarterly Review*
*Quiver*
*Reliquary and Illustrated Archaeologist*
*Review of Reviews*
*The Rose, the Shamrock, and the Thistle*
*San Francisco Morning Call*
*Saturday Review of Politics, Literature, Science and Art*
*Scottish Review*
*Scribner's Monthly*
*Spectator*
*Standard*
*Statesman*
*St James's Gazette*
*Studio*
*Times*
*Today*
*Truth*
*Unitarian Review and Religious Magazine*
*Vassar Miscellany*
*Victoria Magazine*
*Vogue*
*Wesleyan-Methodist magazine*
*Westminster and Foreign Quarterly Review*
*Workshop*
*Young Ladies' Journal*
*Young Ladies Treasure Book*

# INDEX

Note: Page numbers in *italic* indicate a figure on the corresponding page.

accessories 397–9
advertising 522–4, 541–2, 547–8
advice: 'The Arts in the Household; or Decorative Art Applied to Domestic Uses' (Atkinson) 147–8, 149–53; 'Concerning Interiors,' *The Landscape Gardening and Landscape Architecture of the Late Humphrey Repton, Esq.* (Repton and Loudon) 123–4, 125–9, *128–9*; 'Decoration of the House' (Heaton) 175–6, 177–80; 'The Dining Room. No. I' 'Hints for the Decoration and Furnishing of Dwellings' (anon) 131–2, 133–8; 'Furnish,' *The Cabinet Dictionary* (Sheraton) 117–18, 119–21; *Home Truths for Home Peace* (M. B. H.) 141–2, 143–6; 'Interior Decoration of the House' (Atkinson) 155–6, 157–64; *Ornamental Interiors Ancient and Modern* (Smith) 165–6, 167–74; 'What to Avoid in House-Furnishing' (Cutler) 181, 183–9;
aesthetics 3–4; 'Art in Domestic Matters; or Æsthetics in the House' (Arne) 19, 21–5; *Beauty in the Household* (Dewing) 27–8, 29–31, 33, 35–8; 'Making the Best of It' (Morris) 11–12, 13–16; "Principles of Interior Decoration" (Edis) 39–40, 41–7; 'Some Remarks on Architectural Design, as Affecting the Inferior Arts Connected with Building' (Trotman) 5–6, 7–10; 'Women's Aesthetic Mission' (Falke) 337–8, 339–43
'Aims and Conditions of the Modern Decorator, The' (Voysey) 459–60, 461–9

amateur: 'Amateur and Architectural Amateur Decorators' (Smith) 373, 375–8
antiquarian 148, 332, 473
antiques 119–20, 333–4, 409–11, 512–14
architect: 'The Architect versus the Cabinet Maker and Others' (anon) 439–40, 441–4; 'The Relation of the Architect to the Decorator' (Day) 451–2, 453–6
architecture 437–8; 'Amateur and Architectural Amateur Decorators' (Smith) 373, 375–8; *Remarks on Secular and Domestic Architecture, Present and Future* (Scott) 561–2, 563–5; 'Some Remarks on Architectural Design, as Affecting the Inferior Arts Connected with Building' (Trotman) 5–6, 7–10
aristocracy 180, 256, 511–14
Arne, R. W.: 'Art in Domestic Matters; or Æsthetics in the House' 19, 21–5
art: 'Art in Domestic Matters; or Æsthetics in the House' (Arne) 19, 21–5; 'The Arts in the Household; or Decorative Art Applied to Domestic Uses' (Atkinson) 147–8, 149–53; 'Art Room, An' (Hood) 491, 493–5; 'Decorating Art as an Employment for Ladies' (anon) 325, 327–35; domestic 417–23; 'Interior Decoration of the House' (Atkinson) 155–6, 157–64; *Principles of Domestic Taste* (Salisbury) 81–2, 83–6; 'Some Remarks on Architectural Design, as Affecting the Inferior Arts Connected with Building' (Trotman) 5–6, 7–10;

'A Visit to Bailey, Banks & Biddle's Art Rooms' (Riordan) 497, 499–508
art furnishing 383, 482
'Art in Domestic Matters; or Æsthetics in the House' (Arne) 19, 21–5
artisan 331, 342
Art Nouveau 176, 540
*Art of Housekeeping: A Bridal Garland* (Haweis) 231–2, 233–7
'Art Room, An' (Hood) 491, 493–5
Arts and Crafts 452, 517
'Arts in the Household; or Decorative Art Applied to Domestic Uses, The' (Atkinson) 147–8, 149–53
Atkinson, Joseph Beavington: 'The Arts in the Household; or Decorative Art Applied to Domestic Uses' 147–8, 149–53; 'Interior Decoration of the House' 155–6, 157–64

bad taste 51–2, 71, 105, 126, 149–51
bathrooms 181, 193, 236, 533
Bayard, Mary Temple: 'How to Beautify a Home' 379, 381–6
'Beautiful Woman's Home, The' (Marquise de Fontenoy) 403, 405–12
beauty 3–4; 'Art in Domestic Matters; or Æsthetics in the House' (Arne) 19, 21–5; *Beauty in the Household* (Dewing) 27–8, 29–31, 33, 35–8; 'Making the Best of It' (Morris) 11–12, 13–16; "Principles of Interior Decoration" (Edis) 39–40, 41–7; 'Some Remarks on Architectural Design, as Affecting the Inferior Arts Connected with Building' (Trotman) 5–6, 7–10;
*Beauty in the Household* (Dewing) 27–8, 29–31, 33, 35–8
bedrooms 406–8
beds 106, 224–8
bedsteads 207, 224, 272, 543, 570
Beecher, Catherine Esther: 'On the Care of Parlors' *A Treatise on Domestic Economy for the Use of Young Ladies* 195–6, 197–9
billiard rooms 539
blinds 205–6, 224, 227, 283
bookcase 68, 258, 283, 285, 400, 508, 548
borders 90–1, 333–4
boudoirs 144–5, 408–9
breakfast room 23, 119, 539
bric-a-brac 187–9, 382–3
Brussels carpet 224, 331

building: 'Some Remarks on Architectural Design, as Affecting the Inferior Arts Connected with Building' (Trotman) 5–6, 7–10
Bunce, Mrs Oliver Bell: 'Mrs. Kate Collins, the Artist Decorator' 395, 397–402

Caddy, Florence: *Household Organization* 221–2, 223–9
Cardwell, John Henry: *Two Centuries of Soho* 509, 511–15
carpets 14, 73–4, 90, 136, 144–5, 151, 162–3, 168, 197–8, 203–7, 224, 235–6, 244, 250, 350, 376, 390–2, 401, 406–10, 448–9, 520–1, 528–9, 534, 543
ceilings 13–16, 41–2, 45–7, 90, 99–100, 134, 138, 157–8, 162–3, 212, 335, 348–9, 391, 467, 531–2
chairs: cleaning 206
chimneypiece 134, 514
class 113, 133–4, 142–3, 179, 211–18, 249–50, 305–6, 325
cleanliness 193–4; *Art of Housekeeping: A Bridal Garland* (Haweis) 231–2, 233–7; *Common-Sense Homes* (Sills) 239–40, 241–5; *Household Organization* (Caddy) 221–2, 223–9; 'The Influence of Order, Method, and Cleanliness, in Factories and Workshops, upon the Homes of the Industrial Population of Large Towns' (Richards) 209–10, 211–19; *Miss Leslie's Lady's House-Book* (Leslie) 201, 203–7; 'On the Care of Parlors' *A Treatise on Domestic Economy for the Use of Young Ladies* (Beecher) 195–6, 197–9
Cobbe, Frances Power: *The Duties of Women* 355–6, 357–9
collector's system 549
colour: aesthetics and beauty 14–16, 27, 41–7; architects, designers and decorators 455, 462–8, 474–6; comfort 271–4; decorating advice 134–8, 147, 150–3, 158–64, 167–8, 171–3; gender and identity 330, 333–5, 348–50, 361–2, 375–6; retailers and purchasing practices 520–2, 528–34, 550–1; taste 67–9, 73, 89–91
colour schemes 27, 361, 543
comfort 249–50; 'Comfort' *The Gentleman's House* (Kerr) 277–8, 279–80; *Common-Sense Homes*

(Sills) 239–40, 241–5; 'Concerning Interiors,' *The Landscape Gardening and Landscape Architecture of the Late Humphrey Repton, Esq.* (Repton and Loudon) 123–4, 125–9, *128–9*; 'Home is Home Be It Never So Homely' (Mayhew) 261–2, 263–7; *Home Truths for Home Peace* (M. B. H.) 483, 485–9; *Notes on England* (Taine) 281–2, 283–4; 'Our Household Goods' (anon) 269, 271–5; *Saunterings in and about London* (Schlesinger and Wenckstern) 251–2, 253–60; *Thrift* (Smiles) 285, 287–9

conservatories 53, 125–6, 249, 283, 409, 495

consumption 259, 264

Cook, Eliza: 'Three Hundred Pounds a Year' 305–6, 307–8

cooking 167, 235, 375, 429–30

Cooley, Anna M.: *Shelter and Clothing* 315–16, 317–19

cornice 15–16, 44–6, 349, 532–3

cosy corner 520, 522

cottages 242–3, 419, 431–2, 535–6, 581–2, 587

'Crace Company' (*Wymans Commercial Encyclopædia of Leading Manufacturers of Great Britain*) 471, 473–7

craft 11–12, 367, 466

craftsman's system 549–50

culture 331–3

Cunliffe-Owen, Marguerite: 'The Beautiful Woman's Home' 403, 405–12

curtains: aesthetics and beauty 21; cleanliness and housekeeping 197–8, 207, 223–9; decorating advice 144–6, 187; gender and identity 331–5, 351, 384–5, 390–1, 399–400, 405–6; retailers and purchasing practices 521, 527–30, 534–6

Cutler, Martha: 'What to Avoid in House-Furnishing' 181, 183–9

dados 23, 167, 375, 445

Day, Lewis F.: 'Decoration by Correspondence' 517, 519–24; 'How to Decorate a Room' 345, 347–53; 'The Relation of the Architect to the Decorator' 451–2, 453–6

'Decorating Art as an Employment for Ladies' (anon) 325, 327–35

decoration 113–15; 'The Arts in the Household; or Decorative Art Applied to Domestic Uses' (Atkinson) 147–8, 149–53; 'Concerning Interiors' (Repton and Loudon) 123–4, 125–9, *128–9*; 'Decorating Art as an Employment for Ladies' (anon) 325, 327–35; 'Decoration by Correspondence' (Day) 517, 519–24; 'Decoration of the House' (Heaton) 175–6, 177–80; 'The Dining Room. No. I' 'Hints for the Decoration and Furnishing of Dwellings' (anon) 131–2, 133–8; 'The Ethics of Home Decoration' (Miller) 573–4, 575–8; 'Furnish,' *The Cabinet Dictionary* (Sheraton) 117–18, 119–21; *The Hearthstone, or Life at Home* (Holloway) 579, 581–8; *Home Truths for Home Peace* (M. B. H.) 141–2, 143–6; 'How to Decorate a Room' (Day) 345, 347–53; 'Interior Decoration of the House' (Atkinson) 155–6, 157–64; 'Interior Decoration as a Profession for Women' (Wheeler) 387, 389–93; 'Luxury in House Decoration' (anon) 567, 569–72; *Ornamental Interiors Ancient and Modern* (Smith) 165–6, 167–74; "Principles of Good Taste in Furniture and Decoration" (anon) 87–8, 89–91; "Principles of Interior Decoration" (Edis) 39–40, 41–7; 'Relations of Interior Decoration with Costume and Complexion' (anon) 361–2, 363–5; 'What to Avoid in House-Furnishing' (Cutler) 181, 183–9

decorators 437–8; 'The Aims and Conditions of the Modern Decorator' (Voysey) 459–60, 461–9; 'Amateur and Architectural Amateur Decorators' (Smith) 373, 375–8; 'The Architect versus the Cabinet Maker and Others' (anon) 439–40, 441–4; 'Crace Company' (*Wymans Commercial Encyclopædia of Leading Manufacturers of Great Britain*) 471, 473–7; 'Doing Up One's House' (Loftie) 445–6, 447–50; 'Mrs. Kate Collins, the Artist Decorator' (Bunce) 395, 397–402; 'The Relation of the Architect to the Decorator' (Day) 451–2, 453–6; 'Women and Men: Women as Household Decorators' (anon) 367, 369–71

design: aesthetics and beauty 3–4, 46–7; architects, designers and decorators 439–40, 441–3, 445, 451–2, 455, 459; cleanliness and housekeeping 224, 239; decorating advice 114, 131, 160–3, 165, 175–6, 181, 186–7; gender and identity 334–5, 337, 345, 397–401, 410; 'Some Remarks on Architectural Design, as Affecting the Inferior Arts Connected with Building' (Trotman) 5–6, 7–10; taste 51–2, 63–4, 87–8, 93

designers 437–8; 'The Aims and Conditions of the Modern Decorator' (Voysey) 459–60, 461–9; 'The Architect versus the Cabinet Maker and Others' (anon) 439–40, 441–4; 'Crace Company' (*Wymans Commercial Encyclopædia of Leading Manufacturers of Great Britain*) 471, 473–7; 'Doing Up One's House' (Loftie) 445–6, 447–50; 'The Relation of the Architect to the Decorator' (Day) 451–2, 453–6

design reform 131, 209

Dewing, Maria O.: *Beauty in the Household* 27–8, 29–31, 33, 35–8

dining rooms 411–12; 'The Dining Room. No. I' 'Hints for the Decoration and Furnishing of Dwellings' (anon) 131–2, 133–8

disease 240, 242–5

'Doing Up One's House' (Loftie) 445–6, 447–50

domestic art 417–23

domestic interiors xvi–xvii

domesticity 293–4; 'The Home Paradise' (Lethbridge) 299, 301–4; 'The Ideal Home' (Swan) 309, 311–13; *The Nemesis of Faith* (Froude) 295, 297–8; *Shelter and Clothing* (Kinne and Cooley) 315–16, 317–19; 'Three Hundred Pounds a Year' (Cook) 305–6, 307–8

Dow, Jesse E.: 'The Happy Home' 557, 559–60

draperies 224–5, 364, 381–6, 399–400, 406, 520–1

drawing rooms 409–11

dress and appearance 43, 84, 178, 214, 283, 288, 400, 422, 514, 569

dressing rooms 225–6

*Duties of Women, The* (Cobbe) 355–6, 357–9

Edis, Robert W.: "Principles of Interior Decoration" 39–40, 41–7

Elder-Duncan, John H.: 'Hints to Purchasers' 539–40, 541–3

electricity 430

Elizabethan 14, 74, 244, 445, 515, 547

empire xv, 501–2, 511

emulation 30, 118, 159, 328

entertaining 571

equipment: *Common-Sense Homes* (Sills) 239–40, 241–5

'Ethics of Home Decoration, The' (Miller) 573–4, 575–8

exhibitions 39, 148, 209, 327, 382–3, 471, 476, 509, 545, 570–1

Falke, Jacob von: 'Women's Aesthetic Mission' 337–8, 339–43

family: aesthetics and beauty 30–1; architects, designers and decorators 471, 474–6; comfort 257, 263–6; domesticity 293–4, 317–19; gender and ideni328, 391–3, 415, 432; housekeeping 235; retailers and purchasing practices 487–8, 513–14; spiritual matters 555–6, 563–4, 573–4, 585–7

femininity 323

feminism 299, 309, 415

fireplaces and mantelpieces 99–100, 167–71, 225, 351–2, 375–7, 406–7, 410–11, 529–35

flooring 430; scrubbing 206–7

Fontenoy, Marquise de: 'The Beautiful Woman's Home' 403, 405–12

form: aesthetics and beauty 5, 8–9, 27–8, 44–5; decorating advice 158–9; decorators 465–7; gender and identity 334, 337, 349–52; taste 56–60, 68, 96–7, 101–2

friezes 15–16, 21–2, 35–6, 44–6, 159, 171–2, 349, 467–8, 504–6, 534

Froude, James Anthony: *The Nemesis of Faith* 295, 297–8

furnishing: The Dining Room. No. I' 'Hints for the Decoration and Furnishing of Dwellings' (anon) 131–2, 133–8; 'Furnish', *The Cabinet Dictionary* (Sheraton) 117–18, 119–21; *The Hearthstone, or Life at Home* (Holloway) 579, 581–8; *Hints on House Furnishing* (Sparrow) 545–6, 547–52; 'What to Avoid in House-Furnishing' (Cutler) 181, 183–9

Furniss, Averil Sanderson: 'The Views of the Woman in the Home' 425–6, 427–33

furniture: 'Good and Bad Furniture' (Hunter) 103–4, 105–9; 'Principles of Good Taste in Furniture' (anon) 71–2, 73–9, *75–9*; "Principles of Good Taste in Furniture and Decoration" (anon) 87–8, 89–91

gardens 29, 53–4, 57, 98, 123, 126, 301–2, 429–32, 445–6

gas 24, 260, 370, 410, 430

gender 323–4; 'Amateur and Architectural Amateur Decorators' (Smith) 373, 375–8; 'The Beautiful Woman's Home' (Marquise de Fontenoy) 403, 405–12; 'Decorating Art as an Employment for Ladies' (anon) 325, 327–35; *Duties of Women, The* (Cobbe) 355–6, 357–9; *Home, Its Work and Influence, The* (Gilman) 415–16, 417–23; 'How to Beautify a Home' (Bayard) 379, 381–6; 'How to Decorate a Room' (Day) 345, 347–53; 'Interior Decoration as a Profession for Women' (Wheeler) 387, 389–93; 'Mrs. Kate Collins, the Artist Decorator' (Bunce) 395, 397–402; 'Relations of Interior Decoration with Costume and Complexion' (anon) 361–2, 363–5; 'Views of the Woman in the Home, The' (Furniss, Sanderson and Phillips) 425–6, 427–33; 'Women's Aesthetic Mission' (Falke) 337–8, 339–43; 'Women and Men: Women as Household Decorators' (anon) 367, 369–71

gender roles 195, 293

*Gentleman's House*: 'Comfort' (Kerr) 277–8, 279–80

Gilman, Charlotte Perkins: *The Home, Its Work and Influence* 415–16, 417–23

glass 14, 22–3, 37, 127, 205, 225–9, 333–4

'Good and Bad Furniture' (Hunter) 103–4, 105–9

good taste: *The House in Good Taste* (Wolfe) 93–4, 95–102; 'Principles of Good Taste in Furniture' (anon) 71–2, 73–9, *75–9*; "Principles of Good Taste in Furniture and Decoration" (anon) 87–8, 89–91

Gothic Revival 475, 561

graining 42, 66–7, 135, 168–9, 376–7

Great Exhibition 1851 131, 471, 476

halls and staircases 42–3, 119–20, 126–7, 206–7, 332–3, 408–9, 448–9, 505–6, 514–15, 521–2

'Happy Home, The' (Dow) 557, 559–60

Haweis, Mrs Mary: *The Art of Housekeeping: A Bridal Garland* 231–2, 233–7

health and hygiene 39–40, 43, 193, 213–18, 239, 241–5, 318–19

*Hearthstone, or Life at Home, The* (Holloway) 579, 581–8

heating 99, 193, 319, 588

Heaton, John Aldam: 'Decoration of the House' 175–6, 177–80

Hibberd, James Shirley: 'Homes of Taste' 53–4, 55–61

*Hints on House Furnishing* (Sparrow) 545–6, 547–52

'Hints to Purchasers' (Elder-Duncan) 539–40, 541–3

hire purchase 542, 547–8

Holloway, Laura C.: *The Hearthstone, or Life at Home* 579, 581–8

home 293–4; 'The Beautiful Woman's Home' (Marquise de Fontenoy) 403, 405–12; *Common-Sense Homes* (Sills) 239–40, 241–5; 'The Ethics of Home Decoration' (Miller) 573–4, 575–8; 'The Happy Home' (Dow) 557, 559–60; *The Hearthstone, or Life at Home* (Holloway) 579, 581–8; 'Home is Home Be It Never So Homely' (Mayhew) 261–2, 263–7; 'The Home Paradise' (Lethbridge) 299, 301–4; 'Homes of Taste' (Hibberd) 53–4, 55–61; *Home Truths for Home Peace* (M. B. H.) 483, 485–9; *The Home, Its Work and Influence* (Gilman) 415–16, 417–23; 'How to Beautify a Home' (Bayard) 379, 381–6; 'The Ideal Home' (Swan) 309, 311–13; 'The Influence of Order, Method, and Cleanliness, in Factories and Workshops, upon the Homes of the Industrial Population of Large Towns' (Richards) 209–10, 211–19; 'The Views of the Woman in the Home' (Furniss, Sanderson and Phillips) 425–6, 427–33

home-making 113–15

home management 221

'Home Paradise, The' (Lethbridge) 299, 301–4

'Homes of Taste' (Hibberd) 53–4, 55–61

*Home Truths for Home Peace* (M. B. H.)
141–2, 143–6, 483, 485–9
Hood, John V.: 'An Art Room' 491, 493–5
hospitality 59, 288, 318, 564
*Household Organization* (Caddy) 221–2,
223–9
*House in Good Taste, The* (Wolfe) 93–4,
95–102
housekeeping 193–4; *Art of Housekeeping:
A Bridal Garland* (Haweis) 231–2, 233–7;
*Common-Sense Homes* (Sills) 239–40,
241–5; *Household Organization* (Caddy)
221–2, 223–9; 'The Influence of Order,
Method, and Cleanliness, in Factories
and Workshops, upon the Homes of the
Industrial Population of Large Towns'
(Richards) 209–10, 211–19; *Miss Leslie's
Lady's House-Book* (Leslie) 201, 203–7;
'On the Care of Parlors' *A Treatise on
Domestic Economy for the Use of Young
Ladies* (Beecher) 195–6, 197–9
housework 432
housing 425–6, 427–9, 433
'How to Beautify a Home' (Bayard) 379,
381–6
'How to Decorate a Room' (Day) 345,
347–53
Hunter, George Leland: 'Good and Bad
Furniture' 103–4, 105–9

'Ideal Home, The' (Swan) 309, 311–13
identity 323–4; 'Amateur and Architectural
Amateur Decorators' (Smith) 373, 375–8;
'The Beautiful Woman's Home' (Marquise
de Fontenoy) 403, 405–12; 'Decorating
Art as an Employment for Ladies' (anon)
325, 327–35; *Duties of Women, The*
(Cobbe) 355–6, 357–9; *Home, Its Work
and Influence, The* (Gilman) 415–16,
417–23; 'How to Beautify a Home'
(Bayard) 379, 381–6; 'How to Decorate
a Room' (Day) 345, 347–53; 'Interior
Decoration as a Profession for Women'
(Wheeler) 387, 389–93; 'Mrs. Kate
Collins, the Artist Decorator' (Bunce) 395,
397–402; 'Relations of Interior Decoration
with Costume and Complexion' (anon)
361–2, 363–5; 'Views of the Woman
in the Home, The' (Furniss, Sanderson
and Phillips) 425–6, 427–33; 'Women's
Aesthetic Mission' (Falke) 337–8, 339–43;
'Women and Men: Women as Household
Decorators' (anon) 367, 369–71

imitation 7, 42, 74, 133–5, 168, 171, 376,
421–2, 449, 462, 511–12
individuality 312, 385
Industrial Revolution xiv–xv
'Influence of Order, Method, and
Cleanliness, in Factories and
Workshops, upon the Homes of the
Industrial Population of Large Towns,
The' (Richards) 209–10, 211–19
ingrain carpet 197–8, 412
'Interior Decoration as a Profession for
Women' (Wheeler) 387, 389–93
'Interior Decoration of the House'
(Atkinson) 155–6, 157–64
interior designers 481

Kerr, Robert: 'Comfort' *The Gentleman's
House* 277–8, 279–80
Kidderminster carpet 224
Kinne, Helen: *Shelter and Clothing* 315–16,
317–19
kitchens 145–6, 206–7, 211–13, 228,
234–7, 259–60, 418–19, 430

lace curtains 229, 384
lady decorators 165–6, 169, 373, 377, 395
*Landscape Gardening and Landscape
Architecture of the Late Humphrey
Repton, Esq.*:
'Concerning Interiors' (Repton and
Loudon) 123–4, 125–9, *128–9*
laundry 193–4
leisure 56–7, 153, 298, 428–9, 454
Leslie, Eliza: *Miss Leslie's Lady's House-
Book* 201, 203–7
Lethbridge, Joseph Watts: 'The Home
Paradise' 299, 301–4
libraries 119–21, 125–6, 134–5, 502,
507–8
lighting 22, 39, 102, 193, 364, 504
linoleum 181
Loftie, Martha Jane: 'Doing Up One's
House' 445–6, 447–50
Loudon, John Claudius: 'Concerning
Interiors,' *The Landscape Gardening
and Landscape Architecture of the Late
Humphrey Repton, Esq.* 123–4, 125–9,
*128–9*
Louis styles 98–101, 105–6, 410–12, 495,
499, 511–12, 522–3
luxury 150–2, 226–7, 250, 274–5, 405–6;
'Luxury in House Decoration' (anon)
567, 569–72

'Making the Best of It' (Morris) 11–12, 13–16
mansions 59, 474–6, 512–13, 563
mantelpieces 167–71, 225, 375–7, 406–7, 410–11, 532–5
manuals: *The Hearthstone, or Life at Home* (Holloway) 579, 581–8; *Miss Leslie's Lady's House-Book* (Leslie) 201, 203–7
manufactures 51, 71, 87, 131, 150–2, 155, 214–16, 335, 345, 387, 390–2, 439–40, 547–52; 'Crace Company' (*Wymans Commercial Encyclopædia of Leading Manufacturers of Great Britain*) 471, 473–7
marble 199, 226–8, 257–9, 364, 411–12, 512–13, 532–5
matting 197–8, 283, 399, 529–30, 534
Mayhew, Henry: 'Home is Home Be It Never So Homely' 261–2, 263–7
M. B. H.: *Home Truths for Home Peace* 141–2, 143–6, 483, 485–9
medievalism 152, 164
middle classes 249–50, 325
Miller, James Russell: 'The Ethics of Home Decoration' 573–4, 575–8
mirrors 125–7, 578
*Miss Leslie's Lady's House-Book* (Leslie) 201, 203–7
modern house, development of 95–9
Moorish style 522
morality 54, 88, 269, 555–6
morning room 539
Morris, William: 'Making the Best of It' 11–12, 13–16
moulding 41, 44–6, 67, 79, 443, 449, 549–51
"Mr. Eastlake on Taste" (anon) 63–4, 65–9
'Mrs. Kate Collins, the Artist Decorator' (Bunce) 395, 397–402

*Nemesis of Faith, The* (Froude) 295, 297–8
*Notes on England* (Taine) 281–2, 283–4
novelty 61, 175–6, 178, 331, 400
nurseries 23, 84, 145, 257, 267, 487, 588

oilcloth 226, 259, 283, 449
'On the Care of Parlors' *A Treatise on Domestic Economy for the Use of Young Ladies* (Beecher) 195–6, 197–9
Orientalism 186, 278, 279, 335, 407–8
ornament 5–6, 36–7, 41–5, 74, 77, 90–1, 105–7, 158–9, 165, 330–1, 364, 373;

*Ornamental Interiors Ancient and Modern* (Smith) 165–6, 167–74
'Our Household Goods' (anon) 269, 271–5
overmantels 530, 535

paint 15, 185, 389, 447–9, 521–2, 531–4; cleaning 205
panelling 16, 468, 509, 514, 530–1
Panton, Jane Ellen: 'Parlours' 525–6, 527–36
papier mâché 41–2
parlours: 'Parlours' (Panton) 525–6, 527–36
periodicals 19, 39, 148, 155, 218, 557
personality 3, 97–8, 100, 105, 385
Phillips, Marion: 'The Views of the Woman in the Home' 425–6, 427–33
planning and arrangement of rooms 13–14, 27–8, 43–7, 89, 96–7, 280, 341, 348, 390–2, 428–9, 432–3, 494, 529, 542
plants and flowers: aesthetics and beauty 19, 24–5, 41; cleanliness and housekeeping 229; decorating advice 150–1, 161–3, 168; domesticity 303; gender and identity 332–4, 376, 398–401, 408–12, 421; retailers and purchasing practices 504–6, 528–31; spiritual matters 576; taste 56–7, 74–6, 90–1
plumbing and sanitation 98, 170, 193–4, 240, 315, 319
portieres 187, 364, 370, 384, 409, 521
possessions 269, 527–8
poverty 30, 271, 386, 411, 463, 586
Pre-Raphaelites 175
*Principles of Domestic Taste* (Salisbury) 81–2, 83–6
'Principles of Good Taste in Furniture' (anon) 71–2, 73–9, 75–9
"Principles of Good Taste in Furniture and Decoration" (anon) 87–8, 89–91
"Principles of Interior Decoration" (Edis) 39–40, 41–7
privacy 84, 195, 234, 317–18, 530, 587
proportion 99–102
purchasing practices 481–2; 'An Art Room' (Hood) 491, 493–5; 'Decoration by Correspondence' (Day) 517, 519–24; *Hints on House Furnishing* (Sparrow) 545–6, 547–52; 'Hints to Purchasers' (Elder-Duncan) 539–40, 541–3; *Home Truths for Home Peace* (M. B. H.) 483, 485–9; 'Parlours' (Panton) 525–6, 527–36; *Two Centuries of Soho* (Cardwell) 509, 511–15; 'A Visit to Bailey, Banks & Biddle's Art Rooms' (Riordan) 497, 499–508

Queen Anne 22, 170–1, 330

'Relation of the Architect to the Decorator, The' (Day) 451–2, 453–6
'Relations of Interior Decoration with Costume and Complexion' (anon) 361–2, 363–5
religion 298, 555–6, 573, 577–8, 586
*Remarks on Secular and Domestic Architecture, Present and Future* (Scott) 561–2, 563–5
Renaissance styles 74, 95–7, 105–6, 474–5
reproduction method 550–2
Repton, Humphry: 'Concerning Interiors,' *The Landscape Gardening and Landscape Architecture of the Late Humphrey Repton, Esq.* 123–4, 125–9, *128–9*
respectability 72, 193, 249, 271, 293
retailer *see* role of retailer
revivalism 462, 465
Richards, Samuel Wall: 'The Influence of Order, Method, and Cleanliness, in Factories and Workshops, upon the Homes of the Industrial Population of Large Towns' 209–10, 211–19
Riordan, R.: 'A Visit to Bailey, Banks & Biddle's Art Rooms' 497, 499–508
rococo revival 481
role of architect: 'The Aims and Conditions of the Modern Decorator' (Voysey) 459–60, 461–9; 'The Architect versus the Cabinet Maker and Others' (anon) 439–40, 441–4; 'Crace Company' (*Wymans Commercial Encyclopædia of Leading Manufacturers of Great Britain*) 471, 473–7; 'Doing Up One's House' (Loftie) 445–6, 447–50; 'The Relation of the Architect to the Decorator' (Day) 451–2, 453–6
role of designer: 'The Aims and Conditions of the Modern Decorator' (Voysey) 459–60, 461–9; 'The Architect versus the Cabinet Maker and Others' (anon) 439–40, 441–4; 'Crace Company' (*Wymans Commercial Encyclopædia of Leading Manufacturers of Great Britain*) 471, 473–7; 'Doing Up One's House' (Loftie) 445–6, 447–50; 'The Relation of the Architect to the Decorator' (Day) 451–2, 453–6
role of retailer 481–2; 'An Art Room' (Hood) 491, 493–5; 'Decoration by

Correspondence' (Day) 517, 519–24; *Hints on House Furnishing* (Sparrow) 545–6, 547–52; 'Hints to Purchasers' (Elder-Duncan) 539–40, 541–3; *Home Truths for Home Peace* (M. B. H.) 483, 485–9; 'Parlours' (Panton) 525–6, 527–36; *Two Centuries of Soho* (Cardwell) 509, 511–15; 'A Visit to Bailey, Banks & Biddle's Art Rooms' (Riordan) 497, 499–508
role of women 141, 196, 269, 294, 355
romanticism 95, 173, 258

Salisbury, Edward Elbridge: *Principles of Domestic Taste* 81–2, 83–6
Sanderson, Dorothy: 'The Views of the Woman in the Home' 425–6, 427–33
sanitation 98, 193, 240, 315
*Saunterings in and about London* (Schlesinger and Wenckstern) 251–2, 253–60
Schlesinger, Max: *Saunterings in and about London* 251–2, 253–60
Scott, Sir George Gilbert: *Remarks on Secular and Domestic Architecture, Present and Future* 561–2, 563–5
self-expression 249
servants 23–4, 143–6, 193–4, 221–2, 227–9, 232, 233–6, 256–7, 282, 585
*Shelter and Clothing* (Kinne and Cooley) 315–16, 317–19
Sheraton, Thomas: 'Furnish', *The Cabinet Dictionary* 117–18, 119–21
shops 101, 117, 214–15, 397, 541–3
Sills, Spencer: *Common-Sense Homes* 239–40, 241–5
simplicity 77, 97, 99–102, 105, 150–2, 163–4, 318–19, 418–20, 468
Smiles, Samuel: *Thrift* 285, 287–9
Smith, J. Moyr: 'Amateur and Architectural Amateur Decorators' 373, 375–8; *Ornamental Interiors Ancient and Modern* 165–6, 167–74
social reform 355, 379, 415
'Some Remarks on Architectural Design, as Affecting the Inferior Arts Connected with Building' (Trotman) 5–6, 7–10
Sparrow, Walter Shaw: *Hints on House Furnishing* 545–6, 547–52
spiritual matters 555–6; 'The Ethics of Home Decoration' (Miller) 573–4, 575–8; 'The Happy Home' (Dow) 557,

559–60; *The Hearthstone, or Life at Home* (Holloway) 579, 581–8; 'Luxury in House Decoration' (anon) 567, 569–72; *Remarks on Secular and Domestic Architecture, Present and Future* (Scott) 561–2, 563–5
stained glass 175, 454
stairway 97
status 3, 58, 103, 249, 482, 525, 562
stencilling 47
stock furnishing system 548–9
suburbs 244, 525; 'Parlours' (Panton) 525–6, 527–36
suitability 99–102
Swan, Annie S.: 'The Ideal Home' 309, 311–13

Taine, Hippolyte: *Notes on England* 281–2, 283–4
tapestries 103, 178, 332–3, 411–12
taste xvi, 51–2; 'Good and Bad Furniture' (Hunter) 103–4, 105–9; 'Homes of Taste' (Hibberd) 53–4, 55–61; *The House in Good Taste* (Wolfe) 93–4, 95–102; "Mr. Eastlake on Taste" (anon) 63–4, 65–9; *Principles of Domestic Taste* (Salisbury) 81–2, 83–6; 'Principles of Good Taste in Furniture' (anon) 71–2, 73–9, *75–9*; "Principles of Good Taste in Furniture and Decoration" (anon) 87–8, 89–91
textiles and drapery 224–5, 364, 381–6, 387, 399–400, 406, 409, 421, 520–1
'Three Hundred Pounds a Year' (Cook) 305–6, 307–8
*Thrift* (Smiles) 285, 287–9
tiles 532–3
tradition 95–7, 175–6, 178–80, 193, 552
Trotman, Ebenezer: 'Some Remarks on Architectural Design, as Affecting the Inferior Arts Connected with Building' 5–6, 7–10
*Two Centuries of Soho* (Cardwell) 509, 511–15

United States of America 81, 367, 387, 403, 573
upholstery 63–4, 329–31
utility 155, 158–9

Venetian blinds 198, 224
ventilation 223–4, 535

vestibules 125, 333
'Views of the Woman in the Home, The' (Furniss, Sanderson and Phillips) 425–6, 427–33
'Visit to Bailey, Banks & Biddle's Art Rooms, A' (Riordan) 497, 499–508
Voysey, Charles Francis Annesley: 'The Aims and Conditions of the Modern Decorator' 459–60, 461–9

wainscotting: cleaning 205
wallpaper 131, 415
walls: aesthetics and beauty 13–16, 22–3, 35–6, 41–3, 46–7; cleanliness and housekeeping 197–9, 204–5, 212; decorating advice 119–21, 133–7, 152–3, 159–62, 167–8, 183–8; gender and identity 329–33, 340–1, 348–9, 364, 375–6, 406–11, 418–20; retailers and purchasing practices 506–8; spiritual matters 577–8; taste 56–7, 90–1
water supply 193
Wenckstern, Otto: *Saunterings in and about London* 251–2, 253–60
'What to Avoid in House-Furnishing' (Cutler) 181, 183–9
Wheeler, Candace: 'Interior Decoration as a Profession for Women' 387, 389–93
white-washing 204–5
windows: aesthetics and beauty 13–14, 30, 36; architects, designers and decorators 448–50; cleanliness and housekeeping 223–9, 244; comfort 257–9, 265–7, 280, 288; decorating advice 127, 183–5; gender and identity 331–4, 349–51, 406; retailers and purchasing practices 506, 520–1, 527–36; taste 56–7; washing 205–6
Wolfe, Elsie de: *The House in Good Taste* 93–4, 95–102
women: 'Women's Aesthetic Mission' (Falke) 337–8, 339–43; 'Women and Men: Women as Household Decorators' (anon) 367, 369–71
woodwork 183–7, 350, 447–9
working class 214–18, 261–2, 556
world power xv
*Wymans Commercial Encyclopædia of Leading Manufacturers of Great Britain*: 'Crace Company' 471, 473–7